Images of the Pacific Rim

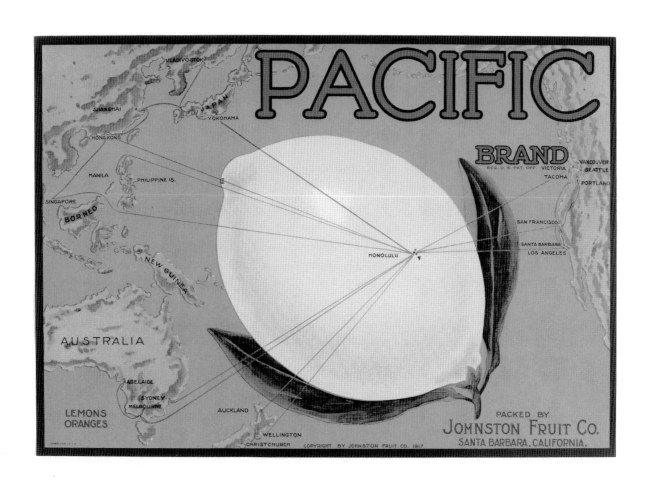

Images of the Pacific Rim

AUSTRALIA AND CALIFORNIA, 1850–1935

by Erika Esau

POWER PUBLICATIONS

Published with the assistance of the Getty Foundation and the Nelson Meers Foundation

Australian Studies in Art and Art Theory

Published by
Power Publications
Power Institute Foundation for Art and Visual Culture
University of Sydney
NSW 2006 Australia
www.sydney.edu.au/arts/power/power_publications

Managing Editor	Victoria Dawson
Assistant Editors	Kirsten Krauth and Emma White
General Editors	Mary Roberts and Anita Callaway
Executive Editor	Roger Benjamin
Copyeditor	Kirsten Krauth
Index by	Erika Esau and George Boeck
Design by	Marian Kyte, Victoria Dawson and Emma White
Printed by	Tien Wah Press

National Library of Australia Cataloguing-in-Publication entry:

Esau, Erika.

Images of the Pacific Rim: Australia and California, 1850-1935. 1st edn.

ISBN: 9780909952396 (pbk.)

Series: Australian studies in art and art theory.
Includes index.

Aesthetics.
National characteristics, Australian.
National characteristics, American.
Art, Australian.
Art, American.
Architecture.

Dewey Number: 111.85

Front cover and back cover (right): **James Northfield**, *Canberra, Federal Capital & Garden City, Australia* (detail), c. 1930. Colour lithograph. Courtesy of the James Northfield Heritage Art Trust ©.

Back cover (left): Glendora Brand citrus label, c. 1925. Courtesy of The Jay T. Last Collection. The Huntington Library, San Marino, California.

Frontispiece page 2: Pacific Brand label, Johnston Fruit Co., Santa Barbara, California, 1917. Courtesy of The Jay T. Last Collection. The Huntington Library, San Marino, California.

This book is part of the series *Australian Studies in Art and Art Theory* and is published with the assistance of the Getty Foundation and the Nelson Meers Foundation

NELSON MEERS
FOUNDATION

CONTENTS

FOR GEORGE

Auf welches Instrument sind wir gespannt?
Und welcher Geiger hat uns in der Hand?
O süßes Lied.

—Rainer Maria Rilke, 'Liebes–Lied', 1907

When the spin meister of post-modernity Jean Baudrillard laid out his 1986 exegesis of America's West, he conjured up a place with no there *there*. California, and particularly its southern reaches, was a mere simulacrum of every American sensual desire, domestic fantasy and nature-loving mantra. Witless California, filled up with suburban sprawl and theme parks, was the final, glorious result of America's 'mythic banality'. California was a lost land so joyfully mindless it would never savour the soulful pleasures of Old World angst.

What Monsieur B experienced as absence was in fact a seductive illusion created by California's unique and defining industry—the lucrative business of building a secular paradise. After the woeful losses of the Civil War and environmental abuses of robber baron industrialists, America needed an Eden to restore and preserve treasured Protestant ideals of society in harmony with an untouched nature. California delivered big by offering, literally and metaphorically, a ray of sunshine to restless inhabitants living in the moral darkness of Chicago, New York and Boston.

The Eden that California built was voracious. The state rendered what it had and what it received as inevitably Californian. The result was an infamous eclecticism, a forgiving world where the woodsy, Arts & Crafts bungalow shaded by Australian eucalypti was as welcome as a sun-filled Spanish revival *hacienda* in a garden of English perennials. To some, California appeared culturally indiscriminate. But that was the point: Everything and everyone had to be welcome in a profitable heaven on earth.

As Erika Esau reveals with literary élan, California sold its alluring dream through images received by way of cultural osmosis and capitalist strategies. The intersection of a national need for a California and the rapid evolution of printing technology, combined with new modes of distribution, made possible a proliferation of imagery at a speed unimagined. It is no wonder given the early histories of media production illuminated in these pages that California welcomed the movies and Silicon Valley.

America's 31st state teeters on an earthquake shelf along the Eastern length of the Pacific Rim. Already by the 1860s prescient entrepreneurs understood that California was not at the edge of America; it was mid-globe, positioned to engage with parts known and parts to be known. To the East was the other America, with tens of thousands of disenfranchised citizens who fled to the Pacific when railway tickets got cheap. To the West was Asia and, most pertinently, a continent with English-speaking folks: Australia.

If there is any place left today for destiny, manifest or not, then Australia and California are destiny's children. Both were maligned, sunny outposts under the thumb of old paternalistic cultures. Both needed to define their place in the world and both accomplished the task through interpretation and appropriation. How images assisted in the cultural definition of these lands is told here by a native Californian, who, not surprisingly, found herself at home in Australia.

Sam Watters is the author of *Houses of Los Angeles, 1885-1935* and other books and articles on American culture. He lives in Venice, California.

FOREWORD

A ustralia and California have shared much in environment and history. The export of Australian eucalyptus trees in the nineteenth century both contributed to and reflected a shared cultural history, and made certain aspects of Californian and Australian cultural landscapes seem more similar than before European settlement. From the time of the Victorian gold rushes that began in 1851, Californians have visited and sometimes stayed in this land, making contributions to Australian politics (including at the Eureka Stockade revolt of 1853), culture (cartoonist Livingston Hopkins among others) and business (the example of coachmakers Cobb and Co. is famous in Australia). More recently, American popular culture in the form of music and film has invaded Australia and adapted to local circumstances. The deeds of pioneers in gold digging and irrigation technology and enterprise have been told many times, and no one would be surprised to hear that the impact of the United States upon Australia has been large in the late twentieth century. But the story of the many Californian influences in the nineteenth century on Australian popular culture remains partly hidden.

Erika Esau's *Images of the Pacific Rim: Australia and California, 1850-1935* contributes to a growing understanding of these cultural connections. Her book is the first to focus squarely on visual representations of Australian and Californian landscapes and culture in transnational perspective. This is a story of the circulation of images as commodities made possible by the era of mass reproduction and consequent 'portability' of commercial art and design, and even architecture.

This Pacific Rim exchange was made possible by improvement in communications. The age of fast sail in the mid-nineteenth century—soon complemented and then superseded from the 1880s and beyond by regular steamship services—carried miners, and other people on the make in both directions. These links encouraged an itinerant class of artists and photographers whose work circulated widely. Technology, however, was key to the increased velocity of circulation—the lithograph, the camera, mass-market magazines and the like proliferated. Esau incorporates in her work the widely-dispersed visual resources encouraged by these technological and communications changes. She has sought out precious and obscure images from journals, posters, commercial advertising such as fruit-box labels, and popular art magazines. A feature is the vivid and little-known illustrations that do more than embellish the text; Esau's documentation of iconographic images is informed by critique and analysis as well as assiduous research. In her career as an art historian, Esau has herself lived the trans-Pacific life and is almost uniquely well-qualified to comment on shared experiences and perceptions. *Images of the Pacific Rim* is a labour of love, a delight to the casual reader, and a rich resource for future cultural historians to explore.

Ian Tyrrell is the Scientia Professor of History, The University of New South Wales, Sydney, Australia. He is the author of *True gardens of the gods: Californian-Australian environmental reform, 1860-1930.*

A project that has taken nearly 10 years to complete and that traverses the Pacific Ocean engenders debts of gratitude as enormous as that ocean. Ten years have also made inroads into my memory, so I first beg forgiveness to all those who contributed to this study but whom I may have forgotten to mention here. First and foremost, my deepest thanks must go to the entire staff of The Henry E. Huntington Library, Art Collections, and Botanical Gardens (The Huntington), San Marino, California, where I found the ideal setting in which to carry out research, find images and write. What a marvellous resource and what a splendid environment! Its serendipitous location near Pasadena also enabled me to fulfil a childhood dream of living there in a bungalow. Roy Ritchie, W. M. Keck Foundation director of research, oversaw the committee that awarded me two Andrew W. Mellon Library Fellowships, in 2001 and 2003, without which I would never have been able to move to California. I will be eternally grateful to Alan Jutzi, Avery chief curator, Rare Books, who by welcoming me into The Huntington 'family' made it possible to illustrate this book so richly. Special thanks must also go to the following curators and staff for their advice both practical and scholarly: Peter Blodgett, Sue Hodson, Erin Chase, Jean-Robert Durbin, Mario Einaudi, Jennifer Goldman, Dan Lewis, David Mihaly and Jenny Watts. Library volunteer Bob Herman has also shared his knowledge of Los Angeles history and offered an ear over many lunches. Within The Huntington scholarly community, I have appreciated the sage advice of Bill Deverell, director of The Huntington–USC Institute on California and the West, and leading voice on all Californian topics. In the Art Collections, I consulted Amy Meyers and her successor Jessica Smith, curators of American art; and Jacqueline Dugan, registrar, offered assistance. Linda Zoeckler, former librarian of the Art Collection Library, gave me free rein in that now-merged collection. Ann Scheid, curator of the Greene & Greene Archives, has been particularly generous with her knowledge about Pasadena architecture.

While The Gamble House staff are not an official part of The Huntington, the ties are so close that I want here to thank Ted Bosley, director, and curator Anne Malik for their support and advice on the subject of Arts & Crafts in California. Marian Yoshiki-Kovinick, formerly archivist at The Huntington's office of the Smithsonian's Archives of American Art, remains along with her husband Phil Kovinick an invaluable source of information about Californian art. In the botanical gardens, I talked to the late Michael Vasser, Gary Lyons and Kathy Musial on questions about Australian plants in California; Melanie Thorpe kindly allowed me access to the Botanical Library. Over the years, several fellow Readers have offered enlightening opinions and shared resources. I am particularly grateful to Jared Farmer, Greg Hise, Barbara Donagan, Timothy Erwin, Roberto Alvarez, Nicole Rice, Malcolm Rohrbough, Beth Haas and Veronica Castillo-Muñoz. Finally, my most heartfelt appreciation at The Huntington must go to my colleagues in Reader Services, who have offered friendship, employment and tremendous support throughout this long process. I list them here alphabetically: Christopher Adde, Romaine Ahlstrom, Meredith Berbee, Phillip Brontosaurus, Jill Cogen, Bryan Dickson, Juan Gomez, Kadin Henningsen, Leslie Jobsky, Claire Kennedy, Susi Krasnoo, Anne Mar, Mona Noureldin Shulman, Laura Stalker and Catherine Wehrey.

My research has, of course, led me to many other institutions and individuals. In the initial stages of this project (in 1998!) I was lucky enough to meet with Dr Kevin Starr, then California state librarian and now professor of history at the University of Southern California. Dr Starr has been one of the most enthusiastic supporters of my topic, for which I am immensely grateful. I owe my introduction to Dr Starr to my friend and fellow Santa Barbaran, Peter Detwiler, staff member for the California State Senate and networker extraordinaire. Peter also introduced me to Gary Kurutz, curator of Special Collections at the California State Library in Sacramento; Gary and his staff at the History Room have been particularly helpful from the beginning. Other important scholars on California studies that I have consulted include the late Peter Palmquist, leading collector and authority on photography of the American West; Graham Howe, Pasadena, an Australian–Californian, founder of Curatorial Assistance and keeper of the E. O. Hoppé estate; Joan deFato, former librarian at the Los Angeles County Arboretum; Sue Rainey, expert on Picturesque publications; Nancy Dustin Wall Moure, author of important books on Californian art; Michael Dawson, proprietor of Dawson's Books and a great source on the history of Los Angeles culture; Karen Sinsheimer, curator of photography at The Santa Barbara Museum of Art; Drew Johnson, curator of photography, Oakland Museum of California, who in turn put me in contact with Tom Horning, descendant of Isaac Wallace Baker; Romy Wylie, California Institute of Technology, an expert on Bertram Goodhue; John G. Ripley, indispensable researcher at the Pasadena History Museum and archivist of Pasadena architects; Julie Armistead, curator of the Hearst Gallery, St Mary's College, Moraga, California, who shares my enthusiasm for eucalypts in Californian art; Scott Shields, Crocker Art Museum, Sacramento, who has written about northern Californian artists; and Barbara Beroza, curator, Yosemite Museum National Park Service. My former professor at Bryn Mawr College and friend Barbara Miller Lane kindly read a draft of the chapter on bungalows and offered great ideas and corrections. I must also thank my advisor Steven Levine of Bryn Mawr who invited me to speak on my research at the college's Visual Culture Colloquium in 2002.

My affection for good librarians, archivists and curators was furthered by getting to know people such as Elise Kenney, archivist, Yale Art Gallery, who went to extraordinary lengths to help me with questions about Frederic Schell; Janene Ford, Holt–Atherton Special Collections Library, University of the Pacific, Stockton, California, and her staff for working with me in their John Muir Collection; Kim Bowden, librarian, Haggin Museum, Stockton, California, who ferreted out unknown Batchelder photographs; Simon Elliott, Department of Special Collections, Library, University of California, Los Angeles, offered aid and a serene attitude; and Patricia Keats, Library Director, Society of California Pioneers, San Francisco, whose many kindnesses have furthered this work. John Wickham at the Theodore Payne Foundation, Sun Valley, California, deserves thanks for allowing me access to Payne's archives on eucalypts.

I thank as well the staff of the Bancroft Library, University of California, Berkeley; North Baker Research Library, California Historical Society, San Francisco; Seaver Center for

Western History Research, Natural History Museum of Los Angeles County; the Phillips Library, Peabody Essex Museum, Salem, Massachusetts; Avery Architectural Library, Columbia University, New York; Photographs Collection, J. Paul Getty Museum, Los Angeles; Research Library, San Diego Historical Society, Balboa Park, San Diego; the Santa Barbara Historical Society Library; the Architecture and Design Collection, University of California, Santa Barbara; Tuolumne County Historical Society, Sonora, California; Madera County Historical Society, Madera, California; the San Francisco Historical Photograph Collection, San Francisco Public Library, San Francisco; and the Central Library of the Los Angeles Public Library. The Los Angeles County Museum of Art's library staff deserves special recognition, particularly Susan Trauger and Alexis Curry, for hiring me and thereby giving me access to amazing archival materials. Also at the museum, I thank Bruce Robertson, formerly chief curator of American Art, for his conversations about the challenges of comparative art history.

In Australia, my gratitude list is even longer. First I must thank my colleague and old Bryn Mawr friend Roger Benjamin from The University of Sydney (and former director of the university's Power Institute), for asking me to submit my book proposal for application to the Getty Grant program. Mention should be made here of The Getty Foundation of the J. Paul Getty Trust in Los Angeles, whose award of a publications grant to the Power Institute (their publishing section, Power Publications) made this book possible. Thanks also must go to the Nelson Meers Foundation, Sydney, for its grant to Power Publications to assist in publishing the book series of which this volume is a part. Since then, the publishing process has been almost entirely in the hands of Victoria Dawson, managing editor at the press, now with assistance of Emma White and guidance from Anita Callaway. Kirsten Krauth did a splendidly efficient job of copy editing. I would also like to thank the anonymous readers of the manuscript, who offered such detailed and insightful suggestions.

At the Australian National University, where this project began, many colleagues, some now at other institutions, offered advice and intellectual conversation over the years: Margaret Brown, Sasha Grishin, Paul Duro, John Clark, Rico Franses, Andrew Montana, Nicolas Peterson, Iain McCalman, Ian Farrington, Elisabeth Findlay, Jill Matthews and Christopher Forth, the latter now Jack and Shirley Howard Teaching Professor in Humanities and Western Civilization at the University of Kansas. I am also grateful to the university's Humanities Research Centre; as a Visiting Fellow there in 2001, I was able to begin formulating my ideas on the topic and presented the results at a symposium. Other venues in which I presented aspects of this research include the 2001 Conference of the Art Association of Australia and New Zealand (AAANZ) and, in 2002, the Biennial Conference of the Australian–New Zealand American Studies Association (ANZASA) at Deakin University, Geelong, Victoria. As a living example of cross-cultural exchange himself, Terry Smith, now at Carnegie-Mellon University in Pittsburgh and formerly at The University of Sydney, also deserves thanks for allowing me to present a talk at his session on Pacific exchange at the 2004 College Art Association Conference in Seattle.

Other ANU colleagues at the Art School were particularly thoughtful in our discussions of

Australian art and photography; I thank especially Martyn Jolly, Helen Ennis, Nigel Lendon and Gordon Bull for lively exchanges on the nature of Australian culture. My students at the ANU taught me much of what I know about Australian life and provided me with a forum in which to present my ideas—I hope the influential ones know who they are. Amongst my graduate students, Chiaki Ajioka has remained a friend and intellectual confidante; and Peter McNeil, now professor of design history at the University of Technology, Sydney and fashion history phenomenon, continues to support and share. For carrying out research once I had left Australia, I thank Charlene Ogilvie Smith, Canberra, and Lee Sanders in Sydney. Ian Tyrrell, Scientia professor of history, The University of New South Wales, Sydney, generously offered advice and has written the Australian foreword here. Other scholars who offered an exchange of ideas, read drafts of chapters, and were generally interested in what I was doing include Tony Hughes-d'Aeth, Senior Lecturer, English and Cultural Studies, University of Western Australia; Prue Ahrens, lecturer in art history, The University of Queensland; Robert Freestone, professor, Planning and Urban Development Program, School of the Built Environment, The University of New South Wales, Sydney; Christopher Vernon, senior lecturer, School of Architecture and Fine Arts, The University of Western Australia; and Mike Butcher, heritage officer for the City of Bendigo. I am grateful for having in Canberra the example of an independent scholar in the person of Robin Wallace-Crabbe, who shared much of his prodigious knowledge about Australian literature. I most especially want to thank my good friend Gael Newton, senior curator of photography at the National Gallery of Australia, Canberra, and her husband Paul Costigan. Gael has been unstinting in her support of this project, offering words of encouragement, sharing her expertise and providing images as well. She made me believe the book was a worthy endeavour despite the sacrifices it required.

Librarians, archivists and curators on this side of the Pacific also offered enthusiastic aid and common sense. I thank particularly Linda Groom, Sylvia Carr and their staff at the Pictures Collection, National Library of Australia, whom I have known since my first days in Australia. Also at the National Library, Paul Hetherington offered me the chance to write about Cazneaux, and Michelle Hetherington, now at the National Museum of Australia, Canberra, is responsible for introducing me, through her exhibition of travel posters, to the Northfield poster that started me on this path. Megan Martin, senior librarian and curator, The Caroline Simpson Library and Research Collections, Historic Houses Trust of New South Wales, Sydney, was exceedingly generous with her time and resources. Alan Davies, curator of photographs, State Library of New South Wales, introduced me to Merlin & Bayliss (amongst others) and the phrase 'You Bewdy!' Robert Lawrie, manager of the archives of the Parliament of New South Wales, Sydney, supplied previously unseen materials about the *Picturesque atlas of Australasia*. At the Powerhouse Museum, Sydney, I worked with Jill Chapman, archives; Charles Pickett, curator of social history; and Eva Czernis-Ryl, curator of decorative arts and design. Anne Higham, heritage architect/NSW Chapter, Australian Institute of Architects, personally escorted me on tours of Sydney architecture and

has graciously provided documents and images; I also thank Noni Boyd, heritage architect, for her insights and advice, and Roy Lumby and David de Rozenker-Apted of the Twentieth Century Heritage Society of NSW, Sydney. I appreciate the efforts of Howard Tanner, Tanner Architects, Sydney, who helped with James Peddle images. Annabelle Davey Chapman, who wrote the only thesis on Peddle, has been tremendously generous in providing more information and images. Peter Barrett, Architectural Conservation Consultants, Melbourne, was always available for discussions of American–Australian architectural exchange. For the wonderful images of the Perth campus and information about its development, I must thank Gillian Lilleyman, University of Western Australia, Perth. Stuart Read, heritage officer with the NSW Department of Planning, shared his work on Max Shelley at Boomerang. Harriet Edquist, Professor of Architecture and Design, Royal Melbourne Institute of Technology (RMIT), sent early versions of her book on Australian Arts & Crafts and offered insights into Victorian architecture. I also consulted with Miles Lewis, Professor in the Faculty of Architecture, Building and Planning at the University of Melbourne and the leading expert on prefabricated building. In the National Archives of Australia, Canberra, I thank Melanie Harwood and Anne McLean. Other librarians who were especially helpful were Arijana Hodzic and Moya Lum, PTW Architects, Sydney; and Gael Ramsay and Anne Rowland, Ballarat Fine Art Gallery, Ballarat, Victoria. Further afield, colleagues in New Zealand also contributed opinions on the history of Arts & Crafts in the antipodes; I must acknowledge Walter Cook, librarian, Alexander Turnbull Library, National Library of New Zealand, Wellington; John Adam, Auckland, who knows everything about New Zealand's garden history and connections to California; and fellow Bryn Mawr graduate Ian Lochhead, associate professor in art history, School of Fine Arts, University of Canterbury in Christchurch.

My greatest appreciation—for their contributions to this study and to my mental well-being—is, of course, reserved for my family and friends. In Australia, Chris Bettle, formerly director of art at the Australian Parliament House, read many chapters and did his own digging for information and contacts on plants and architecture; his long letters were a blessing. To the following Australian friends, I hope you know how much your conversations meant to me: Bruce and Diane Swalwell, Sydney; Andrew and Deb Bowman, Canberra and Corryong, Victoria; Pam Frost and Dennis Tongs, Canberra and Melbourne; Carol Croce, Canberra; Diane Carey, Canberra; and Roger Moloney, Melbourne. In California, I must thank again Peter and Carrie Detwiler, Sacramento, for offering continuous encouragement, their house and their great California contacts; and David Levine and Joanna Weinberg, Berkeley, for similar kindnesses. Bob Smith of Oakhurst, California, was a treasure when it came to computer questions. Colleen Paggi, Tulare, California, was a tenacious researcher on all things genealogical. Finally, I must thank all my Canberra and Pasadena friends who, by their efforts in seeking a design for living over the last decade, have enhanced my own life journey—this book would not have been written without their support.

To Sam Watters—whom I met while examining the same architecture photographs at The Huntington—I owe more than I can express here. At least two chapters of this book would have been far thinner without the benefit of Sam's insights and urbane opinions, and his guidance through the rough waters of the publishing process have been inestimable. I was particularly delighted that he was willing to contribute such an insightful foreword from the Californian perspective for this book. That I have had someone to talk to who shared my views on art and life, and who gave me so much stalwart support both moral and intellectual, has made all the difference.

My sister Robyn Holland allowed me weeks of solitude at her house in Oakhurst to compose and write (and gave me the companionship of her cats). My son Max—the real Aussie in this family—had just left for college when I started working on this book; he is now in graduate school. He has always brought me down to earth when I strayed too far from the task at hand; I treasure our conversations. My husband's family provided enthusiastic readers of the entire book; I am touched that Gloria and Stan Yalof, Escondido, California, found the time to read it and made such thoughtful comments. In many ways, Chapter 1 can be dedicated to my father-in-law, George Boeck, Sr, Professor Emeritus of American History, University of Northern Colorado, Greeley, Colorado; I am so happy that he was impressed enough to read and offer opinions about every chapter. And finally, to my husband, George Albert Boeck, Jr, this book is dedicated. He has been throughout my muse, my mentor, my rock; without George and our 'duprassness', without his willingness to share in our adventures and to support me in every way, none of my achievements would have been possible.

—Pasadena, California, 2008.

Whatever our official pieties, deep down we all believe in lives. The sternest formalists are the loudest gossips, and if you ask a cultural-studies maven who believes in nothing but collective forces and class determinisms how she came to believe this doctrine, she will begin to tell you, eagerly, the story of her life.
—Adam Gopnik, 'Will power', *The New Yorker*, 2004[1]

This book is in many ways the story of my life. Its themes grew out of my own history, my ruminations about art, 'home' and an aesthetics of place. I was born and raised in California, the daughter of a native son. I grew up amidst eucalypts and on the beach. Having left the state to go to college after high school, I have only now, more than 30 years later, returned to live here. In the intervening years, I lived and worked, an itinerant scholar, in every region of the United States except the south-east. With every move, I tried to absorb as much as possible of the visual signifiers of those places. I spent several intellectually stimulating years in Germany and Vienna, grounding myself in the culture of the Old World. My academic training and intellectual predilections prepared me for a professional life as an art historian on European topics.

Then, in 1990, freezing in the upper Midwest, I got a call to interview for a teaching position in Australia. When I arrived, direct from subzero temperatures to full summer in Canberra, a trip to the botanic gardens there convinced me that this was a place where I could happily live. The familiarity of the landscape—and the smells!—spoke to me of 'home' in a visceral and aesthetic way. Intellectually, teaching art history at the Australian National University was also transformative. Since one requirement of the position was to teach the history of Australian art, I immediately switched course, relegating research in German art to the background to concentrate on Australian topics and the history of photography. My appointment to teach Australian art at one of the country's leading universities had not gone unnoticed by local pundits, of course. The writer Humphrey McQueen even complained in print, indignantly asking the question, 'How can an American who wrote a dissertation on an obscure Austrian painter teach our art history?'[2] Indeed.

My family and I were successful transplants. We took up Australian citizenship as soon as it was allowed. We learned all the verses to *Advance, Australia fair* and we followed every incident in cricket and three different football codes, none of them gridiron (as Australians refer to American football). We revelled in the magnificent birdlife and the beautiful beaches. After a few years in Canberra, I was commissioned to write, along with my husband, the *Blue guide Australia*, a cultural tour guide of the entire country.[3] We considered the book, which took seven years to complete, a love letter to our new country.

The *Blue guide* project necessarily focused my attention on the whole question of cultural identity and how a 'new' Western-oriented country like Australia developed its own aesthetic vision and its own national icons. As an art historian, I was particularly aware of cultural iconographies and the process by which images are absorbed into a society's everyday aesthetic as part of the construction of its visual world-view. When I began looking deeper

for the roots of these iconographies, I kept seeing, if only vaguely, affinities between image-making practices in California and Australia. I discovered images, especially popular and reproduced ones, that reminded me again of that visual template formed in my childhood. At the same time, I found very little substantive academic work on the connections between Australian and American (especially western American) art production. While some comparative work has been done in history—I am thinking particularly of David Goodman's *Gold seeking: Victoria and California in the 1850s* (1994); Philip and Roger Bell's *Americanization and Australia* (1998); and Ian Tyrrell's *True gardens of the Gods: Californian–Australian environmental reform, 1860–1930* (1999)—very little work considered the *aesthetic* interaction between photographers, illustrators and artists of the two places. *New worlds from old*—the joint exhibition organised in 1998 by the National Gallery of Australia and Hartford's Wadsworth Athenaeum—focused, rightly so,

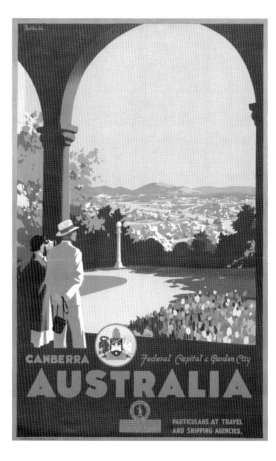

Fig. 0.02 James **Northfield**, *Canberra, Federal Capital & Garden City, Australia*, c. 1930. Colour lithograph. Courtesy of the James Northfield Heritage Art Trust ©.

on a comparison of nineteenth-century landscape painting and presented some interesting arguments about 'high art' affinities.[4] I wanted to know more about 'lesser' aesthetic practices, where the similarities appeared to be most striking.

I can trace my decision to write this book in this form back to a single moment comparing two images. The first image was designed as a tourist poster promoting the newly created city of Canberra, produced in about 1930 and shown at an exhibition of Australian posters at the National Library of Australia.[5] A precise description of this image figures in Chapter 7 (see page 310), so here I will point out only what so caught my attention at the time. I noticed especially the red-roofed buildings placed in the middle of the scene and the bird's-eye view of the light-infused landscape with the hills in the background. Trying to think of what the poster reminded me of led to the other image, one of the thousands of pictures produced in the early twentieth century, for California's citrus-box label industry. These labels, produced in enormous quantities in the first decades of the twentieth century and dispersed around the world, established the most enduring iconography of California: a perpetually sunny place, fertile and lush, often including a romanticised vision of the state's Hispanic past. What struck me particularly about these labels was that one repeated object: a red-roofed house (or houses) placed in the middle of the orchards, with a sweeping vista back to the mountains. Here was the most vernacular imagery with an established iconography of salubriousness, prodigiously reproducible, distributed worldwide, and from the 1910s widely seen not only in California but in Australia as well.[6]

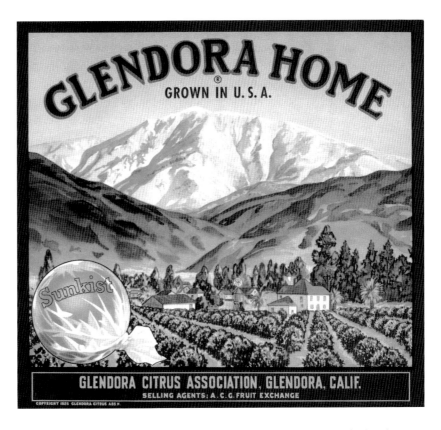

Out of these vernacular images, with their pervasive visual icons of a specific landscape, and based on the visual mood that they evoked in me, I began to construct a framework to examine what I knew had to be there: some very real aesthetic connections between image-making on that other Pacific coastline, California, and the emerging colonies of Australia. This exchange and much of the distribution of these iconographies occurred through the reproductive arts of the mass media: photography, illustration and graphic design, often dispersed through journals, illustrations, posters, commercial advertising and popular art magazines. The so-called 'high arts' of painting and sculpture were available to so few in these frontier societies that aesthetic ideas were more readily accessible and understood through portable and reproducible artistic mediums. The significance of widely dispersed visual resources in these new cultures offers living testament to Walter Benjamin's famous statement that the '[m]echanical reproduction of art changes the reaction of the masses toward art'.[7] Linking these ideas back to Benjamin gave me a critical peg on which to hang my arguments about the absorption of pictorial information into modern, image-dependent societies.

From the 1850s, art and image-making in the Western world, and particularly in new 'settler colonies' such as Australia and Pacific America, are dependent on three important factors: the itinerancy of the artists and artisans producing images on the frontier and in the new settlements, moving from place to place with their own cultural baggage made visible through their creative production; the reproducibility of images, made possible by technological advances in printing and photography; and the portability of these images enabled by the processes of visual reproduction, across oceans and over great distances.[8] With these factors in mind, the central question for consideration in this comparative aesthetic

analysis concerns both distinction and affinity: Can we see stylistic transformations in visual representation when Western artists and photographers confront a different place, a different culture, or different ideologies? What gets shared visually, and what remains distinct to each place? These two regions, geographically linked by their location on what would come to be called the Pacific Rim, and first tied together by their shared participation in the greatest social transformation of the nineteenth century, offer unprecedented opportunity to explore questions about the transmission and consumption of images in the modern age.

I have formulated my ideas as a series of essays as case studies, arranged in overlapping chronological order by decades and connected by the overriding assertion of aesthetic exchange dependent on itinerancy, reproducibility and portability. The overarching theme in these chapters is that the exchange of reproducible images and forms creates a specific aesthetic that eventually produces a modern 'Pacific Rim' style. This incipient style is most prevalent in vernacular image-making through which modernity, or more aptly aesthetic modernism, first appears in these 'cultures on the periphery'.[9] The seven chapters cover a range of topics within these parameters. In each case, my arguments focus on one individual or several individuals as exemplars of the aesthetic processes discussed in the period: the photographer Benjamin Batchelder travelling to the gold regions on both continents; the entertainer Stephen Massett plying his music and his accompanying illustrations in San Francisco and Victoria; *Harper's* illustrator William T. Smedley and other Americans working on the *Picturesque atlas of Australasia* of 1888; the Sydney architect James Peddle bringing back bungalows from Pasadena in the 1910s; former Australian Prime Minister Alfred Deakin at the 1915 California Expositions; Theodore Payne and F. Franceschi embracing eucalypts as part of the Californian landscape; and English-born architect Leslie Wilkinson adapting Mediterranean architecture for Australians, with an eye focused on California's Spanish Style houses of the 1920s.

In keeping with the emphasis on the importance of reproducible images in this story of aesthetic exchange, illustrated magazines figure prominently in each chapter, as the most potent medium of the time for the delivery of these visual forms. *Harper's, Land of Sunshine, The Craftsman, Sunset, Century, Pacific Coast Architect, Touring Topics/Westways* from America; and *Australasian Sketcher, The Lone Hand, Building, Home* and *The Australian Home Beautiful* in Australia—amongst many other examples of the era's growing fascination with modern mass media, these journals play a pivotal role in the story of Australian–Californian aesthetic exchange.

After completing research in Australia, I returned to California to carry out work on that half of the comparative study. Landing in Los Angeles, the place felt immediately familiar to me, despite the years of absence. We settled in Pasadena, where, miraculously, we bought a 100-year-old bungalow around the corner from the very buildings that I had come to study. Personally, it was a homecoming. Intellectually, my assumptions that most scholarly work about Californian culture and art would have already been published proved to be optimistic. I found instead that California as a subject of cultural or aesthetic study is only now beginning to hit its stride. Much has been accomplished in recent years since the publication of Kevin Starr's magisterial series of books on Americans and the California dream; but the same parochial sense of inferiority that caused so much anxious soul-searching in Australia has

persisted in the American West, encouraging the idea in many that California has little history or culture worth studying outside of a regional context.[10] In this attitude, my two homes on the Pacific continue to be linked culturally, making a comparison of their fascinatingly rich visual histories ever more relevant.

As the opening quotation suggests—despite whatever elements of the 'cultural-studies maven' I may have accrued after 30 academic years in America, Europe and Australia—my aims in writing this book are not primarily polemical. I want to tell an interesting story about the exchange of ideas between two new cultures, ideas manifested in images that people saw and buildings that they built. As a comparative study, I want to present new information about the deep aesthetic connections between these modern cultures—information that will contribute to a greater understanding of how Australia and California have interacted and influenced each other for the last 150 years.

NOTES

1. Adam Gopnik, 'Will power', *The New Yorker*, 13 September 2004, p. 90.

2. Humphrey McQueen, review article, *Australian Society*, June 1991, p. 42.

3. Erika Esau and George Boeck, *Blue guide Australia*, A & C Black, London, 1999.

4. Elizabeth Johns, et al., *New worlds from old: 19th century Australian & American landscapes*, National Gallery of Art, Canberra, 1998.

5. *Follow the sun: Australian travel posters, 1930s–1950s*, National Library of Australia, 13 November 1999 to 30 January 2000. See also Michelle Hetherington, *James Northfield and the art of selling Australia*, National Library of Australia, Canberra, 2006.

6. In the context of vernacular images, as Richard White points out, Australia from the mid-nineteenth century looked to America for vernacular forms of culture, while Britain remained the source for those forms considered to be 'high art' such as painting and sculpture. See Richard White, '"Americanisation" and popular culture in Australia', *Teaching History*, vol. 12, August 1978, pp. 3–12. See also my own essay on the exchange of fruit-box labels, 'Labels across the Pacific', in Prue Ahrens and Chris Dixon (eds), *Coast to coast: Case histories of modern Pacific crossings*, Cambridge Scholars Publishing, Newcastle upon Tyne, forthcoming 2010.

7. Walter Benjamin, 'Art in the age of mechanical reproduction', in *Illuminations*, Schocken, New York, 1969, p. 234.

8. In the '2009 Call for Participation' for the College Art Association's 97th Annual Conference, two sessions refer to itinerancy. One focuses on 'Artistic itinerancy in early modern Europe'; session convener Lloyd De Witt remarks that the work of itinerant artists in this period 'fostered a dynamic cultural convergence between peoples and continents that is potentially far more revealing about the character of their age', p. 6. The other session is even more cogent to the topics of this book: The Association of Historians of Nineteenth-Century Art sponsors 'The networked nineteenth century', to speak of a 'networked society' and to analyse 'the dynamics of a nineteenth-century art world shaped by global trade, technologies of exchange, and rapid dissemination of print.' Anne Helmreich, session convener, p. 10.

9. For definitions of post-colonial studies terms such as 'settler culture' and 'cultures on the periphery', see Bill Ashcroft, et al., *Key concepts in post-colonial studies*, Routledge, London and New York, 1998.

10. Kevin Starr's books in this series are: *Americans and the California dream 1850–1915*, Oxford University Press, New York, 1973; *Material dreams: Southern California through the 1920s*, Oxford University Press, New York and Oxford, 1990; *The dream endures: California enters the 1940s*, Oxford University Press, New York, 1997; *Endangered dreams: The Great Depression in California*, Oxford University Press, New York, 1997; *Embattled dreams: California in war and peace, 1940–1950*, Oxford University Press, New York, 2003; *Coast of dreams: California on the edge, 1990–2003*, Knopf, New York, 2004; and *Golden dreams: California in an age of abundance, 1950–1963*, Oxford University Press, New York, 2009

1850s: Artist–photographers in gold country

Some people say that the Australian mines are all that is said of them, while others believe they are a humbug ... The truth of the matter it is impossible to learn, without personally going ...
—George W. Hart to James Wylie Mandeville, San Francisco, 30 October 1851.[1]

~

The gold seekers were harbingers of modernity, and one had to be rather modern in 1850 to be untroubled by the world they seemed to fore-shadow ... The dislocations of the gold rush were symptomatic because they resembled the dislocations of modernity.
—David Goodman, *Gold seeking*, 1994.[2]

~

Photography is equally a technology of its time, but it generated few ... impositions on the landscape or on workers; it was an artisan's technology ... It did not impose itself on the world but interpreted it, transporting appearance as the railroad transported matter ... For if railroads and photography had one thing in common, it is that they brought the world closer for those who rode or looked.
—Rebecca Solnit, *River of shadows: Eadweard Muybridge and the technological wild west*, 2003.[3]

The shared aesthetic experience of Australia and the American West begins in the mid-nineteenth century with the discovery of gold in each country. What makes the aesthetic story of these two places on the Pacific Rim so important is that this historical moment—the rush for gold, with its massive population shifts on all continents—coincides almost precisely with the development of the most significant mechanical forms of reproduction, forms that would transform and define the idea of art and modernity itself well into the twentieth century. With its demographic explosions and social upheavals, the gold rushes of the 1850s provided the initial catalyst for this aesthetic exchange.

In California and in Australia, a substantial number of opportunistic photographers and itinerant artists joined the hordes of miners and other immigrants hoping to make their fortune through their image-making capabilities, if not through their luck, on the goldfields. The exchange went both ways: many of these young adventurous men travelled between Australia and California and worked in both places, creating images of people, social life and, most especially, of landscape in these frontier communities.[4] Producing views of the landscape and portraits, they established distinct photographic techniques and stylistic interpretations that began to reveal the unique circumstances of their geography and their fledgling societies. Their interpretations began to diverge in exciting ways from the

established artistic forms inherited from their home cultures. These visual records, based on the merging of traditional artistic modes and the products of mechanical reproduction, provide an unprecedented opportunity to examine the incipient construction of a shared visual culture—a new idea of the aesthetics of place—at the beginning of the modern age.

In December 1848, word of the gold discoveries in California reached Australia, from newspapers on board the US ship *Plymouth* out of the Sandwich Islands.[5] The initial response was one of scepticism and understandable ignorance: where was California? The Australian colonies were certainly aware of the United States of America before 1848, but California was a place virtually unknown to those on the southern continent. American whalers and other trading vessels had been docking in Sydney and Hobart since the earliest

days of white settlement in the antipodes, but the men on these ships were from places like Massachusetts and New York.[6] The West Coast of North America was unknown territory, even more mysterious to Australians than it was to Americans on the eastern seaboard already caught up in the excitement of westward expansion across the continent. The very recent acquisition through conquest of the Spanish–Mexican territory of California had brought this region into the consciousness of Americans before the announcement of gold discoveries; but Australia had no reason to pay attention to such events.

The Australian newspapers were at first loathe to print news of gold-strikes in this distant land, for fear of wholesale emigration. But word of such a discovery could not be concealed for long and by the early days of 1849, printed posters along Sydney's Circular Quay and on its main streets announced 'GOLD, GOLD, CALIFORNIA'.[7] On 21 January of that year, *The Eleanor Lancaster*, a ship fitted out by Sydney merchant Robert Towns, left Sydney Harbour bound for San Francisco, with 52 passengers on board—the first of the Australian gold seekers to reach California. The ship arrived in San Francisco in early April. As one of its most peripatetic passengers would later write: 'There were but few vessels in the harbor, the big rush not having yet set in, it being now early in 1849 … The vessels were mostly from Australian ports; the gold fever had not extended to the Old Country or the American cities as yet.'[8]

Australians were some of the first to arrive in this previously isolated outpost in western North America, for they had, as citizens of a British colony facing the eastern shore of the Pacific Ocean, an easier run than any European or American ship, indeed the closest access (other than the nations of western South and Central America) to this other Pacific coast. While people on the East Coast of North

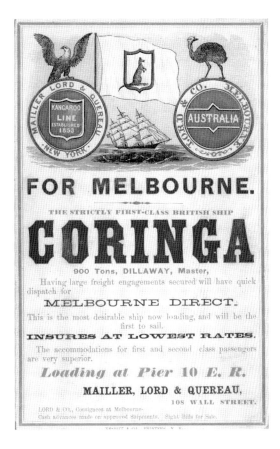

Fig. **1.01** Clipper ship card for *Coringa*, sailing between New York and Melbourne, c. 1870s. Robert B. Honeyman, Jr, Collection of Early Californian and Western American Pictorial Material. Bancroft Library, University of California, Berkeley, California.

FOR MELBOURNE.

THE STRICTLY FIRST-CLASS BRITISH SHIP

CORINGA

900 Tons, DILLAWAY, Master,

Having large freight engagements secured will have quick dispatch for

MELBOURNE DIRECT.

This is the most desirable ship now loading, and will be the first to sail.

INSURES AT LOWEST RATES.

The accommodations for first and second class passengers are very superior.

Loading at Pier 10 E. R.

MAILLER, LORD & QUEREAU,

108 WALL STREET.

LORD & CO., Consignees at Melbourne.
Cash advances made on approved Shipments. Sight Bills for Sale.

America were paying exorbitant amounts to cross the Panama Isthmus or round the Cape of Good Hope, or making gruelling treks by wagon train across the treacherous American plains, ships from Sydney and Hobart were bringing passengers across the ocean in as little as 70 days and for relatively low fares. Jay Monaghan recounts that people were being charged as much as $500 to cross the isthmus in early 1849 and points out: 'These figures were important, because they disclosed that Americans must pay twice as much to get to California as Hobart ship owners were asking and three or four times the price charged from Sydney.'[9] Such brave and to some foolhardy souls would be the first of the more than 7000 Australians who would eventually head for California and the goldfields in the 1850s.[10] Among these opportunistic migrants were freed convicts, shopkeepers, artists, printers, stockmen, families and adventurers, all of whom would have different experiences in newly Americanised California.

The tumultuous days of the California gold rush would also provide the first opportunity for recognition by Americans of a people newly called Australians. They were, according to early accounts, recognisable by their distinctive clothing—'cabbage tree hats and moleskin trousers'—and even from the colour of their possum-skin rugs and bedding, certainly characteristics that would distinguish them from their British counterparts.[11] In the free-for-all of gold-rush society, first impressions were usually based on visual appearances, and descriptions of all nationalities by observers in San Francisco emphasised the differences in dress to distinguish them, rather than the similarities. The Australian colonists were nevertheless most often figured in with the British in the eyes of the American authorities, thus making it difficult to determine the numbers of Australians in California from official records. Australians joined in the unprecedented mul-

ticultural mixture that amazed everyone who arrived in the gold-rush town. When the sailor-cum-photographer Isaac Wallace Baker (1818–1862) landed in San Francisco in January 1850, he wrote in his journal: 'It takes all sorts o' people to make a world, but you can find a sample of all sorts o' worlds in California!'[12]

Australians' first independent reputation in San Francisco was unfortunate and quickly established: the inevitable presence of several criminals among the earliest Australian arrivals, either escaped convicts or newly emancipated ones, forever determined their reputation. The term 'Sydney Ducks' was applied to all those who congregated in San Francisco in the neighbourhood at the edge of Telegraph Hill; the area became known as Sydney Valley and became identified, whether accurately or not, as the source of most criminal activity in this lawless town. (This same section of town later became infamous as the rowdy Barbary Coast.) The first victims hanged by the Vigilance Committees that sprang up in the city in 1851 (and again in 1856) were Australians, a fact that did not go unnoticed by the multicultural populace then developing in the city and in the California mountains where gold was being unearthed. That several members of the earliest Vigilance Committee were upper-class Australian merchants, and that Australian products such as flour and printed goods were more readily available and often of superior quality to what could be obtained from the American states,[13] does not seem to have entered the public consciousness as firmly as the idea that all Australians carried the convict taint.[14] Australian as criminal is the stereotype that stuck.

Still, Australians of every sort participated in the earliest forays into the California hills, setting up businesses in Sacramento and Stockton, and pioneering settlement throughout northern California. As only one example,

Captain W. Jackson Barry, one of the first Australian migrants on the *Eleanor Lancaster*, helped found Shasta City, California, and was involved in many significant events in the gold-mining communities of California and, later, back in Australia and New Zealand.[15] Many made the biggest fortunes in those first months when the gold was still relatively easy to find; but many also ended up with nothing more than a knowledge of how gold could be found and how it could be mined more efficiently.

Edward Hargraves (1816–1891) was one of those Australians early on the diggings for gold in California.[16] In 1851, convinced after his own experiences of the geological similarities between the gold regions of California and the hills of Australia, Hargraves returned to New South Wales and began digging around Bathurst on the plains of that colony. Soon he announced substantial discoveries of the metal at Ophir, and within weeks hundreds had flocked to the region. Earlier colonial governments had suppressed information about such finds, for fear of losing much-needed workers to the goldfields and losing control of a society only recently freed of the dubious status of being nothing but a penal colony. This time the New South Wales officials enthusiastically announced the discovery.

Galvanised by this announcement and the support it received from the government, others soon found even bigger strikes in the newly proclaimed colony of Victoria, in an area directly north of the then small settlement of Melbourne, a town founded only in 1838. Australians recently returned from California made most of these finds. One was James Esmond (1822–1890), who was on board the same ship out of San Francisco that brought Hargraves back to Sydney.[17] While Esmond made the most significant gold discovery at Clunes in Victoria in 1851 that led to the first early rush in that colony, he had less business acumen and self-aggrandising ambition

than Hargraves. Most importantly, in 1855, Hargraves published his book, *Australia and its goldfields*.[18] His name appeared in print as the 'discoverer' of Australian gold, and so Hargraves, rather than Esmond, gained enduring international fame as such. The printed word, preferably with accompanying illustrations, was the central force behind the worldwide dispersal of information that caused the phenomenon of the gold-rush era.

Once news of the Australian finds reached California, the migratory influx reversed itself. Not only did many Australians in California return to look for gold at home, but many of the Americans and foreign gold seekers who had flocked to San Francisco now clambered for passage to the antipodean continent. Australians all over the country also put down their tools, left their shops and headed for the territory north of Melbourne. As one Englishman then residing in Australia wrote, 'since the commencement of this gold revolution society in the antipodean regions has become almost as migratory as among the Bedouin Arabs'.[19] A later author claimed: 'Australia became the new El Dorado of the world. California was forgotten—Marshall's discovery belonged already to the past. The tide of emigration from Australia became a flood of immigration.'[20] The rise in population in Victoria in the decade between 1851 and 1861 was as remarkable as had been the growth of San Francisco and northern California a few years before: 77,000 in 1851, 237,000 in 1854, and by 1857, 411,000 in a colony only 20 years old.[21] Australia's overall population in that same period rose from 400,000 to almost 1,200,000.

The relative rapidity with which the news from Australia reached even the remotest California mining camps speaks to the fact that the unprecedented movement of people caused by the announcement of gold discoveries in the 1850s precipitated an equally

unprecedented movement of printed materials and images along with the people. Books, newspapers, journals, letter-sheets, illustrated posters and photographic images—all products of technological innovation in the mid-nineteenth century and the first indications of truly mass reproductive media—arrived by ship in the port of San Francisco, just as they did into Sydney Harbour. All these mails were then dispersed by post—on a steamer to Sacramento and Stockton, and then by pack mule or coach into the various mountain communities—with relative speed to the eager and often homesick miners throughout the new settlements and on the diggings. Literacy among the miners was a valuable and already not uncommon asset, but even those who could not read looked forward to the images in the newspapers and illustrated journals that began arriving in abundance.

The demand for visual information on the part of those away from home, and the hunger by those left behind for pictorial descriptions of these new places where their loved ones had gone, explains the immense popularity in the goldfield communities of the illustrated letter-sheets produced in California throughout the 1850s and into the 1860s.[22] These sheets constitute some of the earliest visualisations of the California that miners wanted to convey to the audience back home. As the historian Joseph Baird points out in his essay on letter-sheets, the image was what the sender wanted: ' ... most of the writers preferred to send a picture or pictures; all expected a rich, purely written, return from their correspondents.'[23] These pieces now represent remarkable documents of life and work in the mining towns, as well as evidence of the wonders of the Western landscape as it was first confronted by new settlers.[24] The demand for these images also led in San Francisco to the first art-printing activities—and thereby the first inklings of a

distinctively California illustrative style—as lithographers, engravers and photo-engravers were put to work producing scenes that would be mailed around the world.[25]

Baird quite rightly identifies these letter-sheets as 'the major surviving visual account of California in that era'.[26] Foremost among the preferred images were the first depictions of California's wondrous natural landscape, especially the newly discovered Mammoth Trees. As early as 1854, magazine editor James Hutchings (1820–1902) was producing letter-sheets with photo-engravings from daguerreotypes of the redwoods found in Calaveras Grove near Yosemite—a site that had not been discovered by white men until 1851. Hutchings, who participated in some of the earliest explorations of Yosemite and its surrounding region, was instrumental, largely through his illustrations and reproductions of photographs published in letter-sheets and in his publication *Hutchings' Illustrated California Magazine*, in promoting the glories of the California landscape.[27]

Like so many other artists and photographers of the time, Hutchings also attempted to create panoramas of California scenes. Although he never achieved his ambitious conceptions for panoramas, other engravers and photographers were able to produce panoramic views of San Francisco Bay and other sites translated into letter-sheet illustrations. The marvellous work of the lithographic firm of Britton & Rey included town views and San Francisco scenes that were often taken from photographs.[28] The firm's rendering, for example, of the meeting of the Vigilance Committee in 1856—one of their many recordings of contemporary events—credits Robert Vance as the daguerreotypist who provided the image for printing. Britton & Rey's prolific output of letter-sheet illustrations of all sorts of subject matter pertaining to California are the most vivid examples of

Fig. 1.02 *The Mammoth Trees*, in *Hutchings' California Scenes*, 1854. Letter-sheet engraving. Courtesy of The Huntington Library, San Marino, California.

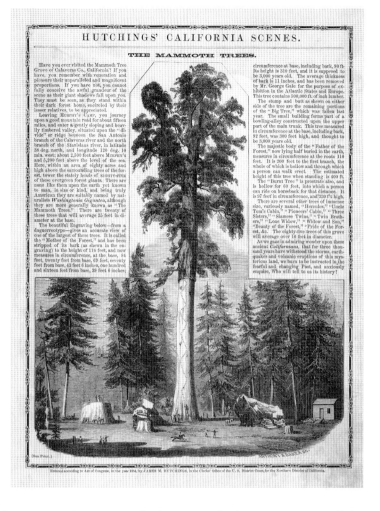

an early visual formulation of the region. The firm, the best of those that popped up all over San Francisco to meet the demand for images, provided opportunity for a wide variety of artists and image-makers, with varied levels of artistic skill, to step forward to provide illustrations for this burgeoning market. Nearly every artist now associated with the gold-rush era in California at one time produced images for letter-sheet production.

The preference on the part of California's new arrivals for illustrated letter-sheets does not necessarily imply an illiterate populace. Indeed, the surprising sophistication of the miners' reading habits, and the relative ease with which printed material could be accessed even in the remotest settlements, is often remarked upon in the histories written of the gold-region mountain towns. In her account of Tuolumne County written in 1935, Edna Buckbee describes the cultural life of mid-1850s Sonora, the main settlement of that county in the Southern Mines region. The town had by the early 1850s three bookstores enthusiastically patronised by the transient yet ever-expanding population. The Miner's Bookstore of Mintzer & Company had 'the most complete line of standard books and magazines obtainable at that period', including the most popular illustrated journals *Harper's*, *Godey's Lady's Book* and Frank Leslie's *Lady's Magazine*. The Union Book Store carried 'a full line of Atlantic Coast and European newspapers and magazines'.[29] The Tuolumne

Book Store, opened in 1854 by J. Roberts, had complete runs and regular deliveries of international journals of all political persuasions: 'the London Quarterly Review (conservative), Edinburgh Review (Whig), North British Review (Free Church), Westminster Review (liberal), Blackwood's, Edinburgh Magazine, and a large variety of American magazines and newspapers'. The proprietor complained that he could not keep in stock enough copies of any French dictionaries and immediately sold out of whatever editions he could get of 'Bulwer, Dickens, and Shakespeare'.[30] On 28 October 1854, one of Sonora's newspapers, the *Union Democrat*, included an article entitled 'The Australian mines' in which the editor refers to a report in a recent *Melbourne Herald*, indicating that even Australian newspapers were available to him.[31] Sonora at the time served a county population of about 5000. Other towns in neighbouring counties of the gold-regions had similar numbers of bookshops and newsagents, and also managed to produce several local newspapers.

These sources of print material provided not only literature, but, as the overwhelming popularity among miners and their families of the profusely illustrated *Harper's* and the ladies' journals demonstrates, visual stimulation. As Buckbee comments:

> ... these periodicals were strong factors in the decorations of Far-West homes, for they devoted many pages to the designs, the making of hooked rugs, crocheted and knitted tidies, and the never to be forgotten, or forgiven, colorful mottoes that hung above the doors and over the chimney pieces of both log and lumber houses.[32]

In Australia, similar conditions created similar patterns of dispersal of printed and visual material. The central factors in the distribution process of printed materials played as great a role in Australian cultural life in the mid-nineteenth century as they did in gold-rush California. Once news of Australian gold discoveries reached California and the rest of the world, the flow of illustration and mass-produced printed matter out of America would become a flood, as thousands poured in to the southern continent, bringing their books, journals and pictures with them.

The means by which far-flung miners in California learned of the Australian gold-strikes—and acted, almost immediately, upon hearing the news—can be traced in numerous first-hand accounts by the miners themselves. Charles Ferguson, an Ohioan who in the 1880s wrote an apparently accurate reminiscence of his experiences in both gold-rush societies, recounts how quickly the word spread of Australia's golden fields and 'infected' the California miners with a new gold fever. In the summer of 1851, Ferguson and his mining partners had staked a claim near Nevada City, but they were getting bored and looking for new adventure. He describes the sequence of events that quickly led to their departure for Australia:

> It was customary in the mining regions to go about on Sundays visiting one's neighbors, or to town to see the sights, so that that day was generally the most stirring day in the week. Loveland went to town to see a dentist ... Taft staid [*sic*] at home, while I went to see Beauclerc, who was a great friend or ours. He told me he had just received a letter from an uncle of his in Australia; that gold had been discovered there by a man named Hargreaves [*sic*], that was liable to become very rich diggings. I thought nothing more of it until I went home. Taft was cooking supper. I inquired for Loveland ... I went out and found him standing a little distance from the cabin, his face turned starward, though I don't believe he was conscious of a star, for his mind seemed elsewhere. I asked him for his

thoughts. He said Dr. Livermore, the dentist, who was formerly from Sidney [*sic*], told him that he had just received a letter from Australia advising him that gold had been found there in quantity and richness surpassing anything then discovered in California. I then told him about Beauclerc's letter. 'What do you say about our going?' said he. 'All right,' said I, 'if you will go, I will.' At that moment Taft called us to supper, and when we went in we told Taft that we were going to Australia … We then talked over the whole matter, and finally, the same evening, all three of us started off to see Beauclerc. We found him as ourselves, but how to get away was a more difficult question. He had lately got married, and it was out of the question to take his wife with him on what might, after all, be but a wild goose chase.[33]

Far removed from the comforts of settled society, these young men learned about a momentous event in a distant country through letters sent to two different acquaintances. On the basis of this written word, they made a joint decision to travel halfway around the world to seek their fortune. That there was a dentist from Sydney in Nevada City in 1851 also gives some indication of how far-flung were the earliest immigrants to the American West—and how quickly they had taken up occupations other than goldmining to make a living. Ferguson consistently refers to their restless anticipation as a 'fever':

> Loveland, Taft & myself were the first victims in Nevada City, but it spread rapidly, and others were soon as bad as ourselves … George Scott, of the Empire gambling house, and his wife took the fever, which carried them off

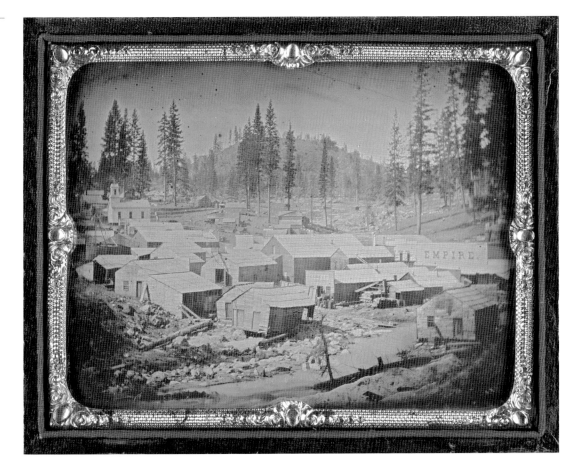

Fig. 1.03 Attributed to **Joseph B. Starkweather**, 1852. Daguerreotype. Nevada City. Courtesy of the California History Room, California State Library, Sacramento, California.

'between two days.' ... Beauclerc had now made arrangements with Scott and wife at Rock Creek to keep his wife, so in the course of a week there were eleven in all 'carried off'.[34]

The whole group was in San Francisco by the first weeks of 1852, waiting for a boat to Australia and sightseeing along with 'those afflicted with the Australian epidemic'.[35] They finally gained passage, for 60 dollars each, on board the barque *Don Juan*. At this stage in Pacific travel, no regular shipping service had been established, although transit was much more frequent than it had been three years earlier. According to Ferguson, the voyage was filled with tensions between the returning 'convict' Australians and the Americans; but, as he writes, '[a]t last, on the twenty-sixth of July, 1852, the sunny shores of Australia hove in sight, and great was the rejoicing on board that little barque, and all our troubles were forgotten'.[36] They came filled with as much hope and anticipation and excitement as they had experienced a few years before in California. Anything could happen, and they were up for the adventure. In the end, it is estimated that more than 12,000 Americans joined the throngs in the decade of the 1850s; some of them stayed for a brief time, while others remained in Australia permanently.[37]

Just as the delirium surrounding the California discoveries led to extraordinary societal transformations on the newly Americanised Pacific frontier, so, too, did Australia experience cultural displacements in the 1850s unlike those of any earlier colonial settlements. As had been the case in California, the real and lasting fortunes were to be made in Australia in the provision of services and supplies for the new settlements that arose where the would-be miners congregated. Itinerancy became the norm rather than the exception, as people from around the world arrived daily in the thousands, ships cramming

into Melbourne's Port Phillip Bay and crowds trudging up the dirt tracks north from the town. Many of the new arrivals moved from goldfield to goldfield, and from occupation to occupation, and confronted in most instances new, or at least newly established, rules of social order. Skilled workmen and artisans, as well as manual labourers, voluntarily displaced from their traditional rung on the societal ladder of their home cultures, found themselves thrown into a 'free market' system that, at least initially, liberated many from traditional wage structures and broke down hierarchies of class and occupation. One had to be creative and willing to try one's hand at new trades among new kinds of people. A certain level of tolerance of difference was an essential attribute in these newly developing societies, in which old ideas of social stratification and appropriate decorum appeared to be inappropriate to the real conditions into which people had thrown themselves.

Contemporary accounts of 'digger' life are rife with examples of these opportunistic arrangements.[38] Ferguson notes that, having managed to make the trip from Sydney to Melbourne, he and his mates then realised they had to set out on foot to get to the diggings, still some hundred miles away. En route toward the Ballarat fields, they were told to stop at an establishment already set up by their countrymen: 'They baked pies and made money. Of course all the Americans went there and were told of our arrival, as we went there to get our meals until we got our house in order and some cooking utensils.'[39] New arrivals, then, as early as 1852, learned by 'bush telegraph'—that is, by word of mouth—of fellow immigrants already setting up businesses to accommodate the burgeoning population heading for the gold. Opportunism became the greatest asset and nearly everyone became of necessity an independent entrepreneur, despite the well-documented fact that the

Victorian colonial government was from the outset intent on maintaining economic and social control to a far greater degree than had existed in the California gold regions.[40]

This kind of entrepreneurial spirit affected as well the less utilitarian aspects of civil society and activity. Artists and artisans also had to apply their hand to whatever activities presented themselves. William Howitt (1792–1879), an Englishman of Quaker family and with high-level connections in the colonies, wrote in *Land, labour and gold* (1855) an account of his two years in the Victorian gold country. Howitt's narrative is replete with fascinating characters and vivid descriptions of a society where traditional hierarchies of occupation had to be abandoned. Howitt himself encouraged his travelling companion Edward Bateman (1815–1897)—cousin of the Victorian lieutenant-governor and a skilled watercolourist known to the London Pre-Raphaelites[41]—to take advantage of the businessmen on the diggings who wanted pictures of their holdings, 'but not under 5 *l.* [shillings] per sketch, as this class of people have plenty of money, and are all amazingly proud of their establishments'.[42]

This pride in ownership, and the desire to have visual evidence of one's material prosperity in the colonies, greatly determined the kinds of images produced in Australia in the middle decades of the century, as subsequent images will demonstrate. Bateman, then, had to produce images of things and people quite unlike the ones he had produced back in England—but his academic style, his pictorial devices, would have been the same as those he used in English parlours. On the goldfields, artists, whether amateur or formally trained, became itinerant tradesmen along with everyone else. Their works, whether painted, graphic or photographic are in many cases more significant as historic documents than as aesthetic artefacts. Elements of artistic

style nonetheless were transmitted to and consumed by the viewers of such seemingly modest image-making endeavours. Not only image-makers but book men, stationers and artisans of other cultural trades were part of this itinerant parade in the Australian gold country. In his book, Howitt described 'the most distinguished character' on the diggings, 'a Mr. Langley, an American auctioneer', whose main stock in trade was books, and whose sale for high prices earned him 'several hundred pounds per week'.[43] That Mr Langley was identified by Howitt as an American would simply have fit into commonly held assumptions that the Americans were the most opportunistic and skilled itinerants of all the incoming immigrants.

The traditional artistic skills of draughtsmanship and painting were in evidence in these new societies, and the selling and dispersal of illustrated books, journals and prints occurred regularly, even in the remotest regions. But in gold-rush society, both in Australia and in California, the most potent manifestation of the significance of reproducible imagery and the indispensable role of itinerancy in the dispersal of these images is the nearly simultaneous development of that new technological invention, photography. Martha Sandweiss begins her book on photography and the American West by stating that these two elements represent 'a new medium and a new place that come of age together in the nineteenth century'.[44]

While the circumstances in Australia make for a less seamless metaphorical merging of westward expansion and photographic experimentation, the Australian gold rush also led to a massive upsurge in photographic activity in the colonies, activity which photographic historian Gael Newton describes as the era's 'new growth industry'. Australians had participated in photography from its beginnings. They knew about the invention within

weeks of its announcement in Paris, proving, Newton writes, that 'what was once the *Terra Incognita* of the Antipodes was, by 1839, part of a global network of Western culture'.[45]

A consideration of photographers working in the goldmining regions in the 1850s through the 1870s provides not only the most convincing historical record of the period; it also presents the most tangible evidence that ideological constructions of place began to determine the look of something so seemingly straightforward as early photographic views. In this context, photography in California as well as in Australia must be considered against 'home',—that is, 'the metropolitan culture from which they stem'—whether that home is the eastern United States or Anglo-Celtic Europe.[46] California at this time—isolated by months of travel from the eastern American seaboard and newly acquired from Mexico as a political entity of the United States—was in many respects just as 'colonial' as Australia in terms of its relation to its 'metropolitan culture', a relatively distant location, as its source of cultural attitudes and identity. The political circumstances were, of course, quite different in Australia than they were in 1850s California, but in terms of cultural influences and attitudes about aesthetic traditions, one can speak of a colonial mentality determining the artistic and artisanal activities in both of these English-speaking societies on the Pacific Rim.

When examining Australian photography during this period, most critics place its practices firmly against an English, or more broadly, a European model. Paul Fox writes, for example, that '[c]olonial photography, while sharing a sense of progress conceived of in terms of European time and space, simultaneously figures displacement from Europe'.[47] Although this statement recognises the source of Australia's most pervasive cultural values and aesthetic modes, it fails to incorporate the significant contribution in Australia, particularly in the field of photography, of Americans coming from California who were also negotiating an aesthetic identity in relation to their own distant home culture. Does the idea of displacement that Fox suggests pertain to the settler colony of California as well? And does this sense of displacement actually engender a *shared* aesthetic between photographers working in Australia and in California in the mid-nineteenth century, or do differing ideological and political agendas determine the stylistic choices of photographers and artists in these new societies?

While grandiose conceptions of Manifest Destiny played a considerable part in the development of western American photography in this period,[48] in Australia the ideological attitudes about the land and about opportunity were played out against the framework of colonial dependency and government control to a far greater extent than occurred across the Pacific in California. Contemporary observers and later critics frequently commented upon this fact. Charles Dickens, for one, was intent on making this comparison; in his journal he wrote, '[t]he contrast is very great between the orderly behaviour at the goldfields in Australia, and the disorders of California'.[49]

These circumstances have some bearing on Australian artistic and photographic practice. But despite the differences in the larger conceptual sphere—that Australia's political situation was different than that in gold-rush California—interaction between the *populations* of both places was from the 1850s vital and continuous. On a popular level, ideas, attitudes and material goods—including images—were in constant movement and transformation between these two frontier cultures. These elements of vernacular culture are those that California and Australia share, and continue to share into the twenty-first century. In that popular

realm, photography was already by the 1850s one of the most easily exchanged of these portable visual artefacts.

Because of the alacrity with which Americans had embraced the new medium of photography, American photographers by the mid-nineteenth century had gained the reputation internationally of being at the forefront of new photographic developments. This enthusiasm for technologies of the camera and its images pre-dated the most aggressive American drive to the West, but as Sandweiss and others emphasise, the development of photographic processes indeed coincides with, and so is to some extent determined by, the movement of settlers into the American frontiers, first during the California gold rush and then after the Civil War, with the completion of the transcontinental railways and the numerous exploratory expeditions in the 1870s.[50]

At the time when so many people from all over the world began to pour into California and then a few years later into Australia, Americans were already identified as embracing completely the most modern technological skills. As the photo-historian Alan Trachtenberg notes of Americans' production of daguerreotypes:

> For the nation's boasters and boosters, it was an occasion akin to the expansionist fervor of manifest destiny, that homemade daguerreotypes were recognized not only as the best made things of their kind anywhere, but also as signifiers of qualities distinctively American, as emblems or icons of the national identity. A rhetoric seemed already in place, or was very rapidly improvised, for claiming the daguerreotype as an example and a proof of what was unique and *exceptional* about the nation itself.[51]

Their technical know-how made Americans flaunt the most advanced photographic styles wherever they went—an attitude based as much on their flair for self-promotion and enthusiastic salesmanship as on their actual competence. This aggrandising disposition, along with the whole range of actual photographic equipment and supplies, accompanied the migrants from California to the antipodes. A combination of practicality and ideological enthusiasm worked surprisingly well on the Australian frontier. An examination of the compendium of early Australian photographic establishments reveals that a large number of early photographers in Australia included the term 'American' in the title of their businesses, even when their only connection to the United States was their use of American equipment and American photographic materials.[52] The assurance that a photographer was connected to the technologies of American style obviously was a strong selling point, if the numbers of 'American Photographic' establishments in Australian cities and country towns is anything to go by.

The most effective example of this advertising by association can be seen in the photographs produced by the team of Beaufoy Merlin and Charles Bayliss at Hill End, New South Wales, in the 1870s. As the American & Australasian Photographic Company, Merlin and Bayliss set up shop in this mining town. One of their photographs from Hill End shows them standing in front of their shop, with the large black graphic letters 'A & A'—for 'American and Australasian'—emblazoned across the facade. Neither photographer had any known connection to the United States, nor as far as can be determined had even visited there. Nonetheless, even the logo on the back of their photos included the linking of American and Australian flags, along with a locomotive, that most potent symbol of technological modernity, in the middle, and two hands clasped together in friendship below.[53] By this decade—more so than in previous

Fig. 1.04 Merlin & Bayliss, *Studios of American & Australasian Photographic Company, Tambarorra Street, Hill End, showing members of staff and passers-by*, c. 1870–75. Photograph. Holtermann Collection, State Library of New South Wales, Sydney.

decades—American photographic practice represented progress, ambition, quality, skill and most significantly, modernity. Merlin & Bayliss conveyed all of these attributes with their printed symbols on the back of their photographic cards. The work of these two men, some 20 years after the first linking of American and Australian photographic practice, and during that decade when in the American West view photography would reach its peak, certainly warranted their assertion of tenacious ambition and the most modern photographic vision.[54]

In the 1850s, however, before the unprecedented efforts of Merlin & Bayliss, photography in Australia, along with all other artistic practices and artisanal .activities, was still one of the itinerant, mobile occupations that many opportunistic young men thought might make them their fortune where new settlers congregated. Labelled by the Australian photographer and historian Jack Cato 'a vagrant process', this chemical method of reproducing images was particularly well-suited to the needs of a population on the move. The process offered a convenient way to document and record their new lives, their new possessions and their achievements for those 'back home'.[55] Some of these photographers had been initially trained as painters or illustrators, but given the paucity of patronage for high art endeavours in frontier communities, took up photography as a necessary or supplementary creative activity.

What is most intriguing about these artist–photographers is that no matter how great their artistic ambitions were or how skilled or amateurish they were as artists,

Fig. 1.05 Merlin & Bayliss, reverse of Merlin's *cartes*, with trademark of American & Australasian Photographic Company's Sydney office in George Street. Private collection.

they saw photography as the legitimate and appropriate choice of alternative occupation. From the beginning of its invention, then, despite all the debates about its place in the pantheon of the arts, photography was somehow connected with artistic practice in the minds of even the most entrepreneurial practitioners of the photographic trade. For the many wandering artists on the roads to goldfields in the mid-nineteenth century, whether self-taught or formally trained, photographic process was seen to involve similar acts of composition and to require some of the same aspects of pictorial imagination associated with painterly image-making. As John Wood notes, 'photography simply appeared at a moment when both the Western pictorial vision and the camera's eye coincided, a time at which painters and photographers were producing similar kinds of compositions'.[56]

Such attitudes about artistic production were no doubt necessary and indeed liberating for those artists on the frontiers of Western society far removed from the strictures of European academic hierarchies.

The transition from painting to photography was, of course, first and most conspicuously achieved in the field of portraiture. As Trachtenberg points out, early photographic portraiture 'played an inestimable role in creating the fetish of the portrayed or imaged face that has so large a role in the public life of modern cultures'.[57] In frontier California and in Australia, those artists trying to find patronage as portrait painters were the first to add photography to their repertoire, since the daguerreotype's superiority at producing 'a good likeness' was immediately recognised by artist and sitter alike. The first known photographs produced in California and in Australia were portraits,[58] and comprised the vast majority of images of the daguerreotype era.[59] While the coming of the wet plate in the mid-1850s, with the possibility of multiple copies and greater mobility, allowed an easier expansion of photography's subjects, portraiture continued for many years to be the mainstay of most photographers' business.

Describing William Freeman, one of Sydney's most influential early photographers, Jack Cato gives further explanation for the rapid transition by some artists to portrait photography:

> It is said that William Freeman was an artist, and that he took up photography because the coming of the Daguerreotype destroyed the early phase of Colonial art, and with it the livelihood of the painters. The facts are that in Sydney's small-town population of the 1840's, the few painters who lived there were either starving, or on the bread line, or supporting themselves by some other occupation.[60]

The situation for artists in early American California was just as precarious. While the gold rush may have increased the populations of California and the Australian colonies, art patronage did not expand substantially in either place, and more people could afford a photographic portrait than a painted one. Well into the twentieth century, anyone trying to make a living as an artist in these cultures on the periphery of Western civilisation routinely took up other occupations in order to survive.

In photography, artists found an occupation that gave them at least some chance of applying their skills in composition and picturesque arrangement. Not incidentally, the practice also allowed them, once they decided to settle in a town or city, to establish studios with all the accoutrements of the artistic salon. In some cases even the itinerant wagons used by the early practitioners of daguerreotypy were self-consciously rigged out as 'sumptuously outfitted galleries rivaling the lesser establishments of the cities'.[61]

Portraiture may have been the first genre in which photography gained artistic prominence, but the visual representation of landscape also preoccupied frontier artists who turned to photography in the decades of the gold rushes. In views photography, enterprising operators almost immediately attempted to cash in on the public's desire to see images of new and, they hoped, exotic or spectacular places. In this field, the connection, at least initially, to popular artistic practices and longstanding traditions of pictorial composition was even more obvious than in portraits. Here one finds that the ideologies of place, of concepts of land and man's relationship to geographical location, play the largest role in what frontier artists create and what frontier and colonial audiences begin to incorporate into their own aesthetic attitudes.

While in the 1850s touring wagons roamed the California terrain taking pictures of new settlements and men at work that often included landscape elements, no 'pure' landscape photographs—that is, a picturesque view composed of nothing but scenery—were made until the 1860s.[62] The earliest ambitious views photographs in San Francisco and in Australia were of the towns. In California, George Robinson Fardon (1807-1886) introduced the glass plate negative to the city in 1852.[63] Unlike most of the commercially minded operators in that boomtown who concentrated on portraiture, he quickly established himself as a specialist in cityscapes. Fardon's *San Francisco album* of 1856 contains 30 to 33 plates depicting overviews of sections of the new city, as well as images of the most stolid, 'civilized' buildings that had been erected, as if he wanted to 'promote San Francisco's image as a stable, prosperous, and permanent city'.[64] The album is considered to be the first photographically illustrated book of an American city. Fardon, like so many other restless practitioners of the photographic trade in the West, eventually left the city he had memorialised and settled in British Columbia, capturing views of newly developing places there as he had in California.[65]

In Australia in December 1848 a visiting Englishman, J. W. Newland (fl. 1848–1854), took the earliest surviving view photograph on the continent, a daguerreotype of Murray Street in Hobart, Tasmania. The itinerant Newland set up shop in Sydney before heading off to Calcutta and eventually back to London.[66] His Hobart view is particularly striking, not only for its astounding clarity, but because it was taken from some height, out of a window of his second-floor studio, and gives a clear view of the waterfront in the distance.

Newland exemplifies the showmanship so often associated with these early travelling photographers. Along with his exhibition of daguerreotypes and his sale of views and

portraits, while in Australia he also advertised an elaborate presentation that he described as a 'BEAUTIFUL SCIENTIFIC EXHIBITION OF DISSOLVING VIEWS'. He mounted this spectacle at the Sydney Royal Victoria Theatre and in London at the Adelaide Gallery. It consisted of a magic lantern show, illuminated illustrations of animals and insects, and a rolling diorama some 10,000 feet (3048 metres) long of scenery, all accompanied by minstrel songs.[67] Newland's varied efforts at popular entertainment while working as a photographer were not an unusual practice. Artists as well as photographers often made painted moving panoramas, all the rage for entertainment in the days before motion pictures. Hundreds of these home-made and imported panoramas, sometimes thousands of metres long and moved by rolling mechanisms, toured the countryside, both in California and in the Australian colonies.[68]

While artists and showmen of every sort in the gold regions were producing and exhibiting panoramas and other types of painted entertainments, photographers were also applying photographic technique to similar feats of scenic display. In some cases they exhibited the photographs themselves as panoramas, or used photographs as sources for painted scenes. While most of these efforts were considered ephemeral in their own time and have subsequently disappeared, tantalising hints of ambitious photographic undertakings have surfaced in the research of many dedicated historians. The late photo-historian of the American West, Peter Palmquist, wrote of the 'Daguerreian Holy Grail', the lost 300-plate daguerreotype panorama of San Francisco and the California gold regions produced in 1850 to 1851 by the 'Matthew Brady of the West', Robert H. Vance (1825–1876).[69] Vance's ambitious panorama was known to have been exhibited in New York and received rave reviews in photographic journals, although the public was apparently less than enthusiastic.

James Mason Hutchings, who has already

Fig. 1.06 George Robinson Fardon, *San Francisco Album*, 1856, p. 5. View down Stockton Street to Bay. Albumen print. Courtesy of The Huntington Library, San Marino, California.

been mentioned in connection with letter-sheets of the Mammoth Trees and who would occupy such an important place in promoting California through his publication *Hutchings' Illustrated California Magazine*, had initially embarked on an ambitious moving panorama project using his own daguerreotypes and travel notes. He finally abandoned the project in 1856 when he lost his financial backing.[70] Martha Sandweiss also discusses at length panoramas that used photographs as artistic sources, most particularly John Wesley Jones's *Great pantoscope of California* of 1852. Jones produced this gigantic work by consulting his own collection of some 1500 daguerreotypes made in the field on expedition.[71]

While these photographs have disappeared, some panoramic views have survived from the daguerreotype period and even more appeared after the wet plate had been introduced in the 1850s. The wet-plate or collodion process allowed multiple prints to be made from the glass negative and printed on paper, a fact that photographers recognised was ideal for the large-scale production and sale of views.[72] These early processes offer some of the first attempts on the part of photographer-showmen to produce majestic, expansive photographic images of the landscape that could be viewed and appreciated on public display rather than as intimate private images that most photographs had been in the daguerreotype era.

In Australia, panorama painting and panoramic photography also went hand in hand, and arrived just as quickly in the colonies as they did in frontier California. Panorama paintings of Sydney and Hobart had been an important part of 'topographical landscape' images coming out of Australia since the invention of the panorama in the 1820s.[73] By the time of the gold rushes, moving panoramas, many of them arriving from America, were regularly traversing the colonies. After J. W.

Newland's 1848 display, scores of ephemeral entertainments held the attention of audiences in the goldfield towns and in the cities. As late as 1872, the American R. G. Bachelder (sometimes written Batchelder, and believed to be a relative of the photographers Batchelder)[74] was exhibiting in Sydney his *Colossean pantoscope*, which included 'beautiful views of New York, along the Central Pacific Line to San Francisco, to Sandwich Islands and New Zealand, then to Sydney Cove'.[75] Cycloramas, a more elaborate form of panorama often requiring separate buildings for exhibition, remained popular in the antipodes until the arrival of motion pictures at the beginning of the twentieth century.[76] But the earliest panoramas were designed for wandering. The panorama artists made an asset of their itinerancy, presenting these images of distant places as eyewitness accounts of their own journeys, or at least implying that they had visited all the places they depicted in their exhibited views.

Photographers in the antipodes were also quick to jump on the panoramic bandwagon. While no daguerreotype panoramas of Australian origin have survived, consecutive views produced with standard wet-plate cameras were quick to appear.[77] As early as 1854 to 1857, Walter Woodbury created an eight-plate view of Melbourne, one of the first panoramas to be created in Australia;[78] in 1856, Sharp & Frith made a five-section view, printed on paper, of Hobart in Tasmania;[79] and Alexander Fox applied the idea of panoramic continuity to views of Bendigo's main street in 1858.[80]

These early panoramic efforts appear to be serially composed plates taken from ground level. While expansive in scope and continuity, they lack the grandiosity that a sweeping vista could provide. The most affecting use of panoramic method, both in painting and photography, took advantage of elevated sites. It is no surprise that the most common subject

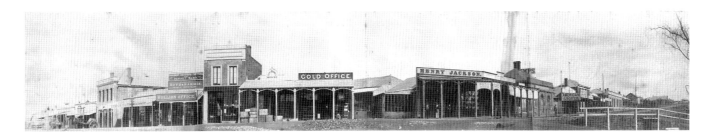

Fig. 1.07 Alexander Fox, *Panorama of View Point, Bendigo*, 2 views. October 1858. Courtesy of Bendigo Art Gallery, Bendigo, Victoria.

for the early Californian panoramas was San Francisco Bay, as captured by photographers setting up their camera apparatus on one of the city's many hills, the better to provide an uninterrupted and all-encompassing view down to the water's edge below and across the bay to the other shore. While the small size of daguerreotypes limited the impact of public display of such panoramic attempts, the immediacy of the detail in each plate, and the stimulating sensation of contiguous views, were thrilling discoveries nonetheless. The arrival of the wet-plate process simply made the panorama photographer's job easier and allowed for larger images.

So it was in Australia: the most impressive early panorama taken from an elevated vantage point depicted overlapping sequential views of Sydney Harbour. In 1858, O. W. Blackwood (1824–1897) created a 'panorama of eleven imperial plate images' of the harbour taken from the roof of Government House; he then announced he would 'have the pleasure of offering the above to the public'.[81] The plates, processed as albumen prints and put into albums, were described in the Sydney newspapers as 'super-excellent' and as 'eminently superior to anything of the kind we have yet seen'.[82] Most significantly, Blackwood was hailed as an 'artist' as fully deserving of the title as any panoramic painter—perhaps lauded even more highly because of his obvious technical mastery in creating a seamless circular representation of a natural setting on several sectioned plates.[83]

Blackwood's splendid production proves that Australian photographers by the 1850s were as skilled and ambitious in their efforts to produce artistic views as any European or American photographers were. The materials, the equipment and the technological know-how were as advanced in Sydney and Melbourne as in San Francisco or London at the time, although some materials, such as chemicals and photographic papers, were sometimes in short supply. Panoramic photographs of Sydney Harbour would become in the next decades an obsessive focus for several important photographers.

This linking of painterly skill and photographic craft among the itinerant opportunists on the goldfields of both continents is a leitmotif for this period. In one of the most colourful accounts written by an American in Australia, appropriately titled *Knocking about*, the Massachusetts man Augustus Baker Peirce (1840–1919) gives delightful, albeit exaggerated, description of his picaresque adventures throughout Victoria after he jumped ship in Melbourne in 1859.[84] He worked at various times in his 30 years in the colony as a sign painter, a butcher, a snake-oil salesman, a theatrical set designer, a sailor, an actor, a singer, a river boat captain, a photographer and, indeed, a panorama painter. As Anita Callaway writes of him, Peirce is a prime example of a New World artist 'removed from the claustrophobia of the Old World academies … free to respond to the demands of a new popular market'.[85]

Peirce seemed to be particularly proud of his panoramas, which he always described in terms of length and number of scenes rather than artistic quality. If the illustrations

reproduced in his book are any indication, his artistic abilities were far inferior to his talents at self-promotion, a fact he himself light-heartedly acknowledged. Describing his first venture into scene painting, he freely admitted his ignorance of the requested scenes, but demonstrated the true opportunist's willing-ness to put his hand and his imagination to any task:

> In Melbourne, I met a Canadian named William Chisholm, who engaged me to paint a picture of the great American falls for his Niagara Hotel. I had not seen the falls, never having been out of Massachusetts before my sailing on the *Oriental*, and I did not remember ever having seen a picture of them; but as Chisholm's patrons were in the same boat, the view which I managed to produce was very satisfactory, and old Chisholm, when questioned, would lean across the bar and murmur, 'Perfect picture, fellows; almost makes me homesick to look at it!'[86]

Peirce and his cheeky reminiscences will figure further in this story of photography and aesthetic exchange, for his peripatetic adven-tures epitomise the kind of activities and occupations—and the kind of characters—that appeared so frequently in this period of colonial life.[87]

While public display and exhibition for entertainment were the primary factors determining the production of both painted and photographic panoramas, other frontier artists turned their hand to photography just to survive. In California, the French artist Henri Penelon (c. 1827–1879) exemplifies one of many artists turned photographer, who eked out an existence in new settlements bereft of much artistic life or cultural patronage. Penelon is particularly intriguing, for unlike many other foreigners drawn to San Francisco and northern California because of the gold

rush, he settled after a very short time in San Francisco in Southern California, in what was then the village of Los Angeles. In 1853, when Penelon arrived, the Spanish–Mexican town, newly acquired by the American government, had a population of about 4000 (the county about 10,000), with very little in the way of art patrons.[88] Why Penelon decided to bring his talents here rather than join in the increas-ingly cultivated society up north is unclear, but he is consequently considered Los Angeles's first resident artist.[89] He set up a studio near the town plaza, where he gained some employ-ment as a portrait painter among the old *Californio* families. He also painted a fresco on the facade of the mission church on the plaza (the painting survived into the 1950s, when it was painted over). Penelon was French and Catholic, leading some writers to infer that he was more easily accepted by the Mexican Catholic Californian families that comprised Los Angeles society of the time.

One of Penelon's best paintings is an eques-trian portrait of Don Jose Sepulveda, owner of the enormous Rancho San Joaquin, which covered nearly all of what is today Orange County. Legend has it that in the painting Sepulveda sits astride his Australian mare, Black Swan, considered the first thoroughbred horse in California and the winner in 1852 of the most famous horse race in early Californian history.[90] The painting shows Penelon to have had some knowledge of standard European artistic modes such as equestrian portraiture, but his execution was primitive enough that one doubts he had much, if any, professional training as an artist. As John Dewar remarks in the only essay on Penelon, '[a]ll of the Penelon paintings are painted thinly, also the mark of the self-taught artist'.[91] He continued nonethe-less as an artist until the mid-60s, when, in April 1864, he began to advertise in the newspaper as 'H. Penelon, Daguerrean Gallery', including as one of his offerings, 'Pictures in Oil Paint

executed in the Best Style'.[92] From this time, he seemed to carry out painting when he could find the clients, but increasingly depended on making photographs.

After 1870 Penelon worked almost entirely as a photographer, but still called himself in his advertisements and on his photographic cards 'artist'.[93] His photographs, what few can now be identified, reveal the same kind of compositional modes as his portrait paintings do (although without the horse). Falling on hard times due to increased competition in the booming Los Angeles of the 1870s, Penelon, in partnership with another photographer, Dudley P. Flanders, set out with photographic equipment for the Arizona Territory. He was apparently forced by financial need back to the itinerant photographic trade. He died suddenly in Prescott and was buried there, leaving behind a wife and two daughters in Los Angeles.

Penelon had limited his peregrinations to adjoining territories after settling in Southern California even when forced by lack of patronage in the culturally deprived region to hit the road again. More adventurous artist–photographers, whether by necessity or through restlessness, peripatetically followed the gold-induced migrations around the globe to find custom. One such figure was Thomas Flintoff (1809–1891), an artist from Newcastle-upon-Tyne, England, who had studied art in England (and perhaps in Germany) before setting off in 1851 for the new state of Texas.[94] In Galveston and Austin, Flintoff painted portraits of all the 'many ladies and gentlemen' of Texan society, including Texas founders Stephen F. Austin and Sam Houston, and was praised for his 'delineation of features and life-like tone and expression'.[95] His portrait style was more polished than Penelon's and demonstrated an acceptable, if modest, mode of middle-class painting. He also produced several watercolour sketches of buildings and scenes of Texas towns that are some of the earliest views of these new settlements.

Flintoff had an apparently successful studio in Galveston when in the spring of 1852 he left there as mysteriously as he had arrived. Since records indicate that he boarded a ship in San Francisco with his son, he must have travelled to California, but there is no evidence of any art produced by Flintoff there. He arrived in Melbourne in June 1853 on board the *S. S. New Orleans*, having visited Mexico and the Society Islands along the way (in 1874, he painted a scene from this journey, *A past experience: Crossing the line by moonlight on board the* S. S. New Orleans *March 24th 1853*, a photograph of which is now in the State Library of Victoria). Probably drawn by news of a gold-rich society, Flintoff headed directly for Ballarat, where by 1856 he had established the Tyne-side Photographic Gallery on Sturt Street. Here for many decades he produced

paintings, both portraits and views, including a delightful example of pride in ownership, *Henry F. Stone and his Durham ox* (1887), now in the Ballarat Fine Art Gallery. This portrait of a man and his prize-winning beast exudes Englishness as Flintoff's Texas portraits do not, even when the background landscape is stylised and generic. His style of painting here is reminiscent of those images of farmers with their champion bulls that appear in provincial galleries or as signs at high-class butcher shops in nineteenth-century London—traditionally painterly and old-fashioned. He did not, as other newly arrived painters in Australia did, attempt to delineate the eucalyptus or other Australian vegetation to identify the place as antipodean. Flintoff became a popular member of Ballarat society and even applied his artistic skills to the painting of banners for fraternal organisations such as the Ancient Order of Foresters, filled with Scottish emblems and ornamental flourishes.[96]

The most telling fact about artists' difficulties in colonial Australia is that Flintoff had from the beginning of his stay announced himself as a photographer, despite no indication of having had any previous photographic training; there are no known examples of photographs made by Flintoff in Texas or California. By the 1860s, he advertised himself as 'Thomas Flintoff, ARTIST', itemising his willingness to produce *cartes de visite*, as well as 'Portraits in Oil, Crayon, and Water Color executed on the premises'; he also advertised 'Oil Paintings Cleaned and Renovated'.[97] His advertisements in the local newspapers also declared his invention of 'Flintoff's Infallotype', which he maintained were 'superior for Permanency, Magnificence & Beauty to any Photograph produced in the colony'.[98]

The logo on the back of his photographs in the 1860s included text written in a painter's palette, 'Flintoff, Photographer and Portrait Painter', but with no evidence of a camera or any mechanical apparatus. Flintoff took great pains in his photographs to show his 'artistic' hand. His *cartes* portraits are often constructions in which the photograph is cut out and placed against a painted backdrop, posing the figure as if in an outdoor setting. He created what now look like sweetly manipulated photo-montages. While he may have acquiesced to the demands of the market for instantaneous and inexpensive portraits, he still felt compelled to give evidence of his skills as an artist of high, if whimsical, degree.

Others on the frontiers were first and foremost photographers, both entrepreneurial and itinerant, continuing in their profession for decades and mastering along the way all of the technological changes of the trade in the nineteenth century. Exemplary of these early

Fig. 1.09 Thomas Flintoff, *Baby Bernard*, c. 1870s. *Cartes de visite*. Photograph. Courtesy of Mitchell Library, State Library of New South Wales, Sydney.

adventurer-photographers who experienced both gold rushes were the Batchelder brothers, originally from Beverley, Massachusetts. They first travelled to the California goldfields in the early 1850s and then made their way to the Australian colony of Victoria once word of the gold rush there had reached American shores. Significantly, none of the four Batchelder brothers seems ever to have taken up mining in either place. The Batchelders exemplify the primarily commercial ambitions of most frontier photographers: 'They developed a highly mobile, flexible, and practical style of operating that took full advantage of the rapidly expanding commercial possibilities of the era.'[99] With their peregrinations around the globe, establishing photographic businesses from Massachusetts to California to Australia and back again, the Batchelders epitomise the adventurous itinerancy that in these new societies was so essential to the spread of modern photographic technology, artistic practice and popular aesthetic exchange.

The oldest brother Perez Mann Batchelder (1818–1873) arrived in the California goldfield communities after practicing the daguerreotyping trade in Boston.[100] His brother Benjamin Pierce Batchelder (1826–1891) apparently learned the business with him there, and joined him when Perez followed the pioneers to the California gold country. As early as 1851, they operated a daguerrean cart located on Washington Street in Sonora, California, staying there as long as business continued.[101] Sonora at the time was one of the most bustling of the mountain gold towns (so named because many of the earliest arrivals to this region came from the Mexican state of Sonora), and the Batchelders would have taken advantage of every opportunity to cash in on the desire of the early miners to give photographic evidence, to bear visual witness, of their circumstances for loved ones back home.[102]

The Batchelders were not consciously striving for artistic stature, nor did they ever refer to themselves as artists. They had taken up photography as a commercial venture. Aesthetic devices in Batchelder photographs are simply there as part of the nineteenth-century photographic bag of tricks. But the images produced out of their wagons in the California hills demonstrate selectivity in the kinds of views that the operators, whether the Batchelders themselves or their trainees, decided to take. That these photographs often captured something of the surrounding landscape was perhaps at this point merely serendipitous and not a conscious inclusion. But soon views of the settlements, and the relationship of these settlers to the land that they were settling, would become a significant and carefully considered part of the photographers' repertoire.

In early 1852, the Batchelders sold their cart in Sonora to William Herman Rulofson (the same Rulofson who would later gain fame as a leading photographer in San Francisco)[103] and John B. Cameron. The brothers moved on to San Joaquin County, where they established another roving gallery operating out of the river port city of Stockton. In a letter from 1853, Perez indicates that he and Benjamin were still working out of wagons; it was probably at this time that Benjamin again ventured into the mountain communities around Jamestown near Sonora with another portable cart.[104] In a letter to his brother John from Sonora dated 22 March 1853, Perez exuded enthusiastic enterprise: 'We have two saloons in operation and shall have two more on the 1st of April. Since the 9th of January I have taken in this Saloon $2200. My expenses being no more than they were in the States. Ben has done nearly as much, so you see we are just beginning to do something.'[105]

In keeping with their enterprising aims to set up what can only be considered daguerrean franchises, the Batchelders were constantly taking on and training new

operators. In March of 1853, a particularly fun-loving and seafaring man named Isaac Wallace Baker, also from Beverly, signed on with the Batchelders to learn the art of daguerreotypy (or, as he referred to it in one of his own letters, 'dogtyping'[106]). Baker had rounded the Horn to sail to San Francisco in August 1849; he returned to Boston in 1850, only to return to California, again by ship, in 1852, at which time he apparently headed for the gold country.

The exact whereabouts of Baker's training with the Batchelders is unclear. Palmquist states that Baker worked with P. M. Batchelder in Sonora, and quotes Batchelder's letter to Baker, in which he brags that he would 'learn you the Daguerreotype business during the first two months'.[107] In any case, one of the most well-known images from the California goldfields substantiates that he was indeed involved in the production of daguerreotypes out of a Batchelder travelling cart by the summer of 1853. Whether operated by Benjamin or by Baker alone, a 'Batchelder's Daguerreian Saloon' was at this time parked on the road between Vallecito and Murphys Camp, some 32 kilometres from Jamestown and eight kilometres from Sonora. It is most likely Baker who stands in front of this 'Saloon' in one of the most emblematic images produced in the California gold country.[108]

This quarter-plate daguerreotype, a very small and insubstantial artifact, nonetheless captures the intrepid spirit of the California 'Argonauts', as the pioneer Californians were called. Baker stands arms akimbo at the entrance to the wagon, from which curtains billow out the window. He wears a jaunty scarf around his neck and looks directly at the camera, which is perhaps operated by Benjamin Batchelder, situated with the camera far enough away to include the entire wagon (with advertising sign), some seated bystanders and an entire line of evergreen trees ranged along the hillside behind. A sense of expansiveness, of being open for whatever opportunity comes along, emanates from the frame. Even the two onlookers seated in front of a sturdier structure to the left of the wagon contribute to the adventurous mood of the image. Endless possibilities—the sense that the world was their oyster and they were going to enjoy the opportunities that came their way—are symbolised by this frequently reproduced image.

Baker, signing himself as 'operator' of Batchelder's Daguerreotype Saloon, confirmed this mood of transient excitement in a broadside advertisement, printed by the *Sonora Herald* from Murphys Camp, July 1853. This 'Proclamation!' as Baker called it, ends with a cheery exhortation to visit before he has moved on:

SALOON ON WHEELS,—boys, recollect,—
It may be off ere you expect.
Pictures good, and prices low,
Now's your chance, before I go;
Recollect the name, and call in soon,—
BATCHELDERS' DAGUERREOTYPE SALOON.[109]

Baker did not stay long at the daguerreotype wagon. Soon after this advertisement, he returned east, where he often gave lectures of his travels, illustrated with his own paintings and photographs. Eventually he took up the seafaring life again, perhaps prompted by word of gold discoveries in Australia. Family legend has it that Baker had a collection of boomerangs, which he acquired while in the South Seas on a voyage as a sailor. According to a newspaper article from a Massachusetts paper in the Baker biographical file at the Bancroft Library, 'in September, 1862, while on a voyage to the East Indies, he was taken with a fever when on the coast of Sumatra, from which he died'.[110]

The sense of immediacy is what makes the

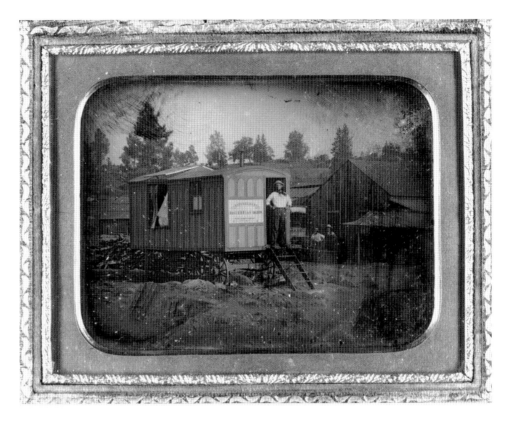

Fig. 1.10 Isaac Wallace Baker, *Baker standing in front of Batchelder's Daguerreian Saloon*, 1852. Daguerreotype. Oakland Museum of California, Oakland, California.

Batchelder carts and the images produced out of them so significant. While the daguerreotype operators were producing formal portraits inside the saloon for anyone who came along in need of a 'good likeness', they were also able to capture the scenery around them, on the spot and at their leisure. The Batchelders' clever ability to cash in on the transience of these gold communities by remaining mobile speaks to the opportunistic nature of their ventures, and those of many other photographers in the mountainous terrain. In a letter to his brother, Perez speaks of being able to 'take a circuit of five or six miles out round among the mines during this beautiful weather'.[111] The system of mobile carts was ideally suited to the times and to the geography of the California mountains.

Letters to Baker make it clear that Perez also maintained a wagon on the main plaza in Stockton, and both Batchelders were busy in several locations training as many assistants

in the daguerrean art as they could.[112] Since attribution to either Batchelder is in most cases impossible to claim for the California photographs, one cannot establish whether the brothers had begun to specialise in any style or genre of photography at this point. Their Australian efforts make clear that Perez made his name almost exclusively through portraiture, while Benjamin was throughout his career more interested in depicting views and events.

Ever on the move, Perez Batchelder had by 1854 emigrated to Australia, where he established in May of that year a gallery in Melbourne. He even managed to include three photographs in the 1854 Melbourne international exhibition.[113] Benjamin continued to operate at least one travelling wagon in and around Sonora until at least 1855, although whether a Batchelder operated the camera there or not is open to question. In any case, in this year a Batchelder's Daguerreian Saloon

is known to have been in Volcano, another gold-town settlement some 24 kilometres from Jackson in Amador County, and 90 kilometres north-west of Sonora. The colourful Nevada character and inveterate diarist Alfred Doten mentions in his journal that he had his 'Daguerreotype' made in Batchelder's wagon in Volcano, on 29 May and again on 10 June 1855.[114] Its presence so far away from Vallecito and Sonora gives good indication of the mobility of these wagons and the freedom that they allowed to take full advantage of the fluctuations of the market as the miners moved from place to place.

The photo-historian Peter Palmquist maintained that he knew of no photographs that could be substantiated as taken by Benjamin Batchelder in California before he went to Australia.[115] A search of the collection of stereographs at the Haggin Museum, Stockton, California, has uncovered one image with Batchelder's imprint that is identified, in handwriting on the edge of the stereo, as 'Sonora 1856'. The view depicts from an elevated position the main street of the newly constructed town, all freshly timbered roofs with stacks of lumber to the side of the buildings. The only sign that can be seen is a large hori-

zontal banner announcing 'TIN SHOP'; a few tall trees appear along the road and behind the shops. This one image, significantly enough, is not a portrait, but a view that incorporates the fledgling settlement and the surrounding mountains as well.

If Benjamin Batchelder did indeed produce this view himself, then it would substantiate Mike Butcher's dating of Benjamin's arrival in Melbourne as 15 July 1858 rather than Palmquist's belief that he was the Batchelder who arrived in Melbourne in February 1856.[116] This dating would also make sense of the fact that Benjamin was listed as operating as a daguerreotypist in Danvers, Massachusetts, in 1856 and in Boston in 1857 to 1858. The family was still interested in keeping their photographic enterprises alive back east and Benjamin probably continued there to train others who would work as photographic operators under the Batchelder name. Perez also must have returned at least briefly to Massachusetts at this time, for he is listed as marrying his second wife in Beverley on 16 June 1858.[117] Perhaps Benjamin had also returned to Massachusetts to round up his other brother Nathaniel (1824–1860), who was then working in the family trade in

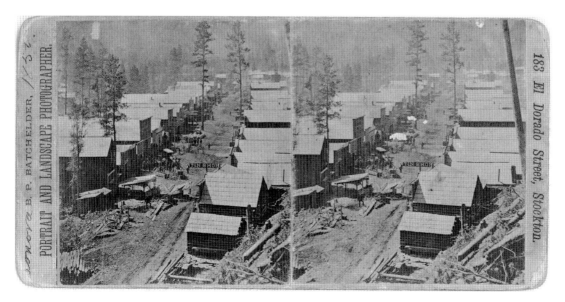

Fig. 1.11 Benjamin Batchelder, *Sonora*, 1856. Stereograph. Courtesy of Haggin Museum, Stockton, California.

Danvers, to accompany him to Australia. He also got married there and his wife travelled with him to Melbourne.[118] A fourth brother, Freeman Ezra (1834–1862), was already working with Perez in Australia by 1857.

By the mid-1850s, Melbourne had experienced the same kind of transformations that the discovery of gold had brought about in San Francisco. Within 20 years of its founding in 1835, the Victorian city had grown so enormously wealthy and supported so much cultural aspiration that the town fathers had already established a university, a botanical gardens and a library.[119] At the time when the Victorian gold regions were still largely the realm of itinerant tradesmen and more unsettled populations, the colonial capital was, like San Francisco, taking on all of the cultivated trappings of Western civilisation. These trappings included elegant photographic salons.

Perhaps aware that his greatest financial opportunities were to be realised in Melbourne, Perez never ventured into the goldmining towns nor established travelling wagons, but set up shop immediately on Melbourne's most fashionable street, at 57 Collins Street East. As had been his practice in California, Batchelder began training others to make photographs and also had an active trade in the sale of photographic supplies—one of the most lucrative and important commodities in the colonial markets. Batchelder even advertised his sale of 'Photographic Materials of every description … sent to any part of the colonies' in the Hobart newspapers.[120]

One of Perez's most accomplished assistants in Melbourne was the young Englishman Walter Woodbury (1834–1885), the same photographer who made the first panorama of Melbourne. Woodbury's letters home to England provide a rousing account of 1850s Melbourne and Victoria and, most specifically, detailed descriptions of both Batchelders'

operations. In 1855, Woodbury wrote to his mother that he was earning four pounds a week at Batchelder's, and described his Collins Street studio as 'the head daguerotype [sic] establishment in Melbourne'.[121] Woodbury also wrote that Batchelder had sought him out because he had noted that he, Woodbury, was the 'best wet-plate operator in Melbourne'.[122]

By the year that Benjamin and Nathaniel had arrived in Australia, Perez had established, with another Massachusetts man Daniel O'Neill, a studio that would become a longstanding Melbourne firm, Batchelder & O'Neill. Perez mentions O'Neill in a delightful letter sent to his brother, in which he recounts a 'Glorious Fourth' celebration staged at Melbourne's Imperial Hotel in 1855, at which some 120 Americans, 'representing in their respective persons every State in Yankeedom', were in attendance.[123] Overcome, as he writes, by the 'rosy god', Perez persuades Mr O'Neill to leave the extravagant proceedings; 'we were soon makeing [sic] a streight [sic] line for home which we reached without difficulty'.[124] 'I don't wish you to infer that I was tight (far from it)', he insists, 'I merely got a little more elated with the idea of being a free born artisan of the United States than I remember ever to have been on any previous annaversary [sic].'[125]

Perez himself presided over the firm Batchelder & O'Neill for only a few months, before leaving Australia and turning this Melbourne operation over to his brother Freeman; the elder Batchelder was back in the United States by 1868. He died in San Francisco in 1873, having resided in Oakland, California, for some years, where tax records indicated his occupation as 'farmer'. He left an estate worth some $53,000, most of which was in property that was given upon his death to his surviving wife (his father, Col. Henry Batchelder, was still alive at the time of Perez's death, and inherited one-fourth of the estate).[126]

The certificate from California Probate Court concerning Perez's estate also delineates that at this time, Benjamin Batchelder still owed him money on two promissory notes, even though Benjamin already had an established business in Stockton.[127] The probate certificate also indicates that Oakland photographer William B. Ingersoll (1834–c. 1908) owed Batchelder a small sum and, most interestingly, that as late as 1870, Batchelder had sold Ingersoll 'instruments and materials in a photographic Gallery in Oakland'.[128] This could mean that Perez continued to make photographs once he left Australia, although no images exist that can be identified as his, and Ingersoll's imprint appears on the stereograph of Batchelder's Oakland residence. The obituaries in the California papers described Perez Mann Batchelder as a California 'Pioneer', evidence that he was acknowledged for his arrival in California during the gold-rush years. By the 1870s, such status was already being romanticised and nurtured as part of the California frontier legend.[129]

Benjamin and Nathaniel meanwhile remained in Australia and had established a Sydney studio on George Street (the location, according to Jack Cato, of 10 of the 16 photographic studios listed in the Sydney city directory for 1858)[130]. Here they probably knew and competed with another American-trained, although English-born, photographer, Thomas Skelton Glaister (1825–1904), whose studio was on nearby Pitt Street at this time.[131] Glaister epitomised the aristocratic studio photographer, with elegant accommodations and prices based on exceptional aesthetic quality. Unlike the more commercially oriented Batchelders, he strove to appeal to a high-class clientele seeking formal portraits, and he charged accordingly. Glaister's works remain the best examples of early Australian portrait photography. He, too, touted his American training, calling his studio the American and Australian Portrait Gallery. His American know-how is most evident in the polished surfaces of his daguerreotypes, a finish unlike most other photographs produced in Australia at this early date. More than any other early photographs in the colony, Glaister's surviving works provide evidence that Australians had access to the highest standards of photographic art and that they were willing to pay for quality.

The Batchelders's work was certainly less glamorous and more utilitarian than Glaister's elegant images, at least in terms of portraiture. Later, in Bendigo, Benjamin would be conscious of compositional elements in his selection of pleasing scenes to photograph, but the idea of artistic 'polish' does not seem to have entered his or his brothers's photographic vocabulary. The Batchelder brothers remained in the George Street studio, apparently never venturing out to any country outposts, until 1860, when upon Nathaniel's untimely death of a heart attack, Benjamin returned to Victoria and set up shop in the goldfield town of Bendigo.[132]

Once in Bendigo, Benjamin again began employing and training others to make photographic views—including, fortunately for the purposes of this study, the memoir-writing Augustus Baker Peirce, the same one who made the bar-room paintings of Niagara Falls. Perhaps following his brother Perez, Benjamin returned to California in 1868, where he set up again as a photographer, with his wife Nancy, in Stockton. He advertised himself on his stereographs and in the *San Joaquin County directory* as 'Portrait and Landscape Photographer' and as making 'Photographs in Every Style'. He entered into the life of the city and resumed his penchant for recording civic events. He continued to make photographs until his death in 1891. His wife Nancy continued the business in Stockton—with her own logo on the photographs as 'woman

Fig. 1.12 Benjamin Batchelder, *Batchelder & wife (Nancy) in Stockton studio at 183 El Dorado Street*, c. 1885. Stereograph. Haggin Museum, Stockton, California.

artist'—until 1914.[133]

The relatively clear albeit peripatetic trail left by the Batchelder brothers and especially by Benjamin make their work the ideal specimens to analyse changes in photographic style or aesthetic direction caused by their movement from America to Australia and back again. Since Benjamin continued all the while to produce photographs that record the events of this exciting time in Victoria, his work, or that produced under his name, gives one of the clearest indications of how photographic compositions changed in keeping with the demands of customers on different continents. While the documentary aspect of these views, both in California and in Australia, are of primary importance and are a response to the photographer's desire to record what is there, there can be no denying that underlying ideological stances—the story that the patrons want to tell—determine to some extent the photographer's choices of what to document.

As has already been mentioned, it is difficult to determine which California images were produced by Perez or Benjamin Batchelder as they roamed the mountains in their daguerreotype wagons. Some of the many unidentified photographic images that have survived from this period were by their hand or out of their wagons; and one can assume that the stylistic devices and iconographic motifs that begin to appear in these early productions both influenced and were influenced by the Batchelders's efforts. Because of these intrepid itinerants, a surprisingly large number of photographs were known to be made in the California hills during the height of the gold rush in the early 1850s. Hundreds, perhaps thousands, have been preserved to the present day, no doubt still extant because the vast majority of these treasured objects were intended for private use and consumption, sent home to the eastern United States or to Europe as evidence of personal circumstances rather than for public display.

What kind of images were produced in the West in the 1850s, when so many itinerant photographic operators along with the

Batchelders were in the California mountains and on the goldfields? What concepts of place did these operators choose to emphasise in these photographic records? Looking at the variety of daguerreotypes that still exist, one is struck by two central elements. First is the emphasis in so many images on the relation of the figure to the landscape, and the man-made to nature. Most early views include people, posing in front of newly constructed buildings, as signs of the conquest of the daunting terrain. But even the seemingly straightforward depiction of a settlement that includes posed people often includes evidence, if only coincidentally, of the rugged geography surrounding the new towns.

This natural element is also evident in the many photographs taken in the goldfields themselves. While the miners working appear in the foreground, almost every photographer of the era in California took pains to include the landscape that surrounded them, as if to emphasise more clearly the strenuous obstacles that these individuals had to overcome and to underscore the tenacity necessary to conquer such an adverse, if awe-inspiring, environment. The one known view of Sonora by Batchelder is as consistent to this trope as other photographers' views. Taken from the hills above town, the town looks as if newly embedded in primeval wilderness, with all the banal and industrious contrivances of nineteenth-century American commerce.

The second striking fact of the California photographic record is that so many photographs survive that were taken in the mines and diggings themselves. Despite the treacherous conditions and the hardships

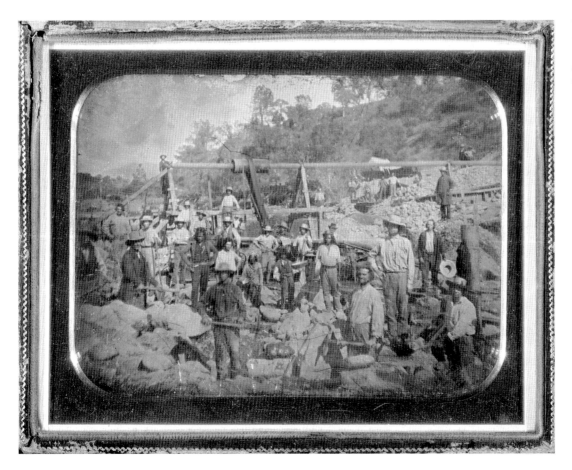

Fig. **1.13** *Miners at Taylorsville, California*, c. 1851. Daguerreotype. Courtesy of The Huntington Library, San Marino, California.

faced by miners and photographers alike, photographers from the first days of the gold rush recorded the miners on-site, at work in a vast and wild landscape. Not only do the images provide evidence that these men had to overcome daunting physical hardships to get to the gold; they also display in many cases a self-conscious sense of conquest. These companies of men (and sometimes women) engaged in mining pose for the camera, in the middle of their laborious activities, as if laying claim not only to the gold they dig, but to the craggy, imposing land itself. The photo-historian John Wood describes these configurations of men at work in nature as depicting an iconography of corporate cooperation:

> But on a more prosaic level—on the most obvious visual level—they record a chronology of cooperation ... They represent a kind of early corporate mentality. These are pictures of mining companies, often with their homemade signs proclaiming their names ... These daguerreotypes, then, are little utilitarian vignettes, pictures of communes of possibility. And therein was the beginning of what I called the twenty-four-karat American dream ... These nineteenth-century Americans had formed companies, business communes, that allowed the possibility for all of them to if not get rich at least become much better off by working for the good of the group.[134]

As portraits of groups, engaged in activities for 'the good of the group' in wilderness surroundings, these small visual records fit as comfortably into the ideological construction of the American frontier as the grander images of the Western landscape that would become such significant documents of conquest and artistic splendour in the next two decades, into the 'golden age' of Western photography in the 1870s. Many writers of photographic history have discussed these later views of the West as evidence of concepts of Romanticism, of the

Sublime or even of the anti-Darwinian ideas of Catastrophism, with a sometimes subliminal focus on the pioneers' efforts to conquer and tame the wilderness.[135]

These attitudes about the land are as evident in the earlier daguerreotypes taken of the miners in the California goldfields and of the burgeoning mining towns as they are in any later photography for the views trade.[136] Batchelder's vista of Sonora in 1855 easily conveys a sense of newness and, with its high vantage point, an awestruck recording of Anglo civilisation rising up in virgin territory. But the famous image of his operator Isaac Wallace Baker standing in the doorway of the Batchelder daguerreotype wagon at Murphys Camp also speaks of Manifest Destiny and the will to conquer nature. In California, the photographer was compelled, by patrons' demands and geographical circumstance, to emphasise individualism and man's conquest of a magnificent land, a wondrous topography.

The photographic record in Australia, at least that which has survived from the daguerrean period, presents different priorities, even in images made by photographers who had operated in California before arriving in the antipodes. What is particularly striking is the dearth of images taken in the Victorian goldfields themselves during the first decade of the gold rushes. In the early days of the Australian gold rush, from 1851 to 1861, very few examples of photographs, public or private, taken in the goldfields survive, and none possess the self-conscious ambition so apparent in the Californian examples. Photographers were certainly there from the beginnings of the mass influx of hopeful diggers, and travelling cameramen had traversed the colonies from the mid-1840s. George Goodman (d. 1851), credited by Cato and Davies with taking the first extant photographs in Australia, travelled throughout the colonies taking daguerreotypes, from Sydney to Hobart to Melbourne, and to

points in between.[137] Goodman had acquired a licence to make daguerreotypes in the British colonies from Richard Beard in London, when England still required such licences. He came to Australia in 1842 and took photographs, almost always out of doors, until his departure for England in 1847. He set up his apparatus most often at hotels and in pubs, where he made likenesses of all in the vicinity who came to him; but there is no indication that he travelled with a daguerrean wagon.[138]

Of the scant photographs known to be taken of miners at the early Victorian diggings the best known are those published in 1858 by the geologist Richard Daintree (c. 1832–1878) and the extraordinary Frenchman Antoine Fauchery (1823–1861) in their magnificent album *Australia: Sun pictures of Victoria*.[139] As Dianne Reilly notes in *The dictionary of Australian artists*, '[t]he Fauchery–Daintree partnership produced some remarkable photographs for the time'; indeed, their efforts

stand alone as the most skilfully produced images made in Victoria in the decade. Even Fauchery's images of diggers, obviously posed as the photographer told them to, presents a different vision of the diggers' circumstances and attitudes than that in the Californian scenes of miners at work. His *Group of diggers* is posed theatrically, capturing some sense of the excitement of gold discovery and camaraderie among the men working the fields. But there is little of the single-mindedness of corporate effort that is such a prominent attitude in the California images.

A few other scenes in *Sun pictures of Victoria* do depict the development of primitive settlement amid the muddy landscape of the Victorian fields and demonstrate as well Daintree's focus on geological conditions in the colony.[140] These views speak particularly to the difference in geographical setting between the Victorian fields and the claims in the California mountains. It is indeed

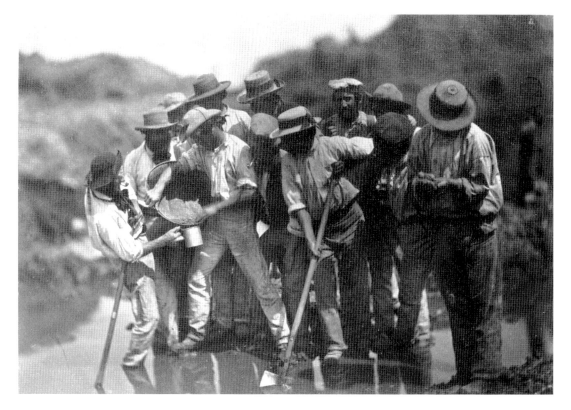

Fig. 1.14 Fauchery & Daintree, *Group of diggers*, 1858. Albumen silver photograph. From *Australia: Sun Pictures of Victoria*, Melbourne, 1858. La Trobe Picture Collection, State Library of Victoria, Melbourne.

Fig. 1.15 Frederick Grosse, *Gold diggers' puddling machine*. Wood-engraving. Published by John P. Brown, Melbourne, April 1858. Image by Nicholas Chevalier. National Library of Australia, Canberra.

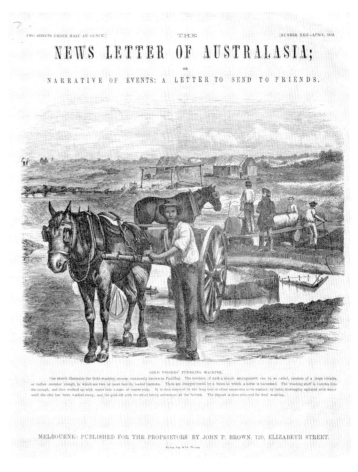

difficult to find anything picturesque or ruggedly geological to conquer in these mud-mired plains where tents, shacks and a few substantial buildings have been haphazardly raised. There are no high hills here upon which the photographer could conveniently place his camera for a sweeping view. But there were such spots in other Victorian diggings, such as Beechworth, and daguerreotype operators were there. Other reasons, other priorities, must have determined the photographic record that has survived in Australia.

In the illustrated newspapers published in Melbourne in the period, some of the engraved images in their pages have obviously been taken from photographs made on the site. *The News Letter of Australasia* in April 1858, for example, includes on its front sheet a detailed scene of the 'Gold Diggers' Puddling Machine',

including a horse and wagon held by a man looking at the viewer; in the background, other men are engaged in operating the puddling machine. While the engraved initials indicate that Nicholas Chevalier was the artist and Frederick Grosse was the engraver, the clarity and the immediacy of the image indicate that it was copied from a photographic source. Alexander Fox in Bendigo provided the photographs for several engravings that served as letter-sheets in the 1850s. None of these photographs have survived, although some letter-sheets do, and demonstrate that images from the goldfield towns were more prolific than the extant record would lead us to imagine. Other engravings in the illustrated journals of the period are identified as taken from photographs; in very few cases do the photographs still exist, indicating that they were viewed

primarily as tools for the artists to use to render their artistic products.

Visual depictions, then, of life in the Australian goldfields were abundant, but the preferred medium by most of those with artistic aspirations was printed illustration. The most prolific and beloved of these image-makers was Samuel Thomas Gill (1819–1880), always referred to as S. T. Gill, and one of the more colourful characters associated with this period in Australian history and art.[141] First in South Australia, where he became known for his drawings and watercolours of the Eyre and Sturt expeditions into the Australian interior, and from 1852 in the goldfields, Gill showed a remarkable facility for humorous sketches of goldfield life made on the spot and later worked on for publication. His images are detailed enough to provide later viewers with historical information about the miners' dress, material culture and social mores. In the tradition of great English illustrators such as Cruikshank, Gill's illustrations became immediate hits with the public when they were reproduced in journals and books. Gill also learned the lithographic process and as early as August 1852 he published his illustrations as a series of lithographs, titled *Victorian gold diggings and diggers as they are*. These sets, followed by several more in the mid-1850s, were immediately published both in Melbourne and in London, and established Gill as 'the artist of the goldfields'. As Shar Jones writes, 'His success ... was so great that his work continued to be pirated in both England and Germany.'[142] Books such as John Sherer's popular *The gold-finder of Australia* included engravings of Gill's images but the publisher failed to attribute them to the artist.[143] His many vignettes for letterheads became so widely disseminated that his authorship was lost in their prolific reproduction.

Gill's illustrations, along with those of other artists publishing in Australian and English illustrated journals, remain as the most extensive visual record of the Victorian goldfields. Many of them were reproduced so often that they have become icons of Australian colonial life, serving as the model for subsequent re-enactments of goldfield culture, in films and on television. As Goodman indicates, such books as Sherer's, with its appropriated illustrations by Gill, provided the template for 'the colonial narrative' accepted by subsequent generations as the truthful picture of the colonial age.[144]

This apparent preference for illustrative over photographic narrative is all the more intriguing when one learns that Gill was purported to have purchased a camera and photographic equipment early in his career. Some historians believe that he was the first person in South Australia to obtain a daguerreotype licence in 1842.[145] As far as can be determined, however, he never made any photographs. His illustrations, while filled with precise detail, are not ones that are photographic or appear to be taken from photographs. They are more in the traditional style of genre illustration, similar in type to Charles Nahl's illustrations in the California journals of the time and John David Borthwick's oft-reproduced depictions of California camp life. They derive from popular print traditions rather than photographic models.

The popularity of these visual descriptions of life on the Australian goldfields demonstrates that images from Victoria were certainly as sought-after a commodity as were Californian images. Photography, moreover, was as well established a resource by this time in Victoria as it was in 1850s California. These facts give rise to the obvious question: what happened to the photographic images of the Australian goldfields? Why are there so many and such vivid images of labour and activity in the Californian goldfields, of miners working together within the rugged moun-

tainous landscape, when virtually none are extant from this period in Australia? Further, those few that do exist convey a very different attitude about the landscape and underscore different aspects of these new settlements and their polyglot peoples. The equipment and supplies necessary to produce up-to-date photographs of the landscape and its inhabitants were not unknown in Australia by this time—the photographic panoramas in Sydney and in Melbourne by photographers as expert as Blackwood and Woodbury make that clear, as do the refined portraits of Thomas Glaister. Rough conditions—the heat, dust, limited water and impassable trails—did not deter many operators from traversing the gold country and producing photographs there.

The fact nonetheless remains that the majority of Australian photographic images that exist from the time, whether made in the cities, in the goldfield towns or points in between, were either portraits or views of settlement. For reasons that can only be described as ideologically and economically determined, photographers in the Australian colonies turned to these genres for their subject matter, to the exclusion of some of the iconographic formulations that had preoccupied the adventurous spirits at work in California's gold country.

Benjamin Batchelder's photographic views offer some of the most revealing examples of these iconographic shifts and give evidence of changing ideological attitudes about landscape in seemingly straightforward images of place. Returning to Melbourne from Sydney when his brother Nathaniel died in 1860, Benjamin found Perez's Melbourne company Batchelder & O'Neill to be thriving as a portrait studio, well-known along with its more mundane portraits for producing thousands of copies of *cartes de visite* of famous actors and performers who visited the colony.[146] Benjamin continued on to Bendigo, where by the beginning of

1861 he had established the leading photographic business in town.[147] While he did not himself take to setting up mobile wagons, at least not on the scale that the Batchelders had carried out in the California mountains, he did continue to hire and train camera operators who worked under his direction. Most notably he employed at this time Augustus Baker Peirce, sent to him by Perez from the Melbourne studio. As Peirce writes in *Knocking about*, Benjamin was at this time commissioned to produce photographs to be exhibited at an exposition in London. To this end, he sent Peirce and another operator on an expedition through the Bendigo region. Peirce described their gear: 'We were furnished with a little black push-cart holding the camera and other necessaries, and we were to get pictures of all objects of interest.'[148]

The exhibition that Peirce mentions was the London international exhibition of 1862, held in a specially constructed building in Kensington that would later become the Victoria & Albert Museum. The centrepiece of the Victorian display was a pyramid of gold bars 13 metres high, representing the amount of gold extracted in the colony in the previous decade. Accompanying this impressive exhibit, each Australian colony submitted photographic views meant to display the colonies' progress and development. Richard Daintree, Charles Nettleton (1826–1902) and many other photographers sent their work from Victoria, and many received medals at the London show. As part of this effort, Benjamin was commissioned by the Sandhurst Town Council to photograph Bendigo and surrounds.[149]

In the end, Benjamin's work may not have been sent to the exhibition, but his contributions to this event were compiled as the *Bendigo album*, 53 plates of which still survive in the La Trobe Picture Collection of the State Library of Victoria in Melbourne. Each plate was signed as produced by Benjamin himself,

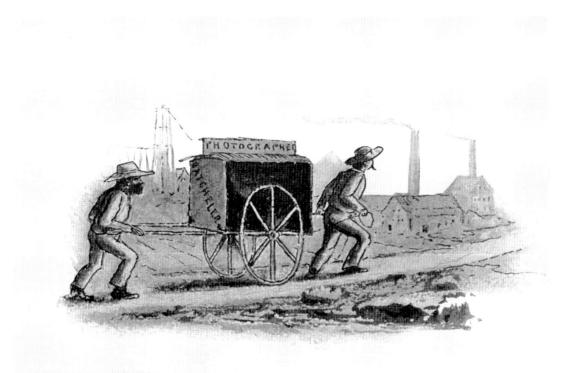

Fig. 1.16 Augustus
Baker Peirce, *Peirce and
Creelman with Batchelder
cart.* Illustration in Peirce,
Knocking About, Yale
University Press, New
Haven, 1924, p. 32.

although at least some of these views were undoubtedly produced by Peirce and his companion.[150] Benjamin's cart appears in nearly every view, usually at the side with the Batchelder name prominently displayed. In at least one photograph, a man, possibly Gus Peirce, poses next to the cart itself. The cart, with its clear signage, is a charming example of the Batchelder penchant for American promotionalism and advertising.

The album's subject matter, so thoroughly described in Mike Butcher's recent catalogue,[151] was no doubt influenced by the nature of the commission; Benjamin was producing them for the purposes of official exhibition. These are not images of activity in the mining fields or of active conquest of the land; they are images instead of the trappings of British civilisation and settlement. Pictured are Bendigo banks, gold exchanges, cemeteries, substantial residences and breweries—the most solid structures in the region. These scenes, then, include objects and views that would make sense of

a colonial landscape, a foreign geography, for an audience at home, a 'home' that was still identified largely as England. As Paul Fox has written, new settlers and their officials in Australia were constantly concerned with the 'image' of the country, newly opened for free settlement, that would be presented to a European audience. Fox states further that '[b]ecause colonial photography portrayed the colony ambiguously, the need for consistent signifiers to make sense of disparate colonial geographies was imperative'.[152] For this reason, any photographs commissioned for an official exhibition such as those in Benjamin's *Bendigo album* would focus on evidence of 'civilised', specifically British, settlement itself, and reveal a deflection of any grandiose sentiments about a landscape of 'otherness' for which most early settlers felt ambivalence and unease.

As the leading photographer in town, Benjamin was once again commissioned in 1866 to produce views of Bendigo's Korong

Fig. 1.17 Benjamin Batchelder, *Sayer Brothers' Norfolk Brewery, Bayne Street frontage, Bendigo*, 1861. Albumen photograph. La Trobe Picture Collection, State Library of Victoria, Melbourne.

Shire for another exhibition in Melbourne that was then intended for display in Europe.[153] The results of this venture conveyed similar notions of Australian land and space to those displayed in the 1861 commission. One Victorian newspaper, in reviewing the images of the colony sent to the exhibition, described Benjamin's view of *Sunday Morning Hill, Brenannah Station* in revealing terms. While the depiction represents a typical Australian station with sparse vegetation, a few grazing animals and a solid house with verandah and pitched roof surrounded by mallee fence, the reviewer, as if willing it to be so, maintained that it 'might be mistaken for a view of an English upland residence on a sabbath day because of the softness of the scene and the brightness of the verdure'.[154] Photographers, then, were aware that their job was to stress a 'typicality of view' with a consciousness of the audience back in England and Europe

who would see these images exhibited, and would recognise that 'wild nature' had been overcome in Australia, not by white man's brute conquest, as was implied in many of the Californian goldfield views, but by the civilising effects of British culture and law.[155] The land, so aggrandised in California as both awe-inspiring and as an obstacle to be confronted and tamed, was either ignored in Australian views, or at most was made to fit into a familiar context, readable by those who understood the landscape compositions, whether painterly or photographic, of European culture. Benjamin Batchelder and his operators were happy to oblige in this construct.

In Bendigo, Benjamin was drawn, as he always would be, to the depiction of civic events that included crowds. The first plate in the Bendigo album focuses not only on the stolidness of the town's public office building, but shows the crowd gathered to hear the

results of a local election.[156] He attempts to capture the movement of the gathered citizens, although the necessary exposure time still led to the blurring of some figures. He was more successful with his most ambitious photographic document, a shot of the procession accompanying the arrival of the Duke of Edinburgh, Queen Victoria's son, in Bendigo on 18 December 1867. As Butcher comments, '[i]t provides a contrast to the customary static views, and an illustration of the rapid progress of photography'.[157] It also conveys something of Benjamin's own photographic style, his interest in recording events and people at celebratory moments in civic life.

Shortly after the Duke of Edinburgh's visit, in 1868 Benjamin sold his Bendigo business and returned to California, first to Oakland and then setting up shop again in Stockton. By this time, all the roughshod and enterprising newness of the gold-rush years when the Batchelder brothers roamed the California mountains had disappeared to be replaced by agricultural gentility and small-town prosperity. California was now interested in constructing a visual image of domesticity rather than emphasising plucky scenes involving the conquest of nature. Benjamin's Stockton pho-

tographs exemplify this transformation, concentrating most often on scenes of town life and civic events. A most delightful example of his eye for the crowd survives as a stereograph depicting Stockton's centennial celebrations on the Fourth of July 1876. It shows people assembled in the town's main square watching the inflation of an enormous air balloon (an activity that was by all accounts less than successful).[158] People crowd the balconies of a neighbouring building—Benjamin apparently took the picture from his own studio's balcony. One of Stockton's most substantial structures, Mansion House, can be seen in the background. The crowds on the square surrounding the balloon are dressed in their finest outfits, the women wearing white dresses and elegant hats. That so many women and children are participating in the town's celebrations is evidence enough of the enormous transformations that had taken place in California since Isaac Baker stood in the doorway of Batchelder's Daguerrean Saloon on the outskirts of Sonora, when women and children were a rare commodity in places like Stockton. Benjamin's many photographs of Stockton people at their leisure, playing croquet and going on picnics, speak delight-

Fig. 1.18 Benjamin Batchelder, *View of Littlehale's croquet tent, Stockton, California*, c. 1885. Stereograph. Courtesy of Haggin Museum, Stockton, California.

fully to the state's genteel transformation.

By the 1870s, California and Australia were both enormously different places than they had been in the 1850s, when gold 'brought the world in'. Photography, in documenting these transformations, participated in the visual construction of place for these new societies. Photographers created new ways of seeing, with visual modes that were sometimes aesthetic, sometimes reportorial, sometimes a combination of both. All of these modes were meant to explain these new sites of Western colonisation to themselves and to others far removed from these landscapes. Given their shared experience of forging a new Western society out of a wilderness invaded by gold-hungry hordes from all over the globe, California and Australia exchanged iconographic expression in the popular imagery that accompanied these immigrants.

The question, however, remains: What did these two peoples choose to share visually? What iconographies had resonance once California became part of the United States and Australia developed as a prosperous colony of free settlers within the British Empire? The most intriguing photographic comparisons centre always on representations of the land itself. The visual construction of the frontier, first formulated in the 1850s, would continue to inform reproducible illustration and views photography into the 1880s, by which time the conquest of the American West was already becoming romanticised by writers and artists, and Australian images nurtured more consciously a sense of British culture placed against this 'other' landscape. The grandiose images of the American West produced in the 1860s and 1870s by Eadweard Muybridge (1830–1904), Carleton Watkins (1829–1916) and others had no direct equivalent in Australia, although similar intentions of documentation began to inform the efforts of Beaufoy Merlin and Charles Bayliss as they traversed the gold regions of New South Wales and Victoria in the same decades. But this story more appropriately fits into a later iconographical development, as Californians and Australians began to confront their own ideas of the picturesque applied to their own landscapes and geographical affinities.

By the end of the first decades of the gold-induced population booms along the Pacific coasts, the interchange of ideas and images between California and Australia became a commonplace. A common language, similar climate, material trade and shared concepts of law and democracy meant that the two regions would continue to have close cultural ties. But distinct differences in popular aesthetic choices would also appear, as their cultural identities began to coalesce more clearly. Despite the seeming similarities of two frontiers transformed by massive migration brought about by the discovery of gold, despite the arrival of similarly opportunistic artists and photographers and in some cases, like the Batchelders, the same artists and photographers producing in both places, the visual record often reveals this disparity in ideological expectations. In the case of California, the photographic record reveals a rough-and-tumble yet self-conscious conquest of the wilderness by the proponents of Manifest Destiny filled with the desire to get rich. In the case of Australia, visual documentation emphasises that British culture and British virtues were manifestly established in this colonial outpost, where virtue and morality prevailed over lawlessness and a hostile environment. Still, as the nineteenth century progressed and as increasingly sophisticated forms of mass communication appeared, these newly developing countries on the Pacific Rim would depend increasingly on reproducible images to learn about each other and to share aesthetic ideas about their identities as Western nations.

NOTES

1. George W. Hart to James Wylie Mandeville, 30 October 1851, San Francisco, California. James Wylie Mandeville Papers, Manuscripts Collection, The Huntington Library, San Marino, California (MA42).

2. David Goodman, *Gold seeking: Victoria and California in the 1850s*, Allen & Unwin, St Leonards, New South Wales, 1994, p. 221.

3. Rebecca Solnit, *River of shadows: Eadweard Muybridge and the technological wild west*, Viking, New York, 2003, p. 14.

4. No doubt there were adventurous women, too, but so far none have been identified who worked as photographers both in California and Australia in this period. Among the many sources about women in gold-rush California, see JoAnn Levy, *They saw the elephant: Women in the California gold rush*, University of Oklahoma Press, Norman, 1992; and JoAnn Chartier, *With great hope: Women of the California gold rush*, TwoDot, Helena, Montana, 2000. For women photographers in early California, see Peter Palmquist, *Women photographers: A selection of images from the Women in Photography International Archive, 1852–1997*, Iaqua Press, Arcata, California, 1997; and *A bibliography of writings by and about women in photography, 1850–1990*, Borgo Press, Arcata, California, 1994. On the role of women in gold-rush era Australia, see Anne Summers, *Damned whores and God's police*, 2nd edn, Penguin, Melbourne, 1994; and Penny Russell, *'A wish of distinction': Colonial gentility and femininity*, Melbourne University Press, Melbourne, 1994. Some interesting contemporary quotations concerning women on the Australian diggings are cited in Bruce Moore (ed.), *Gold! gold! gold! The language of the nineteenth-century Australian gold rushes*, Oxford University Press, South Melbourne, 2000, pp. 185–88. On women photographers in Australia, see Barbara Hall and Jenni Mather, *Australian women photographers 1840–1960*, Greenhouse Publications, Richmond, Victoria, 1986.

5. Jay Monaghan, *Australians and the gold rush*, University of California Press, Berkeley, 1966, p. 3.

6. As L. G. Churchward remarks: 'Contact between the United States and Australia was not initiated by the gold rush; but only then did Americans find in Australia a steady market for their goods, and Australia moved from the frayed edge to a proper place within the world pattern of American communications.' See 'Australian–American relations during the gold rush', *Historical Studies/Australia & New Zealand*, vol. 2, no. 5, April 1942, pp. 11–24.

7. 'We were walking down George Street one day and noticed a placard posted on the old barrack wall, "Gold, Gold, California", and then followed an advertisement that a vessel was to leave at a certain date for the new Eldorado.' W. Jackson Barry, *Past & present, and men of the times*, McKee & Gamble, Wellington, 1897, p. 80.

8. ibid., p. 84.

9. Monaghan, p. 44.

10. Charles Bateson writes: '[i]n the first six months of 1849, twenty-five vessels and six hundred and seventy-nine passengers sailed from Australia for California', and that 'between seven and eight thousand people sailed from Australia and New Zealand for San Francisco while the Californian gold rush was on'. *Gold fleet for California: Forty-Niners from Australia and New Zealand*, Michigan State University Press, East Lansing, 1963, pp. 46, 142.

11. Monaghan, p. 75.

12. Isaac Wallace Baker, *Journal 1849–50*, entry for 18 January 1850. Bancroft Library, The University of California, Berkeley, California (microfilm, C-F53).

13. Monaghan, p. 143; and L. G. Churchward, 'Australia and America: A Sketch of the Origin and Early Growth of Social and Economic Relations between Australia and the United States of America, 1790–1876', unpublished MA thesis, University of Melbourne, 1941.

14. Captain W. Jackson Barry, one of the first Australian migrants in San Francisco, wrote in his memoirs: 'I noticed particularly that whatever the crime was that was committed the Sydney men were blamed for it. No doubt many bad men, the dregs of a convict population, came from Australia to California in those days, but there were rowdies from New York, and gamblers and blacklegs from New Orleans and other American cities, who were equally as criminal as the Australians.' *Past & present*, p. 89. Demographic studies have demonstrated that Sydney migrants in the 1850s may have actually included fewer violent criminals than many other groups. S. L. Richards and G. M. Blackburn state: 'It is clear that the males from Sydney differed from other males in California: they had brought their wives and children.' In 'The Sydney Ducks: A demographic analysis', *Pacific Historical Review*, no. 42, 1973, p. 28.

15. See Barry's books for fascinating tales of his adventures in America, Australia and New Zealand:

Up and down, or, fifty years' colonial experiences in Australia, California, New Zealand, India, China, and the South Pacific, Sampson Low, Marston, Searle & Rivington, London, 1879; and *Past & present*, 1897.

16. On Hargraves, see *The Australian encyclopedia*, Angus & Robertson, Sydney, 1956, vol. 4, pp. 430–31; and J. A. King, *Edward Hammond Hargraves*, Summit Books, Sydney, 1977.

17. On Esmond, see Louis R. Cranfield, 'Esmond, James William (1822–1890)', *Australian Dictionary of Biography (ADB)*, vol. 4, Melbourne University Publishing, 1972, p. 142.

18. Edward Hammond Hargraves, *Australia and its gold fields: A historical sketch of the progress of the Australian colonies, from the earliest times to the present day; with a particular account of the recent gold discoveries, and observations on the present aspect of the land question. To which are added notices on the use and working of gold in ancient and modern times; and an examination of the theories as to the sources of gold*, H. Ingram and Co., Milford House, Strand, London, 1855.

19. R. G. Jameson, *Australia & her gold regions*, Cornish, Lamport & Co., New York, 1852, p. 78.

20. Bateson, p. 143.

21. Figures taken from Goodman, p. ix.

22. Letter-sheets were also produced in Australia at this time, but not as prolifically as in California, and did not often appear to be made for the specific purpose of writing a letter with an accompanying illustration. An example of such a sheet, with a lithograph taken from a photograph, can be seen online in the Pictures Catalogue of the National Library of Australia: A. J. Stopps, *Bruce's quartz crushing machine, Kangaroo Flat, Bendigo*, from a photograph by Alexander Fox; on stone by Stopps. Sandhurst (Pall Mall), published by Geo. Stater, [185–]. Lithograph, 13 x 20 cm. Folded sheet of blue letter-head paper, Rex Nan Kivell Collection (NK6338. nla.pic-an8628827).

23. Joseph Baird, *California's pictorial letter sheets, 1849–1869*, D. Magee, San Francisco, 1967, p. 16.

24. For examples of letter-sheets, see Peter J. Blodgett, *Land of golden dreams: California in the gold rush decade, 1848–1858*, Huntington Library Press, San Marino, California, 1999; and J. S. Holliday, *Rush for riches: Gold fever and the making of California*, University of California Press, Berkeley, 1999.

25. For an early description of the development of letter-sheets and other illustrations in California, see Francis E. Sheldon, 'Pioneer illustration in California', *The Overland Monthly*, vol. xi, 2nd series, no. 64, April 1888, pp. 337–55.

26. Baird, p. 11.

27. James Hutchings was himself an important character in gold-rush California history. An English businessman and journalist, Hutchings took the first tourists into Yosemite and established there the first hotel; through his publication of his magazine and through the illustrations seen there and on the letter-sheets he sold to miners, Hutchings more than any other person spread the word about the wonders of California. As Kevin Starr states in his book *Americans and the California dream 1850–1915*, Hutchings 'must take the most credit for helping to reverse the frontier relationship of Californians to their landscape', p. 181. His *Hutchings' Illustrated California magazine*, with profuse illustrations, was published from 1856 to 1861. See also Peter Palmquist and Thomas R. Kailbourn, *Pioneer photographers of the Far West: A biographical dictionary, 1840–1865*, Stanford University Press, Stanford, 2000, pp. 312–16; and Hank Johnston, *Yosemite's yesterdays*, vol. 2, Flying Spur, Yosemite, California, 1991.

28. On Joseph Britton (1825–1901) and Jacques Joseph Rey (1820–1892), see Palmquist and Kailbourn, pp. 124–25, 454–55.

29. Edna Bryan Buckbee, 'Sonora, metropolis of the southern mines', in *The saga of old Tuolumne*, The Press of the Pioneers, New York, 1935, p. 203.

30. ibid., p. 208.

31. 'The mines in Australia,' *Union Democrat*, Sonora, California, 28 October 1854, p. 2, col. 3.

32. ibid.

33. Charles D. Ferguson, Frederick T. Wallace (ed.), *The experiences of a Forty-Niner during thirty-four years' residence in California and Australia*, The William Publishing Co., Cleveland, 1888, pp. 202–03 (HEH RB5858).

34. ibid., p. 205.

35. ibid., p. 206.

36. ibid., p. 235.

37. It is difficult to get any accurate figures for American emigration to Australia in this period, because ships' records were not always reliable in their counting of nationalities and because many arrived by jumping ship or were otherwise unrecorded; further, many emigrés came and went during the tumultuous days of the early gold rush. *The Australian encyclopedia* states, 'in the years 1851–56 more than 10,000 persons from the United States arrived in Sydney and more than 8000 in Melbourne. Not all of them

were Americans', vol. 1, p. 169. Daniel Potts in *Young America and Australian gold*, University of Queensland Press, St Lucia, 1974, provides some statistics that give rough estimates of Americans arriving by ship as approximately 5400 entering Australia between 1852 and 1855 (pp. 50–51). But he also states that Americans accounted for 1.23 per cent of the population of Victoria in the 1854 census (p. 216). Goodman indicates in *Gold seeking* that the population for Victoria in 1854 was 237,000 (p. 1), meaning that Americans at that time would have numbered 2915 in the colony, but this would only count those who stayed for a long period. Other sources are equally contradictory.

38. Long before its adoption as a term for an Australian soldier, 'digger' was the appellation given to '[a] miner on the Australian goldfields'. See Moore, *Gold! gold! gold!*, pp. 30–31.

39. Ferguson, p. 244.

40. On the American and Australian governments' different approaches to control of gold-rush populations, see Goodman, Chapter 3: 'Order', pp. 64–104.

41. Edward La Trobe Bateman was also the nephew of the American architect Benjamin Latrobe, famous for his Greek Revival buildings in Baltimore and Philadelphia. When Edward left England for Australia in 1852, along with two other artists Thomas Woolner and Bernhard Smith, their departure was said to have inspired Ford Madox Ford to create his most famous painting, *The last of England*. After sketching Australian scenery and flowers, as well as scenes from the diggings, Bateman settled in Melbourne, where he worked as a decorator of houses, book covers and architectural designs. He also had a hand in the planning of several public gardens in Melbourne and laid out the grounds of the University of Melbourne. After an accident damaged his drawing hand and lawsuits over the accident were unsuccessful, he left Australia to become a landscape gardener in Scotland. See *Dictionary of Australian artists* (*DAA*), pp. 51–52; Allan McCulloch, *Artists of the Australian gold rush*, Lansdowne Editions, Melbourne, 1977, pp. 44–46; and Daniel Thomas, 'Edward La Trobe Bateman', in *ADB*, Melbourne University Press, Melbourne, 1969, vol. 3, p. 117.

42. Howitt, 'The American auctioneer', quoted in Nancy Keesing (ed.), *Gold fever: The Australian goldfields 1851 to the 1890s*, Angus & Robertson, Sydney, 1967, p. 124.

43. ibid., p. 125.

44. Martha A. Sandweiss, *Print the legend: Photography and the American West*, Yale University Press, New Haven, 2002, p. 2.

45. See Gael Newton, *Shades of light: Photography and Australia, 1839–1988*, Australian National Gallery and Collins Australia, Canberra, 1988, pp. 1, 15.

46. See the entries for 'settler' and 'settler culture' in Ashcroft, et al., *Key concepts in post-colonial studies*, pp. 210–12.

47. Paul Fox, 'The *Intercolonial exhibition* (1866): Representing the colony of Victoria', *History of Photography*, vol. 23, no. 2, Summer 1999, p. 174.

48. Wikipedia describes 'Manifest Destiny' as 'a term that was used in the 19th century to designate the belief that the United States was destined, even divinely ordained, to expand across the North American continent, from the Atlantic seaboard to the Pacific Ocean. Sometimes Manifest Destiny was interpreted so broadly as to include the eventual absorption of all North America: Canada, Mexico, Cuba and Central America. Advocates of Manifest Destiny believed that expansion was not only ethical but that it was readily apparent ("manifest") and inexorable ("destiny"). Although initially used as a catch phrase to inspire the United States' expansion across the North American continent, the 19th century phrase eventually became a standard historical term.' See Albert K. Weinberg, *Manifest Destiny: A study of nationalist expansionism in American history*, Johns Hopkins, Baltimore, 1935.

49. *Household Words*, no. 113, 22 May 1852, p. 217; as quoted in Goodman, p. 65. See also Goodman's long note concerning the standard comparative arguments about law and order on the goldfields, Chapter 3, endnote 3, p. 241.

50. 'Still, no part of the American historical imagination is so shaped by visual imagery as its image of the nineteenth-century West. Photography's role here is central, for photographers truly bore witness to the epic story of the American settlement of the western half of the continent.' Sandweiss, p. 13.

51. Alan Trachtenberg, 'The daguerreotype and antebellum America', in Grant B. Romer and Brian Wallis (eds), *Young America: The daguerreotypes of Southworth & Hawes*, Steidl, Göttingen, Germany; The George Eastman House, Rochester, New York; The International Center of Photography, New York, 2005, p. 14.

52. See Alan Davies and Peter Stanbury, *The mechanical eye in Australia: Photography 1841–1900*, Oxford University Press, Melbourne, 1985, pp. 122–24.

53. For the remarkable story of the achievements of Merlin & Bayliss, the best source is still Keast Burke, *Gold and silver: Photographs of Australian goldfields from the Holtermann Collection*, Penguin, Ringwood, Victoria, 1973. Burke discovered the photographers' plates from Hill End and Gulgong in 1951, still in the Holtermann family's possession, locked and ignored in a garden shed.

54. Sandweiss, p. 13.

55. Jack Cato, *The story of the camera in Australia*, Georgian House, Melbourne, 1955, p. 11.

56. 'Nineteenth-century science allowed this new art to spring, like Athena, full-blown into life ... There was no "primitive" stage of photography, nothing that resembled cave drawings or aboriginal glyphs.' John Wood, *The photographic arts*, Iowa City, University of Iowa Press, Iowa City, 1997, p. 1.

57. Trachtenberg, p. 18.

58. The late Peter Palmquist still maintained in the introduction to his comprehensive volume, *Pioneer photographers of the Far West*, that 'California's first identified daguerreotypist was an adolescent girl', p. 10: Fannie Vallejo, the daughter of General Vallejo, who made a portrait of her mother in 1847, when she was 12. Alan Davies has identified as the earliest extant daguerreotype made in Australia a portrait of Dr William Bland, 'taken before 14 January 1845', in Sydney, by George B. Goodman, the country's 'first professional photographer ... who opened a ... studio on the roof of Sydney's Royal Hotel on 12 December 1842'. See Alan Davies, *An eye for photography: The camera in Australia*, Miegunyah Press, Carlton, Victoria, 2004, p. 2; and *The mechanical eye*, p. 8.

59. 'The daguerreotype dominated the first twenty years of American photography; and the overwhelming majority of examples were portraits.' William F. Stapp, in Harold Francis Pfister, *Facing the light: Historic American portrait daguerreotypes*, National Portrait Gallery, by Smithsonian Institution Press, Washington, DC, 1978, p. 13. See also Beaumont Newhall, *The history of photography*, Museum of Modern Art, New York, 1982, p. 13.

60. ibid., p. 12. The entry for William Freeman in *DAA*, written by Tim Robinson, gives no indication that he was ever anything other than a photographer. Since William and his brother James had bought the first right in their English county to produce daguerreotypes from Richard Beard in the 1840s, he must have been committed to the photographic business from his arrival in Australia in 1853. See *DAA*, pp. 276–78.

61. Richard Rudisill, *Mirror image: The influence of the daguerreotype on American society*, University of New Mexico Press, Albuquerque, 1971, p. 131.

62. Peter Palmquist, conversation with author, Emeryville, California, May 2001.

63. See Palmquist and Kailbourn, pp. 223–25.

64. ibid., p. 223.

65. On Fardon, see also his *San Francisco album: Photographs of the most beautiful views and public buildings*; reprint, Hans P. Kraus, New York, 1999; and Joan M. Schwartz, 'G. R. Fardon, photographer of early Vancouver', *Afterimage*, December 1978, p. 5.

66. J. W. Newland, *Murray Street 1848*. Tasmanian Museum and Art Gallery. See Newton, p. 11.

67. Anita Callaway, 'Prospects and predictions: An antipodean perspective', in her *Visual ephemera: Theatrical art in nineteenth-century Australia*, University of New South Wales Press, Sydney, 2000, p. 144; and *DAA*, p. 570.

68. The literature on panorama painting and its conceptual implications is vast and growing. Some of the best sources are Sandweiss's '"Of instructions for their faithfulness": Panoramas, Indian galleries, and Western daguerreotypes', in her *Print the legend*, pp. 48–86; Ralph Hyde, *Panoramania: The art and entertainment of the 'all-embracing' view*, Trefoil Publications in association with Barbican Art Gallery, London, 1988; and John L. Marsh, 'Drama and spectacle by the yard: The panorama in America,' *Journal of Popular Culture*, vol. 10, Winter 1976, pp. 581–90. On the panorama in Australia, see Mimi Colligan, *Canvas documentaries: Panoramic entertainments in nineteenth-century Australia and New Zealand*, Melbourne University Press, Carlton South, 2002; Callaway, 'Prospects and predictions: An antipodean perspective', pp. 136–52; Keast Burke, *Newsreel in 1862: Moving diorama of the Victorian exploring expedition*, Australian Documentary Facsimile Society, Sydney, 1966; and Gordon Bull, 'Taking place: Panorama and panopticon in the colonisation of New South Wales', *Australian Journal of Art*, vol. 12, 1994–95, pp. 75–95.

69. Peter E. Palmquist, 'The sad but true story of a Daguerreian Holy Grail', in Drew Heath Johnson and Marcia Eymann (eds), *Silver & gold: Cased images of the California gold rush*, University of Iowa Press for the Oakland Museum of California, Iowa City, 1998, pp. 43–73.

70. Palmquist and Kailbourn, pp. 3–4. It is interesting

that Hutchings uses the photographs of C. L. Weed (1824–1903), the first photographer of Yosemite Valley, as the source for the illustrations of the valley in his book, *Scenes of wonder and curiosity in California*, Hutchings & Rosenfield, San Francisco, 1861. Most importantly, he credits Weed as the source for the engravings; see, for example, p. 62, 'The Yo-Semite Waterfall, Two Thousand Five Hundred and Fifty Feet in Height. From a Photograph by C. L. Weed'.

71. Sandweiss, pp. 48–86.

72. 'For the representation of architectural works or landscapes, the paper process is admirably adapted.' *The Sydney Morning Herald*, 7 February 1856; as quoted in Davies, *The mechanical eye*, p. 26.

73. Bernard Smith discusses this 'highly popular form of entertainment', if unwillingly, in his *Australian painting 1788–1990*, Oxford University Press, Melbourne, 1991, pp. 16–18. See also Bull, 'Taking place'.

74. Under the entry for Perez Mann Batchelder, Kerr writes: 'His surname was commonly spelt "Bachelder" and he was possibly a kinsman of R. G. Bachelder, a touring showman who brought several popular panoramas from New York to the Australian colonies in 1867–68.' *DAA*, p. 50.

75. *Freeman's Journal*, 28 September 1872. Bachelder (or Batchelder)'s earlier forays into the Australian countryside are discussed in Burke, *Newsreel in 1862*, n.p.

76. Colligan, pp. 157–206.

77. Photo-historian Alan Davies writes that 'although a Lerebours panoramic camera, taking daguerreotypes measuring 12 by 38 centimetres, was sold in Sydney in February 1850, no Australian extended landscape or cityscape daguerreotypes have survived'. *An eye for photography*, p. 80.

78. Davies maintains that Woodbury's panorama was the first one made in Australia, giving a date of 1854. *The mechanical eye*, p. 26. But Newton states that the date for the panorama was more likely 1857. *Shades of light*, p. 19.

79. Davies, *The mechanical eye*, p. 26.

80. 'The Fox panoramas were taken in October 1858 (View Point, 4 panel) and sometime in 1859 (Pall Mall, 6 panel)'; correspondence with Mike Butcher, City of Greater Bendigo, Victoria, 1 July 2004. I wish to thank Mr Butcher for bringing the panorama photographs by Fox to my attention.

81. Davies, *The mechanical eye*, p. 26; and *DAA*, pp. 70–71.

82. *The Sydney Morning Herald*, 4 August 1858; quoted in Davies, *Mechanical eye*, p. 26. It is interesting that Blackwood's next ambitious project, also produced as an album for sale, consisted of photographs of Sydney's nine banks. See W. Wickmann and B. Groom in the section on Blackwood in *DAA*, p. 70.

83. On Blackwood, see also Anne-Marie Willis, *Picturing Australia: A history of photography*, Angus & Robertson, North Ryde, New South Wales, 1988, pp. 13–21.

84. Augustus Baker Peirce, *Knocking about: Being some adventures of Augustus Baker Peirce in Australia*, Mrs. Albert T. Leatherbee (ed.), with an introduction by Edwin Howard Brigham, MD, illustrated by the writer, Oxford University Press, London and Yale University Press, New Haven, 1924.

85. Callaway, p. 147.

86. Peirce, p. 22.

87. On Peirce in Australia, see also Callaway's entry in *DAA*, pp. 614–16; and her discussion of him in *Visual ephemera*, pp. 146–48.

88. In 1850, the population of the city of Los Angeles was officially given as only 1610; by 1860, it was 4385. Los Angeles County in the same period grew from 3530 to 11,333, according to Leonard Pitt and Dale Pitt (eds), *Los Angeles A to Z: An encyclopedia of the city and county*, University of California Press, Berkeley, 1997, p. 403.

89. On Penelon see John Dewar, *Adios Mr Penelon!*, Los Angeles County Museum of Natural History, Los Angeles, 1968; Nancy Dustin Wall Moure, *Loners, mavericks and dreamers: Art in Los Angeles before 1900*, exhibition catalogue, 26 November 1993–20 February 1994, Laguna Art Museum, Laguna, California, 1993, p. 20; Claudine Chalmers, *Splendide Californie! Impressions of the Golden State by French artists, 1786–1900*, no. 212, Book Club of California, San Francisco, 2001, p. 26; and Palmquist and Kailbourn, pp. 434–35.

90. The story of the 1852 race between the Australian thoroughbred Black Swan and Pio Pico's Californian-bred Sarco figures in most of the accounts of early Los Angeles, as proof of the obsessive ends to which the gambling Californios would go in their desire for horse-breeding stock and entertainment. The equally fascinating fact that an Australian horse was the first thoroughbred in California, and that it had arrived in Los Angeles at such an early date in the history of Australian–American trade, is less remarked upon. As evidence of the rapidity with which such exchanges took place after the discovery of gold, and

the lengths to which traders would go to advertise and expedite their goods, this story certainly merits deeper research. For an account of the race itself, in which hundreds of thousands of dollars exchanged hands and entire estates were won and lost, see *Los Angeles Star/La Estrella*, Saturday, 3 April 1852, p. 2; and Los Angeles Centennial Celebration Literary Committee, *An historical sketch of Los Angeles County, California: From the Spanish occupancy, by the founding of the mission San Gabriel Archangel, September 8, 1771, to July 4, 1876*, Louis Lewin & Co., Los Angeles, 1876, pp. 39–40. More recent accounts include Leo Carrillo's poignant memoir recounting his grandfather's ruin by betting everything on the race in Chapter 19, 'Horse race lament', *The California I love*, Prentice-Hall, Englewood Cliffs, New Jersey, 1961, pp. 115–25. As a recent article writes, 'the highly celebrated matchup between Black Swan and Sarco was one of the first to pit a Thoroughbred against a Spanish horse'; see Morgan Yates, 'Track stars', *Westways*, January–February 2004.

91. Dewar, n.p. [p. 7].

92. *Los Angeles Star*, 16 April 1864; quoted in Palmquist and Kailbourn, p. 434.

93. 'In 1874 Penelon travelled to Prescott, Arizona Territory, with a man named Flanders, both photographers calling themselves "artists," as was the custom.' Chalmers, p. 28.

94. The only evidence that Flintoff may have studied in Germany is a note in the Ballarat Fine Art Gallery registrar's files, compiled by Frank McDonald. Consulted 20 March 2003.

95. *Texas Star Gazette*, 14 February 1852; quoted in *DAA*, p. 265. His best painting in Texas was *The Jones children of Galveston*, 1855. Oil on canvas. Museum of Fine Arts, Houston. See Pauline A. Pinckney, *Painting in Texas: The nineteenth century*, University of Texas Press, Austin, 1967; and *The handbook of Texas online*, viewed 21 September 2004, <http://www.tsha.utexas.edu/handbook/online/articles/view/FF/ffl12.html>.

96. Thomas Flintoff. Large banner: *Ancient Order of Foresters/No 3200/Court Unity/Ballarat*, c. 1880s. Painted in oil paint on green taffeta. City of Ballarat Fine Art Gallery, Ballarat, Victoria (item id no. 89 210). The banner now hangs in Museum Victoria's Social History Collection; a reproduction appears online at AMOL, Australian Museums and Galleries, viewed 4 March 2005, <http://amol.org.au>.

97. Advertisement from *Ballarat Star*, January 1860;

reproduced in Davies, *The mechanical eye*, p. 173.

98. ibid., p. 173.

99. Palmquist and Kailbourn, p. 99.

100. Documents in the Phillips Library, Peabody Essex Museum, Salem, Massachusetts, demonstrate that Perez Mann Batchelder had already led a roaming life before heading to California in 1851. In 1841, he was working as a merchant out of Peoria, Illinois, along the Mississippi River. In 1843, he wrote home from Cincinnati, where he was working on a river boat and then on a dairy farm. He returned home to Massachusetts via New Orleans in 1845; but by 1849, he was in Wisconsin Territory (W.T.), settled as a farmer and trapper. A letter sent to his brother John from Summit, W.T., expresses his desire to come home soon as he 'would like to get married ... next fall'. The next letter to 'Brother J. H'. is dated 'Oct. 29th 1852' from Stockton, California. He describes in detail here the daguerrean wagon that he and his brother Benjamin had arranged in Stockton. None of the earlier letters give any mention of photography; so Perez must have learned the trade some time after returning to Massachusetts from Wisconsin and before travelling to California. Benjamin may have already learned the process by the time Perez returned home in 1850. Since the Peabody Collection includes a photograph of Perez as a boy taken at 'Black, photographer' in Boston, and the photograph of Perez reproduced in Palmquist's book was also taken by 'J. W. Black' at the same Boston address, it is tempting to assume that the Batchelders learned the business from this same J. W. Black. In the 1860s, one of the Batchelders, presumably Perez, went into business with James Wallace Black. Several photographs still exist that include the logo for 'Black & Batchelder', including a famous image of Walt Whitman, taken in March, 1860. See Ed Folsom, '"This heart's geography's map": The photographs of Walt Whitman', *The Virginia Quarterly Review*, 2005, viewed 14 July 2005, <http://www.vqronline.org/printmedia.php?prmMediaID/9082>. Letters and other documents pertaining to the Batchelders are from the Batchelder Collection, Phillips Library, Peabody Essex Museum, Salem, Massachusetts (F.Ms. B3287).

101. Rudisill discusses the advantages and disadvantages of these peripatetic operators in *Mirror image*, p. 133.

102. Edna Buckbee provides a vivid depiction of Sonora's cultural life in the 1850s in *The saga of old Tuolumne*; on p. 194, she states that 'Batchelder, a prominent

daguerreon [*sic*], opened a 'dag' salon on Washington Street in the spring of 1851'. She is apparently referring to Perez at this point, although the fact that she only mentions Batchelder's family name might mean that the documentation upon which she had relied does not distinguish which Batchelder opened this wagon.

103. See Robert Bartlett Haas, 'William Herman Rulofson: Pioneer daguerreotypist and photographic educator', *California Historical Society Quarterly*, vol. xxxiv, no. 4, December 1955, pp. 289–300.

104. Rudisill quotes from a letter written to Isaac Wallace Baker from Perez: 'Ben is in the saloon at Jamestown. Have not heard from him don't know what he is doing', p. 133; see also Palmquist and Kailbourn, p. 99.

105. Perez Mann Batchelder, letter to John H. Batchelder, dated Sonora, 22 March 1853, Manuscripts Collection, Phillips Library, Peabody Essex Museum, Salem, Massachusetts (F.Ms. B3287). Batchelder has apparently ignored the fact that by 1853 California was part of 'the States'.

106. See Rudisill, p. 71. For more on Baker, see Therese Thau Heyman in the preface of Johnson and Eymann, pp. x–xv; and Margaret S. Creighton, *Dogwatch & liberty days: Seafaring life in the nineteenth century*, Peabody Essex Museum, Salem, Massachusetts, 1982.

107. See Palmquist and Kailbourn, p. 94.

108. The copy of this daguerreotype in the Bancroft Library, presented along with other materials about Baker by his relative Frederick Baker in 1942, includes the following note: 'Batchelders Daguerreian Saloon, summer of 1853. Most of the time it was located on the east side of the highway that runs from Vallicta [*sic*] to Murphys, in Vallicita as shown by the map in another picture. Whether this is the location pictured here is not certain. Dag. by Isaac W. Baker. The man in the doorway is probably Batchelder. Baker was his partner in the business.' Subsequent known portraits of the Batchelders and of Baker would indicate by appearance that the figure in the doorway is indeed Baker. Reproduced in Rudisill, pl. 45, p. 294; in Johnson and Eymann, pl. 48, p. 124, listed in catalogue as by Baker, *Baker in front of Batchelder's Daguerreian Saloon*; and in Palmquist and Kailbourn, p. 95, fig. 74, as 'Isaac Wallace Baker in the doorway of Batchelder's Daguerreian Saloon, 1853'.

109. Reproduced in *Capturing light: Masterpieces of California photography, 1850 to the Present*, exhibition catalogue, Oakland Museum of California, Oakland, 2001, fig. 4, p. 10.

110. Baker's biographical file at the Bancroft Library consulted on 12 May 2001. The author wishes to thank Drew Johnson, curator of photography, Oakland Museum of California, for providing information about Baker; and Baker's descendent Tom Horning, of Seaside, Oregon, for family information about Baker's life after his California sojourn. Telephone conversation, 7 June 2004.

111. Perez Mann Batchelder, letter to John H. Batchelder, dated Sonora, 22 March 1853, Manuscripts Collection, Phillips Library, Peabody Essex Museum, Salem, Massachusetts (F.Ms. B3827).

112. In a letter to Baker quoted in Rudisill's book, Perez mentions two other operators, 'David [and] Patch', working in the Murphys Camp area out of a Batchelder wagon, and compliments Baker for his prodigious work. See Rudisill, p. 133.

113. Palmquist and Kailbourn, p. 101; and Mike Butcher and Yolanda J. M. Collins, *An American on the goldfields: The Bendigo photographs of Benjamin Pierce Batchelder*, Holland House, Burwood, Victoria, 2001, p. 3.

114. In his journals, Alfred R. Doten (1829–1903) makes the following entries: 'May 29, 1855 … I went down to a sort of Daguerreotype saloon on wheels (Batchelder's) and had my likeness taken (for 5.00)—John Slaven, Jake Chinn, Theodore & all who saw it said it was a first rate likeness—"couldn't be bettered"', vol. 1, p. 221. In the same volume he wrote, 'Sunday, June 10 … morning I went over to Volcano for more provisions &c … I went into Batchelder's saloon & had my daguerreotype taken'. Walter van Tilburg (ed.), *The journals of Alfred Doten 1849–1903*, University of Nevada Press, Reno, Nevada, 1973.

115. Conversation with Peter Palmquist, Emeryville, California, May 2001.

116. Butcher and Collins, p. 4; and Palmquist and Kailbourn, p. 99.

117. Butcher and Collins, p. 3.

118. The marriage date given on their son's birth certificate—10 December 1858—is later than the arrival of the ship in Melbourne upon which they were meant to have landed in Australia; see Butcher and Collins, p. 4.

119. As Goodman points out on p. 87, the desire on the part of the governing bodies to control and order a potentially reckless society was one of the reasons behind these institutionalising efforts: 'Institutions were central to the attempt by elites to reassert

order in gold rush Victoria'. On the astonishing rise of Melbourne to the ranks of great cosmopolitan cities with cultural aspirations, see Geoffrey Serle, *The golden age: A history of the colony of Victoria, 1851–1861*, rev. edn, Melbourne University Press, Melbourne, 1963; and his *From deserts the prophets come: The creative spirit in Australia, 1788–1972*, Heinemann, Melbourne, 1973.

120. *Hobart Town Daily Mercury*, 12 June 1858; see Davies, *The mechanical eye*, pp. 22, 44.

121. In Walter Woodbury Papers, Royal Photographic Society, Bath, England; quoted in *DAA*, p. 878. See also Alan F. Elliott, *The Woodbury Papers: Letters and documents held by the Royal Photographic Society*, South Melbourne, 1996.

122. See Newton, p. 176, note 11.

123. Perez Mann Batchelder, letter to John H. Batchelder, dated Melbourne, 28 July 1855, Manuscripts Collection, Phillips Library, Peabody Essex Museum, Salem, Massachusetts (F.Ms. B3827).

124. ibid.

125. ibid.

126. In the 'Delinquent tax list' published in the *San Francisco Chronicle* on 10 February 1873, a 'Batchelder, P M' appears as in arrears on the taxes for a mortgage by 32 dollars. 'Daily Chronicle supplement – Delinquent tax list', p. 3, The Huntington Library (Rare Book 54467), inserted into a set of old *Chronicle* issues.

127. Probate Court document in the Matter of the Estate of Perez M. Batchelder, County of Alameda, California, dated 27 February 1873, Manuscripts Collection, Phillips Library, Peabody Essex Museum, Salem, Massachusetts (F.Ms. B3287).

128. In a 'Probate Court partition done May 4, 1874', the eighth item on p. 3 states: 'an agreement of Wm. B. Ingersoll, with the decedent, dated Dec. 21 1870 relating to the purchase & ownership of the instruments and materials in a photographic Gallery in Oakland. This agreement is of doubtful value.' Probate Court partition document, Manuscripts Collection, Phillips Library, Peabody Essex Museum, Salem, Massachusetts (F.Ms. B3287).

129. When Richard Henry Dana, Jr, returns to visit San Francisco in 1859, he gives a speech at the Pioneer Society, about which he writes, 'Any man is qualified for election into this society who came to California before 1853. What moderns they are!' *Two years before the mast*, Modern Library, New York, 2001, p. 417.

130. Cato, p. 11.

131. See Erika Esau, 'Thomas Glaister and early Australian photography', *History of Photography*, vol. 23, no. 2, Spring 1999, pp. 187–91. Glaister, who is now recognised as the greatest Australian daguerreotypist, would also leave Sydney in the 1870s, ending up in Santa Rosa, California, where he became a wine-maker, and never seemed to have created another photograph.

132. Bendigo was officially named Sandhurst until 1891, but was unofficially called Bendigo from the 1840s. *The Australian encyclopedia* describes the situation: 'It is generally believed that the place was named after an employee on the Ravenswood property, who professed to be an accomplished boxer and who was nicknamed "Bendigo" after the English prize-fighter, William ("Abednego") Thompson, known by that name at the time.' Vol. i, p. 489, col. A.

133. Benjamin Pierce Batchelder was buried in Rural Cemetery, Stockton, California, on 11 November 1891, aged 64. A logo on one of the Batchelder photographs indicates that his wife carried on the business after his death. The small card printed on the back of a boudoir card photograph includes the Batchelder name, but with a silhouette of a woman sitting at an artist's easel. The lettering is the same as Benjamin's earlier Stockton works, but the fashions in the photograph indicate a date in the later 1890s or early 1900s. Records indicate that Nancy Ellen Batchelder was buried in Rural Cemetery, Stockton, California, on 24 December 1914, aged 76. See 'Burials in rural cemetery, Stockton, California' in *Old cemeteries of San Joaquin County, California*, vol. ii, San Joaquin Genealogical Society, Stockton, California, 1962.

134. John Wood, 'Theatrical narratives and the documents of dream: California and the great American image,' in Johnson and Eymann, pp. 23–42.

135. For the quaint conceptions of Catastrophism and its philosophical linking with attitudes of Manifest Destiny, the original presentation appears in geologist Clarence King's address in 1877 at Yale College, *Catastrophism and the evolution of environment. An address by Clarence King, delivered at the Sheffield School of Yale College, on its thirty-first anniversary. June 26th, 1877*, [s.l.] 1877 (Huntington RB 266287). As Ian Jeffrey writes about the photographs of the Western geological surveys, 'Photographers have rarely had such an explicit theoretical basis for their work.' *Photography: A concise history*, Oxford University Press, New York, 1981, p. 60.

136. Peter Palmquist always maintained that there were no

'pure' landscape photographs—that is, landscape as artistic composition—of the West until the 1860s. In conversation with the author, Emeryville, California, May 2001.

137. Cato, p. 3; and Davies, *The mechanical eye*, p. 8, and *An eye for photography*, pp. 4–8.

138. Davies, *The mechanical eye*, pp. 8–9; and *DAA*, pp. 307–09.

139. Antoine Fauchery, *Sun pictures of Victoria: The Fauchery–Daintree collection 1858*, facsimile of Antoine Fauchery's *Lettres d'un mineur en Australia*, text by Dianne Reilly and Jennifer Carew, Library Council of Victoria, South Yarra, 1983. See also Fauchery's *Lettres d'un mineur en Australie; precedees d'une lettre de Theodore de Banville*, Poulet-Malassis et de Broise, Paris, 1857.

140. See Richard Daintree, *Hill mining under lava. Jim-Crow diggings, ca 1858*. Albumen photograph. From *Australia: Sun pictures of Victoria*, Melbourne, 1858. La Trobe Picture Collection, State Library of Victoria, Melbourne, Australia (acc. no. H84.167/23, call no. PCV LTA 355); and *Falls of the Campaspie River, ca. 1858*. Albumen photograph. From *Australia: Sun pictures of Victoria*, Melbourne, 1858. La Trobe Picture Collection (acc. no. H84.167/29, image no. B22462).

141. See S. T. Gill, *Victoria gold diggings and diggers as they are*, Macartney & Galbraith, Melbourne, 1852. On Gill, see Ron Appleyard, et al., *S. T. Gill: The South Australian years*, Art Gallery of South Australia, Adelaide, 1986; Keith Macrae Bowden, *Samuel Thomas Gill: Artist*, Hedges and Bell, Melbourne, 1971; Sasha Grishin, *S. T. Gill: Dr Doyle's sketches in Australia*, Mitchell Library and Centaur Press, Sydney, 1993; Grishin, 'S. T. Gill: Defining a landscape', *Voices*, National Library of Australia, vol. ii, no. 4, Summer 1992–93, pp. 5–19; E. J. R. Morgan, 'Samuel Thomas Gill', *ADB*, vol. 1, pp. 444–45; and J. Tregenza, 'The visual dimension of colonial history', *Art and Australia*, vol. 19, no. 1, 1981, pp. 91–96.

142. Shar Jones, in *DAA*, p. 297.

143. John Sherer, *The gold-finder of Australia: How he went, how he fared, how he made his fortune; edited by John Sherer; illustrated with forty-eight magnificent engravings from authentic sketches taken in the colony*, Clarke, Beeton, London, 1853.

144. Goodman, pp.131–34.

145. Jones in *DAA*, p. 296.

146. Butcher and Collins, p. 3; and Cato, p. 22, quoting from *The Argus*, 22 November 1865.

147. Butcher and Collins, p. 4.

148. Peirce, pp. 31–33.

149. While Batchelder's photographs were displayed in Bendigo and then in Melbourne at an exhibition of the photographs to be sent to London, no mention of his Bendigo views appeared in the London exhibition catalogue; it is possible that they never made the trip to the final exhibition. See Butcher and Collins, p. 12.

150. In his recent essay for a catalogue on Batchelder's *Bendigo album*, Mike Butcher asserts that these images were indeed shot by Peirce, and that he may be pictured in at least one of them, standing next to the Batchelder cart, see Butcher and Collins, pp. 11, 82.

151. ibid., p. 12.

152. Fox, p. 175.

153. The Melbourne intercolonial exhibition of 1866 to 1867 would provide objects to be sent as the Victorian entry at the *Exposition Universelle* in Paris in 1867. See Fox, p. 174.

154. *Inglewood Advertiser*, 29 September 1866; quoted in Fox, p. 174. For a view of *Sunday Morning Hill. Brennanah Station*, see Fox, p. 176.

155. 'The 1866 photographs of the municipality became the eye of the democratically elected representatives of the people who directed the images taken by the photographer.' Fox, p. 175.

156. See B. P. Batchelder, *Bendigo Town Hall, Declaration of the Poll, 13 August 1861* in Butcher and Collins, p. 27. Albumen photograph. La Trobe Picture Collection, State Library of Victoria, Melbourne (cc. no. H26090, call no. PCV *LTAF 61).

157. Butcher and Collins, p. 6.

158. ibid., p. 8.

1870s: Bret Harte and
Euchre in the bush

But the hands that were played
By that heathen Chinee,
And the points that he made,
Were quite frightful to see,—
Till at last he put down a right bower,
Which the same Nye had dealt unto me.
Then I looked up at Nye,
And he gazed upon me;
And he rose with a sigh,
And said, 'Can this be?
We are ruined by Chinese cheap labor'—
And he went for that heathen Chinee.
In the scene that ensued
I did not take a hand,
But the floor it was strewed
Like the leaves on the strand
With the cards that Ah Sin had been hiding,
In the game 'he did not understand.'
In his sleeves, which were long,
He had twenty-four jacks,—
Which was coming it strong,
Yet I state but the facts;
And we found on his nails, which were taper,
What is frequent in tapers,—that's wax.
Which is why I remark,
And my language is plain,
That for ways that are dark
And for tricks that are vain, The heathen
Chinee is peculiar,—
Which the same I am free to maintain.
—Bret Harte, 'The Heathen Chinee', 1870.[1]

~

… And to the busy concourse here the States have sent a part,/The land of gulches that has been immortalised by Harte;/The land where long from mining camps the blue smoke upward curled,/The land that gave the 'Partner' true and 'M'liss' unto the world.
—Henry Lawson, 'Eureka (A Fragment)', 1889. [2]

One of the most charming paintings in the Ballarat Fine Art Gallery is a small, crudely rendered narrative piece entitled *Euchre in the bush* (c. 1867) (see Fig. 2.01 on page 209). We know that this specific card game and this specific setting is the painting's subject, because the artist, one Joseph Colin Johnson (1848–1904; later to be known as J. C. F., or 'Alphabetical', Johnson), has written the title into the painting, in careful black lettering, in the middle of the canvas. The artist's signature, written at an artistic angle and underlined, appears in the right hand corner; if the signature were not there, no artistic evidence would exist to link this particular Johnson to this image, since he was not known for any other paintings. The specificity of details in the scene depicted has always led viewers to assume that the artist was seeking to illustrate a story, a story that was, by virtue of these details, recognisably taking place during the years of the gold rush in Australia.

Seated around a simple table inside a miner's hut (so identified by the shovels placed against the left wall) are three men: in the middle (and

in the dead centre of the canvas) a bearded white miner, wearing the high-crowned hat and red plaid shirt and vest often identified as 'Yankee' garb in the Australian goldfields.[3] On the left is a Chinese man with pigtail and in traditional clothing (the pigtail appears here as a braid around the top of his head); and on the right, a black man in stockman's outfit and with white sideburns that mark him as aged. In each of their hands are playing cards; on the table next to the white miner a Four of Clubs is prominently displayed next to his pipe, while the Chinese and the black man have stacks of downturned cards next to them on the table. At their feet in the foreground of the picture are various objects, rendered in detail to set the scene in the Australian bush during the late nineteenth century: a bullwhip, an overturned hat, two sticks and a disk somehow associated with the Chinese man have all been carefully included by the artist. On the right edge in the painting, next to a fireplace, is a basin with billy can and cup—again, signifying the activities of a miner or a bushman. The back wall holds a lone cup hanging on a nail, as well as two sinister looking knives held in place vertically by a horizontal piece of wood. This is not a comfortable middle-class home in which a woman tends the domestic hearth, but a rougher cabin where men settle temporarily. The view out the cabin, seen through a door behind the black man, presents a generic landscape, with a small hut in the distance. The artist's hand is not skilled—he has no grasp of perspectival rendering and struggles with colour and shading—but his efforts to delineate each item so meticulously speak to the importance of the details in conveying the story he so obviously wants to tell.

What is the story he wants to tell? Who is this untrained artist, so intent on telling this particular story in this image? Johnson, it turns out, was a well-enough known figure to have an entry in the *ADB*.[4] He also appears in *The*

Oxford companion to Australian literature.[5] Joseph Colin Johnson was born in Adelaide in 1848, the son of a Roman Catholic migrant family (he added the third name Francis later in life, for reasons known only to him). When Johnson's father abandoned the family in 1864, young Joseph 'went bush', beginning the kind of itinerant and adventurous career typical of so many young men in Australian frontier society. Ambitious, educated and romantic—one critic described him as 'disputatious and showy',[6] and another wrote that he 'was a flamboyant figure given to energetic physical activities such as long distance travel and swimming exploits'[7]—Johnson tried his hand at a variety of occupations, from journalism to mining to politics.

In the 1870s he worked as a journalist for the Adelaide newspaper *The South Australian Register* (1839–1900), and in the 1880s was editor of *Adelaide Punch* (1868–1884). The latter position allowed him to carry on the kind of writing that he had begun earlier, when he compiled his so-called 'campfire yarns'. These short stories, often written in Johnson's version of Australian bush dialect and filled with eccentric bush characters, were ostensibly based on his own experiences in the mining towns and rural settlements throughout the Victorian and South Australian colonies. Often he published these yarns personally; many of them, such as 'The Wallaby Track' of 1872, were written in verse form. One of his best known stories was 'Moses and Me', a sentimental tale about the narrator's horse with vivid descriptions of the goldfields of Mount Browne in New South Wales, where Johnson had himself prospected in 1880.[8] *The ADB* described these stories as 'ordinary in style', but stated that 'they anticipated Lawson and others in depicting bush life'.[9] Henry Lawson (1867–1922), the most revered of early Australian writers, will have a role to play later in this story.

Mention of Johnson's tenure as an editor of *Adelaide Punch* highlights that Australia had by the 1850s already developed an industry in illustrated journals and newspapers. Sydney, Adelaide and Hobart had established printers and illustrated publications by the 1840s, but Melbourne was able to support more of these endeavours than any other Australian city. There, in 1850, the *Illustrated Australian Magazine* (1850–1852) became the first Australian journal to feature black-and-white illustrations as a regular feature of the publication. The most successful of these weekly publications was the *Melbourne Punch*, which began in 1855 and remained a popular fixture in Victorian homes until 1925. While so many other pictorial journals failed for lack of sufficient patronage to support the high costs of printing illustrations—including the *Illustrated Sydney News* (1853–1855)—this ambitious version of the London *Punch* managed to keep an audience because it attracted and paid the best writers and the best artists to produce its abundant illustrations. It was also the first publication to replace wood-engraving with zinc etching—an example of the editors' awareness of the importance of adopting the most modern printing technologies.[10]

In these early days of the Australian illustrated press, many of the most sought-after artists arrived from abroad. *Melbourne Punch*'s first official artist was Nicholas Chevalier (1828–1902), a well-trained European artist who came to Melbourne from London in 1855, already adept in oil painting as well as printmaking.[11] Chevalier and other Europeans were employed regularly by *Punch* and created by the 1860s a fanciful yet polished illustrative style that appealed to an educated popular audience for whom the illustrations sold the journal. Melbourne was also the home of many weekly or monthly illustrated supplements to the daily newspapers, most notably the *Australasian Sketcher*

(1873–1889), the monthly companion to the weekly *Australasian* (1864–1946) of the daily Melbourne paper, *The Argus* (1848–1957). Editors early discovered that illustrations were sought-after commodities and could increase enormously the always tenuous circulation figures of colonial publications.[12]

While the *Adelaide Punch* included caricatures, cartoons and illustrative vignettes similar to those in the London and Melbourne publications that inspired the humour magazine, J. C. F. Johnson while editor did not seem to have made any illustrations himself, nor did he personally illustrate any of his other publications. His 1881 edition of 'Moses and Me' was illustrated by H. J. Woodhouse (active 1868–1884) and Arthur Esam (c. 1850–1919), both of whom were relatively skilled illustrators of the time.[13] Indeed, Johnson himself at one point stated:

> Had I the skill of H. J. Johnstone I would be glad to put this scene on canvas for my readers, for it was well worthy of the brush of our truest Australian artist. As, however, my artistic flights do not usually soar higher than a big brush and a pot of whitewash for my back fence, I'll try a monotint painting in printer's ink.[14]

Johnson is referring here to Henry James Johnstone (1835–1907), a British-born artist, who by the 1870s had established himself as a landscape painter, particularly of billabong scenes in South Australia. He was especially popular in America in the 1880s.[15]

Johnson had a practical side as well. He lectured prodigiously about mining and mining enterprise, and his book *Practical mining* (Adelaide, 1889) sold more than 10,000 copies. His *Getting gold: A practical treatise for prospectors, miners and students*, first published in the 1890s, was a standard work, in its sixth edition and still in print in the 1920s. In 1884, Johnson became a Member of

Parliament for the seat of Onkaparinga, South Australia, where he continued his efforts to improve mining legislation and, significantly, travelled in the early 1890s to America as part of a commission into improved mining techniques. In his 1897 London edition of *Getting gold*, Johnson presented America as at the forefront of mining technology, at one point referring to the United States as 'the wonderland of the world, America'.[16]

Throughout his political career he continued his literary endeavours, compiling and publishing his short stories under the title *An Austral Christmas* in 1889. Apparently bored with political life, he retired from parliament in 1896. Johnson remained committed to his own nationalist causes, including a campaign to raise a monument to commemorate the South Australian bushmen. Johnson's efforts were instrumental to the erection of an enormous commemorative statue in front of Government House in Adelaide in 1904, the same year that he died after a fall down stairs at his mother's house.

As far as anyone can discern, his small painting in Ballarat with its quaint title and primitive style was Johnson's only foray into the visual arts. This fact is all the more intriguing when one learns that he created at least three pictorial versions of this same theme.[17] The image's iconography—the three races playing euchre at a table in the bush landscape of the Australian goldfields, each figure defined by costume and activity, and with the implements of mining and the bush life so distinctly delineated—clearly suggests a specific literary source that must have had significance for Johnson, the ardent Australian nationalist so involved in the romanticising of this period in his country's history.

That source becomes apparent when one turns to the most widely circulated version of Johnson's artwork. The *Australasian Sketcher* issued in its 1876 Christmas issue a printed

colour supplement. The main feature of the supplement, reproduced in what was for the time an advanced colour wood-engraving technique, was an artistically improved version of Johnson's own *Euchre in the bush*. One of the *Sketcher's* artists corrected the perspectival deficiencies of Johnson's original work, added some pictures to the back wall and generally enhanced Johnson's clumsy composition, but the figures seated around the table and the objects in the foreground are precisely as Johnson had conceived them in his Ballarat painting.

Because of his association with *Adelaide Punch* and with the Adelaide newspaper *The Register*, Johnson had a following or some connections within the Melbourne journalistic community that made it possible for him to persuade the *Sketcher's* publishers to give his image such a prominent and popular venue for display. The publication also gave him the opportunity to describe the image's narrative to the public, for here the coloured plate was accompanied by explanatory text:

> Our plate depicts a scene not infrequent at some of the out-of-the-way gold-fields in this, or either of the other colonies, and especially in Queensland, where the three races shown are found living closely mixed together. It is a bright Saturday afternoon, and Jack, the black packer, 'Harry, my friend', the digger, and Ah Sin, the Chinese fossicker, have met to while away an hour or two at a game of 'cut-throat euchre', for a pennyweight a corner. On the present occasion fortune has smiled on Ah Sin. It was his deal and he has 'taken it up'. He is 'all but'. The digger is only four, and the aboriginal has not 'turned his cards', or, in other words, has not made a point. The Chinaman has taken the first trick on suit and led the ace of trumps. The European has the kind, say, and a small one. Jack holds the queen. But it is no service, for Ah Sin, as his complacent smile seems to indicate,

Fig. 2.02 J. C. F. Johnson,
A game of euchre.
Wood-engraving, in
Australasian Sketcher,
Melbourne, December 25,
1876. National Library of
Australia, Canberra.

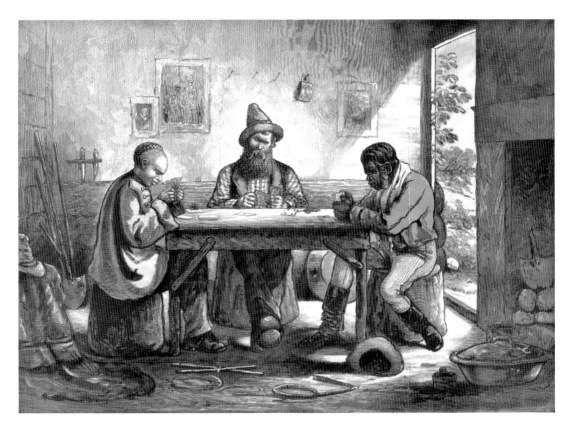

has 'left bower' and two small ones in reserve. He is sure of the point wanting to bring him through triumphant, and he already enjoys the pleasure of victory. The incident recalls the lines of Bret Harte's best-known poem—

'Which we had a small game,
 And Ah Sin took a hand;
 It was euchre. The same
 He did not understand:
 But he smiled as he sat by the table,
 With the smile that was child-like
 and bland.'

But it may be that there is a meaning in the picture besides the plain matter-of-fact one that appears on the surface. The three races have been for some time playing a game for life on this continent. The aboriginal race have very nearly played their last card, and the game is henceforth between the whites and their yellow-skinned competitors. John Chinaman holds his own remarkably well, and in some parts, as in North Queensland, scores one point after another. The immense extent of Chinese immigration to that region some time back was viewed with alarm, and the thought expressed in Bret Harte's poem, 'we're ruined by Chinese cheap labour', was present to the minds of large numbers of the colonists. But although that colony has seen fit to adopt measures intended to act as a restriction on this influx, the alarm appears to have practically died out, and there is no reason to doubt that the two races may work on amicably together and aid in the development of an immense territory, where 'there's room enough for all.'[18]

Given the direction of Johnson's literary aspirations and his own experiences in the ethnically diverse goldfields of Australia, it is no surprise that the inspiration for his one piece of

visual art, as well as for his own 'camp yarns', was his American contemporary, the hugely popular writer Bret Harte (1836–1902). Harte had become in the 1870s the most highly paid author in America,[19] gaining that position through his wildly successful stories based upon his own memories of the California mining towns of the 1850s and the colourful characters who inhabited them.

The poem that Johnson quotes as inspiration for his image's theme, 'The Heathen Chinee', was first published in 1870 in the San Francisco journal *Overland* (1868–1875, 1883–1935), a monthly publication which hoped to emulate, for a California audience, the format of the East Coast's prestigious *Atlantic Monthly* (1857–).[20] Harte was involved in *Overland*'s publication from its beginnings. With this bit of colourful regional doggerel—originally entitled 'Plain Language from Truthful James', 'Truthful' being the narrator of the poem and one of Harte's stock characters—Harte became an international celebrity, as if 'in a single night'.[21] The most recent bibliography of Harte's works lists five pages of reprints and publications for this single verse.[22] As the advertising annotations announce at the back of an early London edition of 'The Heathen Chinee', the poem represented '[a]n entirely new style of humour. Since the publication of these poems in this country extracts from them have been copied and re-copied in every newspaper throughout the country, giving the public an infinity of delight'.[23]

This overwhelming popularity brought some predictable discomfort not only to Harte, but to his literary contemporaries. The New York journal *Galaxy* (1866–1878)—described on its title page as 'An Illustrated Magazine of Entertaining Reading'—expressed the ambivalence with which Harte's literary celebrity was met. Discussing not only Harte's poetic prominence, but that of John Hay

(1838–1905), another serious writer who gained a national audience for his uncharacteristically sentimental *Little breeches*, the magazine noted, with some dismay, how widespread was the reception and the reproduction of their works:

> They are copied and gravely approved by English reviews of the first class. They are read on benefit nights at the theatres, and recited in good faith at Sunday-school picnics. They are pinned up on the walls of gin-shops, and carried furtively in the portemonnaies of Doctors of Divinity. No poem of its length in the language has furnished such a store of quotations to the newspapers as Mr. Harte's ballad of 'Ah Sin.' It is not too much to say that it has sensibly modified the colloquial speech of the day. Among that large class who take their ideas, and especially their liveliness, ready made from the press, the 'Heathen Chinee' has had no rest for a single hour since it appeared in the pages of the 'Overland Monthly'.[24]

The article went on to say that as 'the recreations of cultivated men',[25] such amusing ditties were acceptable; but when they were taken up by the public as real literary achievement, they could have nothing but a demeaning effect on literary culture. That the verse was so widely disseminated through popular editions, newspapers and illustrated journals made uneasy those still intent in the mid-nineteenth century on maintaining a line between high art and popular culture. As Harte's biographer Stewart put it: '[T]he remarks of Truthful James swept beyond the comparatively narrow circle of polite readers, and like a popular song or a vaudeville joke became the property of the man in the street; picture and word of mouth carried it even to the illiterate.'[26] Harte's popularity, then, was worldwide and immediate; his fame and the imitation of his

style serve as dramatic evidence of the transformation of Western culture caused by the development of mass communications in the mid-nineteenth century.[27]

Not only did Harte receive enormous attention in the American and English press; but as early as 1871, the Melbourne publisher George Robertson put out an Australian edition of his poems, which included 'That Heathen Chinee', along with several others of Harte's 'In Dialect' works. In paperback and conveniently pocket-sized, the Robertson edition would have been readily available to avid readers like J. C. F. Johnson. Clearly Johnson modelled his own stories, such as 'Jimmy the Chum' and 'Christmas on Carringa',[28] with his awkward attempts at Australian vernacular speech and his multicultural characters, on Harte's stories and poems. The popular literary affinities between Harte and Johnson are manifest: both construct images of themselves as itinerant adventurers in gold-rich frontier societies on the peripheries of Western culture who were retrospectively nurturing a nostalgic picture of an era already past.

Harte considered Dickens as one of his main literary inspirations and was, as were most American literary aspirants of the nineteenth century, enamoured of all British authors. His own style of writing nonetheless presented a new humorous genre that had little to do with British models of high literary style, or even with more popular forms of British storytelling. This newly dubbed 'Pacific Slope' style, filled with characters brought together in the cultural melting pot of gold-rush society, was what appealed to an Australian such as Johnson. In his book *Gold seeking*, David Goodman cites Bret Harte as a central inspiration for Australian writers' 'sentimental' depiction of the period.[29] Goodman quotes none other than Marcus Clarke (1846–1881), author of the first significant Australian novel *His natural life* (1874), who in an 1871 review of Harte's 'Luck of the Roaring Camp' (1870) praised the characters as realistic and familiar: 'We have met them, or men like them, at Ballarat, Bendigo, or Wood's Point.'[30]

A few years later, Harte's style and characters would inspire Henry Lawson as well. Australia's best-known author, Lawson freely admitted that Bret Harte was his major literary model.[31] In one of his best known poems, 'Eureka' (1889), about the famous moment of armed rebellion on the Victorian goldfields in which many American miners participated, Lawson paid homage to his literary hero and his homeland.[32] In their drive to develop a national cultural identity, Australians such as Lawson expressed a cultural connection to America, and most specifically, looked to the American West for those attitudes and cultural models that were shared between their Pacific cultures. Bret Harte's popular verses and colourful characters were irresistible examples to a people who had since the gold rushes of the 1850s experienced similar cultural transformations and an influx of many ethnicities.

Despite a content that today represents blatant racism, filled with cultural stereotypes that would (especially in the case of Harte's 'Chinee') endure well into the twentieth century both in Australia and the United States, Johnson's and Harte's works expressed as well the fascination and excitement that the unprecedented ethnic mixing in these frontier societies had generated. Never before in modern history had there been such massive movement of peoples of such cultural diversity as occurred from the 1850s through the 1870s in California and in Australia. Ethnocentric defensiveness and nationalistic xenophobia, which in some cases led to violent racial intolerance, was an unfortunate if inevitable product of this cultural displacement.

Harte apparently was chagrined throughout his life that enormous fame arrived because of his poem about the 'Heathen Chinee' and

particularly lamented that his line about 'Chinese cheap labor' was taken up with such alacrity as a statement in support of government attempts to ban Asian immigration into America. Such debates were then taking place in California and in Washington, DC.[33] He was appalled to see the poem quoted by anti-immigration congressmen in congressional debates; one congressman from Ohio even reprinted the last lines of the poem on the cover of the publication of his speech proposing immigration bans.[34] Mark Twain, at one time Harte's close friend and colleague, summed up Harte's dismay at the inaccurate appropriation of his silly little poem: 'Critics have ignored the occasion of its publication while elaborating its opportune appearance, and have been content to account for its popularity without explaining the poet's dislike of that popularity.'[35] Ironically, Twain and Harte's only collaboration would be a play based loosely on 'The Heathen Chinee', hoping to cash in on the poem's popularity. It was this play, entitled *Ah Sin* (1877), 'one of the most spectacular flops in the history of American theater', that ended their friendship.[36]

More lamentably in terms of the popular imagination, the comical figure of Ah Sin, deviously clever in his contrived ignorance of white man's ways, dressed in blue pajama-like clothing and always with traditional 'coolie' pigtail, long fingernails and 'childlike' smile, established the cultural stereotype of 'otherness' for Chinese which many Australians and Americans of the era wanted to maintain.[37] This stereotype was most clearly delineated and dispersed through the visual renderings that accompanied or were inspired by Harte's poem, in a variety of popular forms and in several countries. The images were as important as the literary narrative that inspired them, establishing in the popular imagination the accepted physical appearance of this 'otherness'.[38]

That people wanted to see what these strangers looked like—whether in exaggerated drawn likenesses or in more 'factual' depictions—can explain why so many early photographs and drawings depict the Chinese in the goldfields; they were one of the most numerous and the most exotic of the national groups to come to California and Australia. They consequently highlighted for the nineteenth-century viewer the extraordinary transformations caused by the gold discoveries.

One of the only extant photographic images from the Victorian goldfields in the 1850s depicts an overloaded coach of Chinese immigrants heading for the diggings. Chinese working in the fields or visiting Melbourne were also a common subject in the Australian illustrated press.[39] In California, Isaac Wallace Baker's daguerreotype of a Chinese man, holding his pigtail, is one of the most reproduced images from the daguerreotype era in California.[40] In the 1860s, none other than Eadweard Muybridge produced a series of photographs that he entitled *The heathen Chinee*, documenting in part the Chinese workers who built the Central Pacific Railroad line from California through the Sierra Mountains to the meeting point at Promontory, Utah.[41] The Chinese are present in the earliest depictions of these chaotic gold-rush societies, from an image of the celebrations for California's admission into the Union,[42] to an on-site drawing of the Black Hill mines at Ballarat in 1857.[43] They also appear, either as the main topic or as peripheral figures, in many of the prints and drawings of the famous chroniclers of goldfield life, J. D. Borthwick in California, and S. T. Gill in Australia.[44]

The 'colourful' Chinese offered enticing opportunities for the visual chroniclers of the gold-rush story, but they were not the only 'others' to provide anecdotal artistic flavour. That the Australian Johnson chose, along with the Chinese figure, to include in his pictorial

version of *Euchre in the bush* a black man—which had no part in Harte's poem—gets to the heart of his metaphorical ambitions for this image. As Johnson makes clear in his description for the *Sketcher*, the figure represents 'the aboriginal race' who 'have very nearly played their last card'—an allusion to the widely held belief, both in America and in Australia, that the indigenous races would inevitably die out with the advance of Western 'civilisation' into their lands.[45]

Johnson sees his little image, then, so carefully delineated and eventually reproduced for mass circulation, as a symbolic rendering of his most ardent concern, a 'game for life on this continent', one which he felt was a competition by the 1870s between the Asians and the white race alone. In the end, his hopeful statement, 'that the two races may work on amicably together and aid in the development of an immense territory, where "there's room enough for all"', is his plea for ethnic harmony and the Australian idea of 'giving everyone a go'.[46] Here Johnson also expressed affinity with Bret Harte's own attitudes, at least about the persecution in California of the Chinese.[47] That his rendering of Ah Sin portrays him at a moment of calm, and without emphasis on the length of his pigtail, evokes a less aggressive attitude to the Chinese immigrant than the more lurid or comical images on sheet music and in magazines that followed Harte's publication of his poem in *Overland*.

The cultural manifestations of racial politics during the late nineteenth century is not the main focus of this study. What makes this comparison so striking—that the Australian Johnson was directly inspired by the American Bret Harte—is the evidence it provides of the easy accessibility by the 1870s of cultural and aesthetic exchange between the Pacific Slope communities of America and Australia.[48] Harte's Californian depictions and Johnson's earnestly Australian image of

Euchre in the bush share a stylistic attitude determined by the similarities in their geographical and cultural locations, similarities that they knew about because of regular and prolonged interaction and continued exchange of portable images and texts. This interaction and exchange, moreover, took place on a popular level, whereby images and texts were dispersed and absorbed by the masses—the newly mobile, multicultural, masses that the discoveries of gold on two continents had engendered. The connections were widespread and eclectic: the same volume of *Overland Monthly* that was first to print Harte's 'Plain Language from Truthful James' included as well an article on sheep-farming in Australia by John Manning and another entitled 'Life in the bush' by John Hayes.[49] Manning had also written an article on gold-digging in Australia in the September 1869 issue of *Overland*, in which he expresses, with bemused irony and self-deprecation, the simplistic reasoning behind their early searches for gold:

> To the best of my recollection, I think we reasoned this way: California was a new country; that was clear, for nobody had before ever heard of it. Australia was, also, a new country. Gold was found in California; therefore, there must be gold in Australia.[50]

In San Francisco, Australia and Australians had also made an impact by this time on the cultural life and aesthetic psyche of this new metropolis. Before the appearance of *Overland*, Harte himself provided vivid evidence of the popular level of exchange that was already taking place between the two countries. On the first page of his first newspaper, *The Californian* (1864–68), editor Harte published his humorous poem, 'The Ballad of the Emeu',[51] reference to the ostrich-like bird of the Australian outback that had arrived as a zoo specimen in California by the

1860s.[52] Interestingly, and not for the only time, the Australian contribution to cultural exchange was in this case an animal—in its own way, like magazines, sheet music and posters, another kind of portable object for popular consumption. As will become increasingly evident in the last decades of the nineteenth century, Australia's greatest aesthetic, one could even say iconographic, contribution to popular culture centred, as it still does, on its unique flora and fauna.

By the 1870s in San Francisco, the oddities of Australian wildlife had already achieved notoriety at the city's leading amusement park, Woodward's Gardens—no doubt the source of Harte's knowledge of the emu. On the grounds of his own estate in the Mission District, Robert Woodward (1824–1879),

who had made his fortune during the gold rush by providing decent accommodation and dining for San Franciscans, opened in 1868 his 'private pleasure park', with educational as well as entertaining exhibits and presentations.[53] The grounds included live animals, but were most prolific in examples of the taxidermist's art. As the 1878 guidebook to the gardens explains, one of the major exhibits was 'The Zoögraphicon, or, Rotating Tableaux of Natural History. Invented by F. Gruber'. This moving diorama displayed the wonders of the exotic parts of the world, filled with painted scenery and stuffed animals.

The description of the 'Australia' section demonstrates not only the depth of Woodward's educational aims, but the increasingly elaborate efforts taken to appeal to the

Fig. 2.03 Anonymous, *Emu in Woodward's Gardens,* 1874. Photograph. San Francisco History Center, San Francisco Public Library.

Fig. 2.04 *Woodward's Gardens diorama.* Stereograph. Courtesy of the California History Room, California State Library, Sacramento, California.

public's desire to be visually entertained and stimulated:

> AUSTRALIA./ Presents a view of distant mountains. A waterfall rushes down the rocks. The blue gum trees and the cassuarina [*sic*] are prominent. A kangaroo jumps across the scene. Over rocky cliffs climbs the native cat. The platypus, echida [*sic*] and Australian opossum are plainly visible. On a tree to the right a sulphur-crested cockatoo bows to his mates. A tree opposite seems to be the rendezvous of flocks of bright parrots. Under the tree a bowerbird is constructing his wonderful nest. The emeu [*sic*] attracts attention in the foreground. Magnificent rifle and regent birds swing in the branches, while the curious kingfisher, called 'laughing jackass', is in the act of descending to a fern tree to fight a large crow-shrike. Even the bee-eater, the pardalote finch and the showy pitta are present.[54]

Woodward's Gardens was wildly popular while it existed, disseminating through its brochures and its advertising posters images of exotic wildlife and entertaining performances that delighted generations of San Franciscans.

Harte was not the only one who would have learned about Australian 'exotica' from this beloved venue. The masses that experienced these tableaux became increasingly sophisticated in their need for visual tools to explain their ever-expanding modern world.

Harte's 'Ballad of the Emeu' was not his only Australian reference at this time. The second issue of his newspaper *The Californian* included, on page four, a small anecdotal article, 'A wife in need is a friend, indeed', which referred to a humorous incident in Australia,[55] and one of the stories Harte published in the newspaper that year, from 'Miss M.E. Braddon's New Novel' entitled *Only a clod*, centred on a character described as an 'Australian merchant'. One of his better-received plays, *Two men of Sandy Bar* (1876), includes as main characters not only a Chinese laundryman but an Australian convict.[56] Harte in San Francisco was particularly attuned to popular attitudes and cultural fads. These references offer proof that as early as the mid-1850s, and certainly by the 1860s, Australians and Californians were well-known to each other and were sharing—if only subliminally aware of it—a Pacific Slope culture. Members

of both cultures were participating in the construction of new societies dependent for the most part on the exchange of popular information through portable and reproducible texts and imagery.

Given this awareness of each other and accessibility to popular forms of communication, it is not surprising that Bret Harte's unprecedented celebrity, generated by a poem about a Californian cultural condition, should have served as a model for aspiring Australian author and artist J. C. F. Johnson. Not only were there popular editions of Harte's 'Heathen Chinee' published and distributed by Australian publishers and readily available even in the remotest goldfields, but it is also possible that Johnson, along with many in the newly burgeoning populations in California and Australia, may have seen other printed visual images depicting Harte's poem that would have influenced his own artistic iconography.

As a popular poem, his 'Heathen Chinee' received numerous visual interpretations in the international press and publications. Harte's poem served as the narrative reference for at least one ambitious Californian oil painting—Rufus Wright's *The card players* (1882).[57] Such examples of high art were unlikely the source of Johnson's iconography, since oil paintings, and the venues in which to view them, were available to so few in these frontier societies. One popular form of imagery by which such narrative poems could gain visual form was the touring panorama, so beloved of the showman-artists on the goldfields. Indeed, the inveterate itinerant Augustus Baker Peirce wrote that while making a panorama for Bernard Holtermann called *The mirror of Australia*, he had included an illustration of 'Bret Harte's celebrated poem, The Heathen Chinee, which was to be rolled off as I repeated the stanzas'.[58] While such entertainments were frequent, the most likely and pervasive images to serve as

inspiration for an author like Johnson were reproductions: printed, portable images widely circulated, distributed in Californian mining camps as well as in the Australian bush.

By the 1870s, reproduced images from a variety of sources were everywhere, consumed immediately by literate and illiterate alike. At least three sets of lithographic reproductions illustrating the 'Heathen Chinee' appeared almost immediately after its publication, both as a separate set of illustrated cards and in illustrated editions of Harte's poems published in books, journals and newspapers in America and in England. The 'official' illustrator for Harte's stories published by Fields, Osgood & Co. in Boston was Sol Eytinge (1833–1905), one of the most prolific draughtsmen of the day, who would later be an important illustrator of Dickens' works.[59] Eytinge also created popular depictions for John Hay's *Little breeches*, another potboiler of the era that gained considerable popularity. The illustrator produced as well an early iconic image of the frontiersman, Seth Kinman—a favourite figure of Bret Harte's.[60] Eytinge's illustrations for the 'Heathen Chinee' also appeared in *Frank Leslie's Illustrated Newspaper*, probably the most widely read of the many American illustrated journals to reprint Harte's poem.[61]

In every set of illustrations, with some stylistic variations, the image of Ah Sin emphasises his supposed deviousness through a focus on his demeanour and on the details of his exotic dress, solidifying the prototypical image of the Chinese man in Western culture. But the depiction of the scene while playing cards around the table—the scene that most specifically inspired Johnson's Australian version—differs widely in terms of the visual interpretation of the level of violence that ensued in the next scene.

The set of lithographed cards produced in 1870 by the Western News Company of Chicago—referred to by Harte's biographer

George Stewart as 'unauthorized'[62]—are particularly interesting, for they appear to have been published as supplements or inserts to a newspaper. In format at least, these cards seem to be a forerunner to one of the most popular forms of mass-circulation imagery that emerged in the late nineteenth century: baseball, cigarette and other kinds of trading cards that could be collected as a series. It has also been suggested that the cards were produced in such a format so that they could be framed individually, but the fact that they were produced sequentially, and by a newspaper, supports the assertion that they were meant to

be collected over time and with the purchase of several issues of a newspaper.

These 'Heathen Chinee' cards sold in the thousands. When displayed in the window of a New York shop, they caused crowds to form outside on the sidewalk, where people laughed and guffawed at the sight of the comedic illustrations.[63] The 'artist'—or more correctly, the image-maker—is identified as Joseph Hull. Hull uses a style that is decidedly vernacular in its caricatured humour, as if these images prefigure the kind of pictorial role that the newspaper comics would soon fill in American newspapers, or as illustrations in popular magazines such as *Frank Leslie's Illustrated Newspaper* already did.[64]

As examples of the most mass-produced and therefore most pervasive form of image-making made possible by new print technology, these cards deserve a close reading—not for their aesthetic qualities, but for the cultural attitudes conveyed and consumed in the guise of comedic interpretation. In card no. 1, 'Truthful James' is seen as a tattered-looking, beak-nosed man with a floppy hat either rising or about to sit down on a chair, and from which a speech bubble appears (in some versions) to announce 'The Heathen Chinee!!'[65] At the top of the page under the title 'Plain Language from Truthful James' is printed the first verse of the poem itself. The second card introduces 'Ah Sin', with exaggeratedly 'crossed' Asian eyes, a long pigtail, long fingernails and in Chinese dress. No. 3 depicts Bill Nye, a caricature of the Anglo-Irish California miner, as with Truthful James in beak-nosed profile, but carrying a pick-axe and smoking a pipe.

Card no. 4 depicts the image most closely associated to Johnson's Australian version of *Euchre in the bush*: the three men introduced in the previous illustrations are now seated around a table and holding cards; Truthful James looks unhappy, Bill Nye puffs away on his pipe and concentrates on his cards (the

Fig. 2.05 Joseph Hull, illustration for Bret Harte's *The heathen Chinee: Plain language from Truthful James*. Lithograph, no. 4 of 9 illustrated cards. The Western News Co., Chicago, 1870. Courtesy of The Huntington Library, San Marino, California.

No 4.

Which we had a small game,
And Ah Sin took a hand;
It was Euchre. The same
He did not understand;
But he smiled as he sat by the table.
With the smile that was child-like and bland

Yet the cards they were stocked
In a way that I grieve,
And my feelings were shocked
At the state of Nye's sleeve;
Which was stuffed full of aces and bowers.
And the same with intent to deceive

verse on the card indicates that Bill Nye has aces up his sleeve, but the picture does not emphasise this detail), while Ah Sin smiles inscrutably—or, as Harte's verse states, '[w]ith the smile that was child-like and bland'. His pigtail dangles prominently behind him. In card no. 5, Ah Sin smiles as he plays his hand on the table, and Truthful James 'blows his hat', hair standing on end in the best cartoon style while Bill Nye looks at the Chinese man's cards. In no. 6, with Harte's phrase 'We are ruined by cheap Chinese labor' written across the bottom of the card, Bill Nye stands and points accusingly at Ah Sin; and Truthful James stands in agitation. By card no. 7, only one line from the poem, 'And he went for that heathen Chinee', suffices to explain the action. Bill Nye throws the table at Ah Sin, while kicking him, Truthful James is out of the frame, cards are flying, and the pigtail is high in the air.

The next card's scene is the most violent of any of the pictorial renditions of the poem by Harte's contemporaries and exaggerates the intention of the verse itself. Beginning with the line 'In the scene that ensued …', the artist introduces an entire mob of miners who, with bottles in hand and shooting off pistols and tossing boots, throw Ah Sin in the air, while the narrator, hair still on end to denote fright and extreme action, hovers on all fours next to an overturned chair. The effect of the image is riotous action by white miners against the single figure of the Chinese player—a more vociferous vision, for the sake of sensationalist popular consumption, than Harte's poem ever intended, and the image which most upset Harte himself. The final card, no. 9, shows a saddened narrator, now with his hat back on his head, recounting the last verse of the poem, which ends: 'The heathen Chinee is peculiar— Which the same I am free to maintain.'

The other illustrations of this poem in books, magazines and newspapers of the 1870s, in Australia and England as well as in America, were less crude and caricature-like, and none of them delineate mob action against the Chinese card-player. The iconography of Ah Sin nonetheless remains constant. Johnson's image of *Euchre in the bush* emphasises the same visual details in his rendition of the Asian playing cards with two men of the Australian outback, albeit without the melodramatic bursts of violent attack or exaggeration of cultural difference.

While it is now difficult to substantiate that these specific illustrations arrived in Australia, it is possible that they were available and seen by Australian crowds, given the steady stream of illustrated journals, newspapers and other reproduced material that was known to have reached Australian shores by ship from the western coast of America in the 20 years since the gold discoveries. The Hull cards were discussed in a British newspaper in 1871, indicating that they had at least reached Britain, making it all the more likely that they would have ended up at some point in the Australian colonies.[66] Further, as the current holdings in the State Library of New South Wales in Sydney substantiate, *Overland Monthly,* the journal published in San Francisco with which Bret Harte was so intimately involved and in which the poem first appeared, was held in some library collections in Australia from the beginning of its publication in 1869, and was probably sold in bookshops and newsagencies there and elsewhere from that time.

The exchange of publications and imagery between these far-flung settlements was by this time regular and had become part of the fabric of frontier life. Historians today such as David Goodman continue to express astonishment at the pervasiveness of the level of popular exchange between these cultures:

The two societies were well aware of each other. Many miners were to visit both places, and the

metropolitan press kept each other informed of the dramatic developments in the other. We should not underestimate the extent to which in the mid-nineteenth century there was already a steady commerce of ideas and products around the world—even in outposts like Australia and California ... [t]o attempt to understand these societies outside the context of this commerce and communication, this heightened and informed sense of national difference, is to run the risk of misunderstanding the cultural expressions we find in them. Even the provincial presses of the two societies seemed somehow to keep in touch. The Victorian *Warrnambool Examiner*, for example, ran a story in 1858 about the poisoning of a family in Grass Valley, California, citing as its sources the *Marysville Express* and the *Grass Valley Telegraph*— neither of them major urban newspapers.[67]

One of the most popular venues for this kind of exchange was the mechanics' institutes, working-men's educational venues that were an essential part of gold-rush societies in California and in Australia. The Mechanics' Institute Library in Ballarat, the most populous of the Victorian goldfield towns, was founded in 1857 (the San Francisco Mechanics' Institute was founded in 1854). The library of that institute is still operating as a members' library. It still carries many of the complete sets of its earliest holdings, including a run of *Harper's* from 1850, *Godey's Lady's Book* from 1871 and the *Atlantic Monthly* from the 1880s.[68] In these publications and in Australian ones available at the institutes, the most trivial of popular news was exchanged and reported upon with a matter-of-factness that suggests a shared mundanity. Melbourne's *Australasian* of 5 December 1868, in an article about fish in Massachusetts, refers to the *Atlantic Monthly* as being readily available in the city at that time and known to the *Australasian*'s readers.[69] The same issue contains what was

a regular column entitled 'Theatrical gossip from England, New York, San Francisco, and Calcutta'.[70] Such publications, along with the many pictorial journals from London and those already published in Australia, included some of the illustrations of Harte's and other Californian writers' works. Since these illustrations were portable and easily reproduced, they were easily transported and distributed, and fulfilled the settlers' hunger for visual stimulation, no matter what their class or social status. Egalitarianism—the most fundamental tenet of Australian life— functioned in the visual realm as it did in all other aspects of antipodean society.

Even more significantly for the popular dispersal of both words and images, the text of such a popular verse as 'The Heathen Chinee' was quickly set to music. By the end of 1870, at least three different tunes to Harte's lyrics had appeared, presented in a variety of formats.[71] From the 1840s, sheet music usually included a lithographed or engraved illustration on the cover, images that then would have appeared on thousands of piano stands and would have been viewed in music shop windows and general stores throughout the world. This worldwide dispersal of illustrated sheet music provides yet another form by which Australia and California shared popular imagery that expressed contemporary sentiment and cultural connection.

Sheet music covers supply snippets of imagery in a printed format that was ubiquitous (if ephemeral, because of constant use), presenting a plethora of aesthetic styles and the full array of visual commentary on contemporary events. These images provide some of the earliest examples of the subliminal consumption by the masses of popular art and iconic visual information. Sheet music's illustrated covers contribute significantly to the beginnings of an image-based popular culture in these frontier societies. Unlike the Hull illustrated cards—

which seem to have few if any precedents and cannot now be firmly established as having been in any Australian collections—the lithographed covers of these musical versions of the 'Heathen Chinee' were available in Australia at that time, and could have been known to J. C. F. Johnson and others involved in popular entertainment and mass publishing ventures.

The illustrations selected to describe 'The Heathen Chinee' on these sheet music covers were either exaggeratedly comical[72] or racist and violent—as one writer states, 'the cover to *The heathen Chinee musical album* vividly depicts the punishment meted out to Ah Sin' by focusing on the Chinese man's queue.[73] They consequently offer an interesting framework against which to consider Johnson's choice of a moment of calm and harmony for his depiction of the three races playing cards together and with no emphasis on a visible pigtail (see Fig. 2.06 on page 210). Other covers were less caricatured, but just as telling about mid-nineteenth-century vernacular print styles.

The sheet music for *The heathen Chinee* produced by Oliver Ditson & Co. in Boston was exemplary of the poem's most pervasive visual iconography. The cover included a lithograph by an unknown artist and was printed by J. H. Bufford (1810–1870). Bufford was one of the leading figures in the production of lithographed sheet music in America throughout the nineteenth century.[74] The unknown artist's style was recognisably illustrative and within the more realistic, less sentimental, tradition of action drawings of the 1870s. The image focuses on the moment when Bill Nye grabs Ah Sin by the neck, an overturned stool in the corner of the picture frame indicating aggressive action. Cards come spilling out of Ah Sin's voluminous sleeve and the illustrator places great emphasis on the well-established markers of Chinese otherness, long claw-like fingernails and sinuous pigtail. Within the frame of the lithographed illustration, as a

caption, is that infamous section of the poem, referring to 'Chinese cheap labor'.

This version of the poem set to music was included in an album of six songs of Bret Harte's poems, with music by F. Boott. An illustrated cover sheet by the same artist and in the same format introduced each song within the album.[75] Oliver Ditson (1811–1888), the publisher of this musical series, was from the 1840s and well into the twentieth century one of the most prolific publishers of sheet music in America, with an enormous network of

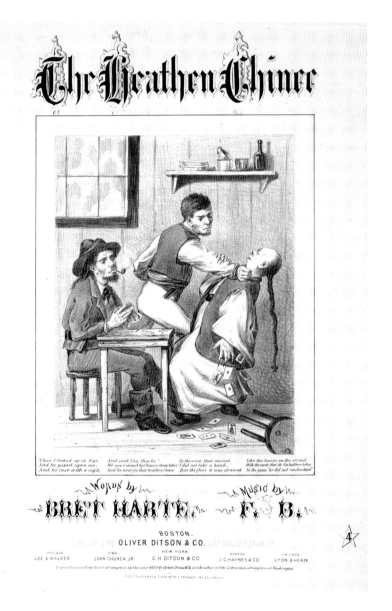

Fig. 2.07 Anonymous, cover, *'The Heathen Chinee'*, words by Bret Harte, music by F. B. Lithograph. Oliver Ditson, Boston, c. 1870. Courtesy of The Huntington Library, San Marino, California.

agents throughout the country and, eventually, the world. Ditson's publications were distributed in Australia as early as the 1850s,[76] and by the 1870s, the company's sheet music and music albums were routinely available in the antipodes. The album of six Bret Harte poems set to music, with their vividly realistic illustrations, were among those purchased throughout the country.

The fevered movement of people and ideas engendered by the gold rushes that began in California and Australia 20 years before Harte's fame and Johnson's painting offered an unprecedented opportunity for the publication and dissemination of transportable entertainments, of which sheet music was one of the most efficient and functional. While illustrated sheet music publication was already in the 1840s a well-established industry in the English-speaking world, the events surrounding the discovery of gold in these distant (yet English-speaking) places precipitated the production of quantities of illustrated sheet music covers, in England, America and Australia.[77] As pictorial rendering of the popular sentiments expressed in the music and lyrics, sheet music's images often related to these events in the most sentimental, moralistic or comical way. *California; or, the feast of gold*, published in London in 1849, includes on the cover a crudely made woodcut depicting among the mob thronging to the river banks a Black, a Chinese, a Scotsman and what appears to be an American Indian, all digging for gold, while the Man in the Moon laughs at their folly.[78] A much more ambitious lithographed illustration accompanied *The good time's come at last*, an early tune published by the London company Leoni Lee & Coxhead, described as 'Music Sellers to Her Majesty Queen Victoria'.[79] Signed as designed and lithographed by G. E. Madeley, the cover shows, in a style reminiscent of the British caricaturist George Cruikshank, a motley procession of men encir-

cling the floridly ornamental title text. The men are seen departing happily for the mines with picks and shovels, and returning loaded down with ingots. The lyrics of the song end with the phrase, 'Everybody's running after gold, gold, gold …', the most common catchcry of the 1850s.

One of the most extraordinary sheet music pieces coming out of London—a veritable 'Musical Bouquet', as the cover announces it—confirms that California and Australia were linked in the popular imagination almost as soon as the antipodean gold discoveries were made public. *Pull away cheerily! The gold digger's song* appeared in 1853 and included a detailed cover illustration of men (and, curiously, small children, who also figure in the lyrics) engaged in mining a stream with various kinds of sluicing equipment. The background depicts many bent-over figures panning for gold in a rocky landscape.[80] The cover's text continues to explain that this rollicking tune was 'written and sung by Harry Lee Carter, in his entertainment of "The Two Lands of Gold"', alluding to Carter's stage performance which debuted in London on 11 April 1853. The tune, the cover states, was '[A]lso Sung by George Henry Russell, in Mr. Payne's Popular Entertainment, "A Night in the Lands of Gold."/Music composed by Henry Russell'.

Pull away cheerily! speaks to the widespread sharing not only of popular imagery but also stage entertainment in the mid-nineteenth century by those English-speaking countries most directly affected by the rush for gold. The explanatory text accompanying a reprint of this sheet music cover provides a vivid description of the nature of such performances:

London, April 11, 1853: the first performance takes place at the Royal Marionette Theatre of a new musical and panoramic entertainment, *The Two Lands of Gold; or, The Australian*

and Californian Directory for 1853. The stage becomes a digger's tent, with native birds surrounding a 'conspicuous' kangaroo. Carter sang to his own accompaniment as the dioramic views (some after 'oil sketches made expressly for this entertainment by Mr. Catlin, the great American traveller') are shown by opening a curtain at the back of the tent.

Part I—'To New York and across the Rocky Mountains, by the Great Salt Lake and the Colony of Mormons, to Saint Francisco, California'—includes an 'Encounter with the Grisly Bear in the Sierra Nevada, or Snowy Mountains.'

To Part II—Australia—belongs *Pull Away Cheerily!* An advertisement in *The Times*, May 4, 1853, says of it: 'Published this day … Quaintly rhymed to a pretty tune, and sung with great spirit by Mr. Carter … 'The Musical Bouquet cover is a later edition, by an artist unknown to us and probably lithographed by Chas. Sheard, a music printer. A cover of remarkable fidelity to the words of the song.

The music is by Henry Russell (1812–1900), who composed over 800 songs, including *Oh! Woodman, Spare That Tree!, The Maniac, Mighty Niagara* and *The Gambler*. He had entertained in America in the 1830's; 'half American', he called himself and said his own style of descriptive song came from listening to Henry Clay orate. While playing the organ in Rochester, Russell discovered that sacred music played quickly gave popular airs when, 'quite by accident', he turned *Old Hundred* into his *Ole Dan Tucker*. He travelled with Catlin, beyond the Missouri, hoping, while Catlin painted the Indians, to record their songs—a plan given up with the first sound of what he called 'hideous noises.'

Russell was a great propagandist for America. He even gave away free passages to California and Australia during his own entertainments.[81]

Such an extravagant performance exem-plifies an enthusiastic, opportunistic show-manship that would be appreciated by any game-show host or popular entertainer today. While the cover text indicates that Harry Lee Carter wrote the lyrics of *Pull away cheerily!*, the song itself was composed by Henry Russell for his friend Carter's production of *The two lands of gold*, and also performed by Russell in his own stage-work, *A night in the lands of gold*.[82]

Henry Russell (1812–1900) was the most popular composer of his day in Britain and in America (he was the creator, among many others, of *Cheer boys cheer!*, still sung today). He contributed personally to an avid exchange of British and American musical and visual sources. While his connections to Australia were not as direct and immediate as his associations with America, Russell's songs were certainly known in the Australian colonies through his sheet music, many of which included illustrations by American artists.[83]

Russell's preference for American artists to embellish his music was not by the 1850s an unusual attitude. American music publishing, along with British firms, experienced a 'golden age' of illustration from the 1840s into the 1870s,[84] during which artists as talented as Winslow Homer (1836–1910) and Fitz Hugh Lane (1804–1865) applied their skills to the design of these lithographic covers.[85] Not only was the artistic quality high, but 'staggering quantities' of sheet music were produced, responding to every conceivable narrative and commenting on every kind of contemporary event.[86]

American publishers, like their British counterparts, took advantage of the exciting, if to many people terrifying, events in California as a subject that would appeal to the masses who now bought music. As early as 1849, songs such as *California as it is*, using comical lyrics to warn of the gold-seekers' possible fate, began to appear at music publishers in

New York, written by tunesmiths who had never set foot in the American West.[87] In 1853 Oliver Ditson published *He died in California* by I. B. Woodbury, again with sentimental words about dying along the trail to the mines, never to see one's family again.[88] Interestingly, despite the fact that by this time elaborately illustrated covers were usually employed to increase the value of the sheet music,[89] these songs had simple decorative covers, as if the writers were reluctant to visualise these tragic ends in distant locations.

Any hesitancy on the part of American publishers to imagine these dramatic events

in new lands was short-lived. By 1853, the Philadelphia firm of Lee & Walker brought out *The age of gold—directions on how to get it; with notes (ad lib) by a Director to California*, printed by Peter S. Duval from artwork by a Philadelphia drawing teacher named Matthew S. Schmitz.[90] Similar in design to *The good time's come at last*, with a circular procession of figures carrying mining gear and climbing into the rocks, this amusing illustration has the figures disappear into the clouds, while on the left a cornucopia-like sea-serpent, straddled by a pipe-smoking man, belches forth gold medallions, some portraying active scenes of the adventures awaiting those setting out to find gold. A caption at the bottom of the page quotes Shakespeare: 'Put money in thy purse.' Such elaborate narrative images bespeak the significance of this visual form in conveying popular sentiment to the masses newly on the move across the country and across the oceans. Australia was as caught up in these musical entertainments as Californians. An article as early as June 1849 in the *Hobart Daily Courier* talks of the enormous amount of music about gold and California that arrived by ship and then entered the repertoire at Hobart performances.[91]

Because they were reproduced in portable formats in large quantities and were in such demand, sheet music prompted publishing companies everywhere to attain from an early date astonishingly sophisticated levels of printing technique. An article in the British journal *The Photographic News*, in a discussion of landscape art in Australia, mentions that lithography arrived in that country in 1834, at which time 'the first sheet of music was printed in Sydney'.[92] The National Library of Australia in Canberra contains, in its 200,000-piece collection of sheet music,[93] a particularly well-preserved example from the gold-rush era called *News from home quadrille*, published in London

by Julien & Co. The cover includes a full-colour reproduction by George Baxter of an oil painting by Harden S. Melville entitled *The squatter's news from home* (1851).[94] The painting was completed in London by Melville after his journeys through Australia from 1842 to 1846; it is signed 'H. S. Melville/Australia', and the National Gallery of Australia in Canberra lists its date as 1850 to 1851.[95] The print and its inclusion on the cover of sheet music for a tune about yearning for home while far away, may have been inspired by the gold discoveries in Australia.

Fig. 2.09 Harden S. Melville, cover, *News from home quadrille by Jullien.* Baxter color print after oil painting by Melville. London: Jullien & Co., c. 1851. Music Collection, National Library of Australia, Canberra.

RESPECTFULLY INSCRIBED TO
MRS. J. EMERSON SWEETSER.
"Words & Music
BY
Dr M. A. RICHTER

Published & Sold by ATWILL & Cº in San-Francisco.
N.B. The First Piece of Music Pubᵈ in Calᵃ

Fig. 2.10 Quirot & Co., cover, *The California Pioneers: A song.* Lithograph. Atwill & Co., San Francisco, 1852. Courtesy of The Huntington Library, San Marino, California.

Despite the appearance in the picture of an Australian cockatoo, a dead kangaroo on the floor and two 'exotic' albeit ethnographically inaccurate natives meant to represent Aboriginal people, the iconography of three 'civilised' white men trying to read the news from home in a bush cabin surrounded by an array of unfamiliar peoples, animals and objects mirrors similar images of miners in California's rugged landscapes—and evokes much of the same feeling as Johnson's *Euchre*

in the bush. The iconography of separation from home was shared between the two gold-rich and newly transient countries.[96]

Because the lithographic process made production of images so simple, illustrated music publishing spread immediately to the frontier itself; indeed, '[m]usic printing and publishing began in San Francisco almost as soon as the gold from the newly rich miners came to the city' and illustrations accompanied the earliest pieces.[97] One of San Francisco's first musical entrepreneurs, a publisher and tradesman from New York named Joseph F. Atwill (c. 1820–1893), was aware enough of the historical significance of his first forays into publishing there that he made sure his sheet music cover of *The California pioneers*, which he produced in 1852, included the phrase, 'N.B. The First Piece of Music Pub'd. in Calᵃ'.[98] The music cover was festooned with a grand print by Quirot & Co., the leading lithographic firm in early San Francisco; Quirot was responsible for some of the most polished images coming out of the city during the gold period.[99]

What is most striking about the cover of *The California pioneers* is its romanticising of the Californian landscape. Quirot shows two mountain men, dressed in fur-lined jackets and high boots and holding hunting rifles. One is astride a fiery steed and points westward. The two figures are surrounded by rocks and evergreen 'big trees'—a landscape motif that already denoted the western wilderness in the popular imagination. The words of the song speak of these adventurers—'I love the man, the man with valor clad'—but the main thrust of the text rejoices in the idea of a sublime western American countryside: 'I love this land, its sunny clime, its golden sand, its birds, their chime, its turfy vales, its flowry hills, its woodland dales, its crystal rills.' The self-conscious attitude of conquest of the American West and the desire to champion the salubriousness of the

Californian landscape was already in place within the popular consciousness by this date; and this visual trope was apparent immediately in sheet music imagery. Finally, this first piece of California music is dedicated to Mrs. J. Emerson Sweetser, the wife of a leading merchant of the city[100]—further indication of the small circles then constructing a cultural life in San Francisco and the important place that Atwill, as owner of a music shop and publisher of illustrated sheet music, occupied in this incipient society. Atwill, along with his successor Matthias Gray and several others, continued to produce increasingly elaborate illustrated music covers and song-books for the next 20 years.[101]

Many of these mass-produced sheets from San Francisco, often with distinctly 'Pacific' imagery and texts pertaining to events occurring on the western American coast, made their way to Australia, where they were performed, adapted and sometimes reprinted by Sydney and Melbourne publishers.[102] By the time Johnson in Australia was writing and performing in amateur theatrical productions,[103] and Bret Harte was basking in international celebrity far from California, the exchange of music, the interaction of performers and the sharing of imagery accompanying these events was thoroughly commonplace between San Francisco and the Australian colonies.

That images accompanied popular music and performers across the Pacific and between Californian and Australian societies, and that itinerancy was the means by which these images and these popular forms of entertainment were spread, is nowhere made clearer than in the fascinating and neglected story of Stephen C. Massett (1820–1898).[104] Among his many other accomplishments, Massett is universally credited with giving the first performance of any kind in San Francisco.[105] As one biographer put it, 'Stephen Massett was the start of theatre in this State'.[106] An

Englishman by birth, like Henry Russell and many others Massett came to America as a young man, in 1837. He first worked in law offices in Buffalo, New York, and for merchants in New York City, all the while seeking the opportunity to launch a theatrical career. According to his picaresque memoirs, published as 'Drifting about', or what 'Jeems Pipes of Pipesville' saw-and-did (1863), he frequented in New York City Joseph Atwill's Music Saloon—the same Atwill who ended up in San Francisco producing the first piece of West Coast sheet music. At Atwill's on Broadway, Massett met Henry Russell and all the other musical entertainers of the period. A meeting there with a theatre manager from Charleston, South Carolina, led to the start of his stage career down south. In Charleston Massett wrote his first hit tune, When the moon on the lake is beaming, and on the basis of its good press and sales in New York City, returned there to sing in an opera at the Olympic Theatre. Ever the vagabond and opportunist, Massett in 1843 set out on a tour of Malta and the Middle East, supporting himself by writing entertaining accounts of his journeys for William T. Porter's popular weekly, Spirit of the Times (1837–1861), a newspaper which advertised itself as '[a] chronicle of the turf, agriculture, field sports, literature and the stage'.[107] At this time Massett began to use the nom de plume of 'Jeems Pipes', apparently an affectation based on the nickname of 'Colonel Pipes' bestowed upon him by favourable critics of his singing in New York.

Massett established peripatetic ways early, fuelled by a quest for adventure and new audiences for his versatile talents. As the writer for the WPA Theatre Project in the 1930s so eloquently expressed it, '[h]is sallies never seem to have been tempered with very great wisdom, but luck was perpetually hovering about—either in the box office or

in the person of some friendly sponsor'.[108] It is no surprise that a showman as energetic as Massett would have wholeheartedly jumped in to the biggest adventure of his time. He sailed from Baltimore for the California gold-fields on 13 January 1849.[109]

In gold-rush San Francisco, Massett's charming eccentricities found a welcoming audience; and despite subsequent wanderings and years spent in New York City at the end of his life, his writings indicate that he always maintained an affectionate attachment to all things Californian. While first working there as a notary public for a real estate agent, Massett re-established contact with Joseph Atwill at his music shop, and through friends found there he organised to present the city's first public entertainment. On 22 June 1849, borrowing the only piano in town, Massett performed three of his own songs as well as other popular tunes, then ended the evening with what was described as 'recitations and impersonations'—nineteenth-century stand-up comedy routines.[110] Every chronicler of the event points out that although the front seats in the hall were reserved for ladies, only four were in attendance—evidence of the rawness and lopsided masculinity of San Franciscan society in those early days. The evening was a financial success and encouraged Massett to continue his musical and acting pursuits. He spent time in Sacramento, where he worked as an auctioneer, a newspaper editor and as an actor, and in Hawaii, where he performed for King Kamehameha. By the end of 1853 Massett was again in San Francisco. At this time, he began to nurture more completely his theatrical identity of 'Jeems of Pipesville', Pipesville being the name he gave to a small piece of land he purchased in the sand dunes of lower San Francisco.[111] He built there— in the vicinity of present-day Second and Mission Streets—a tiny house in the middle of these dunes, from which he flew a flag

announcing its address as Pipesville.

Stories vary wildly about the nature of Massett's residence in Pipesville. Some accounts indicate that he retreated to Pipesville when melancholy overtook him; other articles emphasise an orgiastic lifestyle, with rollick-ing bachelor parties in his 'country seat'.[112] He became, in other words, a true San Francisco eccentric. Until his death in the 1890s, Massett alternated identities between his real name and his alter-ego of 'Jeems of Pipesville', in his writings and in his varied entertainments, remaining an enigmatic figure who managed somehow to establish connections to the socially prominent everywhere.

In California, Massett wrote and published many songs, sometimes providing his own illustrations for the sheet music cover as well. In 1856, caught up in the excitement generated by news of plans to build a transcontinental railroad (and apparently prompted by the need to raise money through a benefit concert after losing his funds in a bank collapse), he wrote 'Clear the way!' or Song of the wagon road. He dedicated it to 'The Pioneers of the Great Pacific Rail Road!' Included on the cover was his own simplified drawing of an already well-established motif of progress on the frontier: a train cutting across the landscape, Indians looking on in agitation on one side and a view of San Francisco with the harbour on the other side. Massett may have copied the motif from a variety of printed images then in circulation. He may have seen, for example, a lithograph by the leading San Francisco printing firm of Britton & Rey entitled What we want in California. This lithography from 1855 depicts a very similar scene to promote the benefits of the arrival of the railroad in the state.[113] Britton & Rey provided the illustration for Learning to walk, one of Massett's later pieces of California-produced music, published in 1873 by Atwill's successor Matthias Gray. In his usual attempt to flatter potential patrons,

Massett dedicated this tune to Mrs. Romualdo Pacheco, wife of the lieutenant-governor of California from 1871 to 1875, and stated that the tune was 'sung by Mad. Anna Bishop', the era's most popular singer, for whom Massett had already composed several songs. As one critic writes about this work, this 'sweetly sentimental song made publishing history with one of the handsomest lithographs in full colour on its cover ever done by the famous San Francisco lithographers'.[114]

Into the 1870s, Massett maintained his connections to the best California publishers and thereby the best illustrators for his music. Just as Bret Harte in his San Francisco days kept abreast of the most popular literary and artistic currents, Massett, ever the self-promoter, took every opportunity to cash in on topics of current interest, writing tunes that captured popular sentiment, whether romantic or rousing, and borrowing imagery for his illustrations from whatever sources were at hand. According to comments in his autobiography, *Drifting about*, he took much of his sheet music and other promotional literature with him on his many tours of 'the provinces'. Throughout his life, Massett established a pattern of itinerancy, touring with his music, posters and glowing testimonials. He would continue this pattern on his peregrinations around the world.

San Francisco considered Massett with some affection and gave him due recognition for his amusing performances as 'Jeems of Pipesville', as is evident from a note appearing in that most influential of early California publications, *Hutchings' Illustrated California Magazine*.[115] In 1857, the magazine included among its announcements of events in San Francisco the following note:

> From the composer, Stephen C. Massett, we acknowledge the receipt of two pleasing pieces of music, one is entitled 'A Sabbath Scene', and

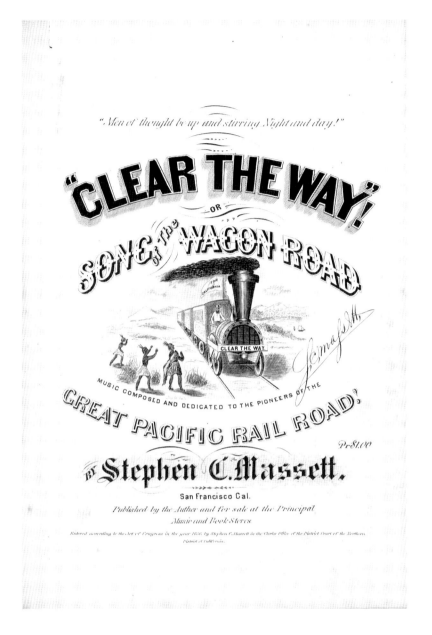

the other, 'I would not have thee young again' … Mr. Massett is the author of several beautiful and favorite pieces, among others 'When the moon on the lake is beaming', 'The love knot', &c., &c. Moreover, to him is entitled the honor of giving the first musical entertainment in California. At that time we were delving among rocks, in the deep cañons of the mountains, and remember only, the ever welcome visits of the 'Placer Times' and 'California True Delta', each of which frequently contained some literary

Fig. 2.11 Stephen C. Massett, cover, *'Clear The Way!' Or, Song of the wagon road; music composed and dedicated to the pioneers of the Great Pacific Rail Road!* Lithograph. Published by the author, San Francisco, 1856. Courtesy of The Huntington Library, San Marino, California.

gem from the fun-loving and fun-giving pen of Mr. M under the euphonious cognomen of 'Jeems Pipes.'

We see that Mr. M. is about to visit Australia and the East Indies; we bespeak for him a cordial welcome, and we hope it may be as profitable as it must be pleasant. Good luck attend him—Always.[116]

Frank Soulé, the well-known chronicler of early California, also wished Massett well, in a poem published in the newspaper *True Californian* on 15 September 1856. The second verse of his 'Lines to Stephen C. Massett, on His Departure for Australia' was predictably sentimental and optimistic about opportunities in the antipodes; it also demonstrates that Massett had quickly endeared himself to all manner of San Francisco society:

There's treasure in that land, Steve,
Beyond the Ocean old;
There may you float, and change
each note
Of music into gold.
And warm hearts in that southern clime,
And true hearts will you find,
But none more faithful than a few
Which you will leave behind.[117]

Massett's wanderlust led him this time, along with so many other American entertainers and artists, to Australia. As he later recounted, he travelled with all the accoutrements of his varied trades, from newspaper clippings to sheet music, brochures and posters to advertise his performances, as well as his melodeon, to play in venues where no piano was available. Massett himself wrote that, when he was off on such adventures, he had gone 'to itinerate'.[118] On board a French ship to the South Pacific, he wrote, 'I had with me—thinking it might be agreeable to the isolated stranger—a file of "New York Heralds", and of the "Spirit of

the Times'".[119] Both publications were, by no means coincidentally, ones for which Massett had written articles himself, and which had also produced lengthy and flattering reviews of Massett's earlier performances.

In every town where he played in Australia, Massett identified the main newspapers and established which one was considered the leading voice in terms of cultural reviews. In Melbourne, he wrote, 'the three leading journals here are the "Argus", "Herald", and "Age". A "Punch" also flourishes, very cleverly edited'. Massett also determined that: 'The Melbourne "Argus" bears the same resemblance in that community to the "Times" in London; and it seems to be a pretty well understood fact, [*sic*] that by its censure or praise the fate of a public performer is sealed.'[120]

Of greatest interest in Massett's entertaining book, along with the cartoon-like illustrations, is his description of his personal method for setting up his tour. He arrived in Melbourne on 10 December 1856 and was greeted there by two old California friends who worked in Melbourne in banking. They introduced him to George Loder (1818–1868), then the impresario for the popular singer Anna Bishop (1810–1884), also touring Australia at this time.[121] Massett let Loder know of his 'Monologue Entertainments', as he called them, and also proposed that he could provide many songs for Anna Bishop to perform—a fact that bore fruit for Australian audiences as it had done in America.[122] In his writing, he then provides fascinating insight into the nineteenth-century world of self-promotion in the days before tour managers and theatrical agents—or at least into the methods employed by those performers like 'Jeems of Pipesville' who were itinerant and eccentric enough to be outside the sphere of the more established touring companies. He describes the steps he took to prepare for his opening night:

The 'posters' were upon the walls, the shops and houses were strewed with programmes— the papers properly attended to—the 'Hall' taken—the 'Erard' (such a beauty) selected— the ticket 'taker' and 'seller' secured—the 'free list' duly cared for—and the fatal moment of my 'first appearance' before a colonial audience had arrived.[123]

He goes on to let the reader know that '[t]he next day *all* the papers came out in the most laudatory manner'. Massett himself, with some helpers, seems to have handled all of these promotional activities, including in some circumstances the design of the posters and the programs, although later on he mentions problems with the printing fonts selected by the printing company he used for his Sydney appearances.[124] He was always conscious of the competing entertainments and the adver- tisements that appeared for them; he wrote in Melbourne that the 'walls of the city were covered with large posters of various perform- ers', most prominently Anna Bishop;[125] and in Ballarat, he found:

[l]arge transparencies were suspended from the front windows of each [hotel]: One announc- ing that the 'Great American Tragedian, Mr. McKean Buchanan, would that night appear in his celebrated character of Hamlet'; the other, that the world-renowned Pablo Fauque would perform his daring feats upon the tight-rope; and the other, that the most perfect and faultless representation of the play of the Lady of Lyons would that night be given.[126]

In every location he visited throughout Australia—and later the world—Massett was alert to the cultural scene and to every opportu- nity to ingratiate himself with the local elites. His own posters, broadsides and sheet music mixed with the images that were already in circulation and on the walls throughout the colony.

Pieces of Massett's own songs were published in Australia. The cover of an Australian edition of the sheet music for one of Massett's most popular tunes, *Take back the ring, dear Jamie*, has a simple embossed decoration, with coloured touches added to the ornamental raised parts. What makes this piece so interesting is that it was printed in Sydney by J. R. Clarke. The cover also declares proudly that the music is 'As sung by Madame Anna Bishop', just as he advertised on so many of his California-published songs. The date of publication is believed to be some time between 1860 and 1864, but given that Massett was in Australia in 1857 at the same time as Anna Bishop was touring there, it is likely that Clarke would have published an Australian edition of the tune to coincide with their visits, to take advantage of a momentary rush of celebrity engagement.[127] Whether Massett himself arranged for the publication of his songs in Sydney is unclear, although his autobiography demonstrates that he made every effort to sell himself and his products wherever he travelled. Since he also brought along copies of his already-published works, pieces like *Clear the way!*, with its iconic image of frontier progress, would probably have had some circulation in the Australian colonies, at least on view for sale at some of Massett's many concerts in the cities and small gold-mining settlements.

J. R. Clarke published another of Massett's tunes, *My bud in heaven*, also presented as one of Anna Bishop's songs.[128] This melody, with maudlin lyrics by one Spencer W. Cone, includes a more elaborate illustrated cover, with a reproduction that appears to be a bas- relief sculpture of a mother and child floating in space and surrounded by putti; the lettering is in colour and with ornate filigree ornamen- tation. Finally, Clarke produced sheet music of Massett's most famous song, *When the moon on the lake is beaming*, with a cover image

**Fig. 2.12 Edmund
Thomas**, cover for
Massett, *When the moon
on the lake is beaming*.
Lithograph. J. R. Clarke,
Sydney, c. 1860. Music
Collection, National
Library of Australia,
Canberra.

by an accomplished local artist, Edmund
Thomas (1827-1867), signed by Massett and
touted as 'Sung with the most enthusiastic
applause by Madame Anna Bishop, to whom
it is respectfully dedicated by the composer'.
This final piece of music, with its ambitious
landscape image by Thomas, indicates that
the illustration of sheet music was a well-
established industry in Australia by the 1850s.
The publisher Clarke continued to produce
sheet music into the 1890s, including many,
such as the clever rebus-like cover for Walter
Rice's *Up in a balloon galop* (c. 1869–73), that
had coloured lithographs.[129] In Australia, as

in America, sheet music was being produced
from the 1850s with an eye for aesthetic
appeal and to meet the public's demand for
visual illustration.

Clarke also advertised his firm on the cover
of Massett's *My bud in heaven* as a 'Fine Art
Repository'. Clarke's company had one of the
best art-printing facilities in Sydney from the
1850s; and as his obituary stated, 'Mr. Clarke's
knowledge of pictures, and especially of every
class of engraving, was proverbial'.[130] In 1857
Clarke had published Walter G. Mason's
Australian picture pleasure book; with 200
wood-engravings one of the most ambitious
illustrated publications of the decade in
Australia. Walter George Mason (1820–1866)
came from a long line of English artists and
engravers. His father Abraham 'took the
family to the United States where he worked
and taught Walter his craft'. In 1852, Walter
arrived in Sydney, where he became one of
the original owners of the *Illustrated Sydney
News*. Mason has been called 'the father of
illustrated journalism in this colony'.[131] His
illustrations in the *Picture pleasure book*
included, along with Australian landscape
views and renderings of local oddities such
as 'A petrified ham found in Barrack Square,
Sydney', many excellent character portraits,
including not only the discoverer of gold, E.
H. Hargraves, but also the American perform-
ers Lola Montez, Edwin Booth and Emma
Waller.

Since Mason's book was making a splash
in the colonies when Massett was touring
there, it is tempting to speculate that he may
have seen Mason's illustrations, voracious as
he was in his efforts to glean information and
imagery wherever he could find it. Perhaps the
two even met, since Mason shared an interest
in theatre and performance with Massett and
his American brethren. Mason also produced
for Clarke several sheet music covers, such
as the lithographed view of Sydney for *City*

of *Sydney polka* (1854). The image depicted includes the Commercial Bank in George Street, which Robyn Holmes writes was 'the centre of activity for emerging music publishers and sellers such as Woolcott and Clarke'.[132]

Clarke's music publishing company published Australian editions of Stephen Foster's songs, including *Gentle Annie* (c. 1858–1864),[133] advertised as 'Sung by The Christy Minstrels', that most famous of American minstrel groups that toured Australia during the 1860s.[134] In terms of illustration, the images used on Clarke's music often emphasised distinctly Australian views and landscapes. At the time Massett was in Sydney, Clarke published the instrumental work *Australian flowers* (1857) by Miska Hauser, a popular Viennese musician then touring in Australia.[135] The cover for this song included an illustration of the rockery in the botanical gardens, again by Edmund Thomas, who had made a localised landscape scene for Massett's *When the moon on the lake is beaming*.[136] The same floral view appeared in the *Australian album*, another book of Sydney views published by Clarke in the same year.

By the 1870s, Australian publishers—just as American music publishers were doing—began to include tipped-in photographs on their sheet music covers. *The eucalypti waltzes* (1879) by Walter Cope and published by Clarke, included a small photographed scene depicting gum trees. While the image is pleasingly bucolic, there is none of the artistic ambition of the earlier lithographed covers and the photographer is not identified. Just as in America, the 'golden age' of illustrated sheet music had passed by the 1870s. Australian illustration also moved into different, and in many cases less artistic, directions, taking advantage of cheaper forms of printing technology. The evidence from these cover sheets by Clarke and other music publishers nonetheless verifies that in J. C. F. Johnson's time,

COMIC SKETCH OF MRS. WALLER AS OPHELIA.

a variety of illustrative sources was available to him and other Australians. Many of the images produced to sell sheet music were shared and dispersed both across the Pacific and to Europe. Massett's music, and some of his artistic work, joined a veritable sea of imagery that drifted back and forth in printed form from San Francisco to the Australian colonies in the middle decades of the nineteenth century. In this most vernacular format people on both Pacific coasts learned of the most popular aesthetic styles and the most pervasive iconography of late nineteenth-century popular culture.

Massett left Australia, from Launceston in Tasmania, on 20 July 1857, never to return. He continued his peregrinations to India, then on to London, and back to New York by 1858. He visited San Francisco again in that year, and travelled as far as Japan on another touring trip. He was often in debt, and sometimes in trouble over debt. But he continued to produce music and accumulate

friends and influential patrons of all sorts. As late as May of 1897—the year before his death in New York City—he was still writing gossipy reminiscences to people like Los Angeles journalist and promoter *par excellence* B. C. Truman (1835–1916). Truman published them as 'Chatty Letters from "Jeems Pipes of Pipesville"' in his new newspaper of Southern California boosterism, *Greater Los Angeles*.[137] Along with his other travels, Massett apparently had been in Los Angeles in the 1860s or 1870s, and wrote about that visit:

> How well I remember the orange groves of Mr. Wolfskill and Messrs. Rose and Wilson, and … the lovely vale, beautiful orchards and gardens at Santa Anita, where the once-upon-a-time 'Village Blacksmith', 'Lucky Baldwin', flourished, and whose matrimonial squabbles and infelicities fill the eastern and western papers.[138]

That he was still reading all the newspapers and still writing to everyone of consequence marks Massett as the most modern of celebrity hounds, a nineteenth-century Louella Parsons. His ability to retain a widespread network of correspondents also points to the immense transformations in communication and mass media that had taken place in the late nineteenth century—transformations that helped create the image-based society at the heart of modernity itself and made possible the exchange of imagery between the Pacific cultures of California and Australia.

When Massett died in 1898, his obituary in the *New York Times* duly noted his fame 'some time ago' as 'Jeems Pipes of Pipesville'.[139] Described as 'an author, song writer, and entertainer', the newspaper went on to state that he 'wrote several books on his life and adventures, which were in style much like Mark Twain's'. Comparing Massett to Mark Twain was perhaps simply a facile remark to

make, given that Twain was by that time at the height of his world fame, but it demonstrates a recognition on the part of the press of Massett's contribution, along with Twain and Harte, to a Pacific Slope aesthetic that romanticised the earlier decades. The 1890s represented the peak of nostalgia for California's gold-rush days.

In 1898, Twain had returned from his only tour of Australia—a tour precipitated by his need for money—where his lectures were enormously well-attended and he was followed by journalists everywhere. By this time, his friendship with Bret Harte was long over. In an interview while in Australia, Twain said of Harte, 'I detest him, because I think his work is "shoddy" … He has no heart, except his name, and I consider he has produced nothing that is genuine. He is artificial'.[140] Twain had published *Following the equator* in 1897, with accounts of his travels in Australia. In response to continual queries about his impressions of Australian life, Twain wrote that the 'Australians did not seem to me to differ noticeably from Americans, either in dress, carriage, ways, pronunciation, inflections, or general appearance'.[141] This attitude did not at the time seem to disturb Australians unduly, nor did Americans find it a particularly odd opinion to voice; such cultural connections were accepted as a matter of fact.

Bret Harte, by 1898, was living a rather elegant life in London, far removed from his California days, and vociferously rejecting his Californian past as an uncivilised period in his life. Mrs Sherwood, a well-known doyenne of East Coast high society, recounted in her memoirs of 1897 her meetings with Harte: 'He was pathetically pleased to get rid of California, which he hated'; she wrote that the author 'gave me such an idea of the dreariness, absence of color, and degradation of a mining camp that I never read one of his immortal stories that I do not seem to taste that dust-laden air'.[142]

While his writing career and his fame receded sharply after the 1880s, Harte's old California stories continued to be published, some in illustrated editions. When he died in 1902, *Overland*—the journal Harte helped found and for whom he created a memorably Californian logo of grizzly bear and railroad—presented a 'special Bret Harte number', filled with reminiscences of Harte by old Californian writers such as Joaquin Miller (1841–1913).[143] The issue also contained yet another reprinting of 'The Heathen Chinee', this time illustrated by C. Merriam Peter in a nearly surreal style that, once again, exaggerates for comic effect Bill Nye's violence toward Ah Sin. By this date in California, attitudes about the Chinese had not improved much from those read into Harte's poem when it first appeared, even though the *Overland* editors did attempt to make some editorial comment by publishing in the same issue a facsimile of Harte's original manuscript of the poem. Aware of the myriad of racist readings attached to the poem, the editors may have wanted to demonstrate that Harte's original lines did not contain the infamous words, 'We're ruined by Chinese cheap labor!'[144]

As this later illustration of 'The Heathen Chinee' demonstrates, the real situation for the Chinese at the end of the nineteenth century, both in California and in Australia, was hindered by now-entrenched stereotypes that the illustrations to Harte's verse had done so much to imprint into the public mind. In the legislative sphere, their situation was more precarious than it had been in the mid-nineteenth century. In Australia, an 1888 ruling by the colonial government restricted Chinese immigration almost entirely. J. F. Archibald's influential publication *The Bulletin* also maintained a vehemently anti-Asian stance, expressed most overtly in its editorial cartoons (see Chapter 3). At the same time, the Chinese communities were still there, living in San

Francisco and in Melbourne in relatively sequestered sections of the cities.

While politicians, Australian and American, continued to fulminate against the arrival of Asians into their lands, artists and other image-makers by the 1890s began to turn their romanticised visions of 'The Celestials' in Chinatown into a popular artistic genre, in many ways elaborating on those earlier illustrative versions.[145] In 1898, when Stephen Massett died, photographer Arnold Genthe (1869–1942) produced some of his most memorable photographs of San Francisco's Chinatown and its inhabitants, and many popular California artists such as Theodore Wores (1859–1939) specialised in Chinese subjects.[146] Melbourne's Chinatown, with its elaborate entrance gate, also became a favoured motif for photographic views at the turn of the last century. When the Duke of York visited Australia for the celebrations accompanying Federation in 1901, stereoscopic photographs of The Chinese Arch on Swanston Street were reproduced repeatedly, demonstrating the inclusion of the Australian Chinese and their exotic architecture into the festivities.[147]

As for J. C. F. 'Alphabetical' Johnson, who had expressed both in writing and in his simple naive painting such heartfelt sentiments about the need for racial and ethnic harmony in colonial Australia, he had by 1898 retired from parliament and had the previous year completed his tour of mines in Britain and America. Aside from some articles about mining and editorials in conjunction with his campaigns for funds to support the Australian Natives' Association and the Australian soldiers sent to the Boer War, Johnson did not produce any more published works of literature, nor, as far as anyone knows, any more paintings. He did continue to be involved in theatrical and literary circles, and was on the board of the Public Library, Museum and Art

Gallery of South Australia. But the nationalist fervour that had sparked his one foray into artistic expression had, apparently, abated by this time.

Johnson was still alive in the 1890s, but he did not participate personally in one of the most significant breakthroughs in journalism and reproductive art that took place in that decade, a breakthrough that would have profound implications globally for the development of aesthetic modernism and popular culture. By mid-decade publishers of all stripes, including sheet music producers and art printers, were beginning to adopt a new technology that made it possible for the first time to integrate photographs and other illustrative forms seamlessly onto a page of text. As the cover for *The eucalypti waltzes* already reveals, the halftone photograph, whereby images were reproduced with tiny dots of ink, became the most pervasive form of image reproduction by the turn of the last century. Just as earlier innovations in printing techniques had made possible sophisticated reproductions in journals and in books, this 'half-tone revolution' would directly affect the subsequent directions in art, illustration and mass culture around the world. The impact was profound:

> Halftone made it possible for turn-of-the-century page designers to create multimedia compositions with ease. Halftone freed journalists and advertisers to create meaning through juxtaposition and association by combining photographs not only with texts, but with other images like charcoal sketches, watercolors, and line drawings as well.[148]

The wood-engravings that had been central to the success of the illustrated journals since mid-century—the method by which Johnson's *Euchre in the bush* had reached a wide audience in the 1870s through the *Australasian Sketcher*, the method used by itinerant performers such as Stephen Massett for sheet music illustrations and promotional material, and the method so often used by the many illustrators of Bret Harte's 'Heathen Chinee'—would now be nearly abandoned as a means of mass visual reproduction.

In these new societies of Australia and California, where reproducible images were by necessity the most pervasive means of promulgating aesthetic styles and dispersing visual icons, and where popular culture determined most significantly what people knew of the modern world, such a technological invention had even greater consequences for artistic attitudes than it did in the so–called 'home' cultures of England and the eastern United States. Aesthetic modernism, then, reached the settler cultures of Australia and California through mechanical reproduction, and in the forms of mass and popular culture. Itinerancy included not only the movement of people, but also the transport around the world of the machinery and technological know-how upon which so much of twentieth-century image-making would depend.

NOTES
1. Francis Bret Harte, 'Plain Language from Truthful James: Table Mountain, 1870', in Thomas R. Lounsbury (ed.), *Yale book of American verse*, Yale University Press, New Haven, 1912.
2. Henry Lawson, 'Eureka (A Fragment)', quoted in Hilton Barton, 'Bret Harte and Henry Lawson: Democratic realists,' *The Realist*, Sydney, vol. xxvi, no. 26, Winter 1967, pp. 7–10.
3. On the importance of clothing as an identifying characteristic in the Australian goldfields, see Margaret Maynard, *Fashioned from penury: Dress as cultural practice in colonial Australia*, Cambridge University Press, New York, 1994, pp. 168–70.
4. R. M. Gibbs, 'Johnson, Joseph Colin Francis (1848–1904)', *ADB*, vol. 9, 1983, pp 495–96.
5. *Oxford companion to Australian literature*, 2nd edn, Oxford University Press, Melbourne, 1994, p. 410.
6. *ADB*, vol. 9, p. 496.

7. Austin Dowling, registrar's notes, Ballarat Fine Art Gallery files, 1996.

8. See J. C. F. Johnson, *To Mount Browne and back, or, Moses and Me*, Advertiser Print, Adelaide, 1881.

9. *ADB*, vol. 9, p. 495.

10. *Australian encyclopedia*, vol. 7, p. 59.

11. See Melvin N. Day, *Nicholas Chevalier, artist: His life and work with special reference to his career in New Zealand and Australia*, Millwood, Wellington, New Zealand, 1981; and Day's entry in *DAA*, pp. 147–49.

12. One of the best histories of Australian illustration industries is Geoffrey Caban's *A fine line: A history of Australian commercial art*, Hale & Ironmonger, Sydney, 1983.

13. The National Library of Australia lists one work by H. J. Woodhouse, a wood-engraving of a cricket match at the Melbourne Cricket Ground in 1858 (NLA PIC S3726 LOC 7011-F). Arthur Esam (b. 1850) produced several depictions of rural life, including coloured lithographs of activities on a cattle station produced for mass publication. See Esam's *Life on a cattle station*, from 'Pictorial Australian', c. 1880 (nla.pic-an8929083-v), on 'PictureAustralia', National Library of Australia, Canberra, viewed June 2005, <http://www.nla.gov.au>.

14. This quotation was included in notes made by Deirdre Chisholm, recorded 9 March 1996, in the Ballarat Fine Art Gallery Registrar's files.

15. Johnson's reverence for Johnstone's work was in keeping with contemporary sentiment in South Australia. Henry James Johnstone (1835–1907), British–born, came to Victoria for gold in 1853 and began to work as a photographer. By the 1870s, he had established himself as a landscape painter, particularly of billabong scenes in South Australia. By 1880, after many years of acclaim and a *bon vivant* lifestyle in Melbourne and Adelaide, he was reported to be in California, where he established and retained enthusiastic patronage for his Australian views. Even after moving to London, his works continued to sell well in America and he also maintained contacts with Australian sources. In 1883, his narrative painting *Off the track* was purchased by the Art Gallery of New South Wales. When it was reproduced as a chromolithograph in the *Illustrated Sydney News*, it gained tremendous circulation throughout Australia. As Candice Bruce and Frank Cusack assert in *DAA*, Johnstone's painting *Evening shadows, backwater at the Murray, South Australia* (1880), purchased by the National Gallery of South Australia from the *Melbourne international exhibition*, 'was (and has remained) one of the South Australian Gallery's most popular paintings'. See *DAA*, pp. 407–09.

16. J. C. F. Johnson, *Getting gold: A gold-mining handbook for practical men*, Charles Griffin, London, 1897, p. 4.

17. According to Deirdre Chisholm, who in 1996 owned the second version of *Euchre in the bush*, the other version was in the home of Johnson's mother in Mt Gambier, South Australia, at the time of his death in 1904. Chisholm purchased it from a Miss Megaw, whose father was the auctioneer for Mrs Johnson's estate. Registrar's notes, Ballarat Fine Art Gallery, 9 March 1996.

18. *Australasian Sketcher*, 23 December 1876, text to accompany the colour supplement of *Euchre in the bush*, 'Our coloured supplement: A game of euchre', under section 'Sketches with pencil', p. 150.

19. Gary Scharnhorst, *Bret Harte's California: Letters to the* Springfield Republican *and* Christian Register, *1866–67*, University of New Mexico Press, Albuquerque, 1990, p. 1.

20. George Stewart gives a thorough description of the editors' ambitions to be the Pacific version of the *Atlantic Monthly*, pointing out that Harte and the other editors even chose the emblem on the title page—a grizzly bear on a railroad track—in reference to the *Atlantic*'s own emblem and layout. See Stewart, *Bret Harte: Argonaut and exile*, pp. 157–60.

21. Ina D. Coolbirth, 'Introduction', in Bret Harte, *The heathen Chinee: Plain language from Truthful James*, Book Club of California, San Francisco, 1934, p. iv; see also Stewart, *Bret Harte*, pp. 177–82: 'The success of this sixty-line poem is probably without parallel before or since. "The Luck" and its companion stories had reached about as far as a really literary production can', p. 179.

22. G. Scharnhorst, *Bret Harte: A bibliography*, Scarecrow Author Bibliographies, no. 95, The Scarecrow Press, Lanham, Maryland and London 1995, pp. 41–45; entry no. 151, 'Plain Language from Truthful James/ (Table Mountain, 1870)', *Overland Monthly*, no. 5, September 1870, pp. 287–88.

23. *That Heathen Chinee and other poems mostly humorous … the music by Stephen Tucker*, John Camden Hotten, London, 1871.

24. *Galaxy*, vol. 12, November 1871, p. 635.

25. ibid., p. 638.

26. Stewart, *Bret Harte*, p. 179.

27. Contemporary observers were prescient in their warnings about the effects of such imitation. *The*

California Mail-Bag in June of 1871 noted: 'The Washington Critic thinks that Bret Harte is eventually bound to be ruined and sunk into oblivion by the downward pull of his numerous imitators, or in other words, that the peculiar style of writing upon which his celebrity is based will be cheapened and brought into disrepute by the superabundance of the supply of an article identical in kind, and very little … in quality.'

28. J. C. F. Johnson, 'Christmas on Carringa', Wigg & Son, Adelaide, 1873; and *An Austral Christmas*, 2nd edn, W. K. Thomas & Co., Printers, Grenfell Street, Adelaide, 1889. The title page for *An Austral Christmas* announces Johnson as 'Author of "A Fine Fortune", "Over the Island", "Moses & Me", etc.'

29. Goodman, pp. 4, 7.

30. ibid., p. 7.

31. 'An aunt gave him a volume of stories by Bret Harte which fascinated him and introduced him to a new world.' *Australian encyclopedia*, 1958, vol. 5, p. 263.

32. Barton, pp. 7–10.

33. Australian politicians looked upon the American restrictions of Asian immigration, particularly the enactment of the *Chinese Exclusion Act of 1882*, with approbation, but also with fear that these bans would cause a new flood of Chinese onto their shores. By the time of Australian Federation in 1901, the *Immigration Restriction Act 1901* effectively began the 'White Australia' policy that would operate in Australia until the 1970s. See *Australian encyclopedia*, vol. 5, p. 79.

34. See William Mungen, '"The heathen Chinese": Speech of Hon. William Mungen, of Ohio, delivered in the House of Representatives, January 7, 1871', F. & J. Rivers & Geo. A. Bailey, Reporters and Printers of the Debates of Congress, Washington, DC, 1870.

35. Quoted in William P. Fenn, *Ah Sin and his brethren in American literature*, College of Chinese Studies cooperating with California College in China, Peking, 1933, p. 47.

36. See Scharnhorst, '"Ways that are dark": Appropriations of Bret Harte's "Plain Language from Truthful James"', *Nineteenth-century literature*, vol. 51, 1996–97, p. 393.

37. See Fenn, *Ah Sin*, pp. ix–x; and Lewis H. Carlson and George A. Colborn (eds), *In their place: White America defines her minorities 1850–1950*, Wiley, New York, 1972, pp. 171–73.

38. According to a 1955 article by Stuart W. Hyde, the Chinaman as comic figure in American melodrama, centred on his 'ridiculous-looking appearance', began to be a commonplace as early as the 1850s on the New York and even on the San Francisco stage. See Hyde's 'The Chinese stereotype in American melodrama', *California Historical Society Quarterly*, vol. 34, 1955, pp. 357–67.

39. The photo is in the State Library of Victoria, viewed 1 March 2004, <http://www.statelibrary.vic.gov.au/pictoria/b/0/8/doc/b08021.shtml>.

40. See Johnson and Eymann, pl. 39, p. 115.

41. See Rebecca Solnit, *River of shadows: Eadweard Muybridge and the technological wild west*, Viking, New York, 2003, p. 166. For examples of Muybridge's images, and for in-depth description of the contribution of the Chinese in building the railroad, see Central Pacific Railroad Museum, viewed 15 April 2004, <http://cprr.org/Museum/index.html>.

42. 'Grand Admission Celebration. Portsmouth Square Octr. 29, 1850', letter-sheet by C. J. Pollard, The Huntington Library (RB 48052 #137), reproduced in Blodgett, p. 104.

43. Samuel Douglas Smith Huyghue, *The Black Hill Ballarat Sept. 1857*, State Library of Victoria (acc. no. H25190).

44. See 'Chinese camp in the mines', from James Borthwick's *Three years in California*, William Blackwood, London, 1857; reproduced in Blodgett, p. 83; and Gill's lithograph, *John Alloo's Chinese Restaurant, main road, Ballaarat*, James G. Blundell & Co., Melbourne, 1855, National Library of Australia Picture Collection, viewed 17 April 2004.

45. For concepts of 'the dying race' in Australia see Bernard Smith, *The spectre of Truganini*, ABC Broadcasting, Sydney, 1980; and Russel McGregor, *Imagined destinies: Aboriginal Australians and the doomed race theory*, Melbourne University Press, Melbourne, 1997. On the visualising of the 'vanishing race' idea amongst Native Americans, see Joseph K. Dixon, *The vanishing race: The last great Indian Council*, Doubleday, Page & Co., Garden City, 1914: and Robert L. McGrath, 'The endless trail of the *End of the trail*', *Journal of the West*, vol. 40, no. 4, Fall 2001, pp. 8–15.

46. Such sentiment may also reflect the editorial stance of *The Argus* itself, rather than Johnson's own opinion.

47. According to his biographer, Gary Scharnhorst, 'Harte was also a social liberal who roundly protested racial intolerance & persecution, his apparent ethnocentrism notwithstanding'. Scharnhorst also maintains that despite 'his tendency to echo racial

cliches ... Harte was genuinely sympathetic to the plight of the local Chinese and African–Americans'. *Bret Harte's California*, p. 3.

48. By the 1870s, 'Pacific Slope' is the preferred term for the West Coast American region in eastern American and English publications. In the 1871 London edition of Harte's poems, the following text appears on the verso of the title page: 'These humorous verses come to us from California, where there are a great many Chinese emigrants. The Americans on the Pacific Slope are not remarkable for any particular dullness or want of smartness, but occasionally the Oriental is more than a match for them. His ancient tricks are a novelty to the New World. Euchre, the favourite American gambling game of cards here alluded to, is a variation of the old French game of écarté.' *That Heathen Chinee & other poems mostly humorous by F. Bret Harte, Author of 'The Luck of Roaring Camp' and 'Sensation Novels Condensed', the music by Stephen Tucker, composer of 'Beautiful isle of the sea.'*, John Camden Hotten, London, 1871.

49. John Manning, 'Bold Dick Donohue', *Overland Monthly*, vol. 5, July–December 1870, pp. 147–52 and pp. 495–504.

50. *Overland*, vol. 3, September 1869, p. 265.

51. *Californian*, vol. 1, no. 1, 28 May 1864, p. 1.

52. In G. R. Stewart, *Argonaut and exile*, p. 127. 'The Ballad of the emeu—that "Emeusing ballad," Inigo called it—was suggested by the kind kept on exhibition at a resort on the edge of the city.'

53. For a contemporary description of Woodward's Gardens, see Charles B. Turrill, *California notes*, E. Bosqui & Co., San Francisco, 1876.

54. F. Gruber, *Illustrated guide and catalogue of Woodward's Gardens*, Francis, Valentine, & Co., Book and Job Printers, 517 Clay Street, San Francisco, 1879, p. 65, Huntington Rare Book (RB 493901).

55. *Californian*, 4 June 1864, p. 4.

56. See Hyde, 'The Chinese stereotype', p. 361.

57. Rufus Wright, *The card players*, 1882. Oil on canvas, Oakland Museum of California, Kahn Collection. See Janice T. Driesbach, *Art of the gold rush*, exhibition catalogue, Oakland Museum of California, University of California Press, 1998, pp. 114–15.

58. Augustus Baker Peirce, *Knocking about: Being some adventures of Augustus Baker Peirce in Australia*, Mrs. Albert T. Leatherbee (ed.), with an introduction by Edwin Howard Brigham, MD, illustrated by the writer. Oxford University Press, London; Yale University Press, New Haven, 1924, pp. 132–33.

59. See Frederic G. Kitton, *Dickens and his illustrators: Cruikshank, Seymour, Buss, 'Phiz', Cattermole, Leech, Doyle, Stanfield, Maclise, Tenniel, Frank Stone, Landseer, Palmer, Topham, Marcus Stone, and Luke Fildes*, George Redway, London, 1899, pp. 224–25. Eytinge also rates an entry in *Thieme-Becker*, which singles out his 'Negerdarstellungen' (images of Negroes) as particularly famous. See *Thieme-Becker, Allgemeines Lexikon der bildenden Künstler*, Leipzig, 1915, vol. 11, p. 144.

60. Eytinge's depiction of Seth Kinman, Californian frontiersman, appeared first on 3 June 1857 in *Leslie's Illustrated Weekly Newspaper* and is one of only two works by the artist in this magazine to be signed. As Budd Gambee states in his thesis on the cultural significance of the magazine: 'This picture provides the prototype of many similar figures by Eytinge, not only in *Leslie's* but in his later book illustrations, particularly Bret Harte's *The luck of Roaring Camp* and *The heathen Chinee*.' See also 'Budd Leslie Gambee, Jr, *Frank Leslie's Illustrated Newspaper, 1855–1860: Artistic and Technical Operations of a Pioneer Pictorial News Weekly in America*', PhD thesis, University of Michigan, Ann Arbor, 1963, p. 250.

61. *Frank Leslie's Illustrated Newspaper*, supplement, 21 January 1871, p. 324.

62. Stewart, ill. opp. p. 180. This set of images was apparently a source of great consternation to Harte, so much so that he brought suit against the paper. See also Scharnhorst, '"Ways that are dark"', pp. 381, 387–88.

63. Stewart, p. 180.

64. According to Wikipedia online, the very first newspaper comic strip was the German *Max und Moritz* in 1865. The first American newspaper comic strip was *The little bears* in William Randolph Hearst's *San Francisco Examiner* in 1893. See Wikipedia, viewed June 2005, <http://www.wikipedia.org/wiki/Comic_strip>. On the significance of *Frank Leslie's Illustrated Newspaper*, see Gambee, p. 250.

65. In an original set of the cards at The Huntington Library, complete with mailing envelope, this speech bubble appears, but is not found on any of the other copies of the cards in The Huntington's collection. Without the examination of the card by a conservation expert, it is impossible to tell if the bubble has been hand-written in pencil after publication or if it was printed into the original card. See The Huntington Library (RB 17012 and

RB 202490).

66. See Scharnhorst, '"Ways that are dark"', p. 381, quoting from *London Daily News*, 21 March 1871, p. 5, cols 1–2.

67. Goodman, pp. xxiii–xxiv.

68. See Ballarat Mechanics' Institute, viewed 17 March 2008, <http://www.library.org.au/index.html>.

69. *The Australasian*, 5 December 1868, p. 710.

70. ibid., p. 722.

71. 'The Heathen Chinee', words by Bret Harte, music by Chas. Tourner, S. Brainard's Sons, Cleveland, 1870, illustration by Vallendar & Co., pl. 107 in Harry T. Peters, *California in stone*, Doubleday, New York, 1935; *'The Heathen Chinee'; words by Bret Harte, music by F. B.*, Oliver Ditson & Co., 277 Washington St., Boston, lithography by J. H. Bufford's Lith., 490 Washn St., Boston, 1870; *'That Heathen Chinee' & other poems mostly humorous by F. Bret Harte, author of 'The Luck of Roaring Camp' and 'Sensation Novels Condensed', the music by Stephen Tucker, composer of* Beautiful isle of the sea, John Camden Hotten, 74 & 75, Piccadilly, London, 1871; *The 'Heathen Chinee' songster*, Beadle & Co., New York, 1871; *The 'Heathen Chinee' musical album: Containing 15 pieces of the most popular songs, mostly comic*, R. M. DeWitt Publisher, 33 Rose St. New York, music by Henry Tucker, 1871; another version with music by Matthias Keller, J. F. Loughlin, Boston, 1871.

72. See the Vallendar & Co. lithograph reproduced in Peters—although its smaller vignette also shows the iconography of pigtail flying from Bill Nye's punch.

73. 'In both *Leslie's Weekly* and the *Musical Album*, significantly enough, Bill Nye targets Ah Sin's queue, an ornament of honour and male pride; that is, Nye not only pummels Ah Sin, he figuratively emasculates him. In each case, these illustrations fill the gaps and silences in Harte's poem by portraying overt violence against the Chinese.' Scharnhorst, '"Ways that are dark"', p. 381.

74. See David Tatham, *The lure of the striped pig: The illustration of popular music in America 1820–1870*, Barre, Massachusetts, 1973, p. 25; and Nancy R. Davison, 'The grand triumphal quick-step; or sheet music covers in America', in John D. Morse (ed.), *Prints in and of America to 1850*, Winterthur Conference Report 1970, University Press of Virginia, Charlottesville, 1970, pp. 264-68.

75. Tatham describes the technique as indicative of the end of the grandiloquent style of sheet music illustration of the 1850s and 1860s, pl. 60, pp.

148–49: Unknown artist, *Flynn of Virginia*, 1870. '[T]he lithographer of *Flynn* seeks direct, plain, and immediate communication with any and all viewers in the simple terms of his purposefully rough execution of a singularly unbeautiful subject', p. 148.

76. Oliver Ditson & Co. was prominent enough to be the subject of at least two histories of the company. See William Arms Fisher, *Notes on music in old Boston*, Oliver Ditson Co., Boston, 1918; and Fisher, *One hundred and fifty years of music publishing in the United States*, Oliver Ditson Co., Boston, 1933.

77. For the most complete history of American music in this period, see Russell Sanjek, *American popular music and its business: The first four hundred years*, Oxford University Press, Oxford, 1988. The liveliest descriptions of the sheet music trade and its art can be found in Tatham (see note 64 above) and in the many works by renowned sheet music collector Lester Levy, especially his *Grace notes in American history: Popular sheet music from 1820 to 1900*, University of Oklahoma Press, Norman, 1967.

78. *'California; or, the feast of gold*. A new comic song, written by Henry Valentine, sung by Messrs. Carrol, Warde, Martin, Mills, and all the principal comic singers, with thunders of applause', R. MacDonald, 30, Great Sutton Street, Clerkenwell, London, in Clara E. Howard (ed.), *Three pioneer California gold rush songs*, private pub., Menlo Park, California, 1948; and reproduced in Blodgett, p. 81.

79. *'The good time's come at last', or the race to California*. A comic song, written to a Golden Measure. and dedicated to the Master of the Mint by One of the Golden Fleece', Leoni Lee & Coxhead, London, (n.d.).

80. 'Musical Bouquet./PULL AWAY CHEERILY! THE GOLD DIGGER'S SONG./written and sung by Harry Lee Carter, in his entertainment of "The Two Lands of Gold". Also Sung by George Henry Russell, in Mr. Payne's Popular Entertainment, "A Night in the Lands of Gold."/Music composed by Henry Russell.' Musical Bouquet Office, 192, High Holborn; & J. Allen, 20, Warwick Lane, Paternoster Row, London (copyright nos 691, 692) in *California sheet music covers*, The Book Club of California, Keepsake Series, 1959, sheet no. 3. Description by John and Mary Belle Swingle, Berkeley.

81. Swingle, sheet no. 3.

82. Harry Lee Carter produced a booklet called *The two lands of gold, or, the Australian and Californian directory for 1853*, which purported to serve as a guide for immigrants, but was actually a guide to

the panorama and stage show he produced, with illustrations painted (Carter claimed) 'on the spot' by Charles S. James, George Catlin, William Kelly and in Australia by Charles Robinson, 'an Australian Settler'. In the booklet he states that the music was composed by Henry Russell, with words by himself. The final page of the booklet is an advertisement for 'The original copyright songs, by Henry Russell, in Harry Lee Carter's New and highly successful Entertainment, entitled "The Two Lands of Gold"'. See Harry Lee Carter, *Two lands of gold*, with an amusing cover illustration by C. S. James, The Huntington Library.

83. In *The lure of the striped pig*, Tatham mentions Russell's preference for American illustrators: 'As the Songs of Henry Russell, the most popular composer and singer in America in the early 1840s, went through multiple editions here, publishers in his native Britain brought them out as well. In his case the American illustrations were more often adapted, perhaps because he had been so well served by Fitz Hugh Lane and Benjamin Champney.' See Tatham, p. 16. On Russell, see also Sanjek, *American popular music*; and also an excellent thesis by John Stephens, 'Henry Russell in America: Chutzpah and Huzzah', University of Illinois at Urbana–Champaign, 1975.

84. Tatham, p.11.

85. Some confusion surrounds Fitz Hugh Lane's name: 'In 2004, researchers in Gloucester found the 1831 letter he sent to the Commonwealth of Massachusetts requesting a name change, not to Fitz Hugh Lane but to Fitz Henry Lane. His petition was granted, but why he did it is still a mystery', Cape Anne Museum, viewed 3 March 2009, <http://www.capeannhistoricalmuseum.org/fine%20art/fitz_hugh_lane.htm>. Most sources still refer to Lane as Fitz Hugh.

86. Lester Levy, *Picture the songs: Lithographs from the sheet music of nineteenth-century America,* Johns Hopkins University Press, Baltimore, 1976, p. 1. Levy also makes note of the cultural significance of these images: 'Their inclusion in any history of American art has inherent value, for they represent the art form most readily and reasonably available to people of moderate means.'

87. 'California as it is; Comic song written by Thaddeus W. Meighan, and sung to over fifty thousand persons at American Museum and elsewhere by Pete Morris, The inimitable comic vocalist', Wm. Hall & Son, 239 Broadway, New York, 1849. The final verse, entitled 'MORAL', concludes: 'If you've enough to eat and drink and buy your Sunday clothes,/Don't listen to the gammon that from California blows,/But stay at home and thank your stars, for every hard earned cent,/And if the greenhorns go to dig why colly let 'em went,/If you go why you will see, the elephant, yes, sir ee,/And some little grains of gold that nor no bigger than a flea;/I've just come from California and if any here there be/Who is got that yellow fever they need only look at me,/And I think New York, will suit 'em yes exactly to a T'. In *Three pioneer California gold rush songs*, Huntington Library (RB288510).

88. *He died in California*, by I. B. Woodbury, publisher Oliver Ditson, Boston, 1853. The lyrics were all about missing a verdant, forested home and dying alone in a distant, and apparently hostile, country. Verse 4 is typical: 'Aye, a dream so wild had crossed him,/vision fair, and bright, but brief,/As the raging fever tossed him,–/ But now he sleeps in death;/Thus in distant Sacramento/Sadly died this lonely one,/And no record, no memento,/Told his fate so sad and lone.'

89. '[A] music publisher could sell a printed march or song for ten to twenty-five cents more if the title page was attractively illustrated.' Levy, *Picture the songs*, p. 2.

90. Peter S. Duval and Matthew Schmitz, *The age of gold: Directions how to get it; with notes (ad lib) by a director to California*, lithograph, Lee & Walker, Philadelphia, c. 1853, in Levy, *Picture the songs*, pp. 106–07.

91. *Hobart Daily Courier*, 23 June 1849. As Monaghan describes it on page 44: 'Along with the California news from New York and London came a new commodity to be sold in the colonies. British publishers were sending bales of printed verses about the gold rush, some set to music. Australian bards immediately began writing their own ditties. Guests at Mrs. Mills' "First Rate" Devonshire House in Hobart played and sang *The age of gold*, *Put money in thy purse*, … another, *The race to California*, was advertised as "a comic song written to a golden measure."'

92. *The Photographic News*, no. 47, vol. ii, 29 July 1859, p. 245.

93. On sheet music in Australia see Robyn Holmes and Ruth Lee Martin, *The collector's book of sheet music covers*, National Library of Australia, Canberra, 2001. The image on the cover of *News from home quadrille* is also reproduced in Verona Burgess's 'Picking up a tune: Researching the provenance of Australian traditional music', *NLA News*, vol. xii,

no. 3, December 2001, p. 12, and in the 'Pictures Catalogue' online, National Library of Australia (nla.pic-an8930071).

94. Kerr lists the title as *The squatter's hut – news from home*; p. 527. George Baxter (1804–1867) was the inventor of a colour printing method made from blocks and plates, and using oil-based inks. Baxter prints, as a more elegant style of chromolithography, are now highly sought-after collectors' items. See James Cordingley, *Early colour printing and George Baxter: A monograph*, North-Western Polytechnic, London, 1949; Harold George Clarke, *The centenary Baxter book*, Sign of the Dove with the Griffin, Royal Leamington Spa, 1936; and C. T. Courtney Lewis, *The picture printer of the nineteenth century, George Baxter, 1804–1867*, S. Low, Marston & Co., London, 1911.

95. On Melville, see *DAA*, p. 526–27, and Tim Bonyhady, *The colonial image: Australian painting 1800–1880*, Ellsyd Press, Chippendale, New South Wales, 1986, pp. 58–59.

96. This iconography of separation, although already present in the gold-rush illustrations of the 1850s, became particularly pronounced once the 'nostalgic perspective', to use Jan Driesbach's term, comes to the fore 20 years after the fact of rugged goldmining conditions. Paintings such as Ernest Narjot's *The Forty-Niner* (1881) and *Miners: A moment at rest (gold rush camp)* (1882) reinforced this sentimental interpretation. See Driesbach, pp. 105–08; and Claire Perry, 'The golden dream', in her *Pacific arcadia: Images of California 1600–1915*, Oxford University Press, New York, 1999, pp. 50–58.

97. Mary Kay Duggan, 'Music publishing and printing in San Francisco before the earthquake & fire of 1906', *The Kemble Occasional*, no. 24, Autumn 1980, p. 1.

98. In *A collection of songs with words and music*, a bound volume at The Huntington Library (HEH RB 55565), the original cover page reads: 'The California Pioneers/A Song/Respectfully inscribed to Mrs. J. Emerson Sweetser./Words & Music by Dr. M.A. Richter/Published & Sold by ATWILL & Co. in San-Francisco./N.B. The First Piece of Music Pub'd. In Cal a.' On the last page of music it reads 'Copy right secured in the U.S. District Court of Calif[a] March 19, 1852'. Joseph F. Atwill was an important figure in the early cultural life of San Francisco; his music shop served as a meeting place for entertainers looking for work in the new city and his publishing ventures brought him in contact with businessmen, artists and musicians alike. See Frank Soulé, et al.

(eds), *The annals of San Francisco*, D. Appleton & Co., New York, 1855, pp. 781–83; Levy, *Grace notes*, p. 52; R. Stevenson, 'California pioneer sheet music publishers and publications', *Inter-American Music Review*, vol. viii, no. 1, 1986, pp. 1–7; and Duggan, pp. 1–8.

99. Little is known of Quirot, although he appears as the lithographer for many of the California letter-sheets sent home by the early miners, with images that provide some of the most iconic depictions of the first rush of events in 1849 and 1850. On the letter-sheets, see Baird's *California's pictorial letter sheets*. On Quirot and other early California lithographers, see the landmark study by Harry T. Peters, *California in stone*, Doubleday, New York, 1935.

100. Stevenson, p. 1.

101. Matthias Gray, who bought out Atwill's shop in 1860, became the leading San Francisco music publisher throughout the 1860s. As Duggan makes clear, Gray 'hired the finest engravers, lithographers, and woodcut artists in San Francisco for the covers of his sheet music', some of them in full colour and others with actual photographs pasted to the sheet. See Duggan, pp. 4–6. On Gray, see also *The Bay of San Francisco: The metropolis of the Pacific coast and its history*, vol. ii, Lewis Publishing Co., Chicago, 1892, p. 403.

102. 'Far from being a distant and alien antipodean culture, the colonies rapidly imported the latest musical fashions, either directly from Europe or via the American circuit.' Holmes and Martin, p. 49.

103. In notes at the Ballarat Fine Art Gallery, collector Deirdre Chisholm states that in the 1870s, Johnson was 'heavily involved in amateur theatricals' (registrar's notes, consulted 17 February 2003); Johnson's biography states that he was known as a theatre critic as well. See *ADB*, vol. 9, p. 495.

104. Despite Massett's contemporary fame as a beloved eccentric, his persistent acts of self-promotion and his very real contributions to popular music and theatrical performance in nineteenth-century America, his biography does not appear in *The new Grove dictionary of American music* (1986) nor in several other sources where one would expect him to be included. The best biographical sources are still Lawrence Estavan (ed.), *San Francisco theatre research*, vol. 1, WPA Project 8386, San Francisco, May 1938; and R. Stevenson, pp. 7–15. The latter work includes the music, with a reproduction of the covers, of his songs *Clear the way!* and *Learning to walk*.

105. A delightful recounting of this event can be found at The Virtual Museum of the City of San Francisco, viewed 18 November 2003, <http://www.sfmuseum.org/hist/chron1.html>.

106. *Biobooks presents Stephen C. Massett in 'The first California troubadour'*, prologue by Joseph A. Sullivan, Oakland, 9 September 1954.

107. William T. Porter founded the original *Spirit of the Times* in 1831 as a humorous weekly and 'sporting magazine' that became well-known for establishing a style known as 'Old Southwest Humor', an early example of 'local color' writing. Porter's version of the title continued until 1861, while he established another edition, with the same title, in 1856 along with publisher George Wilkes; this version ran for only two years, until 1858. See 'Spirit of the Southern Frontier', viewed 17 February 2004, <http://writing2.richmond.edu/spirit/about.html>.

108. Estavan, vol. 1, pp. 54–55.

109. Stevenson, p. 8.

110. ibid.

111. Several resources on Massett recount that 'Jeems of Pipesville' was born in 1843, after the journalist William T. Porter, having heard Massett sing at the Olympic Theatre, dubbed him 'Colonel Pipes'; Massett then took up the name of 'Jeems Pipes' when writing correspondences for Porter's newspaper. See Estavan, vol. 1, p. 28.

112. An article in the *Evening Bulletin*, 6 June 1896, recounts how the actor Edwin Booth stayed there in dubious circumstances: 'With Charley Tippett, Stephen C. Massett and Dave Anderson, young Booth kept bachelor's hall at a place out on the Mission Road called Pipesville … The orgies that took place in that tip-tilted dwelling can be better imagined than described, when the license of the times is taken into account'; quoted in Estavan's WPA Theatre Project 1938, vol. 1, p. 47. In the WPA Theatre Project volume on Edwin Booth, the editor notes that Booth and his companion David Anderson lived in 'a small house near that curious and fantastic place known as Pipesville' (vol. 4, first series, p. 92). A later article in the *San Francisco Chronicle*, 18 June 1916, describes 'Pipesville' more nostalgically, and states that it was 'in the district now bounded by Market, Seventh, Eighth and Mission streets'. This article is reprinted online, viewed 4 March 2004, <http://www.zpub.com/sf50/sf/hgsto1.htm>.

113. Reproduced in Kathleen Neils Conzen, 'Saga of families' in *The Oxford history of the American West*, New York, 1994, p. 322; and in Blodgett,

p.99. Another version of the same iconography appears on one of the pictorial letter-sheets produced by Hutchings in his *The pictorial news letter, for the steamer golden age*, 20 April 1858, no. 3; reproduced in *A sampler of California's pictorial letter-sheets 1849–1869*, The Zamorano Club, Los Angeles, 1980.

114. R. Stevenson, pp. 9, 15.

115. On Hutchings, see Chapter 1, endnote no. 25.

116. *Hutchings' Illustrated California Magazine*, vol. 2, 1857, p. 191.

117. Printed in Massett's autobiography, *'Drifting about'*, p. 258.

118. ibid., p. 365.

119. ibid., p. 262.

120. ibid., p. 267.

121. George Loder was another Englishman whose musical works and activities as a conductor and an impresario became better known in America and Australia than in England. He conducted the American premiere of Beethoven's Ninth Symphony in May 1846 with the New York Philharmonic, and in 1852, was the conductor for the San Francisco Philharmonic Concert Orchestra. In 1856 he went to Australia as the tour manager for Madame Anna Bishop and in Melbourne worked as conductor with Lyster's opera troupe. After returning to London in 1860, he took a second trip to Australia, where he worked in Melbourne and Adelaide. After a long illness, he died in Adelaide on 15 July 15 1868 and is buried there. See *DNB*, vol. xxxiv, pp. 56–57; and several entries in George C. D. Odell, *Annals of the New York stage*, vol. v, New York, 1931.

122. *'Drifting about'*, p. 268.

123. ibid.

124. ibid., p. 293.

125. ibid., p. 271.

126. ibid., p. 275. For a fascinating discussion of the importance of transparencies in Australian visual culture, see Anita Callaway's excellent study of popular sources of imagery, *Visual ephemera*.

127. Massett had already published *Take back the ring, dear Jamie* in Sacramento in 1854, and it was at that time advertised as a song for Anna Bishop, so Bishop had included it as part of her repertoire in America, when Massett had probably courted her favour. Interestingly, the song itself, with a lettered-only cover, was lithographed in Sacramento by B. F. Butler (1795–1858), who would later become an important lithographer in San Francisco. One of Butler's best works is the cover for *San Francisco quadrilles*

(1852), published by Atwill & Co., which includes a view of San Francisco Bay, a view of miners in the goldfields and a depiction of the personification of California with a grizzly bear, now the emblem of the new state. See Mary Kay Duggan, 'Nineteenth century California sheet music', viewed 14 May 2005, <http://www.sims.berkeley.edu/~mkduggan/art.html>.

128. '*My bud in heaven* by Stephen Massett; as sung by Madame Anna Bishop; pianoforte accompaniment newly edited by C. E. Horsley', J. R. Clarke, Sydney. See National Library of Australia, Petherick Reading Room, Music Collection (MUS N mb 784.3061 M415); reproduced at <http://nla.gov.au/nla/mus-an6056352>.

129. For a reproduction in colour of the cover of *Up in a balloon galop*, see the National Library of Australia, Digital Collections for Music (nla.mus-an22610669-s1-v).

130. Clarke's obituary appeared, in identical words, in the Sydney *Evening News, Town and Country Journal, Illustrated Sydney News*, 13 July 1893, and in *The Freeman's Journal*, 22 July 1893. See National Library of Australia, 'Death of an old citizen: Mr Jacob Richard Clarke' (JAFp BIBLIO F 8319).

131. See Kevin Quinlan's entry for Mason in *DAA*, pp. 520–21.

132. Holmes and Martin, p. 54.

133. 'Gentle Annie. Sung by The Christy Minstrels', J. R. Clarke, Sydney, c. 1858–64. Music Collection, National Library of Australia (nla.mus-an7853430-s1-v).

134. According to an article about minstrelsy in Australia, this group visited in the 1860s and even inspired the forming of a NSW Christy Minstrels. 'Minstrelsy in Australia: A brief overview', viewed 19 March 2008, <http://www.nugrape.net/minstrel.htm>.

135. '*Australian flowers*; impromptu for the piano forte, by Miska Hauser. "Dedicated to Miss Aldis"', J. R. Clarke, Sydney, 1857. Music Collection, National Library of Australia (nla.mus-an24847299-s1-v).

136. On Thomas, see *DAA*, pp. 788–90.

137. 'Jeems Pipes of Pipesville', *Greater Los Angeles*, vol. ii, no. 8, 20 February 1898, p. 4; and 'Another chatty letter from "Jeems Pipes of Pipesville"', in the same publication, vol. ii, no. 21, 22 May 1897, p. 3. Truman introduced Massett's first letter with the following provocative note: 'A sweetly-scented letter came to the editor of GREATER LOS ANGELES a few days ago, with the coat-of-arms of the Windsor hotel in New York. It was from Steve Massett, an old 49er, who was for many years the only recognized 'Beau' of the Pacific coast, and the first 49er who dared to wear a nail-keg hat in California. He was a handsome fellow of about twenty in those days, with ambrosial locks and an eagle eye, and he was a troubadour who could write his own beautiful verses and compose his own sweet music, and he was a most charming all-round fellow, who could play Gottschalk's Lullaby or Lost Hope and sing a song as tenderly as Harrison Millard.'

138. *Greater Los Angeles*, 22 May 1897, p. 3.

139. *New York Times*, 9 October 1898, p. 10, col. 2.

140. *Argus*, 17 September 1895; viewed 29 March 2004, <http://www.twainquotes.com>.

141. Mark Twain, *Following the equator*, American Publishing Company, Hartford, 1897, p. 129.

142. See M. E. W. Sherwood, *An epistle to posterity: Being rambling recollections of many years of my life*, Harper, New York, 1897, p. 192.

143. *Overland*, September 1902.

144. Gary Scharnhorst discusses the *Overland* Bret Harte issue in his '"Ways that are dark"', p. 379.

145. Claire Perry in *Pacific arcadia* discusses these artists and images as part of her chapter on 'Urban visions', pp. 182–88. For images of the Chinese in Australia, see 'Multicultural Australia', 'PictureAustralia', National Library of Australia, viewed 4 April 2004, <http://www.pictureaustralia.org/index.html>.

146. On images of San Francisco's Chinatown, see Perry, pp. 184–88.

147. In the Ron Blum Collection of Rose's Stereoscopic Views of Australia Federation Celebrations, 1901, Pictures Collection, National Library of Australia (nla.pic-an22482025).

148. David Clayton Phillips, 'Art for Industry's Sake: Halftone Technology, Mass Photography and the Social Transformation of American Print Culture, 1880–1920', PhD thesis, chapter 4, section 11, Yale University, New Haven, 1996, viewed 14 April 2004, <http://dphillips.web.wesleyan.edu/halftone/chap4.html#sec3>.

1888: Australia, California and the Picturesque industry

The majority of important artists who began their work during the eighties and nineties of last century graduated through the illustrated periodical.
—Bernard Smith, *Place, taste and tradition*, 1945.[1]

~

The quiet, haunting spell the woodcuts cast is, in part, a gift from the medium. It is hard to find a really ugly woodcut in all of Harper's Weekly in the eighteen-sixties and seventies. There's an instinctive elegance to the black-and-white-and-gray linearism, patches of sun and shade built up from an obvious code of visible line.
—Adam Gopnik, 'Homer's Wars', *The New Yorker*, 2005.[2]

I n 1888, the still-separate colonies that comprised the British-governed continent of Australia set out to celebrate 100 years of white settlement at Port Jackson, now the colony of New South Wales. Plans to mark the event elicited ambivalent reactions in many quarters, for the economic and social conditions varied significantly in each region of the Australian land mass. On the one hand, in 1888 the colony of Victoria was still enjoying the era of 'Marvellous Melbourne', that miraculous two decades so labelled by writers to describe the transformation of a bedraggled gold-rush town into a thriving and immensely prosperous cosmopolitan centre, a major provincial city within the British Empire already creating substantial cultural institutions.[3] Writing of the period, cultural historian Geoffrey Serle has maintained that '[n]o British city outside London could boast of as many large public buildings or … as fine ones'.[4] A report on the 'Chinese problem' in Australia that appeared in the *Los Angeles Times* in April of that year called Victoria 'by far the leading colony'.[5] An Australian visiting the United States in 1884 wrote:

San Francisco is a wonderful place, one of the wonders of the world, but Melbourne is a still more marvellous example of rapid growth, and substantial progress. Melbourne has more permanent and solidly constructed buildings, far better streets, and a larger population than San Francisco, so that it has no equal in the world among cities of nearly the same age.[6]

In his book *Inventing Australia*, Richard White notes that Melbourne's drive for 'cultural respectability' was so aggressive in the 1880s that 'one visiting journalist advised Victorians to worry less about cultural societies and more about building better hotels'.[7]

Energised by this enthusiastic institutionalisation of cultural activity, Melbourne in the 1880s also developed a modern art movement, emanating not only from the officially sanctioned art academies and galleries, but also from the casual establishment of artists' camps by independent young men and women in the outer suburbs of Heidelberg and Eaglemont. Interested in developing a 'national' style of art and committed to painting in nature, these young artists were grounded—after study abroad, with the influence of émigré artists and through knowledge gleaned from illustrated publications—in an up-to-date, if at times second-hand, understanding of European *plein-air* painting.[8] Many took on the trappings of 'serious' European artists, portraying themselves as modern, urban sophisticates and enjoying what they thought of as 'aesthetic' lifestyles.

The Victorian capital also supported a thriving illustrated press—one that often offered these same artists a much-needed source of income while they honed their skills in printmaking. These presses produced several journals and pictured publications that rivalled anything coming out of the home culture of England. The English writer Anthony Trollope, upon visiting Australia, wrote that the country had 'the best daily papers I have seen out of England'.[9] The illustrated press had become by this time an essential source of news and visual entertainment for most Australians.

In the most sensational example of the growing dependence on image-based records of events, the decade had begun with the documentation of the thrilling capture in Glenrowan in the Victorian countryside of Australia's most notorious outlaw, Ned Kelly, and the killing of his gang members. The confrontation and capture had been visually and textually documented in gruesome detail by the press and consumed voraciously by a readership that already expected pictures along with their descriptions. Julian Ashton (1851–1942), a major force in Sydney's artistic life who would later work as an illustrator for the *Picturesque atlas*, was in 1880 working in Melbourne and was one of the artists who took the train to Glenrowan to be present at the scene. He, along with several other artists, produced sketches on site that would be turned into woodblock engravings for the *Illustrated Australian News*, while photographers such as J. W. Lindt on the scene had their images of Kelly's gang reproduced as photo-engravings throughout the country (see Fig. 3.01 on page 108).[10] Australians, then, were already participating in the world of mass-media culture, dependent on visual reproductions, that was transforming the idea of art and culture in the late nineteenth century.

Victoria, first settled in the 1830s and largely free of the burden of convictism, was in 1888 the place most likely to want to celebrate the centenary of the arrival of Western settlement and culture in the antipodean colonies. The neighbouring colony of New South Wales, on the other hand, as The First State, considered itself the obvious venue for such historic celebrations, for it was the arrival of the First Fleet into Sydney Harbour in 1788 that the centenary was intended to celebrate. Sydney had also by this time developed into a burgeoning metropolis with all the cultural amenities, but it was in some economic crisis at the time and so not as confident as its southern sister about its ability to support grand symbolic festivities. Unlike its freewheeling, entrepreneurial Californian neighbours on the Pacific, Australia never had enough flamboyantly wealthy individuals to support ambitious

Fig. 3.01 J. W. Lindt, *Joe Byrne's body outside Benalla Police Station*, 1880. Photograph. Courtesy of National Gallery of Australia, Canberra.

private cultural institutions and events. Most momentous communal occasions and nearly all public institutions were dependent on governmentally allocated resources.

Despite Melbourne's prosperous cultural position in the colonial hierarchy, Sydney also supported ambitious artistic and literary endeavours. Most notable in terms of future directions was the establishment in 1880 of what the writer Sylvia Lawson has called the 'vicious and electrifying' magazine *The Bulletin* (1880–2008).[11] This journal, under its volatile founder J. F. Archibald (1856–1919), vigorously embraced in its editorial writing the campaign for Australian nationalism and championed the 'man on the street', the working-class and middle-class Australian. Iconoclastic and libertarian, Archibald's magazine 'had crusaded against monopolies in wealth, power and privilege, "stood against avaricious clergy who claim to monopolise salvation", and wrote passionately about "the dark despotism of grasping plutocrats"'.[12] At times sadistically racist, often misogynist, *The Bulletin* at the same time nurtured a scintillating, creative Australian voice and a distinctive style of illustration and editorial cartooning known in the press as 'The Black and

White School'. The magazine defined much of Australian cultural life by supporting local talent such as Henry Lawson and A. B. 'Banjo' Paterson (1864–1941), along with world-class illustrators. *The Bulletin* determined much of Australia's illustrative and literary aesthetic well into the twentieth century.[13]

Even with *The Bulletin*'s energetic presence in the city, New South Wales's fiscal problems in 1888 caused centennial celebrations to be hampered by political wranglings and budget disputes. Further, any focus on such commemoration required Sydneysiders—more so than other Australians, who carried less or no convict taint—to acknowledge and examine their less than glorious origins as a penal colony, something that always required some discomforting truths to be confronted by those who had carefully accumulated all the privileges and moral attitudes of civilised Victorian society. The rest of the colonies were also unsure of just what the year was meant to celebrate. As Tony Hughes-d'Aeth writes, 'there was little in terms of symbolism around which popular sentiment could congeal'.[14]

The real problem was that in 1888 Australia as a united nation did not yet exist. Nationalist sentiments, aggressively

supported by *The Bulletin* and especially among native-born citizens, were beginning to coalesce by this time, but most citizens' popular allegiances in terms of symbolic celebrations and festive emblems were still more regional than national. The official choices for marking the occasion made by the individual colonies epitomise these divides. New South Wales had week-long celebrations around 26 January; the day that colony alone had previously celebrated as Settlement Day would now be deemed a national holiday for the first time. During this week Sydney's Centennial Park was opened, many monuments to Queen Victoria and other dignitaries were unveiled and banquets with boring governmental speeches were undertaken, all events that were considered a drain on the colony's fragile finances. To add to the disgruntled atmosphere, these occasions, to quote a newspaper report of the time, were carried out 'in that melancholy and despondent fashion we all so well remember'.[15]

In contrast prosperous Victoria held a six-month-long international Centennial exhibition beginning in August 1888. The displays and main activities of the celebrations were held in Melbourne's Exhibition Buildings, already erected in the suburb of Carlton for the Melbourne international exhibition in 1880; here the Queen's Jubilee had been feted only the year before. With participants from Europe and America—America sent an Edison phonograph and chewing gum[16]—and filled with displays of local products and the cream of Australian artisanal achievement, the exhibition was consciously meant to emphasise not only Victoria's 'place among nations',[17] but also its cultural and financial superiority over its less affluent rival to the north.[18] Throughout the year, other colonial cities such as Adelaide and Perth as well as many country towns celebrated to varying degrees, largely by holding picnics, fireworks displays

and sporting events, just as they would for any other declared holiday.

The real and enduring cultural achievement of the year was an illustrated publication. The planning and initial work on this publication had begun a few years before in Sydney and, conveniently, gained financial and official backing because its appearance coincided with the marking of the centennial year. Upon completion of its many sections in the early 1890s, the *Picturesque atlas of Australasia* became the most elegantly illustrated publication produced in the Southern Hemisphere. The *Atlas* precipitated the arrival of an entire fleet of artists, engravers and printers, most of them from America (and, most notably, not from England). Of even greater significance for subsequent directions in Australian art and media production was the importation, again from America, of the most modern printing equipment to produce the images. The arrival of new printing technology along with American printers and craftsmen would greatly influence the stylistic direction that illustration took in Australia.

While not as laden with symbolic momentousness, California in 1888 was also experiencing the high end of one of the first of its dizzying land booms. This boom was stimulated by the completion of the transcontinental railroad into San Francisco in 1869 and, most specifically, by the arrival of the railroad in Southern California in 1876.[19] By 1885, the Atchison, Topeka, & Santa Fe (popularly referred to as 'the Santa Fe') created a second direct line across the country and into Los Angeles, giving rise to intense fare wars aimed at encouraging travel and settlement. These offers targeted primarily Midwestern and eastern agricultural families and business concerns, and focused on the southern part of the state and the Central Valley regions. The impetus of the fare wars led to frenzied real estate speculation in Southern California, as

farmers and merchants flocked to the region, accompanied by what Carey McWilliams labels 'the townsite sharks of the Middle West' who gleefully bilked the innocents out of their money through land deals.[20]

Los Angeles's population in 1870 was little more than 5000. By 1880, it had grown only to 11,200, but by 1890, it had reached over 50,000. By the turn of the century, California's main southern city had a population of over 100,000, with all the accompanying accoutrements of a nineteenth-century American metropolis. As Glenn S. Dumke has written, the land boom of the 1880s, although its demise by the end of the decade was dramatic, forever changed the demographics and culture of the state: 'The gold rush made northern California a real part of the United States; the boom of the eighties did precisely that for the south … The boom was the final step in the process of making California truly American.'[21] California, then, just as Australia did, became by the 1880s intensely self-conscious of its 'image' in the world. The state's boosters had already learned the value of printed publicity to spread its fame, based largely on its climate, to an international audience (see Fig. 3.02 on page 211).

Two other events occurring in 1880s Southern California would affect the motifs exploited in 'selling' the state through visual imagery. The first was the rise of the citrus industry as the dominant agricultural activity in the southern counties. By the end of the decade, more than a million trees were growing in the region. Oranges alone occupied some 13,000 acres of land, most of the fruit destined for shipping east by train.[22] As the importance of this industry to the state's economy grew, so too did the need to incorporate the image of a citrus-filled landscape into the picture of California itself, as part of the promoter's pitch to potential immigrants and visitors. The orange and its orchards now

joined other incipient emblems of California in mass-produced imagery emanating out of San Francisco and Los Angeles.

A thoroughly romanticised iconography of Hispanic Southern California also gained real impetus in this decade, following the publication in 1884 of Helen Hunt Jackson's wildly popular bestseller *Ramona*. Jackson (1830–1885), who had begun her career championing the cause of dispossessed Native Americans, had written the book to highlight the inequities perpetrated against California Indians by settlers in the West. With *Ramona*, she hoped to do for the cause of Native Americans what Harriet Beecher Stowe had done for black slaves with *Uncle Tom's cabin* (1852). But her setting of the story in a picturesque 'Old California' of missions, colourfully costumed Spanish dons and señoritas, and adobe *haciendas*, allowed readers—and the region's eager boosters—to construct a 'Ramona' landscape that expressed their desired aesthetic for contemporary California. By 1888, tourist sites arose throughout Southern California claiming to have some link to places in the book, or as the home of the 'real' Ramona. The Ramona phenomenon coincided neatly with the height of the railroad's fare wars and the companies were quick to cash in on the book's immense popularity, offering Ramona tours and special rates for those going to visit these sites. *Ramona* and the romantic imagery it created put Southern California on the world's tourist map. Quantities of postcards, photographs, illustrated brochures and books appeared, dispersing an emblematic picture of Hispanic California that put in place a fanciful aesthetic vision that endured well into the twentieth century.[23]

Although populations began to shift south in this decade, San Francisco remained the unrivalled cultural centre of the state. In many ways, the city's outlook in the 1880s mirrored the Victorian-era aspirations and ambitions of

that other new English-speaking town of the Pacific Rim, Melbourne. Gone entirely, at least from official civic life, were the rough and ragged gold-rush days of brawling sin, unregulated building and vulgar hedonism. Now self-conscious efforts were made by 'the better classes' to create a genteel, elegant Victorian city of substantial mansions and ostentatious public institutions.

San Francisco more than any other city reaped the rewards of the unprecedented individual wealth accrued by the 'Big Four' of the railroads—Collis Huntington (1821–1900), Leland Stanford (1824–1893), Charles Crocker (1822–1888) and Mark Hopkins (1813–1878)—along with the many other 'bonanza kings' who had struck it rich in the Nevada mines.[24] Along with their ostentatious mansions, these men, keen to gain through lavish displays of public spending and flamboyant building projects the veneer of cultural respectability, supported and in many cases singlehandedly endowed libraries, universities, theatres, opera houses, fine dining establishments, elegant hotels renowned throughout the world, men's clubs, parks and gardens, museums and ambitious publishing concerns. The characteristically American tradition of extravagant cultural philanthropy mixed with commercial enterprise and entirely separated from governmental expenditure was most vividly in evidence in San Francisco in the 1880s and 1890s.

Just as happened in Melbourne, this heady, free-spending cultural atmosphere also helped to encourage and enliven those drawn to a more 'bohemian' artistic life in the City by the Bay. Indeed, at the end of the nineteenth century the very term 'bohemian' had become associated with San Francisco, for in 1872, a group of young artists and writers founded The Bohemian Club. The club's founders created a convivial and aesthetic group which continued into the twentieth century as the most vibrant

centre of regional cultural life. As Kevin Starr has written, The Bohemian Club's 'roster might function as a Who's Who of local creativity', including members as diverse as Mark Twain, the San Francisco printer Edward Bosqui (1832–1917), and the Berkeley geologist-philosopher Joseph Le Conte (1823–1901).[25]

The most remarkable aspect of this particular club—the event that made its way even into the pages of international journals such as Archibald's *Bulletin* in Sydney—was its annual summer retreat into the redwood forests north of the city, in a celebrated grove where they combined communion with nature, boisterous shenanigans and elegant entertainment.[26] This very Californian predilection linking outdoor life and cultural pursuits perhaps explains why John Muir (1838–1914), the most revered of the Californian naturalists but no aesthete, was also a member of The Bohemian Club. Other artists' colonies, literary as well as painterly, thrived in the city and surrounding region, dedicated by the 1880s to fostering a distinctly Californian style of art and craft. Most significantly, San Francisco began to support a substantial art press and fine printing industry, one that participated fully in, and eventually defined, a distinctly Pacific Slope approach to typography, graphic art and design.

In the exciting cultural atmosphere that San Francisco provided by the end of the century, and given the woozy boosterism about California brought on by the booming economy in its southern portion, it is not surprising to find that in the same year as the Australian centenary and the publication of the *Picturesque atlas of Australasia*, one ambitious publishing house in the Bay City came out with the first segments of its own grandly illustrated publication. It, too, included in its title the term 'picturesque', and also strove to convey a particular ideological message about the region through text and images. Further,

Picturesque California, published as serial segments by J. Dewing, Publishers, Importers and Booksellers, included work by some of the same American artists and engravers who worked for the *Picturesque atlas of Australasia*.

Such fortuitously shared activity and aesthetic exchange is not simply serendipitous. It indicates a common desire by the artisans and publishers in these two new societies bordering the Pacific Ocean to participate in one of the most popular artistic enterprises of the nineteenth century—the production of volumes illustrating a modern transformation of the idea of the picturesque, intent on selling a vision of the landscape to tourists and 'armchair travellers' alike. These substantial volumes provide not only an opportunity to trace the trajectory of this picturesque aesthetic into the newest Western societies; they also offer an opportunity to examine the development on the Pacific Rim of a modern printing industry and the importance of this industry in the production of a self-consciously regional aesthetic employing modern graphic forms.

The so-called Picturesque industry of which these Australian and Californian writers and artists wanted to be a part began in the 1870s, when a whole series of books 'demonstrating good taste and interest in picturesque scenery and art' began to appear on the market in North America.[27] These publications emerged because of the technological advances in printing that facilitated an increase in high-quality, artistically illustrated magazines and journals. Usually sold by subscription and often as segments of serial publications that already had substantial circulation, these productions in the 1870s and 1880s made enormous profits for their publishers. The most significant fact was that these books emanated from American publishers and printers. The main artist and leading instigator for the first volumes was a transplanted Englishman, painter and printmaker Harry Fenn (1837–1911), and the initial impetus was in emulation of European illustrated publications, but the entire enterprise was a product of the United States.

Motivated by a desire to demonstrate to sceptical Europeans that America did indeed have picturesque scenery, Fenn proposed this venture to the firm of George S. Appleton (1821–1878), publishers of *Appleton's Journal* and other art books. Filled with entrepreneurial spirit tied to a zeal for popular education and a desire to express unifying national cultural ideals after the schisms of the Civil War, the company also wanted to demonstrate its technical expertise in printing. The publishers spared no expense in presenting huge tomes comprised of effusive text and full-page illustrations of beautiful views in nature. Depictions of cosmopolitan urban scenes also appeared, but in romantic modes that attempted to fit into the then-popular

Fig. 3.03 Frontispiece, *Picturesque America*, 1872. Courtesy of The Huntington Library, San Marino, California.

ERODED SANDSTONES, MONUMENT PARK.

Fig. 3.04 *Eroded sandstones, Monument Park*, in *Picturesque America*, vol. 2, pt. 2, p. 493. Courtesy of The Huntington Library, San Marino, California.

conception of the term 'picturesque'.

Picturesque America, completed in 1872, was the pivotal production in the series. This enormous undertaking, guided by its enthusiastic editor Oliver Bell Bunce (1828–1890), tapped into the progressive mood in America following the Civil War. As people became more prosperous, better educated, desirous of cultural improvement and able to travel throughout the entire country, they became more interested in owning illustrated books that depicted the country's natural landscape, especially of newly accessible sections of the American continent. The transcontinental railroad, seen by the public as the supreme example of American achievement, opened up the possibility of visiting these new places, especially in the Western frontier, already widely mythologised in the dime novels and other popular press.

As America had so enthusiastically demonstrated at its own Centennial exhibition in Philadelphia in 1876, technological superiority through better machinery was the aspect by which the country staked its proudest claim to progress and the advancement of Western culture. The very notion of modernity was represented for many Americans by the printing machines that made it possible to reproduce artistic imagery. As Sue Rainey contends in her book on the making of *Picturesque America*, this merging of new technology and national cultural aspirations led to the volumes' tremendous success in post-Civil War America: '[T]he extraordinary outlay yielded huge profits from subscription sales that may have reached one million copies.'[28] The books also mark the implementation of a truly visual culture, an image-based world, dependent on pictures to provide education about new places and new inventions, and to impart a sense of shared cultural and national identity. Further, the volumes' monumental size, and their attention to artistic printing techniques, gave them the weight of valuable commodity. In many ways, *Picturesque America* and the subsequent editions that appeared under the Picturesque rubric were the first examples of luxurious coffee-table books, purchased by middle-class families to be displayed in a prominent place in the parlour as evidence of cultural taste and respectability. In its format, the publication also offers the first glimmerings of mass-market 'picturesque tourism'—using printed images to encourage people to travel to see natural wonders and historic sites.

The editors of *Picturesque America* brought together the best American artists (along with Harry Fenn) to travel and sketch on-site what

were considered the most pleasing views of the country's scenery, most prominently of its natural beauty-spots. In the 1870s, these pictures, produced in the most polished forms of wood- and steel-engraving using the most skilled engravers available, concentrated on romantic notions of 'wild' scenery: waterfalls, craggy rocks and treacherous coastlines. City scenes were also included but usually rendered from the most pleasing angles, seen from above or across a sweeping plain, or as depictions of quaintly intimate, well-ordered streets and avenues with stately, substantial buildings. Alternately, more modest neighbourhoods and dwellings were rendered as romantically crumbling or asymmetrical structures, making Dubuque slums (in Iowa), for example, appear as poetic as traditional Italian villages. While some views of industry and commerce did make it into the pages as illustrations, the emphasis in these views was on the monumentality of machines and processes of fabrication rather than gritty depictions of labour.

Emphasis in illustrations in *Picturesque America* revealed the framework in which Americans in the 1870s had redefined and expanded earlier conceptions of the picturesque aesthetic. English philosophers and artists since the 1780s had discussed the idea of the picturesque as finding the most pleasant scenery to be seen by those on tour on the European continent or in the Middle East. They emphasised what Tony Hughes-d'Aeth has called 'a pre-modern land of aesthetic purity'.[29] American writers and artists by the 1870s, and certainly the publishers of *Picturesque America*, had diluted the term to refer to a more eclectic, less philosophically determined, vision of 'pretty', albeit dramatic, views of nature and culture that were meant, as Rainey states, to encourage 'a positive self-image of the United States, and thus nationalism and tourism'.[30] The illustration style was conventional, revealing well-established

academic tropes of Romantic landscape, either bucolic or monumental, and emphasis on realistic delineation of details of the views rather than 'painterly' or atmospheric effects.

By the end of the 1870s, the commercially successful franchise that the Picturesque series had become engendered numerous imitators and further transmutation of the word to refer in the public's mind to this kind of publication itself: profusely illustrated books displaying images meant to impart detailed information about the appearance of towns, cities and natural scenery of a region or nation, and to provide the owner of the books with beautifully executed artworks that displayed the highest skill of the engravers and the artist-illustrators. The Appleton company also published *Picturesque Europe* (1875) and *Picturesque Palestine, Sinai and Egypt* (1881). Other publishers also jumped on the picturesque bandwagon, with varying degrees of success based on the quality of the prints provided.

For the future Australian publication, the

A Cross-Street in Dubuque.

Fig. 3.05 A. R. Waud, *A cross-street in Dubuque*, in *Picturesque America*, vol. 2, pt. 2, p. 332. Courtesy of The Huntington Library, San Marino, California.

abroad, are also striking evidences of local wealth and progress, and of the advance of art and skill.

The activities of the journalistic profession in the Provincial Metropolis are also matters of pride to its citizens. The growth of the newspaper press of Toronto, particularly in the last ten years, has been very marked. The building erected by the proprietors of the *Mail*, the chief conservative organ of the Western Province, is at once an instance of enterprise and of the public favour which enterprise wins. The *Mail* was established in 1870, and is a vigorously conducted journal, with writers of trained and disciplined talent on its staff. The *Globe*, which dates back to 1844, long led the van of journalism in Canada; it is recognized as the chief organ of the Reformers, or, as they are now frequently designated, the "Liberal Party." The *Telegram* and the *World* are journals that pay some tribute to independence; and with the growing class now throwing off the ties of partyism, they are increasingly popular. The *Evening News* and the *Evening Canadian* are recent additions to after-

QUEEN'S PARK.

noon journalism. The "weeklies" chiefly represent the denominations. The *Christian Guardian*, founded in 1829, is the organ of the Methodist, and the *Evangelical Churchman* of the Episcopal body. The *Irish Canadian* speaks for Roman Catholicism. The titles of the *Canada Presbyterian* and the *Canadian Baptist* at once

Fig. 3.06 W. T. Smedley, *Queen's Park*, in *Picturesque Canada*, 1884, vol. 1, p. 427. Courtesy of The Huntington Library, San Marino, California.

most significant one of these earlier publications was *Picturesque Canada*, produced by Belden Brothers in Toronto in 1882 to 1884. Along with Canadian writers and artists, the enterprise saw the participation of several of the leading American illustrators from New York, including those who would subsequently travel to Australia to work on its *Picturesque atlas*. The aesthetic formula in each of these publications was set: wood- and steel-engravings to accompany descriptive text written by locally well-known literary figures about each region or city, either produced as full-page

images, sometimes with ornamental framing devices, or—as evidence of innovative printing techniques—as visual motifs integrated into the page of text itself. This artistically enhanced, often clever, merging of text and image was the real sign of modern style in these publications as far as the publishers and artists were concerned, for these processes were hailed as the epitome of the printer's art.

By 1888, when the *Picturesque atlas of Australasia* and *Picturesque California* appeared, the use of the term 'picturesque' in their titles clearly meant to play to the public's knowledge of these earlier illustrated publications, or at least to impart the same connotations of generously illustrated pages exhibiting high artistic quality and the most modern reproduction techniques. But the date also proved to be a particularly pivotal year for printing technologies, as the industry began the inevitable shift to photographic reproduction in halftone that would become by the 1890s the dominant mechanical method for most illustrative needs. This process of transformation from the labour-intensive and therefore costly art forms that had made the American illustrated press a superior branch of the graphic art industry to a thoroughly mechanical mode of photographic illustration gives added significance to the Australian and Californian forays into the world of picturesque illustration. This transitional moment also explains the fascinating mixture of printing techniques that these late entries into the picturesque industry exhibit.

Ideologically, a comparison of ambitious illustrated books aimed at representing these new English-speaking societies on the Pacific Rim—two settler-cultures on the periphery of Euro-American civilisation—reveals, of course, many points of difference in terms of cultural aims. But both appear at a time when these developing societies needed to express similar aspirations about the cultivation of

Anglo-centric values of gentility and progress. That these undertakings share some of the same artist-illustrators operating in related artistic spheres and expressing similar graphic iconographies makes such a comparison a particularly revelatory exercise.

Plans for the production of the *Picturesque atlas* began in the early 1880s, stemming directly from the efforts behind the publication of *Picturesque Canada*.[31] The publishers of that enterprise had sent out to Australia an American 'book canvasser' named Silas Lyon Moffett (1841–1923), a Civil War veteran whose purpose was to drum up interest for a proposed book on Australian 'men of mark' that would be sold by subscription to the leaders of the country's governing society.[32] While nothing came of his initial concept, Moffett's enthusiastic pitch to Sydney journalists and artists for a grand illustrated undertaking to highlight Australia's century of progress as a Western nation was apparently infectious: The Picturesque Atlas Publishing Company was registered in Sydney in February 1886 with four American directors. The involvement in the project of two important Australian figures, the artist and *Bulletin* journalist William Macleod (1850–1929) and the artist–illustrator Julian Ashton, dates from about 1883.[33] Soon other Australian illustrators and writers were hired; by 1885, artworks destined for eventual publication in the *Atlas* were put on display in Melbourne and the newspapers began to include regular reports about this audacious project intended to be ready to mark the centenary in 1888.[34]

Moffett's connection with the men behind the *Picturesque Canada* project provides one explanation for the Americans who had been involved in that undertaking coming to Australia to work on the *Picturesque atlas*. The directors appointed the artists William T. Smedley (1858–1920) as 'Pictorial Commisioner',[35] Frederic B. Schell (1838–

1902) as Head of the Art Department; and William C. Fitler (1857–1911) as travelling artist.[36] All three had worked on the Canadian volumes, and all of them, along with an entire crew of American engravers and printing people, made the most substantial contributions to the aesthetic and technological sophistication of the Australian volumes.

These names also point to an even more important source of connection to American publishing, for these artist–illustrators all worked primarily (but not exclusively) for the New York-based publishing house, Harper's, which by the 1880s had been the leading publisher of American illustrated journals and books for decades. *Harper's Weekly* and *Harper's Monthly*, founded in 1850, set the aesthetic tone and perfected the most popular iconography and sophisticated graphic forms for all other illustrated journals from the 1860s. Leading American artists such as Winslow Homer and Frederic Remington (1861–1909) began their careers as illustrators at *Harper's*, and they continued to contribute to its pages throughout their careers. The House of Harper was largely responsible for the high regard that American illustrated publications enjoyed from artists and writers around the world.

By the 1870s other firms such as the house producing *Scribner's* (which became *Century* in 1881) joined the fray of illustrated journalism, fostering competition based on the quality of wood- and steel-engravings that led to greater technical advances and printing innovations on the part of American companies. By 1880, even the London papers had to confess, '[t]he impartial critic who is asked where the best wood cuts are produced has, we fear, but one answer possible: Neither England, Germany nor France, but America'.[37] As late as 1899, in a biography of W. T. Smedley, the author confidently stated:

In pictures, make-up, and general typographical appearance, our publications, and in particular our magazines, are the admiration of Europe; we have raised the standard of such work to a very high degree. It is no exaggeration to say that our three leading magazines are not equalled to-day, and a goodly share of that which has contributed to their success must be accredited to the men who have drawn the pictures.[38]

The American publishing houses spent enormously to hire the most skilled engravers and craftsmen. J. Henry Harper himself, in his memoir of the company *The house of Harper*, wrote that by 1888, 'the demand for first-class engravers was very great and the market value of their work [as high as $500 for engraving one page] became a serious consideration for the publishers'.[39] The superiority of Harper's works depended even more directly, in terms of its claims of 'modernity' and beauty of reproduction, on technological expertise. The publisher demanded the most advanced printing presses and indeed provided the incentive for such technical progress to be made. Harper attributed the publications' success to the machines:

> [T]he stop cylinder presses invented by Col. Richard M. Hoe, and purchased for our work about 1875, proved a great advance on any presses available up to that time, and the exquisite illustrative work produced in HARPER'S MAGAZINE, WEEKLY and BAZAR [sic] was largely due to the ability of these presses to turn out work rapidly and satisfactorily ... From this time on the execution of engraved cuts for the MAGAZINE made steady improvement, until about 1885, when wood-engraving for periodical use reached its greatest perfection.[40]

The improvements made by American publishing firms, pictorial as well as technological,

were already well-known—and envied—in Australian cultural circles by the time the *Atlas* project became a reality. *Harper's* publications, as has already been mentioned in previous chapters, were readily available throughout the continent from the first issues, viewed in Mechanics' Institutes and libraries on the goldfields and in the cities, along with British illustrated journals, *Melbourne Punch* and *The Illustrated Australian News*. As one of the first newspaper reports about the *Atlas* project demonstrated, Australian readers readily subscribed to the American publications: 'In America the art [of engraving] has almost reached perfection, as subscribers to such magazines as the *Century* and *Harper's* are very well aware.'[41]

Australian illustrated publications, led by *The Bulletin*, were actively seeking to emulate the work of the American firms and their illustrators years before the influx of American equipment and artists imported for the *Atlas* project. In their quest to find a first-rate cartoonist for their fledgling publication, *The Bulletin*'s Archibald, along with his editors William Traill (1843–1902) and William Macleod, had already travelled to the United States in hopes of securing one for the magazine. In 1883 in San Francisco, they had first tried to recruit 'the reputedly brilliant Keller of the *Wasp*'—G. Frederick Keller (1846–1883?), the cartoonist for the city's leading satirical magazine—but that deal fell through.[42] Traill, writing years later in an article on 'The genesis of the *Bulletin*', described how and why they finally found Livingston Hopkins (1846–1927), the Midwestern American who would become a household name in Australia as *The Bulletin*'s cartoonist 'Hop':

> I decided to visit America, via San Francisco, and there to endeavor to secure several means for advancing *The Bulletin* ahead of anything previously attempted in Australia. A prime

necessity was a humorous artist of the first rank. The sketches in the American comic papers made me and Archibald yearn. I determined to make a desperate effort to engage and bring to Australia some one of the many clever comic draughtsmen whose work embellished various Yankee papers which we received regularly.[43]

Hopkins already had an established career in America as a comic illustrator. His abilities as a political caricaturist were already evident in his work for Robert J. Burdette's *Hawk-eyes* (1879), an exercise that emboldened him to publish his own *A comic history of the United States* (1880), filled with droll comments about American historical figures and contemporary American politics.[44] He joined the Sydney paper in 1883, arriving in Australia with his family, initially for a three-year contract. They stayed for life.

In Sydney 'Hop' joined the British cartoonist and *bon vivant* participant in Sydney's bohemian life, Phil May (1864–1903), whom

Traill had lured to *The Bulletin* in 1885, to initiate 'the golden age of Australian caricature', as architect and aspiring cartoonist George Taylor later called it.[45] Along with other *Bulletin* artists, they formed The Black and White School of political cartooning and editorial illustration in the 1890s. The products of their pen made *The Bulletin* the leading illustrated publication on the continent. It is no exaggeration to say that their artwork contributed most effectively to making *The Bulletin* a national rather than local publication, and in so doing, caused a shift in perception about Sydney as a cultural and artistic centre in Australia.[46]

The American Hopkins created some of the most memorable satirical expressions of Australian political life. His *Little boy from Manly*, first depicted in the magazine in 1885, served as a humorous and ultimately iconic representation of the Australian nation as *The Bulletin* envisioned it.[47] Although Phil May was the better artist of the two, editor and

Fig. 3.07 Livingston Hopkins ('Hop'), *A young gentleman of culture on his way to California*, in *A comic history of the United States*, American Book Exchange, New York, 1880, p. 172. Author's collection.

art critic of *Art in Australia* Bertram Stevens later maintained that Hopkins's impact on Australian art was more enduring, for, among other things, he had introduced etching as a serious art form to the country.[48] The sober, quietly authoritarian Hopkins—often described as a 'puritan'[49]—was particularly close to the magazine's artist and business director William Macleod and worked alongside its editor William Traill throughout their *Bulletin* years.[50] These two were the real creative powers at the magazine.[51] Given Macleod's and Traill's significant involvement with the *Picturesque atlas* project, it is not surprising that Hopkins, along with nearly every other artistic figure in Australia, would contribute work for its pages.[52]

The *Bulletin* editors looked with envy at the finesse of American artist–illustrators and cartoonists in productions as grand as *Picturesque America* and as mundane as those in the myriad number of illustrated magazines that poured into Australia from the United States. They were even more envious of the obvious aesthetic advantage these publishing firms gained by virtue of their graphic printing capabilities. The machines that Harper so proudly touted in his biography of the company were the key, as Macleod and other Australian publishers recognised, to the production of such skilled integration of text and illustration, and to the refined wood-engraving style associated with the American magazines. Those working for *The Bulletin* were also aware of these advantages: Phil May had asserted that his linear, less sketchy technique came about because he had to adjust to the inadequacies of *The Bulletin*'s presses,[53] and stories of the blunders by the magazine's management in purchasing printing equipment are a leitmotif in many discussions of this publishing enterprise.[54] Prints curator Roger Butler states that 'Hopkins' early work for Traill was hampered by the primitive technique—a form of relief etching which required him to draw onto a zinc plate—being used to reproduce his sketches'.[55] These problems had already led Traill to hire an American technician, Charles Shugg

(c.1862–1933), to improve these methods in the mid-1880s. The best printers, artists and pressmen in Australia, then, were aware of the full range of American illustrated publications and wanted to emulate these works, both artistically and technically, in their own industry.

When The Picturesque Atlas Publishing Company was formed in 1886, with such ambitious intentions and thorough involvement of American artists and printers, the men in charge of the project determined to import the very best equipment, paper and ink from the United States, with the aim of creating the finest engravings that the colonies had ever seen. The newspapers in Sydney proudly announced that the company had 'imported the most modern and perfect machinery known … including three of R. Hoe and Co's double stop cylinder fine art printing presses'.[56] 'These presses are made especially for fine-art printing', another article explained, 'and run at the slow speed of 350 revolutions per hour each press. They run with extreme smoothness, and almost without noise'.[57] R. Hoe & Co. was, to quote the company founder's son-in-law Henry Harper, 'the manufacturer since the 1840s of the machines that revolutionised the illustrated press'.[58]

The printing equipment sent from R. Hoe & Co. arrived in Sydney in the middle of 1886. One reason that the Atlas Company set up shop in Sydney was that Victorian trade levies made the cost of importing the equipment to Melbourne prohibitively expensive—another sign of how divided were the still-separate Australian colonies in 1888.[59] Most of the American artists were also in the country by June of that year; works by Schell were included in the display put together in August at the company's headquarters when Governor of New South Wales Lord Carrington visited.[60] By autumn of that year, the entire crew of American, Australian and various European artists, printers, technicians and writers were

in the country and beginning to sketch, write and collect photographs of scenery for further artistic production.

The aforementioned Harper's employee Frederic B. Schell was superintendent of the Art Department.[61] His colleagues from *Picturesque Canada*, Smedley and Fitler, joined him at some time during the summer. Horace Baker (1833–1918), another American who had worked for *Harper's* and had been chief of wood-engraving for *Frank Leslie's Illustrated Newspaper*, served as head of the *Atlas*'s Engraving Department.[62] The department consisted of Baker's own team, all of whom had previously worked in New York, at least eight Americans, one Italian and three Germans. Two Australians, the Collingridge brothers, also joined the wood-engravers. Overseeing the printing was M. E. Emrich, another American who had worked on *Picturesque Canada* and came originally from *Scribner's*. The *Sydney Morning Herald* praised Emrich as having 'achieved a reputation in America as a printer of artists' proofs … In his own department Mr. Emrich is decidedly an artist'.[63]

Conspicuously absent from this enormous undertaking was any active English contribution. As Hughes-d'Aeth puts it, 'while the American contribution was decisive—all the material, machinery and much of the expertise—the specific contribution "from England" was virtually nil'.[64] Even the mapmakers—unlike others in the Picturesque series, a distinctive part of the Australian volumes involved cartography—included draughtsmen from the United States.[65] The Australian planners of the *Atlas* were consciously aligning themselves with American approaches to publishing, commercial enterprise and modes of illustration, and meant to signify to potential purchasers of the volumes that the undertaking was striving for the most up-to-date methods of reproduction and the highest quality production values. Reviewers

recognised the project's 'conceptual audacity' in this respect and commented upon it in the Australian press even before the first fascicles in the series began to be produced. [66]

In contrast, for the written sections on Australian life, history and geography, the *Atlas* directors selected Australian journalists and writers. Only those who had experienced Australian culture directly were deemed capable of expressing the desired ideological stance for the text. Chief editor was Andrew Garran (1825–1901), a respected journalist and politician, who had an essentially titular role, just as the American poet William Cullen Bryant (1794–1878) had had with *Picturesque America*.[67]

While the written sections of the *Atlas* played a significant role in setting the ideological agenda to which the book aspired, its real *raison d'être*, the true focus of its intentions, resided in the illustrations and an explicit emphasis on the elaborate reproductive processes involved in producing the volumes. This makes an analysis of the images of Australia produced by the Americans all the more intriguing. Why and how were American artists, most of whom had only been in the country for a short while, entrusted with presenting a valid picture of Australia's natural wonders and urban landscapes to a largely homegrown audience?

Many Australian illustrators did make substantial contributions in specific depictions for the *Atlas*. Frank Mahony (1862–1916), considered a master illustrator of horses, was assigned to make 'action scenes' and re-enactments of historical events,[68] well-established artist Julian Ashton sketched in 'all the larger townships of Victoria, South Australia and Western Australia', particularly capturing 'picturesque' spots;[69] and a very young A. H. Fullwood (1863–1930) travelled throughout the country, and even to New Guinea and New Zealand, making landscape sketches and

collecting photographs that would become engravings for the *Atlas*.[70] (In an example of the competitive spirit with which the *Atlas* was imbued, Fullwood, who came to Australia from England at 18, wrote in his sketchbooks while on the road that he wanted 'to get through as soon as possible to show the Americans attached to the business I am engaged in that an Englishman can also get over ground'.[71]) One woman, the already renowned floral painter Ellis Rowan (1848–1922), was appointed in the initial hirings of Australian artists for the project and completed several images and ornamental frames of Australian flora. She later used her involvement with the *Atlas* and its company to promote further commissions, including ones in the United States.[72]

While many Australian artists did work on the project, the American trio of Schell, Smedley and Fitler nonetheless completed the most substantial number of the more elaborate depictions in the *Atlas*'s three volumes, including views of Australian cities and many images of its natural scenery. Frederic Schell created the majority of the full-page engraved plates of landscapes and urban scenes, including majestic depictions of such iconic Australian locations as the Jenolan Caves in New South Wales, *A sassafras gully on the Black Spur*, and Queensland's Darling Downs (see Fig. 3.17 on page 134). A collection of photographs acquired by Schell while in Australia proves that, in some cases, their works were produced from photographs that the artists embellished and then had made into engravings.[73]

One of the distinct achievements of the *Atlas* was the introduction to Australia of high-quality photo-engravings from photographs, made possible by the new printing equipment. While the American artists worked from photographs for some of their views, they also travelled through the other states to sketch on site. Schell, at least, also

went to New Zealand at some point. Smaller illustrations created by the Americans' hands, along with views based on photographs and reproductions of Australian artworks (Smedley copied a drawing by S. T. Gill and a scene of the Eureka Stockade), are integrated directly onto the pages of text throughout the volumes. This integration of text and illustration was the most vaunted achievement of the *Atlas*'s new printing presses.

The ease with which American artist–illustrators adapted to creating views of Australia for the *Atlas* speaks to the fact that the entire picturesque enterprise was not striving to display its accomplishment through artistic innovation or aesthetic modernism in its imagery. The Picturesque Atlas Co. intended rather to express Australia's progressive cultural status as a Western nation by showcasing the most technologically advanced processes of mechanical reproduction that the Picturesque series and the illustrated magazines in North America signified. What the Australian directors wanted from American artists was an application of their well-honed iconography of urbane sophistication and charming views to an Australian context.

The case of William T. Smedley, the most famous and prolific of the American illustrators to contribute to the *Atlas*'s pages, is particularly revealing. By the time he came to Sydney in the summer of 1886, Smedley was already a leading illustrator in New York City. In October 1886, a Sydney merchant and shareholder in the *Atlas* enterprise named H. S. Chipman sent a letter on behalf of The Picturesque Atlas Co. introducing Smedley to Joseph Syme, an editor at *The Age* in Melbourne.[74] Here he stated that 'Mr. Smedley is an artist of high reputation in America, many of his sketches having adorned the pages of *Scribners* and *Harper's Magazine* and other works of art'.[75]

Smedley was an inveterate clubman, an active participant in the genteel world of New

York high society that he illustrated. As one critic has written, 'Smedley's work pictures an elite, upper class society. Smedley's people are often dressed in the latest fashions, participating in activities appropriate to their privileged class … Smedley's people embody a social ideal: respectability'.[76] His views in the *Atlas* depict for the most part pleasantly composed scenes of the leisurely world of Victorian city life, rendered in an identifiable style that had already marked him as an exemplary 'narrative' illustrator. His rendition of *Saturday night in George Street* in the *Atlas*'s Sydney section demonstrates his best technique and his favoured motifs: elegantly dressed people stroll along illuminated arcades while horses and carriages provide 'bustle' and action in the middle ground. In the foreground are two of Smedley's slender-waisted women, seen in full-frontal silhouette walking toward the viewer.

This 'bustle' of modernity, as Hughes-d'Aeth calls it, had become by the time of the *Atlas* an important iconographic trope signi-

Fig. 3.10 Smedley and Fitler, *Pleasure grounds, Sydney*, in *Picturesque atlas*, vol. 1, opp. p. 317. Author's collection.

familiar through a gradualist approach that linked old concepts with new phenomena. Its hackneyed language promised to turn the urban realities of class disparity and ethnic hereogeneity into potentially pleasant aspects of the modern experience.[78]

In his *Pleasure grounds, Sydney*, Smedley, working with his friend and colleague W. C. Fitler, combined this iconography of bustle and the 'pleasant aspects' of city life with the graphic devices so beloved in the more artistically sophisticated publications of the period. Here several views are placed in one frame, distinguished as separate scenes by differing formats: the central roundel of the entrance to the botanic gardens by Fitler is superimposed on two scenes by Smedley of people at their leisure in the gardens and at Hyde Park. At the bottom of the picture is a small sketch of Frazer Drinking Fountain in Hyde Park, probably also by Fitler, which appears as if it were composed on a separate piece of paper pinned onto the other sheet, complete with the illusion of shadow beneath the curled edge of the paper. The artists' carefully constructed scenes with *trompe l'oeil* devices had to be transferred onto a block by the engraver, who then produced the final image for reproduction.

These 'visual tricks', with their intricately composed details and overlapping imagery, represented the height of the illustrators' and engravers' art in these last great volumes of the engraving era before photographic halftone processes came to dominate the print world.[79] The *Atlas* is rife with these kinds of illustrations, from 'illustrated flow diagrams'[80] depicting in several frames Australian industrial and agricultural processes, to photographic-like scenes in roundels surrounded by still-life ornamentation in another artistic style, and cleverly inserted vignettes amidst the text. These virtuosic exercises in graphic

fying urban picturesqueness.[77] Smedley and other illustrators sought to convey in their pictures the kind of transformation of the picturesque conception that was also occurring in literature of the time:

> In the emergent magazine culture of the late nineteenth century, the picturesque sought to make modernity less terrifying by making it

of office were published in 1835, and are still valuable.

OLD GOVERNMENT HOUSE.
PARRAMATTA.

OLD BARRACKS.

Astronomy, however, did not absorb the Governor's attention. Like most of his predecessors, he showed his interest in the work of

the principal officials.

cc
m
pe
W
of
ar
ec
in
18
af
pa
tii
ca
th
in
by
pa
th
fr
na
worth led the agitatioɪ

Fig. 3.11 A. Henry Fullwood, *Old Government House, Parramatta/Old Barracks*, in *Picturesque atlas*, vol. 1, p. 28. Author's collection.

experimentation conveyed to the viewer that Australia now possessed the most advanced printing capacities, able to produce artistic reproductions on a par with anything coming out of London or New York.

Smedley's images for the Melbourne section of the *Atlas* particularly reveal the shared aesthetic conventions that the global franchise of the Picturesque industry dispersed. That Smedley actually came to Melbourne and sketched directly on site is apparent in some of these images. His friend Fitler, described in newspaper accounts as a specialist in architectural views,[81] seems to have travelled through Victoria as well, although his illustrations are stiffer and less polished than Smedley's, giving the impression that some may have been produced entirely from photographs. While Smedley's rendering of the women working at the Melbourne Telephone Exchange is derived

from a photograph he overpainted, his sketch of the Public Library and the *Horse bazaar* appear to have been sketched on the spot, and were reproduced by a different photo-mechanical method.[82]

His larger depiction of *Collins Street on Sunday morning* is as artistically formulaic as any of his illustrations for stories in *Harper's* magazine, focusing on fashionably dressed couples, the women carrying parasols against the brilliant sun, streaming out of the Collins Street churches seen on the right hand side of the picture. All is gentility, prosperity and respectability on parade. These motifs, of elegant people walking along a street or garden path, mirror the kind of iconography of cosmopolitanism that Australian artists in Melbourne such as Tom Roberts (1856–1931) and the visiting English painter Charles Conder (1868–1909) were applying in their

SPRING STREET

Fig. 3.12 W. T. Smedley,
Spring Street, in
Picturesque atlas, vol. 1,
p. 235. Author's collection.

another favoured element, and one that is particularly cogent in relation to the Melbourne artists' iconographic predilections.[84] Here Smedley again depicted stylish figures walking and standing on a city street with substantial buildings placed diagonally along one side of the picture. But now he focused on the added visual illusion of rain shimmering on the ground, the figures' forms reflected in the pavement. Smedley had created this graphic impression of wet city surfaces in many earlier illustrations for New York magazine articles. As a sketch in his own notebooks demonstrate, dated from about 1884, the rendering of such atmospheric effects was a fascination for him at this time, no doubt a response to his own absorption of European impressionists' images then just being discussed and reproduced in art journals, and his own desire to be taken seriously as a painter rather than just as an illustrator.

What is particularly striking about Smedley's sketches is how closely his motifs coincide with those favoured at this time by the Heidelberg group of artists. This is especially true of the paintings done in the 1880s by Charles Conder. Conder, who was in Sydney at the time The Picturesque Atlas Publishing Company began its project, was part of the crowd of young artists there and studied with Julian Ashton and others working on the *Atlas*. Like them he frequently contributed while in Australia to what journalists referred to as the 'black and whites' such as the *Illustrated Sydney News*.[85] Conder met Tom Roberts—newly returned from his studies in Europe—through other members of Ashton's Art Society of New South Wales. Inspired by Roberts's ideas, Conder moved to Melbourne in 1888. There, in the few years until he left for England in 1890, he participated in the exciting aesthetic experimentation and lived 'the artist's life' that Roberts's circle considered so integral to their stylistic formulations.

'impressionistic' paintings and drawings at this time. In the years from 1886 to the early 1890s, Roberts, Conder, Frederick McCubbin (1855–1917), Arthur Streeton (1867–1943) and others now labelled as the 'Heidelberg School'[83] created quick sketches and painted impressions that often contain the motif, or a variation of the type, of upper-class people promenading along the same kind of streets that Smedley rendered for the *Atlas*.

Along with this repeated form, Smedley's *Spring Street* in the Melbourne section included

Two of Conder's most successful works focus on the effects of rain and atmospheric light. His painting, *The departure of the S.S. Orient – Circular Quay* (1888), shows figures on the quay carrying umbrellas in the rain, their forms reflected in the wet surface. Conder's method of painting is usually ascribed to the direct influence of the visiting Italian painter Girolamo Nerli (1863–1926), who also painted rainy scenes.[86] But Conder's figures could equally have been influenced by knowledge of Smedley's motifs and images he saw reproduced in *Harper's*. The Englishman's small study on a cigar-box top—part of the seminal 1889 *9 x 5* exhibition of the Melbourne group—is even more closely aligned to the content of Smedley's *Spring Street* and the American's earlier sketchbook drawing. Entitled *Going home (the gray and gold)* (1889), this scene portrays a fashionably dressed couple, he with walking stick, strolling along a rain-dappled street, a strong diagonal of the street receding into the distance, where clouds coloured by the rain create atmospheric hues.

This similarity in aesthetic motifs does not imply that the American illustrator Smedley directly or singlehandedly influenced the Melbourne artists, nor that Conder and Roberts were not inspired by the Italian Nerli's paintings. It does point to the fact that all of these ambitious young artists were expressing similar aesthetic values through their choice of subject matter and technique. They were inspired by the same artistic influences, whether experienced first-hand by study abroad or, more frequently, absorbed second-hand through reproduced illustrations in European and American magazines. It also indicates that artists of the time in Australia as well as in America relied on reproduced imagery for their understanding of what was considered modern in terms of fashionable subjects and up-to-date methods. They made

less aesthetic distinction between the so-called 'low art' of mechanically reproduced illustration and the 'high art' of painting than European artists did, since they were so dependent on reproduction to learn of contemporary aesthetic ideas. Even Roberts, the de facto spokesman of the Heidelberg School group, had supported himself in England by producing illustrations for the press; to quote one of his biographers, he 'would have been acutely aware of the inroads being made on the traditional domain of the painter/illustra-

Fig. 3.13 Charles Conder, *Going home (the gray and gold)*, 1889. Oil on wood panel, 40.7 x 28.7 cm. National Gallery of Australia, Canberra.

tor'.[87] While in Australia, Smedley came into contact with the whole range of Australian artists and participated in many artistic events. Letters in his papers indicate that he was an active member of the Art Society of New South Wales. At Smedley's departure from the country (he left in February 1887), the secretary of the society wrote to express the group's regret that 'a member of the Society' was leaving and requesting his support in their endeavours for greater recognition of the arts in the colony.[88]

The Australian artists' aims, along with their American counterparts, were to construct in their images and through their lifestyle an attitude of urbane sophistication. Their city scenes frequently depicted Victorians carrying out leisurely activity, the subject that was such an important visual trope in the late picturesque publications. The *Atlas*, through the subject matter of its reproduced illustrations, whether by Americans or others, sought to

link Australia with the most sophisticated, albeit socially *acceptable* and decidedly not bohemian, iconographic forms favoured by the Euro–American culture of which the Australian colonies were an integral, if geographically separated, part. The Americans Smedley, Fitler and Schell, along with the engravers such as Horace Baker, were emissaries of that world.

The major achievement of the *Picturesque atlas of Australasia* lies in its monumental existence. The organisers spared no cost (more than 60,000 pounds) to produce an enormous work of 'fine art printing' that could serve not only as an 'educational' work of art, but also as a promotional tool—a 'textbook'—for the idea of a unified Australia. Despite early pronouncements of an international campaign to advertise the books, in the end the subscription audience appeared to be largely homegrown, and the international press paid little heed. A few comments about the books appeared in London papers, but the New York press carried no reviews. Even *Harper's Weekly*, which later used Smedley's drawings to illustrate articles about Australia, made no mention of his work for the *Atlas*.[89] While more committed to a presentation of historic aspects than other of the Picturesque volumes—evident in its frequent inclusion of fanciful portraits of historical figures and reconstructed images of historical events, most of them done by William Macleod[90]—the majority of its illustrations fell within the prescribed iconography of picturesqueness as it was understood in the last decades of the nineteenth century.

On the other side of the Pacific, *Picturesque California*, the first segments of which appeared in 1888, is in some ways a more complicated production to decipher, graphically and ideologically. Part of the reason for this complexity arises from the fact that so little is known of its provenance. While the *Picturesque atlas of Australasia* was conceived, at least in theory,

Fig. 3.14 Title page, *Picturesque California*, 1888. Courtesy of The Huntington Library, San Marino, California.

as an aesthetic tool educating its readers about Australian history and as a beautiful weapon in a grand national cause, its counterpart in California appears to have grown initially out of more commercial aims. Despite its announced aversion to 'booster' language, its promotional aspirations were nonetheless just as ideologically driven as the *Atlas* project. The enterprise was the brainchild of a San Francisco shopkeeper named James Dewing (c. 1846–1902) who decided to cash in on the popularity of the picturesque publications by highlighting the scenic glories of California and the other states west of the Rockies; the volumes even included sections on western Canada and Alaska. The initial intentions, then, originated in the same sense of regional pride and the desire to satisfy a public—prospective immigrants as well as armchair travellers and tourists—hungry for images of the American West. The many versions of *Picturesque California* produced between 1888 and 1894 exemplify the graphic confusion of work during this period of transformation in printing technologies. They also speak to the public's growing desire—or at least the publisher's perception of the public's desire—for profusion as well as novelty in their illustrated books at the end of the century.[91]

According to a promotional article for The J. Dewing Company that appeared in the *San Francisco Chronicle* in December 1889, 'The Dewing brothers commenced a small subscription book business in 1860 and now do what is perhaps the largest business in that line on the Pacific coast.'[92] The article, which included a picture of the Dewing establishment 'in the Flood building', went on to explain that the company had expanded to include a piano factory and 'art rooms' along with its bookselling enterprises. A colour lithographed trade card from about this time, produced by San Francisco printers, portrays a woman in 'Japonesque' costume on the front, and on the

back touts the company's 'Rare Art works and Etchings', as well as juvenile books, greeting cards, albums and pianos. Clearly The J. Dewing Company was seeking to compete with San Francisco's unique and much beloved emporium S. & G. Gump Co., always known as Gump's, which by the time of Dewing's project had become a leading importer of Asian art and artefacts and supplied most of the West Coast wealthy classes with artworks and other finery.[93]

Dewing's had incorporated in 1887 for the purpose of producing art books, their crowning achievement being *Picturesque California* (in 1888, it also published a *Society Directory* for San Francisco).[94] In effusive prose, the newspaper article mentioned above described:

> [T]he company's widely known and beautiful publication, *Picturesque California*, which, though absolutely free from even the suspicion of advertising, is credited with having done more to make California widely and favorably known than all the direct advertising matter yet issued. The work is already about two-thirds issued. Two years ago an art printing establishment was opened by the company in New York city for the issuance of this work, and through it has become known even beyond the sea as well as in every State and Territory of the Union.[95]

The Dewing brothers, then, wanted to stress that the book was more than just cheaply produced tourist promotion, and that, by virtue of its being printed in New York, it would exemplify the highest standards of art printing that could be attained at that time. Australian publishers in 1888 had sought respectability and evidence of technological superiority by importing American artists and printers for the *Atlas*. At the same time, a Californian publisher with high aesthetic aspirations still felt that he needed the imprimatur of a New

York address and the capacities of East Coast printing equipment to assure potential readers that the publication would achieve a high level of artistic polish. While San Francisco did have by the 1880s the beginnings of a fine-art printing industry, the scale of the *Picturesque California* project was probably still beyond the scope of local establishments, although later editions relied in part on printers in the city.

Dewing's initial intentions were lofty ones: to use the cachet that the New York engravers and illustrators had acquired in the decades after the Civil War to sell their own illustrated books. As the *Picturesque California* project progressed, these aspirations would be affected not only by the transformation of the printing industry and Dewing's own bungling of finances, but also by marketing forces tied to the burgeoning tourist trade in California.

How John Muir, already a leading advocate for the preservation of Yosemite and California's other natural wonders, was persuaded to become the chief editor for *Picturesque California* remains a mystery. In 1887, when the project began, Muir had been in California for nearly 20 years and was already known for his passionate writing in praise of the sublime beauty of the Western wilderness; but he was not yet the venerated figure that he would become in later years. William L. Oge, a leading San Francisco attorney and secretary of The J. Dewing Company, may have known Muir through Bohemian Club circles and recommended him to James Dewing (Oge wrote the section on 'Monterey to Ventura' for *Picturesque California*).[96] In a letter from the company to Muir dated 5 September 1887, urgently asking for more copy 'for Passes' (referring to the Sierra's famous mountain passes, which constituted a separate section in the book), the Dewing employee requests that he 'write again that little discription [*sic*] of yourself—

the other has been mislaid', indicating that he was not yet a well-known entity for the firm.[97]

According to a 1974 reprint of *Picturesque California*, Muir was the instigator of the project:

> Evidently, Muir hit upon the idea of putting together a series of articles for a national magazine, written by knowledgeable observers, in which the features and life forms of each of the regions west of the Rockies would be described. He convinced an editor to undertake the project, of which Muir became the enthusiastic overseer.[98]

This assertion contradicts Muir's own remarks in letters he later wrote to the volume's contributors; but unlike the titular editors for previous Picturesque volumes, Muir was an active participant in the production of *Picturesque California*. He recruited his old friend Jeanne C. Carr (1826–1903) to write the section on Southern California and he personally travelled to the Pacific North-West, Canada and Alaska to gather information for the text on those parts of the region. In the end, he wrote six chapters for the book, including a magisterial entry based on earlier writings about his beloved Yosemite Valley. He was also instrumental in securing for the publication the services of his friend, the 'Dean of California painters' William Keith (1838–1911), and corresponded with other artists who contributed to the book, including another well-known California artist Thomas Hill (1829–1908).[99] In the summer of 1888, he travelled with Keith throughout the north-west in conjunction with the writing of the book.[100] Muir's close connections with California's leading literary and artistic figures enabled The J. Dewing Company, a relatively new entity in the Californian publishing world, to attract many prominent Westerners, both

writers and artists, to work on the project. As Sue Rainey has written, 'it was the first major illustrated work on the West produced primarily by westerners'.[101] Other prominent figures to contribute to the publication were the flamboyant San Francisco poet–writer Joaquin Miller; renowned landscape painter and illustrator of the West, Thomas Moran (1837–1926); the pre-eminent painter of cowboys, Indians and Western scenes, Frederic Remington (1861–1909); Californian Charles Howard Shinn (1852–1924), who had written extensively about mining in the state; San Francisco literary critic George Hamlin Fitch (1852–1915); Southern Californian booster T. S. Van Dyke (1840–1923); and widely published naturalist of the Rocky Mountains, Ernest Ingersoll (1852–1946).

The inclusion in *Picturesque California* of the work of F. O. C. Darley (1822–1888)—he provided, along with large plates, the icon of the grizzly bear on the book's title page—signals the publishers' artistic intentions most clearly. English-born Darley was in the 1840s and 1850s 'the most popular, most productive, and best illustrator of his generation … For the first twenty-five years of his career, the phrase "illustrated by Darley" on the title page virtually assured the success of a book'.[102] Darley died while *Picturesque California* was in production; but his popular iconography of frontier life, replete with mountain men, Indians and wild animals, embellished many of the book's pages, representing a significant strand in the visual construction of the West.[103]

Darley's conception of the West, however, was already dated by the time *Picturesque California* appeared; other artistic and literary directions, more in keeping with the representation of agrarian settlement then taking place in the state, were more prevalent modes in the book. In October 1887, Muir wrote to Jeanne C. Carr, wife of Muir's teacher in Wisconsin,

Dr Ezra Carr, and herself a devoted naturalist settled then in Pasadena at her showplace property Carmelita.[104] He enjoined her to write about the Southern California that she knew so well. His description to her of the project provides the most detailed information about the aims of the publication as Muir understood them:

> *Picturesque America* is about the style and kind of stuff required. Nothing that savors in the least of advertising booming, etc. can be allowed, but latitude wide as you please in picturesque description and choice of objects. Should have abundance of flowery brush, birds, bears, priests of the olden time, adobes gray, old oaks. Old Spanish life but still more fully should the life, Yankee life of to-day in its picturesque aspects be portrayed. Olive orchards, orange, nut trees, vineyards, groups of gatherers of the sunny harvests, views of the main towns, etc., etc. I guess you know what I mean. No scent, flavor, savor of commercial advertisement or any sort of favoritism as to places written or pictured. What a bright appreciative traveler would like to see and hear is what is wanted as near as I can make out.[105]

Here Muir already defines the emerging iconography of Southern California, prescribing a template for the visual and literary motifs that would determine the popular aesthetic idea of California into the twentieth century.

In this letter and later ones, Muir also requested photographs from Carr, to be used by the artists and engravers for illustrations. Mrs Carr must have followed through on this request, for in November 1887, M. S. Dewing—James's brother—wrote thanking her for the photographs she had provided. 'The Photos you sent are very pretty', Dewing wrote:

> We shall always require newness and origin-

ality. While we must have the best pictures or photos of the principal subjects, we shall require to make all such things have a degree of rich freshness which shall do credit to our undertaking.[106]

From the beginning of their *Picturesque California* project in 1887, the main object of the Dewing firm was to render artistic style and modernity by an emphasis on printing processes. They pulled out all the stops in producing the book, employing every modern printing technique then possible and that included the latest photo-mechanical methods. Their purpose was to 'sell' the region through an integration of knowledgeable text and profuse illustrations in a variety of mediums that they hoped would appeal to the public's increasing demand for innovative graphic effects.

The variety of illustrative methods evident in the Dewing production—used, as Rainey writes, to 'aestheticize' the West[107]—is what makes a comparison with its exact contemporary, the *Picturesque atlas*, such a revelation. While the Australian publishers could not have known it at the time, their *Atlas*, employing the most skilled craftsmen and the highest quality of reproducible methods available to them, stands as the last great Picturesque publication in the great era of engraving. The artists of the Australian project at times used photographs along with drawings as sources for the engraved illustrations and sometimes varied technique within this medium; but as a whole, the *Atlas* presented a cohesive aesthetic experience dependent entirely on black-and-white engravings, either as single elegant pages surrounded by pastel-coloured ornamental frames, or as smaller illustrations integrated artistically into the text.

In contrast, as the segments of *Picturesque California* appeared over several years, this same sense of artistic harmony disappeared into a visual hodgepodge of graphic styles and effects. As a means of showing off their slick

Fig. 3.15 *Interior of the old El Carmel Mission./'Cassiano', the Mission Indian, supposed to be 136 years old*, in *Picturesque California*, vol. 1, p. 36. Courtesy of The Huntington Library, San Marino, California.

Sleepy as the old town looks in its mid-day siesta, it has had a stirring history. It was founded by Junipero Serra, the leader of the Franciscan monks, who established a chain of missions along the Californian coast, and for fifty years created there the idyllic pastoral life, now seen only in the poet's dream of Arcadia. The Bay of Monterey witnessed the arrival of stout Spanish troopers from Mexico, the building of a rude fort on the hill that overlooks the town, and the establishment of the seat of government of Alta California.

INTERIOR OF THE OLD EL CARMEL MISSION.
"CASSIANO." THE MISSION INDIAN, SUPPOSED TO BE 136 YEARS OLD.

Then came the American adventurers under Fremont, the turmoil that preceded the Mexican war, the seizure of Monterey by the American troops and marines, and the conversion of the place into the capital of the new American territory. This was the heyday of Monterey's prosperity. General Fremont made his headquarters in the low-browed log house on the hill, now so quaint in its ruin, and cannon bristled from the old fort—

modishness, the book's designers attempted to reproduce the images using modern photo-mechanical processes, producing what author Estelle Jussim labels a 'kind of menagerie of the media'.[108] The majority of small images inserted within the text were wood-engravings or photo-engravings—many exhibiting the same kind of framing devices and *trompe l'oeil* effects used in the *Atlas*. But most of the showcased plates reproducing the artists' paintings and drawings were photogravures, a photographic process that allowed monochrome prints to be made of paintings or photographs themselves.

Photogravure, although a short-lived process, was initially seen as a major repro-ductive breakthrough, because artists were no longer dependent on the engravers' interpre-tative skills.[109] To modern eyes, these plates often appear muddy, undifferentiated and dull; but artists as good as Remington considered the process a great improvement over wood-engravings, because there was no intrusion by 'clumsy' woodcarvers.[110] Artist-illustra-tors such as Remington and Smedley were great champions of the new photographic processes at the end of the nineteenth century, believing that their work as artists could be more faithfully reproduced with these photo-mechanical methods. Such sentiments, along with economic decisions that favoured photo-graphic reproduction, were the death knell for wood-engravers who had been so instrumental in putting American illustrated publications at the forefront of international graphic art.

Other methods represented in *Picturesque California* included 15 original etchings as full-blown plates; and, most significantly, true photographic halftones, both of artworks and of photographs themselves (although no pho-tographer is ever identified by name). Some illustrations awkwardly combined all of these techniques into one mishmashed plate or as overlapping images inserted onto a page of text; these composites were often 'visually

his choice of the spot where first to sink his pick, for so much depends on this; and no man, if the party is experienced in prospecting, ever intrudes a word upon the leader at such a moment. At length the man fixed his eyes on a little spot down the stream, and stepping briskly forward buried his pick to the handle in a place where he did not break a single lily or even disturb or soil the singing water. And that is all there is to say of this silent man, this Argonaut; he did not crush a single flower or disturb a single note in the long, lone melody of the waters, singing only for Him who divided the waters from the dry land. And there was one there who loved him as a brother for that. And how he wrestled then, and grappled with his work! He took the shovel from the man at hand, as he stood there, knee-deep in the loosened soil, and threw

ambiguous' and aesthetically incompatible.[111] Added to this mixing of techniques was the application of coloured inks for some of the plates and smaller illustrations. Many photo-gravure plates were tinted blue or sepia, and smaller illustrations appeared in red, blue and orange-brown ink. The tissued letterpress pages in front of the earliest photogravures in the first volume included a small motif of the painting and an excerpt from the relevant text as caption, all printed in red. This device dis-appeared as printing progressed—no captions or coloured motifs appeared on the later tissue papers with titles of the photogravures in most of the later editions. These omissions are

Fig. 3.16 *Plate of hydraulic mining, Bear Valley*, in *Picturesque California*, 1888, pt. 5, p. 235. Courtesy of The Huntington Library, San Marino, California.

perhaps evidence that The J. Dewing Company was beginning to have difficulties keeping up an artistic level of production. The implementation of colour tones nonetheless continued throughout the earlier editions of the volumes: a halftone reproduction of *Among the orange groves – the golden harvest* by W. C. Fitler (the same Fitler who had travelled to Australia to work on the *Atlas*) appeared in one of the better edition printings in an orange-brown tone; and a reproduction of a painting by the California artist Julian Rix was printed in the deluxe versions in purple.

While these mixed graphic effects and coloured additions were at times misguided, aesthetically jarring and visually incongruous, they represented the best efforts of the publisher to take advantage of the changing methods of reproduction that would, in only a few more years, entirely eliminate the need for the labour-intensive efforts of skilled engravers. Innovative originality in printing was the one aspect of the publication highly commended by reviewers. The first review in *Overland Monthly*, appearing in 1888 when only a few of the sections had been completed, took the opportunity to discuss the relative merits of these new techniques in reproducing paintings:

> The atmospheric effects, the appearance of work by masses of color laid on with a brush, instead of by line, could not be achieved by a cutting tool in hard material. Nothing can ever supersede engraving for clear and strong rendering of subjects where detail is wanted— for realistic work; and all paintings would not be adapted to this photogravure: but for reproducing painting broadly and simply done, with a good deal of '*motif*' and atmosphere, the result is really remarkable … In the India proofs, and still more in some satin prints that accompany the most expensive editions, it has also a peculiar silky delicacy of surface that is very pretty, and

oddly enough, seems to interfere very little with the strong paint-like look of the lights and shades. They are printed not only in black, but in various shades of brown, and some in other colors—reds and greens, but all well-chosen, rich shades, so that the fancy is quite pretty and decorative.[112]

The efforts made to integrate visual and textual elements on a single page reveal as well the first signs of development of a new field of arts production—coordinated graphic design, in which the illustrations, type fonts and page layout were an integral part of the entire production process.

Finally, the numerous designs for covers and frontispieces of the various bound versions of *Picturesque California* give sometimes amusing evidence of the publisher's attempts to create an appropriately Californian aesthetic that would sell the book.[113] A 'Connoisseur Edition', a numbered set replete with duplicated separate plates in mounts, had the photogravures printed on silk and even pasted in some of the smaller plates produced in various colours. Its first frontispiece, also tipped in, consisted of a full-scale version of F. O. C. Darley's grizzly bear straddling a log—the same motif of California that would appear as a small icon on the title page of all of *Picturesque California*'s many editions. Another deluxe edition portrayed on its frontispiece, again printed on silk, a diaphanously clad semi-nude sprite—a personification of California—standing on a rock by rushing water holding gold that beams down on three miners; in the background, emblematic elements of high mountains and pine forests. Other covers contained versions of a Julian Rix landscape incorporating the mountains, lake and pine trees of the Sierras with palm trees and Spanish churches of the South, over which was superimposed a diamond-framed rendering of a mission in ruins. Publishers and

artists alike had not yet settled on the image of California or the graphic style that they wished to project as emblematic of the region, and so experimented with a variety of visual interpretations and typography.

These variations in editions also related to the grade of paper used in the book's many versions, a factor tied to the volume's price. As the publisher's costs mounted and the need for sales increased, the volumes became less luxurious until the last edition, in 1894, added many more halftone reproductions and used the cheapest paper. The product was still copiously illustrated and used most of the original plates; it even added photographic reproductions of popular tourist sites. But this once grand artistic venture had now joined the ranks of mass-market magazines or tourist brochures.

Despite the difference in artistic quality between the *Picturesque atlas* and *Picturesque California,* a comparison of their icono-graphic modes—the visual manifestations of their ideological message—still reveals intrigu-ing intersections in the cultural attitudes that both linked and separated these two regions on the Pacific Rim. Stylistically, both produc-tions demonstrate an adherence to the most acceptable categories of the picturesque in High Victorian illustrated art. Landscapes in the *Atlas* emphasised Australia's wild nature with waterfalls, tall trees and rocky scenes, but just as often recorded these as views that could comfortably be visited by tourists seeking a pleasant vista or hiking destination on a day's excursion. Recognisably indigenous flora and fauna were sometimes included in these views but usually displayed as part of ornamental arrangements framing some scene of work or activity by the white settlers of the continent—so as a controlled aspect of a pro-ductive Western-oriented society.

Towering eucalypt specimens did occasion-ally appear as evidence of Australia's most

Fig. 3.17 Frederic Schell, *Sassafras Gully,* in *Picturesque atlas,* vol. 1, opp. p. 121. Author's collection.

famous tree but these were usually delineated within the context of standard picturesque compositions of 'the bush', with little precise distinction made of species type. The American Schell, perhaps cognisant of the well-docu-mented competitive claims between redwoods and eucalypts as the world's tallest trees, often seemed intent on emphasising their size in his landscapes.[114] Urban scenes of promenades and public gardens downplayed the specific nature of the vegetation, highlighting instead natural settings of the cities that had been thoroughly domesticated with 'English' plants

and European approaches to garden design. In most cases, the purpose of the pictures of the landscape was to demonstrate how securely Westernised Australian culture had become by virtue of the settlers' cultivation of the land (see fig 3.10 on page 123).

In *Picturesque California*, big trees, mountains and rushing water were also given prominent iconographic status in the views of the state's most well-known tourist sites such

as Yosemite and Mount Shasta, and many plates concentrated on majestic visions of wilderness already popularised through the romantic paintings of Albert Bierstadt and Thomas Moran. The sublimity of California's mountains was, of course, the main theme of Muir's text, and many of the images mirrored his grandiose expressions. The use of photographs as artistically valid representations of this landscape seemed to concern the editors of the book as it had the editors of the *Picturesque atlas*: despite the fact that the awe-inspiring photographs of Yosemite by Eadweard Muybridge and Carleton Watkins would have already been known to many readers in the late 1880s, *Picturesque California* contains only one photographic reproduction of the valley's famous sites and the photographer is not identified.[115] Paintings, no matter how unsatisfactory the methods for reproducing them, were still considered the only medium acceptable to denote a publication as artistic.

This emphasis on the region's natural beauty was only one of the concepts about the West that the editors wanted to nurture. As Rainey states, '[t]he primary theme of *Picturesque California* is a dual one: that these western regions contain both countless natural wonders—surpassing those of the East—and impressive works of civilization'.[116] Scenes in the cities and towns focused on California's salubrious climate and geography through the inclusion of palm trees, cactus, yucca plants and other emblems of a semi-tropical landscape. But these views most often depicted typically Victorian couples placed in the landscape, complete with parasols and elegantly dressed, walking on well-tended garden paths. The important message conveyed was that California's land, no matter how tropical, majestic or lush, had been contained and controlled by white settlers.

One of the most telling of these urban views is a full-page photogravure titled *Eucalyptus*

Avenue, captioned on its letterpress page as 'From a PAINTING by W. C. Fitler.' The caption describes this 'Avenue', meant to be in the new Los Angeles suburb of Inglewood, as 'wisely chosen where grand avenues of eucalyptus and pepper trees are already grown, and citrus orchards are in full bearing'.[117] The eucalypts as Fitler depicted them here lose clarity in the reproduction but are detailed enough to emphasise a gum tree's characteristic bark and spindly leaves (they are probably meant to be blue gums, *Eucalyptus globulus*, the most widely cultivated of the trees in California). What is most striking about the scene is that these Australian natives, planted in California less than 30 years before, serve the same function in this scene of 1880s Los Angeles as the generically 'European' trees in the *Atlas*'s views of Melbourne or Sydney gardens do: they provide a shaded *allee* for a genteel promenade of carriages and strollers and indicate that cultivation of the land has brought civilisation to once wild places. This new city of the Pacific West, then, is portrayed as having artificially constructed nature spots equalling anything in London, Vienna or Paris.

The landscape motifs throughout *Picturesque California* include all of the markers of gentility and references to familiar Victorian leisure activity, thus assuring viewers that California was a place where respectable people could live.[118] That the gum trees, identified by name, are more readily incorporated into a Californian version of the urban picturesque than they are in scenes in their native home is an ironic indication of the importance of this introduced species in the constructed image of an increasingly Anglo culture on America's Pacific coast. That Australians were less likely at this time to highlight their dominant native tree verifies Tim Bonyhady's assertions in his book *The colonial earth* that in 1888 most citizens of the antipodean colonies still con-

Fig. 3.19 W. C. Fitler, *Eucalyptus Avenue*, in *Picturesque California*, vol. 1, opp. p. 132. Courtesy of The Huntington Library, San Marino, California.

sidered the gum tree 'unpicturesque', if not downright 'ugly'.[119]

Further comparisons of the depictions of specific places in the *Atlas* and in *Picturesque California* reveal how formulaic, indeed how hackneyed, the picturesque devices had become by the late 1880s. An engraving of Parramatta by A. H. Fullwood and a large-plate photogravure of Los Angeles from a painting by Thomas Hill, for example, convey specific details about each location— intended to be recognisably of the place. (The caption on the letterpress of Hill's painting quotes the text, 'Los Angeles, new and old, dense and straggling, growing out over a hundred hills, presents a shifting and bewildering panorama'.) The church spires and buildings with billowing chimneys, the identifiable physical features of the setting and the delineation of singular vegetation (a Parramatta garden has a banana tree and ferns, in Los Angeles the hillside has palms, cacti and yucca)—these are visual details

PARRAMATTA.

meant to impart specific geographical information. Yet the compositional conventions in both pictures are nearly identical: both are depicted as if from above looking down onto a height and into the distance, trees and shrubs are bunched together in the foreground at the sides and strolling figures are shown walking on pathways rendered perspectivally. The women strollers in both scenes carry parasols, that picturesque trope of pleasurable walking in the Victorian era.

These picturesque formulas were not difficult to apply to the depictions of the more 'European' aspects in both of these new societies, to pleasing scenery and the development of cities and industry. But the volumes' representations of their regions' original inhabitants provide intriguing, if to modern eyes sometimes distressing, points of comparison and difference. In the *Atlas*, Aboriginal people are most often presented as anthropological specimens, in which case the images used derive most clearly and identifiably from photographs. That the photographers of these photographs are named as the creators of the images is unusual in the *Atlas*'s pages. The only other photographer to be named made a telescopic photograph of the moon—another scientific specimen. As Hughes-d'Aeth writes, 'A desire for scientific exactitude' determined this decision: 'The mimetic aura of the scientific photograph ... may well have been drawn upon by the editors of the *Atlas* in order to constitute Aboriginality as an 'object-sphere' of the science of anthropology.'[120]

The only other renderings of Aboriginal people included in the volumes are without exception ideologically loaded ones, in which the natives are presented carrying out the actions of 'savages', either attacking famous white men or, in one famous example, being attacked by one of their own.[121] Frank Mahony, the *Atlas*'s specialist in the illustration of animals, created this unfortunate narrative view to accompany

AN ABORIGINAL WOMAN.
From a photograph by J. W. Lindt.

Fig. 3.22 *An Aboriginal woman. From a photograph by J. W. Lindt*, photo-engraving by W. Hirschmann, in *Picturesque atlas*, vol. 1, p. 347. Author's collection.

William Traill's bluntly racist text on the colony of Queensland. Mahony portrays a native tracker gleefully shooting at a fleeing 'tribal' Aboriginal man. Mahony conveniently turned this action scene—stylistically aligned with his drawing in the same section of a jackaroo rounding up a steer—into one of 'black on black' violence.[122] Indigenous people, then, were presented either as wild animals on a par with cattle, or as examples of a dying race whose members had to be recorded for science before they disappeared.

The editors of *Picturesque California* chose a more subtle, yet similarly self-conscious, strategy in their visual characterisation of Native Americans. Aware of the need to demonstrate that California was no longer the wild frontier of dime-novel myth, they nonetheless vacillated between the already popular iconography of cowboys and Indians that F. O. C. Darley and Frederic Remington represented, and a more comforting vision of Indians as they lived then in a settled, contemporary Western United States. The predominant image of Indians that *Picturesque California*

Fig. 3.23 A. I. Keller, *Indian Squaws gathering berries*, in *Picturesque California*, vol. 1, p. 24. Courtesy of The Huntington Library, San Marino, California.

projected was one of an emasculated domesticity. The only cowboys shown in action are either branding cattle, trading or chasing rabbits in the San Joaquin Valley (see Fig. 3.24 on page 140). For Native American people the editors overwhelmingly selected images that portrayed women and children, usually sitting quietly or collecting food. Seldom are men portrayed, and if they are, they are usually seen as very old men or involved in benign activities such as fishing. The visual message was a reassuring one for travellers and prospective settlers: Indians posed no threat to the white community in the West. The text for these sections also portrayed the Indians as entirely subdued, sometimes degraded and, at best, part of the region's romantic past.

Editorial decisions in both publications about the depiction of other ethnicities reveal their concerted effort to construct a visual and textual narrative that the editors hoped would appeal to the books' intended audiences. Australia presented itself in the *Atlas* as an entirely 'English' society, despite the fact that Chinese and other ethnic groups had been part of its population since the beginning of European settlement; as the previous chapter demonstrates, a Chinatown in Melbourne was by the 1880s as 'authentic' and colourful as similar enclaves in San Francisco and New York.[123]

California at the time was already well-known for its 'exotic' populations, widely publicised and illustrated back East and around the world in magazines and books. Mrs Frank Leslie (1828–1914), for one, wife of the founder of *Frank Leslie's Illustrated Newspaper*, described San Francisco's Chinatown with fascinated approbation in the 'profusely illustrated' 1877 account of her trip out West,

Fig. 3.24 Frederic Remington, *Branding cattle (an incident of ranch life)*, in *Picturesque California*, opp. p. 184. Courtesy of The Huntington Library, San Marino, California.

California: A pleasure trip from Gotham to the Golden Gate.[124] Since the railroad publications and tourist enterprises promoting travel to the West had already focused romanticised attention on these 'other' Californians, *Picturesque California* naturally had to include some visual representations of these groups. Chinese children and merchants appeared in the illustrations for Joaquin Miller's section on the city, portrayed as suitably exotic in native clothing and with characteristic pigtail, surrounded in shops and temples by oriental objects. Some smaller illustrations in other sections also emphasised their participation in fishing and agricultural activities in the state, thus placing them as picturesque elements within the landscape. The passages of text discussing the Chinese were more ambivalent in their characterisations. While the decade had seen virulent anti-Chinese sentiment resulting in the enactment of the *Chinese Exclusion Act* in 1882, their presence in the state still called for visual portrayals that added narrative colour to the story of California being presented to a local and out-of-state audience.

Picturesque California had another, even richer, source for images of ethnic diversity. California's Spanish–Mexican past had already become pivotal to the picturesque formulation of the state's aesthetic iconography. The popularisation of this past was for the Anglo editors of the volumes 'a past cloaked in nostalgia', a chance to formulate 'the Spanish Fantasy Past', as William Deverell describes it.[125] The image-making opportunities presented by this aspect of the state's history had been brought into focus most spectacularly by Helen Hunt Jackson's book *Ramona*. The tourist craze with accompanying images sparked by the novel's publication was already under way by the time Muir's volumes appeared. The smaller illustrations in *Picturesque California* emphasised charming ruins of original Mexican-era adobes as evidence that such remnants of old architecture could be seen by anyone coming to visit the region. Depictions of the Franciscan

missions were either rendered as quaint scenes incorporating Mexican *paisanos* and women in native costume, or conspicuously displayed well-dressed tourists visiting sites such as Mission San Juan Capistrano (see Fig. 3.15 on page 131). As Sue Rainey says, these locations were presented as an 'alternative to foreign travel'.[126]

The portrayal of 'Spanish Californians' presented a more difficult problem, for the editors needed to downplay the actualities of present-day Mexicans in the region, while still nurturing an inviting idea of accessible and 'authentic' picturesqueness. As Los Angeles's great chronicler Carey McWilliams put it in 1946, '[b]y 1885, the Mexicans had become a picturesque element, rather than a functional part, of the social life and economy of the region'—but they were still there.[127] Identifiably Hispanic figures appeared in Carr's section of the book as part of a romanticised narrative: dancing, playing instruments, making food and dressed in exotic costumes—the preferred Anglo impression of 'Old California' that McWilliams so memorably described as 'one big happy guitar-twanging family'.[128]

Picturesque California contains its requisite share of depictions of dancing and music-making Mexicans. One extraordinary vignette integrated into the text about Los Angeles pictures Spanish women alluringly sequestered, as if encaged like birds behind the elegant iron grillwork of a Spanish adobe's window. One photogravure titled *Under the fan palms (types of early days in Los Angeles)* by a mediocre genre artist named Albert E. Sterner (1863–1946) demonstrates how clearly the stereotypical tourist image of Spanish California was already beginning to fall into place. The standardised motifs of dark-haired girls with shawls and full skirts standing in bright sunlight next to a quaint little burro with palm trees or other tropical vegetation prominently displayed in the landscape seem to have been taken directly from the well-established imagery of 'Mediterranean' types that had already proliferated in European genre paintings of Italians for the tourist trade. The specific iconography of Spanish California was not yet entirely distinct from a more generalised conception of 'the Mediterranean'—Charles Dudley Warner's book on Southern California entitled *Our Italy* appeared in 1891—but the process of creating the visual template of Spanish–Americanness as a positive part of the image of California, with stereotypical motifs promoting 'the aesthetics of living', was well

Fig. 3.25 A. I. Hencke, *A vision through the trellised vine*, in *Picturesque California*, vol. 1, p. 129. Courtesy of The Huntington Library, San Marino, California.

PICTURESQUE CALIFORNIA. 129

vines (where ruby-throated humming birds bathed in the spray of the fountain,) perchance he saw the hostess preparing his breakfast of coffee and tortillas, or the more appetizing "tamales." There was no hurry, no bustle—Angeleños might labor; they never toiled.

There was much informal visiting, and whatever the number of guests none lacked a cordial welcome. After the early dinner came the *siesta*. There was never a word about poor crops or bad investments; the sun was the bank, and had never failed. The family circle gathered on the wide veranda, where the guest was entertained with stories of pioneer experience, or took part in a dance to the music of the ever present guitar. The moon was their familiar friend and they made the most of her company.

Outside of the single business street and straggling lanes of the old *Pueblo*, one might easily lose himself for days or weeks in a wilderness of vineyards and groves of walnut and orange trees. The waters of the Los Angeles river were conveyed through every plantation by *zangas*, or distributing canals; flowing with a speed of five miles an hour, these streams were an important element among the homestead charms. The leafless walnut trees, with their silvery trunks and intricate net work of branches, relieved the monotony of the orange groves; and frequent patches of blooming almond trees were a foretaste of celestial gardens.

In Tustin one may still enjoy the delightful sense of solitude and society under corresponding natural conditions; but nowhere in Los Angeles is there a representative home of the period when it was the capital of California. Many of the old houses remain, full of interesting mementoes of the vanished social life, heirlooms brought from Spain and Mexico; but they have lost their setting. The Coronel and Wolfskill homesteads and orchards are impressively suggestive of the wonderful changes which have overtaken the city. The first orange trees in Los Angeles were planted by Louis Vignes, from trees obtained at the San Gabriel Mission. The Wolfskill orchard was started in 1841, and increasing year by year, soon became the largest in the country. In 1867 the orange crop of Los Angeles and San Gabriel was valued at over half a million dollars. In 1872 the average product of the oldest trees was two thousand to the tree; of the younger, eight hundred. The Wolfskill residence was typical. Its low roof was overhung with vines, and hedges of myrtle and pomegranate defined the private gardens. Certain orange trees which produced the choicest fruit were sacred to hospitality; so were the magnolias and other flowering exotics. No place in California has a more fascinating story. After having furnished an important chapter in the industrial development of the country, it is numbered among departed blessings; and the Wolfskill railroad station is its monument.

The mother vine, *vina madre*, was also found at San Gabriel. To it the fathers had brought vine slips of a Spanish variety, now universally known as the Mission grape. While these were growing, *aguardiente* was manufactured from the wild grapes of the country. In 1831 this pioneer vineyard contained 50,000 vines, and 50,000 more had been distributed among the Indian *rancherias*. Little was known of these growing industries in the Atlantic States until 1857, when Mr. H. D. Barrows of Los Angeles presented President Buchanan with a representative collection of fruits and vines.

How these products spread and drew attention to the fertility of the country is shown by the fact that in 1883-4 there were 350,000 bearing orange trees in Los Angeles County, and 6,000,000 vines. San Gabriel had the largest vinery in the world, and the town of Florence the largest

A VISION THROUGH THE TRELLISED VINE.

under way by this time.[129]

As the editors of these two monumental productions had envisioned their projects, the story being told in text and in pictures was meant to appeal to middle-class, upwardly mobile consumers, themselves participants in the cultural transformations of these societies developing on the edge of their home cultures. The earliest promotional materials for the *Atlas* and *Picturesque California* may have had aspirations of an international audience but in the end both seemed to have had little promotional impact outside of their local regions. Responses to Dewing's Californian volumes were even more locally confined than were the notices of the *Atlas*. The *San Francisco Chronicle* and *Overland Monthly* carried reviews as the various fascicles appeared and the *Los Angeles Times* provided lengthy excerpts from the Southern Californian sections, praising 'this excelsior work, preëminent for its typographical excellence and the number and beauty of its illustrations'.[130] Virtually nothing discussing the work appears in the Eastern press.[131] Dewing's efforts at advertising the volumes seems to have been curiously limited, despite some initial attempts at promotion. The firm never seemed to have advertised in the standard journals of the day and depended largely on displays of published segments at bookshops and other shops throughout the state.[132]

The story being told through florid descriptions and pretty illustrations, then, while ostensibly to promote immigration and tourism, ended up being an exercise in self-aggrandisement aimed at convincing the homegrown audiences of the ideological picture being espoused. That picture meant to demonstrate, through word and image, that despite differences in landscape and demographic make-up, the values of progressive nineteenth-century Anglo society were developing in these Pacific locations so far removed from their 'home' cultures.

Not unexpectedly given the enormous financial expenditure by the publishers and scale of these undertakings, both publications shared an unfortunately litigious fate. In 1892 to 1893, The Picturesque Atlas Co. became the focus of an inquiry before the Legislative Assembly of New South Wales. Lawsuits were based on the company's failure to provide their subscribers with timely delivery of each segment as had been laid out in the contracts subscribers had signed years before. In many cases, subscribers did not receive all of the segments until four or five years after the initial publication and then they arrived as incomplete sets. The complaints focused squarely on the tactics of the 'Yankee' canvassers, most especially Silas Moffett, who had apparently coerced people into signing contracts that the company did not then fulfil.[133]

The company never recovered its expenses for the *Atlas*'s production. While volumes adorned the tables and bookcases of every Australian institution and many Australian homes, its status as the premier illustrated publication in the antipodes was muted by the legal wranglings that followed. As for its aesthetic reception, the *Atlas*, while always recognised as a monumental achievement of nineteenth-century graphic art, suffered the fate of other publications at the end of the wood-engraving era, as more modern forms of reproduction relegated these tomes to the category of old-fashioned visual style and antiquated information.

The J. Dewing Company's fall was even more immediate. As early as 1891, the company was in debt to the tune of 200,000 dollars and requested a compromise from its debtors.[134] In 1893, the New York printers of *Picturesque California* sued the J. Dewing Publishing Company for non-payment; the claim was upheld in court.[135] The firm's efforts to produce less expensive editions of the volumes to recoup losses continued

until 1894, but by the end of the century, the company had ceased to exist. (The last edition in 1894 contained promotional flyers in the back of the book that gave Dewing's address as Philadelphia and San Francisco, with no mention of a New York publisher.) Dewing's well-meaning efforts to present a grandly illustrated volume on the American West in the tradition of other Picturesque publications failed to generate much market, despite the involvement of some of the region's leading artists and writers. Even more so than the *Atlas*, whose quality of illustration was superior to what *Picturesque California*'s artists achieved, the book ultimately fell victim to financial overreaching and more readily available volumes on the region's attractions.

Even more significantly, Dewing's volumes, while intent on incorporating all of the era's new printing technologies, failed to create a coherent aesthetic message that could withstand the pressures for graphic innovation that audiences began to expect from the illustrated book industry. *Picturesque California* disappeared almost entirely from the literature and visual record of publications about the West, superseded by photographic reproductions and locally created fine-art printing of a more coherent and refined style. The term 'picturesque' now deteriorated into ever more vaguely defined generalities, applied increasingly to advertising slogans in popular tourist brochures and promotional materials.

Despite the failings of The J. Dewing Company and the stylistic inadequacies of its grandest illustrated production, the impetus behind the appearance of *Picturesque California* speaks to cultural ambitions in San Francisco that would have lasting aesthetic implications for the entire Pacific Rim at the opening of the twentieth century. The same year that *Picturesque California* began saw ambitious examples of artistic printing in that other modern printing technology, colour lithography.

This lithographic industry offered the one aspect in graphic art that the products of the Picturesque industry had lacked: colour. This element was the necessary ingredient to kick-start the West Coast's development of their own modern graphic style, one that, not surprisingly, most brilliantly coalesced in the more ephemeral forms of commercial art. The euphoria and excitement of the land-boom 1880s in the state precipitated a flowering of elaborately illustrated promotional materials and posters, extolling California's semi-tropical climate and fertile agricultural opportunities.[136] Increasingly, these profusely illustrated items were produced in the state, where lithographic companies had begun to set up businesses from the earliest gold-rush days. By the last decades of the nineteenth century, these firms, led by San Francisco's Schmidt Lithographic Company founded in 1873, were as modern in their printing abilities as any firms back east.[137] These companies were from the beginning commercial enterprises, in business to produce labels, advertising, and whatever other printing jobs their clients required. Despite these business demands, the San Francisco printing industry attained a distinctive and high level of artistic quality. As Kevin Starr asserts, 'the graphic elegance evident in even the most routine job-printing done by these firms declared that the machine could be made to serve beauty.'[138] While *Picturesque California* insisted on looking east to print their black-and-white illustrations in emulation of *Harper's*, San Francisco printers were beginning to formulate their own regional style of graphic art and typography.

The opening pages of the 1889 volume of *Overland Monthly* included among its advertisements a full-page, multi-coloured lithograph for a publication entitled 'California Illustrated no. 1, Semi-Tropical Northern California Pictures, highlighting "Solano

Country Fruit Growing"' (see Fig. 3.26 on page 212). According to the copyright line at the bottom of the page, it was 'photographed and lithographed by The California View Publishing Company, 12 Montgomery St. San Francisco'. Just as in the Picturesque books and illustrated periodicals of the decade, the page contains several overlapping images, some as roundels, some with curled edges and illusionistic shadows, all depicting a scene of the fruitful products of the county, including olive, orange and fig trees. Most were photographs that had been artistically altered and colour-printed. Captions in a bold type font proudly announced 'Grapes June to Jan' and 'Twelve-Acre Apricot Orchard—1200 Perfect Trees'. As the reverse of the page announces, one California newspaper raved that 'California Illustrated no. 1' had the 'handsomest fruit pictures ever seen in book form'.

The middle rectangular image in the advertisement, framed with chiaroscuroed clusters of apricots and lemons and two bluebirds in foreshortened flight, depicts, in full colour, what would soon become the iconic vision of California agricultural prosperity: vast orchards of neatly rowed trees extending back to the hills, viewed from a height to dramatise the expanse. Dotted throughout the orchards, as evidence of settlement, are farmhouses, crowned by their red roofs. While the details of the views are blurred and figures have been retouched, all the pictorial conventions used in the more ambitiously artistic volumes of the era have been employed.

The most advantageous element, however, in terms of its aims of selling a place, is that the advertisement used brilliant colour. The publisher, The California View Publishing Co., incorporated just as The J. Dewing Company had been in 1887, advertised themselves as 'publishers of Elegantly Illustrated California Books for Popular Sale'. These images were always geared, then, at tasteful advertising to illustrate the merits of the state. As the editors wrote in the preface to *California Illustrated No. 1* in 'The Vacaville early fruit district of California', 'a very different grade of work is necessary to meet the taste of the class of people coming to the Pacific Coast at this time, from that which may have served its purpose when only horny-handed pioneers were coming and settling upon the Government lands'.[139] In justifying their use of colour lithography for their illustrations, the editors explained:

> We have adopted color in spite of the heavy expense, simply for the business object of gaining profitable circulation for the work, believing that if our artists have done their part as well as they claim, the 'California colors' will make the book interesting to many people who would never look at it if in plain black and white.
> CALIFORNIA IS A LAND OF COLOR,
> And perhaps in no other part of the world is there such a variety of subjects requiring the use of color to properly illustrate them,—bright color, the magnet which attracts all eyes, interests all to read, and opens all pockets to buy for children and friends.[140]

All iconographic elements devised in earlier illustrations to visualise California are brought to bear here, but these devices are now quite freely used as part of boosterist advertising. In the most modern application of the picturesque idea, artistic renderings based on standardised motifs of landscape and pleasant scenery are consciously meant to sell land as product rather than simply viewed as a work of graphic art in books that fulfilled the book-owner's desire to represent himself as a person of cultural status or aesthetic taste. The era of 'commercial art' had begun and the graphic artists of the Pacific coast would make a distinctive, indeed iconic, contribution in this new field merging art and advertising.

An enduring, distinct and modern icon-

ography popularising the visual idea of California—an image that would be transmitted around the world—grew out of this colour lithographic industry rather than through the poorly formulated aesthetic that *Picturesque California* projected. As early as 1885, Max Schmidt's firm in San Francisco, along with other lithographic concerns throughout the state, began to apply the aesthetic style already beginning to be formulated for tin can labels and seed packets to the state's burgeoning new industry, citrus marketing and packing. As Nancy Moure writes, '[t]his industry arose after railroads facilitated rapid shipment of oranges to Midwest and East coast markets. Growers quickly decided upon a paper label, about 11 by 10 inches, that would capture the eye of the wholesaler'.[141] Thus began the most prolific, the most mass-marketed method for dispersing an aesthetic idea that consciously highlighted California's climate and agricultural bounty.

During an 80-year period, California label artists, most of them highly skilled graphic artists, produced some 8000 distinct designs for crate labels, the majority featuring some aspect of Southern Californian scenery or some uniquely Californian icon.[142] These labels, affixed to wooden crates shipped all over the world, appeared on over two billion boxes of oranges alone.[143] More than any other visual artifact, these images dispersed the emblematic representation of the American West that remains to this day.

At first the labels, produced until the beginning of the twentieth century by stone lithography, mimicked the styles and techniques of popular printing firms in the East and Midwest (see Fig. 3.27 on page 213). A 1907 label for Playmates Brand, for example, used the most popular lithographic 'crayon drawing' styles to delineate popular sentiments about sunny California. Produced in the year in which the railroads, in conjunction with the

California fruit growers' organisations, most specifically targeted Iowa in its campaign to entice winter-weary Midwesterners to buy the oranges they sent them by refrigerated train cars, the image shows Little Miss Sunshine California standing in an orchard in the glowing warmth of her state, handing an enticing basket of oranges to freezing Boy Iowa depicted in the gloom and snow.[144] The Sunkist logo appears as if pasted on rather than as a graphically coherent part of the background scene.

By the 1910s, distinct motifs and a unique approach to typographic lettering had consolidated among the artists of the label-making companies to create what can now be called a 'Pacific Rim' style (see Glendora Brand citrus label on back cover). The subject matter sometimes depicted missions, Spanish–Mexican figures, emblematic birds and animals representing the brand name or historic monuments. But the most pervasive symbolic element included in millions of labels was the template of the California landscape: those same neat rows of trees shown in the earliest lithographs of California fruit companies of the 1880s, depicted from a height looking across the expansive orchards to the hills and mountains beyond. The scene almost always included some kind of red-roofed house and superimposed oranges or other fruit outside the framed picture in one corner of the scene. The label lettering devised also took on a distinctively modern simplicity, usually of opaque bright colour and often delineated with black outline so that it was easy to read from a distance.

The artists in these lithographic firms now began to apply this same style to other printing projects, such as tourist brochures and travel posters for the railroad and steamship companies. These, too, were dispersed internationally, conveying an aesthetic that increasingly became identified as western American

and modern. Finally, foreign companies in Asia, Australia and New Zealand, having seen these labels on the quantity of boxes of California citrus that arrived in their ports, hired these same companies to design labels for their own goods and export items. One of the largest companies was the San Francisco-based Australian New Zealand American Trading Company, for whom San Francisco's Olsen Lithographic Company produced a crate label featuring identifiably Australian animals (see Fig. 3.28 on page 214). While the designer may have been a bit uncertain of the kangaroo's anatomy, the label's typography included the fonts already standardised by West Coast companies as the label typography of the Pacific. It is no coincidence that Australian fruit labels made in Australia began to emulate these same graphic forms in their own lithographic label industry.[145]

On the most popular level of commercial imagery, then, far more widespread in its aesthetic impact than the *Picturesque atlas* or *Picturesque California* could hope to achieve, Australia and California exchanged visual expressions of a constructed idea of Pacific modernity and lifestyle in the sun. These pervasive printed images nurtured particular attitudes about cultural identity that were beginning to show signs of divergence from the aesthetic of the home cultures, as well as reflecting shared values having to do with climate, geography and a sense of newness. They inform the region's new aesthetics of place, and this place increasingly came to be identified as the Pacific Rim.

Fig. 3.29 Sunrise Orchards Brand label, Lyetta, Tasmania, c. 1930. Courtesy of Apples of Oz, Inc., Tasmania.

NOTES

1. Bernard Smith, *Place, taste and tradition*, Ure Smith, Sydney, 1945, p. 71.
2. Adam Gopnik, 'Homer's wars', *The New Yorker*, 31 October 2005, pp. 69–70.
3. The term 'Marvellous Melbourne' was coined by English journalist George Augustus Sala (1828–1895) when he visited the colony in 1885. See Geoffrey Serle, *The rush to be rich: A history of Victoria 1883–1889*, Melbourne University Press, Melbourne, 1971, p. 275. On Melbourne's cultural life in this period, see also Serle's *From deserts the prophets come*, pp. 60–88; and Graeme Davison, *The rise and fall of marvellous Melbourne*, Melbourne University Press, Carlton, Victoria, 1978.
4. Serle, *The rush to be rich*, p. 274.
5. 'The Chinese in Australia (Melbourne Cor. New York Age)', *Los Angeles Times*, 21 April 1888, p. 6.
6. T. K. Dow, 'A tour in America', *The Australasian*, Melbourne, 1884, p. 28.
7. Richard White, *Inventing Australia: Images and identity 1688–1980*, Allen & Unwin, Sydney and London, 1981, p. 62.
8. The literature on the development and significance of the Melbourne artists' movements in the 1880s is substantial, including major monographs on each of the artists in the various groups. Serle gives a good synopsis of the artistic scene in *The rush to be rich*, pp. 287–291. See also Serle's *The creative spirit in Australia: A cultural history*, Heinemann, Richmond, Victoria, 1987, pp. 60–87; Smith, *Australian painting*, pp. 71–106 and *Place, taste, and tradition: A study of Australian art since 1788*, Oxford University Press (OUP), South Melbourne, 1979, pp. 120–135; and Helen Topliss, *The artists' camps*, Hedley, Melbourne, 1992.
9. Anthony Trollope, *Australia and New Zealand*, Chapman and Hall, London, 1873, vol. i, p. 484; quoted in White, p. 62.
10. See Nigel Lendon, 'Ashton, Roberts and Bayliss: Relationships between illustration, painting and photography in the late nineteenth century', in

T. Smith and A. Bradley (eds), *Australian art and architecture: Essays presented to Bernard Smith*, Oxford University Press, Melbourne, 1980, pp. 71–82.

11. Sylvia Lawson, *The Archibald paradox*, Penguin, Ringwood, Victoria, 1983, p. ix.

12. Marguerite Mahood, *The loaded line: Australian political caricature 1788–1901*, Melbourne University Press, Carlton, Victoria, 1973, p. 178.

13. A book that Jack London had in his library and apparently read before travelling to Australia, C. Buley described *The Bulletin*'s importance: 'The most talented artists and the brightest writers of all Australia are in its service, and nowhere in the world is a political situation better expressed in a clever cartoon, or a newly proposed legislative measure more ably reduced, in a small space, to perfect lucidity and simplicity.' *Australian life in town and country*, The Knickerbocker Press, New York and London, 1905, pp. 225–26. On Archibald and the significance of *The Bulletin* in Australia's cultural life, see Lawson, *The Archibald paradox*.

14. Tony Hughes-d'Aeth, *Paper nation: The story of the* Picturesque atlas of Australasia *1886–1888*, Melbourne University Press, Melbourne, 2001, p. 15.

15. *The Sydney Morning Herald*, 2 August 1888, p. 6. Quoted in Maya V. Tucker, 'Centennial celebrations 1888: Australasia: Her trials and triumphs in the past: Her union and progress in the future', in Graeme Davison et al., *Australia 1888*, Fairfax, Syme & Weldon, Sydney, 1987, vol. 7, p. 20.

16. ' … for sheer ingenuity the Americans beat all comers. They gave Australians the first glimpse of the Edison phonograph, the petrol engine and a curious substance known as chewing gum'. Davison, *Australians 1888*, vol. 7, p. 24. William Macleod's notebook of the exposition includes a two-page scene of the exhibition hall that includes a sign reading 'NEW American Sewing Machines'. See Macleod Papers, Mitchell Library, State Library of New South Wales (manuscript A2147, item no. 3, p. 99).

17. Serle, *The rush to be rich*, p. 286.

18. See Tucker, 'Centennial celebrations', vol. 7, pp. 11-25.

19. On the coming of the railroads to California, see especially William Deverell, *Railroad crossing: Californians and the railroad, 1850-1910*, University of California Press, Berkeley, 1994; and Remi A. Nadeau, *City makers: The men who transformed Los Angeles from village to metropolis during the first great boom, 1868-76*, Doubleday, New York, 1948.

20. Carey McWilliams, *Southern California: An island on the land*, Peregrine Smith, Salt Lake City, rev. edn, 1973, p. 118.

21. Glenn S. Dumke, *The boom of the eighties in Southern California*, Huntington Library, San Marino, California, 1944, p. 276.

22. ibid., pp. 13-15.

23. See Dydia DeLyser, *Ramona memories: Tourism and the shaping of Southern California*, University of Minnesota Press, Minneapolis, 2005.

24. On the Big Four and building of the railroads, see Oscar Lewis, *The Big Four: The story of Huntington, Stanford, Hopkins, and Crocker, and of the building of the Central Pacific*, A. A. Knopf, New York and London, 1938; and Stephen E. Ambrose, *Nothing like it in the world: The men who built the transcontinental railroad, 1863-1869*, Simon & Schuster, New York, 2000. On the 'bonanza kings' see Richard H. Peterson, *The bonanza kings: The social origins and business behavior of western mining entrepreneurs, 1870-1900*, University of Nebraska Press, Lincoln, 1977.

25. Kevin Starr, *Americans and the California dream*, p. 246.

26. David M. Dow, 'The spirit of San Francisco', *The Lone Hand*, 1 December 1908, pp. 172-75.

27. Sue Rainey, *Creating* Picturesque America: *Monument to the natural and cultural landscape*, Vanderbilt University Press, Nashville, 1994, p. 3.

28. ibid., p. 3.

29. Hughes-d'Aeth, *Paper nation*, p. 41.

30. Rainey, *Creating* Picturesque America, p. 276.

31. Hughes-d'Aeth, *Paper nation*, pp. 24-25.

32. According to the records of Rookwood Cemetery, Sydney, Moffett was a Civil War veteran, born in New York, who was buried in the cemetery in 1923, viewed 14 January 2008, <http://www.users.bigpond.com/bcrompton/Ausdied.htm>.

33. Ashton states in his own biography that the *Atlas* began in 1883 and several other writers, including Katherine Harper for his official entry in the *ADB*, maintains that Ashton left Melbourne for Sydney to work on the *Atlas* in that year. See also Ashton, *Now came still evening on*, Angus & Robertson, Sydney, 1941, pp. 39-45, 62; and Harper, 'Ashton, Julian Rossi (1851-1942)', *ADB*, vol. 7, pp. 114–15.

34. 'Picturesque atlas of Australasia - the genesis of colonial art', *Sydney Daily Telegraph*, 14 August 1886, p. 9 and 21 August 1886; 'Picturesque Atlas Co.', *Town and Country Journal*, 19 June 1886, p. 1256, col. 4.

35. William T. Smedley Papers, Archives of American Art (reel 1207). See also *The illustrations of W. T. Smedley (1858-1920)*, Brandywine River Museum of the Brandywine Conservancy, Inc., Chadds Ford, Pennsylvania, 1981, p. 14; and the entry for Smedley in *Dictionary of American Biography (DAB)*, vol. 17, Scribner, New York, 1935 pp. 227-28.

36. On Fitler, see Thieme-Becker, vol. 12, p. 58; *Quarterly Illustrator*, vol. 2, April-June 1894, p. 191; and *American Art News*, vol. 8, no. 5, 1915, p. 3, col. 3. Fitler was the husband of still-life painter Claude R. Hirst (1855-1942); see Martha M. Evans, *Claude Raguet Hirst: Transforming the American still life*, Hudson Hills Press, New York, 2005.

37. *Saturday Review*, London, 1880; quoted in Albert F. Moritz, *America the picturesque in nineteenth century engraving*, New Trend, New York, 1983, p. 45.

38. *Life and character: Drawings by W. T. Smedley, A.N.A.*, with accompanying text by A. V. S. Anthony, Harper & Bros., New York and London, 1899, p. 9. The three magazines alluded to were probably *Harper's*, *Century* and (perhaps) *Leslie's Weekly*.

39. J. Henry Harper, *The house of Harper: A century of publishing in Franklin Square*, Harper & Bros., Publishers, New York and London, 1912, p. 202. See also G. Ehrlich, 'Technology and the Artist: A Study of the Interaction of Technological Growth and Nineteenth Century American Pictorial Art', PhD thesis, University of Illinois, Urbana, 1960, p. 162.

40. Harper, p. 202.

41. 'An Australian art industry', *The Australian*, 2 October 1886, p. 4.

42. See Lawson, *The Archibald paradox*, pp. 102-03. On Keller, see Grey Brechin, '*The Wasp*: Stinging editorials and political cartoons', *Bancroftiana*, vol. 121, Fall 2002, viewed 14 January 2008, <http://bancroft.berkeley.edu/events/bancroftiana/121/wasp.html>; and Richard Samuel West, *The San Francisco 'Wasp': An illustrated history*, Periodyssey Press, Easthampton, Massachusetts, 2004. West recounts that in 1883 Keller's 'health was broken' and that at age 37 he left San Francisco and was never heard from again. One of Keller's cartoons from 1882 depicts the railroad monopoly as a many tentacled octopus—a motif that reappeared in Phil May's *Bulletin* cartoon about the dangers of the 'Yellow Peril': 'The Mongolian Octopus—his grip on Australia', *The Bulletin*, 21 August 1886.

43. William Traill, 'The genesis of *The Bulletin*', *The Lone Hand*, 1 November 1907, p. 68.

44. For Hopkins's American illustrations, see for example his illustrated version of Don Quixote, *The adventures of the ingenious gentleman, Don Quixote de la Mancha. By Miguel de Cervantes Saavedra*, Hurst & Publishers, New York, [1879?]; and silhouettes for a French story, *The story of a cat*, Houghton, Osgood and Company, Boston, 1879. See also Robert J. Burdette, *Hawk-eyes*, G. W. Carleton, New York, 1879; and Hopkins' own *A comic history of the United States*, American Book Exchange, New York, 1880.

45. George Taylor, 'Section xxi – Modern caricature: Australian', *Building*, 12 July 1913, p. 89. Taylor, describing Hopkins as 'a Yankee born', went on to say that the 'spirit of Hopkin's [sic] caricature, essentially American, found in our independent conditions a welcome field', pp. 91-92.

46. 'In Sydney also the last two decades of the century saw an outburst of artistic endeavour, largely inspired by the compilation of the *Picturesque atlas of Australasia* and the rise of the Sydney *Bulletin*.' *Australian encyclopaedia*, vol. 1, p. 249.

47. On Hopkins, see B. G. Andrews, 'Hopkins, Livingston York (Yourtee) (1846 - 1927)', *ADB*, vol. 4, pp. 421-22; Dorothy June Hopkins, *Hop of the 'Bulletin'*, Angus & Robertson, Sydney, 1929; and Hopkins' own book, *On the Hop!*, The Bulletin Newspaper Company, Sydney, 1904. On The Black and White School, see Joan Kerr, *Artists and cartoonists in black and white: The most public art*, S. H. Ervin Gallery, Sydney, 1999; Vane Lindesay, *The inked-in image: A social and historical survey of Australian comic art*, Hutchinson, Richmond, Victoria, 1979; Vane Lindesay, *Drawing from life: A history of the Australian Black and White Artists' Club*, State Library of New South Wales Press, Sydney, 1994; and Mahood, *The loaded line*.

48. Bertram Stevens, 'Etching in Australia', *Art in Australia*, no. 9, Sydney 1921, n.p. Roger Butler also discusses Hopkins' importance to new print processes: 'Hopkins not only stimulated the development of the "process block", as photo-engraving came to be known, but also acted as a catalyst for the Australian painter-etcher's movement. Artists met at his studio for informal talks and etching demonstrations.' In 'Printmaking and photography in Australia: A shared history', *Imprint: The Journal on Australian Printmaking*, vol. 24, no. 4, December 1989, p. 3.

49. In her biography of husband William Macleod, Conor Macleod wrote about Hop: 'At heart he was a Puritan; my husband told me that anything resembling

a risky joke, or even an allusion, caused his natural gloom to deepen to a terrifying degree.' *Macleod of 'The Bulletin': The life & work of William Macleod*, Snelling Printing Works, Sydney, 1931, p. 25.

50. On Macleod, see Conor Macleod, *Macleod of 'The Bulletin'*; Lawson, *The Archibald paradox*; and B. G. Andrews, 'Macleod, William (1850-1929)', *ADB*, vol. 10, pp 335-36.

51. Hopkins's relationship with Traill was always fraught: 'Hopkins more than once threatened resignation when Traill tried to "improve" the new processes of reproducing illustrations that he had brought back from America.' B. G. Andrews, 'Traill, William Henry (1843–1902)', *ADB*, vol. 6, pp. 298–99.

52. One of the only identifiable illustrations by Hopkins, *A night attack by Blacks*, accompanies Traill's text on Queensland—a segment that Hughes-d'Aeth discusses at length in *Paper nation*, pp. 91–97. See *Picturesque atlas*, vol. i, p. 329.

53. 'In a number of interviews he ascribed the development of his style to the inadequacies of the *Bulletin*'s printing machines.' H. P. Heseltine, 'May, Philip William (Phil) (1864–1903)', *ADB*, vol. 5, pp. 232–33.

54. See, for example, Lawson, *The Archibald paradox*, pp. 99 –103.

55. Butler, 'Printmaking and photography', p. 3.

56. *Town and Country Journal*, 19 June 1886, p. 1256, col. 4. Quoted in Roger Butler, *Printmaking and Australia: Means of production*, typescript, Canberra, Australia, p. 35.

57. *The Sydney Morning Herald*, 14 June 1886, p. 4, col. 1. Butler clarifies, 'an ordinary newspaper press in 1886 would print at 5000 revolutions per hour'. *Printmaking and Australia*, p. 84.

58. Harper's father-in-law was Richard March Hoe, 'head of the firm of R. Hoe & Co., manufacturers of printing-presses'. See Harper, p. 557. On the history of R. Hoe & Co., see Stephen D. Tucker, 'History of the R. Hoe & Company, 1834–1885', *Proceedings of the American Antiquarian Society*, vol. 82, pt. 2, 1973, pp. 351–453; and *A short history of the printing press and of the improvements in printing machinery from the time of Gutenberg up to the present day*, printed and published for Robert Hoe, New York, 1902.

59. 'The *Atlas* was brought to Sydney and not Melbourne because Sydney was not subject to the protectionist duties that were levied by the Victorian Govt. This was a significant factor for an operation which relied on foreign equipment.' Email correspondence to the author from Tony Hughes-d'Aeth, 26 November 2007.

60. See 'The Picturesque Atlas Publishing Company', *The Sydney Morning Herald*, 24 August 1886, p. 5; and Hughes-d'Aeth, *Paper nation*, p. 19.

61. Schell, who contributed so much to the aesthetic quality of the *Atlas* and *Picturesque Canada*, was Head of the Art Department at Harper's and later at *Frank Leslie's*. Some letters exist from artists to him while he was at Harper's, but very little else has been uncovered to illuminate what was a lengthy career as a print artist. While in Australia, he wrote an articulate essay on the production of illustrated books; see 'How books are illustrated', *Centennial Magazine*, vol. i, no. 2, September 1888, pp. 118–21. A letter from Horace Baker to Australian artist A. H. Fullwood, with whom he had worked on the *Atlas*, clarifies some of the confusion about when Schell died (some sources list his death as 1905): 'Your mention of Mrs. Roth and her Husband suing for a divorce brings us back to Fred Schell, poor Fred after gradually failing, was buried in the early summer. I attended his funeral, and had been up to see him only about a week before. His end was tragic (that was a hard word). He fell out the third story window and was found dead in the alley by a passer-by. Nobody knows how it happened.' Baker, letter to Fullwood, 16 August 1902, A. H. Fullwood Papers, Manuscripts Collection, National Library of Australia, Canberra, (MS8022). Schell's obituary appeared in *The New York Times*, 27 May 1902.

62. On Baker, see Glenn B. Opitz (ed.), *Mantle Fielding's dictionary of American painters, sculptors and engravers*, Apollo, New York, 1983, p. 40; and Thieme-Becker, vol. 2, p. 378. A caricature of Baker as Superintendent of *Leslie's Weekly* Engraving Department appears as one of many in a lithograph by Edward Jump, *Saturday afternoon at* Frank Leslie's, *1868–69 (537 Pearl St. N.Y. City)*, from the Print Collection, Miriam and Ira D. Wallach Division of Art, Prints and Photographs, The New York Public Library, Astor, Lenox, and Tilden Foundations. Reproduced in Joshua Brown, *Beyond the lines: Pictorial reporting, everyday life, and the crisis of Gilded Age America*, University of California Press, Berkeley, 2002, pp. 64–66.

63. *The Sydney Morning Herald*, 14 June 1886, p. 6.

64. Tony Hughes-d'Aeth, 'An Atlas of a Difficult World: The *Picturesque Atlas of Australasia* (1886–1888)', PhD thesis, University of Western Australia, Perth, 1998, p. 51, note 90.

65. 'Bristling with superlatives and persistent technological pride, the maps in the *Atlas* are put forward as one of its real achievements. The striking colours used in their printing stand out against the monochrome of the other pages.' Hughes-d'Aeth, *Paper nation*, p. 101. See also 'Picturesque atlas of Australasia', *Daily Telegraph*, 21 August 1886, p. 9.

66. Hughes-d'Aeth, *Paper nation*, p. 27.

67. On Andrew Garran and the *Atlas*, see Hughes-d'Aeth, *Paper nation*, pp. 26–27. On Bryant's role in *Picturesque America*, see Rainey, *Creating Picturesque America*, pp. 83–87.

68. 'For twenty years he was the only one in Australia that could paint a horse as it should be painted.' George A.Taylor, *Those were the days: Being reminiscences of Australian artists & writers*, Tyrell's, Sydney, 1918, p. 26. 'From the centenary until Federation Mahony was one of the best-known Australian artists and illustrators, specialising in horses, which he studied assiduously, and in action scenes which stimulated—and reflected—national sentiment.' B. G. Andrews, 'Mahony, Francis (Frank) (1862–1916)', *ADB*, vol. 10, p. 381.

69. Ashton, p. 44.

70. Albert Henry Fullwood left a delightful album of sketches from his time working for *Picturesque atlas*, as well as correspondence with several of the *Atlas* artists, including the Americans, long after the project was finished. See A. H. Fullwood Papers, National Library of Australia, Canberra (MS8022). See also Bertram Stevens, 'A. H. Fullwood', *Art in Australia*, no. 8, 1921, n.p.; and Martin Terry, 'Fullwood, Albert Henry (1863–1930)', *ADB*, vol. 8, pp 598–99.

71. Fullwood Papers (MS8022) , in sketchbook through rural New South Wales, 1887.

72. Marian Ellis Rowan, constantly seeking patronage for the publication of her images of flowers from all over the world, took advantage of her connection with the *Atlas* to promote her own work. A typewritten transcription of a letter-prospectus, written by the great botanist Ferdinand von Mueller and found in Rowan's manuscripts, indicates that Rowan hoped the Picturesque Atlas Co. would produce a book for her; it closes with the statement, 'our friends who have already subscribed to the *Picturesque Atlas of Australasia* know something of our quality and they may rely upon there being no falling away in the future, either in matter or in execution'. Ellis Rowan Papers, Manuscripts Collection, National Library of Australia, Canberra (MS422). This same collection includes another promotional letter (MS2206) from c. 1896, stating that she was at that time having an exhibition at the Art Gallery of Stanford University in California. On Rowan's peripatetic life see H. Hewson and M. Hazzard, *Flower paintings of Ellis Rowan*, National Library of Australia, Canberra, 1982; Patricia Fullerton, *The flower hunter: Ellis Rowan*, National Library of Australia, Canberra, 2002; and Margaret Hazzard, 'Rowan, Marian Ellis (1848–1922)', *ADB*, vol. 11, pp. 465–66.

73. Schell collected more than 1500 photographs on a round-the-world tour, taken at the time he came to Australia. These are now housed at the Yale University Art Gallery's Print Room, donated by Schell's grandson, who was a graduate of Yale. They include at least 237 photographs from Victoria and about 300 from New South Wales, as well as many photographs, both commercial and personal shots, of New Zealand. I am grateful to Gael Newton, National Gallery of Australia, Canberra, for alerting me to this collection; and to Elise Kenney, archivist of the Yale University Art Gallery, for information about its contents.

74. Joseph Cowen Syme was the nephew of *The Age*'s legendary owner and editor David Syme (1827–1908) with whom he had a rocky partnership in the newspaper from 1879 to 1891. See C. E. Sayers, 'Syme, David (1827–1908)', *ADB*, vol. 6, pp. 232–36. Canadian-born Holmes S. Chipman (b. 1850) is named as one of the original shareholders of the company in the proceedings of The Select Committee of the New South Wales Legislative Assembly that looked into the question of distribution irregularities of the *Atlas* after its publication. See 'Minutes of Evidence taken before The Select Committee on the Picturesque Atlas Company', Legislative Assembly, New South Wales, 1892–93, section 59, p. 3, Parliamentary Archives, Parliament of New South Wales, Sydney, New South Wales.

75. H. S. Chipman, letter to Joseph Syme, Melbourne, 21 October 1886, William Smedley Papers, Archives of American Art, Smithsonian Institution (reel 1207).

76. Alan M. Pensler, introductory essay, in *The illustrations of W. T. Smedley*.

77. Hughes-d'Aeth, *Paper nation*, p. 111.

78. Carrie Tirado Bramen, 'The urban picturesque and the spectacle of Americanization', *American Quarterly*, vol. 52, no. 3, September 2000, p. 444.

79. Moritz writes about these 'trompe l'oeil devices', pp. 43–44.

80. Hughes-d'Aeth, *Paper nation*, p. 120.

81. *The Australian*, 2 October 1886, p. 4.

82. 'W. T. Smedley used a photograph for his illustration of "The Melbourne Telephone Exchange". Leaving the background untouched, Smedley overpainted the foreground, including the nearest group of operators. Their original photographic bodies no doubt lie beneath Smedley's brushstrokes, but the camera had not caught them in the fashion that art demanded.' Hughes-d'Aeth, *Paper nation*, p. 172.

83. In 1891, a visiting American art critic Sidney Dickinson (or Dickenson) (1851–1919) first used the term 'Heidelberg School' to describe the group of artists who had worked out in the countryside near Melbourne around the suburb of Heidelberg. As Bernard Smith writes of him: 'Sidney Dickinson has more than a fair claim to be regarded as the first serious art critic to support an indigenous school of Australian painting.' *Documents on art and taste in Australia*, Oxford University Press, Melbourne, 1975, pp. 245–51; and Smith, 'Dickinson, Sidney (1851–1919)', *ADB*, vol. 8, pp. 302–03.

84. Roger Butler reproduces Smedley's work in his *Printed images in colonial Australia 1801–1901*, National Gallery of Australia, Canberra, 2007, pp. 249–50.

85. See Ann Galbally, *Charles Conder: The last bohemian*, Melbourne University Press, Carlton South, Victoria, 2002, pp. 13–28.

86. See Smith, *Australian painting*, pp. 74–76; and Galbally, pp. 26–28 .

87. Lendon, p. 81.

88. Art Society of NSW, letter, 11 February 1887, Smedley Papers, Archives of American Art (reel 1207). The letter reads: 'It having been made known to the Council of this Society that you were about to take your departure from Sydney at an early date, I have been commissioned to convey to you our expressions of sincere regret for the loss of a member and fellow artist whose presence amongst us has been much prized, and whose departure will create a gap in the two small bands of art lovers in Sydney, not easily filled up … Following this aim, the Art Society would take it as a favor if you would furnish them before you leave with a report criticising from the standpoint of an independent artistic mind, the present national collection of pictures here and the manner in which they are housed.'

89. See Gilbert Parker, 'Glimpses of Australian life', *Harper's Weekly*, vol. xxxv, no. 1791, 18 April 1891, pp. 232–36.

90. See Conor Macleod's section on '*Picturesque atlas*' days' in *Macleod of 'The Bulletin'*, pp. 8–12.

91. Estelle Jussim, *Visual communication and the graphic arts*, Bowker, New York, 1983, p. 285.

92. 'The J. Dewing Company. A glimpse at a large and artistic business', *San Francisco Chronicle*, 6 December 1889, p. 5, cols 5 and 6.

93. On Gump's, see Carol Green Wilson, *Gump's treasure trade: A Story of San Francisco*, Crowell, New York, 1949; 1965.

94. *Our society directory for San Francisco, Oakland and Alameda. Containing the residence address of over eight thousand society people and a complete visiting, club, theatre and shopping guide*, The J. Dewing Co., Publishers, San Francisco, 1888.

95. *San Francisco Chronicle*, 6 December 1889.

96. Oge's name appears on the letterhead of The J. Dewing Company as secretary and treasurer of the firm. See The J. Dewing Company, San Francisco, letter to Mr J. Muir, Martinez, California, 5 September 1887, John Muir Papers, Holt–Atherton Special Collections, University of the Pacific, Stockton, California.

97. ibid.

98. Richard E. Nicholls, in John Muir, *West of the Rocky Mountains*, J. Dewing, New York, 1888, and Running Press, Philadelphia, 1974.

99. On Keith, see Alfred C. Harrison, Jr, and Ann Harlow (eds), *William Keith: The Saint Mary's College collection*, Hearst Art Gallery, Saint Mary's College of California, Moraga, California, 1988. On Thomas Hill, see Janice T. Driesbach and William H. Gerdts, *Direct from nature: The oil sketches of Thomas Hill*, Yosemite Association and Crocker Art Museum, Sacramento, 1997. Nancy Dustin Wall Moure also discusses Keith and Hill in her *California art: 450 years of paintings and other media*, Dustin Publications, Los Angeles, 1998.

100. A letter to Muir's wife dated 11 July 1887 is addressed from 'Keiths [*sic*] Studio' in Sacramento. It goes on to describe the journey that the two will take via Shasta to the 'Klamath country' and into Washington State. John Muir Papers, Holt–Atherton Special Collections, University of the Pacific, Stockton, California.

101. Sue Rainey, 'Picturesque California: How Westerners Portrayed the West in the Age of John Muir', www.common-place.org, vol. 7, no. 3, April 2007, viewed 29 January 2008, <http://www.common-place.org/vol-07/no-03/rainey/>.

102. Mildred K. Abraham and Sue Rainey (eds), *Embellished with numerous engravings: The works of American illustrators and wood engravers, 1670–1880*, exhibition catalogue, Rare Book Department,

University of Virginia Library, Charlottesville, 1987, n.p.

103. On Darley's significance in the popularising of the image of Indians, see John C. Ewers, 'Not quite Redmen: The Plains Indian illustrations of Felix O. C. Darley', *American Art Journal*, vol. 3, no. 2, Autumn 1971, pp. 88–98.

104. On the relationship between Jeanne Carr and John Muir, see Bonnie Johanna Gisel, *Kindred and related spirits: The letters of John Muir and Jeanne C. Carr*, University of Utah Press, Salt Lake City, 2001; and Elizabeth Pomeroy, *John Muir: A naturalist in Southern California*, Many Moons Press, Pasadena, California, 2001. Helen Hunt Jackson, author of *Ramona*, wrote an affectionate memoir of her friend Carr that survives as a handwritten manuscript, *One woman and sunshine* (1907), in which she described Carr as 'prophetess and priestess combined of nature's worship and work', Helen Hunt Jackson Collection, Manuscripts Collection, The Huntington Library (HM 11908).

105. John Muir Martinez, California, letter to Jeanne Carr, Pasadena, California, 22 October 1887, John Muir Papers, Holt–Atherton Special Collections, University of the Pacific, Stockton, California.

106. J. Dewing, Publishers, Importers and Booksellers, San Francisco, letter to Jeanne Carr, Pasadena, California, 5 November 1887, Jeanne C. Carr Papers, Manuscripts Collection, The Huntington Library (MS CA78).

107. Rainey, 'Picturesque California', online.

108. Jussim, p. 285.

109. 'It used photography to make intaglio printing plates' is how Rainey describes the photogravure process. 'Picturesque California', online.

110. 'Remington called them "those clumsy blacksmiths turned woodchoppers, who invariably made my drawings say things I did not intend them to say."' Quoted in JoAnn Early Levin, 'The Golden Age of Illustration: Popular Art in American Magazines', PhD thesis, University of Pennsylvania, Philadelphia, 1980, p. 70.

111. Jussim, p. 286.

112. *Overland Monthly*, vol. xii, second series, no. 72, December 1888, pp. 659–60.

113. A list of these editions and versions appears in William F. Kimes and Maymie B. Kimes (eds), *John Muir: A reading bibliography*, Panorama West Books, Fresno, California, 1986, pp. 44–48.

114. On the competition for world's tallest trees, see Tim Bonyhady, *The colonial earth*, Miegunyah Press,

Carlton South, Victoria, 2000, pp. 250–79.

115. On the 'embarrassment' of photography, see Hughes-d'Aeth, 'Photographic friction', in his *Paper nation*, pp. 168–95.

116. Rainey, 'Picturesque California', online.

117. From Jeanne C. Carr's text on Southern California in *Picturesque California*, 1888, p. 133.

118. When and how Fitler was commissioned to work for the Californian publication is unclear; but it seems that these works were completed after his time in Australia. He went on to produce several illustrations for the work's sections on Oregon and Washington, perhaps made on a trip through California and into the Pacific north-west at the behest of the Dewing Brothers after his return from the antipodes. Given that the works he produced for the publication are not as polished as any that he produced for either *Picturesque Canada* or the *Atlas*, Fitler may also have drawn them entirely from photographs viewed back in New York.

119. 'As colonists prepared to celebrate the centenary of European settlement in Australia in 1888, the publisher William Frederick Morrison blamed artists for the gum trees' bad reputation. Referring most likely to Sydney's landscape painters, Morrison maintained: "Artists have with ridiculous unanimity pronounced it unpicturesque, and have decried its glory. They assume to say it is positively *ugly*."' Bonyhady, *The colonial* earth, p. 182.

120. Hughes-d'Aeth, *Paper nation*, pp. 185–86.

121. For a reproduction of this image, see ibid., p. 92.

122. ibid., p. 93.

123. The *Atlas*'s competitor, *Cassell's picturesque Australasia* (1887–89), did include a section on Melbourne's Chinatown, written by Hume Nisbet, but as a 'world apart'; see Ben Mountford, 'Hume Nisbet's Little Bourke Street: "Slumming" it in 1880s Melbourne', first place winner, essay competition, Melbourne Arts Student Society, 2007, viewed 12 February 2008, <http://www.m-assonline.com/1stPlaceBen.doc>. On Melbourne's Chinatown, see also Bon-Wau Chou, 'The Chinese in Victoria: A Longterm Survey', PhD thesis, University of Melbourne, Melbourne, 1993; Alison Blake, 'Melbourne's Chinatown: The Evolution of an Inner Ethnic Quarter', BA (Hons) thesis, Department of Geography, University of Melbourne, Melbourne, 1975; and "Chinese–Australian Historical Images in Australia', viewed 12 February 2008, <http://www.chia.chinesemuseum.com.au>.

124. Mrs Frank Leslie, *California: A pleasure trip from*

Gotham to the Golden Gate (April, May, June, 1877), G. W. Carleton & Co., Publishers, New York and S. Low, Son & Co., London, 1877.

125. William Deverell, *Whitewashed adobe: The rise of Los Angeles and the remaking of its Mexican past*, University of California Press, Berkeley, 2004, pp. 59–60.

126. Rainey, 'Picturesque California', online.

127. McWilliams, *Southern California*, rev. edn, 1973, p. 67.

128. McWilliams, *Southern California*, rev. edn, 1973, p. 22; quoted in Deverell, *Whitewashed adobe*, p. 60.

129. On Warner, see Starr, *Americans and the California dream*, p. 378. Warner's book, published by Harper's, contained many illustrations, most of them engravings, similar to those found in the *Atlas* and in *Picturesque California*. See Charles Dudley Warner, *Our Italy*, Harper's, New York, 1891.

130. 'Fresh literature', *Los Angeles Times*, 16 December 1889, p. 2; and 'Picturesque Southern California', *Los Angeles Times*, 1 January 1890, p. A1.

131. Sue Rainey comments about this: 'Something that puzzled me was the scant attention to Picturesque California in reviews and in Publishers' Weekly, the New York publication serving the publishing trade. Most other illustrated books were given attention in it. Maybe Dewing wasn't on hand to push for coverage (or not able to buy ads).' Email correspondence, 27 November 2007.

132. A note in the *Los Angeles Times* in 1891 invited readers to 'examine this most elaborate and magnificent souvenir of the Pacific Slope ... for a few days only at 423 South Spring Street'. *Los Angeles Times*, 25 October 1891, p. 8.

133. One complainant, Mr James Henry Rainford, in his sworn testimony before the Select Committee, described events after finally receiving his set two years after the *Atlas*'s completion: 'I was called upon by an American gentleman—no mistake, he was a thorough American. He was very nice. He asked me for the amount of money at the rate of 5s. per copy for the rest, which I refused to pay. He was one of those peculiar people with whom you could not get annoyed ... He was so nice that I gave him a cheque without ever looking at the books. After I had given him a cheque I found out to my disgust ... that my copies were thoroughly incomplete.' 'Minutes of Evidence taken before The Select Committee on the Picturesque Atlas Company', Legislative Assembly, New South Wales, Thursday 16 February 1893, section 99, p. 111.

134. 'A book firm in trouble', *Los Angeles Times*, 18 June 1891, p. 1.

135. 'Say it is a broken contract; Walbridge & Co. sue the J. Dewing Publishing Company', *Brooklyn Eagle*, 26 January 1893, p. 1.

136. See 'Railroad advertising of the Far West: A portfolio', *California History*, vol. 69, Spring 1991, pp. 65–75.

137. On Max Schmidt and the history of his company, see Max Schmidt, Jr, et al. and Ruth Teiser (interviewer), *The Schmidt Lithographic Company*, vols. i and ii, Berkeley, California: Regional Oral History Office, The University of California, 1968; Charles Murdock, 'History of printing in San Francisco, part xii', *The Kemble Occasional*, no. 35, Winter 1985, p. 2; Bruce L. Johnson, 'Labels, lithography, and Max Schmidt', *The Kemble Occasional*, no. 22, Autumn 1979; and Eddy Elford, *The log of a cabin boy*, San Francisco, December 1922.

138. Starr, *Americans and the California dream*, p. 257.

139. Edward J. Wickson, 'The Vacaville early fruit district of California', *California Illustrated, No. I*, California View Publishing Co., San Francisco, 1888.

140. ibid., p. ii.

141. Moure, *Loners, mavericks and dreamers*, p. 91.

142. Gordon T. McClelland and Jay T. Last, *California orange box labels*, Hillcrest Press, Beverly Hills, 1985, pp. 6–7.

143. ibid.

144. See Judith Elias, *Los Angeles: Dream to reality, 1885–1915*, California State University, Northridge, 1983, p. 39.

145. 'Australia's first apple case label was printed in 1913 in the United States for Geo. Heatherbell & Sons (the early labels were heavily influenced by the designs on California's orange crates).' *National treasures exhibition*, National Library of Australia, viewed 24 February 2008, <http://nationaltreasures.nla.gov.au/%3E/Treasures/item/nla.int-ex5-s1>. See also Christopher Cowles and David Walker, *The art of apple branding: Australian apple case labels and the industry since 1788*, Apples from Oz, Hobart, 2005.

1910s: The bungalow from California to Australia

The California bungalows stand for emancipation in home building. They have been designed with no previous custom in mind ... A delightful cosmopolitanism prevails about them—for while traditions for the most part have been left behind by the wayfaring Californian of to-day, yet unconsciously or subconsciously, there creeps into this unconventional western home a suggestion of the elements in a home he has loved best elsewhere.
—Una Nixson Hopkins, 'The California bungalow', 1906.[1]

~

In the bush bungalow the human condition to be met is the desire of the prospective owner to secure temporary release from some of the conventionalities of our social system; to live more simply ... It is the super-conventionalities, the starched collar and the shoe polish, not the tooth-brush and the bath, from which he desires relief, and the plan problem is to find the line of demarcation between that which is worthwhile and that which is not ...
—James Peddle, 'The bush bungalow', 1920.[2]

~

The climatic and social conditions of the American Far West were closely parallel to those in Australia. It followed, then, that its houses should transplant well. They did.
—J. M. Freeland, *Architecture in Australia*, 1968.[3]

One year after the announcement in Australia of the California gold discovery, a mason named Timothy (or William) Bushton out of Hobart, Van Diemen's Land, erected a frame house on the corner of Munras Avenue and Webster Street in the old Hispanic capital of California, Monterey.[4] Bushton and his family had endured a peripatetic voyage on the *Elisabeth Starbuck* to come to the new American state. He had brought along all of the timber from several pre-existing Hobart buildings—later identified in Monterey tourist labels as 'Australian ironwood'[5]— in the hold of the ship transporting him and his family. Each piece of timber was perfectly matched and Bushton put an entire twelve-room structure together without nails, simply mortised.[6] Shortly after finishing the house, Bushton died. His widow married Thomas Allen, a prominent American settler in Monterey, and the house became known as the Allen House. According to later aggrandising accounts, the house was 'the center of much of the romance of our early California history, [visited by] Sherman, Fremont, General Castro, Governor Pio Pico, Sloat, Larkin and many other eminent men'.[7] Captions on prints produced for the tourist trade in the 1920s inaccurately claimed it was 'the most photographed house in the world'.

The house gained additional romantic cachet in those early years when Australian tenants of the house—Mrs Allen had apparently been forced to take in renters—stashed

50,000 dollars in gold robbed from the Monterey Customs House under the Allen House stairway. By the 1910s, the house was a prominent tourist destination, advertised as one of the many 'firsts' in California so intently sought by American settlers trying to construct an Anglo–Saxon history for the region that would validate its connection to the rest of the nation and white, Protestant culture. The ironic fact that this supposed 'first' wooden-frame house was built out of Australian timber brought to California by ship ready-cut to be reassembled on the other side of the Pacific was not as significant to the American image-makers as was its palpable link to the Anglo–American architectural tradition of the frame house. In the early days of the twentieth century, much was made of this architectural style, presented in California as a contrast to the aesthetic of the surviving Hispanic adobes,

about which the state's new American estab-lishment had ambivalent feelings.[8]

As Australia and California entered a new century, the importance of their Anglo–Saxon kinship would manifest itself most visibly in architectural form. Their English-speaking affinity coincided with an increas-ingly self-conscious nurturing of a Pacific Rim lifestyle that could somehow incorporate a Mediterranean aesthetic appropriate to their climatic conditions, at the same time repre-senting their Anglo–Protestant heritage in the design of buildings, both domestic and public.

Politically, the twentieth century began aus-piciously for both of these English-speaking countries on the edge of the Pacific Ocean. After nearly a decade of economic depression and spurred on by increasingly intense nation-alist sentiments, the six separate Australian

Fig. 4.01 Bushton–Allen House, Monterey, California. Courtesy of The Huntington Library, San Marino, California.

colonies became a political federation of states proclaimed as the Commonwealth of Australia on 1 January 1901—the first day of the new century. On that day, some 60,000 people gathered in Sydney's Centennial Park to witness the ceremonial Proclamation of the Commonwealth of Australia,[9] an event that took place in an ornate Victorian-style pavilion constructed in the park for the occasion. Similar celebrations took place throughout the country, even in those places still ambivalent about the benefits of Federation.[10]

Perhaps symbolic of the hesitations many felt about Australia becoming a unified nation, the pavilion in Sydney was made of plaster-of-Paris over a wooden framework—in other words, ephemeral.[11] The American-born cartoonist Hop, already familiar to Australians from his many illustrations in *The Bulletin*, captured this mood with his amusing portrayal of the first Prime Minister, the rather colourless 'tosspot' Edmund Barton (1849–1920),[12] depicted as a dowdy mother holding her newborn unsteadily. The momentous deed had nonetheless been accomplished and Australia became the youngest of Western nations as the century started.

California was at the same time experiencing staggering population growth.[13] By 1901, the increasing national importance of America's Pacific coastline warranted the first visit by a sitting President. William McKinley (1843–1901)—the same man who had overseen expansion of American influence into the Philippines, Hawaii, Guam and other Pacific islands[14]—arrived in California in May of that year to be greeted by enthusiastic crowds everywhere. Great throngs turned out especially in Los Angeles, a city that was then beginning its phenomenal transformation from a small Hispanic pueblo to a sprawling modern city. McKinley and his wife participated in the city's most important civic event, the Fiesta de los Flores, a parade only recently concocted

by the city's merchants and political boosters. The parade was rife with emblematic expressions of Los Angeles's desired place as part of the United States, in the West, and on the Pacific Ocean.[15] President and Mrs McKinley rode in a flower-draped carriage to a podium. There they witnessed a carefully constructed procession of Southern Californian ethnicities, including a Chinese dragon; Mexican *caballeros* on horses bedecked in silver ornament; an assortment of Native Americans not necessarily of local tribal background; and beautiful young women from 'good families' dressed in white and surrounded by abundant floral arrangements grown in the Mediterranean climate for which Los Angeles was already acclaimed. Similar parades filled with floral symbols and patriotic banners celebrated the presidential visit in the northern part of the state, all meant to declare California's participation in the expansion of American ideals into a new century and outward to the Pacific.

President McKinley's successor was even more enthusiastic in his embrace of Pacific America. Theodore Roosevelt (1858–1919) would be the first true champion of the West, a figure who understood the region's symbolic importance in the national psyche and its significance for future American ambitions in the Pacific. Roosevelt made one of his many visits to California in 1903, this time as the President rather than as the eager outdoorsman he had been on his earlier visits. His official gestures were rife with symbolism: he planted an orange tree in Riverside—birthplace of California's navel orange industry—and a redwood tree in Santa Clara. He visited Yosemite where he met again with his old friend John Muir, who this time persuaded the President to establish the site as a federally controlled national park. He was feted throughout the state for his recognition of the West and for his sincere appreciation of the wonders of the Californian landscape.

Fig. 4.02 President
Roosevelt planting an
orange tree at Mission
Inn, Riverside, California,
1903. Courtesy of The
Huntington Library, San
Marino, California.

Roosevelt was also aware of America's increasing importance in the region beyond California's western border. In Oakland, he gave a speech stating that 'We must command the Pacific'[16]—opinions that the Australian press reported with particular interest. As an expression of the United States' growing naval might, the President in 1907 sent 16 American battleships throughout the Pacific and then around the world. This 'Great White Fleet' landed in Australia in August 1908, where it was greeted with elaborate fanfare for its representation of Anglo–Saxon hegemony on the seas.[17] The excitement generated by this event is evident in articles appearing in *Art & Architecture*, the journal of The Institute of Architects of New South Wales, which proudly published illustrations of the pavilion designed for the occasion by Walter Liberty Vernon

(1846–1914), then government architect for the state.[18]

The early years of the twentieth century, then, were for both regions a time of deliberate focus on their Pacific locations as distinct geographical and cultural entities. In Australia, this identity was framed in the context of a new Anglo–Saxon nation within the British Empire situated in the Pacific Ocean, and thereby a representative of imperial interests within that region and in relation to Asia to its north. In a similarly self-conscious attitude, California increasingly presented itself to the rest of the United States and the world as the 'Gateway to the Pacific' for an emerging American Empire, aware of its position as the westernmost American state with an enormous coastline facing out to Hawaii, Asia and the South Pacific.

Greater public consciousness about the Pacific region and the possibilities for trade with Asia and other Pacific nations led to the establishment of increasingly regular and frequent shipping lines between the American West Coast and the Southern Hemisphere. While steamship lines had operated for passenger and mail service from the 1860s out of San Francisco and Vancouver, Canada, to and from New Zealand and Australia, financial crises and competition dogged many of the lines well into the 1890s and ease of passenger travel was often played down.[19] Advertisements for journeys to the South Pacific in this period still made the venture appear arduous and a bit uncertain for travellers.

This situation improved significantly by the early years of the twentieth century. Passenger travel to the South Pacific until World War I and then into the 1920s was as convenient and well-organised as it would ever be. Firms such as the Oceanic Steamship Company operated the American and Australian Line in conjunction with American and Canadian railroad companies. The purpose of such concerns was to provide regular and well-established transportation between Australia and the United States and Canada, and thereby on to England and Europe. Their brochures included advertisements that emphasised speed and experience. In one from 1904, a globe-headed figure appears above the statement 'Pacific Meditation: Experienced Travellers Say That This is the Best Way'—meaning that the trip 'home' to the Old World was best accomplished by the Pacific route and then across the American continent. The 'E. & A.'—the Eastern & Australian Steam Ship Company out of Brisbane and Sydney—produced an elaborate handbook in 1904, festooned with breezy illustrations of a smiling Japanese woman in kimono holding a parasol, while an Australian woman upholds the E. & A. maritime flag in an ornamental roundel above

a ship passing through Sydney Heads on out to sea. The handbook's text, which served as a guidebook to the exotic ports of call 'via China and Japan, Canada and The United States', focused on the traveller's comfort and extolled the 'beautiful scenery' on a 'smooth-water voyage'.[20]

In the same year, the California magazine *Sunset* included a full-page advertisement promoting the fledgling port city of San Diego, boldly entitled 'Westward The Course of Empire Takes its Way'. The illustration depicts the Pacific shipping lines that converge on San Diego, 'The City of Destiny, The Gateway to the Orient'. New Zealand and Australia figure prominently in the advertisement, with a direct shipping line from the South Pacific to San Diego dotted across the ocean. In the 1903 volume of *Sunset* that announced the opening of the first 'Commercial Pacific Cable between San Francisco, Honolulu, Guam and Manila',[21] another advertisement announced the schedule of the steamers of the Pacific Mail to Asia and Australia.[22] By 1904, the entire journey from Sydney to London via America—some 13,557 miles (21,818 kilometres)—took only 30 days, with the longest time at sea under six days between ports. Sydney to San Francisco was a 20-day cruise in 1904—a vast improvement over the 70 days or more required when the first gold-seekers were travelling to San Francisco from Australia in 1849.

As passenger service and expeditious shipping methods for the delivery of mail and freight between the two continents increased, the exchange of goods between America and Australia became by the turn of the century ever more commonplace. Among these goods consumed by Australians and Californians alike was a plethora of illustrated journals and printed material of all kinds. In the last decades of the nineteenth century, the production of popular illustrated magazines, books and posters had become a huge industry in

Fig. 4.03 W. Lorck (ed.), *The Eastern and Australian Steamship Company's illustrated handbook to the East: Australia, Manila, China and Japan, including trips to America and Europe*, Edward Lee & Co., Sydney, 1904. Cover illustration. Courtesy of The Huntington Library, San Marino, California.

America, much more abundant, innovative and varied in subject matter than the output in England, Australia's traditional source of printed matter. The western American states had by this time begun to develop a printing industry devoted to regional issues and to an expression of what was becoming a 'Pacific coast' lifestyle. These publications, along with hundreds of specialised trade and art journals from Chicago and the American East Coast, made their way onto the steamships that arrived in Sydney and Melbourne every week. Publications as varied as *Harper's*, *Century*, *Atlantic Monthly*, *Sunset*, *The Pacific Monthly*, *The Craftsman* and even trade journals such as *Brick*[23] and *Architect and Engineer of California* were regularly quoted in the pages of Australian magazines and books.[24] Most importantly, illustrations from these publications were often reproduced in local magazines for Australian audiences.

This exchange of visual imagery through reproduction was not confined to graphic illustration, photography, advertising logos and typography. These magazines and illustrated books also disseminated, through textual description and illustrations, the newest ideas in building and architecture to readers on both sides of the Pacific. As the most 'utilitarian' art, buildings as rendered through drawings and photographs offered particularly good opportunities for an expression of regionally shared cultural ideals.[25] The exchange of images had concrete results. It led to buildings and houses that became material metaphors for the eclectic mixing of cultures that contributed to the shaping of these new Pacific nations. Alluring reproductions of new buildings also prompted many artists and architects to visit the other country. Architecture, then, became the field in which the process of stylistic assimilation and visualisation of a 'Pacific' modernity was made most obviously manifest.

At the time of Australian Federation, California and Australia were both still considered, architecturally speaking, victims of an 'extreme colonialism'.[26] Both regions for the most part depended on architectural styles adapted from European and East Coast American models—that is, from the styles of their home cultures—with some minor adjustments for geographical conditions. Although some professional architects began to have an impact on building by the beginning of the twentieth century, more commonly these styles arrived on the Pacific coasts either through immigrant itinerancy—individual self-trained builders brought their skills with them—or through the appearance of reproduced architectural renderings and instructions in pattern books, building manuals and journals. But growing awareness of the need for buildings that took advantage of the distinct climate, economic conditions and cultural attitudes on the Pacific Rim began to affect the kinds of

structures, and especially housing, that accompanied population growth in both places by the early 1900s.

In Australia, a search for an appropriate national architecture that would convey the country's new status as a separate nation within the British Empire led in one direction to what is now loosely labelled as the Federation Style. The art historian Bernard Smith, writing at the time of modernist hegemony, describes the evolution of this style (and claims credit for the coining of the term) in conjunction with political developments from the mid-1890s:

> The style in question is an Australian style if ever there was one, and deserves its own name. My own nomination would be Federation style. For it was born within the context of a discussion about the nature of an Australian style which parallels the political discussion that led to the

foundation of the Commonwealth. [It is a style] with characteristics as marked and definable as any domestic style within the tradition of western architecture ... Perhaps we have not grasped its originality because it has so often offended our architectural tastes.[27]

In reality, no clear set of architectural principles defined this so-called Federation Style. Instead, houses of the time increasingly combined several eclectic ideas, reliant on foreign sources with a few superficial Australian elements in ornamentation. A typical house of the late 1890s and into the early 1900s, built in the suburbs rapidly developing in Sydney, Melbourne, Brisbane, Adelaide, and even in Perth out in Western Australia, often included elements associated with a British-derived 'Queen Anne' Style, adding touches of Arts & Crafts or Art Nouveau inspiration;

Fig. 4.04 Appian Way House, Burwood, Sydney, New South Wales, c. 1905-1910. Author's photograph.

some local interpretation of Henry Hobson Richardson's (1834–1886) American domestic architecture; and a bit of vernacular verandah-and-tin-roof bush station often thrown in.[28] The architectural historian Richard Apperly has even described some buildings of this period as 'Federation Filigree' and 'Federation Anglo–Dutch',[29] indicating the wide range of sources from which Australian builders sought inspiration.

In her book *Pioneers of modernism: The Arts and Crafts movement in Australia*, Harriet Edquist argues that, instead of using the loosely defined 'Federation' term, the houses built in this period in Australia can most specifically be labelled as products of a local adaptation of the Arts & Crafts movement itself. Here one sees, Edquist argues, how closely Australian practitioners were beginning to look to America for inspiration:

> While the British Arts and Crafts movement provided the initial impetus for the Australian movement, the way in which it was transformed here owed as much to Australia's close ties to the United States of America. Both were countries of the New World where the social order was markedly different from that in Britain or Europe … It picked up rather the American idea of the Arts and Crafts as a style of a democratic country, one that expressed freedom, both in terms of society and in terms of design.[30]

Given this wide-ranging search for architectural inspiration that included a view to North America, it is not surprising to find that one of the most innovative architects in Australia at the time was a Canadian-born, Boston-trained eccentric named John Horbury Hunt (1838–1904).[31] Hunt arrived in Sydney in 1863, having left America (it is said) to avoid the Civil War. He quickly found work in the offices of Edmund Blacket (1817–1883), the colony's leading ecclesiastic architect. In his many church projects, both while with Blacket and later in private practice, Hunt applied his knowledge of Gothic architecture and, most specifically, his understanding of the ideas of Eugène Emmanuel Viollet-le-Duc (1814–1879), the French theorist of medieval architecture so admired in the Boston circle of which Hunt had been a part. In his use of motifs and ideas taken from Viollet-le-Duc's famous writings, Hunt reveals a most important aspect of his influence in Australian architectural circles: he brought with him from America, and continued to acquire, the most comprehensive architectural library in the country, eventually numbering some 4000 volumes. Just as the Greene brothers in California would do a few decades later, he also maintained volumes of scrapbooks with cuttings taken from the many periodicals and newspapers that he continued to receive from America and Europe.

Along with his admirable work on churches and public buildings, in which he often combined elements of the Romanesque, 'Lancet Gothic'[32] and British Queen Anne Style, Hunt has lately been 'rediscovered' primarily for his remarkable series of houses built throughout the 1880s and into the 1890s. In buildings such as Pibrac, Trevenna, and especially in the grand house called Booloominbah, built for the pastoralist White family in Armidale, New South Wales, Hunt expresses his adaptation of the American Shingle Style as conceived by H. H. Richardson. While other Australian practitioners absorbed the timber-covered house style associated most frequently with American New England, Horbury Hunt produced the most original examples in the Australian colonies. He gained some official recognition during his earlier working years in the colony, but was nearly forgotten in his later life. His buildings appeared anomalies by the turn of the century, when so many styles were competing for attention as the so-called

Fig. 4.05 John Horbury Hunt (arch.), Pibrac, Warrawee, New South Wales, 1888. Photo. Department of the Environment, Water, Heritage and the Arts (Australia).

Federation houses were being constructed. His works nonetheless prove that clearly American architectural sources had entered the Australian building vocabulary by the end of the nineteenth century.

What is most significant about buildings that fall under the Federation rubric is that they indicate a sincere desire to find a style, albeit derivative, that would represent a distinctly Australian way of living. This eclectic searching for suitable architectural modes to express new lifestyles ties Australia most directly to developments in California at the turn of the last century and ultimately leads to the most tangible expression of cultural affinities between the two Pacific coasts. Californians were also looking for ways to adapt architectural ideas to suit the needs and aspirations of a new population, in unprecedented demographic and geographic circumstances. Elaborate Victorian housing models copied from pattern books and vernacular farmhouse types that had accompanied the

early agrarian American settlers to California appeared alongside American variations on Queen Anne Styles in the 1880s and 1890s, creating more exuberant wooden variants than houses built in Australia in those decades (see Fig. 4.06 on page 214). But it was soon clear to newly arrived Midwesterners and Easterners that the California climate required a different relationship between the outdoors and indoor living spaces. This circumstance was also increasingly apparent in Australia, where British Victorian building forms, no matter what kinds of local adaptations were tried, were wholly unsuited to the geography and climate.

The turn of the twentieth century marked a crucial moment of transition on the American west coast. Californian artists and builders began to learn through journals and books, and the arrival of idealistic immigrants to the West, of exciting new approaches to building, craft and design. Original inspiration came, as it did in Australia in the last decades of

the nineteenth century, from the Englishman William Morris (1834–1896). His widely dispersed aesthetic philosophies about handicraft and design, along with the philosophical writings of artist and critic John Ruskin (1819–1900), transformed architecture and product design alike. These ideas were the basis for what came to be called everywhere the Arts & Crafts Movement. Given their adherence to all aspects of the home culture, Australians were particularly taken with these British models. Dispersed through journals such as *Studio* and absorbed by craftsmen and artists who had travelled abroad, Morrisonian elements began to appear in the Australian cities at the end of the nineteenth century, particularly in crafts such as stained glass and plasterwork applied to the interiors of houses.

Californian architects and designers looked most enthusiastically and immediately to these ideas as interpreted in the writings and designs of 'the American William Morris'—the New York furniture-maker Gustav Stickley (1858–1942). This term linking Stickley to the British founder of the Arts & Crafts Movement came from the writings of the Pasadena artist, collector and writer George Wharton James (1858–1923), who would soon be an active participant in the Californian version of the style.[33] Stickley's journal *The Craftsman*, beginning in 1901 and continuing under his editorship until 1916, became the major organ in America for the dissemination of an aesthetic lifestyle as had first been espoused by Morris and his followers. The publication also provided the name, often vaguely and inaccurately applied, for a worldwide aesthetic movement that would preoccupy designers and architects throughout the 1910s. Stickley was not the first adherent of the Arts & Crafts aesthetic in America, but he was the most influential exponent. For the coalescence of the distinctly Californian brand of the movement, he and his magazine were the most significant catalysts.

Stickley first visited California in 1904. From that time on his journal was replete with articles that rhapsodised about the delights of the state's Mediterranean climate, exhorting more of the artistically inclined in the state to follow the inspiring accomplishments of those landscape designers and architects developing a regionally appropriate style.[34] As he wrote in one of his earliest articles about his California experience:

> In order to assure the fitness and beauty in their works, it would seem as if, in this region, the builders of dwellings had but to follow the sure, clear indications given by Nature. The climate invites to out-of-door life. The vegetation is magnificent and rare. The atmospheric effects are too beautiful to be wasted. These facts alone should suffice to determine the style of California dwellings, as they have already done in several countries of similar situation.[35]

Stickley's enthusiasm was reciprocated: these same craftsmen and architects adopted his aesthetic of simplicity and integrated design with alacrity, enhancing with additional idealism a design for artistic living on the Pacific coast.

In the same year he first visited California, Stickley began publishing in *The Craftsman* a monthly series called 'A Craftsman House', in which a house design with pictures, floor plans and detailed instructions appeared. For three dollars any member of the Craftsman Homebuilders' Club—essentially any subscriber to the journal—could purchase blueprints for each house. This series continued in the magazine for many years, providing an important practical source for the dissemination of the Craftsman style, whether bungalow or its other architectural variants. Californians who read and contributed to *The Craftsman* also began to have a bearing on the formulation and expansion of Stickley's

Arts & Crafts ideas, including the features of the houses exhibited in each issue.

As *The Craftsman* craze grew throughout the United States in the first two decades of the century, other companies and individual artisans produced voluminous quantities of brochures, booklets and product catalogues, all with carefully designed type fonts, graphic formatting and, of course, photographs to extol the virtues of Arts & Crafts products. These publications were as important to the spread of Arts & Crafts ideas worldwide as *The Craftsman* magazine itself, widely copied by lesser, if just as ardent, practitioners of the style. In northern California, the Pacific version of *The Craftsman* ideas centred around Charles Keeler (1871–1937), described as a poet, ornithologist, traveller and 'prominent oracle for the Arts & Crafts ideals'.[36] Keeler and his close friend, the eccentric architect Bernard Maybeck (1862–1957), were ferv-

ently dedicated to the whole artistic notion of Berkeley, California, as the epitome of the 'Athens of the Pacific'—the Mediterranean metaphor as the appropriate model for artistic California living. They espoused this notion of a special Californian aesthetic sensibility through writings and in actual construction. As a manifestation of their shared world-views, Maybeck prevailed upon Keeler to allow him to build a house for him in the Berkeley Hills. Here Maybeck expressed their common ideas about unadorned wooden homes set in natural landscapes. Soon he built other homes on the same hill for other Berkeley friends. They all demonstrate Maybeck's eclectic utopianism, with stylistic elements taken from influences as varied as the Swiss chalet, New England Shingle Style homes, Classical architecture and Beaux-Arts motifs. They were, in other words, the epitome of the Californian house. The houses also convey the pair's commitment to a

A California House and Garden

Myron Hunt & Elmer Grey, Archts.

"THERE ARE HALF-COVERED PORCHES (PERGOLAS) THAT SUGGEST SHADE AND COOL, AND STILL ALLOW THE SUN TO CARPET THE GROUND WITH DAPPLED SHADOWS."

Fig. 4.07 *A California house and garden, Myron Hunt & Elmer Grey, architects*, in Craftsman, October 1907. Courtesy of The Huntington Library, San Marino, California.

communal lifestyle for like-minded artists, an aspiration that led others of the group to form The Hillside Club—named in honour of those living aesthetically in Maybeck houses on the Berkeley hillside and organised primarily by the women associated with these houses.

Out of this community and through his other pronouncements came Keeler's Ruskin-inspired book, *The simple home*, a poetic explication of California-style Arts & Crafts sentiment about the home.[37] The book was reviewed widely, receiving praise for its message of simplicity in *The Craftsman* and the other journals of the Arts & Crafts Movement.[38] Here Keeler, in his role as 'Policeman of the Arts',[39] condemned Victorian ornamentation as 'the makeshift of a shoddy age', as nothing but 'veneer and stucco'.[40] In California, where the surroundings were so salubrious, Keeler argued:

> The thought of the simple life is being worked out in the home. In the simple home all is quiet in effect, restrained in tone, yet natural and joyous in its frank use of unadorned material. Harmony of line and balance of proportion is not obscured by meaningless ornamentation; harmony of color is not marred by violent contrasts.[41]

Maybeck's early houses for the Hillside community embody this concept: made of wood, usually shingled redwood, and having sleeping porches to allow as much contact with nature as possible.[42] Photographs of these houses as well as images of other vernacular influences such as Maori and Hawaiian buildings that Keeler saw on his world travels appeared in the original 1904 edition of *The simple home* (most of the photographs were taken by Keeler's sister, Sarah Isley Keeler).[43]

Other publications, such as the many books by Arts & Crafts publisher Paul Elder (1872–1948) about San Francisco and its artistic activities, and magazines such as *Sunset* and *The Craftsman*, were quick to champion these architectural precepts.[44] Most significantly, these widely distributed publications dispersed

images of the work of Maybeck, Keeler and the rest of the Bay Area Arts & Crafts followers to the world.[45] An illustration of Maybeck's early masterpiece, the Christian Science Church in Berkeley (1910), for example, appeared in the Australian architectural journal *Building* as early as 1915.[46]

In Southern California, an Arts &Crafts-inspired lifestyle was championed most exuberantly in Pasadena, the prosperous winter residence of the eastern and Midwestern rich at the foot of the San Gabriel Mountains and next to the Arroyo Seco riverbed some 16 kilometres north-east of Los Angeles proper. From its beginnings as an agrarian settlement in the 1870s, Pasadena attracted artists and utopians as well, all intent on transplanting the cultural activities of gentility into an idyllic sun-drenched landscape. Proponents of the movement in Southern California took a slightly different tack than their Bay Area brethren, who aligned their practices more closely with Classical Mediterranean allusions. (They were, however, equally dedicated to the ideals of *The Craftsman*). While as eclectic as their northern counterparts, the Arts & Crafts groups in Los Angeles and Pasadena nurtured more immediately a romantic linking both to the region's Spanish past and, in some cases, to a Westernised notion of Japanese styles.

Dreamers of the Southern Californian stripe were exemplified by people such as the ex-Methodist preacher and ethnologist George Wharton James (1858–1923). James had already worn many cultural hats by the time he fashioned himself into a high priest of the Arts & Crafts Movement, most notably and prolifically as a writer on south-west Indians and their basket making. These interests brought James into the sphere of those constructing a south-western image revolving around the California missions. As early as 1905, James published articles in *The Craftsman*, first about the history of the Franciscan missions in

the state.[47] Encouraged by the response to this topic, he then wrote another article about the 'Mission Style' and its influence on contemporary architectural practice.[48] In emulation of Stickley's model, James, along with another English-born member of his circle, the artist, teacher and stained-glass designer William Lees Judson (1842–1928),[49] also began his own journal in 1909, appropriately named *Arroyo Craftsman*. James hoped to establish a thriving Arroyo Seco artists' group, which he and Judson dubbed The Arroyo Guild. Emulating Morrisonian ideas of a monastic order of artists, he fashioned himself as 'Frater Primus and Editor' of the journal.

Despite all of James' optimistic aspirations for an artistic community centred on the journal, he was only able to publish one issue. This issue emphasised architecture and landscape gardening, including 'the elevation and plan, with full description, of one of its houses'.[50] The house illustrated was a cottage built in Santa Barbara by the well-established Los Angeles firm of Robert F. Train (1869–1951) and Robert Edward Williams (1874–1960)—described here grandly as 'directors of the architectural department of the ARROYO GUILD'.[51] While the style of the cottage is a relatively conservative adaptation of 'Old English' motifs, James's lengthy description of the details of the construction, all done by the master craftsmen associated with his group, focus on the specifically Californian elements of the design: the sleeping porch, an open plan, and such distinctive features as 'the pair of large French windows leading out into the rear garden', which in James's florid prose would 'tone down into delicious restfulness the clear flood of sunlight which California so richly bestows upon its well-favored inhabitants'.[52] Just as Keeler and his San Francisco followers appealed to the idea of a shared aesthetic sensibility, so too did James and the other Pasadena Arts & Crafts members speak

Fig. 4.09 *Two suite cottage for J. P. Ferguson, Santa Barbara, Cal. Train and Williams, architect* in *Arroyo Craftsman*. Courtesy of The Huntington Library, San Marino, California.

of 'Beauty and Service'.[53] *Arroyo Craftsman*'s masthead stated that the Guild's purpose was 'simple living, high thinking, pure democracy … honest craftsmanship, natural inspiration, and exalted aspiration'.[54]

James's vision was one of the most utopian, hyperbolic and opportunistic of the many voices that contributed to the construction of a culture-driven lifestyle in Southern California in the 1910s and into the 1920s. His embrace of the *The Craftsman* message, as well as his harking back to the remnants of the state's Hispanic Mission heritage, was shared in many other publications and put into practice by other, more serious, artists, designers and architects. James nonetheless had more influence on local events and popular understanding of these Arts & Crafts attitudes than subsequent writers will sometimes admit.

For the championing of Southern California's Spanish–Mexican architectural roots and as an antidote to the 'aesthete' pronouncements of George Wharton James, no figure was more influential than the flamboyant newspaperman and mythmaker of the southwest, Charles Fletcher Lummis (1859–1928).[55]

His friend Charles Keeler characterised him as 'William Morris turned into a New Mexican Indian'.[56] As Kevin Starr described him, '[he] wanted Southern Californians to see themselves as the moral heirs of Spain. He encouraged them to internalize in an American way the aesthetic austerity of the civilization which had prepared the way for their own'.[57] Lummis had been a tireless booster for his romantic view of Southern California ever since he walked there from Ohio in the 1880s. The epitome of the energetic Californian eccentric, he began dressing as his own version of a south-western Mexican don, with corduroy suit of tight pants, Spanish wide-brimmed hat and sash. He knew everyone in the state who was interested in his brand of cultural campaign and he was involved in every ambitious activity that had to do with enhancing an understanding of the region's Hispanic and Indian heritage.

Lummis's work as President of the Landmarks Club was instrumental in saving the then-derelict Franciscan missions of California from destruction. His efforts along with those of other members of the club led to the missions' renovation and

romantic integration into the image of the new, modern California. In 1897, Lummis was able to offer Charles Keeler and his wife 'two livable old rooms in the Mission San Juan Capistrano' where Keeler would write a tour guide to Southern California for the Santa Fe Railroad.[58] He built his own house by hand on the Arroyo Seco in what is today the suburb of Highland Park, close to Pasadena. He christened his domain El Alisal, The Sycamore, after the native trees that surrounded it. The house manifested in a rough-hewn manner all of Lummis's heartfelt vision of an Old California frontier *rancho*: built around a courtyard out of enormous boulders with timber beams and concrete floors, he hoped it would 'last for a thousand years'.[59] Lummis also oversaw construction on the hill above his house of The Southwest Museum,

the place where he displayed his superb collection of Native American artefacts, at the same time nurturing and implementing visual and literary versions of his Spanish–Indian–Californian *Weltanschauung*. The museum's concrete tower still looms above the Pasadena Freeway as a kind of Spanish fortress. The architect Charles Moore describes the experience of this magical place:

It is just a bit reminiscent of a Spanish monastery or perhaps a fortress in the Pyrenees or a castle in Castile or a hastily built movie set. The romantic vision slides in and out of focus, between wonder and sleaze. Dense landscaping of dark foliage obscures the foundations, so the building appears as an outcropping of the hill itself. But even the hill has something suspicious about it.[60]

Fig. 4.10 Charles Lummis, (arch.), El Alisal, Highland Park, California, 1895–1910. Courtesy of The Huntington Library, San Marino, California.

Fig. 4.11 'The lands of the sun expand the soul', *Land of Sunshine* logo, vol. 15, July 1901, p. 111. Courtesy of The Huntington Library, San Marino, California.

tions was his own lifestyle journal, *Land of Sunshine*, which he founded in 1895 and edited until 1903 (the magazine's title changed to *Out West* in 1902).[61] Here he pontificated on all manner of south-western topics in his robustly masculine manner. His most enduring logo for the magazine included a picture of a mountain lion above an ornamental vignette of emblematic California poppies; and he referred to his editorial column as 'In the lion's den'. An example of his aggressive advocacy of the superiority of Western living appeared in this column a few months after McKinley's visit to the state:

> Were not the Westerner incorrigibly modest, it would never do for him to revisit the pale glimpses of the East. Conformed, now, to horizons he does *not* dent with his elbows every time he turns around; shriven of provincialism by travel and comparison; fond of the people who still stay where they happened, while he lives where he likes; living next door to Nature and just across the street from the only Better Country that the heart of man hath conceived—by all he is peculiarly surefooted and of well-seasoned head, warranted not to swell. He can view with good-natured pity, and no notion of arrogance, the stuffed-doll 'life' of his unremoved contemporaries. It does not make him vain that 'we do these things rather better'—for he *expects* travel, elbow-room, climate and other evolutionary forces of the first magnitude to have some effect. He remembers what they have done for him, and that he did not invent them.[62]

One of the topics he most frequently discussed in this freewheeling manner, or invited others to discuss, was architecture. Most predictably, given his lifelong activism for a recognition of the region's past cultures, Lummis wrote most vividly about California's Hispanic heritage as offering the most appropriate model for the

Moore has captured perfectly the romantic, larger than life presence of Charles Lummis and his architectural legacy to Southern California in the first decades of the twentieth century. When the Australian James Peddle was working in Pasadena, the opening of The Southwest Museum provided an important point of conversation for architects in town.

One of Lummis's most lasting contribu-

region's future buildings. As early as 1896, Lummis, along with another Landmarks Club participant, the architect Arthur B. Benton (1859–1927), wrote about the need for a truly Californian architecture, emphasising particularly the appropriateness of the patio and the verandah.[63] The synthesis of stylistic elements that would finally merge into the housing form transported to Australia as 'the California bungalow' was taking shape a few miles up the Pasadena road from Lummis's idiosyncratic structures, while the journalist Lummis in his writings gave eloquent voice to—and indeed prepared the way for—the architectural ideas that would determine the next important Californian style to cross the Pacific, the Spanish Revival and all its eclectic offshoots.[64]

The steps in the merging of architectural elements leading finally to the so-called California Bungalow—and the central role played in this architectural process by reproduced images in magazines such as *The Craftsman*—are nowhere more vividly and spectacularly seen than in the work of the Midwestern transplants to Pasadena, the brothers Charles (1868–1957) and Henry Mather Greene (1870–1954). They arrived in California in 1893 to join their parents, having already studied and worked as architects in Boston. En route to the west coast, the brothers stopped in Chicago to visit the World's Columbian Exposition, the famous 'White City' that would figure so prominently as an inspiration around the world for artists and architects of the coming century.[65] The Greenes had their first experience of genuine Japanese architecture there and saw the monumental achievements represented by the fairgrounds' buildings of Daniel Burnham, Louis Sullivan and many others.[66] When the brothers got to Pasadena and found it to be more than a provincial country town—that it had already 'developed into a resort land of

genteel bohemianism',[67] inhabited by wealthy residents who wanted to display their cultivation and wealth through the houses they built—they set up practice. Their early work, in the late 1890s and first years of the new century, displayed among other influences aspects of the Shingle Style and Beaux-Arts design, then so popular back east for prestigious homes. They also began to demonstrate their knowledge of new developments in domestic architecture out of Chicago. While their sense of solid craftsmanship was already apparent, their models were still eastern and Midwestern ones.

In the early 1900s, the Greenes, who had always kept scrapbooks of design ideas gleaned from all the architectural journals, books and international magazines that they could find, began to formulate their own elegant interpretation of Arts & Crafts philosophy, geared consciously to the idea of a Californian house adapted to the Pacific state's landscape and climate. One of their major discoveries in this exploration was Stickley's *The Craftsman*.[68] Their exposure to design ideas through like-minded wealthy patrons and friends in Pasadena, who read Ruskin and Morris and were committed to the Arts & Crafts Movement, also gave them the impetus and the freedom to experiment on a grand scale. What followed from 1903 until the beginning of World War I was a series of magnificent, uniquely formulated homes that stand at the pinnacle of West Coast Arts & Crafts design. Despite, or perhaps because of, their stylistic variations, these buildings have been described as representing 'the ultimate bungalow'.

Whether defined as showing stylistic affinities to Japanese buildings, Hispanic ranchos, Swiss chalets, Native American motifs or English cottages, the emphasis in a Greene & Greene house of this period was on lovingly handcrafted interior woodwork and a masterful use of custom-made leaded

Fig. 4.12 Greene &
Greene (archs), The David
Berry Gamble House,
Pasadena, California,
1908. Exterior: rear
terrace with eucalyptus.
Photograph: The Greene
& Greene Archives,
University of Southern
California, The Huntington
Library, Art Collections
and Botanical Gardens.

glass and other fixtures. The Greenes often
called for Stickley furnishings to be installed
throughout, an example of their adherence
to the Arts & Crafts Movement's demand
for organic interior design. Landscape design
was also a significant part of most Greene
& Greene projects. The architects were said
to have designed The Gamble House (1908)
around two large eucalyptus trees already on
the property and the garden was carefully
planned by the brothers to complement the
house and the setting.

Two houses by Greene & Greene from this
period are especially instructive of their attempt
to find appropriately modern solutions for the
appearance of the California house, in which
the natural surroundings were considered as
an integral part of the building's design. Once
again, the eclecticism of their sources and the

originality of their combined elements stand as
markers of a distinctly west coast approach to
domestic architecture. In 1903, the brothers
were commissioned to design a new residence
for Arturo Bandini, descendant of one of the
most prominent families of Old California,
and, along with his wife Helen Elliott Bandini
(her father was one of the original founders of
Pasadena), an important figure in the region's
cultural life. As Bosley writes, '[h]ere … were
clients with deep roots in California's history
inspiring them to draw from the regional
paradigm to create a home that was uniquely
Californian. In some respects, this was exactly
what the Greenes had been implicitly searching
for since they had arrived in Pasadena a decade
earlier'.[69]

The result of this collaboration was a
sprawling *hacienda* that owed as much to the

fashionable and immensely popular California romance *Ramona* (1884) as it did to the Greenes' adaptation of true colonial *ranchero* style. The plan consisted of a U-shaped wooden house with continuous rooms surrounding a courtyard patio with garden and covered walkway that served as a communal outdoors area for the whole house. Indoors was consciously joined to outdoors. As an early enthusiast of the bungalow wrote:

> French doors open into this courtyard from every room that is in [a] sense a living room, even the bedrooms. The house rambles to suit its will, and there is plenty of ground, so that the wings of the house do not elbow each other.[70]

But even here, in a house so consciously and symbolically 'Californio' Hispanic, the Greenes were not purists to any historicist style. Having purchased a copy of Edward S. Morse's *Japanese homes and their surroundings* during the construction of the Bandini house, they incorporated a traditional Japanese building technique into the posts holding up the verandah around the patio.[71]

This Japanese note, based entirely on the Greenes' access to published illustrations of Japanese style, appeared most noticeably in the home they built for another member of Pasadena society. This time the patron was a newly arrived New Yorker with a substantial art collection named Theodore Irwin, Jr. In 1906 to 1907, the Greenes transformed an already existing residence on Grand Avenue into 'a Japanese-inspired house made for America'.[72] Filled with Craftsman furniture and the Irwins' collection of Native American and

Fig. 4.13 Greene & Greene (archs), Theodore Irwin House, Pasadena, California, 1906–07. Photograph: Alfred Spain Collection, RAIA (NSW), Sydney, New South Wales.

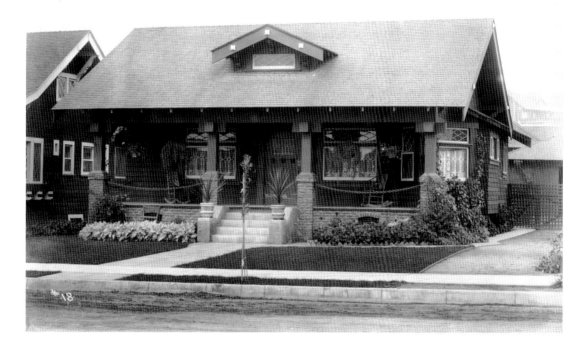

Asian art, the interior spaces comprised fitted cedar joinery, complemented by warm brick fireplaces. Most significantly, the gardens were harmonised with the house itself—including not only a Japanese stone lantern in the front yard, but also a grand old eucalyptus tree that still stands on the grounds. In the Irwin House, as Bosley says, 'the Greenes and their client painstakingly created a classic American Arts-and-Crafts environment, seemingly from (or perhaps for) the pages of *The Craftsman* magazine'.[73]

Now indeed the influences were reversed, as Greene & Greene houses began to offer illustrations of the new California style in the very same magazines that the brothers had initially consulted to formulate their original designs. The Bandini house is one of those illustrated as exemplary of the ideal bungalow in Una

Nixson Hopkins' 1906 article in *The Pacific Monthly*, reprinted in *The Architect and Engineer of California*.[74] A view of the Irwin house appeared in *Craftsman* itself in 1907, in an article by another woman writer, Henrietta Keith, on Japanese influences in contemporary building.[75] All of these publications came to Australia at the same time they appeared back east in New York and Boston. The word—and the image—of exciting Californian innovations in housing had arrived. By the early 1900s, thousands of bungalows in all housing strata began to appear throughout the United States, and nowhere more enthusiastically than in Southern California.

The rarefied architectural achievements of the Greene brothers for their wealthy clients, and even the romantic eccentricities of Keeler and Maybeck in northern California may seem

to have little to do with the kind of cottages that George Wharton James published or the romantic stone frontiersman's *rancho* that Lummis concocted, and they certainly seem removed by great margin from the modest bungalow styles that Australians began to see and adapt to their own conditions in the 1910s. But all of these achievements, including the Greenes' original masterpieces, contributed to the dialogue that led to the formulation of an identifiable Pacific coast bungalow style. This dialogue took place in the illustrated pages of the popular and trade press in which all of these accomplishments were lauded and advertised, and through which their images were reproduced and dispersed internationally.

While the national American magazines such as *Good Housekeeping*, *House Beautiful*, *House and Garden*, *Country Life*, *Harper's* and *Century* were relatively quick to recognise and broadcast these developments, the most enthusiastic and influential proponents were, understandably, the West Coast magazines that began to appear at the same time. In the conscious construction of a Pacific lifestyle, *Sunset* magazine is one of the most important disseminators of imagery and philosophical outlook. Founded in 1898 by the Southern Pacific Railroad (SPRR), its initial purpose was 'to promote and glorify the West in an effort to persuade Easterners to visit and colonize the still thinly settled region served by the railroads'.[76] The name referred to the Sunset Limited, the Southern Pacific's most elegant train.[77] Its lofty aim, stated as early as 1900, was 'publicity for the attractions and advantages of the Western Empire'.[78] At first, the design of the magazine was pedestrian, looking like a trade publication or promotional brochure with limited illustration, chiefly photographs and ornamental vignettes in awkward layouts. Geared entirely toward the passengers of the railway, emphasis was on the numerous advertisements extolling resorts along the SPRR lines. As the

ambitions of the magazine grew, so too did its emphasis on modern graphic design and a specifically Western aesthetic stance in text and illustration.

In 1902, with new editor Charles Sedgwick Aiken (1863–1911), illustration became increasingly important. Poetry and literature appeared by the likes of Jack London and San Franciscan Gelett Burgess (1866–1951; he of 'Purple Cow' fame);[79] and political articles of interest to Californians and people of the Pacific coast focused on the Far East and the American presence there. The covers by this time began to experiment with livelier modes of graphic design, incorporating photographs, allegorical figures and ornamental borders. At first this experimentation produced less than successful styles, and early content was also inconsistent in quality and pitch. But by 1903—the year of Teddy Roosevelt's presidential visit to California[80]— the graphic and

Fig. 4.16 Frances
McComas, *Monterey,
looking seaward*, in
Sunset, vol. 13, May
1904, p. 3. Courtesy of
The Huntington Library,
San Marino, California.

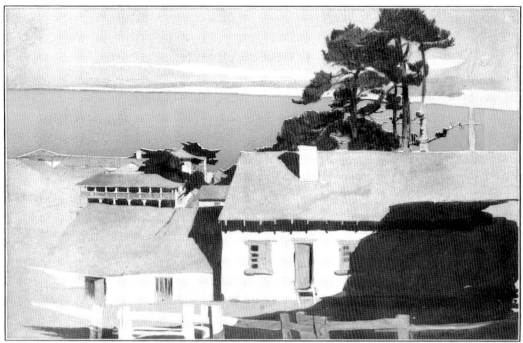

LOOKING SEAWARD AT OLD MONTEREY, CALIFORNIA From water color study by Francis McComas

textual tone solidified into something that moved beyond hackneyed promotion.

Sunset's articles and illustration now focused increasingly on the special qualities of life on the Pacific Rim, in all its multicultural dimensions and with all the delights of its natural setting. In 1902, volume 9 included Western stories by the old San Francisco bohemian Joaquin Miller; photographs and articles about the Santa Barbara Mission by photographer Oscar Maurer (1870–1965) and his wife Madge Maurer (b. 1871; she was one of the co-founders of The Hillside Club in Berkeley); and illustrated advertisements for books on California wildflowers. Also in its pages were many landscape drawings by Francis McComas (1875–1938), 'a young Australian who has his studio with the artists' colony at Old Monterey'.[81]

The interior graphics of *Sunset* also began to take on a more cohesively aesthetic and 'modern' look. The magazine's subtitle by this time was 'Magazine of the Border', no doubt influenced by Lummis's great push for an emphasis on California's position at the Pacific border of the continent and on the edge of the Hispanic West. The magazine's cultivation of a modern, exceptional, coastal lifestyle also included a focus on the 'new woman' living a carefree life outdoors along the Pacific coast. The July 1911 cover by J. A. Cahill depicted, for instance, an extraordinary image of a young woman surfing—only a few years after the introduction of surfing to California by the Hawaiians Duke Kahanamoku and George Freeth (see Fig. 4.15 on page 174).[82] The image would have stunned Easterners, but Australians would have found it comprehensible and amusing.

In 1912 *Sunset* bought out *The Pacific Monthly*, a magazine also founded in 1898 and published by the Pacific Monthly Company of Portland, Oregon. *Sunset* added the words *The Pacific Monthly* to its name on subsequent magazine covers; its coverage now became more inclusive of the other

western states.[83] By 1905, its political stance was excitedly expansionist. An article by Arthur I. Street titled 'Seeking trade across the Pacific' announced:

> The American people are beginning to discover that the Golden Gate is the front door to the Orient ... For, the Orient is not China alone ... It is New Zealand and Australia with their continental area, their rapidly expanding business conditions, and their assuring future potentialities.[84]

Articles on the English-speaking nations of the Pacific now became a regular inclusion in the pages of *Sunset*.

By 1914 the editors at *Sunset* had become so ambitious in their efforts to make the magazine the essential cultural magazine of the West that the SPRR sold it to a consortium of the staff. By this time, the ideological focus of the magazine was clearly centred on the West's unique landscape and lifestyle as manifested in its new architecture, gardens and tourist attractions. Fiction and editorial

articles looked increasingly to the Pacific—to Asia, the Pacific Islands, Australia and New Zealand, as well as the other Pacific states. While articles on examples of new Western architecture and its gardens had appeared from the beginning of the magazine, in 1915 'The home in the West' became a regular column.[85] Here one read about 'The cactus garden' and other examples of 'Western' style gardens. As early as 1915, this section included discussion of 'California's first cubist house', Irving Gill's 1913 concrete residence for Mary Banning.[86] Well-known and novice illustrators alike made significant contributions to the design of the issues, all emphasising the landscape of the south-west and the Pacific states.

By the 1920s this Western publication that had begun in emulation of Eastern journals such as *Atlantic Monthly* had travelled well beyond California's borders. *Sunset* was readily available in Australia from as early as 1909,[87] and earlier to journalists and publishers such as J. F. Archibald and George Taylor. One sees elements of the *Sunset* magazine's style in their own journalistic endeavours, Archibald's

Fig. 4.17 Cover, Los Angeles Investment Co. brochure, 'Bungalows and Cottages in Southern California', 1908. Courtesy of The Huntington Library, San Marino, California.

ambiteously conceived cultural magazine *The Lone Hand* (1907–1921), with its similar ornamental vignettes and colour covers, and Taylor's architectural trade journal *Building* (1907–1942), illustrated in some cases with images taken directly from *Sunset*.[88]

The architectural steps leading to the formulation of the California bungalow—from country cabin to Greene & Greene and Maybeck masterpieces—was meticulously documented in these lifestyle magazines, spreading the message that exciting developments were taking place on the West Coast. The most pervasive source, however, for the eventual spread of the bungalow as the building style for suburban, middle-income housing was the plethora of promotional materials published as pattern books, real estate brochures and the catalogues for ready-made, prefabricated home designs. *The Craftsman* and its building instructions were only one in an enormous stream of illustrated publications for all price ranges. In these publications photographs of available house plans, usually depicted as already built and set in appropriately tasteful gardens on a city allotment, whetted the home-buyers' appetite enough to purchase them.[89]

Bungalows and cottages in Southern California, produced by the Los Angeles Investment Co. in 1908, was a quintessential example of this kind of brochure. The company was a branch of a larger organisation, in Los Angeles since 1895, in which all the employees were stockholders. The cover of this brochure, with its graphic illustration and artistic letter font for the title, identified the location as Southern California by prominently displaying a palm tree behind which was placed a bungalow with stone chimney and in the background some barren California hills. The interior design of the brochure included Art Nouveau-like ornamental flourishes surrounding the photographed images of available house styles (see Fig. 4.18 on

page 178). All of the illustrated houses show elements that came to be identified with the California bungalow: deep porches with supports of wood or stone; sharply pitched, deeply gabled roofs; dormer elements and sometimes enclosed balconies or sleeping porches; wooden frames and cladding; simple, open interior spaces with built-in closets in rooms; and, most importantly, freestanding on a lot ready for gardening. The text—the sales pitch—was geared, as Robert Winter has argued, to the middle class and the working man's desire for 'respectability':[90]

> Southern California is known the world over for its large number of beautiful homes ... the visitor is impressed by the beauty of the home architecture and grounds of the laboring man ... Here the man who earns modest wages may have a home of beauty and comfort. The reasons for this are found in the development of the co-operative building idea, in the adaptation of beauty and comfort to moderate pocket books and in the climate, which quickly develops luxuriant foliage, making it the ideal home city of America.[91]

The company also extolled the fact that the entire construction process was in their hands: they owned the lumberyards, the mills, the factory and the stores. Their motto was 'From Forest to Home', exemplifying a modern approach to building that would be so important to the development of suburban neighbourhoods. Another business called Pacific Portable Construction Company exhibited its 'Ready-cut' System at San Francisco's Panama-Pacific International Exposition of 1915 as 'Built in Southern California—The Land of Beautiful Bungalows' (see Fig. 4.19 on page 179).[92] These illustrated brochures, promotional pamphlets and advertisements were the most effective means of spreading the bungalow aesthetic to the rest of the region, the country

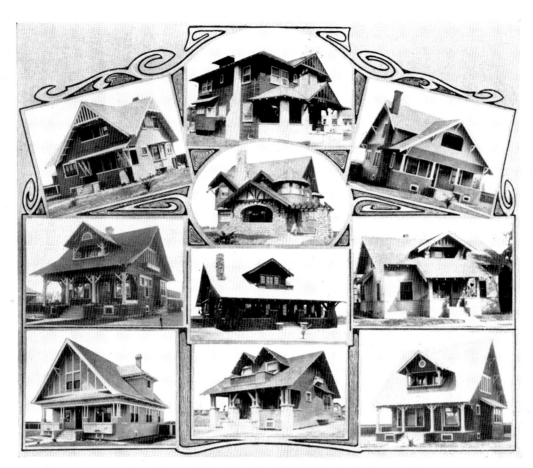

Fig. 4.18 Photographs inside Los Angeles Investment Co. brochure, 1908. Courtesy of The Huntington Library, San Marino, California.

Handsome Houses and Bungalows, Erected by the Los Angeles Investment Co.

and the world.

Many of these bungalow books and plans have survived in the collections of Australian libraries and archives, for nowhere is the California bungalow, as a popular form for suburban housing, more enthusiastically received and adapted than in Australia. As Freeland has written, '[o]f all the exotic importations to Australian architecture the Californian bungalow was by far the most successful'.[93] This transfer was tied to a sense of shared aspiration between Californians and Australians—albeit an affinity that was usually unacknowledged or only vaguely recognised at the time. Graeme Butler clearly expressed this idea in his book *The Californian bungalow in Australia*:

There is more to the bungalow and its ways, however, than the development of a house style. It accompanied a whole way of life. This was a life-style which embraced the holy 1/4-acre block, the nature strip, the motor car and its garage, easy bank home-buyer finance, lower building costs, 'sleeping out under the stars' and recognition of the Australian native planting for urban gardens. In short, everything Australians hold dear today. For an imported, essentially American, style, it seemed to include many Australian things.[94]

That this transmission coincided with architectural formulations already underway in Australia is clear when one looks at

Fig. 4.19 Pacific Factory-Built Houses, advertisement, 'Built in Southern California—The Land of Beautiful Bungalows', c. 1910. Courtesy of the Alice Phelan Sullivan Library at The Society of California Pioneers, San Francisco.

Federation-era houses built in the first years of the twentieth century. Australians had of course been aware of and involved in Morris-inspired Arts & Crafts ideas coming out of England from the 1870s, and many of these elements had already been incorporated into suburban house forms. During the peak years of the bungalow craze, from 1910 to 1925, native-born architects such as the Adelaide-based F. Kenneth Milne (1885–1980)[95] and the Melbourne partnership of Oakden & Ballantyne were designing eclectically derived homes, with some knowledge of American architecture gained only through illustrations in journals.[96] Harold Desbrowe-Annear (1865–1933) in Melbourne, inspired by Frank Lloyd Wright's work and writings, began as early as 1902 to create his own delightfully original timber interpretations of Arts & Crafts forms with elements of the Swiss chalet.[97] In northern Australia, a 'tropical house type' more dependent on original Indian bungalow models was also evolving into a distinct cottage style called 'The Queenslander', a house style most affectionately described by the Brisbane writer David Malouf.[98] But the sheer number of publications about California houses, West Coast building materials and lifestyle choices

that embraced outdoor living—all pouring into Australian newsagents, libraries and bookshops—made it inevitable that Australian architects and developers would discover this kind of bungalow style through printed sources and would adopt these forms from America with alacrity.[99]

By the 1910s, not only were Australians consuming American bungalow magazines and pattern books, but Australian builders were also producing their own brochures, sometimes copying photographs directly from American sources (see Fig. 4.20 on page 215). A Sydney timber company, George Hudson & Son Ltd., even took up Pacific's 'Ready-Cut' system, spelling it 'Redi-Cut', and included similarly ambitious illustrations showing their impressive timber yards and production facilities. By 1913, popular Australian magazines such as *Home & Garden Beautiful* were regularly referring to 'Craftsman Furniture', described in their articles about interior design as made in Australia of Australian hardwood.[100] The magazine often included instructions on how to make Mission Style furniture.[101] Trade catalogues for the Sydney furniture store A. Hall & Co. featured in 1915 'Mission furniture', described as 'Furniture of the correct design

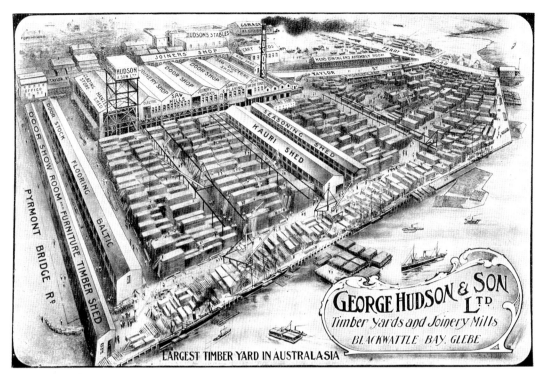

Fig. 4.21 George Hudson & Son Ltd, advertisement, 'Timber Yards', 1913, *Salon*, October 1913.

for the modern bungalow home'. At about the same time, David Jones', the most elegant department store in Sydney, proudly displayed an entire line of Craftsman Furniture, stating 'it is noted for its good workmanship, and only the genuine Stuckley [*sic*] Work is sold by us'.[102] Knowledge of these stylistic developments depended on the availability in Australia of the whole gamut of American publications, from *The Craftsman* to the most modest trade brochure.

As important as these illustrated publications were in the transfer of architectural ideas, other, more direct, methods in this period also played a part in the development of the bungalow style in Australian. Four events in the first two decades of the twentieth century particularly highlight the methods by which this architectural exchange occurred. The first occurred in 1907 when businessman, inventor and artist George Augustine Taylor

(1872–1928) founded *Building* magazine in Sydney. Taylor was a fascinating character, an idiosyncratic enthusiast of, among other things, aerial flight, radio transmission and Australian nationalism.[103] He began his career in the 1890s as a builder's apprentice, but operated as well on the peripheries of Sydney's artistic circles. He was a participant at one time in the Dawn and Dusk Club, Sydney's equivalent of San Francisco's Bohemian Club, and ultimately became its historian when in 1918 he wrote his memoir of the 1890s called *Those were the days*.[104]

Taylor was always more of an 'achiever' than the louche members of bohemian Sydney. At the same time as he was supposedly carousing with artists, he had devised a new material out of sugar fibre to plaster ceilings with prefabricated designs of Australian flora and fauna. In 1909, he became the first Australian to build and fly a real airplane, and

he continued to write about flight throughout his life.[105] He liked to produce caricatures, worked sometimes as a black-and-white artist for journals and was fascinated by the history of illustrations, which he wrote about at length in his magazine. The subjects he examined were as varied as road building, town planning, engineering and brick-making. He also wrote short stories for the magazine, chiefly science fiction, which he illustrated himself.

From 1907 until the onset of World War I, Taylor through his magazine *Building* became a most important commentator in Australia about architectural and engineering develop-ments in America. He was most ardent, if at times quirky, in describing the relevance of these developments to Australia's built envi-ronment. With his wife, Florence (1879–1969)—the first woman architect and engineer in Australia[106]—Taylor published the magazine until his death in 1928; Florence kept it going until 1961. As Apperly described the couple:

> In many ways the Taylors personified Australian architecture itself. They felt satisfied and com-fortable when confronted with traditionally-generated solutions, but at the same time they were excited by the vast technological possibili-ties of the twentieth century (and fascinated by its gadgets).[107]

As an enthusiast for all modern technology, Taylor could not help but be impressed by modern American architecture, building inno-vations and town planning, but his opinions about these accomplishments were sometimes oddly misplaced. He and Florence were in the long run no champions of high modernism, but their enthusiasms for American trends in architecture and town planning dominated the pages of *Building* in the years before World War I. Increasingly that focus centred on California and the bungalow—and, later, on other Revival styles.

Building magazine was not the only pub-lishing concern of the 1910s to champion the bungalow as the most suitable domestic archi-tectural form for the Australian climate and landscape; but the two Taylors were the most vocal exponents of the style.[108] Most impor-tantly, the magazine reproduced images, espe-cially of California bungalows, taken directly from photographs published in American magazines. In these articles, Taylor would usually include his own heartfelt opinions about how these ideas could be applied to Australia, and in what way Australian archi-tects and designers could produce better,

more appropriate, results. The Taylors made constant reference to a huge array of American magazines and trade journals. Their writings give evidence that substantial numbers of even the most obscure journals, such as *Brick and Clay Record*, were available and accessible to Australians.[109]

As early as 1911, Taylor reprinted in *Building* a condensed version of an article originally published in *Sunset* by its editor Walter Woehlke.[110] In *Sunset*, the article was titled 'Los Angeles – Homeland', and included numerous illustrations of Southern Californian homes as evidence of a new lifestyle prospering in this region.[111] Taylor's reprinted version was titled 'Australia leads (but sleeps): Climate as a national asset'. It also included illustrations of California homes, although not the same ones that Woehlke had published. Tellingly, a note at the end of the article informs the reader that the illustrations were 'courtesy of the Paraffine Paint Co., whose Malthoid plays an important part in California bungalows'.[112] Taylor never failed to sing the praises of those companies that advertised in the magazine and he seemed to have a particularly close association with the San Francisco-based Paraffine Paint Co., which had offices in Sydney.

Interspersed among these illustrations in the article, the Taylors included reproductions of bungalow designs submitted by Australian students for a competition of The Institute of Architects of New South Wales. As an introduction to the article, Taylor also includes the following exhortation to his Australian readers:

Australia's climate is world-famed.

It gives us the lowest death-rate of any country on earth, and the development and improvement of local government services is helping Nature to make our living still more healthy.

For long Australia's climate has won the recommendation of the world's physicians for healthy living for invalids. It's about time it won better recognition for healthy living for the well and wealthy.

There is no reason why the world's millionaires tired of their money-building should, [*sic*] not end their days in this land of sunshine and health.

America makes much out of little, and it found a passable climate in California, at Los Angeles, and it is making it a national Homeland.

It is claiming it as the world's health spot; yet is it not so healthy, nor as bracing, nor has the vitalising tang of eucalyptus-scented Australia.

And it knows it—so it is trying to ring it up by planting Australian gum-trees everywhere. It is trying to steal our climate, and make money out of it. Here is the story of what it is doing—Walter Woehlke tells it in 'Sunset'.

It holds a lesson Australia should learn, and learn at once.

Now then N.S.W., with your Sydney harbor charms, your mountain salubrity; Victoria, with your Gippsland sweetness, Queensland with your champagney springtime—get to work![113]

Taylor ends the article with his typically kick-in-the-pants comment, 'What is Australia going to do about it?'

Stimulated by their voracious consumption of American magazines and books, the Taylors poured out a stream of articles praising American advances, comparing them to Australian practices. The achievements of the Chicago School particularly caught their attention. The covers of the magazine in 1912 and 1913 included ornamentation lifted bodily from Wright and Sullivan; and the contents reprinted articles by and about Frank Lloyd Wright, Walter Burley Griffin, F. W. Fitzpatrick, and Daniel Burnham.

From the beginning of the competition

imagination. The great deeds of great men in that wonderful country of 'make haste' seemed always to summon me to 'come across' and people my wonder world with reality … America is inspired by the same motives as inspire us, and is doing things generally in almost every sphere of activity as we should have done them … I propose mainly to study building legislation and civic government, constructional methods and modern architecture, town planning, and, of course, the commercial and literary sides of the press. By the courtesy of Walter Burley Griffin and other good friends, I shall have the opportunity of meeting some big people in those particular spheres; architects like Fitzpatrick, Louis Sullivan and Frank Lloyd Wright, for instance; all men whose work is 'up with the times'… My mission is to strengthen the practical journalism of 'Building' Magazine … and to make it even a more courageous and perturbing influence in deciding the big things that matter.[116]

for the design of Australia's national capital, Canberra, Taylor was the greatest champion of Walter Burley Griffin and Marion Mahony Griffin's submissions. Just as emphatically, and for seemingly personal reasons about the Griffins' pacifist stances during World War I, the Taylors turned against the Griffins once they were in Australia.[114] *Building* also published accounts of Australian architects' impressions of America, such as reports from Sydney architect John Burcham Clamp (1869–1931) recounting his state-sponsored trip through the United States in 1914. In these articles Clamp particularly extolled the wonders of its steel frame structures, and was especially taken with Los Angeles and Chicago.[115]

In 1914 the Taylors were able to travel to the United States themselves, an event heralded in *Building* with great fanfare. In the May issue, Taylor expressed his excitement and his mission:

America has always been a wonder world in my

The Taylors began their trip in June 1914 and provided continuous reports for the magazine of all manner of things that they discovered. Florence wrote about 'women's issues' such as civic duties, schools and kitchens,[117] and George was particularly impressed by America's roads and suburban streetscapes. They stocked up in the United States on magazines and photographs, which continued to be gleaned for material to reproduce in *Building* for years to come.

In Chicago, they met with Frank Lloyd Wright (1867–1959), who gave 'Captain Taylor' an inscribed copy of his own deluxe edition of the Wasmuth portfolio of his works published in Berlin in 1910.[118] Taylor also met the grand old man of Chicago architecture, Louis Sullivan (1856–1924). At this time he produced a caricature of himself, dressed as a derelict bohemian beside an amusing depiction of the dapper Sullivan (see Fig. 4.24 on page 184).[119] Clearly the Taylors were immersing

Fig. 4.24 George Taylor, Cartoon of George Taylor with Louis Sullivan. Courtesy of Caroline Simpson Library and Research Collection, Historic Houses Trust of New South Wales, Sydney.

themselves in the most innovative aspects of American regional architecture.

The couple was in Chicago meeting with Wright when World War I began in August. They returned to Australia in October of that year. While *Building* continued to demonstrate interest in American housing and building ideas, including more images of California designs and housing plans, the United States' hesitation to enter into the war effort offended the Taylors' nationalistic sentiments—a fact made clear by a number of Taylor's anti-American cartoons in the magazine. Now articles focused increasingly on Australian adaptations of American ideas and the work of Australian architects in 'modern' directions. The December 1914 issue—one in which the Chicago-style ornamentation on the cover is still there but overtaken by a superimposed drawing of an Australian soldier—includes an article on 'The bungalow' that hints at this direction:

The Californian bungalow is seen at its best in Pasadena and Los Angeles, and to an Australian there is a remarkable familiarity of setting inasmuch as the Australian Gumtree having been introduced into Southern California is bringing an Australian atmosphere into that semi-tropical country. But the Californian bungalow depends for its main features upon spreading eaves, simplicity of line and novelty of treatment of the chimney. In Pasadena a feature is made of cobblestones let into the brick or cement work, giving a quaint and at times highly artistic effect. This feature … would be too artificial for Australia.[120]

The accompanying illustrations depicted Australian examples of bungalow building. While Taylor's unrealistic expectations of America had been tempered now by his own experience and coloured by his personal eccentricities, he, along with an increasingly involved Florence, continued to disseminate through *Building* the best examples of American archi-

tectural developments and to reproduce the images that they found in American publications for an Australian readership. While their comments accompanying the images became by the 1920s increasingly odd and often missed the mark, the significance of *Building*'s photographic reproductions in introducing an Australian audience to new architectural ideas cannot be overestimated.

The Taylors' many endorsements and ultimate excoriation of Walter Burley Griffin (1876–1937) in *Building*'s pages points to the second exemplary event in architectural exchange between America and Australia during this period. In 1911, the Chicago architect and landscape designer Griffin, an early colleague of Frank Lloyd Wright, won the international competition to design Canberra, the new Australian capital.[121] His success in the competition stemmed largely from the exquisite drawings of his proposed plans for the capital—drawings completed by Griffin's wife and fellow architect, Marion Mahony Griffin (1871–1962). Marion Lucy Mahony worked in Wright's office for 14 years and was considered by many to be, as critic Reyner Banham described her, 'the greatest architectural delineator of her generation, which included mere men like Lutyens, Loos and Wright'.[122] Five years Griffin's senior, she married him in 1911 just before their submission of the drawings to Australia (they found out about the competition on their honeymoon). The watercolour renderings for the Canberra competition, 12 in all, reveal the Griffins' immersion in the achievements of Frank Lloyd Wright and Prairie School design, as well as an awareness of the most advanced architectural ideas in Europe. Marion's finely lined watercolours and her use of gold to accent the contour drawings sent to Australia is reminiscent of the work of the innovators of the Viennese School, Otto Wagner (1841–1918) and Adolf Loos (1870–1933), indicating the close link

between members of the Chicago School and their Austrian counterparts (George Taylor also included articles on Loos and Wagner in *Building* at this time).[123]

Except for a detailed city plan drawn on a contour map of the proposed site, the Griffins' drawings were essentially 'dream sketches', short on specificity, of the future 'Organic City' they envisioned. The "View from summit of Mount Ainslie', for example, shows at the centre a futuristic Parliament House tower, appearing ever so much as if it had been transplanted from Angkor Wat or some otherworldly sphere.

Perhaps it was this lack of detail, as well as suspicion of a 'Yankee' designing the Australian capital, that led to immediate infighting among the Australian political parties about the design. After much political wrangling and bureaucratic interference, the Griffins were allowed to come to Australia to oversee the implementation of the winning plan in 1913. This was the moment at which Taylor's energetic defence of Griffin saved his overall city plan, at least temporarily, from bastardisation. In the end, however, Griffin was only able to implement his innovative radial layout of Canberra before, in 1921, the bureaucratic jealousies became too overwhelming and he was forced to leave his dream of an Organic City in the hands of an Australian-led committee. As Richard Apperly states, Griffin 'was exposed to the typically Australian reaction reserved for The Gifted Foreigner—an attitude compounded from equal parts of awe and mistrust'.[124]

The Griffins built no structures in Canberra. The first buildings that appeared there, most of them overseen by Federal Capital Advisory Board Chairman John Sulman (1849–1934), clearly demonstrate nonetheless that aspects of Chicago School-inspired design, as well as Mediterranean-style approaches in vogue by the time the city began to be built, had made

Fig. 4.25 E. O. Hoppé, *Canberra, Sydney & Melbourne Buildings, ACT*, 1930. Photograph. © E. O. Hoppé Estate, Curatorial Assistance, Inc., Los Angeles, California.

some impact on those involved with the new city's streetscapes and homes.

Even before leaving the Canberra project, the Griffins worked in Melbourne, where their main commissions were a renovated restaurant, the Café Australia (1916; now demolished), complete with superb murals depicting the Australian plants that had already captured Marion's artistic imagination (see Fig. 4.26 on page 187); University of Melbourne's Newman College (1915–1918), a *cause célèbre* about which Florence Taylor fulminated in her attacks on the Griffins;[125] and the stupendous Capitol Theatre (1921–1924), with its cave-like foyer (now destroyed) and 'living rock'-lighted ceiling.[126]

After moving to Sydney in 1925, the couple purchased with shareholders 650 acres of rocky woodland on the north shore of Sydney Harbour. Here in the suburb of Castlecrag, the Griffins sought to design an entire community

of homes, inhabited by like-minded souls who believed in their architectural aesthetic and would participate in communal activities (by this time Marion especially was involved in anthroposophic philosophies). As Graham Jahn writes, Griffin 'laid out the streets, designed the houses and established a pattern of behaviour to which the residents should subscribe'.[127] While the Griffins built several houses that still exist in Castlecrag, such utopian architectural thinking was in advance of most Australians' attitudes at the time. In the end, the Griffins' greatest contribution to the Australian cultural landscape centred on their ideas about town planning and the integration of landscape design into an organic conception of building and surroundings. They 'introduced revolutionary ideas to Sydney, embracing the relationship of buildings to their sites, a reverence for native flora, open planning and a decorative

Fig. 4.26 Walter Burley Griffin & Marion Mahony Griffin (archs), Kerr Bros., *Interior view of the Banquet Hall with balcony and mural, Cafe Australia, Melbourne,* 1916 (now demolished). Eric Milton Nicholls Collection, National Library of Australia, Canberra.

language anchored in imagination rather than historical precedent'.[128]

Eric Nicholls (1902–1966), Burley Griffin's Australian partner in Sydney, continued to use Griffin's name for his firm after Griffin's death in India, where he had gone to carry out a new project in 1937. Nicholls, too, continued to construct houses based on Griffin's ideas— houses that would represent some of the most modern seen in Sydney until the end of the World War II. While the number of Griffin's buildings in Australia was relatively small, the publicity generated by the presence of these two Americans—conduits for all the Chicago-based ideas about organic architecture also influencing Californian practitioners of the time—introduced Australians first-hand to modern American style that the Taylors and others had been presenting through illustrations in their magazines.

The third exemplary event connect-

ing Australian and Californian architecture occurred in 1912, when the English-born architect and designer from Sydney named James Peddle (1862–1930), already 50 years old, arrived in Pasadena. He was determined to learn all he could in California by working there.[129] Several Australian architects had, of course, made study trips to the United States before this time[130] and, as Horbury Hunt's houses demonstrate, North American architectural trends had had an impact on Australian practice as early as the 1870s. In the 1890s 'American Romanesque', based on an Australian interpretation of H. R. Richardson's 'Stick Style' and Richardsonian commercial building, had also made a brief splash in Sydney and Melbourne.[131] In the early 1900s, some Australians gained scholarships to attend the School of Architecture at University of Pennsylvania, then considered 'the greatest one of them all', according to Jack

Hennessy (1887–1955), who attended in 1909 to 1910.[132] Along with Hennessy, at least two active Sydney architects, Percy James Gordon (1892–1976) and Carlyle Greenwell (1897–1971), attended this Philadelphia program in the 1910s.[133] Hennessy and Greenwell graduated from the university's Department of Architecture in the Class of 1911. (Gordon is not listed in School archives, although he may have attended without graduating or did not respond to the School's offices when the book of graduates was compiled.) They would have just missed studying under the great Beaux-Arts architect Paul Cret (1876–1945), who brought renown to the university before leaving the faculty in 1907. Beaux-Arts training would have still been the main focus of the department's program. The minutes of the meeting of The Institute of Architects of New South Wales for 1912 records that 'We are pleased that Mr. Jack Hennessy and Mr. Carlyle Greenwell have returned and intend to remain among us'.[134] Eastern American architectural ideas, then, determined the work of many Australian architects by the 1910s.

Tours, study trips and subsequent articles by Australians about American architecture had usually concentrated on the East Coast and Chicago as locations of the most innovative styles and important practitioners. Peddle's decision to concentrate on Southern California demonstrates a recognition that important things were now happening there architecturally—that an Australian could learn in California about cutting-edge styles and building practices that had a special validity for conditions back home. James Peddle was born in England and trained there as a furniture- and cabinet-maker. His father worked in London as a manufacturer for Edwin William Godwin (1833–1886), one of the Aesthetic Movement's leading designers.[135] James arrived in Sydney in 1889, commissioned by Walker Sons & Bartholomew (later

Beard Watsons) to oversee construction of the interiors of the Hotel Australia. In Australia Peddle was able to reinvent himself as an architect, but his interest in interior design and woodwork endured. From 1899, when he designed the Mosman Council Chambers, until 1906, Peddle designed everything from terrace houses to shearing sheds. His houses of the period display a modified Queen Anne design then fashionable in Sydney's better North Shore suburbs. The business recession in 1909 to 1910 may have been one of the deciding factors in Peddle's move to California. With his background in woodworking and furniture-making, Peddle would have been particularly drawn to the craftsmanship of Greene & Greene designs that he had seen in journals, although no record exists that explains why he decided to try his hand in California.

Peddle arrived in Vancouver aboard the *Zealandia* on 11 March 1912, then travelled down the West Coast to Los Angeles. He spent his first six months in the city studying to pass the examination to practice architecture in California. He had his licence review before the California State Board of Architecture on 29 July 1913 and received a licence some time in 1914—an accomplishment about which he was proud for the rest of his life.[136] The review report also indicates that the Board panel included, among others, the Los Angeles architects Sumner P. Hunt and Frederick L. Roehrig. Once he received his licence, he set up practice in Pasadena, in the St Louis Block at 42 North Raymond Avenue, room 305. In the same building, in room 310, was Irish-born architect Louis du Puget Millar (1877–1945), who wrote an important article about Pasadena's first bungalow courts.[137] Other architects who contributed to the emergence of the Pasadena style also listed offices in this block of Raymond Avenue.[138] Most intriguingly, Peddle's office was across the street from those of Greene & Greene, in the Boston

Building, at that time at the height of their careers.[139] City directories show that Peddle lived in the 500 block of North Fair Oaks Avenue, very near downtown Pasadena; he was joined there by his 23-year-old daughter Elsie in July 1913.[140]

While in California, Peddle did carry out some actual building projects, including a house at 480 East California Street (demolished) for an Illinois lumber broker named Joseph Means[141] and a substantial house at 735 Winona Avenue (demolished), built for Frank May (1858–1942), an ambitious building contractor and civic leader.[142] May was married at that time to the sister of James Culbertson, one of Greene & Greene's most important clients. May had worked as Culbertson's private secretary in Pennsylvania and both families came to Pasadena between 1900 and 1910.[143] Peddle built the Winona Avenue house for May next door to the property in which Cordelia Culbertson, May's sister-in-law, lived while Greene & Greene were building a house for her in another part of town.[144] These associations place Peddle squarely amidst the most exciting developments in Pasadena architecture in these important years.

Peddle also participated in Los Angeles's architectural organisations. From talks he gave in the States and once he was back home, Peddle seemed particularly interested in aspects of the business of running an architectural practice, licensing of architects, issues dealing with building ordinances, the Garden Suburb idea and town planning. In a speech given to the American Institute of Architects in Los Angeles shortly after his arrival, Peddle stated that he was 'making an extended tour throughout the United States, and plans to spend a year or more studying American architecture'.[145] Later speeches back in Sydney refer to his experiences in places such as Berkeley and Seattle, so he must have done some travel at least along the West Coast (or he had

visited them en route from Vancouver to Los Angeles).[146] He stayed in the States until 1914, when, forced by urgent dilemmas confronting his architectural office at home, he returned to Sydney, to continue his practice there, filled with first-hand knowledge of Californian ideas, both aesthetic and practical.

The impact of Peddle's direct contact with Californian styles was apparent in the buildings he and his partner constructed in the years immediately after his return. Peddle had returned to Sydney earlier than planned because his draughtsman Samuel George Thorp (1889–1967) had won the competition for the design of the 'Garden Suburb' of Daceyville, the first planned low-cost housing project of the Housing Board of New South Wales.[147] Thorp had been running Peddle's Sydney office, but was not yet qualified as an architect. He needed Peddle and his qualifications to implement the process of design. The small cottages they formulated for the project reveal some evidence of Peddle's discoveries in California—the use of reinforced concrete as a home building material was especially noted by many Australian builders and architects as an American innovation[148]—although not freely expressed because of the size restrictions of the government project.

The most obvious influences appear in the houses made by Peddle, along with Thorp, now a certified architect, in the period up to 1925. First came several 'bush bungalows', constructed in the rustic environs of Sydney, incorporating such elements as large verandahs, low eaves, stone fireplaces and timbered ceilings.[149] At Lyndholme Farm, Bundanoon, an early summer resort in the Southern Highlands some 150 kilometres from Sydney, Peddle and Thorp created in 1919 a sprawling residence reminiscent in proportions of the Greenes's Irwin House, replete with gabled eaves, porches with timbered roofs, and stonework columns and foundations.[150]

Peddle's Pasadena experiences also informed the designs for a spate of larger homes built by the firm between 1915 and 1922 on Sydney's North Shore and in the newer suburbs such as Bellevue Hill. For George Hudson, the owner of Hudson's Timbers and the initiator of the 'Redi–cut' building system similar to the kind produced in Los Angeles, Peddle designed Ga-di-Rae in Bellevue Hill in 1916. Here he was able to indulge his preference for timber—wooden floors, panelling, built-in furniture—in emulation of the Pasadena Craftsman aesthetic and playing into his past experience as a furniture-maker (see Fig. 4.29 on page 192).[151]

Soon Peddle's partner Thorp began to absorb these Californian stylistic elements as well. Their joint project at 4 Lynwood Avenue, Killara, in 1917, is a good example of how the California style was adapted in Australia, most noticeably in the use of brick instead of timber for construction.[152] As Apperly writes, 'The ground-hugging horizontality of the house is most effective, and the rafter-ends project well clear of the gutters in approved Californian style'.[153] The resulting design is often described as comparable to Greene & Greene's smaller bungalows, but the use of brick so changes the Craftsman aesthetic that it more properly represents the direction that the best of Australian bungalow design would follow than any simple emulation of California style.

The most telling example of Peddle's adaptation of Pasadena style as interpreted by a partner who had not seen the California examples first-hand is Thorp's own house The Cobbles, 49 Shell Cove Road, Neutral Bay, on Sydney's North Shore (see Fig. 4.30 on page 193).[154] Begun by the team in 1918, the house again substitutes clinker brick for timber, but includes a rounded river-stone chimney (hence the name), leaded glass windows and exposed interior rafters. The interior also showcases a brown-tiled fireplace with built-in bookcases

and other evidence of Peddle's concern for handcrafted wood. Subsequent extensions by Thorp in 1927 and 1935 retained some of the rustic feeling associated with the California style as it appeared in Sydney's early examples, retaining the open proportions unlike more conventional building in the city at the time. But Thorp was less interested in Craftsman-era handicraft. His elements are less committed to wood. As his own focus shifted to a so-called Spanish Mission or Mediterranean style he used more arches.[155]

S. G. Thorp's brother Frank Thorp (1903–1968) returned from his own time abroad to join the firm in 1925. The firm's third partner,

GLIMPSES OF SOME BUSH BUNGALOWS

Fig. 4.27 James Peddle, 'The bush bungalow', *The Home*, September 1920, p. 191.

F. H. Earnest Walker (1900–1950), who joined the partnership in 1924, had also studied in the States with Aymar Embury (1880–1966) and the 'prominent Gothicist' Bertram Grosvenor Goodhue (1869–1924).[156] Once Walker joined the company, their style of building changed in scope, with less emphasis on Peddle's small-scale designs and Arts & Crafts-style workmanship, and more projects for apartments and office buildings. Peddle now concentrated increasingly on writing and administration, on the running of an architectural firm and work for The Institute of Architects of New South Wales. When he died in 1931, S. G. Thorp became the senior partner. The firm that they founded was already on its way to becoming, as Peddle, Thorp, & Walker, the leading Sydney architectural group for large-scale projects that as PTW Architects it is today.

Although Peddle seems to be the only Australian architect of the period to set up a practice in Pasadena at this crucial and creative period, his experience in America was by no means the only example of an Australian architect learning about California bungalow style and West Coast Arts & Crafts ideas by visiting the country. Alfred Spain (1868–1954),[157] a Sydney architect active from the 1890s, travelled to Southern California in the 1910s and brought home several photographs of Los Angeles and Pasadena houses, including Greene & Greene's Irwin House. These were found in his effects when he died, along with a book entitled *Artistic homes* (1903) by Herbert C. Chivers, Architect, St Louis—a pattern book with over 800 house designs (see Fig. 4.13 on page 172).[158]

Even more directly, the younger architect John Moore (1888–1958) travelled in steerage in 1914 to San Francisco, then via Mexico on to New York, where he worked briefly in the renowned firm of Bertram G. Goodhue—just at the time when Goodhue was designing the Panama–California Exposition for San Diego in 1915.[159] Moore remained in contact with Goodhue for the rest of Goodhue's life, and

Fig. 4.28 James Peddle (arch.), *Country house at Bundanoon for Eric Lloyd Jones 1919*, Lyndholme [now Spring Hill], Bundanoon, New South Wales. Courtesy of PTW Architects, Sydney.

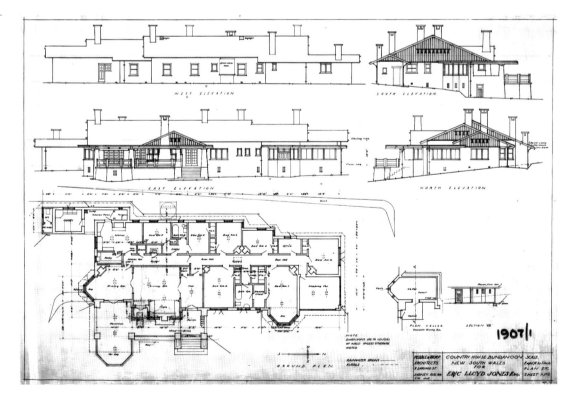

Fig. 4.29 James Peddle
(arch.), Ga-di-Rae,
Bellevue Hill, New South
Wales, 1916. Photograph:
courtesy of Annabelle
Chapman.

while serving in the army during World War I, sent to his New York office photographs of North African architecture he had acquired while travelling there.[160] He worked again for Goodhue in 1919 before returning to Sydney to set up practice, where his residences in Mosman show strong evidence of his American experience and of his discussions with Goodhue about architecture for sunny climates. That Moore stayed in touch with Goodhue until the American's untimely death in 1924 is only one of many examples of the enduring bonds established between Australian and American practitioners intent on devising new architectural styles suitable to their shared geographic conditions and aesthetic philosophies (see Fig. 7.02 on page 297).

By the time Peddle returned to Sydney in 1914, the absorption of California bungalow forms was well under way among architects throughout the country, as can be seen in the pages of *Building*, New South Wales' *Salon* and *Home & Garden Beautiful* magazines, and in the ambitious real estate book *Real Property Annual*. In the period between 1910 and 1925, Australian architects throughout the country, inspired by a combination of direct experience, illustrations in journals, bungalow books and product catalogues, and through interaction with other architects both at home and abroad, created a distinctly Australian approach to what continued to be called the California bungalow style. At the highest architectural level, figures such as Sydney architects Alexander Jolly (1887–1957) (see Fig. 4.31 on page 194), B. J. Waterhouse (1877–1965), Howard Joseland, Edward Orchard and Donald Esplin (1874–1960); Melbourne's Oakden & Ballantyne and Harold Desbrowe-Annear; and Kenneth Milne in Adelaide demonstrated in many ambitious projects their interpretation of the bungalow's formal elements and spatial relations (see Fig. 4.31 on page 194). They were rarely as low-

Fig. 4.30 James Peddle and **S. G. Thorp** (archs), The Cobbles, Seaview Terrace, Neutral Bay, New South Wales, 1922. Author's photograph.

slung as the Pasadena models, were never as grand as a Greene & Greene home and seldom applied as much lovingly crafted woodwork. In proportion and scale, emphasis on verandahs and eaves, and conscious connection between house exterior, interior furnishings and garden design, the California lineage is nonetheless clear. For these architects, an understanding of the Californian form was transmitted entirely through reproductions and word of mouth: none of these architects, who produced some of the most interesting and well-formulated bungalows, ever travelled to California themselves.

Finally, in the pivotal year of 1915, a fourth event occurred that had particular bearing on the Australian adaptation of the California bungalow—and, ironically, on its demise as an innovative style. A Sydney real estate developer named Richard Stanton (1862–1943) imported a prefabricated house from California, christened 'Redwood' and installed at Rosebery, one of his suburban development projects (Rosebery was usually described as an 'industrial suburb').[161] (See Fig. 4.32 on page 195.) The architectural historian J. F. Freeland wrote that 'the house itself was vastly important and influential because by introducing a full-blown, genuine and undiluted example of the Californian bungalow to the Australian scene, it acted as stimulus, catalyst and model'.[162]

Apperly is less categorical in his assessment of Redwood's significance, but acknowledges that Stanton's import introduced Sydney to the kind of middle-class or working-class suburban bungalow proliferating all over the American West Coast in the 1910s:

Fig. 4.31 Alexander Jolly (arch.), Belvedere, Cranbrook Avenue, Mosman, New South Wales, 1919. Photograph: Anne Higham, RAIA.

It indicated an acceptance by the Californian small-homes market of the idiom evolved a few years earlier by the Greenes and Maybeck. It represented the kind of house most likely to be acquired by a Californian family in the middle to low-income group, and it was thus quite suitable for putting on exhibition in the working man's suburb of Rosebery.[163]

What made Redwood so unusual to Sydneysiders was not only its simple compact size and open plan. It was also revelatory for its use of stained undressed redwood timber—an unheard-of construction material in a place convinced that 'real' urban homes must be made of brick or stone, and where such luxurious wood was hard to come by. As soon as Redwood appeared, *Building* magazine described it at length, praising its 'beautifully grained natural wood panels finished with dull stain and wax finish'.[164] This article further emphasised a most important aspect of the whole enterprise: it prominently identified the Redwood Export Co., with offices on Castlereagh Street, Sydney, as providers of the wood. Stanton's exhibition house, then, was promoted largely as an advertisement for product companies and for his suburban development projects, rather than touted as the work of a particular builder or architect or aesthetic style.

In this outlook and his other ambitious endeavours, Stanton represents a new type of figure in the architectural landscape: the salesman/developer, whose main aim is promotional rather than aesthetic. Stanton was one of the best of these salesmen, but he was certainly not without an interest in the architecture itself. He moved with his family to Haberfield in 1907, buying the venerable Dobroyde Estate, which had been the property

Redwood
Bungalow at
Rosebery

The Redwood Bungalow at Rosebery

The comfortable home requires two things—a good building and good site, and neither is satisfactory without the other.

There is no more comfortable home than the bungalow, and as this special issue of "Building" proves, it gives ideal comfort with ample space at a minimum cost.

The most famous bungalow centre in the world is at California, where after many experiments with various materials, it was found that best satisfaction could be won with California Redwood.

To demonstrate the artistic and one of the economical advantages of California Redwood

A Five-room Bungalow has been erected by the REDWOOD EXPORT CO., of 12 CASTLEREAGH STREET, SYDNEY, on the Rosebery Estate, showing some of the uses of California Redwood in Bungalow construction. As the Bungalow is essentially of a rustic and informal design, an informal but artistic weatherboard and, shingle exterior is most appropriate and effective. The sides of the Redwood Bungalow are covered with a rough redwood weatherboard stained with an oil stain which, although thoroughly covering and protecting the exterior shows up the natural grain of the Redwood. This affect is possible only with a clear timber free from knots and other defects so common to many woods, and which must be hidden with several coats of paint. This pattern of weatherboard is not only artistic in appearance, but is little more than one half the cost of the old pattern rusticated board. No dressed timber is used on the exterior, and the rough effect is carried out in the barge boards, posts and plates.

The roof and gables are shingled with Redwood Shingles laid 5in. to the weather, making a most artistic and durable roof for this type of building. Such a roof can be stained any color to conform with the affect desired. Failures in shingle roofs have been found upon investigation to be caused by the use of improper shingling nails, which rust away and allow the shingles to work loose. For this reason a hot-dipped zinc coated or galvanised nail should be used. This makes a very economical roof for the bungalow and should last from thirty to forty years with slight attention.

The interior of the Bungalow must be simple but affective, highly polished woodwork and elaborate wall decorations being out of place. In the Redwood Bungalow we have the beautifully grained natural wood panels finished with dull stain and wax finish. The living and dining rooms are lined with 16in. Redwood panels, the ceiling being covered with T. and G. lining and built-up beams. These rooms are stained with Golden Oak, Lacklustre stain thinned with Lionoil.

The Number 1 Bedroom and Hall are simply waxed with a clear wax and well rubbed down. This preserves the natural salmon pink color of the wood and acts as a filler and finish as well.

The Number 2 Bedroom is finished with a gray stain, which is put on evenly with an ordinary painter's brush and rubbed over smoothly while still wet. This finish gives a beautiful gray and shows up the natural grain of the wood as well.

Fig. 4.32 *Redwood bungalow at Rosebery,* in *Building,* 12 October 1916.

of an important colonial family since the 1820s. Here he built The Bunyas, a two-storey Queen Anne Style villa (probably built by his development's architect D. Wormald) with extensive gardens.[165] His property was prominently displayed in the pages of *Home & Garden Beautiful*, depicting Stanton as living the country gentleman's life.

In 1901—the year of Federation—Stanton had developed at Haberfield an estate marketed as a Garden Suburb in which he

integrated all aspects of the real estate transaction along with the construction of model homes as part of an overall marketing process. As the epitome of Federation-era exuberance for the Garden Suburb idea and as Australia's first real subdivision, the slogan of Haberfield was 'Slum-less. Lane-less. Pub-less'. The development's focus was on detached brick single-storey houses sitting on individual lots (see Fig. 4.33 on page 196).[166] Of the more than 700 houses designed by its architects, D. Wormald and John Spencer-Stansfield, no two were alike. Each had roofs of Marseilles tile, leadlight windows, front verandahs, garages and indoor plumbing. Appealing to the idea of genteel respectability so desired by the striving middle and working classes, and latching onto a current concern for the idea of town planning, Haberfield was a tremendous success, largely owing to Stanton's genius at marketing and his eye for practical architectural solutions.[167] While Haberfield did demonstrate a commitment to high standards of architectural integrity and town planning, Stanton's accomplishment had more to do with recognising a housing trend and capitalising on contemporary needs for such housing. As his biographer has written: 'Stanton was influenced by an astute assessment of the real estate market, rather than by attachment to the *rus in urbe* ideal.'[168]

Richard Stanton's approach to housing sales and real estate development demonstrates a clear connection with wholesale building linked to 'modern' advertising as practiced on the other Pacific coast. He had travelled to North America in 1905 and made other world tours in 1913, 1923 and 1927. Stanton may have been in direct contact with Redwood's manufacturers. In any case, he had seen any number of bungalow books and West Coast product catalogues in Australia and had focused on housing development on his world tours. Just as the projects of companies

"HABERFIELD" GARDEN SUBURB.—"The Place of Beautiful Homes."

A Typical View of "HABERFIELD," showing intersection of Stanton and Haberfield Roads.

like the Los Angeles Investment Company, the 'Redi-Cut' systems and other West Coast bungalow suburbs were constructed and sold primarily by builder-businessmen rather than designer–architects, so, too, did Australia engender its own mass-housing developers. Men like Stanton and Australia's own 'Redi-cut' man George Hudson appealed to a new class of aspiring homeowners: the middle-class wage-earner, eager to escape landlords and rent payments and to own a freestanding, comfortable home with access to an individual garden.

In the States, a similar figure was 'housing entrepreneur' Jud Yoho (1882–1968). Yoho, who was based in Seattle, took over the pub-lication of *Bungalow Magazine* from 1912 to 1918; it had previously been published in Los Angeles by Henry L. Wilson, 'The Bungalow Man of Los Angeles'.[169] Yoho in this period created an entire industry centred on his 'Bungalow Books' which presented house plans for buyers. His Take Down Manufacturing Company manufactured 'Craftsman Master Built Homes', which were in some examples similar in construc-tion to Stanton's Redwood.[170] In Yoho's case, the emphasis given to timber construction as the most affordable material was based on, as he wrote in his Take Down catalogue, 'the fact that we are located in the heart of a vast timber region, and being at the base of supplies we are able to purchase lumber and other materials at prices much lower than can

be obtained in other cities'.[171] This was not the case in Australia, where timber was less plentiful, which may account for some of the Australian aversion to wooden houses.[172]

What does link Yoho's enterprises to Stanton's is that both were primarily salesmen. As Janet Ore has said of him, '[t]o Yoho, Craftsman bungalows were products to be sold, not symbols of a reform impulse asso-ciated with a larger Craftsman movement'.[173] Just as Stanton at Haberfield and Rosebery emphasised the inclusion of modern con-veniences in each house and focused on tidy neighbourhoods, so did Yoho tout household technology and 'modern' features to sell his mass-produced houses. He was also aware enough of the symbols of prestige and respect-ability to remember to keep 'Craftsman' in the title of his publications. Both entrepreneurs depended on the popular press and illustrated catalogues to promote their products. Their housing projects were also based on new financing arrangements by which consumers could buy their homes on credit. This social and economic attitude marks the beginnings of the consumerist society for which the United States and Australia, as the newest countries of the Western world, began in the 1920s to stand as the leading exponents.

Yoho abandoned bungalows altogether as interest in the style waned and housing con-struction declined by 1920. Stanton's efforts at large-scale production of small bungalows based on pattern books or prefabricated

Fig. 4.33 Foldout brochure, Haberfield, New South Wales, c. 1915. Courtesy of Caroline Simpson Library and Research Collection, Historic Houses Trust of New South Wales, Sydney.

building such as Redwood also signalled the end of the hegemony of the California bungalow in Australian housing styles. As Richard Apperly points out, '[i]n his hands the once-fresh Californian idiom rapidly deteriorated into a lifeless collection of motifs which were applied to the stodgy body of the already well-established Australian suburban house'.[174] Once the bungalow mode was applied to mass housing in Australia and California, its originality disappeared. American developers continued to apply the bungalow's open plan, albeit in a more formulaic method, to the early expanses of California's 'tract houses'. These layouts enshrined the quarter-acre lot, and homeowners clung fiercely to their patch of the outdoors. Equally dedicated to the individual plot of land, Australian builders of the burgeoning suburbs nonetheless reverted in most cases to the small-roomed, many-doored interior with central hallway and high-pitched roof of the English cottage. The red Marseilles tile roof, however, became ubiquitous in all Australian suburbs, just as the tiled roof came to dominate Californian houses in the 1920s. In this element, Australia and California again shared practical reasons for adopting the tiled roof: both arid regions on the Pacific were prone to raging wildfires in the places where new houses were being built by the thousands.

The 'bungalow craze' in America and in Australia established two significant factors that would have lasting implications for future architectural development on the Pacific Rim. The first was that California could now be seen as expressing its own architectural and aesthetic idioms, and these idioms were recognised as having something to say to practitioners on the other side of the Pacific. The second was that West Coast-produced 'lifestyle' magazines, illustrated catalogues and advertising images—a true mass media—became a major source of shared inspiration for these cultures on the periphery. In the decade of the 1920s, these factors would play an increasingly significant role in the adoption of other eclectic building styles, especially in housing.

NOTES

1. Una Nixson Hopkins, 'The California bungalow', *The Architect and Engineer of California*, vol. iv , no. 3, April 1906, pp. 3–34.

2. James Peddle, 'The bush bungalow', *The Home*, September 1920.

3. J. M. Freeland, *Architecture in Australia: A history*, Penguin, Ringwood, Victoria, 1968, p. 227.

4. Some documents give Bushton's first name as William, others as Timothy. A search of genealogical and census records indicates that a Timothy Bushton, Mason, who was 32 at the time of the 1850 US census, was born in England and came to Monterey from Hobart, Tasmania, with his wife and five children in 1850. They arrived in Monterey on board the American ship *Elisabeth Starbuck* on 18 June 1850. His wife, Jane, nee Lockyer, had been transported at age 16 for a seven-year term to Van Diemen's Land (Tasmania) in 1834 for theft, arriving in Hobart on the ship *New Grove* in March 1835. See 'The Proceedings of the Old Bailey', 'Jane Lockyer, William West, John Jones, Theft: Pick Pocketing, 4th September, 1834', viewed April 2004, <http://www.oldbaileyonline.org/browse.jsp?ref=t18340904-189>. Timothy had arrived in Hobart, apparently as a free settler, in 1833. Jane and Timothy were married in Hobart in March 1836. Timothy, who seems to have gone by the name William once in Monterey, died some time between 1850 and 1852, whereupon Jane married Thomas Allen, by whom she had three more children. The house that Bushton had built now became known as The Allen House. Allen died between 1858 and 1859. By the time of the 1870 census, Jane had married again, this time to Jacob Kampner; but by the 1880s, she was again using the last name Allen. By the 1880s, two of her sons by Bushton, James and William, were serving sentences in San Quentin for murder. See San Luis Obispo, *Mirror*, 15 August 1889. Jane was still alive in 1900, by which time the census gave her birthdate as 1815, her age as 84, and includes the note that she 'gave birth to 14 children, 5 living at present'. I am indebted to Colleen Paggi, Tulare, California, for her research on the Bushton family.

5. According to Peter Andrew Barrett in his thesis on architectural influences between Australia and

California, California carpenters often referred to Australian wood as 'ironwood', 'because it was too hard to nail'. See 'Building through the Golden Gate: Architectural Influences from Trans-Pacific Trade and Migration between Australia and California 1849–1914', MArch thesis, University of Melbourne, Melbourne, 2001, p. 29; and *Launceston Examiner*, 2, 20 and 27 March 1850.

6. See Harold Kirker, *California's architectural frontier*, Peregrine Smith, Santa Barbara and Salt Lake City, 1973, p. 28; *Adobes and old buildings in Monterey*, WPA Project, project no. 4080 typescript, 1937, pp. 64–67; A. C. Jochmus, *Monterey: All of it between two covers, 1542–1930*, Pacific Grove, 1930, p. 34; and Jochmus, *Monterey, California: First capital of the state*, Pacific Grove, 1925. A recent article by Miles Lewis, Professor of Architecture, University of Melbourne, extends, corrects and substantially amends this information: 'A myth has grown up about a house of Australian origin that was said to be the oldest-known building in Monterey … It was thought to date from just before the discovery of gold. William Bushton, an Australian carpenter, and his wife, Jane, are said to have set out for San Francisco in the belief that the climate would benefit their invalid daughter. After a dispute between the ship's captain and the passengers, they were, in fact, landed at Monterey. Bushton bought land at the corner of Munras Avenue and Webster Street and put up a 12-room house that he had precut himself in Australia and brought with him. The building, partly of one and partly of two stories, survived in an increasingly decrepit and picturesque form until its demolition in 1924.

However, the story of the landing at Monterey seems to have been taken from that of the *Volunteer* [another ship from Australia landing at Monterey earlier] referred to above. Recent research by Peter Barrett has shown that Bushton was not in fact a carpenter and that his story was more complex. He had been in business near Hobart until December 1849. At about this time six timber houses were advertised for sale in Hobart, each measuring 22 ft. by 10 ft. 10 in. and with a mortised frame, and it is likely that the Bushtons bought them, for the description resembles that of the houses they subsequently took to California. Around 2 February 1850, the American barque *Elizabeth Starbuck* sailed for California, with passengers including Mr. and Mrs. Bushton and their five children and with cargo including 22 wooden houses and a considerable range of building materials.

The Bushtons are believed to have taken at least six houses, of which at least two were two storey, and finding that the market had dropped, they used at least four, including two of two stories, to build their house in Monterey. This structure certainly was not the first framed building in Monterey, nor even the first house from Australia, nor were the Bushtons by any means the first Australians in Monterey, for a number were living there already.' See 'Prefabrication in the gold-rush era: California, Australia, and the Pacific', *APT Bulletin*, vol. xxxvii, no. 1, 2006, p. 9.

7. Label for photo, affixed to back of piece of timber from the original house, signed 'T. R. Watson 1924', gift of George R. Kirby. Collection of California State Library, California History Room, Sacramento, California.

8. The Bushton–Allen House, visited by busloads of tourists, photographed from every angle, was demolished in 1923. Pieces of the house, identified as Australian ironwood, were sold for some years as souvenirs. That the house was made entirely of wood distinguished it from the Larkin House of 1835, built by one of the earliest American Monterey settlers Thomas Larkin as a 'combination of adobe walls and a redwood timber frame'. Peter Barrett, p. 14; and Kirker, pp. 16, 22. A mixture of Mexican, French and American styles prevailed in many of the goldfield towns. James Borthwick wrote about the town of Sonora as he saw it in the early 1850s: 'The lower end of the town was very peculiar in appearance as compared with the prevailing style of California architecture. Ornament seemed to have been as much consulted as utility, and the different tastes of the French and Mexican builders were very plainly seen in the high-peaked overhanging roofs, the staircases outside the houses, the corridors round each storey, and other peculiarities; giving the houses—which were painted, moreover, buff and pale blue—quite an old-fashioned air alongside of the staring white rectangular fronts of the American houses. There was less pretence and more honesty about them than about the American houses, for many of the latter were all front, and gave the idea of a much better house than the small rickety clapboard or canvass concern which was concealed behind it. But these facades were useful as well as ornamental, and were intended to support the large signs, which conveyed an immense deal of useful information.' See Borthwick, pp. 328–29.

9. 'The *Commonwealth of Australia Constitution Act (UK)* passed on 5 July 1900 and was given Royal Assent by Queen Victoria on 9 July 1900.' See 'Federation of

Australia', Wikipedia, viewed 9 July 2009, <http://en.wikipedia.org/wiki/Federation_of_Australia>.

10. The state of Queensland joined the other states unwillingly, because Federation required the big sugar companies to end their black labour system, which essentially kidnapped 'Kanakas', people from Melanesia and other South Seas islands, to work in the cane fields of the state. See the history of this practice online, viewed 10 February 2006, <http://www.janeresture.com/kanakas/>; and Myra Willard, *History of the White Australia Policy to 1920*, Melbourne University Press, Melbourne, 1923.

11. The wooden framework for the pavilion still exists, but moved to Cabarita Park, some 16 kilometres west of its original location in Centennial Park. See Peter Luck, *A time to remember*, Mandarin, Port Melbourne, Victoria, 1991, p. 23.

12. See *Australian encyclopedia* 1958, vol. 1, pp. 442–43.

13. '[T]he tide of immigration once more rose and new multitudes flocked in, swelling the population by 60 percent in the decade from 1900 to 1910.' *California: A guide to the Golden State*, American Guide Series, Hastings House, New York, 1939, p. 60.

14. In a book published immediately after McKinley's assassination, his achievements were recounted on the basis of how much territory was annexed for America: 'In the three last years of McKinley's administration the area of the nation was extended 124,340 square miles. It may be interesting to add … that the total annexation preceding the war with Spain averaged 24,696 square miles annually; while the expansion accomplished by President McKinley's administration from the moment he secured the first treaty of addition down to the present time averages 41,446 square miles annually.' The annexation of Hawaii, Puerto Rico and the Philippines were justified as 'the means of holding the markets' and as necessary for America to take 'its rightful place among the nations of the earth'. In this pursuit: 'William McKinley has advanced the borders of his nation to include the seas.' From 'McKinley and expansion', Chapter XXII, in Marshall Everett, *Complete life of William McKinley and story of his assassination* [Chicago?], 1901, pp. 251–62.

15. On the importance of the fiesta in the construction of Los Angeles's image of its past and its portrayal of the future, see Deverell, 'History on parade', in *Whitewashed adobe*, pp. 49–90.

16. The phrase appears on the side of a popular stereograph of Roosevelt giving a speech in Oakland, 14 May 1903. Underwood & Underwood (no. TR97), viewed 23 February 2006, <http://www.minnesooota.com/item97.asp>.

17. A letter in Alfred Deakin's papers records Deakin's comments when the US fleet was in Australia: 'We live in hopes that from our own shores some day a Fleet will go out, not unworthy to be compared in quality, if not in numbers with the magnificent Fleet now in Australia.' Alfred Deakin Papers, Manuscripts Collection, National Library of Australia (no. 1540/17/9).

18. 'The reception of the American Fleet', *Art & Architecture: Being the Journal of The Institute of Architects of New South Wales*, vol. v, no. 3, May–June 1908, pp. 96–97. On Vernon, see Peter Reynolds, 'Vernon, Walter Liberty (1846–1914)', *ADB*, vol. 12, 1990, pp. 320–22.

19. 'In 1867 the company launched the first trans-Pacific steamship service with a route between San Francisco and Yokohama, Japan. This route led to an influx of Japanese immigrants, bringing additional cultural diversity to California', viewed 9 March 2006, <http://en.wikipedia.org/wiki/Pacific_Mail_Steamship_Company>. A summary in Archibald's magazine, *The Lone Hand*, includes the following description: 'Early in the "seventies" Sydney established the first mail service to San Francisco. It was founded by Mr. H.H. Hall, the American Consul, and the steamers were the *City of Melbourne*, *City of Adelaide*, and *Albion*. The service was a ten-knot one, and proved a failure. The writer made the trip from San Francisco to Sydney, via Honolulu and Levuka in the last named; it occupied forty days.' In 'Old time Australian shipping', *The Lone Hand*, 1 July 1913, p. 212.

20. W. Lorck (ed.), *The Eastern and Australian Steamship Company's illustrated handbook to the East: Australia, Manila, China and Japan, including trips to America and Europe*, 3rd edn, Edward Lee & Co., Sydney, November 1904.

21. *Sunset*, vol. xi, no. 6, October 1903: front advertisement section.

22. *Sunset*, vol. xii, November 1903: back advertisement section.

23. 'The federal city', *Building*, vol. 6, no. 67, 12 March 1913, p. 37.

24. In an article on the upcoming Panama–Pacific International Exposition in San Francisco, George Taylor in *Building* comments on the appointment of Jules Guerin as designer for the event: 'Jules Guerin, the famous colorist, whose work is well-known to Australians, through his wonderful Oriental

and Egyptian studies in Scribner's and the Century Magazines, is the Director of Color for the exhibition.' *Building*, 12 February 1914, p. 166.

25. 'Thus it happens that architecture, the most utilitarian of the arts, underlies all other expressions of the ideal; and of all architecture, the designing of the home brings the artist into closest touch with the life of man.' Charles Keeler, *The simple home*, Peregrine Smith, Santa Barbara, 1979; reprint of 1904, p. [xlv].

26. Kirker, p. viii.

27. Bernard Smith, 'Architecture in Australia', *Historical Studies*, vol. 14, no. 53, pp. 90–91, quoted in Serle, *The creative spirit in Australia*, p. 83.

28. 'Australian Queen Anne was certainly an original interpretation of its English and American ancestry.' See Howard Tanner, 'Stylistic influences on Australian architecture: Selective simplification 1868–1934', *Architecture in Australia*, April 1974, p. 53.

29. See Apperly, et al., *A pictorial guide to identifying Australian architecture: Styles and terms from 1788 to the present*, Angus & Robertson, Sydney, 1989, pp. 108–15.

30. Harriet Edquist, *Pioneers of modernism: The Arts and Crafts Movement in Australia*, Miegunyah Press, Melbourne, 2008, p. xii.

31. See J. M. Freeland, *Architect extraordinary: The life & work of John Horbury Hunt 1838–1904*, Cassell, Melbourne, 1970; and Peter Reynolds, et al., *John Horbury Hunt: Radical Architect 1838–1904*, Historic Houses Trust of New South Wales, Sydney, 2002.

32. ibid., p. 26.

33. See his article 'The Arroyo Craftsman', *Arroyo Craftsman*, no. 1, October 1909, p. 52.

34. See Stickley's article, 'Nature and art in California', *The Craftsman*, vol. 6, no. 4, July 1904, pp. 370–90.

35. ibid., p. 370.

36. See 'San Francisco Bay Area Arts & Crafts Movement: Charles Augustus Keeler', viewed 24 April 2006, <http://www.geocities.com/SiliconValley/Orchard/8642/cakeeler.html>. On Keeler and his influence in San Francisco, see Ed Herny, et al., *Berkeley bohemia: Artists and visionaries of the early 20th century*, Gibbs-Smith, Salt Lake City, 2008, pp. 33–50.

37. Charles Keeler, *The simple home*. [Note: The Berkeley Architectural Heritage Association has photocopied this publication with permission from Dimitri Shipounoff and Peregrine Smith Books, September 1993.]

38. *The Craftsman*, vol. vi, no. 3, June 1904, p. 319.

39. Dimitri Shiponouff, introduction to 1979 edn of Charles Keeler, *The simple home*, p. xii.

40. ibid., p. 4.

41. ibid., p. 5.

42. George Wharton James maintained that Keeler introduced the sleeping porch to California houses at his Highland Park house. See ibid., p. xxiv; and James, 'Charles Keeler, scientist and poet', in *Heroes of California*, Little, Brown, & Co., Boston, 1910, p. 20, n.p.

43. Keeler made two trips to the South Pacific, including visits to New Zealand and Australia on the first journey. In 1900 to 1901, he travelled with his family, writing reports for the *San Francisco Chronicle*; he was especially impressed with the Maori and their craftsmanship. In 1910, he made a round-the-world tour during which he read his poetry in Hawaii, Japan, India and European capitals. See Shipounoff, 'Introduction', in Keeler's *The simple home*, 1979 edn, pp. xxxii–xxxiii.

44. See David Mostardi, *A checklist of the publications of Paul Elder*, 2nd edn, Morgan Shepard, Washington, DC, 2004.

45. Herman Whitaker, 'Berkeley the beautiful', *Sunset*, vol. 18, December 1906, pp. 138–44. The photographs in the article are by Oscar Maurer, the artist, photographer, friend of Keeler, and member of The Hillside Club.

46. The reproduced image in *Building* carries an odd caption, typical of the Taylors' commentary. The title is 'A Rational Church for Christian Scientists', with the following explanation: 'This church is built in bungalow style, at Berkeley, California. Its departure from the customary Gothic eliminates the excuse of the 'flapper' that she has not been to a church with a chimney on.' *Building*, 12 February 1915, p. 112.

47. George Wharton James, 'Franciscan mission buildings of California', *The Craftsman*, vol. v, no. 4, January 1905, pp. 321–35.

48. George Wharton James, 'The influence of the "Mission Style" upon the civic and domestic architecture of modern California', *The Craftsman*, vol. v, no. 5, February 1905, pp. 458–69.

49. On Judson and the Judson Glass Studios, which still exist, see Jane Apostol, *Painting with light: A centennial history of the Judson Studios*, Historical Society of Southern California, Los Angeles, 1997. Robert Winter writes in the introduction to the book on p. x: 'I looked forward to finding a copy of the following issue which was to be devoted to a presentation of the ideas of Gustav Stickley, the American promoter of Morris's faith. It would undoubtedly have been

edited by George Wharton James, who with William Lees Judson founded the Guild and was the western correspondent for Stickley's *The Craftsman* magazine. In spite of the Guild's motto 'We Can', the promised next issue of *The Arroyo Craftsman* never appeared.'

50. *Arroyo Craftsman*, vol. 1, no. 1, 1912, p. 39. The 'its' of the sentence refers, in typically optimistic fashion, to James's so-called Arroyo Guild, the members of which would provide all the buildings, crafts, furniture and gardening for the completion of an Arroyo lifestyle.

51. *Arroyo Craftsman*, vol. 1, no. 1. Sam Watters has pieced together the following biographical details on Robert F. Train: 'Robert Farquhar Train (1869–1951) was born in Nottingham, England and came to Los Angeles in 1884. With Robert E. Williams he formed the partnership of Train & Williams in 1900. A prolific firm in the first decades of Los Angeles development, Train and Williams moved through a range of styles from the neo-Egyptian receiving vault at Rosedale Cemetery (by 1902), the Beaux-arts First National Bank (1902) and the Colonial Revival Dr. W. E. Waddell residence (by 1902). They designed craftsman houses, including Williams's own house (c. 1905), and were the only architects associated with the Arroyo Guild of Fellow Craftsmen who featured Train and Williams's work in the single issue of *Arroyo Craftsman*, October, 1909. In 1910 Train and Williams prepared a general campus plan for the University of Southern California, founded in 1880.' On Williams, Sam Watters writes: 'After matriculating from the Lindsay Collegiate Institute to Victoria University in his native Canada, Robert Edward Williams (1874–1960) enrolled in the first architectural course at Toronto University. Williams worked as a political cartoonist for Toronto newspapers before moving to Los Angeles in 1884. He was employed as a draftsman before joining the Train & Williams partnership.' *Los Angeles houses, 1885–1935*, vol. i, Acanthus Press, New York, 2007, p. 357.

52. ibid., p. 40.

53. ibid., p. 39.

54. ibid., p. 1.

55. One of the best of many books about Lummis is still Edwin R. Bingham, *Charles F. Lummis, Editor of the southwest*, The Huntington Library, San Marino, 1955.

56. Quoted in David Gebhard and Robert Winter, *Los Angeles: An architectural guide*, Gibbs-Smith, Salt Lake City, 1994, p. 288. From Keeler, 'Friends bearing torches', unpublished manuscript, c. 1936, Charles Keeler Papers, Bancroft Library, University of California, Berkeley, pp. 210, 212.

57. Starr, *Americans and the California dream*, p. 399.

58. 'But let me offer. As pres't of the Landmarks Club I can let you take two livable old rooms in the Mission San Juan Capistrano, 42 miles south of here. No rent; except that the Club will expect one of Mrs. Keeler's sketches for its museum.' Lummis, letter to Keeler, 3 December 1897, file of correspondence to Keeler from Charles Fletcher Lummis, 1895–1910, in Charles Augustus Keeler Collection (MS), The Huntington Library (Box 4 LU–O). The book Keeler worked on while at San Juan Capistrano was published in 1899 as a tourist guide for the Santa Fe Railroad; it included line drawings by his wife, Louise. See Charles A. Keeler, *Southern California*, illustrated with drawings from nature and from photographs by Louise M. Keeler, Passenger Department, Santa Fe Route, Los Angeles, 1899.

59. Quoted in Charles Moore, *Los Angeles: The city observed*, Hennessey + Ingalls, Santa Monica, 1998, p. 68.

60. ibid., p. 66.

61. Ironically, George Wharton James would himself be editor of *Out West* in 1912, long after Lummis's heyday, when the magazine was in decline. See Roger Keith Larson, *Controversial James: An essay on the life and work of George Wharton James*, Book Club of California, San Francisco, 1991, p. 62.

62. 'In the lion's den', *Land of Sunshine*, vol. 15, nos 2 and 3, August–September 1901, p. 158.

63. See Karen Weitze, *California's Mission Revival*, California Architecture and Architects, no. iii, Hennessey + Ingalls, Los Angeles, 1984, pp. 74–77.

64. '[N]ow he would organize his life around the all-compelling task of coaxing the emerging American Southwest and Southern California toward an organized integration of Latin values into its way of living.' Starr, *Americans and the California dream*, p. 398.

65. While the Greene brothers left no record of what they thought of the exposition, most scholars of Greene & Greene assume that they probably would have seen the famous Japanese buildings on the Wooded Isle, as well as the Johore Bungalow Village from the Malay Peninsula. See Edward R. Bosley, *Greene & Greene*, Phaidon, London, 2000, pp. 24–25; and Randell L. Makinson, *Greene & Greene: Architecture as a fine art*, Gibbs M. Smith, Salt Lake City, 1977, p. 32.

66. The literature on the Chicago World's Columbian

Exposition is enormous. A most fascinating study about the cultural situation surrounding the construction of the fair is the recent bestseller, Erik Larson's *The devil in the White City: Murder, magic, and madness at the fair that changed America*, Random House, New York, 2003. Earlier studies include Julie K. Brown, *Contesting images: Photography and the World's Columbian Exposition*, University of Arizona Press, Tucson, 1994; David F. Burg, *Chicago's White City of 1893*, University of Kentucky Press, Lexington, 1976; James Gilbert, *Perfect cities: Chicago's utopias of 1893*, University of Chicago Press, Chicago, 1991; Thomas S. Hines, *Burnham of Chicago*, Oxford University Press, New York, 1974; Hugh Morrison, *Louis Sullivan: Prophet of modern architecture*, W. W. Norton, New York, 1998; Robert Muccigrosso, *Celebrating the New World: Chicago's Columbian Exposition of 1893*, Ivan R. Dee, Chicago, 1993; and *The World's fair, Being a pictorial history of the Columbian Exposition*, Chicago Publication and Lithograph, 1893; reprint by Chicago Historical Society.

67. Bosley, p. 25.
68. 'At what point Charles Greene began to clip illustrations from *The Craftsman* is unknown, but his work soon began to reflect an intimate awareness of its aesthetic message.' ibid., p. 39.
69. ibid., p. 58.
70. Hopkins, 'The California bungalow', p. 36.
71. Bosley, pp. 59–60.
72. ibid., p. 95.
73. ibid., p. 96.
74. Una Nixson Hopkins, 'The California Bungalow', *The Pacific Monthly*, vol. xv, no. 1, January 1906, pp. 51–57; and reprinted in *The Architect and Engineer of California*.
75. Henrietta Keith, 'The trail of Japanese influences in our modern domestic architecture', *The Craftsman*, vol. 12, July 1907, pp. 446–51.
76. Elias, p. 18. See also Kevin Starr, '*Sunset* and the phenomenon of the Far West', in *Sunset Magazine: A century of Western living, 1898–1998: Historical portraits and a chronological bibliography of selected topics*, Stanford University Libraries, Palo Alto, California, 1998, pp. 31–76.
77. *Sunset Magazine: A century of Western living*, p. 3.
78. *Sunset*, vol. 4, no. 3, January 1900, p. 110.
79. See Gelett Burgess, *The Purple Cow and other poems*, Huntington Library, Pasadena, 1968.
80. In its section entitled 'The course of Empire', *Sunset* applauded Roosevelt's visit to the West: 'It is doubtful if ever California received a greater advertisement than was given by the publication throughout the United States of President Roosevelt addresses. Take it all in all the visit of the President did as much to inform many Californians about the possibilities of their own state as it did to apprise easterners of the wonderful possibilities of the Pacific Coast country.' July 1903, p. 291.
81. *Sunset*, vol. 9, December 1902, pp. 106–07, 167. On Francis McComas and his transformation from Australian to Californian artist, see Scott A. Shields, 'Manufacturing dreams: Francis McComas and California "reductivism"', Chapter 6, *Artists at continent's end: The Monterey Peninsula Art Colony, 1875–1907*, exhibition catalogue, Crocker Art Museum, published by University of California Press, Sacramento, 2006, pp. 130–52.
82. On Duke Kahanamoku, see Malcolm Gault-Williams, 'Legendary surfers: A definitive history of surfing's culture and heroes', *Surfer Magazine*, vol. 1, chapter 10, viewed 22 June 2006, <http://www.legendarysurfers.com/surf/legends/ls07z_duke.html>. On George Freeth (1883–1919), the Hawaiian-born American credited with introducing both surfboard riding and water polo to the West Coast, see online, viewed 22 June 2006, <http://www.beachcalifornia.com/fth.html>.
83. 'Gradually the words became less prominent but are still used today.' *Sunset Magazine: A century of Western living*, p. 5.
84. Arthur I. Street, 'Seeking trade across the Pacific', *Sunset*, vol. 15, no. 5, September 1905, pp. 407.
85. *Sunset*, vol. 34, February 1915, pp. 350–54, 398.
86. *Sunset*, vol. 35, August 1915, p. 368. The house was located at 5th Street and Commonwealth Avenue, Los Angeles. Mary Banning was the widow of Los Angeles pioneer Captain Phineas Banning (1830–1885), 'Father of the Port of Los Angeles'. On Banning, see Maymie R. Krythe, *Port Admiral: Phineas Banning, 1835–1885*, California Historical Society, San Francisco, 1957; on Irving Gill, viewed 22 June 2006, <http://www.irvinggill.com/biblio.html>.
87. Prof. Harriet Edquist, Head of the School of Architecture and Design, RMIT, Melbourne, reports that *Sunset* was in the State Library of Victoria by 1909. Email correspondence, 13 November 2005.
88. According to some sources, Taylor's immediate source for the graphic style of *Building* magazine was the American journal *The House & Garden*. See Poppy Kouvaris, 'The Origins of the Spanish Mission

Style', BArch thesis, University of New South Wales, Kensington, 1992, p. 77.

89. In America at the most mass-produced end of the scale, the house plans supplied by the Sears Roebuck Co.'s mail-order catalogue from 1908 to 1940 are probably the most famous and well-known of these plans, widely dispersed and now profusely discussed in print and online; see for example the website of the Sears Archive, <http://www.searsarchives.com/homes/index.htm>. Of the more than 100,000 home plans sold, many were built in California; but the majority of the Sears homes appeared in the Midwest. The special qualities of the California Bungalow were the focus of bungalow books and catalogues published on the West Coast. Sears Roebuck catalogues, moreover, do not seem to have reached Australia, at least not in any significant numbers. Miles Lewis, Professor of Architecture, University of Melbourne, and a specialist in prefabricated housing, has not identified any Sears houses built in Australia. Interview with the author, 2 October 2006.

90. Robert Winter, *The California bungalow*, Hennessey + Ingalls, Los Angeles, 1980, p. 14.

91. Los Angeles Investment Co., *Bungalows and cottages in Southern California*, [Los Angeles, 1908?].

92. Brochure from Alice Phelan Sullivan Library, The Society of California Pioneers, San Francisco (CU 43926, B001025).

93. Freeland, *Architecture in Australia*, p. 227.

94. Graeme Butler, *The Californian bungalow in Australia*, Lothian, Melbourne, 1992, p. 2.

95. Nurair Seropian, 'California Bungalow', MBEnv thesis, University of New South Wales, Kensington, September 1986, p. 18. Milne's own house in South Terrace, Adelaide, appeared in *Building* magazine, September 1915. For Milne, see *ADB*, 1940–1980, vol. 15, pp. 378–79; and Donald Leslie Johnson, et al., *F. Kenneth Milne: Portrait of an architect*, exhibition catalogue, Flinders University Art Museum, Adelaide, 1984.

96. Richard E. Apperly, 'Sydney Houses 1914–1939', 2 vols, MArch thesis, University of New South Wales, Kensington, 1972, p. 79.

97. Harriet Edquist, *Harold Desbrowe-Annear: A life in architecture*, Miegunyah Press, Melbourne, 2004, p. 52.

98. See Malouf's *A spirit of play: The making of Australian consciousness*, ABC Books, Sydney, 1998, pp. 62–68, and his collection of essays, *12 Edmonstone Street*, Chatto & Windus, London, 1985. See also Ray Sumner, 'The tropical bungalow—the search for an indigenous Australian architecture', *Australian Journal of Art*, vol. 1, 1978, pp. 27–39.

99. 'In about 1911 a new style had come across the Pacific from its home in California. It was a result of the search which had been gathering strength for fifty years for a type of architecture appropriate to Australian conditions and which the more optimistic believed could be a starting point for the evolution of a true native style.' Freeland, *Architecture in Australia*, p. 227.

100. 'In "Kyalite", the furniture throughout is Craftsman, having been made on the premises by Mr. Elmore, and is of Australian hardwood.' *Home & Garden Beautiful*, 1 December 1914, p. 831.

101. 'Home-made Mission chair', *Home & Garden Beautiful*, September 1913, p. 110.

102. The author wishes to thank Megan Martin, senior librarian and curator, The Caroline Simpson Library and Research Collections, Historic Houses Trust of New South Wales, for finding these trade catalogues.

103. Michael Roe, 'Taylor, George Augustine (1872–1928)', *ADB*, vol. 12, pp. 178–79.

104. George A. Taylor, *'Those were the days': Being reminiscences of Australian artists and writers*, Tyrrell's, Sydney, 1918.

105. On Taylor's writings and artistic accomplishments, see Peter Fitzpatrick, *The sea coast of bohemia: Literary life in Sydney's Roaring Twenties*, University of Queensland Press, Brisbane, 1992, pp. 42, 45, 358; and J. M. Giles, *Some chapters in the life of George Augustine Taylor*, Building Publishing Co., Sydney, 1917. Taylor also published an eclectic mix of books and articles, reflecting his diverse interests, including among others *Fight for Canberra: The history of the chequered career of Australia's capital city* (1915), summarising his arguments about the competition in *Building*; *There!: A pilgrimage of pleasure* (1916) about his travels through America; *Air Age* (1918); *Art and the woman: A plea for better recognition* (1919), an homage to his wife Florence; and *Town planning with common-sense* (1918), also a compilation of opinions expressed in *Building*.

106. See the entry for Florence Mary Taylor, Australian Women's Archives Project of the National Foundation of Australian Women, viewed 4 July 2006, <http://www.womenaustralia.info/biogs/IMP0064b.htm>.; and Robert Freestone and Bronwyn Hanna, *Florence Taylor's hats*, Halstead Press, Sydney, 2007.

107. Apperly, 'Sydney Houses', p. 78.

108. For an index of articles on 'The bungalow' published in *Building*, see Apperly, 'Sydney Houses', Appendix

B, pp. 339–43.

109. Taylor writes: 'Our congratulations go out to that fine American publication of the clay worker, "Brick and Clay Record", in its annual review number … It knits American claymen together with its fine style'. In 'A hand across the sea', *Building*, 11 April 1914, p. 167. In a later article, Taylor praises American brickwork and includes the following comment: 'Writing in "Brick and Clay Record", Chas. A. Byers gives some interesting notes on brick chimneys and their effect on bungalow work.' In 'Burnt clay section', *Building*, 12 December 1914. *Brick and Clay Record* ran as a semi-monthly trade publication from 1911 until 1987.

110. *Building*, 13 March 1911, pp. 49–52.

111. *Sunset*, vol. xxvi, no. 1, January 1911, pp. 3–16.

112. *Building*, no. 123, March 1911, p. 56. The Paraffine Paint Co. had an office in Sydney from 1910 into the 1920s. See Annabelle Davey, 'James Peddle: Craftsman Architect', BArch thesis, School of Architecture, University of New South Wales, Kensington, 1981, p. 58.

113. *Building*, 13 March 1911, p. 56.

114. 'One of his greatest fights was that to preserve Walter Burley Griffin's original plan for Canberra and save it being turned into a mongrel.' Giles, n.p.

115. *Building*, 12 January 1914, pp. 89–94. On Burcham Clamp, see Peter Reynolds, 'Clamp, John Burcham (1869–1931)', *ADB*, vol. 8, p. 1.

116. 'On common ground', *Building*, 12 May 1914, p. 49.

117. Florence wrote in her own article called 'Other women' such personal observations as: 'I noticed particularly that Chicago women were very much more advanced with civic duties than Australians'; this applied to such things as tree plantings along streets. *Building*, vol. 15, no. 88, December 1914, pp. 97–98.

118. I am indebted to Megan Martin, senior librarian and curator, Library and Conservation Resource Centre, Historic Houses Trust of New South Wales, Sydney, for bringing this fact to my attention. Taylor's inscribed Wasmuth portfolio now resides in the Trust's library. See *insites*, Historic Houses Trust of New South Wales, no. 36, Spring 2003, pp. 4–5.

119. The drawing is in the library collection, Historic Houses Trust of New South Wales, Sydney. See *insites*, p. 4.

120. *Building*, vol. 15, no. 88, December 1914, pp. 99–100.

121. For the Griffins in Australia, the bibliography is expanding rapidly. The best sources include a documentary film by Wanda Spathopoulus, *City of dreams*, Film Australia, Sydney, 2000. See also *A vision splendid: How the Griffins imagined Australia's capital*, National Archives of Australia, Canberra, 2002; Jeff Navaretti and Jeff Turnbull (eds), *The Griffins in Australia and India: The complete works and projects of Walter Burley Griffin and Marion Mahony Griffin*, Miegunyah Press, 2nd series, no. 22, Melbourne, 1998; Anne Watson (ed.), *Beyond architecture: Marion Mahony and Walter Burley Griffin in America, Australia, India*, Powerhouse Museum, Sydney, 1998; *Marion Mahony Griffin: Drawing the form of nature*, Block Museum of Art, Northwestern University, Evanston, Illinois, 2005; Donald Leslie Johnson, *The architecture of Walter Burley Griffin*, Macmillan, Melbourne, 1977; Donald L. Johnson, *Canberra and Walter Burley Griffin: A bibliography*, Oxford University Press, Melbourne, 1980; and Paul Reid, *Canberra following Griffin: A design history of Australia's national capital*, National Archives of Australia, Canberra, 2002. The best website is The Walter Burley Griffin Society, viewed 8 November 2006, <http://www.griffinsociety.org/index.html>.

122. Reyner Banham, 'Death and life of the Prairie School', *Architectural Review*, vol. 154, August 1973, pp. 99.

123. See *Building*, 12 December 1913, p. 57, and 11 July 1914, p. 59.

124. Apperly, 'Sydney Houses', vol. 2, p. 177.

125. Apperly sums up the Taylors' response to the Griffins succinctly: 'George and Florence Taylor, in particular, found it much easier to enthuse about modern architecture in the abstract than to come to terms with actual buildings embodying new and unfamiliar elements.' 'Sydney Houses', p. 179. About Newman College, Florence wrote, among other things, 'I do not believe in nameplates on public buildings, but the authorities would be well advised, in the protection of the Australian architectural profession, to label this building as not being Australian.' *Building*, 12 March 1918, p. 63.

126. The great Australian architect and critic Robin Boyd described the Capitol Theatre as 'the best cinema that was ever built or is ever likely to be built'. See *The Australian*, 24 December 1965.

127. Graham Jahn, *Sydney architecture*, Watermark Press, Sydney, 1997, p. 112.

128. ibid., p. 81.

129. I am indebted to Anne Higham, RAIA (New South Wales), for access to RAIA's bibliographical

information on New South Wales architects. See also Davey, 'James Peddle'. Peddle's father is discussed under Edward Godwin on the Victorian Web, viewed 14 September 2006, <http://www.victorianweb.org>.

130. As one example of many, the Melbourne architect Edward George Kilburn (1859–1894) made a nine-month study tour of the United States in 1889. He returned with a collection of photographs of American buildings, now housed at the Faculty of Architecture Building and Planning, University of Melbourne. As Miles Lewis writes: '[A]fter his return the firm produced two full blown American Romanesque designs in competitions for the Commercial Bank of Australia headquarters in Melbourne, and the Broken Hill Municipal Buildings, New South Wales. Neither of those was built, but the more modest 'Priory' school in St Kilda was begun in the same year, and was the first thoroughgoing example of the American Romanesque in Australia.' Viewed 12 July 2006, <http://www.apb.unimelb.edu.au/research/kilburn/index.html>. I am grateful to Professor Lewis for bringing this source to my attention.

131. See Orth, pp. 3–18.

132. Jack F. Hennessy, 'A few impressions of modern America', *Art & Architecture*, vol. ix, no. 3, May–June 1912, p. 486.

133. See *Department of Architecture, The University of Pennsylvania 1874–1934*, University of Pennsylvania Press, Philadelphia, 1934.

134. *Art & Architecture*, vol. ix, no. 3, May–June 1912, p. 514.

135. On Peddle and Godwin, see for example, Susan Weber Soros (ed.), *E. W. Godwin: Aesthetic Movement architect and designer*, Yale University Press, New Haven, 1999, p. 246.

136. California State Board of Architecture Minutes, transcript and notes, 29 July 1913. I am grateful to John G. Ripley, researcher at the Pasadena History Museum, for supplying me with this information, from his own notes transcribed in a telephone conversation with the California Architectural Board, Sacramento, California, 10 May 2007. Further conversation with Vicky Mayer at the Board Archives in Sacramento reveals that at the time of his licence review in July 1913, Peddle was not yet approved, as the members wanted to see more 'evidence of his knowledge of mechanics'. No subsequent records indicate when this information was presented, but he did receive his California licence (B787) at least by 1915; a 'correction' to his previously published licence was then sent to his Sydney address. Telephone

conversation with Vicky Mayer, California State Board of Architecture, Sacramento, California, 3 March 2008.

137. Louis du Puget Millar was an Irish-born architect, a graduate of Trinity College in 1902. He emigrated to California in 1907. He had an active practice, specialising in an 'English cottage' style, or as his house at 686 W. California Ave, Pasadena, is called, 'Cotswold Revival Craftsman'. Millar also built bungalows, such as the 1910 residence for Henry Van Arsdale, at the corner of Brooklyn and Mar Vista Avenue, Altadena. He wrote several articles about new developments in Pasadena for national magazines, including 'The bungalow courts of California: Bowen's Court. Arthur S. Heinemann Architect', *House Beautiful*, vol. 40, November 1916, pp. 338–39. At the time Peddle was in Pasadena, Millar worked on a large project for a sanitarium on South Euclid in Pasadena, and had also worked on conversion of the 'Olive Mill' in Santa Barbara. While he continued to practice in Pasadena through the 1920s and 1930s, he appears to have become increasingly unreliable and dissolute. An unidentified biography of Millar in the files of the Pasadena Permit Center is titled 'Louis du Puget Millar: Capable Architect – Troubled Man'. He quit Pasadena in 1940, moved to San Jose and died there shortly thereafter.

138. 'Pasadena classified directory', *Thurston's city directory*, Los Angeles, 1914–15, p. 449. Peddle is also listed in the city directory of 1913 to 1914, at which time he lived at 521 N. Fair Oaks Avenue, Pasadena. His daughter Elsie is also listed at this address for 1914 to 1915. The location of this demolished residence is now the site of a recreation centre and playing fields.

139. In a conversation with the author, Ann Scheid, Curator of the Greene & Greene Archive at The Huntington Library, indicated that the archive, which includes items from the Greenes' personal library, contains one copy of *Building* magazine dated April 1911. It is tempting to think that Peddle could have met the Greenes and provided them with this issue, although no records exist that verify such a meeting. Conversation with the author, The Huntington Library, 23 May 2001.

140. Thanks again to John Ripley for providing the ship's manifest on which Elsie Peddle arrived in Vancouver. Elsie made a subsequent trip to America in 1938, apparently en route to England. Email correspondence, 1 September 2007.

141. Ripley provided this information from his own

database. The building permit for the Means house was lodged on 9 November 1913. Email correspondence, 12 July 2007.

142. James Peddle is listed as architect on the Building Permit lodged by Frank May with the Pasadena Planning Office on 14 April 1913 (permit no. 1797), now lodged in the B. P. & H. Research Room, George Ellery Hale Building, Permit Center, Pasadena, California. Frank May's own house, built by Pasadena architect Benjamin Marshall Wotkyns (1883–1964) in 1909, was located at 801 Winona Avenue, only a block away from the house Peddle built for May. May's house still stands, although it is now given another address, 1 Mayview Lane, since the 210 Freeway cut through that section of Pasadena in the 1970s. The demolition of the house built by Peddle on the same block probably occurred some time around 1970, when the freeway construction was beginning. As late as 1966, a new hot water heater was installed at the property at 735 Winona Avenue, according to building records in microfiche in the Pasadena Permit Center. May's house is now on the list of Pasadena's Cultural Heritage Commission. See *Bungalow reader*, City of Pasadena Urban Conservation, May 1988.

143. I am grateful to Ann Scheid for the information about May and Culbertson's connection. See *Nelson's biographical dictionary and historical reference book of Erie County*, S. B. Nelson, Erie, Pennsylvania, 1896, pp. 788–89.

144. On the Cordelia Culbertson House, 1188 Hillcrest Avenue, Pasadena, see Bosley, pp. 154–60, 232.

145. 'Architects' meeting', *The Los Angeles Builder and Contractor*, 12 September 1912, p. 4, col. 1.

146. James Peddle, 'Some lessons we can learn from our American neighbors', *Building*, vol. 20, no. 110, 12 October 1916, pp. 90–94 and no. 113, 12 January 1917, pp. 98–99.

147. 'Daceyville: The N.S.W. state Garden Suburb', *Building*, vol. 16, 12 November 1912, p. 47. See also Peter Cuffley, *Australian houses of the '20s & '30s*, Five Mile Press, Fitzroy, Victoria, 1989, p. 35.

148. In Peddle's obituary in *Building* magazine, probably written by Florence Taylor, concrete was seen as the main reason for his trip to America: 'Ever a student, right to the time of his death, his object in visiting America, where he stayed for three years, was to study the design of reinforced concrete, which he foresaw as a development of modern architectural design.' *Building*, 12 January 1931, p. 54. Another Australian architect, Leslie Perrott, also travelled to the United States in the 1910s and 1920s, 'studying the progress

of Concrete'. In a booklet written by Perrott upon his return, apparently for the Australian concrete industry, he presents bungalow plans that could be built of concrete, stating for one plan: 'This type of home is almost a distinctly Australian style; certainly it has the influence of the Californian Bungalow.'

149. Peddle, 'The bush bungalow', pp. 29–30.

150. See Tanner, p. 58.

151. As Davey writes about Ga-di-Rae: 'The living room was furnished in Victorian style due to the contrasting taste of Mrs. Hudson. So the usual simplicity in skirtings, architraves and picture rails was relinquished for a restrained expression of Victorian detail.' In 'James Peddle', p. 71.

152. As Davey points out, the use of brick by Peddle and others in place of wood may have been caused by local building requirements, conservative clients who considered brick a sign of solidity and respectability, or because of bad Australian woods and the lack of an adequate supply of imported woods. Further, Davey says: 'Although Peddle had used redwood shingles in his earlier houses, all the houses he was to design in his bungalow period were roofed with small terracotta shingles.' In ibid., p. 63.

153. Apperly, 'Sydney Houses', p. 90.

154. According to Ian Stutchbury, of Clive Lucas Stapleton Architects, Sydney, and author of a thesis about Thorp, Mrs Thorp convinced him in 1971 that Thorp had indeed been the one to go to Pasadena, and that Peddle called him back to work on the Daceyville plans (email correspondence, 9 August 2006). Evidence in Pasadena substantiates only that Peddle was in Los Angeles and Pasadena 1912 to 1914; no records exist of any visit by Thorp at this time. It is possible that he could have visited, perhaps when Peddle was in the state. Stutchbury's assessment was on aesthetic grounds: 'The early Thorp houses show so much Greene & Greene type influence (extended rafters beyond eaves, cobble/rubble chimneys, free art nouveau leadlight glazing etc) and completely different from anything in Sydney at the time that it's hard to believe he hadn't been there and seen them.' Email correspondence, 8 August 2006.

155. See an example of Peddle, Thorp, & Walker's Spanish Style house in 'New ideas allied to Old-World Styles', *The Australian Home Beautiful*, 7 June 1926, cover and pp. 15–19.

156. An article from *Decoration & Glass*, Oct. 1938, p. 53 writes of F. H. E. Walker: 'At the completion of his studies here, Mr. Walker crossed to the United States, where he was associated with Aymer Embury 2nd

[sic] and with B.G. Goodhue, a prominent Gothicist and designer of the Nebraska State Capitol.' Davey also writes of Walker: 'At the University of California, Mr. Walker completed a post-graduate course in architectural and constructional engineering. After several years in America & in Europe, he returned to Sydney.' In 'James Peddle', p. 54. In Peddle's obituary in *Building*, S. G. Thorp's younger brother Frank is mentioned: 'Mr. Frank Thorp was then indentured and following the lead set by Mr. Walker also went to England and America for three years and 18 months ago joined the firm as a partner.' *Building*, 12 January 1931.

157. See Peter Spearritt, 'Spain, Alfred (1868–1954)', *ADB*, vol. 12, pp. 25–26.

158. I am grateful to Anne Higham, heritage architect, RAIA (New South Wales) for bringing these materials to my attention. She notes about the Chivers book: 'The book was probably bought here in Sydney as it is stamped twice Turner & Henderson, Hunter Street, Sydney.' Email correspondence, 30 May 2006.

159. See Cedric Flower, 'Moore, John Drummond Macpherson (1888–1958)', *ADB*, vol. 10, pp 566–567; Apperly, *A pictorial guide*, p. 207; Cuffley, pp. 78–79. Of his time in Mexico, according to Apperly, he wrote home to his parents: '[W]hat struck me about the whole town was the absence of sham. The buildings were all built simple, ornamented where ornament was wanted, and built of local materials, but showing the influence of their early Spanish history and the conditions imposed by the climate. They are wonderfully cool.' Apperly, *A pictorial guide*, p. 207.

160. In a letter from the war front to Goodhue, Moore wrote: 'I am glad you received and liked the North African houses and I hope when the town "in the desert with palm trees etc etc." come along, I may be somewhere handy with a brush and some colors.' John D. Moore, letter to Bertram Goodhue, 20 January 1916, Goodhue Papers, The Avery Library, Columbia University, New York, New York (Box 5: 23[M]).

161. See Terry Kass, 'Stanton, Richard Patrick Joseph (1862–1943)', *ADB*, vol. 12, p. 51. On Stanton's work at Haberfield and the beginnings of his development at Rosebery, see 'Town planning for Australia: An enterprising realty man's tour', *Building*, 12 March 1913, pp. 146–47; and Vanessa Ann Ebbutt, 'Haberfield and the Garden Suburb Concept', BArch thesis, University of New South Wales, Sydney, 1987.

162. Freeland, *Architecture in Australia*, p. 229. On pp.

228–29, Freeland further emphasises the source of the design: 'The project was intended to test the acceptability of both timber building and the Californian (Pasadena) style of bungalow in Sydney.'

163. Apperly, 'Sydney Houses', p. 83.

164. *Building*, 12 October 1916.

165. See '"The Bunyas", the residence of Richard Stanton, Esq, Haberfield, Sydney', *Home & Garden Beautiful*, 1 February 1913, Australia, cover, pp. 145, 147, 149, 151, 156.

166. The Garden Suburb Movement, largely out of Britain, was a particularly popular idea related to Arts & Crafts philosophy for Australians. See Albert Goldie, 'The Garden Suburb idea', *The Lone Hand*, 2 June 1913, pp. 163–67. Here Goldie describes the success of Haberfield and announces plans for another Garden Suburb at Altona in Melbourne.

167. Because of his success at Haberfield, Stanton was asked to sit on a discussion panel with John Sulman and other architects considering town planning after an address by Walter Burley Griffin at a meeting of The Institute of Architects of New South Wales. See 'Town Planning and its architectural essentials', *Building*, 11 October 1913, pp. 50–60.

168. Kass, *ADB*, p. 51.

169. Peter L. Goss and Kenneth R. Trapp, *The bungalow lifestyle: And the Arts & Crafts Movement in the intermountain West*, Utah Museum of Fine Arts, University of Utah, Provo, Utah, 1995, p. 13.

170. Janet Ore, 'Jud Yoho, "The Bungalow Craftsman", and the development of Seattle suburbs', in Carter L. Hudgins and Elizabeth Collins Cromley (eds), *Shaping communities: Perspectives in vernacular architecture VI*, University of Tennessee Press, Knoxville, 1997, pp. 231–43; and Erin M. Doherty, 'Jud Yoho and the Craftsman Bungalow Company: Assessing the Value of the Common House', MArch thesis, University of Washington, Seattle, 1997.

171. Jud Yoho, *Craftsman master built homes catalogue*, Seattle, Washington, 1915, 'General Information'.

172. The novelist David Malouf is more insightful about the issue of timber in Australian houses when he ruminates about 'The Queenslander' houses of his childhood: 'But the truth is that most people in my youth were ashamed of this local architecture. Timber was a sign of poverty, of our poor-white condition and backwardness: it made "bushies" of us. Safe houses, as everyone knows, are made of brick—think of the *Three Little Pigs*. Timber is primitive.' *A spirit of play*, pp. 63–64.

173. Ore, p. 232.

Colour plates

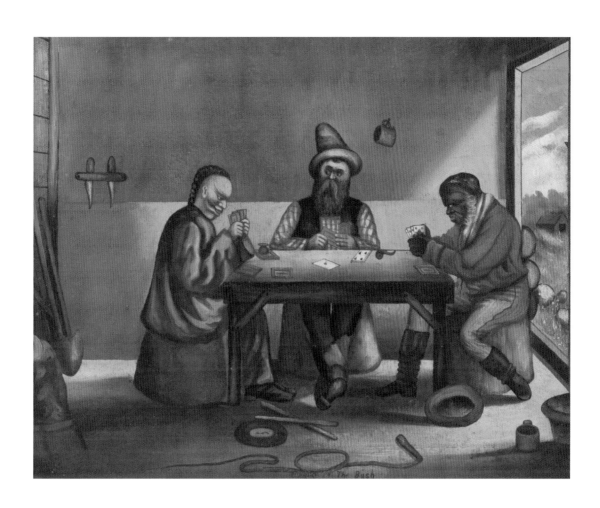

Fig. 2.01 J. C. F. Johnson,
Euchre in the bush,
c. 1872. Oil on canvas,
mounted on board, 42 x
60.2 cm. Bequest of
Clarice May Megaw, 1980.
Collection of Art Gallery of
Ballarat, Ballarat, Victoria.

Fig. 2.06 Anonymous, cover, *The 'Heathen Chinee' musical album: Containing 15 pieces of the most popular songs, mostly comic*. Lithograph. Robert De Witt, New York, 1871. Courtesy of The Huntington Library, San Marino, California.

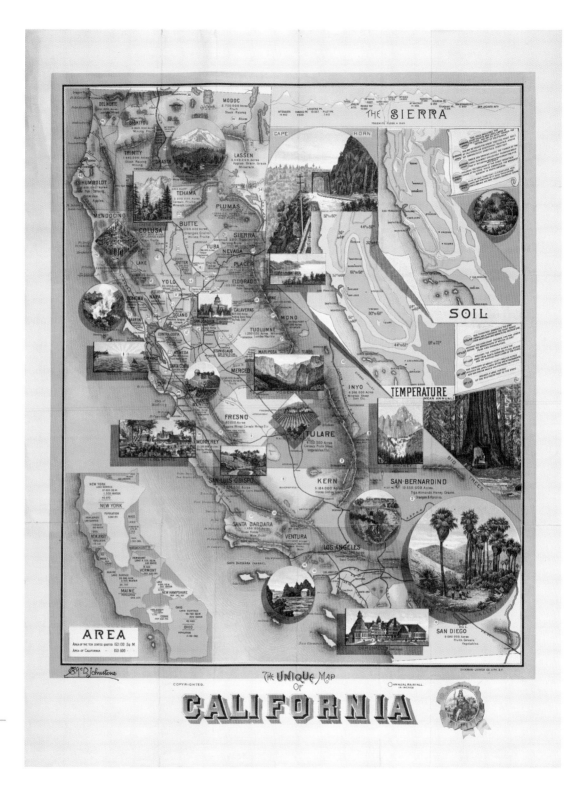

Fig. 3.02 E. McD.
Johnstone, *The unique map of California*.
Lithograph. Dickman-Jones Co., c. 1885.
Department of Special Collections, University of California at Los Angeles.

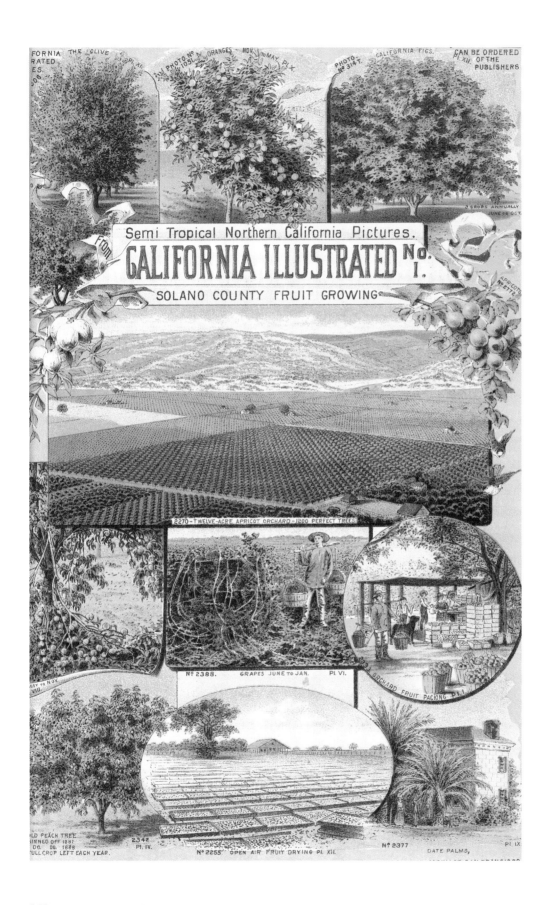

Fig. 3.26 *'California Illustrated No. 1, Semi-Tropical Northern California Pictures'*, *Overland Monthly*, vol. 6, 1889, n. p. Courtesy of The Huntington Library, San Marino, California.

Fig. 3.27 Playmates Brand, Redlands Fruit Association, Sunkist orange label, c. 1907. Courtesy of The Huntington Library, San Marino, California.

Fig. 3.28 Anaco Brand, Valencias orange label, c. 1910. Courtesy of The Huntington Library, San Marino, California.

Fig. 4.06 George W. Morgan (arch.), Hale House, Heritage Square, Los Angeles, California, c. 1888. Author's photograph.

Fig. 4.20 Reginald A. Prevost, cover, *Australian bungalow and cottage home designs*, The N.S.W. Bookstall Co. Ltd., Sydney, 1912. Courtesy of Caroline Simpson Library and Research Collection, Historic Houses Trust of New South Wales, Sydney.

THE INTERNATIONAL EXHIBITION, SYDNEY, 1879-80.

Fig. 5.02 'The
International Exhibition,
Sydney, 1879–80,'
supplement to *Illustrated
Sydney News*, January
1880. Chromolithograph.
National Library of
Australia, Canberra.

Fig. 5.06 'The Pacific
Limited: Chicago to
California, San Diego
Exposition All of 1916',
postcard from the
Chicago, Milwaukee, St
Paul and the Southern
Pacific Railways. Courtesy
of San Diego Historical
Society, San Diego,
California.

Fig. 6.02 William **Hahn**, *Horses grazing, Berkeley*, 1875. Oil on canvas, 50.8 x 86.36 cm. California Historical Society Collections at the Autry National Center, Los Angeles, California.

Fig. 6.05 Karl Eugene **Neuhaus**, *Lone sentinel*, c. 1910. Oil on canvas, 40.6 x 61 cm. Collection of the Hearst Art Gallery, St Mary's College of California College purchase, Moraga, California.

Fig. 6.10 'Eucalyptus: California's Mahogany' brochure. Courtesy of Theodore Payne Foundation, Sunland, California.

Fig. 6.12 'From Eucalyptus cloistered aisles … ' John Muir, card to Theodore Lukens, sent 2 January 1911, Los Angeles, California. From Lukens Papers, The Huntington Library, San Marino, California.

Fig. 6.21 Santa Barbara Courthouse with eucalypts. Author's photograph.

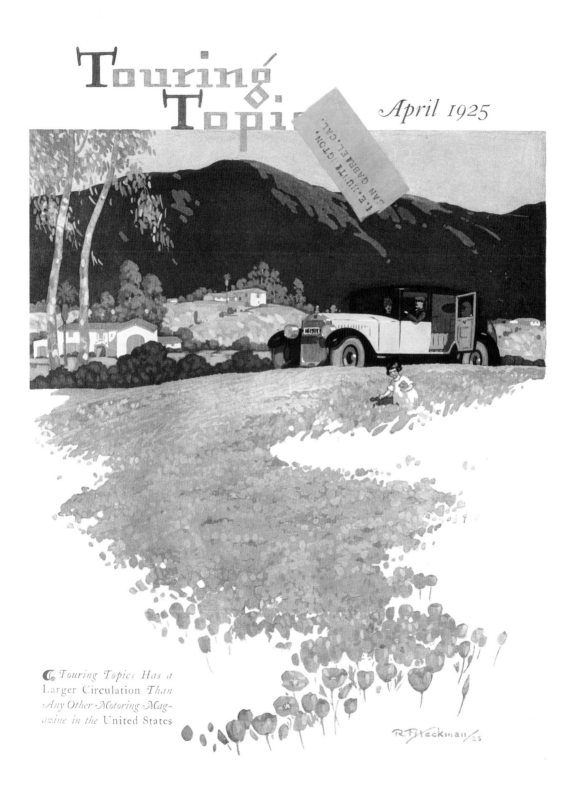

Touring Topics

April 1925

Touring Topics Has a Larger Circulation Than Any Other Motoring Magazine in the United States

R.F.Heckman/25

Fig. 6.25 R. F. Heckman, cover, *Touring Topics*, April 1925. Permission of The Automobile Club of Southern California Archives. Photograph: courtesy of The Huntington Library, San Marino, California.

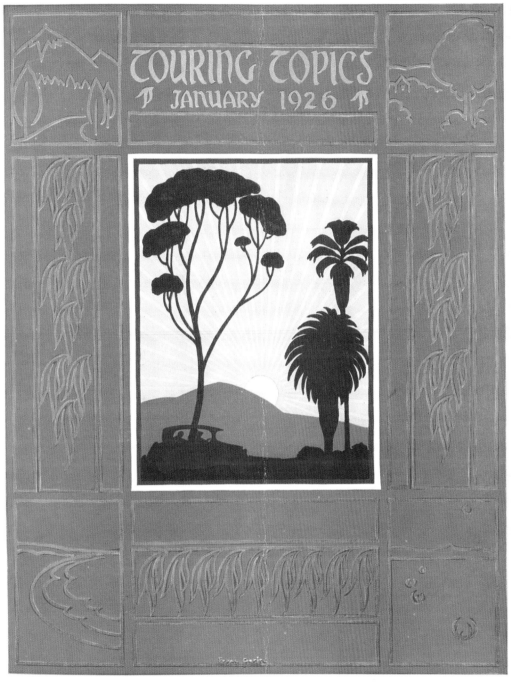

Fig. 6.29 Franz Geritz, cover, *Touring Topics*, January 1926. Permission of The Automobile Club of Southern California Archives. Photograph: courtesy of The Huntington Library, San Marino, California.

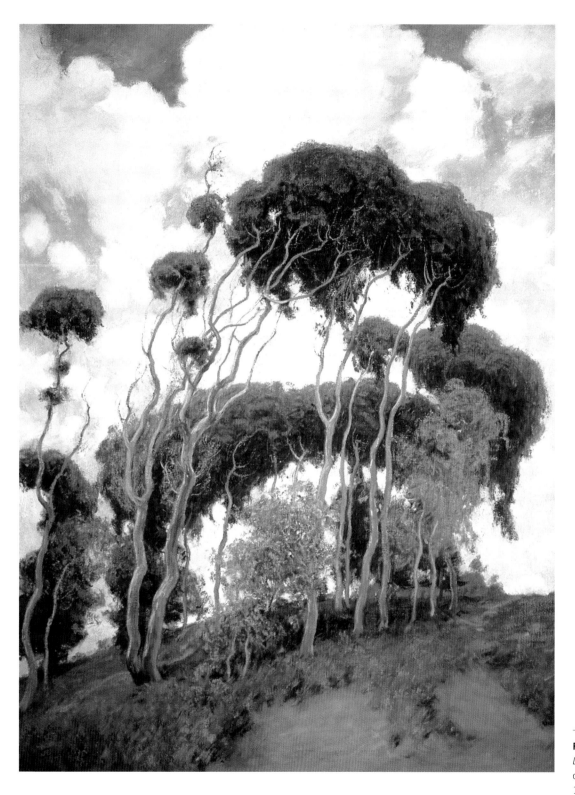

Fig. 6.32 Guy Rose,
Laguna eucalyptus,
c. 1917. Oil on canvas,
101.6 x 76.2 cm.
Courtesy of Irvine
Museum, Irvine,
California.

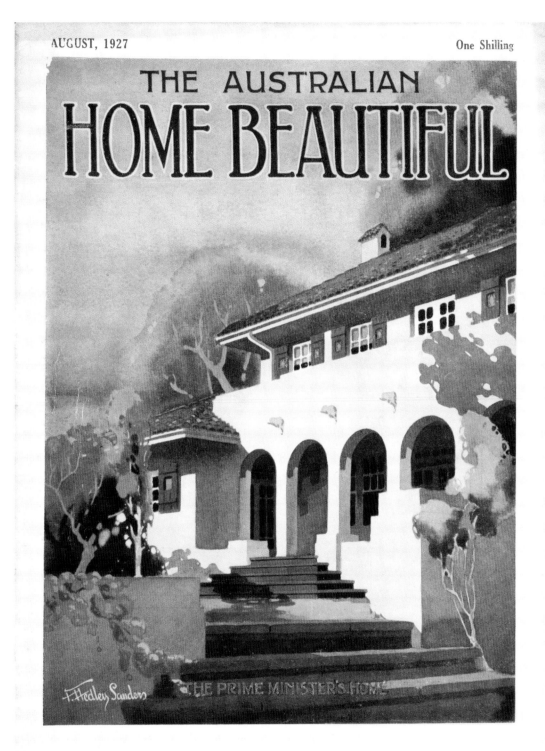

AUGUST, 1927 One Shilling

THE AUSTRALIAN
HOME BEAUTIFUL

THE PRIME MINISTER'S HOME

Fig. 7.21 L. F. Herbert
and E. D. Wilson (archs),
Roxy Theatre, Parramatta,
New South Wales, 1930.
Photograph: National
Library of Australia,
Canberra.

1915: Australia at the California Fairs

It is significant that the architecture which sought to embody this symbolical conception should have found its inspiration so largely in the Orient and the Moorish age of Spain. To California, simplicity in art would appear to make as scanty an appeal as does Stoicism in conduct or Puritanism in religion.
—William MacDonald, 'The California Expositions', *The Nation*, 21 October 1915.[1]

~

The Churrigueresque form of Bertram Goodhue and Carleton Winslow Sr.'s buildings for San Diego's Panama California International Exposition of 1915 were far more learned than any Mission building ... The outcome of the Fair was to make this mode popular and fashionable.
—David Gebhard, 'The Spanish Colonial Revival in Southern California (1895–1930)', 1967.[2]

~

Exposition in San Diego commanding whole town both tributes to people—I covered much ground outside the cities studying rural potentialities bringing knowledge up to date—extraordinary gains from water distribution followed by splendid yields. Resources Cal. by no means fully developed—wealth great prospects golden.
—Alfred Deakin, Diaries, 25 April 1915.[3]

In the process of architectural and artistic assimilation between Australia and California, the year 1915 stands as a particularly symbolic moment for both countries. James Peddle and George Taylor were both newly returned from their American adventures; and Richard Stanton had just imported the bungalow Redwood from an American building company. The California bungalow style was at the height of its popularity and articles with illustrations of Australian and Californian housing examples filled the pages of the magazines. Australian cities continued to expand, with suburban construction demanding new plans and new ideas in architectural design.

This optimistic situation would soon be muted, as the world began to feel the effects of the catastrophic war that had begun in Europe in August 1914. That war would be particularly traumatic for Australia. In April 1915, the horrific battle at Gallipoli in Turkey claimed thousands of Australian lives. The sacrifices at Gallipoli helped to establish the image of the ANZAC (Australian and New Zealand Army Corps) 'digger'—the Australian soldier—that is still the central iconic symbol of Australian nationhood and patriotism.[4] The real costs of this battle and those on the European front, both physically and psychically, would not emerge at home until the end of the war in 1918 and the return to Australia of the soldiers who survived, no longer innocent of or isolated from the world's problems.

But in 1915, other more peaceful events, already planned years before the war began, continued to stimulate the exchange of aesthetic ideas between California and Australia. As early as 1904, two Californian cities, San Francisco and San Diego, began to vie for the right to hold an international exhibition to celebrate the completion of the American-led engineering triumph, the Panama Canal.[5] In the end, both cities were to hold fairs, one with international scope, the other maintaining a more regional focus. The phenomenon of two 'Pacific' international expositions held in California caught the attention of an audience at home not otherwise preoccupied with the war in Europe. Since America did not enter World War I until 1917, the conflict's impact on the expositions was only indirect, as many European countries that had planned to attend either dropped out completely or limited their participation. The completion of the Panama Canal, such a monument to American technological progress, offered the perfect opportunity for Californians to demonstrate symbolically their economic potential and their cultural significance within the United States and throughout the world.

Not only did the Panama–Pacific International Exposition in San Francisco and the Panama–California Exposition in San Diego represent an important and self-conscious coalescence of Californian cultural ideals, but they also offered the first substantial opportunity to formulate visual iconographies that focused on the new conception of America's 'Pacific Empire'. In this formulation, Australia's presence at the fairs would offer symbolically significant evidence of a connection to the other English-speaking countries situated on the Pacific Rim. Such an attitude was in keeping with the rhetoric that had accompanied the appearance of Theodore Roosevelt's naval White Fleet in Sydney in 1908—rhetoric in which the United States

took the lead as the power in the Pacific.

Even before the Panama Canal offered a valid excuse for California to express its claim to hegemony along the Pacific Rim by hosting an international exposition, some had already proposed a fair in San Francisco that would celebrate Balboa's discovery of the ocean itself. This claim rankled some Australians, who pointed out that the Portuguese had already ventured near the Australian continent and into Pacific waters before Europeans had found

Fig. 5.01 Cover, *Sunset*, vol. 34, January 1915. Courtesy of The Huntington Library, San Marino, California.

America's western shores. George Collingridge (1847–1931)—the same Collingridge who had worked as an engraver on the *Picturesque atlas* and an authority on exploration in the South Pacific[6]—suggested that Australia should rightfully host such celebrations:

> ... the point I wish to stress is this, that the first discovery of the Pacific Ocean was made not from the American but the Australian side. By right of first discovery it is "our" ocean rather than America's. It is seriously proposed to hold an International Exhibition in Australia ... to advertise our progress under Federation. Why not fix the date at 1911 and make it a Grand Pacific Exhibition, in celebration of the *real* quarter-centenary of the discovery of the Pacific Ocean?[7]

Nothing seems to have come of the proposed exposition, neither in America nor in Australia. But in 1913, one of the San Francisco Fair's commissioners, former Colorado Governor Alva Adams, visited Australia and New Zealand and convinced both countries to participate in the Panama–Pacific event of 1915.[8] Once war was declared in Europe, America's early isolation was a real bone of contention for the most imperialist Australians, including *Building*'s George Taylor who had previously been such a booster of American architecture. Despite some initial grousing from some Australian politicians about the expense of the fair during a time of war, most officials in the country nonetheless felt it was important to participate in this first 'Pacific' World's Fair to be held in California. In keeping with the jingoistic spirit that coloured much of the Australian–American talk of 'Anglo–Saxon' affinities of the day, the 'official' story of the exposition, published long after the event, presents a particularly imperialist interpretation of this decision:

> Larger motives of racial interest and statecraft played their part in bringing about the Australian participation when war had called a halt to all the early plans, and every man, horse, and shilling that could be spared were needed for military service. For Australia felt that she needed settlers, and English-speaking settlers, if the history of the Pacific was to be formed by men of the English-speaking races and this great, isolated continent secured to the control of an English-speaking posterity.[9]

The very fact that two Californian cities felt compelled to celebrate the opening of the canal with such ambitious ostentation demonstrates the great significance still attached to the international exposition as a symbolic expression of civic pride, tourist promotion and commercial opportunity. San Francisco had an added incentive to demonstrate its cultural resurrection by mounting such an ambitious undertaking. Still reeling from the destruction of the 1906 earthquake, civic leaders in the Bay Area were desperate to show that the city had recovered and could take its place among the world's leading cities. Civic leaders were intent on taking advantage of the canal opening to promote the city as the new 'Paris of America' as well as a salubrious 'playground of America'.[10] Given that so much of the old Victorian-built city had been destroyed, the opportunity to construct new buildings, albeit for a temporary purpose, offered tantalising possibilities for those on the West Coast ideologically intent on constructing a Californian aesthetic. Whether the businessmen and politicians of the city were up to the task remained to be seen.

San Diego's boosters, on the other hand, saw the moment as a golden opportunity to extol the virtues of their still sleepy little harbour town. They had in fact proposed a fair before San Francisco had, arguing that their city was the first American port reached

by the ships passing through the canal or by those coming from the South Pacific, and so had some claim to symbolic priority.[11] After prolonged political negotiation that reached all the way to Washington, D.C., political leaders agreed that San Francisco would take on the more elaborate task of presenting an international fair, while San Diego would present a regional focus and an event that had a longer run than San Francisco's.[12] The preparations began years before the realities of World War I disrupted and tempered the implementation of these utopian visions of artifice and theatrical fantasy.[13] What could not have been foreseen was that these contrived constructions in California, and most particularly San Diego's determination to manifest the visual stereotypes of Spanish California, would have as much lasting aesthetic impact as they did.

These Pacific sites, on the periphery of their home cultures, looked to international expositions not only as important economic opportunities, but as symbolic venues for verification of their place among Western nations—as validation of their cultural identity. As Graeme Davison has written, these exhibitions 'provide an excellent vantage-point for reviewing the import and export of cultural baggage'.[14] Perhaps because it was located so far from its home culture, Australia had always been an especially eager participant in these international fairs. From the first great International Exposition at the Crystal Palace in London in 1851, Australian colonies had sent representative products and crafts to all the world expositions and reported extensively on these events in newspapers and journals, publishing numerous illustrations and explanations of new products and new artistic trends presented there. Each exhibition was preceded by a display at home of the Australian goods to be sent abroad.

Intercolonial exhibitions had also been held frequently since the first one in Melbourne in 1866. In explaining the purpose of this first intercolonial event, the *Australian Illustrated News* included pages of images and columns of hopeful text:

> Complete in all essentials, brilliant as a spectacle, substantial as a display of Australian industry and enterprise, it is at once a testimony to the wise use we have made of the past, and a prophecy of what we may expect to accomplish in the not very distant future.[15]

These fairs were as fervent in their ambitions as the international exhibitions were: leading artists such as Eugene von Guerard, Nicholas Chevalier and Louis Buvelot exhibited their newest paintings,[16] and the grounds included such alluring entertainments as a 'Medieval Court'.[17] This Melbourne Fair was a great success, with more than 240,000 people attending (at a time when the entire population of Australia was less than two million) and garnering a profit of 9000 pounds.[18]

Longing to participate on the world stage, Sydney held the first International exhibition in Australia in 1879 (see Fig. 5.02 on page 216). The affair saw the construction of an enormous Garden Palace, then one of the largest buildings in Sydney, and had an attendance of over one million visitors.[19] Not to be outdone by its rival New South Wales, Victoria followed in 1880, erecting an exhibition building in Melbourne's Carlton Gardens for its own international fair. As the chapter on the Picturesque industry describes, this grandiose structure was deemed elegant enough to hold the Centennial exhibitions of 1888 and the first meeting of the Australian Parliament after Federation in 1901.[20]

Australians had also participated in (as New South Wales) and attended the World's Columbian Exposition in Chicago in 1893, the famous White City that had such an effect on people like the Greene brothers en route to

Fig. 5.03 Harry Fenn,
The California Building,
in Walton, *World's
Columbian Exposition:
Art and architecture*,
G. Barrie, Philadelphia,
189395, opp. p. 173.
Balch Art Research
Library, Los Angeles
County Museum of Art,
Los Angeles, California.

THE CALIFORNIA BUILDING.
DRAWN BY HARRY FENN.

California. They were as affected by its architectural splendour and displays of the era's progressive culture as everyone else had been. (As late as 1914, George Taylor was reproducing images of Louis Sullivan's Transportation Building in his magazine as an example of America's 'rational' architecture.[21]) Aside from some impressive examples of Australian artisanry, New South Wales's entries at the fair were largely agricultural, industrial and—in keeping with the international fair's love of 'authentic' displays of 'people as trophies'—ethnological.[22] The Chicago Exposition's official guide wrote of the Australian entry:

> Represented particularly by the New South Wales exhibit, one of the most extensive and interesting of the Exposition. Occupies 60,000 square feet of space. Display covers Mines, Agriculture, Liberal Arts, Manufactures, Woman's work, Ethnology, Electricity, Fisheries, Plants, Machinery, Live Stock and Forestry, Wool, Wine and woods./ Australia is represented on the Wooded Island by a bushman's cabin. Fourteen Australian natives may be seen in the ethnological section.[23]

The New South Wales exhibit was wedged between the exhibits of Haiti, Canada and Spain, and across from the Clam Bake and Soda Pavilion.

The Chicago Exposition also offered visitors the opportunity to see California's first concerted expression in architecture of a 'Mission Style' structure. The California Building, designed by A. Page Brown (1854–1896) and inspired by leading San Francisco architect Samuel Newsom (1854–1908), displayed an eclectic mixing of various design elements taken from several of the

coastal missions, along with references to Richardsonian Romanesque features as well.[24] In terms of the progression towards a 'Pacific' architectural style, the significance of this building at the most influential of world's fairs cannot be overstated. As Karen Weitze has written, '[w]ith the 1893 opening of the Columbian Exposition … missionizing began in earnest'.[25] Millions of visitors, including Australians, and thousands of articles in the press, including in Australian newspapers, saw and wrote about The California Building and its new stylistic approach to the Spanish traditions of the American Pacific coast.

Inspired by the overwhelming success and aesthetic power of the Chicago World's Columbian Exposition, San Francisco mounted its own Midwinter International Exposition in 1894. California's first attempt at a world's fair also caught the eye of Australian journalists (and at least one Melbourne commercial

participant among 12 included in the British section).[26] The more modest fair was meant to promote California's climate and natural resources, but it also highlighted its Pacific location by mounting 'authentic' Japanese and Hawaiian villages, displays of South Sea Islanders, and a Chinese Building. This design of the fair, which ran for the first six months of the year, followed a traditionally High Victorian aesthetic in its buildings and print materials, despite incorporating a few 'exotic' touches that simply imitated on a smaller scale what had appeared in Chicago and at earlier European expositions. Most of the novelty buildings were simple structures with external ornamentation applied in styles evocative of foreign cultures or themes it was meant to represent. The erection of a miniature Eiffel Tower and Ferris Wheel on the fairgrounds was as derivative as the appearance of the event's printed ornamentation, which followed

Fig. 5.04 Agricultural Building, California Midwinter international exposition, 1894, San Francisco. Courtesy of the Bancroft Library, University of California, Berkeley, California.

Fig. 5.05 *The Midwinter fair at San Francisco*, in *The Illustrated Australian News*, 1 May 1894. La Trobe Picture Collection, State Library of Victoria, Melbourne, Victoria.

Aesthetic Movement and Art Nouveau styles of the day. Still, the construction here of early formulations of a Mission Style architecture in the Agricultural and Horticultural Building, built by Samuel Newsom, and in some of the County Buildings elicited interest internationally. The Australian press admiringly depicted several of these buildings, including renderings drawn with surrounding vegetation as if in situ.[27] This vegetation already demonstrated the abundance of Australian eucalypts in the California landscape—an aspect of the location that would become increasingly important in the visual image of the American Pacific as the new century began. On a more vernacular level, a Redwood Tree Cabin and Foster's Tamale Cottage—the latter captioned as 'built exactly after the style found throughout the land of the Montezumas'[28]—promoted sales in buildings constructed to evoke the product itself. The Californian phenomenon of the fantasy theme park that would become so prevalent in the twentieth century originated in such ephemeral entertainments at the 1894 Midwinter International Exposition.

By 1915, Australia was closer to California in its attitudes about a shared Pacific culture than it had been in earlier decades. Participation in San Francisco's first large-scale international exposition—one of Australia's first opportunities to exhibit internationally as a separate and unified nation within the British Empire—promised to be an important moment. The initial announcement of the California Fair was widely advertised, with colourful brochures and postcards heralding in florid prose San Francisco's location at the edge of the American continent and as a gateway to the nations of the Pacific (see Fig. 5.06 on page 216):

> By gift of America the nations of the world become, as it were, shareholders in America's greatest enterprise. Each is entitled to its dividends in international trade and friendship; each has an open field of opportunity. The

gate is open and East and West will meet more freely.[29]

Given such explicit 'Pacific' emphasis, it is no surprise that George Taylor's *Building* began reporting on the exhibition as early as the planning stages in 1912. Indeed, in the same issue of the magazine in which he presents one of his many pleas to save Walter Burley Griffin's plan for Canberra, Taylor included an announcement about the upcoming San Francisco Fair.[30] By February 1914, Taylor was even more focused on the Californian city that he persisted in calling ''Frisco', despite knowing that San Franciscans hated that term for their city.[31] In this month's issue of the magazine, he published both a report called 'Through Australian Eyes—'Frisco' by one of his correspondents who was able to experience the city's Portola festivals. This annual celebration, held since 1909, was now seen as a prelude to the 1915 festivities.[32] This issue also contained a comment on the plans for the upcoming California Fair from none other than Walter Burley Griffin himself.[33] In the issue of 12 April 1915—the month of the unfortunate battle at Gallipoli—Taylor wrote about 'color' in the planning of the fair; and his pages of advertisements included one for the Oceanic Steamship Co. announcing special voyages to the exhibition.

The Panama–Pacific International Exposition (PPIE) would also figure prominently in segments of Taylor's accounts of his trip to America. He visited the fairgrounds while they were under construction and published his thoughts about the significance of its varied architectural statements in the magazine's pages throughout 1915. These comments were accompanied by profuse numbers of photographic illustrations.[34] Taylor was particularly taken with the architectural diversity displayed in the fairgrounds, which he labelled 'a magic city of temples'.[35]

AN ARCHITECTURAL GEM.

"Spring" Niche in Court of Four Seasons, 'Frisco Exhibition, 1915.

Fig. 5.07 'An architectural gem: 'Spring' niche in Court of Four Seasons, 'Frisco Exhibition, 1915', in *Building*, 12 April 1915, p. 67.

On 6 February 1914, a parliamentary committee in Melbourne wired Charles C. Moore, President of the San Francisco Exposition, accepting an offer to participate in the event and notifying the fair's committee that its appointed 'architect leaving probably seventh March to erect Australian Pavilion'.[36] Plans for Australian participation in the PPIE were approved by the parliament in March 1914—only a few months before the onset of World War I. Once hostilities commenced, transit across the Pacific was sometimes

delayed because of 'German Cruisers' on the seas, but travel under an American flag eased this danger, according to correspondence sent from Australians dealing with travel to the United States.[37]

The old champion of Australian Federation and former Prime Minister Alfred Deakin (1856–1919) was appointed as Commonwealth Commissioner of the Australian contingent.[38] Deakin had long standing associations with the United States. He had first come to America in the 1880s and was partly responsible for bringing the Chaffey brothers to Victoria to implement irrigation projects at Mildura and elsewhere in the colony.[39] While he took on the commissioner's job with some hesitations—he was ill and out of favour with the Australian politicians of the day—he did see it as a chance to get back into service where he was on familiar ground. After much political drama and many emotional compromises, he would manage to see out his term as commissioner.

While initial plans had been enthusiastically grand—there had been serious talk of sending Australian military vessels to remain on display in San Francisco Bay for the duration of the fair[40]—the war necessarily curtailed the Australian contribution. In the end, only New South Wales, Victoria and Queensland participated. Just as had been the case at every other international fair, the exhibits to be displayed in California focused on Australia's natural resources and items for trade. Black opals were a major draw, as were the various arrays of live kangaroo, wallabies and cockatoos. One report at the end of the exposition indicates that at least one joey was born during the running of the fair: 'the little Paddymelon, which was born in the Grounds has left its mother and is hopping round as strong as a kangaroo rat and is at present not unlike a rat.'[41] Displays included a surprising amount of perishable goods, including two tonnes of butter from the state of Victoria.

California did have an embargo on Australian fresh fruit, much to the Australian delegation's consternation, so only canned and bottled fruits were sent. The Australian Pavilion's most popular events, however, were performances: the brochure for the dedication of the Australian Pavilion includes in its program demonstrations by 'Saltbush Bill' (Mr W. Mills) in a 'display of aboriginal boomerang throwing, and manipulation of Australian teamsters' stockwhips'. [42]

Art from Australia was not entirely neglected. The printed guides to the fair pointed out approvingly:

> The commissioners have made it their boast that nothing has been exaggerated; everything is "real." Even art critics who visit the pavilion will not be disappointed, for on the walls they will find many paintings of merit by Australian artists, including loan collections from the National Gallery of New South Wales and the Victorian Art Society.[43]

Most interestingly, for a country that can hold claim to having produced some of the first full-length films in the world, motion pictures about Australia were shown every day at four p.m. and were by all accounts very well-received.[44]

Adhering to the mandate of the fair's organisers to be conscious of the symbolic importance of each country's exhibition buildings, the Australian Committee commissioned an ambitious pavilion for the fair. Designed and constructed by government architect G. J. Oakeshott (1861–1949), it covered some 15,000 square feet (140 x 200 feet) and received as many as 4000 visitors a day during the run of the exposition.[45] Oakeshott received 3000 dollars for the contract; the pavilion itself cost 77,115 dollars and 10 cents.[46] Oakeshott, described by the PPIE's chronicler Frank Morton Todd as 'an architect in the employ of the Commonwealth Government',[47]

Fig. 5.08 G. J. Oakeshott (arch.), Australian Pavilion at the Panama–Pacific international exposition, San Francisco, 1915. San Francisco History Center, San Francisco Public Library, San Francisco, California.

travelled to San Francisco to oversee and supervise construction himself. The design of the building was essentially a single large 'sample room' with a modified Classical facade, friezes depicting Australian flora and fauna and the requisite tower with observation decks.[48] Oakeshott also created elaborate wooden cases for the displays. One Australian report described the interior design: 'On the walls of the Pavilion, care has been taken to advertise the products of Australia in flaming characters on polished Australian timbers.'[49] The southern end of the pavilion had an aviary housing Australian birds and a garden 'with Tasmanian tree ferns over a century old and other examples of antipodean plant life'.[50]

The exterior of the pavilion was described in some of the official exposition literature as symbolising 'the union of the several states in the Australian Commonwealth'.[51] Since ardent symbolism was at the heart of all of the fair's architecture and public art, the guidebooks felt compelled to place the Australian contribution into the organic scheme so sought after by the exposition's planners. While some Australian accounts suggested that the building might 'symbolise the industrial cohesion of the six Australian States',[52] others were floridly descriptive:

Mr. Oakeshott devoted especial attention to the designing of the tower, which is quadrangular and gracefully massive in effect. From its base to the top of its flagpole there is a height of 120 feet, and two observation platforms at different elevations are approached by a winding

staircase. In the high ceiling of the entrance are set five electroplated stars, representing the Southern Cross emblem of Australia, which are arranged so that they will constantly tremble and twinkle.[53]

Most descriptions of the Australian architectural contribution dwelt on more pragmatic matters. Describing the pavilion for *Building* readers, Taylor pointed to the products used in its manufacture—American products available for Australian builders through agents in Sydney: 'The Australian Building at the Panama Exposition is lined throughout with grained Amiwud … The Australian representatives of Amiwud are the Paraffine Paint Company.'[54] This company was the same San Francisco-based firm that sold Malthoid roofing for Californian and Australian suburban bungalows, and one that Taylor and others promoted so avidly in the pages of Australian trade journals. These commercial ties were the real impetus for most fair participants; certainly the majority of Australian exhibitors and planners were more interested in the economic possibilities offered by international exhibitions than in any artistic resonances. Still, this display of products, filled with printed emblems of nationality and place, encouraged a visual template of the land called Australia for all who came to the San Francisco Fair. The displays represent another important example of the power of itinerancy—in this case, the self-consciously grand itinerancy of a world's fair—to affect aesthetic change and to disperse a particular iconography of place to the visitors.

Commissioner Alfred Deakin and his wife departed Australia for Vancouver on board the Oceanic Line's *Sonoma* on 16 January 1915, arriving in early February. They were in San Francisco for the exposition's opening day ceremonies on 18 February. The event was, according to Deakin's diary entry, 'imperfectly managed'—he was not seated properly on the grandstand.[55] Aside from this 'confusion', for which exposition President Moore immediately sent a letter of apology,[56] Deakin had a pleasant time on this trip to California. Signs of his deteriorating mental faculties occasionally surface in his diary entries, but the chance to see old friends and to examine progress made in the Californian cities and landscapes that he had not seen in 30 years encouraged him to continue. At the fairgrounds on 24 February, he met with his old friend George Chaffey (1848–1932), whom he had not seen since the Canadian had left Australia in the 1890s. Chaffey was by this time immersed in his development of the Ontario colony in Southern California.[57] When the Deakins visited Los Angeles in April—their favourite part of the trip—they toured the region with Chaffey while staying in Pasadena, and met him again when back in San Francisco in May.[58] Deakin gave the opening speech for the dedication of the Australian Pavilion on 10 March, in a ceremony attended by California's Governor Hiram Walker and San Francisco's Mayor James Rolph. Music for the occasion was provided by the Young Australia League Band, then touring California from Western Australia, and Saltbush Bill gave a performance of boomerang throwing.

Deakin's most exciting moment while in San Francisco occurred when he was awarded an honorary degree from the University of California in Berkeley in a presentation at the university's Greek Theatre on 12 May. The day before the ceremony, he had travelled to Stanford University in Palo Alto, where he was shown the campus's 'fine buildings' by Stanford's famous President, David Starr Jordan (1851–1931) and Payson Jackson Treat (1879–1972), already a well-known scholar of Asia and Australasia teaching at the university. In San Francisco he met with the artist Ernest Peixotto (1869–1940), the

newspaperman M. H. De Young, and 'Mrs Hearst', probably Phoebe Apperson Hearst (1842–1919), benefactor of the University of California and mother of newspaper magnate William Randolph Hearst. In Los Angeles in April, he attended a 'splendid' baseball game with San Francisco's Mayor Rolph and spent several days touring through Yosemite on the way back to the exposition at the end of the month.[59] He met with Dr Jordan again in early June, just before he left for Vancouver and the ship back to Australia. He was back in Melbourne by early July.

This was his last trip abroad; he spent the last four years of his life in worsening mental health. His writings about the San Francisco Exposition nonetheless give a good sense of how impressed he was with the whole undertaking, and proud that Australia, in its 'small but artistic building', was able to present a positive picture of the country and its achievements as the world's youngest nation. Of the exposition's grand ambitions expressed in its architectural extravagances, Deakin said, 'If the riches of the earth as a whole have ever been summarised pictorially anywhere it is here. If the full extent of man's genius or his grasp of practical and commercial matters have ever been graphically figured it has been in and by this Exposition.'[60] While the realities of the fair's enduring aesthetic impact may not have justified such hyperbolic speech, Deakin's sentiments epitomise the most optimistic of feelings about the shared destinies of the United States and Australia at this critical moment during World War I.

In the end, some concrete, practical, effects did result from the presence of Australians at the Californian Expositions. One of the most ambitious product displays at the San Francisco fair appeared in the exposition's South Gardens: the erection of 'The Home of Redwood' by The California Redwood Association—the same organisation that

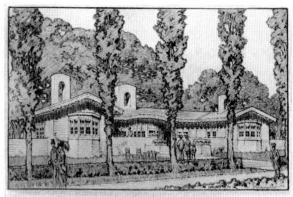

ARCHITECT'S PRELIMINARY SKETCH OF HOME OF REDWOOD

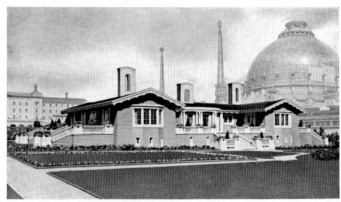

THE HOME OF REDWOOD COMPLETED—EAST VIEW

provided Sydney developer Richard Stanton with his Redwood bungalow and that opened offices in Sydney in 1916.[61] While there is so far no evidence that Stanton personally attended the exposition in San Francisco to see the exhibition house before he purchased and erected his own model home in Rosebery, he may have been inspired by the Redwood Association's advertisements for the project to contact them to arrange for a similar building to be sent to Australia as a prefabricated structure. He may also have contacted the association while in America in 1913. A comparison of the two buildings' designs show striking similarities in form if not scale, and were constructed of similar materials made by the same companies.

Fig. 5.09 'Home of the Redwood', exhibition home at the Panama–Pacific international exposition, brochure. Courtesy of the Alice Phelan Sullivan Library at The Society of California Pioneers, San Francisco.

On a smaller, less ostentatious level, then, the architecture on view at the San Francisco Exposition of 1915 influenced directly the evolution of a suburban architectural style across the ocean—or at least manifested similar intentions and aesthetic directions.

While such relatively modest architectural displays were discussed in Taylor's *Building* and other Australian journals, the grandiose architectural fantasies of the PPIE's main buildings, with their vaguely Orientalist–Romanesque–Moorish cast and 'ancient' effects, were also not lost on Australian commentators. They wrote with approval of the much-touted colour schemes of the fair's designer, the artist Jules Guerin (1866–1946), and the wildly successful modulations created by night-time electrical illumination. Under the title 'A magic city of temples', George Taylor wrote:

> This artificial impress of time was everywhere. Nothing seemed new and garish. Even the material of the building was not that glaring white plaster distinctive of Expositions of the past, but an ivory-yellow toned hydraulic lime trowelled to represent the streaked laminations of old travertine lime stone. That ivory tone was the base for the play of the whole of the color glories of Master Artist Jules Guerin's palette.[62]

All these brightly coloured confections succeeded as lofty, if ambiguous, metaphors both of exotic empires and Anglo–Saxon ideals to which California was meant to aspire. Grey Brechin called the exposition a 'make-believe imperial city' and 'a brief realization of the Byzantine myth'.[63] Their artistic and architectural impact on subsequent styles in California, however, was not groundbreaking. Some of the exposition's conceptions of city planning—in terms of the grouping of public buildings, parks and sculptural monuments—did have some impact on California towns and cities, such as the project for the Pasadena civic

centre built in the 1920s; but its architectural fantasies were too grandly phantasmagoric to have much practical application (see Fig. 7.13 on page 308). The aggressively imperialist attitudes of the exposition planners, moreover, became immediately problematic given the real tragedies of the war then being fought in Europe.[64]

The exposition organisers were certainly not aspiring to be avant-garde. One need only read what the fair's critics thought of the Italian contingent's exhibition of Futurist art to see how far they were removed from any modernist aspirations. Ironically, the Australian Francis McComas, then firmly ensconced in the Bay Area's artistic life, was highly praised as one of 'fifteen distinguished American artists' and received medals, while the Italian Futurist Umberto Boccioni's *Dynamism of a footballer* (1913) hardly received a mention in any of the official documents or reviews of the fine arts section.[65] John Barry, who wrote the most thoughtful review of the exposition's art exhibits, was willing to recognise the 'revolutionary' qualities of the Futurists' work on display, describing Boccioni's *Dynamism of a footballer* as 'sheets of beautifully colored tin, massed together'. But, he goes on to say, 'whether the force that is represented here is mere eccentricity and wildness, or whether it is going to open new avenues to the artists of the future is a big question'. Of McComas, Barry writes, '[t]hough McComas was born in Australia, he is now accepted as a Californian on account of his long residence in or near San Francisco, and on account of his talent for painting Californian scenes'.[66] In the end, the officially approved artworks as well as the modified Beaux-Arts buildings were so overladen with exotic emblems of Empire that they were ill-suited for models of realistic modern artworks or structures—nor were they meant to be.

Ironically, the majority of sites, always

intended as temporary constructions, were summarily demolished at the end of the exposition, while the most 'transitory' architectural symbol at the fair, Bernard Maybeck's Palace of Fine Arts, survived the ball and hammer. Maybeck himself, ever the eccentric, was both pleased for the attention—it 'marked the beginning of a second career'[67] for him designing larger public buildings—and bemused by the fact of the palace's survival. Rife with allusions to melancholy and sentimental elegy, the building was, even more than the structures of fake travertine, intended to evoke the mood of crumbling ruins, which by the 1920s it had become.[68] Maybeck's model for the Palace of Fine Arts was the German conception of *Einfühlung*, aesthetic empathy; his design for the building mirrors the structure in the German artist Arnold Böcklin's popular painting, *The isle of the dead* (1880), which at that time was one of the most prodigiously reproduced paintings in the world.[69]

Temporary structures seemed to be a leitmotif for Maybeck at this time, a fact he expounded upon in person to the Australian representatives at the fair. The architect had been one of many to submit plans for the competition to build Canberra, but he lost out to the Griffins.[70] He continued nonetheless to voice his opinions that the Australian capital should initially consist of buildings meant to last only 25 years. While the San Francisco Fair was going on, a baffled officer at the Australian Pavilion's information desk received a handwritten note from Maybeck addressed to Mr Deakin, which he dutifully if sceptically passed on to the commissioner. Maybeck had joined Mrs Deakin while she strolled through the Australian Pavilion with Mrs Hearst and, emboldened by their conversation about the Australian landscape, felt compelled to submit his ideas about the planned capital directly to Australian representatives. The architect continued this campaign more officially for

several months, sending letters to the parliament and to Walter Burley Griffin himself: 'The way is to make a temporary Capital in the same way that we build a [*sic*] exposition only a little more permanently using cement instead of lime for plaster.' His reasons for this suggestion were that 'Australia is not ready for any great permanent art achievements & it will not be ready for a generation or two'.[71] Griffin's response to these suggestions was understandably cool.

Deakin, on the other hand, made Maybeck's suggestions known to the press. An article in Sydney's *Daily Telegraph* in September 1915, where Maybeck was oddly referred to as 'an American expert in town-planning', seriously considered the architect's suggestions. The newspaper's writer determined that Australia,

'where stability is highly valued', was not the place for such experimentation: 'The mushroom city does not represent an inspiring ideal, and it is out of harmony with the deepest instincts of human nature.'[72] That Maybeck, the most eccentric of the good California architects, should have expressed such interest in the architectural future of Australia gives a good idea of the natural affinity between Californian and Australian practitioners in the first decades of the twentieth century.

Given the tremendous ballyhoo that accompanied the San Francisco exhibition, one can easily overlook that the San Diego Panama–California Exposition taking place at the same time, and for a substantially longer run, actually made a much more significant and lasting mark on California's architectural landscape. Deakin, who attended the southern fair briefly and was given an official reception, summed up many people's experience in his diary note that 'San Diego … far finer in design than expected'.[73] Its architecture was more cognisant of the aesthetic predilections that would inform the state's builders in the next decade—the styles that would have an impact on Australian tastemakers as well. In the same pamphlet that had so effusively described the intentions for the San Francisco Fair, organisers explained the vision for the San Diego event:

> An opportunity to learn of the American Southwest will be presented through the Panama-California Exposition at San Diego in 1915. Rapid progress has already been made upon the Panama-California Exposition, which will be devoted to a demonstration of irrigation, cultivation and reforestation of arid lands, and of the development and resources of the great Southwest, and to such exhibition illustrative of the lives and the tribal history of the various Indian tribes and natives of the United States and of Central and South America as would

arrest at once the attention and the interest of ethnologists the world over in a race that is fast passing away. Such an exhibition of Indian life has never been successfully attempted in the world's history. It is proposed to make it as complete at the San Diego Exposition as to cover all that is possible to learn of the Indian and his life and manners.

San Diego's aims, then, were clearly defined as related to local ethnographic display, culture and art, a fact that gave the planners a more pragmatic set of symbols and forms with which to express their ideal California. Architecturally, the logical historic mode to employ was Spanish Revival, that is, Spanish Colonial building as it appeared in Mexico and the American south-west. The south-western emphasis, which was at the heart of the earliest planning, allowed fair designers to consider an interpretation of Pueblo Indian structures as well, although this aspect was eventually overwhelmed by the Spanish Colonial intricacies of the main buildings. The significance of the structures to the fair's organisers was in any case paramount: as Phoebe Kropp has written, '[i]t would carry the weight of booster visions for the city and determine how residents and tourists saw it—in a romantic Spanish light rather than in political terms'.[74]

The seriousness with which this ethnographic opportunity was greeted is evident when one learns that the Archaeological Institute of America, at the time the leading scholarly organisation studying south-western anthropology and culture, saw fit to publish in their series of papers a thorough discussion of 'Architecture of the exposition', written by Edgar L. Hewett and William Templeton Johnson.[75] Hewett (1865–1946) was the director of the School of American Archaeology and Museum of New Mexico, and a leading figure in the preservation of the archaeological sites of the south-west.[76] Upon

learning of the fair's intentions to highlight south-western culture, and with the coaxing of the exposition's flamboyant director, 'Colonel' D. Charles Collier (1871–1934), Hewett became intrigued enough with the possibilities for educating the public at the event that he agreed to be the Director of Exhibits for the entire exposition. Hewett's participation led the state of New Mexico to set up the largest of the state exhibits, creating on the fairgrounds in Balboa Park an astoundingly accurate replica of the mission church of San Esteban del Rey at Acoma—one of the most extraordinary structures ever built for any exhibition. As the online history of the exposition puts it: 'Whatever he did, Hewett's main motive was to promote the Indians as Indians in lands given to them by spiritual powers to whom they were inextricably bound.'[77] When President Teddy Roosevelt addressed the fair's visitors on 27 July 1915, he singled out the New Mexico building for special comment:

> I feel you are doing an immense amount from an educational standpoint for the United States in the way you are developing the old California architecture and the architecture of the Presidio, and I want especially to congratulate New Mexico on having adopted and developed the American form of architecture.[78]

The other author of the article, Johnson (1877–1957), was a San Diego architect who, already interested in Spanish Colonial structures before the exposition took place, became Hewett's assistant at the exposition; he would later build some of the best-known of San Diego's Spanish Revival buildings.[79]

The tone of the exhibition, then, was set at a high level of ethnographic and historicist fidelity from the start. As The California Building at the Chicago Exposition demonstrates, an interest in Mission Style, Mediterranean and Spanish Colonial architecture was already strongly 'in

the air' in California and elsewhere throughout the country years before the 1915 fair. The prevalence of these modes in current architectural circles nonetheless coincided with the desires of the organisers to highlight through the fair's buildings that San Diego was the first American port of call directly to the north of the Panama Canal and Latin America.

At the time that plans for the exposition began in 1909, the small city of San Diego—its population in 1910 was under 40,000—had very few prominent architects. The visionary Irving Gill (1870–1936) had arrived on the California coast from Chicago in 1893, immediately following the world's fair there, after working in the offices of Adler and Sullivan. Gill was steeped in Arts & Crafts philosophy—his work was often the subject of articles in *The Craftsman* and he wrote many articles for the magazine himself. He had already built with his partner William Hebbard (1863–1930)[80] an exquisite Arts & Crafts home in San Diego for George W. Marston (1850–1946), one of the city's leading citizens and a major force behind the organisation of the exposition. Further, Gill had come into the circle of Charles Lummis and the Landmarks Club in 1900, when he and partner Hebbard had worked on restoration of the ruins of the Mission San Diego. For Gill, Mission architecture was a revelation, leading him to increasingly unornamented simplicity and geometric severity in his work—work that would later, in retrospect, place him at the pinnacle of the California modernist movement.

Irving Gill in 1910 would have seemed the logical choice to be the designer of San Diego's first international fair. When the exposition committee appointed the great Boston landscape architectural firm, the Olmsted Brothers, to lay out the fairgrounds, Gill was still assumed to be the organisers' preference to design the buildings.[81] Tradition has it that Gill was responsible for the design of the event's

first building, the Administration Building, completed in 1912 (although recent research seems to indicate that he had less to do with its construction than previously believed).[82] Word of the exposition's grand architectural ambitions, however, reached other, loftier, personages back East, among them the esteemed New York architect Bertram Grosvenor Goodhue (1869–1924), described as 'the undisputed eclectic synthesist of his generation in America'.[83]

Goodhue's work through his firm Cram, Goodhue & Ferguson had already gained worldwide recognition. Young ambitious architects from all over the world trained in his busy offices. That Sydney architects John

Moore and F. H. Earnest Walker, as well as several other Australians, came to New York to work with him speaks to his prominence as an internationally recognised architectural voice. Despite his frequent concentration on Medievalist and traditional forms and the directions shown in the ecclesiastical work, Goodhue also had a deep and abiding interest in other architectural forms, and most especially in Spanish Colonial styles. He had travelled to Mexico with Sylvester Baxter in 1892 and again in 1899, to measure colonial buildings for subsequent publication in Baxter's 10-volume *Spanish Colonial architecture in Mexico* (1901). These volumes became the leading illustrated resource on the subject for decades and were a major inspiration for his buildings at the San Diego Exposition.

As early as 1902, Goodhue had been able to put into practice some of the lessons of his Mexican experience within a Californian landscape, when his friend James Waldron Gillespie (1866–1954) commissioned him to design a house and gardens in Montecito near Santa Barbara. The house was named El Fureidis, Arabic for 'pleasant place'. Gillespie was as fascinated with Moorish architecture as Hispanic and had sent Goodhue on a study tour to Persia as well as Spain. The house, 'conceived as a Mediterranean villa with white walls and red tile roofs',[84] was praised for its simplicity and scholarly understanding of Hispanic forms. With Gillespie's help, Goodhue had also received a commission to design a cathedral for Havana, Cuba, in 1905.[85]

Given his knowledge of the subject, the ambitious scale of the project and his desire to work in the West again, Goodhue made a vigorous attempt to get the commission when he learned of such an extraordinary opportunity as the Panama–California Exposition to work in a Latin American style. Goodhue wrote to a colleague Elmer Grey (1871–1962), then

Fig. 5.12 Bertram
Goodhue (arch.), The
California Building,
Panama California
international exposition,
San Diego, California,
1915. Author's
photograph.

still working with Pasadena architect Myron Hunt (1868–1952), to speak to the committee on his behalf. Grey and Hunt recommended Goodhue. A letter to Goodhue records Grey's feelings about Gill, describing the local architect's architectural direction as 'dangerous kind of work'.[86] Goodhue had earlier stated his admiration for Gill's approach:

> As for Gill, while I don't, by any means, coincide with all his views, and not at all with his theory that ornament is unnecessary, I do think that he has produced some of the most thoughtful work done in the California of today, and that for the average architect, his theories are far safer to follow than mine, or even perhaps yours.[87]

Gill nonetheless was off the project, and in 1912 moved to Los Angeles to work with the Olmsted Brothers to help in the design of the model city of Torrance.[88]

When Goodhue was appointed by the exposition's Buildings and Grounds Committee in 1911, he brought to California his own assistants from his New York office. While local architects, including Gill, continued to work with Goodhue on the project for a while, the main design and actual work was overseen by Goodhue's site architect Carleton Winslow (1876–1946). (After the fair, Winslow seems to have become a confirmed Californian, setting up practice in Santa Barbara.[89]) While some of the exposition's final buildings, especially those built by concerns other than Goodhue's offices, related to variant styles within the Southwest/Hispanic mode, Goodhue's overall

was planned to remain after the fair closed—epitomises his use of the Mexican style: The California Building, on the north side of the plaza, appears in the form of a Mexican church, complete with a colourfully tiled dome and ornately decorated tower. The facade includes sculptural, nearly overwhelming, ornamentation created in stucco, characteristic of the style throughout Latin America. Goodhue's building, unlike its historical models, was constructed of concrete—a fact that contributed to the plain, massive effect created by the unadorned expanses of the exterior walls.

This expansive element, along with the use of decorative tiles, reminded contemporaries of that other significant influence in Spanish Colonial style—what was then called 'the Moorish'. Eugen Neuhaus (1879–1963), an artist and Professor of Design from the University of California who had already written profusely about the San Francisco Fair, wrote about The California Building in San Diego:

> The colored tile so typical of the Spanish colonial is traceable to the Moors, who were fond of the liberal use of this highly decorative material. Another typical note of Arabic work was their great simple expanses of plain wall surfaces, broken only here and there, as need demanded, but always most picturesquely emphasized by windows, great and small … There is no end to Moorish influence.[90]

The mixing of Islamic elements and Spanish forms that Goodhue had already displayed in El Fureidis informed his most ambitious designs for San Diego as well. Such integration of elaborate, yet superficial, ornamentation on an essentially geometric form with solid, unembellished masses would begin to characterise Goodhue's subsequent work, and marks his transition to a more modernist, even avant-garde, style.

Fig. 5.13 Bertram Goodhue (arch.), The California Building, dome, Panama California international exposition, San Diego, California, 1915. Author's photograph.

design emphasised the most exuberant of the Latin American Baroque styles, the Churrigueresque. Goodhue and Winslow referred to Baxter's volumes for inspiration. In Baxter's pages, they would have found ample illustrations of the richly ornamented church facades and doorways, solomonic curlicue columns and ornate interiors that define the Churrigueresque style. These elements determined the major constructions of the San Diego Fair, several of which were built as permanent structures.

Goodhue's design of one of the main buildings around the central plaza—one that

Other temporary buildings on the fairgrounds, designed and carried out by Winslow, appeared to many, including Goodhue, to carry ornamental elaboration to theatrical extremes: of one of these buildings, Goodhue wrote that it appeared as if it were 'stage scenery'.[91] At the end of the exposition—the event was so popular, in its beautifully landscaped setting, that its run was extended into 1917—the citizens of San Diego overrode Goodhue's hope that the more extravagant temporary structures would be razed. Citizens of the city voted to keep almost all of the buildings that occupied Balboa Park. An article in the San Diego paper in January 1917 captured the feelings of the city planners:

> The gardens with the buildings that count in the picture are to remain and where inharmonious or useless structures are removed, additional landscape features will be installed so that, far from passing, the real exposition will be growing ever more beautiful. That which differentiated San Diego from every other exposition is a living thing, a heritage for the children of today, and not a passing show. Possibly it might be worth the while of those who send abroad the message of the city to emphasize THE LIVING, not the passing of our Exposition.[92]

The exposition grounds, then, with their integration of parkland, landscaped gardens and unified architectural style, became a central part of San Diego's cultural conceptions.

For Southern California—and to a lesser extent, the rest of the state—the fair marked a watershed in regional architectural development. While Spanish Colonial styles—whether in earlier incarnations of Mission Style or less coherently formulated borrowings of Hispanic elements—had been appearing on the West Coast since the 1880s, now, after 1915, Churrigueresque and other earnest evocations of Latin American forms began

to dominate California's architectural directions. For some, this was seen as a derivative catastrophe that hampered the development of a truly modernist architecture on the West Coast. Esther McCoy, the great exponent of California modernism and the earliest champion of Irving Gill, wrote that: '[t]he effects of the Fair were almost immediate. The Churrigueresque style of the buildings, with their concentration on ornament, ushered in a period of cultivation and refinement in which there was little appreciation of Gill's austere simplicity.'[93] Other critics recognised that in many ways, the rampant popularity of the Spanish Revival styles at all levels and in all types of building throughout California in the 1920s actually represented a movement toward an identifiably modern, Pacific architectural style.

David Gebhard, in his groundbreaking article 'The Spanish Colonial Revival in Southern California (1895–1930)', examines this dichotomy. While acknowledging that the Spanish Colonial style as it appeared in Southern California from the time of the San Diego Exposition into the 1920s had little to do with anything that had really been built there in the Spanish period, he asserted that '[f]ew artificially created myths have succeeded in retaining a firm hold for so long and at the same time have been able to maintain a consistently high quality of design'.[94]

The arrival of these Hispanic and Mediterranean styles in Australia was not as immediate or as widespread as was the case in California after 1915, but their appearance by the 1920s in Sydney, Brisbane and Melbourne was certainly evidence of contact with and knowledge of their Californian counterparts. Just as they were in California, these styles were promulgated as appropriate for Australia's Mediterranean climate and for a modern way of living in such a climate.

This step in the process of architectural

exchange between the two coasts is even more intriguing when one considers more closely the other important aspect of the two California exhibitions in that fateful year of 1915: the gardens, the landscaping of the fairgrounds. In their very concentrated efforts at aesthetic and symbolic effects through the planting of the grounds, the directors of landscaping for both San Francisco and San Diego Expositions selected, as the most appropriate accompaniments to the architecture, a substantial number of introduced Australian plants. Central in both sites to their landscape design was the eucalyptus. Why and how this Australian tree came to be associated with a Californian lifestyle—along with the palm tree, and often in conjunction with Spanish Style architecture, a symbol of Pacific modernity—will be the focus of the next chapter.

In its native Australia, the ubiquitous gum tree had already filled a different, if at times ambivalent, aesthetic role. But Australians continued to look throughout the 1920s to the other Pacific coast for its emblems of modernity, emblems which now included their own native tree in its panoply of Californianness. At the same time, reception of Mediterranean modes of building in Australia, filtered through a California lens, represents the second phase of architectural exchange between the Pacific Rim countries, enhanced and complicated by California's appropriation of antipodean flora as its own. These conceptions came to the self-conscious attention of Australia in large part because of their participation in, and the press's coverage of, the California Expositions of 1915.

NOTES

1. William MacDonald, 'The California Expositions', *The Nation*, 21 October 1915; reprinted in *Fifty years of American idealism: The New York Nation, 1865–1915*, Houghton Mifflin, Boston, 1915, pp. 442–54.

2. David Gebhard, 'The Spanish Colonial Revival in Southern California (1895–1930)', *Journal of the Society of Architectural Historians*, vol. 26, no. 2, May 1967, p. 136.

3. Alfred Deakin diaries, in Alfred Deakin Papers, Manuscripts Collection, National Library of Australia, Canberra (MS 1540/2).

4. On the construction of the ANZAC legend through imagery see John Williams, '"Art, war and agrarian myths": Australian reactions to modernism 1913–1931', in Judith Smart and Tony Wood (eds), *An Anzac muster: War and society in Australia and New Zealand 1914–18 and 1939–45*, Monash Publications in History, no. 14, Monash University Press, Melbourne, 1992, pp. 40–57; D. A. Kent, '*The Anzac book* and the Anzac legend: C. E. W. Bean as editor and image-maker', *Historical Studies*, vol. 21, no. 84, April 1985, pp. 376–390; and K. S. Inglis, 'The Anzac tradition', *Meanjin Quarterly*, March 1965, pp. 25–44.

5. For a cultural history of the Panama Canal, see Matthew Parker, *Panama fever: The epic story of one of the greatest achievements of all time—The building of the Panama Canal*, Doubleday, New York, 2008; Alexander Missal, *Seaway to the future: American social visions and the construction of the Panama Canal*, University of Wisconsin Press, Madison, 2008; and Julie Greene, *The canal builders: Making America's Empire at the Panama Canal*, Penguin Press, New York, 2009.

6. On George Collingridge, see the George Collingridge Society, viewed 24 March 2008, <http://gcs.pjf.id.au>; Bertram Stevens, 'George Collingridge', *The Lone Hand,* 1 September 1917, pp. 487–88; and Papers of George Collingridge, Manuscripts Collection, National Library of Australia, Canberra (MS9395).

7. George Collingridge, '"Our" Pacific Ocean', *The Lone Hand*, 1907, p. 115.

8. Frank Morton Todd, *The story of the exposition*, G. P. Putnam's, New York, 1921, vol. 3, p. 251.

9. ibid., p. 248.

10. Quoted in Marjorie M. Dobkin, 'A twenty-five-million-dollar mirage', in Burton Benedict, et al., *The anthropology of world's fairs: San Francisco's Panama Pacific International Exposition of 1915*, The Lowie Museum of Anthropology in association with Scholar Press, London and Berkeley, 1983, p. 73.

11. See Richard W. Amero, 'The making of the Panama–California Exposition 1909–1915', *Journal of San Diego History*, vol. 36, Winter 1990, p. 3.

12. For details of the political process leading to the San

Diego Fair, see Phoebe S. Kropp, 'The fair: Panama–California Exposition and regional ambitions', in her *California vieja: Culture and memory in a modern American place*, University of California Press, Berkeley, 2006, pp. 103–56; and Matthew F. Bokovoy, *The San Diego world's fairs and southwestern memory, 1880–1940*, The University of New Mexico Press, Albuquerque, 2005, pp. 17–79.

13. 'The architecture, sculpture and mural decoration of the fair had been designed and largely executed before August 1914; outwardly, the war modified the Exposition chiefly by limiting the range and scale of European participation.' George Starr, 'Truth unveiled: The Panama Pacific International Exposition and its interpreters', in Benedict, p. 142.

14. Graeme Davison, 'Festivals of nationhood: The international exhibitions', in Samuel Louis Goldberg and Francis Barrymore Smith (eds), *Australian cultural history*, Cambridge University Press, Cambridge, England, 1988, p. 158; reprinted from *Australian Cultural History*, no. 2, 1982–83, p. 5.

15. *Illustrated Australian News*, 27 November 1866, p. 2.

16. ibid., p. 6.

17. ibid., 27 December 1866, p. 8.

18. ibid., 27 February 1867, p. 3.

19. The Garden Palace, designed in four days and erected in eight months, covered nearly two hectares along present-day Macquarie Street. It burned to the ground on 22 September 1882. In the fire were lost some 300 paintings, relics of the Eora, Sydney's Aboriginal tribe, and many records of early convicts. See 'Exhibitions', *Australian encyclopedia*, vol. 3, p. 422-a; and Davison, 'Exhibitions', *Australian Cultural History*, no. 2, 1982–83, pp. 5–21.

20. See 'Exhibitions', *Australian encyclopedia*, pp. 421–22.

21. *Building*, 12 November 1914, p. 63.

22. On the display of people at the world's fairs, see especially 'The anthropology of world's fairs', in Benedict, pp. 43–52.

23. *Official guide to the World's Columbian Exposition in the City of Chicago*, Handbook Edition, The Columbian Guide Company, Chicago, 1893, p. 130.

24. On the design process and competition for The California Building, see Karen J. Weitze, *California's Mission Revival*, pp. 33–43.

25. ibid., p. 51.

26. 'Jos. Ward, Melbourne, fancy novelties—avenue A and Grand' is listed in *The official catalogue of the California Midwinter-International-Exposition San Francisco, California*, 2nd edn, Harvey, Whitcher & Allen, San Francisco, 1894, p. 65.

27. *Illustrated Australian News*, 1 May 1894; viewed 12 August 2006, <http://www.slv.vic.gov.au/miscpics/inter/131465.shtml>.

28. *The official catalogue of the California Midwinter-International-Exposition*, p. 49.

29. From a pamphlet about the PPIE, 1915, viewed 20 August 2006, <http://www.books–about–california.com/Pages/SF_Promote_Pan_Pacific/SF_Promotional_Brochure.html>.

30. *Building*, 12 June 1913, p. 17.

31. Taylor recounts his meeting with M. H. De Young, Editor of the *San Francisco Chronicle*: '"We object to being called "Frisco"', said Managing Editor de Young … The Master Builder [Taylor] couldn't see the reason for any objection. It was fitting that in America, the land of abbreviated spelling, where "through" is spelt "thro" … that the great mouthful of syllables San-Fran-cis-co could reasonably be cut to two. "Besides", he explained, "when the frisky and hilarious pageant of prosperity comes around here in 1915 the word 'Frisk-o' will fit your city like a sausage skin." He escaped with his life.' *Building*, 12 February 1915, p. 103.

32. J. H. Roberts, 'Through Australian eyes—'Frisco', *Building*, 12 February 1914, pp. 35–43. On the Portola celebrations and its imagery, see *West Coast expositions and galas*, Keepsake Series, folder no. 6, Book Club of California, San Francisco, 1970.

33. 'The 'Frisco exhibition: Walter Burley Griffin tells of a remarkable feature', *Building*, 12 February 1914, pp. 165–66.

34. See especially his entries in *Building* issues for 12 January and 12 February 1915.

35. *Building*, 12 March 1915, p. 106.

36. Cablegram to President Moore, PPIE, San Francisco, 6 February 1914. In Deakin Papers, Manuscripts Collection, National Library of Australia (MS1540, item no. 1540/17/1).

37. A letter to Deakin from a frequent traveller to America in Brisbane advises him to travel to America aboard the Oceanic Line: 'Another strong point about this line is you are under the U.S.A. flag thus doing away with the possibility of receiving too much attention from those German Cruisers that are still at large in the Pacific.' James A. Robertson, letter to Alfred Deakin, Brisbane, 13 October 1914, Deakin Papers (MS 1540/17/38).

38. 24 February 1915, Deakin Papers (1540/2/34-36).

39. On Deakin and the Chaffey Brothers in Victoria and

California, see Tyrrell, 'Dreams and ditches: Deakin, Australian irrigation, and the Californian model' and 'Transplanting garden landscapes: The Chaffey ventures and their aftermath', in *True gardens of the gods*, pp. 121–40 and 141–53.

40. A cable sent to Deakin from Niels Nielsen, Trade Commissioner in San Francisco who would be the primary Australian Commissioner for the fair, read in part, 'Urge government send flagship Australia and one each of other types also military unit for opening exposition other participating nations sending fleet & military units.' c. 20 March 1914, Deakin Papers (MS1540, item no. 1540/17/14).

41. The wallabies were taken by Saltbush Bill for his act once the fair closed. C. K. Harrison, Assistant to Australian Commission to the PPIE, letter to Deakin, 6 October 1915, p. 2. Deakin Papers (1540/17/294).

42. Deakin Papers (1540/17/405).

43. Ben Macomber, *The jewel city*, John H. Williams, San Francisco and Tacoma, 1915, p. 155.

44. 'The moving pictures each afternoon from 4 to 5 pm are quite an attraction. We officers give a little talk while the pictures are going through.' C. K. Harrison, letter to Deakin, 28 August 1915. Deakin Papers, Manuscripts Collection, National Library of Australia (1540/17/282).

45. In his final report about Australian representation at the exposition, Deakin wrote to the then Prime Minister Fisher: 'The Australian Pavilion, designed and erected under the supervision of Mr. G. J. Oakeshott, Works Director of N.S.W. in the Home Affairs Department, is admittedly one of the most ornate and striking among the many beautiful edifices in the Grounds. The space for exhibits in the Building covers 15,000 square feet.' Report from Deakin to Andrew Fisher on 'Australia's representation at the Panama–Pacific Exposition, San Francisco 1915'. Deakin Papers (MS1540/17/242-243).

46. Deakin Papers (MS1540/17/159-60).

47. Todd, vol. 3, p. 251.

48. 'The Australian Building at the Panama Exposition', *Adelaide Register*, 23 February 1915.

49. *Argus*, 12 March 1915, clipping in Deakin Papers (MS1540/17/632).

50. Todd, p. 248.

51. Macomber, p. 148.

52. 'The Australian Building', *Adelaide Register*, 23 February 1915.

53. 'The Australian Building', *Adelaide Register*, 23 February 1915.

54. *Building*, 12 February 1915, p. 126.

55. Deakin Papers (MS1540/2/34-36).

56. Moore, letter to Deakin, 23 February 1915. Deakin Papers (MS1540/17/126).

57. For the fascinating tale of Chaffey's life and times in Australia, see J. A. Alexander, *The life of George Chaffey: A story of irrigation beginnings in California and Australia*, Macmillan, London and Melbourne, 1928; and Peter Westcott, 'Chaffey, George (1848–1932)', *ADB*, vol. 7, pp. 599–601.

58. See Deakin's diary entries for April 1915, in Deakin Papers (MS1540/17/2).

59. All of the details of Deakin's trip are taken from his diaries in Deakin Papers (MS1540/2).

60. Speech for opening of the Australian Pavilion, PPIE, San Francisco, typescript, 10 March 1915. Deakin Papers (MS 1540/17/466).

61. Louis Christian Mullgardt, *The home of Redwood erected in the South Gardens of the Panama–Pacific International Exposition San Francisco 1915*. Collection of Alice Phelan Sullivan Library at The Society of California Pioneers, San Francisco (CO43924/B001025).

62. 'Chapter XXI. A Magic City of Temples', from *There! Being the American adventures of three Australians during the period of the Great European War*, first printed in *Building*, 12 March 1915, p. 97.

63. Grey Brechin, 'Sailing to Byzantium: The architecture of the fair', in Benedict, pp. 104, 105.

64. See again Brechin's article, which talks of the 'emblems of aggression and oppression that permeated the fair', ibid., p. 108.

65. John D. Barry, *The Palace of Fine Arts & the French and Italian Pavilions*, Taylor & Taylor, San Francisco, 1915, pp. 54, 64.

66. McComas still communicated his successes to Australian artistic circles; a reprint of an article about the artist in the San Francisco *Bulletin* by Porter Garnett (here called Peter Garnett) appeared in *Salon*, vol. 6, no. 5, June 1916, p. 105.

67. Brechin, 'Sailing to Byzantium', p. 109.

68. The Maybeck Foundation of The City of San Francisco's Parks and Recreation Department has recently launched the 'Campaign for the Palace of Fine Arts 2009' to fund the restoration of the structure, now once again in disrepair. Minimum donation is $1,000. Viewed 7 March 2008, <http://www.lovethepalace.org>.

69. See Keith L. Eggener, 'Maybeck's melancholy: Architecture, empathy, empire, and mental illness at the 1915 Panama–Pacific International Exposition',

Winterthur Portfolio, vol. 29, no. 4, Winter 1994, pp. 211–26.

70. Maybeck's entry survives in the Maps Collection (under Australia. Dept. of Home Affairs. Federal Capital Design Competition plan. Competitor no. 47, Bernard R. Maybeck, M. H. White, and Charles Gilman Hyde. Plan of contour survey of the site for the Federal Capital of Australia. Melbourne: Department of Home Affairs, 1912). National Library of Australia, Canberra (record ID: 445200, MAP G8984.C3S1 FCDC no. 47 1912).

71. Handwritten manuscript, Deakin Papers (MS1540/17/422).

72. *Daily Telegraph*, Sydney, 27 September 1915. Deakin Papers (MS1540/17/562). Interestingly, Canberra did in the end build a 'temporary' parliament building, albeit one that performed its function for 60 years and is still in use as a museum today.

73. Deakin diary entry, 17 April 1915, Deakin Papers (MS 1540/2).

74. Kropp, p. 116.

75. Edgar L. Hewett and William Templeton Johnson, 'Architecture of the exposition', *Papers of the School of American Archaeology*, Archaeological Institute of America, no. 32, Washington, D.C. [?], 1916.

76. 'During one of those public displays, the Panama–California Exposition of 1915, Hewett encouraged the building of the New Mexico state building to represent the mission church at Acoma Pueblo. In 1917, the New Mexico building modelled for the Museum of Fine Arts in Santa Fe. The Museum of Fine Arts, along with the Palace of the Governors in Santa Fe, provided a template for the Santa Fe Style, a regional architectural style.' Jeffery Allen Thomas, 'Promoting the Southwest: Edgar L. Hewett, Anthropology, Archaeology, and the Santa Fe Style', PhD thesis, Texas Tech University, Lubbock, 1999, abstract, viewed 14 November 2006, <http://www.lib.univ.com/dissertations/fullcit/9925619>. .

77. See 'The History of the Panama–California Exposition', San Diego Historical Society, viewed 4 November 2006, <http://www.sandiegohistory.org/pancal/sdexpo39.htm>.

78. ibid., viewed 4 November 2006, <http://www.sandiegohistory.org/pancal/sdexpo35.htm>.

79. On Johnson, see Sarah J. Schaffer, 'A civic architect for San Diego: The work of William Templeton Johnson', *The Journal of San Diego History*, vol. 45, no. 3, Summer 1999, pp. 166–87. Also viewed 4 November 2006, <http://www.sandiegohistory.org/journal/99summer/johnson.htm>.

80. On Hebbard, see Kathleen Flanigan, 'William Sterling Hebbard: Consummate San Diego architect', *Journal of San Diego History*, vol. 33, no. 1, Winter 1987, pp. 1–35; and Bruce Kamerling, 'Hebbard & Gill, architects', *Journal of San Diego History,* vol. 36, 1990, pp. 106–29.

81. The Olmsteds withdrew their services for the fair in September 1911. They were insistent that the fair buildings be kept at the edge of Balboa Park, so that the centre gave 'the illusion of wilderness'. When the organisers shifted this location, they felt they could not continue to implement their design. See Richard Oliver, *Bertram Grosvenor Goodhue*, MIT Press, Cambridge, Massachusetts, 1983, p. 110.

82. See Richard Amero, History of the Administration Building in Balboa Park, San Diego Historical Society, viewed 3 November 2006, <http://www.sandiegohistory.org/bpbuildings/admin.htm> and <http://www.sandiegohistory.org/amero/notes–1917.htm>. Other Gill scholars disagree with this assessment; see, for example, Thomas Hines, *Irving Gill and the architecture of reform*, The Monacelli Press, New York, 2000, p. 180.

83. Oliver, *Bertram Grosvenor Goodhue*, introduction, n.p.

84. ibid., p. 40. For a contemporary account of the house, see also 'El Fuereidas', *Sunset*, vol. xxxii, pp. 1060–63.

85. See Romy Wylie, *Bertram Goodhue: His life and residential architecture*, W. W. Norton, New York, 2007, p. 74.

86. Elmer Grey, letter to Bertram Goodhue, 4 January 1915, in Goodhue Papers, Avery Architectural and Fine Arts Library, Columbia University, New York, New York. Quoted in Bruce Kamerling, *Irving Gill, architect*, San Diego Historical Society, San Diego, 1993, p. 90.

87. Goodhue, letter to Elmer Grey, 29 December 1914; quoted in Esther McCoy, *Five California architects*, Praeger, New York, 1975, p. 90.

88. On Irving Gill and the Torrance project, see Walter Willard, 'Moving the factory back to the land', *Sunset*, March 1913, pp. 299–304; and Kamerling, *Irving Gill*, pp. 88, 92–93.

89. On Winslow, see the entry under 'San Diego Biographies', San Diego Historical Society, viewed 4 November 2006, <http://www.sandiegohistory.org/bio/winslow/winslow.htm>. Winslow worked on subsequent California projects for Goodhue and set up his own practice in Santa Barbara. He also illustrated a delightful book by an enthusiastic 'New

Californian' named Julia M. Sloane, a transplanted Easterner now living on a San Diego hillside. See Julia M. Sloane, *The smiling hilltop, and other California sketches*, Scribner's, New York, 1919. Winslow's records and papers are now in the Architecture and Design Collection, University Art Museum, University of California, Santa Barbara, California.

90. Eugen Neuhaus, *The San Diego Garden Fair: Personal impressions of the architecture, sculpture, horticulture, color scheme & other aesthetic aspects of the Panama–California International Exposition*, Paul Elder, San Francisco, 1916, pp. 18–19. On Neuhaus, see also Scott Shields, *Artists at continent's end: The Monterey Peninsula Art Colony, 1875–1907*, University of California Press, Berkeley, 2006, pp. 248–252.

91. Oliver, *Bertram Grosvenor Goodhue*, p. 112.

92. 'California Garden. The real exposition still lives', [*San Diego Union*], January 1917, cited in Richard Amero, 'Balboa Park Notes', Balboa Park History Project, San Diego Historical Society, Richard Amero Collection, viewed 10 March 2008, <http://www.sandiegohistory.org/amero/notesa.htm>.

93. McCoy, *Five California architects*, p. 90.

94. David Gebhard, 'The Spanish Colonial Revival in Southern California', pp. 131–47.

1920s: Eucalypts and Spanish Style architecture

*How they revelled in the perfume of the euca-
lyptus and the boronias!
How they chortled at the fine old gums away in
the heart of the park, left wild, and so having
a chance of showing what they can do when
they're free! And what an appropriate name
for that Australian-made park—The Golden
Gate!*
—George Taylor, 'Art and architecture at the San
Francisco exposition', *Building*, 1915.[1]

~

*The eucalyptus, as here employed, does not
appear in its quality of 'foreign missionary',
as an absorber of miasma, a healer of disease.
It is used purely as an agent of decoration,
to break the monotony of the view, which …
is the greatest evil threatening the landscape
gardener.*
—Gustav Stickley, 'Nature and art in California',
The Craftsman, 1904.[2]

~

*Once the Mission and Spanish notions had
caught on, builders discovered what Herbert
Croly had pointed out, that 'Southern
California is a country in which almost any
kind of house is practical and almost any kind
of plant will grow.*
—Carey McWilliams, *Southern California
country: An island on the land*, 1946.[3]

~

*Live on an adobe hill: It is a most enchant-
ing spot. A red-tiled bungalow is built about
a courtyard with cloisters and a fountain,
while vines and flowers fill the air with the
most delicious perfume of heliotrope, mignon-
ette, and jasmine. Beyond the big living-room
extends a terrace with boxes of deep and pale
pink geraniums against a blue sea, that might
be the Bay of Naples, except that Vesuvius is
lacking. It is so lovely that after three years
it still seems like a dream. We are only one
short look from the Pacific Ocean, that ocean
into whose mists the sun sets in flaming purple
and gold, or the more soft tones of shimmer-
ing gray and shell-pink. We sit on our terrace
feeling as if we were in a proscenium box on
the edge of the world, and watch ever-varying
splendor.*
—Julia M. Sloane, *The smiling hilltop*, 1919.[4]

In 1928, the Southern Californian embrace
of Spanish Style architecture that had
begun to take strong hold at the San Diego
Panama–California Exposition in 1915 was
in full swing. At the same time, the over-
lathered boosterism aimed at bringing people
to the state to enjoy a sunny Californian
lifestyle reached its most optimistic stride.
By this time, more than a decade after the
watershed expositions in San Francisco and
San Diego, the stylistic elements denoted as
'Spanish' were applied democratically across
the entire spectrum of building. The architects
hired by Hollywood stars and rich eastern

Fig. 6.01 Rancho Santa Fe, advertisement, *Touring Topics*, July 1928. Permission of The Automobile Club of Southern California Archives. Photograph: courtesy of The Huntington Library, San Marino, California.

and Midwestern transplants to the state built sumptuous Mediterranean mansions and gardens for their clients, while the most humble of building contractors incorporated the same ornamentation and design touches in thousands of 'model homes' placed neatly— and quickly—on quarter-acre lots in housing developments throughout the region.

In that same year, *Touring Topics*, the official magazine of The Automobile Club of Southern California, included in their July issue a full-page advertisement for one of the latest prestigious housing communities, Rancho Santa Fe, then being constructed in northern San Diego County.[5] The advertisement announced across the top of the page,

'Why Rancho Santa Fe is a Tremendous Success', and depicted a few of the buildings already constructed on the estate. 'Even structures which serve the most utilitarian purposes are made to conform to the prevailing Spanish theme of architecture', stated the caption under the picture of the pump-house on the so-called 'Fairbanks–Pickford estate'.[6] Another photo of a building for the project's civic centre was described as 'a good example of how commercial buildings are made both useful and artistic through the supervision of a qualified art jury at Rancho Santa Fe'. Obviously, this real estate promotion aimed to appeal to a privileged market, and especially to out-of-staters ready to move to California to enjoy a new lifestyle in the sun and in buildings that captured the romance of the state's Spanish past.

As further enticement and to emphasise 'the natural beauty of the setting', the advertisement inserted yet another picturesque photograph, this time of a grove of full-grown eucalypts. Its caption is particularly revealing: 'There are 2000 acres of eucalyptus trees at Rancho Santa Fe, forming many lovely home settings for Easterners who miss the woodland scenes of their home states.' As a means of selling Rancho Santa Fe as a distinctly Californian place, the promoters merged eucalyptus trees with the site's citrus orchards and promised architecturally designed Spanish Style homes and quaint commercial buildings to enhance the natural landscape.

This one page of advertising in a magazine promoting the liberating modernity of automobile tourism in the West highlights a number of issues relevant to the questions of aesthetic exchange between 1920s California and Australia. The pictorial and textual devices presented here relate directly to the construction of the image of California as embodying a new, modern and Edenic way of living that incorporated the outdoors as part of the living spaces. What makes the presentation in such

a promotion of Rancho Santa Fe all the more fascinating is that the main motifs in this image-making—the eucalyptus tree and the Spanish Style home—originated somewhere else. How did this merging of two 'introduced species'—one a tree from Australia, the other a hybridised house form harking back to Old Spain and Mexico—come to be seen as quintessentially Californian? What does this merging of architecture and nature say about the construction of a Pacific Rim aesthetic?

Finally, this page's appearance in the culturally ambitious magazine of The Automobile Club of Southern California points to that other essential ingredient in the implementation of a modern Pacific lifestyle: the freedom of movement provided by the automobile as a desirable and integral aspect of life in the West. Artistic references in the club's magazine *Touring Topics* (renamed *Westways* in 1934) understandably emphasised images of the automobile on the road, located within California's unique natural landscape or parked in front of identifiably Californian scenes. Increasingly, those scenes displayed Spanish Style buildings and/or vegetation indicative of a Mediterranean climate. In these pages, the eucalypt became, along with other imported and native species, one of the iconic emblems of Californianness, a horticultural sign of difference in the West and an important part of the pictorial iconography associated with life on the American Pacific Rim. In this iconographic role, the tree also played a major part in the emergence of ornamental landscape design focused on the idea of California as a semi-tropical paradise.[7]

The exchange of plants between these two Pacific regions is the one area where the flow of exchange is most generously from Australia to California. Trees such as the California redwood and other North American plants did inevitably make it to Australia. The pine tree (*pinus radiata*) was introduced and widely planted throughout the country at about the same time as the eucalypt came to California.[8] But no New World plant or tree was ever planted by Australians as enthusiastically as antipodean flora were adopted in California, nor were they widely used ornamentally as they were on the other side of the Pacific. While not by any means the only Australian plant to be successfully transplanted in Californian soil—the acacia, for one, was also widely planted in Southern California[9]—the eucalypt was by far the most dispersed tree originating in the Southern Hemisphere. By the 1860s, many species of this many-specied genus were planted around the world, touted as a 'fever tree' to combat malaria and admired for its phenomenally rapid growth. The most prolifically planted species in California, the Tasmanian Blue Gum (*Eucalyptus globulus*), can rightfully claim to be the 'world's most widely grown plantation tree'.[10]

The precise date of any eucalypt's first arrival and propagation in California remains unclear, but most accounts assume that the first seeds came with the gold miners in the 1850s.[11] Ian Tyrrell, in his book *True gardens of the gods*, pinpoints the genus's introduction in California most accurately, stating that Dr Hans Hermann Behr (1818–1904), a student of the German geographer Alexander von Humboldt, brought eucalyptus seeds to the state 'sometime before 1853'.[12] Behr had spent three years in Australia in the 1840s, where he became a friend of Ferdinand von Mueller (1825–1896), the great scientist and champion of Australian plant-life and the central figure in the worldwide distribution of eucalypt species.[13] Behr's introduction, however, seems to have been limited to the scientific community; it did not involve widespread propagation of the tree.

The proliferation and dispersal of eucalyptus trees in the state occurred instead among the pioneer nurserymen of California,

a fact commemorated in many articles by California horticulturist H. M. Butterfield. Butterfield's first article on the topic in 1935 appeared at an early enough date that some of those pioneer trees were still living and a few people remembered when they were planted.[14] Butterfield credited William C. Walker of the Golden Gate Nursery in San Francisco with the first advertised sales of eucalyptus seed and seedlings in California. Walker advertised eucalypts for sale in the trade magazine *The California farmer* in 1857 and his *Catalogue of the Golden Gate Nursery* for 1858 to 1859 included six species, among them *Eucalyptus globulus* and 'Iron Bark', as available in his nursery.[15]

The nurseryman had received the seeds from M. Guilfoyle in Sydney. Michael Guilfoyle (d. 1884) was a nurseryman and landscape gardener who had emigrated to Sydney from England in 1853, and had introduced several Northern Hemisphere plants to Australia.[16] Butterfield also mentioned the efforts of an Oakland nurseryman Stephen Nolan, whose nursery had been in operation since 1860. An 1871 catalogue by Nolan lists numerous varieties of gum tree costing as little as 25 cents a seedling. Such low prices indicate that by this time propagation of initial seeds had been so successful that numerous varieties and ample numbers of well-established trees made the plants less than rare at nurseries around San Francisco. As Butterfield and others make clear, by the mid-1860s eucalyptus were already growing everywhere throughout the Bay Area, often as windbreaks but also ornamentally in gardens. The author describes in his 1935 article 'notable eucalyptus trees still growing in California', some of them over 100 feet tall.[17] Plantings on the campus of the newly founded University of California, carried out in 1870 by the university's newly appointed Professor of Chemistry and Agriculture, Ezra Slocum Carr (1819–1894), would form the basis for

the famous eucalyptus groves that still inhabit the campus and surrounding hills (see Fig. 6.02 on page 217). That Carr, and most especially his wife, Jeanne C. Carr, would later play an important role in the horticultural development of Southern California speaks to the wide-open opportunities California provided in the nineteenth century for ambitious horticulturists. They were working, in many ways, with a clean slate in terms of the aesthetic shaping of the state's image as a gardener's paradise.[18]

The initial reason for the popularity of the eucalypt in California was a functional one: the state was deficient in usable trees for firewood, timber and windbreaks.[19] Californians were rightfully proud of their Giant Trees, the redwoods and sequoias already touted internationally as the world's largest trees and used as a symbol of the state since the 1850s. (As early as the 1860s, as Tim Bonyhady points out in his book *The colonial earth*, fierce competition for visual evidence about who could claim the world's tallest tree led to a new photographic genre pitting images of the redwood against those of Gippsland's giant eucalypts.[20]) But great supplies of other timber-producing species did not exist in the semi-arid regions of the state where most people were settling. In 1874, Professor Carr at Berkeley explained the necessity for this Australian import on such grounds:

> Happily for us, Australia has given us trees, of marvellous strength, durability, and rapidity of growth, in the eucalyptus or sweet gum family, of which not less than thirty-five useful and ornamental species are now acclimated. Trees are indispensable to break the force of the northers, those destructive winds which are the dread of farmers in the Great Valley.[21]

Such practical arguments explain the alacrity with which the acclimatisation of introduced plants, and especially trees, became a valid

pursuit in the late nineteenth century in Australia as well as in California. Sometimes called assimilation or naturalisation, acclimatisation was seen as the solution to California's lack of wooded vegetation. In Australia at the same time, acclimatisation societies were just as assiduously introducing all the plant species of the Old World, considered by settlers an essential step in making the country appear more like the home culture of England and therefore habitable. In this colonial attitude, Australian trees, of which eucalyptus species provided the overwhelming majority, appeared as too strangely shaped and coloured to be anything but alien to the early colonists. The aesthetic aversion to the gum tree by Australia's early settlers, then, grew out of its 'foreign' appearance to English eyes seeking to establish a Western culture in an unusual landscape. As Bonyhady writes of the early colonists' reactions to eucalypts, '[f]ar from delighting in their difference, colonists and visitors judged them against an English standard and found them wanting in ever more extravagant terms'.[22]

To early Anglo settlers in California, the barren hills of the region were just as alienating. These settlers were as driven to vegetate the landscape as the Australians were to making their places appear horticulturally familiar. In many ways, this urge to vegetate was driven by aesthetic sentiments. Californians needed to introduce tree species that would grow quickly in its semi-tropical climate. In that context, the eucalypt was no more foreign than any of the other trees that could be introduced—in fact, less so, because it originated in a climate very similar to California's. 'Exotic' plants from around the world began to appear both in California and Australia as essential to creating a cultivated environment in which English-speaking peoples would feel comfortable. Out of these efforts on both sides of the Pacific grew the most prolific and systematic

exchange of plants between the two coastal regions that shared a similar climate and was to be similarly populated by Anglophones.

While those carrying out such efforts may not have been aware of it, the practical results of this exchange were steeped from the beginning in symbolic import and iconographic significance. Botanical elements, whether as part of the planted landscape or in artistic renderings, became crucial aspects of the regions' efforts to establish appropriate cultural identities. In this process, aesthetic considerations were as important to the early champions of the eucalypt in California as were economic necessities. The tree's ornamental possibilities in the landscape were considered from the beginnings of its exportation to the American West Coast, while colonial Australian attitudes about the eucalypt's unusual appearance initially prevented much of a decorative attachment to their most prevalent floral genus.[23]

The 1870s represented the great 'Eucalyptus boom' in California, when the first mass plantings occurred throughout the state.[24] Two figures were especially important to this early eucalyptus craze. Both were imbued with an American spirit of enterprise and believed that one's horticultural environment could provide moral and aesthetic uplift. The first such pioneer was Ellwood Cooper (1829–1918), a successful businessman and 'gentleman farmer' who arrived in Santa Barbara in June 1870, enchanted by its 'beautiful air'.[25] Cooper purchased about 2000 acres from W. W. Hollister's Rancho Dos Pueblos near Goleta to the north of the city; he called it Ellwood Ranch.[26] Charmed by his salubrious surroundings, Cooper wrote of the ranch in his autobiography: 'Nature had in this view presented us with the most beautiful place that ever was created.'[27]

In an attempt to establish a profitable agricultural enterprise on the property, Cooper introduced olives, creating the first olive oil

industry in the state; later, he also raised English walnuts, sultanas and many other crops. But the gum tree already fascinated him:

> To return to forest planting, I had in a voyage from the West Indies, made the acquaintance of Thomas Adamson, Jr … who played an important part in the eucalyptus industry. In my voyaging in San Francisco, I had seen in two house gardens, two blue gums; these plants had wonderfully interested me; the symmetrical growth, the silver blue leaf. I had never seen such a beautiful plant.[28]

His interest, then, was as much an aesthetic one as a commercial consideration.

After contacting his acquaintance Mr Adamson, who was then American Consul in Melbourne, Cooper corresponded with the acknowledged eucalypt authority, Ferdinand von Mueller, to learn all he could about the propagation of the tree. Out of this contact, Cooper wrote in 1875 his *Forest culture and eucalyptus trees*, based almost entirely on Mueller's personal research notes. While later accounts often consider the work one of the greatest acts of plagiarism in publishing history, Cooper's own account gave Mueller full credit with the following explanation:

> I was written that the Baron had delivered lectures on the eucalyptus, which had been printed, but that the only copies to be had were those in his possession; all the others were sent to London to the government, but that the Baron would let me have his copies, if I would have them published and send him fifty bound copies. I published the volume, 'Forest Culture and Eucalyptus Trees', in 1875. This circumstance created great friendship between myself and the Baron, with whom I corresponded for more than thirty-five years, until his death.[29]

Cooper's greatest achievement in terms of the aestheticising of the landscape in California lay in the fact that he planted some 50,000 trees of 70 species of eucalypts on his own property, forever changing the appearance of Santa Barbara County (see Fig. 6.03 on page 256). He remained a champion of the tree against all manner of critics (of which there were many, of every ideological persuasion, from the first plantings), declaring at the end of his autobiography that 'the future will prove that the family of the eucalyptus is the most important known to civilization'.[30] Cooper held offices on the California Horticultural Board and other state authorities into the early twentieth century, positions in which his views on eucalypts contributed to its widescale adoption as a forest as well as urban planting throughout the state. Most significantly, Cooper had also at this early date considered the Tasmanian Blue Gum—the species most commonly planted— to be 'a beautiful plant', appropriate along with other introduced Australian plants for ornamental gardens.

One of the other prominent figures in the early adaptation of eucalypts to Californian conditions was another energetic, independently wealthy Easterner who had come out to California for his health, Abbot Kinney (1850–1920). Kinney (who had made a fortune in tobacco) settled first in Sierra Madre in the San Gabriel Valley near Pasadena, on an estate he called Kinneyloa, where he set up citrus groves and sultana vines. He immediately became involved in civic affairs of all sorts, from committees to establish a Free Library in Pasadena to agricultural irrigation societies. In 1884, he married the daughter of the Supreme Court Justice of the state, a circumstance that brought him powerful political connections. By the end of the 1880s, he had become a prominent landowner, real estate developer, roadmaster of Santa Monica, Chairman of the State Board of Forestry and President of Los Angeles's Forestry and Water Society.

Fig. 6.03 *Eucalyptus grove, 30 years growth, Cooper's Santa Barbara.* Photograph. C. C. Pierce Collection. Courtesy of The Huntington Library, San Marino, California.

In these last two roles, Kinney involved himself in myriad agricultural activities and became acquainted with nurserymen, plant specialists and forestry experts throughout the world. In letters to the pioneering conservationist and photographer Theodore Lukens (1848–1918), also living in Pasadena, Kinney indicated that he was already carrying out seed exchange with Australian correspondents.[31] Kinney had visited Australia during a world tour in the 1870s. Some sources maintain that he had planned to settle there, but apparently found it not to his liking.[32] During his tour of the Blue Mountains, he had been less than impressed with the look of the eucalypt in its native habitat. His comments, published in his 1895 book *Eucalyptus*, decry the tree's 'scrawny' appearance, in Australian forests that are 'monotonous and depressing'.[33] As

Tyrrell comments, '[c]learly, Kinney was not concerned with foisting an "Australian" aesthetic on the California landscape'.[34]

Once involved with real estate development in Southern California, and having perhaps seen how quickly and lushly the groves of eucalypts already planted in Santa Monica had grown, Kinney became a champion of the gum tree for commercial and ornamental purposes.[35] In his position as land developer, Kinney now laid out eucalypts en masse and encouraged others to plant them as a means of making the California landscape more garden-like.[36] At the State Forestry Station that he arranged to have established in Santa Monica, Kinney experimented, in association with plant expert Alfred McClatchie (1861–1906), with several varieties of eucalyptus trees, all with the purpose of vegetating the

E. GLOBULUS

Fig. 6.04 *Gum tree flowers*, illustration in Kinney, *Eucalyptus*, 1895, pl. 121. Courtesy of The Huntington Library, San Marino, California.

floral elements arranged as they would be in botanical illustrations.

At this same time, and with similar ambitions for aesthetic improvement, Kinney also began his most prodigious project, the construction on the Santa Monica beachfront of the community of Venice, complete with canals, gondolas and amusements intended to enrich the lives of Angelenos hungry for culture and spectacle. Not surprisingly, Kinney also saw to it that eucalyptus trees were planted along Venice's streets and near its residences. Advertised as 'the most unique and artistic pleasure resort and city of seaside homes in the known world'[39], Kinney's fantastical community opened its doors in 1905. By this time, the ubiquitous appearance of gum trees throughout the Southern California region— whether in groves acting as windbreaks, as allees inviting promenades or as single ornamental trees in bungalow gardens—caused many people to believe they had always been there (see Fig. 3.19 on page 136). The naturalisation and ornamentalising of the eucalypt in California was well established by the beginning of the twentieth century.

Cooper and Kinney were carrying out their extensive eucalyptus plantings, as well as their most zealous campaigns to use these trees to enhance the landscape, in Southern California. In this part of the state, the most enthusiastic use of the tree as an ornamental element in the construction of the visual image of California began to take shape. The landscape and garden design in San Francisco and northern California in general do, of course, figure greatly in this aestheticising process from the earliest days of the tree's arrival, and artists in turn-of-the-century San Francisco and in artists' colonies such as Carmel did incorporate the tree into their paintings and prints (see Fig. 6.05 on page 217). But the shift of focus to the south, both in terms of population growth and the subsequent formulation

semi-arid Los Angeles plain with trees that would make home gardens and the streets of new neighbourhoods more attractive.[37] His book *Eucalyptus* appeared as a mixture of self-promotion, facts about how to raise the tree and polemic about the health-giving and aesthetic properties of 'harmonious planting'.[38] The illustrations Kinney included in the book also present the trees as beautiful specimens, in photographs both of the tree in situ and of

of the visual symbols of the modern Pacific, depends more directly on the transformation of Southern California's physical appearance through the planting of introduced species such as the pepper tree and palms from South America and Mexico, and eucalypt, acacia, palms and fig trees from Australia.

Just as it had in the north, debate surrounds the eucalypt's first appearance in the area. Since Anglo settlement in Southern California did not gain much momentum until the late 1860s, it is not surprising that the tree arrived only at this time. Some current scholarship attributes the first plantings to Albert Workman, an Australian who worked as the Superintendent of a ranch owned by pioneers Isaac B. Lankershim and Isaac N. Van Nuys in present-day Canoga Park in the San Fernando Valley.[40] In about 1869, Workman bought the ranch, built a large house and surrounded it with eucalyptus trees he had sent from Australia. The stumps of these original trees, along with a few descendants, still remain in Shadow Ranch Park, Canoga Park. Other sources maintain that the famous trapper-cum-*ranchero* William Wolfskill (1798–1866), instrumental in founding California's citrus industry, obtained eucalyptus seeds from 'a friend in Australia' in 1864 and planted them on the ranch he had purchased from 'Lucky' Baldwin (today's Los Angeles Arboretum) in present-day Arcadia.[41]

In any case, eucalyptus trees were already a pervasive part of the Los Angeles landscape by the mid-1870s. Santa Monica planted their first street stands in 1876. A huge tract, some 190,000 trees, initiated by The Forest Grove Association with leading citizen Judge Robert Widney (1838–1929) as President, took over several acres near the railroad lines in Anaheim in 1875.[42] When the Austrian aristocrat and early conservationist Ludwig Salvator (1847–1915) visited the city in 1877, he found gum trees, along with South American pepper

JULY, 1901.
THE PANAMA CANAL
THE ARK PEOPLE
SMYTHE ON IRRIGATION

Vol. XV, No. 1
Richly
Illustrated

"LOS PAISES DEL SOL DILATAN EL ALMA"

THE LAND OF
SUNSHINE

THE MAGAZINE OF
CALIFORNIA AND THE WEST
EDITED BY CHAS. F. LUMMIS

EUCALYPTUS BLOSSOMS.

Fig. 6.06 Cover, *The Land of Sunshine*, vol. xv, no. 1, July 1901. Courtesy of The Huntington Library, San Marino, California.

trees, flourishing throughout the region. In his wonderfully descriptive book, *Eine Blume aus dem goldenen Lande oder Los Angeles* (1878) (published in English as *Los Angeles in the sunny seventies: A flower from the golden land* in 1929), he wrote with some bemusement that *Eucalyptus globulus*, as well as the pepper tree, were planted mainly as ornamental trees next to houses—as 'ein Zierbaum'—rather than for commercial use.[43] He also noted that the mass

A natural salt water lake within ten minutes' walk of the business center. Oakland has the most equable climate of any city in California; a water front of over fifteen miles, suitable for manufactories, and is growing in population faster than any other city in the State. Why not locate in Oakland?

For more explicit information and illustrated literature address

EDWIN STEARNS, SECRETARY,

OAKLAND BOARD OF TRADE, OAKLAND, CALIFORNIA.

IN WRITING TO ADVERTISERS PLEASE MENTION SUNSET

Fig. 6.07 Oakland, advertisement, *Sunset*, vol. 11, no. 4, August 1903, n.p. Courtesy of The Huntington Library, San Marino, California.

plantings cultivated by Widney and others had begun to produce timber, remarking on the astonishing rapidity of their growth, with some trees as tall as 12 feet after only a year in the ground.[44]

By the 1880s, as one can see in the illustrations of the period, the eucalypt species was already occupying an important place in the image of California that new Anglo settlers were creating. By the turn of the century, the natural forms of the gum tree were already an established part of the illustrative iconography

of the state. Charles Lummis, that inveterate booster of the idea of a Hispanic south-west, included a gumnut in the cover design for his magazine, *Land of Sunshine*. Soon ornamental elements of the gum tree began to appear as vignettes and borders in *Sunset* and other Western magazines.

The March 1903 issue of *Sunset* magazine is particularly telling about this process of botanical iconicising and the ideological ends to which such emblems could be used. The colour cover is by San Francisco artist Ernest Peixotto—the same Peixotto who met with Alfred Deakin at the San Francisco Fair in 1915 (see Chapter 5, page 235). Here he depicts a woman picking poppies—a cherished emblem of native botanical California—in a field of stylised flowers and in the background the other native plant symbol, stylised live oaks. The lead story of the issue is an article, also by Peixotto, entitled 'Italy's message to California', with the following assertion:

The American has not as yet the art of making his home nor his land picturesque—of planning the unexpected, the accidental. California has been endowed with a climate as faultless as any on earth and with every beauty that nature can bestow, yet the American as yet has done little to enhance her attractiveness. I say 'the American' advisedly for before his rule there was another civilization that has left here and there a legacy which we should jealously guard ... Let us in future build strongly and solidly and in a manner appropriate to our climate so that future generations may inherit something from us ... something that can be imbued with the charm of by-gone days—and then will California possess the one thing now necessary to complete her loveliness: the refinement of landscape that comes only after long cultivation.[45]

Only a few pages after Peixotto's romantic plea

for recognition of California's Hispanic past, a 'Study of eucalyptus leaves, and seed pods by Blanche Letcher' appeared as a vignette to accompany a poem, 'The Wide, Free West' by James Cooney, written in a cowboy-style 'regional' dialect.

An advertisement in a later *Sunset* issue of the same year offered equally intriguing juxtapositions of botanical forms. A promotion for 'Oakland, The City of Opportunity' includes a photograph of a eucalypt growing picturesquely beside the 'natural salt lake' of Lake Merritt. This photograph is surrounded by stylised silhouettes of what appear to be more gum trees, rather than oaks as the town's name would imply (see Fig. 6.07 on page 259).[46] The eucalypt's forms, then, were already joining the pictorial repertoire meant to connote a particular vision of California and the West as offering a 'natural', healthy, lifestyle in America.

The illustrative mode used in these *Sunset* illustrations complied with the aesthetic preferences of the day, which preferred an Arts & Crafts-inspired decorativeness for which the eucalypt's sinuous forms were especially suited. This sinuousness may be part of the reason the gum tree's elements became such a favoured source for magazine illustrations and border ornamentation; the forms set the aesthetic tone that *Sunset* and other Western magazines of the period were trying to establish. The 1904 volume of the magazine included several poems and images praising the tree and its flowers, and a poem with a drawing by James Crisp in the September 1905 issue spoke of 'their noble graceful forms … Wherein one reads a royal lineage.'[47] This same issue included an article on 'Seeking trade across the Pacific' by Arthur I. Street, which proclaimed:

> The American people are beginning to discover that the Golden Gate is the front door to the Orient … For, the Orient is not China alone

… It is New Zealand and Australia with their continental area, their rapidly expanding business conditions, and their assuring future potentialities.[48]

The magazine's promotion of California's affinity to the lands bordering the Pacific Ocean gained subtle visual confirmation through the incorporation of Australian plants into its decorative arsenal. Illustrations in *Sunset* became

The Eucalyptus Flower

By Caroline Lange

Eucalyptus—"well concealed,"
Now thy secret stands revealed.
 Vain the hard and woody cell,
 Vain the cover fitted well.

Came the sunshine and the rain,
Spring and Eastertide again,
 Till the thread-like stamens heard,
 Till the coffin-lid was stirred.

Bursting forth, the spirit flower
Hails the sunlight's quickening power.
 Free from bonds, from prison free,
 Flower of immortality!

Drawing by Blanche Letcher

Fig. 6.08 Blanche Letcher, illustration for Caroline Lange, 'The eucalyptus flower', *Sunset*, vol. xii, no. 6, April 1904, p. 524. Courtesy of The Huntington Library, San Marino, California.

Fig. 6.09 Franceschi's house, Montarosio, Santa Barbara, California, c. 1901. Courtesy of Santa Barbara Historical Society, Santa Barbara, California.

more profuse and more graphically coherent with each issue.

As for the tree's actual appearance in the California landscape, its widespread dispersal throughout the state not only met a commercial or agricultural need. Several species had always been considered as aesthetically attractive and appropriate for transforming barren hills and dust patches into a gardening paradise. The tree's use as an ornamental plant—as one that could contribute to Southern California's development as 'America's Mediterranean' or 'Our Italy', as writers began in the 1890s to call it—depended on several nurserymen, instrumental in nurturing its place, along with other exotic species, in the region's image as a semi-tropical garden.[49]

One of these nurserymen was an aristocratic Italian émigré named E. O. Fenzi (1843–1924), known in America as Dr F. Franceschi. Franceschi arrived in Santa Barbara in 1893, having already spent many years in plant cultivation and horticultural improvement in Italy. He established, initially in partnership with the landscape architect and artist Charles Frederick Eaton (1842–1932), a nursery on Santa Barbara's Riviera, where he became a consummate champion of introduced species. He wrote that he had chosen Southern California for the purpose of introducing new plants because the climate would allow the greatest number of botanical specimens from around the world to thrive there.[50] At the same time, he founded The Southern California Acclimatizing Association and carried out voluminous correspondence with other nurserymen in many countries, always seeking new species that would enhance the landscape of salubrious Santa Barbara. In his acclimatising efforts, Franceschi also collected seeds of Californian native plants to use in exchange.

In 1895, Franceschi published an extraordinary little book, *Santa Barbara exotic flora: A handbook of plants from foreign countries*

grown at Santa Barbara, California, in which he identified individual examples of introduced species in the town, pinpointing as closely as he could the persons responsible for a plant's introduction. He stated, for example, with characteristic certainty, that '[t]he introduction of the *Ahuacate* or *Alligator pear (Persea gratissima)* is due to the late Judge Ord, who brought a few plants from Mexico about 1870'.[51] In the section on fine specimens of exotic trees, he wrote, 'Of the strange looking *Casuarina quadrivalvis*, the so-called she oak of East Australia, there are a few remarkable specimens in town, and a perhaps larger one at Mr. J. Sexton's, at Goleta.'[52] As the editors of the Francheschi Papers state, 'Dr Francheschi [*sic*] managed to a large degree to popularize in California the cultivation of avocados, bamboo, figs, the large Japanese persimmon, palm trees, a ground cover named Lippia repens, some roses, cypress, asparagus and acacia.'[53]

A substantial part of Franceschi's plant inventory, and consequently the focus of much of his correspondence, dealt with Australian native plants. His papers at the Bancroft Library contain several letters to Australian botanists and plant men, including J. H. Maiden at the Sydney Botanical Gardens, Phillip MacMahon at the Brisbane Botanical Gardens and David McAuliffe in Greenridge, New South Wales.[54] He was also well-acquainted with Santa Barbara's own Ellwood Cooper and acknowledged the significance of the varied species of eucalyptus that he had planted on his ranch some 20 years earlier. 'Besides the Gums, and within the same period of about 30 years', Franceschi wrote, 'Australia has been supplying to our gardens the bulk of evergreen trees'.[55] He was especially partial to palms, of which he requested seeds from MacMahon at the Brisbane Botanical Gardens.[56]

During his 20 years in Santa Barbara, Franceschi worked tirelessly on his mission to create a beautiful Mediterranean environment in the region. His efforts were always determined by an aesthetic purpose in which plants served as a source of ornamental value and visual pleasure. As the California botanist David Fairchild wrote in 1938 about Franceschi, it was not always easy to convince others of his vision:

> Santa Barbara in 1898 was but a simple, small town. Residents of the beautiful hillside villas today would not credit their eyes could they visualize the bare, sparsely settled roads where I drove with Dr Franceschi … Santa Barbara was so undeveloped that I considered him visionary and over-optimistic. However, he foresaw the future more clearly than I, and lived to see Santa Barbara become a great winter resort containing hundreds of beautiful villas like those on the Riviera.[57]

In his pursuit of new plants and in his efforts to persuade others of his vision for the horticultural appearance of Santa Barbara, Franceschi had little financial success. In order to continue in his efforts, he often took up landscaping and garden maintenance jobs—a situation that allowed him at times to introduce his Mediterranean aesthetic into the gardens then just being established by the wealthy in nearby Montecito and on the Riviera.[58] Most notably, Franceschi had a considerable hand in the landscape design of Charles Eaton's estate, Riso Rivo in Montecito, the site that so entranced Gustav Stickley when he visited in 1904.[59]

An Italian, then, contributed practically to the garden style that became so much a part of the Southern California aesthetic—the verdant, lushly floral image associated with a Pacific landscape. That he carried out his efforts in Santa Barbara—that California 'dream materialized', as Kevin Starr calls it—makes Franceschi's contribution all the more central

to the transformation of Southern California's botanical image.[60] A substantial number of the Australian trees and plants now so visually embedded in the Santa Barbara landscape are descendants of Franceschi's original plantings. His contribution to the Mediterranean aesthetic that Santa Barbara still nurtures remains strikingly apparent today at the site of his nursery and home on Mission Ridge, now christened Franceschi Park on the city's Riviera.[61]

The other emigrant nurseryman to Southern California who helped to transform and shape the region's horticultural landscape provides an even more intriguing relationship to the iconic naturalisation of the eucalypt in the first two decades of the twentieth century. Theodore Payne (1872–1963) was an Englishman who came to California in 1893, 'having passed his 21st birthday at the Chicago World's Columbian Exposition that year'.[62] He was already a well-trained plantsman and a great seed collector. He became throughout his long life one of the foremost advocates for California native plants, especially wildflowers. His life encompassed the period of Southern California's horticultural transformation, a transformation in which he actively participated.

Payne worked first as the gardener at Arden, the extraordinary utopian colony that the Polish actress Helena Modjeska (1840–1909) established in what was then the wilderness of Santiago Canyon in Orange County.[63] During this time and into the early 1900s, Payne tramped around Southern California, collecting seeds and learning about the flora of the natural landscape. He went to Santa Barbara in 1896 and became lifelong friends with Dr Franceschi. Soon he opened his own seed store on Main Street in downtown Los Angeles, where he remained until the 1930s; he then continued his business at a larger location on Los Feliz Boulevard, near Griffith Park. As the landscape architect Ralph

Cornell (1890–1972), who knew him for over 50 years, noted, 'he was basically a plants man—fundamentally, totally, his one love, his one interest'.[64] As early as 1932, Payne envisioned a foundation for the protection and promotion of native Californian wildflowers and plants. In response to a prospectus he mailed out to potential donors to this cause, the Superintendent of Los Angeles schools wrote to him:

> All lovers of California's native flora look to you, as for many years past, as one of its chief leaders in the appreciation and protection of this heritage of natural beauty and charm. You have devoted many of the best years of your life unselfishly, and have fought against many discouraging conditions, in an effort to get Californians to appreciate their own flora, and to take steps, before too late, to protect it for future generations.[65]

Payne's single-minded efforts for regionally appropriate planting make it particularly noteworthy to discover that in the early part of the twentieth century he was entirely wrapped up in the most excited speculative eucalyptus boom in California. This boom hit its stride in 1904, when the United States Government began to issue doomsday statements about the demise of American native hardwood forests. The wholesale planting of enormous tracts of eucalypts, in which scores of people invested, reached a peak in 1910. By 1915, when it became apparent that the extravagant claims about the tree's immediate commercial potential were largely unfounded, the economic component of the boom bottomed out entirely.[66]

At its height, the entrepreneurial frenzy it engendered was comparable to the tulip speculations in seventeenth-century Holland.[67] Investment companies sprang up everywhere in the state. People as well-known as the writer

Jack London invested enormous amounts of capital and land in planting trees. In 1911, London wrote to a friend H. H. Champion in Melbourne, 'I have now 50,000 eucalyptus trees growing' on his property near San Jose, California.[68] The railroad companies, as well as the federal agencies, planted vast tracts of eucalyptus forests to supply timber for railroad ties and other industrial uses. Brochures and illustrated pamphlets, in which the trees were often referred to as 'California's Mahogany' gushed about the riches that would come to those that invested in these rapidly growing trees (see Fig. 6.10 on page 218).

As a nurseryman trying to make a living in Los Angeles at this time, Theodore Payne would have naturally been in the thick of the eucalypt craze. As he wrote in his memoirs, he was already an avid collector of seeds of all the Australian plants then growing everywhere in the region.[69] By 1910, Payne had become one of the main providers of eucalypt seed for the companies and concerns established to plant the forest tracts, as well as for those who wanted trees for ornamental planting. 'My seed store at 345 S. Main Street soon became a sort of clearing house for eucalyptus seed and plants', he wrote in his memoirs.[70] In a flyer he produced in 1910, he wrote, 'I am headquarters for eucalyptus seeds, having the most extensive trade in this line of any firm in the United States, and supplying the largest planters here as well as exporting to many foreign countries.'[71] The flyer included photographs by Theodore Lukens, showing Payne and others gathering eucalyptus seeds. Ralph Cornell wrote that Payne was a master at collecting seeds by placing tarpaulins under the stands of trees that were already planted and had grown to enormous size along the roads. He also scoured the back roads of the region and took seeds from trees going to be cut down.[72]

Payne also began to take photographs of the many species of eucalyptus trees and blossoms, which he kept in an album; he even copyrighted some of his own photographs. He provided hundreds of pounds of seeds to German and French companies and was proud that the trees that Franceschi's daughter had introduced to Libya derived from his seeds.[73] Payne appears also to have been the main supplier of eucalypt seed and seedlings for the Santa Fe Railway in 1910, when the company, as a means to have a quick and lasting supply of railroad ties, established acres of groves of trees in an area just north of San Diego.[74] Once it became apparent that the wood from these trees would not work commercially for the railroad, the trees already planted on those 2000 acres were simply left to grow, creating thick stands of vegetation where none had been before.

Payne's involvement with the eucalypt did not end once the commercial frenzy for eucalypts died down, at about the time World War I began. The nurseryman's continued admiration for this introduced species, even as he promoted the appropriateness of native Californian plants for gardening purposes, proclaims more than any other fact the gum tree's special place in the landscape of twentieth-century California. In the 1920s, at which time the tree re-established its earlier reputation in California as an ornamental planting,[75] Payne proudly laid out a eucalyptus arboretum of some 69 species in Ojai for Mr and Mrs Charles M. Pratt, a Standard Oil executive and his wife. The arboretum was established in a canyon behind the Pratt's summer home, which the architects Greene & Greene had already built for them in 1911.[76] (The Greenes themselves had already demonstrated their own aesthetic preference for the gum tree, in their plans for the gardens of the Gamble House and the Irwin House [see Fig. 4.12 on page 171]). Certainly Payne's intentions here, as in other landscaping projects he

THEODORE PAYNE, EUCALYPTUS SPECIALIST

EUCALYPTUS SEEDS

HEADQUARTERS FOR EUCALYPTUS SEEDS.

I am headquarters for eucalyptus seeds, having t. e most extensive trade in this line of any firm in the United States, and supplying the largest planters here as well as exporting to many foreign countries. The Eucalyptus Timber Corporation, the Pratt Eucalyptus Investment Company and many other large planters have contracted with me for their entire supply of eucalyptus seeds for a number of years. To this department of my business I have devoted much study and personal attention. My seeds are carefully collected by my own men, under my personal supervision, from selected specimen trees, and are both true to name and of the very best stock obtainable. So extensive has become my trade in this line that a trifle under 1800 lbs. was the total amount of seed thus collected in one season. For a few species of which the seed cannot yet be obtained in California I am in direct communication with the most reliable authorities in Australia, who collect the seeds for me in their native habitats.

Theodore Payne and men gathering eucalyptus seeds
PHOTOGRAPH BY T. P. LUKENS

had around Los Angeles, were based on his aesthetic interest in the eucalypt.

To the end of his life, by which time the tree's many defects as an ornamental plant were widely acknowledged and often condemned, Payne wrote admiringly of the tree's appropriateness for the California garden and streetscape. In 1956, in a letter to Cal Tech biologist F. W. Went, he stated:

> I think without any doubt the Eucalyptus is the most remarkable tree in the world ... though these trees are native to just one corner of the world ... they have been taken to portions of five continents and wherever they have been introduced, have in a few years completely

transformed the landscape.[77]

Obviously Payne, who so loved the native vegetation of the state, considered the tree so naturalised that he had incorporated its appearance and ornamental possibilities in the landscape into his own horticultural sense of California.

Payne was not the only one who considered the eucalypt as a desirable element, as an aesthetic enhancer of California's hills and semi-arid plains. As those early illustrations and vignettes in *Sunset* and elsewhere make clear, the iconographic construction of California had already begun to incorporate the forms of the gum tree into

its visual repertoire in the early years of the twentieth century. Even John Muir considered the gum tree appropriate enough to choose its image on a card he sent to Theodore Lukens in 1911 (see Fig. 6.12 on page 219). By the time of California's grand exhibition year of 1915, the investment frenzy surrounding the tree had waned, but its widespread presence on the land meant that artists and designers could not ignore it as one of the recognisable visual emblems meant to represent the state's attributes.

These symbolic motifs coalesced around the international fairs that presented California and the American West to the world. As living representations of California, the trees, both in the ground and on the page in all the promotional material, were everywhere at both fairs, where grand landscaping schemes played a major role in the propaganda for the region.[78] John McLaren (1846–1943), the formidable Scotsman who had already been Superintendent of Golden Gate Park for 30 years at the time of the fair (and would continue to be in charge for another 20 years), directed all of the landscaping for San Francisco's Panama–Pacific International Exposition. This project was a massive undertaking that in the end involved the transplanting of many full-grown trees, careful propagation that began four years before the fair opened and close work with the architects and artists to coordinate floral colour and form.

As chroniclers of the exposition would write of McLaren and his accomplishment, '[h]e, with his wide experience and uncaring energy,

Fig. 6.13 *Unloading and setting eucalyptus 1914.* Photograph. San Francisco History Center, San Francisco Public Library, San Francisco, California.

Fig. 6.14 Official photograph of panorama of the Panama–Pacific international exposition, San Francisco, California, 1915. In: Mullgardt, *The architecture and landscape gardening of the exposition*, San Francisco, 1915, p. 15.

created the garden setting, which ties all the buildings into a natural harmony'.[79] 'Hardly ever have trees, shrubs, and flowers been used in such profusion in an Exposition', the authors continued; 'the stony look of many former expositions is not evident at San Francisco'.[80] Louis Christian Mullgardt, another of the fair's architects and an official voice, described McLaren as a 'Landscape Engineer' and effusively praised his achievement as 'the most colossal system of successful transplanting ever undertaken in the history of the world'.[81] In an event obsessed with symbolic intention, where every building, ornament and artwork 'strained for significance',[82] the fair's landscaping was an integral part of the allegorical presentation and McLaren received full credit for the horticultural effects he created.

Australian plants were central to McLaren's ambitious plan at the San Francisco exhibition. Since becoming Superintendent of Golden Gate Park in the 1880s, the Scotsman, like so many other Californian horticulturists, corresponded regularly with and exchanged seeds with Australian nurserymen and botanists, and he made lists of all the plants he had introduced from Australia to the park. Some of his grandest design statements at the exhibition involved the ornamental use of several species of gum trees. Since McLaren had already planted many of these in Golden Gate Park over the years—in his own book, *Gardening in California* (1909), he described the eucalypt as 'one of the most useful of our introduced exotics'—he already had grown long-established stands of trees that could enhance the exhibition's setting.[83] One need only look at photographs of San Francisco's Midwinter International Exposition of 1894 to see how well-established were eucalypts as an ornamental tree even at that date.

The trees figured prominently in almost all of the images in promotional literature and advertising that appeared before and during the exposition. They were rendered decoratively at the edges of program covers; they appeared in the foreground of photographs that looked down onto the fairgrounds; and presented as if they were a natural part of the environment in the paintings and other artworks displayed at the exhibition as 'Californian art'. The stylised illustrations of brochures and posters

THE 'FRISCO EXHIBITION, 1915.
The View from the Hill, Framed in Australian Gumtrees.

Fig. 6.15 'The 'Frisco Exhibition, 1915. The View from the Hill, Framed in Australian Gumtrees,' in *Building*, 12 April 1915, p. 70.

began to use the picturesque sinuousness of the tree's leaves and branches in the emblematic template that would become so familiar in later renditions of the California eucalypt, while painters depicted the trees in romantic pictorialist landscapes. The florid prose that flowed from the overwrought pens of the exposition's authors also included paeans to the plants' decorative effects. In the deluxe version of the book about the 'palaces and courts' of the exposition, Mrs Juliet H. James's ode to the fair's designer Jules Guerin (1866–1946) and his colour effects included the line, 'And the blue eucalypti against the walls will lend their voices, the yellow acacias will add their cadences', as complementing and enhancing the 'pastel city by the sea'.[84]

Australian visitors to the San Francisco event could not help but be struck by the appearance of their native tree, along with so many other Australian plants, in this garden setting. As the quotation at the beginning of this chapter makes clear, *Building*'s editor George Taylor was among those most impressed with the eucalypt's appearance in the great San Francisco park. When he visited the construction of the exposition in 1914, he wrote with amazement about what would greet an Australian attending the fair:

They will hardly forget Golden Gate, because of its lively drives and music park, with its closely-cropped trees, under which the people can sit and enjoy the music; and most of all, because almost every tree, every shrub, every plant there is Australian![85]

Taylor returned frequently in later issues of *Building* to the phenomenon of the ornamental use of gum trees in the American landscape. A photograph of *A tree-lined road in San Francisco*, probably taken by Taylor himself on his 1914 trip to the state, includes the caption, 'One has to travel far from Australia to find how gum trees are appreciated for street decoration and shade purposes.'[86] Even to an Australian, the eucalypt in California began to appear as if it were a natural part—or at least an appropriately naturalised part—of the region.

That same horticultural aesthetic was also gaining ground in the southern part of the state, as the San Diegans organised their own exposition in honour of the completion of the Panama Canal. Just as Taylor and others were struck in San Francisco by the beauty of 'their' plants as they grew on the other Pacific coast, Australians who visited San Diego were amazed at the plethora of their native species adorning the grounds of this more regionally focused exhibition. The site of the Panama–California Exposition in the newly anointed Balboa Park (formerly City Park) experienced an even more dramatic and rapid transformation through the planting of eucalypts and other introduced trees and plants than had been the case at the more well-established Golden Gate Park in San Francisco.

Some gums had been planted at the edges of the park as early as 1892, but the site immediately to the north of downtown San Diego was still essentially scrub-brush hills in 1904. In that year, spurred on by efforts of the city's remarkable horticulturist Kate Sessions (1857–1940) and as part of state-wide Arbor Day ceremonies, some groups of young gum trees were planted throughout the undeveloped parts of the parkland.[87] As San Diego historian Richard W. Amero writes about Sessions and Balboa Park:

... [s]he planted herself or directed the planting of Monterey Cypress, Torrey pines, eucalyptus, pepper, palm, rubber, cork and camphor trees primarily in the northwest section of the park, which, like her nursery, began to look more like a botanical garden than a park. [88]

The decision by the city fathers to hold the exhibition on this site in 1915 occurred in 1910, at which time further plantings augmented the eucalypt stands already there. By the time of the fair, with its prominent focus on Spanish Colonial and south-western architecture, the trees had already begun the metamorphosis of the sparsely vegetated land given over to the fairgrounds into an ornamentally forested site, although tremendous landscaping work still lay ahead. As the exposition chronicler Eugen Neuhaus wrote about the San Diego site in 1916:

Only three years ago the paradise in which we find the Exposition embedded was nothing but a large tract of land devoid of anything that might be called vegetation ... That was only three years ago, and today we have the surprising spectacle of the pinnacles of a romantic city of Spain rising amidst luxurious verdure.[89]

That the plants creating this paradise were not necessarily Spanish, nor even Mediterranean, did not negate this comparison in the eyes of the writer nor, more importantly, in the mind of the public.

The magnificent promenade of eucalyptus trees at the Cabrillo Bridge entrance to the San Diego Fair, along with the carefully selected species of gum trees and other Australian flora planted near the buildings and in the fairgrounds' many garden areas, created an organic relationship between the horticultural and architectural elements that was the hallmark of the exposition's aesthetic success. 'A gem indeed it is, not alone for the lustre

of its architecture but largely for the splendor of its setting', was Neuhaus's assessment.[90] Photographs of Goodhue and Winslow's Churrigueresque constructions often reveal in the background or next to the building towering gum tree specimens, while palms and pepper trees—those other botanical emblems of Southern California—are placed strategically in front of structures or in the courtyard gardens, all meant to allude to the Spanish–Mediterranean–Moorish theme carried out so meticulously throughout.

Only occasionally did the promotional literature allude to the fact that the eucalypt was an Australian, rather than a Mediterranean, native. As Neuhaus wrote about the exposition's 'garden aspects':

> … then there is our adopted state tree, the eucalyptus, from the common blue gum to the finer red variety and the fig-leafed one with its blaze of brilliant red blossoms. The eucalyptus has become as ordinary as the sparrow, but of the finer varieties, like the ficifolia, one can never see too many.[91]

Just as Spanish Colonial architectural design came into its own as the quintessential California style at the exposition, so too did the eucalypt become more firmly embedded there in the emblematic iconography of the state and joined with an idea of a 'Pacific Mediterranean' aesthetic.

This same romantic disposition—the notion of a Mediterranean–Spanish vision for Southern California that determined the architectural and horticultural choices at the exposition—contributed directly to the development of the planned community of Rancho Santa Fe in northern San Diego County, begun only a few years after the fair ended. The site chosen for the community encompassed the lands upon which the Santa Fe Railroad had initially planted vast expanses of eucalypts and then abandoned them to grow once the commercial bubble burst.[92] To land developers, the selection of this thickly vegetated site was not a matter of mere serendipity. Here were ready-made forests of green, in a landscape that included romantically derelict remnants of California's Spanish era, for the remains of the original Hispanic *rancho*'s houses still stood in the fields. One of these houses, Casa Osuna, would become a central focus and inspiration for the planning of the community.[93]

Rancho Santa Fe provided an ideal landscape in which to realise in permanent fashion for a privileged clientele the architectural and botanical fantasy that the San Diego Exposition had temporarily embodied, to merge these icons of the Mediterranean California dream. It is no coincidence that the architect initially chosen by developers to design the community, San Diego's own Richard S. Requa (1881–1941), was already deeply committed to the notion of Spanish Revival as the quintessential Californian style, not only for building but as a source for landscape design as well. The fair of 1915 only added further impetus to the predilection he had already demonstrated in earlier buildings.

Requa's story provides a good example of how Spanish–Mediterranean styles in architecture became as pervasive in California in the 1920s as roadside and garden eucalypts were in the landscape.[94] Like so many other new Californians, he was originally a Midwesterner who had moved to San Diego with his family in 1900. He began his architectural career in 1907 in the offices of the leading San Diego architect Irving J. Gill (1870–1936), who would later be lauded as the earliest practitioner of a distinctly Californian modernism.[95] By 1912, Requa was in partnership in his own practice with another Gill associate, Frank L. Mead (1865–1940), producing buildings that reflected their time in Gill's offices, in a 'stripped down' Arts & Crafts style.[96] Once

Fig. 6.16 Osuna Ranch House, Rancho Santa Fe, 1934. Photograph: courtesy of San Diego Historical Society.

partners, he and Mead became seriously interested in studying Spanish Colonial architecture in Mexico, as well as in the building techniques of the south-west Pueblo Indians and the Moorish elements evident in early Spanish and African construction that Mead had already photographed. They absorbed, in other words, all of those stylistic directions that influenced the designs of Bertram Goodhue and the others who built at the San Diego Exposition in 1915.[97]

By the time of the exposition, Requa and Mead had already been commissioned to design many buildings in their own versions of Spanish styles, often incorporating Mead's knowledge of Islamic and other 'exotic' imagery. They applied these elements most appropriately and in typically eclectic fashion in 1913 for their Krotona Inn in Los Angeles, headquarters for the Theosophical Society.

This spiritual colony would figure again in Requa's, and particularly in Mead's, career when the society moved to the small town of Ojai.[98] This structure included a pergola constructed of eucalyptus logs and a courtyard inspired by Moorish gardens, while eucalyptus trees surrounded the property.[99]

Perhaps because of these theosophical connections—the leaders of the California movement settled in the Ojai Valley at about this time—Ojai winter resident and glass tycoon Edward Drummond Libbey (1854–1925) learned of the firm and in 1916 commissioned Requa & Mead to rebuild the entire civic centre of the town.[100] The results of their efforts epitomise the heartfelt desire to create an organic interpretation of Spanish Style architecture integrated with the natural surroundings—in this case more native live oaks than eucalypts, although gum trees figured

as well in the promotional literature for the town's development.[101] Requa's pleasing arcade and accompanying buildings, complete with Mission Style parapet and Renaissance arches, represent one of the most consistent transformations of a town centre to a Spanish style to that date. The sources, one promotional publication indicated, were intentionally symbolic, for which Libbey rather than the architects was praised, for he had, the article said, 'conceived in his mind's eye of a dream city of soft harmonies, smooth flowing line and warm colors. A vision like our "castle in Spain" but visualized rather in the terms of the rural architecture of the South of Spain.'[102]

The mention in relation to Requa & Mead's accomplishment at Ojai of Mission Style, as well as references to Mediterranean and Spanish Renaissance elements, points to the fact that many vaguely defined terms evolved to describe these historicist predilections in architecture. These linguistic formulations began to be confused long before the 1915 expositions, for there were abundant forerunners to these architectural directions in California decades earlier. Previous discussions have pointed out how George Wharton James and Gustav Stickley in *The Craftsman* focused on California's missions as early as 1904, and Charles Lummis became a prime mover in the romanticisation of the state's Spanish heritage (see Chapter 4, page 169). Allusions to California's Hispanic past informed the region's architecture, albeit tentatively, as early as the 1880s, when Helen Hunt Jackson's book *Ramona* set off the first craze for Anglo visualisations of Spanish California (see Chapter 3, page 110). As Karen Weitze describes in her book on the Mission Revival, the imagery focusing on California's Missions became a central element in the state's earliest promotional literature.[103]

This period also marks the moment when the terminology for the various modes of

Spanish Style architectural elements employed by Californian practitioners began to lose any clarity, requiring later scholars to attempt to disentangle the appropriate designations for a variety of adaptations.[104] Clearly, Requa's interpretations of 'the Spanish' at Ojai and Lilian Rice's designs at Rancho Santa Fe differ in mood and architectural precedent from Goodhue's exposition buildings at San Diego, as do the varied constructions of the 1920s labelled as Hispanic or Mediterranean in influence. All of these directions, whether clearly defined or not, were meant to represent through architectural elements a distinct vision

Fig. 6.17 Requa & Mead (archs), Ojai Arcade, Ojai, California, 1916. Author's photograph.

of California that nurtured a romantic connection to the state's past while embodying in architectural form a new, elegant way of living on the Pacific coast. As the great scholar of the style David Gebhard explained:

> What is often overlooked in any discussion of the Spanish Colonial Revival in California is that this movement produced not only a wide array of purely eclectic buildings ranging from the wildly bizarre and flamboyant to the highly creative, but also that throughout its existence it served as a continual source of inspiration for the several *avant garde* movements which developed on the West Coast.[105]

The aim was to promote an appropriately Californian style that was at once modern and also tied to a learned tradition and a retrievable past—to devise, as the Los Angeles architect Stephanos Polyzoides has described it, 'an appropriate vernacular expression of a grand land'.[106] This connection to the land, including the concept of the garden as an integral part of the architectural design, was of paramount importance in this image-making process, a fact apparent in almost all of the illustrations accompanying texts that promoted California and the Pacific in the 1920s.

Richard Requa's Spanish Style offerings are, of course, representative of only one of the many approaches taken up by Californian architects by the 1920s. But his early efforts with Mead led him, almost serendipitously, to the commission to construct another entire community at Rancho Santa Fe. Unlike Ojai, where the conditions and intentions were meant to improve and beautify an existing civic centre, Rancho Santa Fe was a purely commercial, ambitiously exclusive, venture from its

Fig. 6.18 'Mission Style' depot at Green Hotel, Pasadena, California, c. 1910. Courtesy of The Huntington Library, San Marino, California.

Fig. 6.19 Lilian Rice (arch.), Rancho Santa Fe, Paseo Delicias, 1920s. Author's photograph.

inception. Furthermore, the community was to be constructed from scratch, on undeveloped land that contained only those abandoned and flourishing eucalypt groves planted by the Santa Fe Railroad. As Phoebe Kropp puts it in her discussion of the development, 'Rancho Santa Fe owed its hallmark suburban style to a corporate blunder.'[107] The contemporary promoters of the project were a little less ironic about it; as one of the elegant little brochures produced to explain the project's intentions wrote, 'W. E. Hodges, vice-president of the Santa Fe, hungered to utilize these wonderfully fertile hills, for they were covered thickly with a native growth that left no doubt as to their richness for agricultural purposes.'[108]

The 'native growth' spoken of—and by Ernest Braunton (1867–1945), an eminent horticulturist and friend of Theodore Payne—was eucalypts.[109] The developers certainly made the most of these existing arboreal stands and in so doing unified two ready-made California icons: the eucalypt, the Australian gum tree, as part of the natural landscaping placed around Spanish Style buildings with red-tiled roofs, stucco surfaces and arched doorways. The original *hacienda* adobes of the Spanish land grant were already there on the site of Rancho Santa Fe with remnants of 'a veritable park'[110] of pepper trees and rose bushes to which the eucalypt was easily added. The houses provided the perfect model for the architects' inspiration and presented the ideal setting in which to construct a romantic story for the project's advertising. Local historian Ruth Nelson wrote about the thinking behind these early promotional efforts:

In the early days of the Rancho Santa Fe development the offices of the manager of the project,

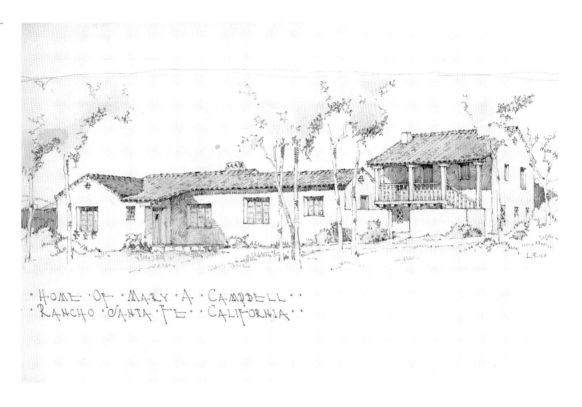

the architects and engineers were housed in this old Osuna home, until the buildings in the village were ready for use. Living in this lovely, historic spot, the early publicity about Rancho Santa Fe was naturally based upon tales of the Land Grant days.[111]

The real estate men, then, fully embraced the setting and formulated their ambitious idea for this privileged development based on an American interpretation of a Spanish model. In 1921, they chose Richard Requa, with his new partner Herbert L. Jackson—Mead had moved to Los Angeles and then to Ojai in 1920—as the architectural firm to realise the Hispanic vision of Rancho Santa Fe.

Requa's immersion in the Spanish idiom in its Californianised permutations helped to determine their choice. In the 1920s, Requa authored two books championing an authentic Spanish style 'for use in developing a logical and appropriate style of architecture for California and the Pacific Southwest',

using photographs he had taken on his travels throughout both Spain and Mexico.[112] (In 1935, Requa was responsible, interestingly enough, not for the architecture but for the landscape design at the second San Diego Fair in Balboa Park, where ornamental eucalypts were even more in evidence than they had been at the 1915 fair.)

Requa, busy with many other projects, turned the entire development of Rancho Santa Fe over to an associate, a young Berkeley-trained architect named Lilian Jenette Rice (1889–1938).[113] Rancho Santa Fe would become Rice's life work and crowning achievement. She designed most of the buildings for the village-like town centre, as well as many of the residential estates throughout the community. Responsible for the complete supervision of the project, Rice ensured that the entirety of the designed community retained the appearance of a Mexican or Spanish village in the town structures, as well as in the residences on the various estates. She even saw that the

town's service station island carried out the style, complete with red-tiled roof over the pumps, looking like it housed the village well instead of petrol. The building at the corner of Paseo Delicias and La Granada, where Rice had her office, is typical of the 'rural Spanish' style of the project, in which the buildings were constructed around courtyards and ovals of existing flowering gum trees and other plants (see Fig. 6.19 on page 274). Most of the structures were single-storey with white stucco surfaces, beamed interior ceilings and arched entryways (see Fig. 6.20 on page 275).

Rice's delicate drawings for residential projects portrayed a modern interpretation of a rural Spanish style that would appear frequently in towns and cities all over Southern California, if not always in such rigidly controlled artistic form. The romance of early California, with all its exotic allusions to rural as well as Moorish Spain materialised at Rancho Santa Fe as a world of perfect white-walled, red-roofed order, in harmony with its 'natural' sunny surroundings in which the eucalypt (and acacia) appear as if they had always been there in the California fields.

A new aesthetic image of California, then, was set, and an Australian tree, largely because it was already there in the landscape in such abundance, became an integral part of this visual template. Other Mediterranean modes and Spanish styles appeared throughout Southern California, and several full-scale town plans adopted such historicist metaphors. After an earthquake in 1925 damaged much of its town centre, Santa Barbara, home of the 'Queen of the Missions' and already deeply committed to its Hispanic heritage as part of its city ordinance planning and as tourist promotion, determined to rebuild all of its public buildings along carefully controlled stylistic lines. Unlike Rancho Santa

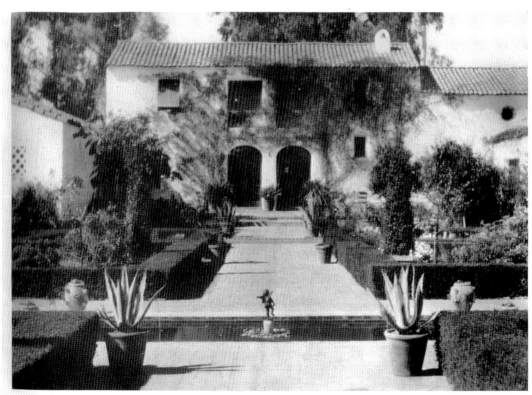

EL HOGAR, THE SPANISH HOUSE AND GARDEN OF MR. AND MRS. CRAIG HEBERTON, MONTECITO. GEORGE WASHINGTON SMITH, ARCHITECT

Fig. 6.22 George Washington Smith (arch.), El Hogar, Montecito, California, 1927. In *California Southland*, December 1927, p. 13.

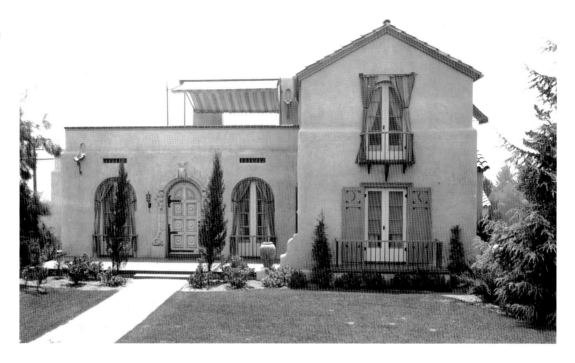

Fe, whose sources were rural Mediterranean emulating the idea of land-grant Californian *haciendas*, Santa Barbara chose for its public buildings a more regal Spanish Renaissance style, in keeping with its own grandiose myth-making predilections (see Fig. 6.21 on page 219). Santa Barbara had already begun its architectural transformation in 1924 with the successful El Paseo complex, of which James Osborne Craig, Mary Craig and Carleton Winslow of San Diego Exposition fame were architects and designers.[114] The city's elaborate Courthouse, completed in August 1929 by the San Francisco firm of William Mooser II, was 'a potpourri of Spanish architectural elements held together by the overall concept of its design', with meticulous attention paid to antiquarian details such as the Castilian signage, woodwork and tilework, and elaborately painted ceiling timbers and murals.[115] Contemporary architect Charles Moore has called it 'one of the century's great monuments to the architecture of inclusion'.[116] Other civic

buildings under the Santa Barbara plan adopted similar forms, all with red-tile roofs and white-washed walls—and, often, with ornamentally placed eucalypts near the buildings and in the carefully planned gardens.[117] As Kevin Starr describes the transformation, 'Santa Barbarans were now bathed in an imagined Spanish identity.'[118]

At the same time Santa Barbara implemented its Spanish plan for civic buildings, many architects here exhibited their own anti-quarian enthusiasm for Mediterranean styles in their plans for residences. The most enduring of these figures was George Washington Smith (1876–1930), who, with his designer assistant Lutah Maria Riggs (1896–1984), perfected a much grander hybridisation of Andalusian and other Mediterranean forms in his estates and gardens created for wealthy clients in Santa Barbara and Montecito (see Fig. 6.22 on page 276).[119] Smith's designs, with their ideal proportions and nearly abstracted spaces, were widely reproduced in magazines inter-

HOME OF MR. AND MRS HAROLD CHASE, SET IN A BEAUTY OF ENVIRON- MENT TRULY CALIFORNIAN, REGINALD D. JOHNSON, ARCHITECT.

FOR THIS HOUSE MR. REGINALD D. JOHNSON RECEIVED AN HONOR AWARD OF THE JURY SELECTED BY THE LOS ANGELES CHAPTER, A. I. A. FOR 1927.

Fig. 6.24 'Putting more beauty into the landscape' (Reginald D. Johnson, arch.), in *California Southland*, December 1927, p. 11.

nationally as epitomising the most elegant of California domestic architecture. Central to these estates were the gardens, in which eucalypts often figured prominently.

Until the rise of the Bauhaus-inspired modernism in Los Angeles in the 1930s, these styles were considered the height of modernity and stylishness. Their sources may have been derivative, but they were well-informed through a plethora of publications of photographic details from Spanish and Mexican colonial architecture.[120] In their adaptations to contemporary lifestyles in the Pacific sunshine, these architects and the many lesser builders and contractors erecting small adobe-style houses by the score throughout the region expressed a fashionable, modern version of these architectural modes that came to embody a romanticised vision of life in Old California. Inherent to these designs was a connection to the outdoors and domestic gardens, whether they occupied acres of estates or the backyards of a quarter-acre lot in the middle-class suburbs

popping up everywhere throughout Southern California (see Fig. 6.23 on page 277). Here, too, Mediterranean motifs and Spanish forms offered home-owners something special for their new way of living on the Pacific coast.

As had been the case with previous styles and fads, the illustrated magazines played a major role in the dissemination of these ideas. By the early 1920s, the architectural and art journals, along with the 'boosterist' publications promoting California, visually documented these efforts in all their variations. Journals such as *Architect and Engineer*, *Pacific Architect*, *California Southland*, along with the old standards *Sunset* and *Out West*, now spread the Spanish Revival gospel as the most appropriate, the most modern, architectural style for California. As the fashion spread to every Southern Californian city and town and to every level of building, these journals reproduced illustrations of these new forms and tips on how to furnish the interiors appropriately. They also gave advice on how to landscape

Fig. 6.26 Karl Struss, *In the Gloaming*, Rotogravure Section, *Touring Topics*, vol. 17, April 1925. Permission of The Automobile Club of Southern California Archives. Photograph: courtesy of The Huntington Library, San Marino, California.

in a style that would suit the Mediterranean house. *California Southland*, one of the publications geared toward a moneyed audience seeking to relocate in the region, was particularly prolific in its illustrations of new Spanish Style buildings set in elegant gardens. Not surprisingly for a magazine promoting lifestyle and real estate, the pages of advertisements were as artistically presented as the articles themselves.

A singularly important conduit for disseminating this new Pacific aesthetic was the journal produced in Los Angeles to champion that most pervasive emblem of California's modernity, the automobile. *Touring Topics*, published since 1909 by The Automobile Club of Southern California (it began in 1900 as America's earliest automobile club), became the most ambitiously elegant of what one writer has labelled the 'boosterist periodicals'.[121] As Kevin Starr points out, 'in Southern California the automobile and its club stood as the very center of organizational life'.[122] The first 10 years of the journal displayed a rather

staid graphic design, with articles geared solely toward automobile maintenance, reports on road building and the promotion of motor tourism. This last aim nonetheless did lead to some lengthy articles by such notable figures as Charles Lummis exhorting people to travel by car to visit the state's missions, an example of how completely the automobile was seen as a necessary part of the California experience from a very early date.[123]

In the early 1920s the editors of the magazine began to recognise the benefits of artistic illustration and coordinated graphic composition to promote the region and idea of a modern motoring-filled life in the West. Cover illustrations became increasingly artistic, even including a bit of colour in the printing. By 1923, a conscious transformation of the magazine occurred: covers were now printed in full colour, often created by established local artists. The artistic themes emphasised the natural wonders of the western landscape that could be seen by touring in an automobile (see Fig. 6.25 on page 220). Each issue also contained a 'Rotagravure Section', which included picturesque, often soft-focus, photographs of the western countryside, with captions that urged motorists to take a trip to see these places for themselves. The editors of *Touring Topics* sought out the best examples of photographic art. Many Californian art photographers, both pictorialist and modernist, published some of their best works in its pages. Stylishness, fashion and, later, full-blown modernism, combined with 'a kind of rarefied aesthetics',[124] became part of the magazine's methods to 'sell' Southern California as a tourist destination and as a cosmopolitan, urbane place in which to live.

The magazine's issue of March 1923 affords a clear example of how these elements came together to form a vision of Pacific contemporaneity and to express the journal's cultural ambitions. The cover depicts, in a

colour painting by Charles Hamilton Owens (1881–1958), The Automobile Club's new headquarters building, set against iconic blue skies, with palm tree and chic automobile in the foreground.[125] Not surprisingly, given the institution's commitment to the most up-to-date image of California, Spanish Revival was the style chosen for the club's grand edifice. The architects were Sumner P. Hunt (1865–1938) and his partner Silas Burns (1855–1940).[126] Hunt was a well-established Los Angeles figure who had built in a variety of styles over many years; he was the architect on the state licensing board when Australian James Peddle applied to practise in the state. From the beginning of the century, he had often adopted Mission Style motifs for his buildings and he had built Lummis's grand Southwest Museum in 1911 to 1912 in an eclectically 'south-western' transitional style. Well-versed in the prevailing Spanish Revival fashion by 1923, Hunt's headquarters is a spacious, well-proportioned example of the prevailing style in Los Angeles as it was applied to public buildings.

Advertisements in these issues also reinforced what would become the magazine's standard visual trope in the 1920s: an automobile, often with fashionably dressed driver, posed in front of a Spanish Style building set amidst distinctly Californian vegetation. Palm trees were the most frequent kind of vegetation surrounding the buildings in such ads, but stands of eucalypts on country roads or in gardens also appeared occasionally to signify Southern California. In 1926, two title pages in the magazine, both by Fred Archer, included stylised gum tree and gum tree blossom as an ornamental element in front of a silhouetted Highway Patrol truck.

The magazine's cover art, too, began to include these same aesthetic symbols of the region. The cover of *Touring Topics* for January 1926 epitomises this linking of botanical icons, modernity and the automo-

President *Valentine's* Annual Report *in This Issue*

bile (see Fig. 6.29 on page 221). The artist, Franz Geritz (1895–1945), was a Hungarian-born painter turned printmaker who was a member of the city's most avant-garde artistic circles.[127] Throughout the 1920s and into the 1930s, he contributed the most stylistically advanced, often expressionistic, woodblock or linocut illustrations for the magazine's pages. In December 1924, he had illustrated a poem about 'Christmas in California' by depicting in the central frame motifs of eucalyptus trees next to the ocean. This issue's cover, also by Geritz, presented in stylised graphic fashion

Fig. 6.27 Charles Hamilton Owens, cover, *Touring Topics*, January 1923. Permission of The Automobile Club of Southern California Archives. Photograph: courtesy of The Huntington Library, San Marino, California.

THE new five-passenger Coupe produced by Studebaker on the Big-Six chassis makes possible an intimate sociability in combination with luxurious comfort and maximum reliability.

The economy of operation of the Studebaker Big-Six is out of all proportion to its roominess, power and fineness, as is the low price of $2935 for delivery in Los Angeles.

PAUL G. HOFFMAN CO. INC.
Studebaker Distributors
LOS ANGELES HOLLYWOOD INGLEWOOD

Fig. 6.28 Paul Hoffmann Studebaker, advertisement, *Touring Topics*, January 1923, opp. p. 25. Permission of The Automobile Club of Southern California Archives. Photograph: courtesy of The Huntington Library, San Marino, California.

indicates the editors' earnest if still ambivalent desire to use whatever aesthetic means they could to present their desired image of Californianness, one that appeared as fashionable cosmopolitanism.

The continued inclusion of artistic photographs in the pages of a touring magazine speaks to the important role that photography played in the artistic construction of 1920s California. Fred Archer (1889–1963), for example, was a serious art photographer who also worked in the movie industry in the Art Title Department; he is credited, among other techniques, as the co-inventor along with Ansel Adams of the zone system.[128] He continued in subsequent issues of *Touring Topics* to submit romantic landscape views in which the sinuous forms of the eucalyptus frequently figured (see Fig. 6.30 on page 282). In the July 1924 issue, one of the images in the Rotagravure Section contained the caption, 'California Eucalypti—Through the Lenses of 2 Noted Camera Pictorialists' beneath the work of Archer and another leading photographer, Karl Struss (1886–1981).[129] The full caption for these photographs gives a good indication of the florid lengths to which *Touring Topics* writers went in their attempts to construct a poetic vision of the West:

the full gamut of California emblems: the sun rising over the mountains, a car silhouetted against the unmistakable forms of palm and eucalyptus trees. The vignettes around this central illustration include corner images representing the beach, the mountains and even a tiny reference to what appears to be a mission tower. Finally, repeated eucalyptus leaves form an ornamental frame on the sides and bottom of the page. Geritz's cover represents the most modern of directions that the magazine would take in the 1920s. That the magazine was disposed to such various modes of expression

Imported from Australia when California was young and while echoes of the padre's feet might still be heard in the canyons and the valleys, eucalypti have offered a theme for thousands of artistic interpretations. Stately yet graceful and sensitive to the kiss of the slightest breeze, entrancing when Jupiter looses his hoarded tears and Zoroaster blesses with his refulgent beneficence, the eucalypti have intrigued the masters of all artistic expression. These studies by famous photographers, both Californians, portray their subjects in totally different moods.[130]

Hardly the prose of an urbane outlook, this

kind of writing no doubt precipitated an editorial change by the club's administrators in 1926. The artistic ambitions for the magazine, to become a leading cultural publication in California, needed a more sophisticated voice to lead the journal beyond such hackneyed sentiment. They found that voice in Phil Townsend Hanna (1897–1957), a native Angeleno with literary ambitions. Hanna served as editor for *Touring Topic/Westways* for more than 30 years, during which time he pushed the journal into more seriously cultural realms. He was himself an amateur photographer and friend of all the literary figures and artists in the city. Described by Starr as one of the city's 'Tory men of letters',[131] Hanna nonetheless participated, as Dawson writes, in 'Southern California's small circle of intellectuals and artists who seamlessly interchanged their commercial and artistic goals', regardless of their political leanings.[132] Under his editorship, *Touring Topics* continued to publish pictorialist-to-modernist photographs in its Rotagravure Section. By the 1930s, soft-focus photographs disappeared entirely, to be replaced by the clear modernism of Californians such as Edward Weston and Ansel Adams.[133] Hanna also began including more serious essays on California history and literary achievements. It was in *Touring Topics*, for example, in 1929, that the English translation of Ludwig Salvator's *Eine Blume aus dem Goldenen Lande* first appeared.[134]

Artistically, Hanna sought to showcase local landscape artists by reproducing their paintings as magazine covers. 'Glorious California in Color!' was how he announced in 1928 that the covers would present landscape views by leading California painters.[135] Reproduced as if in gilt frames, the cover images of this series presented the most traditional of artists, perhaps revealing Hanna's own conservatism and the essentially middle-class aims of the club's constituency. (As John Ott comments,

Fig. 6.30 Fred Archer, *California Eucalypti*, in *Touring Topics*, Rotogravure Section, vol. 16, July 1924. Permission of The Automobile Club of Southern California Archives. Photograph: courtesy of The Huntington Library, San Marino, California.

'The use of high-art images allowed the reader and potential tourist/consumer to take pride in the possession of good taste.'[136]) Still, the magazine under Hanna presented a variety of artistic directions in its illustrations and helped to solidify the visual icons of California in its widely circulated pages.

By the time that *Touring Topics* presented its advertisement for Rancho Santa Fe with which this chapter begins, the mechanically reproducible iconography of California that it helped to establish dominated most of the illustrations in lifestyle magazines, posters and brochures selling the West Coast. Emblems of the 'natural' life on the Pacific appeared everywhere in the magazine: the page in July 1928's issue that precedes the Rancho Santa Fe ad presents a new Studebaker 'Sedan for Seven' parked in front of a grand Spanish Colonial home in Pasadena. The same issue's Rotagravure Section included not only a photograph by leading commercial photographer Will Connell (1898–1961)[137] of '[p]lumy eucalypti', but also etchings entitled *The California countryside* by Arthur Millier (1893–1975), then

art critic for the *Los Angeles Times*.[138] In the October 1925 number, Millier's etching of *The sentinel of the mission* had the following caption: 'Not the least interesting of the many sights that win the admiration of visitors to the San Fernando Mission is this twisted old gum tree, so typically Californian and so thoroughly charming.'[139] The cover for the August 1928 issue reproduced a painting of Morro Bay, with tall eucalypt trees picturesquely situated in the middle ground, by German-born, Paris-trained Jean Mannheim (1863–1945).[140] At the time, The Automobile Club of California's membership was at an all-time high of 129,536. *Touring Topics* and its artistic impressions reached not only these members, but was distributed nationwide and overseas.[141] Under editor Hanna, this magazine was able to reproduce the work of leading writers and artists, both traditional and modern, well into the Depression. As the club's official history said of Hanna, 'he brought with him a vision of Southern California's land, history and people that belied the stereotype of a cultural wasteland'.[142] These images helped to define the artistic look of a cosmopolitan California for a middlebrow, automobile-touring public, and in the 1920s and 1930s, that was the audience that counted.

But 1928 also marked an important moment in California's incipient cultural wars, the battle between traditionalist art and architecture and the modernist directions then beginning to make an appearance in the region. In September of that year, Merle Armitage (1893–1975), Los Angeles's leading impresario and all-round 'aesthetic falangist',[143] published in a small cultural magazine called the *West Coaster* the following commentary:

Soon exhibitions will be hung in our various galleries for the fall season. Our artists have returned from desert and mountain, trail and canyon, and columns will be written about Susie Gumdrop's handling of tree forms, John Popcorn's rendering of California mountains, and Mr. Whosit's lovely handling of desert colors. What does it all mean? Most of it means that nine-tenths of the men and women painting here on the West Coast are grinding out the usual output of pleasant calendars. They all see a desert, a sunset, a mountain or the sea with exactly the same eyes and the same minds. They are simply unintentionally making illustrations rather than creature [*sic—creative*] art. The difficulty of this situation from the standpoint of the reviewer is that most of them are such

Fig. 6.31 Arthur Millier, *Sentinel of the Mission*, in *Touring Topics*, vol. 17, October 1925, p. 20. Permission of The Automobile Club of Southern California Archives. Photograph: courtesy of The Huntington Library, San Marino, California.

20 ᙏ TOURING TOPICS

The Sentinel of the Mission

Not the least interesting of the many sights that win the admiration of visitors to the San Fernando Mission is this twisted old gum tree, so typically Californian and so thoroughly charming. This interesting study is from an etching by Arthur Millier

excellent folk that one shrinks from naming specific instances of their harmless art. I call it the 'eucalyptus school' of painting.[144]

By coining the term 'Eucalyptus School' for all those landscape painters and photographers of the picturesque whose works were among those Hanna selected for reproduction in *Touring Topics*, Armitage in one stroke relegated even serious *plein-air* painters, such as Joseph Kliesch and Guy Rose in Laguna Beach who often included eucalypts among their landscape motifs, to the realm of 'calendar art' (see Fig. 6.32 on page 222). In so doing, he thoroughly naturalised the introduced gum tree as among the most banal of the visual expressions of horticultural California.[145] As a committed modernist, Armitage of course wanted to champion those non-regional styles—abstract, non-representational and internationalist—that still seemed so foreign for most Californians, to create a more intellectual, sophisticated culture on the West Coast.

This same attitude began to inform other critics in their attacks on the Californian enthusiasm for Spanish Style architecture. Once European modernist styles began to make a splash in Los Angeles with the arrival of the Viennese modernists Richard Neutra (1892–1970) and Rudolf Schindler (1887–1953), even the elegant efforts in Mediterranean directions of such innovative architects as Bertram Goodhue and George Washington Smith were most often dismissed as derivative and eclectic. Even Carey McWilliams (1905–1980), the most culturally insightful chronicler of Southern California, fell prey to such assessments of the 'wild' architecture of the period in the region. While praising development of the California Bungalow in his *Southern California country*—'A Greene and Greene bungalow … remains a good home in Southern California', he wrote[146]—

McWilliams considered the Spanish Colonial home to be the outcome of a misguided idea about California's Spanish past, all the fault of the mission craze and the San Diego Exposition. The restoration of the missions had much to do with creating a popular acceptance of 'the stucco rash', was his explanation. As McWilliams saw it, 'It was merely by a kind of accident … that it seemed to be a little more apposite than, say, a New England stone house or a plantation mansion … There then began the wild debauch of eclecticism which has continued unabated to the present time and which has excited the wonder and curiosity of all visitors.'[147]

McWilliams, then, joined in the standard modernist disparagement of Southern California's Mediterranean architectural styles: that these buildings, both domestic and public, were unoriginal and unrealistic in 'reinventing' by Anglo settlers a past for California that never existed.[148] Their 'theatricality' (read 'kitsch'), according to this high modernist interpretation, negated any possibility that they could be taken seriously as appropriately modern forms for a newly developing urban and suburban Pacific landscape.

The canonisation of the modernist architectural ideology, well underway by the time of McWilliams' writing in the 1940s, failed to take into account that these Mediterranean adaptations in California did in many cases accomplish exactly what they set out to do: they functioned admirably in integrating outdoor and indoor spaces, the central requirement for a modern building on the Pacific coast. In the best architects' hands, these styles were intelligently adapted to the specific needs of modern lifestyles; they were not simply imitative or filled with historicist ornamentations, but considered the needs of people inventing a new kind of life in a Mediterranean climate. Houses like those at Rancho Santa Fe—built low around patios,

surrounded by semi-tropical gardens, which often included aromatic eucalyptus trees, filled with modern amenities, completed with tiled roofs and cool tiled floors—offered the owners spatial and sensual experiences that had not existed in America before. Even the more modest examples of small Spanish Style bungalows—those built after the style became so popular that it was 'retailed'[149]—appealed to those living in contact with their natural surroundings for whom their own garden, along with the elements of landscaping surrounding public buildings throughout Los Angeles and the region, became integral parts of their sense of space. People who lived and worked in these buildings did feel that these so-called 'unreal' architectural spaces embodied their new, modern world-view in a new, modern America that looked West out to the Pacific Ocean, to Asia and to Australasia, as much as to the Mediterranean.

Recent revisionist thinking has begun to consider these architectural efforts not as mindless historical pastiches, but as a considered architectural response to a particular place, as something distinctly Californian. The celebrated post-modernist architect Charles Moore called Spanish Revival styles 'a Southland archetype … the image of our transformed semi-desert, climatically Mediterranean landscape, the architecture of our innocence. It is our primal idea of home'.[150] Stephanos Polyzoides admires these structures as symbolic not of a globalising mentality, but as evidence of the specific intersection of people and place, in which its very eclecticism—the word, he points out, deriving from its original Greek meaning of 'to choose'—is its strength.[151]

In such an all-inclusive aesthetic context, the eucalyptus tree, too, takes its place among the emblems of a new lifestyle on the edge of the American continent facing out to the Pacific Ocean. The Australian gum tree worked in the Californian myth of the landscape because

it referred in the minds of the image-makers to a climate and geographical condition that allowed for an allusion to the home of all Western culture, the Mediterranean. By using the tree ornamentally, in a way that had not yet been consciously asserted in its native land, Californians constructed a popular visual template in which its forms combined seamlessly with architectural motifs to create a new aesthetics of place.

NOTES

1. George Taylor, 'Art and architecture at the San Francisco Exposition', *Building*, 12 February 1915, p. 111.
2. Stickley, p. 378.
3. McWilliams, *Southern California*, rev. edn, 1973, p. 360.
4. Sloane, pp. 7–8.
5. *Touring Topics*, vol. 20, no. 7, July 1928, p. 4.
6. The developers of Rancho Santa Fe had initially attracted Hollywood's reigning couple, Mary Pickford and Douglas Fairbanks, to build a home in the development. See Kropp, *California vieja*, p. 159.
7. 'From the time of the Gold Rush onwards, California was transformed into a new paradise based on images and ideals derived from the settlers' places of origin.' David C. Streatfield, '"Paradise" on the frontier', *Garden History*, vol. 12, no. 1, Spring 1984, p. 60. See also Streatfield's *Californian gardens: Creating a new Eden*, Abbeville Press, New York, 1994.
8. Ian Tyrrell writes of the *Pinus radiata*, 'A native of central coastal California, the pine was far from prominent in its home, but in Australasia it served as the reciprocal exchange for the extensive planting of eucalypts in California.' In 'The remarkable pines of Monterey: Californian softwoods in Australasia', in *True gardens of the gods: Californian–Australian environmental reform, 1860–1930*, University of California Press, Berkeley, 1999, p. 87. The author also wishes to thank Christopher Bettle, Canberra, Australia, for his research into the prevalence of redwoods in Australia, most of which were planted in Victoria as early as the 1860s.
9. H. M. Butterfield, 'The introduction of eucalyptus into California', *Madroño*, vol. 3, 1 October 1935, p. 149.
10. E. Van Dyke, 'Blue gum eucalyptus in the Elkhorn

Watershed: 1930–present', presentation at conference, Ecology and Impacts of Blue Gum Eucalyptus in Coastal California, Elkhorn Slough National Estuarine Research Reserve, Coastal Training Program, California Invasive Plant Council, 3 June 2004.

11. According to Robert L. Santos, in his compendium of facts about eucalyptus in California, 'In 1849, over 2,600 Australians left Sydney for San Francisco … It was on one of these voyages that the first sack of eucalyptus seed was imported.' In 'The eucalyptus of California', *Southern California Quarterly*, vol. lxxx, no. 2, Summer 1998, p. 110; viewed 4 April 2007, <http://library.csustan.edu/bsantos/euctoc.htm>.

12. Tyrrell, p. 58.

13. Behr remained in California from 1851 until his death in 1904, active throughout his life in the affairs of the California Academy of Sciences. Upon Behr's death, the academy produced a memorial article about his life, in which the authors stated that 'California is indebted to the friendship existing between Behr and Baron Mueller for the introduction of many valuable Australian plants'. See F. Gutzkow, George Chismore and Alice Eastwood, *Doctor Hans Herman Behr*, California Academy of Sciences, San Francisco, 1905, p. 2.

14. Butterfield, 'The introduction of eucalyptus', pp. 149–80.

15. The advertisement for the Golden Gate Nursery includes '500 Acacias, of 10 varieties', and lists 'Eucalyptus' among its available trees. See *California Farmer*, vol. viii, no. 4, 7 August 1857, p. 32. In that same volume, under the heading 'Mechanics' Fair', the editor includes a list of the plants exhibited by the Golden Gate Nursery at the fair: 'Of the splendid Acacia tribe there were on exhibition fifteen varieties, and this collection we esteem one of the best species of ornamental trees of the Pacific Coast for true grace and beauty.' The article then goes on to list all the Acacia species, along with other plants, including 'Eucalptus [sp] linearis/ 'species/ 'red gum tree'. See *California Farmer*, vol. viii, no. 12, 2 October 1857, p. 89.

16. Butterfield, 'The introduction of eucalyptus', p. 150. M. Guilfoyle opened a nursery in Redfern and then The Exotic Nursery at Double Bay, which he operated from 1851 to 1874. He is credited with introducing the camellia and jacaranda to Australia. His son William Robert Guilfoyle (1840–1912) became a famous plant collector and landscape gardener, and succeeded Ferdinand von Mueller as Director of the Melbourne Botanic Gardens in 1873. See R. T. M. Pescott, *W. R. Guilfoyle (1840–1912): The master of landscape*, *ADB*, vol. 4, p. 307; and Norman Hall, *Botanists of the eucalypts*, CSIRO, Melbourne, 1978, p. 63.

17. Butterfield, 'The introduction of eucalyptus', p. 153.

18. On the Carrs and their botanical achievements, see also Victoria Padilla, *Southern California gardens: An illustrated history*, University of California Press, Berkeley, 1961, pp. 214–17.

19. See Jared Farmer, 'Gone native', *Huntington Frontiers*, Spring–Summer 2007, p. 18; and his upcoming book, *If trees could speak*.

20. See Bonyhady, 'Uncle Sam, The Baron and King Edward VII', *The colonial earth*, pp. 248–79.

21. Ezra S. Carr, *The patrons of husbandry on the Pacific coast*, A. L. Bancroft & Co., San Francisco, 1875, p. 430.

22. Bonyhady, *The colonial earth*, p. 71.

23. ibid.

24. Tyrrell, p. 60.

25. Ellwood Cooper, 'Life of Ellwood Cooper', private pub., Santa Barbara, 1913, p. 17.

26. According to Cooper's autobiography, he purchased a part of Rancho Dos Pueblos from Hollister (see his 'Life of Ellwood Cooper'). But Kevin Starr indicates that the circumstances of the purchase may have been more complicated, as Hollister was already involved in lawsuits about the sale of the land. See *Material dreams*, pp. 245–46.

27. Cooper, 'Life of Elwood Cooper', p. 17.

28. ibid., p. 25.

29. ibid., pp. 25–26.

30. ibid., p. 26.

31. A Kinney letter to Lukens in 1900, is exemplary: 'I have had an inquiry from Australia for some of your Sierra Madre Spruce Seed. If you have any of these seeds I should like to obtain some from you.' Letter, Abbot Kinney to Lukens, 14 September 1900, Theodore Lukens Papers, The Huntington Library, San Marino, California.

32. Local Venice historian Jeffrey Stanton makes this claim about Abbot Kinney on his website, under 'Abbot Kinney–Town Founder', viewed 10 April 2007, <http://www.westland.net/venicehistory/>.

33. Abbot Kinney, *Eucalyptus*, R. R. Baumgardt & Co., Los Angeles, 1895, p. 66. This criticism of the eucalypt forests as monotonous mirrors the early Australians' views; see Bonyhady, *The colonial earth*, p. 71.

34. Tyrrell, p. 66.

35. The first eucalyptus stands in Santa Monica were planted by J. W. Scott, on his property in the vicinity of present-day Sixth Street. See Les Storrs, *Santa Monica: Portrait of a city yesterday & today*, SM Bank, Santa Monica, 1974, p. 9.

36. Tyrrell, pp. 66–67; and Robert L. Santos, *The eucalyptus of California: Seeds of good or evil?*, Alley–Cass Publications, Denair, California, 1997, viewed 4 April 2007, <http://library.csustan.edu/bsantos/euctoc.htm>.

37. One of the most important publications on the eucalyptus in Southern California during the early twentieth-century craze was McClatchie's 'Eucalypts cultivated in the United States', Bulletin 35, Bureau of Forestry, US Department of Agriculture, 1903. See a review of McClatchie's essay by Robert E. C. Stearns in *Science*, new series, vol. 17, no. 439, 29 May 1903, pp. 858–60.

38. Kinney, p. 71. In his book, he also states with characteristically firm conviction: 'The planting of trees of various species of Eucalyptus in California has been carried out since January, 1856, when Mr. C. L. Reimer successfully introduced 14 species.' Kinney does not indicate where this information originated. He may have been referring to Edward L. Reimers, a German horticulturist who arrived in California in 1852. Butterfield mentions that Reimers exhibited at San Francisco flower shows in the 1870s, including many acacias, *Grevillea robusta*, Australian tea tree, '12 kinds of eucalyptus' and 'Hakeas of sorts'. See Harry M. Butterfield, 'Builders of California horticulture, Part I', *Journal of the California Horticultural Society*, vol. xxii, no. 1, January 1961, pp. 6–7.

39. *Sunset*, September 1906.

40. See Charles Bearchell and Larry D. Fried, *The San Fernando Valley then and now: An illustrated history*, Windsor Publications, Northridge, California, 1988, p. 103; Santos, 'The eucalyptus of California', pp. 115–16; Darrell Satzman, 'Eucalyptus trees are rancher's legacy', *Los Angeles Times*, 24 August 1997, p. B3/F; and 'Shadow Ranch', written by the owners, 21 November 1936, from the vertical files of the Canoga Park Branch Library, Canoga Park, California.

41. William A. Spalding, *History and reminiscences of Los Angeles City and County, California*, J. R. Finnell & Sons, Los Angeles, [1930], vol. i, p. 204. On Wolfskill's agricultural role in Los Angeles, see Iris Higbie Wilson, *William Wolfskill: Frontier trapper to California ranchero*, A. H. Clark Co.,

Glendale, 1965; Boyle Workman, *The city that grew*, Southland, Los Angeles, 1936, p. 11; and Harry M. Butterfield, 'Builders of California horticulture, part II', *Journal of the California Horticultural Society*, vol. xxii, no. 3, July 1961, pp. 102–07.

42. See *An historical sketch of Los Angeles County, California: From the Spanish occupancy to the founding of the mission San Gabriel Archangel, September 8, 1771, to July 4, 1876*, Los Angeles Centennial Celebration Literary Committee, Louis Lewin & Co., Los Angeles, 1876, p. 71; reprint O. W. Smith, Los Angeles, 1936.

43. 'Häufig sieht man dem prachtvollen Pfefferbaum, der den weissen Pfeffer des Handels liefert; hier wird er aber nicht dazu benützt, sondern ist blos als Zierbaum verwendet und mit dem Eucalyptus globulus (Blue gum) ein Liebling.' Ludwig Salvator, *Eine Blume aus dem Goldenen Lande oder Los Angeles*, Prague, 1878, p. 99 ('The handsome pepper tree that yields the white pepper of commerce, is seen everywhere. Out here, however, it is utilised solely for ornamental purposes. The blue–gum, Eucalyptus globulus, is likewise a favourite.' Salvator, *Los Angeles in the sunny seventies: A flower from a golden land*, B. McCallister & J. Zeitlin, Los Angeles, 1929, p. 75).

44. ibid., p. 100.

45. Ernest Peixotto, 'Italy's message to California', *Sunset*, March 1903, pp. 366–78. Peixotto wrote several articles and books on his ideas about California as Italy, such as *Romantic California*, Scribner, New York, 1917. On Peixotto and his circle of artists, see Scott Shields, *Artists at continent's end: The Monterey Peninsula Art Colony, 1875–1907*, University of California Press, Berkeley, 2006; and Starr, 'Bohemian shores', *Americans and the California dream*, pp. 239–87.

46. *Sunset*, August 1903, back advertising section, after p. 495.

47. *Sunset*, September 1905, p. 105.

48. Street, p. 407.

49. The allusions to California as 'America's Italy' or Mediterranean began from the first American settlement in the region. In a letter dated 12 March 1851, for example, early pioneer Bernard J. Reid wrote to his sister when seeing the Santa Clara Valley, 'of our entry into this land of promise, this Italy and garden spot of All-America ... ' See Mary McDougall Gordon, '"This Italy and garden spot of All-America": A Forty-Niner's letter from the Santa Clara Valley in 1851', *Pacific Historian*, vol. xxix, no. 1, Spring 1985, pp. 4–16.

50. 'His ambition was to gather together in one area plants from countries all around the globe. He decided to go to Southern California, because the climate was well suited to his purpose.' John M. Tucker, 'Francesco Franceschi', *Madroño*, vol. 7, 1943, p. 19.

51. Dr F. Franceschi, *Santa Barbara exotic flora: A handbook of plants from foreign countries grown at Santa Barbara, California*, Santa Barbara, 1895, n.p. [p. 27].

52. ibid., p. 40.

53. Francesco Franceschi Papers, Bancroft Library, University of California, Berkeley, California (BANC MSS 70/11c, introduction to finding aid).

54. David J. McAuliffe, letter to F. Franceschi, 17 February 1908, Franceschi Papers (correspondence and papers, c. 1904–1913), Bancroft Library, University of California, Berkeley, California (BANC MSS 70/11c). In the same letter, McAuliffe wrote, 'I am posting this pkt. & 1 letter by the Vancouver & Brisbane route so you ought to get it in less than a month.'

55. Franceschi, p. 40.

56. 'In my new Garden I am anxious to gather the largest possible number of PALMS which can be grown in this climate. I have already about 120 species planted, but many more are still missing, and among them several from Australia, all of which I believe ought to do well here.' F. Franceschi, letter to Philip MacMahon, director, Brisbane Botanical Gardens, Brisbane, Queensland, 4 October 1905, Franceschi Papers, Bancroft Library, University of California, Berkeley, California (BANC MSS 70/11c).

57. David Fairchild, *The world was my garden: Travels of a plant explorer*, Scribner's, New York, 1944 [c. 1938], p. 119. David Fairchild (1869–1954) was a plant pathologist who worked for the US Department of Agriculture for 30 years. Married to Alexander Graham Bell's daughter, Fairchild made important botanical expeditions around the world and was a major figure in the introduction of exotic species to the United States. The Fairchild Tropical Botanic Garden in Miami, Florida, contains Fairchild's archives. See also Nancy Carol Carter, 'When Dr Fairchild visited Miss Sessions: San Diego 1919', *Journal of San Diego History*, vol. 50, nos. 3 and 4, Summer–Fall 2004, pp. 75–89.

58. Tucker, 'Francesco Franceschi', p. 21.

59. Hattie Beresford, 'The way it was: Franceschi and Eaton landscape Montecito', *Montecito Journal*, 2007, viewed 19 April 2007, <http://www.montecitojournal.net/archive/13/16/946/>.

60. Starr, *Material dreams*, p. 246.

61. Franceschi left Santa Barbara in 1913. He first returned to Italy, where he wrote his book on tropical and semi-tropical fruits. Then, at the age of 72, he took up an appointment by the Italian Government to lay out a nursery in Tripoli, Libya. His sons stayed on in Santa Barbara and carried on the business for some years, living in Montarosio, the house Franceschi had built on his Mission Ridge property. The house, covered in odd sculptural medallions installed by a later owner, is meant to be restored.

62. Elizabeth Pomeroy (foreword), *Theodore Payne in his own words: A voice for California native plants*, Many Moons Press, Pasadena, 2004, n.p.

63. Payne wrote about the Modjeska community in *Life on the Modjeska Ranch in the Gay Nineties*, Los Angeles, 1962, n.p.; most of these reminiscences are reprinted in *Theodore Payne in his own words*. The literature on Modjeska includes her *Memories and impressions of Helena Modjeska: An autobiography*, Macmillan, New York, 1910; and Marion Moore Coleman, *Fair Rosalind: The American career of Helena Modjeska*, Cherry Hill Books, Cheshire, Connecticut, 1969. Modjeska's life in California also served as the source for the characters in Susan Sontag's novel *In America*, Farrar Strauss Giroux, New York, 2000.

64. Quoted in 'Ralph Cornell: Half a century as a Southern California landscape architect', oral history interview by James V. Mink, Fred Douglas and Richard K. Nystrom, 1967, Oral History Program, University of California, Los Angeles, 1970, p. 132.

65. Clayton F. Palmer, Supervisor, Board of Education of the City of Los Angeles, letter to Theodore Payne, 5 May 1932, carbon copy in letter to Sara Bird Field Wood, 8 June 1932, Charles E. S. Wood Papers, The Huntington Library, San Marino, California (MS WD Box 183 [41-42]). Payne continued to write about plants and gardens in California until the end of his life. Today, The Theodore Payne Foundation for Wildflowers & Native Plants, Inc., Sun Valley, California, carries on his work to promote native planting and preservation of native plant life.

66. On the reasons for the end of this phase in eucalypt planting in California, see especially Tyrrell, pp. 77–82.

67. See Mike Dash, *Tulipomania: The story of the world's most coveted flower and the extraordinary passions it aroused*, Three Rivers Press, New York, 1999.

68. Jack London Collection, The Huntington Library, San Marino, California (Ephemera: Ranch Notes [JLE 2587–2671], JL11401).

69. See his description of 'Gathering grevillea seed', *Theodore Payne*, pp. 125–27.

70. ibid., p. 132.

71. 'Eucalyptus timber culture: A treatise on the best methods for sowing the seed, growing the young plants … by Theodore Payne, Eucalyptus Specialist', p. 2. Theodore Payne Papers, Theodore Payne Foundation, Sun Valley, California.

72. Cornell, oral history interview transcript, p. 131.

73. A letter to Payne from Franco Fenzi, Franceschi's son, verifies this fact: 'Interesting for you is the fact that fully 90% of all Eucalyptus now growing all over Tripolitania are the offspring of the original seeds sent by you to my father Dr Franceschi in the late 'teens.' Franco F. Fenzi, letter to Payne, Palermo, Italy, 25 October 1955, Theodore Payne Papers, Theodore Payne Foundation, Sun Valley, California.

74. A document in the Payne archives indicates that as early as January 1910, the Eucalyptus Timber Corporation contacted Payne with details of the Santa Fe's plans to produce ties from plantations of eucalyptus trees and requested information about the appropriate species and methods of planting. 'Interview with O. E. Faulkner of the Santa Fe Railway', Los Angeles, California, 14 January 1910, Theodore Payne Papers, Theodore Payne Foundation, Sun Valley, California.

75. Tyrrell, pp. 82–83.

76. On the Pratt House, see Bosley, pp. 127–32. Payne wrote later that the arboretum was located 'in the canyon back of the Pratt residence. The conditions were not at all satisfactory … I had hopes of persuading them to purchase a larger piece of ground better suited for this purpose', but circumstances prevented its implementation. In 1938, Payne reported, 'there were 58 groups representing 57 kinds, while the total number of kinds, including those that had failed completely, was 67'. From Payne's own 'Report on the Pratt Arboretum of eucalyptus trees, Ojai, Cal.', Pratt Papers, Theodore Payne Foundation, Sun Valley, California.

77. Theodore Payne, letter to F. W. Went, Pasadena, California, 22 September 1956. Copy in Theodore Payne Papers, Theodore Payne Foundation, Sun Valley, California. See also Payne's 'The eucalyptus in California: The eucalyptus centennial', *Golden Gardens*, January 1957, pp. 9–12.

78. Park Superintendent John McLaren 'devoted most of his time between 1911 and 1915 to that project, growing hundreds of trees that he boxed and stored in the Presidio of San Francisco until they would be needed'. Raymond H. Clary, *The making of Golden Gate Park, 1906–1950*, Don't Call it Frisco Press, San Francisco, 1987, p. 39.

79. Eugen Neuhaus, et al., *The art of the exposition: Personal impressions of the architecture, sculpture, mural decorations, color scheme & other aesthetic aspects of the Panama–Pacific International Exposition*, Paul Elder & Co., San Francisco, 1915, p. 52.

80. ibid.

81. Louis Christian Mullgardt, *The architecture and landscape gardening of the exposition*, Paul Elder, San Francisco, 1915, pp. 6–7.

82. Starr, 'Truth unveiled' in Benedict, p. 141.

83. John McLaren, *Gardening in California: Landscape and flower*, A. M. Robertson, San Francisco, 1909, p. 100.

84. Juliet H. James, *Palaces and courts of the exposition*, California Book Co., San Francisco, 1915, pp. iv–v.

85. George Taylor, 'The city of the Golden Gate', *Building*, 12 February 1915, pp. 110–11.

86. Taylor, *Building*, 11 May 1918, p. 49.

87. See Leland G. Stanford, 'San Diego's eucalyptus bubble', *The Journal of San Diego History*, vol. 16, no. 4, Fall 1970, p. 17. See also Nancy Carol Carter, pp. 75–89.

88. 'When the City of San Diego agreed to grant Kate Sessions the right to put a nursery on the northeast corner of City Park in 1892, the City required her to plant 100 trees each year in the park and 300 throughout the City … Kate was, therefore, obliged to use whatever stock she had on hand and not those plants that in 1889 she considered best for the park.' Richard W. Amero, 'A History of the East Side of Balboa Park', viewed 26 April 2007, <http://members.cox.net/ramero/history-east-side-balboa-park.htm>. On Kate Sessions's extraordinary life and career, see Elizabeth MacPhail, *Kate Sessions: Pioneer horticulturist*, San Diego Historical Society, San Diego, 1976; and Florence Christman, *The romance of Balboa Park*, San Diego Historical Society, San Diego, 1985.

89. Neuhaus, *The San Diego Garden Fair*, p. 59.

90. ibid., p. xi.

91. ibid., p. 61.

92. The most abbreviated version of the railroad's failed eucalyptus project appears in Ruth R. Nelson, *Rancho Santa Fe—yesterday and today*, Coast–

Dispatch, Encinitias, California, 1947, pp. 5–6. For more detailed discussion, see Kropp, pp.159–206; and Farmer, *If trees could speak*, forthcoming.

93. For a description of the Osuna *rancho* see Nelson, *Rancho Santa Fe*. A recent issue of *Preservation* magazine mentions that the original Osuna adobe had fallen into disrepair and had been purchased by The Rancho Santa Fe Association; see *Preservation*, May–June 2007, p. 16; and a more complete description of the adobe in *Reflections: Quarterly Newsletter*, Save Our Heritage Organisation, vol. 37, no. 4, Fall 2006.

94. On Requa, see Lucinda Eddy, 'Frank Mead and Richard Requa', in Robert Winter (ed.), *Toward a simpler life*, University of California Press, Berkeley, 1997, pp. 229–40; Sally West, *San Diego Union–Tribune*, 7 September 1997; Lisa Wolff, 'Requa rediscovered', *Decor & Style*, December 1998; Dennis G. Sharp, 'Reconstructed adobe: The Spanish past in the architectural records of the San Diego Historical Society, 1907–1919', *Journal of San Diego History*, vol. 49, nos. 3 and 4, Summer–Fall 2003, pp. 127–30; Parker H. Jackson, 'Richard S. Requa', 'San Diego Biographies', San Diego Historical Society, viewed 23 May 2007, <http://www.sandiegohistory. org/bio/requa/requa.htm>.

95. On Gill, see especially McCoy, *Five California architects*; Kamerling, *Irving Gill*; and Hines, *Irving Gill*.

96. Frank L. Mead had studied in Philadelphia and practised there from 1896 to 1901. After a trip through North Africa photographing architecture, he came to San Diego in 1903, where he joined Irving Gill's firm. He would be Gill's partner for a year before leaving to work as an advocate for Native American causes. He went into partnership with Requa 'upon [his] return from the wilderness'. See Alfred Willis, 'A survey of the surviving buildings of the Krotona Colony in Hollywood', *Architronic*, vol. 8, no. 1, 1998, pp. 3–7, footnote 17, pp. 15–16; and Eddy, 'Frank Mead and Richard Requa'.

97. 'Although Mead and Requa did not participate in the design of any exposition buildings, Goodhue's lavish use of Churrigueresque imagery, exemplified in his California Building, undoubtedly inspired their own taste for the exotic.' Eddy, 'Frank Mead and Richard Requa', p. 232.

98. Willis, 'A survey', p. 3.

99. Eddy, 'Frank Mead and Richard Requa', p. 234.

100. The story of Requa's commission for Ojai was, according to a San Diego newspaper, the result of more mundane circumstances, based on a house Requa had already built in Los Angeles: 'A wholesale grocer from Ohio saw that house, wanted one like it built at Ojai, in Ventura country. A friend of the grocer saw his house, and he in turn was interested. This friend happened to be E. D. Libbey of glass manufacturing fame—and out of this interest grew one of the most unusual projects of its day, the rebuilding of a city.' See *San Diego Union–Tribune*, 27 December 1958, accessed in biographical file on Requa, San Diego Historical Society, Balboa Park, San Diego, California.

101. One of the publications promoting the new Ojai included, along with photographs of the new residences being built, one captioned 'A fine eucalyptus'. See Frank R. Gerard and Franklin H. Perkins, *Ojai the beautiful*, Ojai Publishing Co., Ojai, May 1927, pp. 18–19.

102. Harold G. Gulliver, 'Arbolada in the Ojai Valley of Southern California'; reprint from *Country Life*, September 1924, pp. 4–5.

103. Weitze, pp. 3–17.

104. See Gebhard, 'The Spanish Colonial Revival in Southern California', pp. 131–47; and Gebhard and Robert Winter's descriptions of the various permutations of Spanish/Mediterranean forms. *Architecture in Los Angeles: The complete guide*, Gibbs-Smith, Salt Lake City, 1985, pp. 481, 485, 486.

105. Gebhard, 'The Spanish Colonial Revival in Southern California', p. 131.

106. Stefanos Polyzoides, lecture, 'The Mediterranean Style', Gosney Hall, Polytechnic School, Pasadena, California, 21 March 2007.

107. Kropp, p. 161.

108. Braunton, n.d.

109. On Braunton, see 'Ernest Braunton: In memoriam, August 21, 1867–March 22, 1945', *California Avocado Society Yearbook*, vol. 30, 1945, pp. 106–07; viewed 11 March 2008, <http://www. avocadosource.com/CAS_Yearbooks/CAS_30_1945/ CAS_1945_PG_106–107.pdf.>

110. Nelson, p. 55.

111. ibid.

112. See Requa's *Architectural details of Spain and the Mediterranean*, J. H. Jansen, Cleveland, Ohio, 1926 and *Old World inspiration for American architecture*, Monolith Portland Cement Co., Los Angeles, 1929. Both publications appeared under the auspices of the Los Angeles company of Monolith Portland Cement—an indication of the

connection made in California between cement and concrete construction and Mediterranean styles. As a source for Rancho Santa Fe Style, see particularly *Architectural details*, section a, plate 3, *A roadside cottage near Algeciras, southern Spain*, and section a, plate 5, *A road overseer's cottage, Province of Cadiz, southern Spain*.

113. See Lucinda Liggett Eddy, 'Lilian Jenette Rice: Search for a regional identity', *Journal of San Diego History*, vol. 29, no. 4, Fall 1983, pp. 262–85.

114. Patricia Gebhard and Kathryn Masson, *The Santa Barbara County Courthouse*, Daniel & Daniel, Santa Barbara, 2001, p. 19.

115. ibid., p. 29.

116. Quoted in ibid., p. 29.

117. The most striking landscaping element at the Santa Barbara County Courthouse, along with the numerous palm trees, are 'two towering araucaria trees, the bunya-bunya ... and the Norfolk Island pine ...' In ibid., p. 57.

118. Starr, *Material dreams*, p. 291.

119. On George Washington Smith, see David Gebhard, *George Washington Smith, 1876–1930: The Spanish Colonial Revival in California*, University of California, Santa Barbara Art Gallery, Santa Barbara, 1964; David Gebhard, *Lutah Maria Riggs*, Capra Press, Santa Barbara, 1992; Marc Appleton (ed.), *George Washington Smith: An architect's scrapbook*, Tailwater Press, Los Angeles, 2001; Rexford Newcomb, *Mediterranean domestic architecture in the United States*, J. H. Jansen, Cleveland, 1928; reprint Acanthus Press, New York, 1999, pp. 42–68, 188–89; and David F. Myrick, *Montecito and Santa Barbara*, 2 vols, Trans–Anglo Books, Glendale, 1988 and 1991.

120. Of the myriad of books published in the 1920s and 1930s on the topic of Spanish, Spanish Colonial and Mexican architecture for the purposes of architectural inspiration for California architects, all of the following were consulted in the period by the architects of the Los Angeles County Architectural Office: Austin Whittlesey, *The Renaissance architecture of central and northern Spain: A collection of photographs and measured drawings*, Architectural Book Pub. Co., New York, 1920; Alfred C. Bossom, *An architectural pilgrimage in old Mexico*, C. Scribner's Sons, New York, 1924; Garrett Van Pelt, Jr, *Old architecture of southern Mexico*, J. H. Jansen, Cleveland , 1926; Atlee B. Ayres, *Mexican architecture: Domestic, civil & ecclesiastical*, William Helburn, Inc., New York, 1926; Rexford Newcomb, *The Spanish house for America: Its design, furnishing, and garden*, J. B. Lippincott Co., London and Philadelphia, 1927; and G. Richard Garrison and George W. Rustay, *Mexican houses: A book of photographs & measured drawings*, Architectural Book Publishing Company, Inc., New York, 1930.

121. See John Ott, 'Landscapes of consumption: Auto tourism and visual culture in California, 1920–1940', in Stephanie Barron, et al., *Reading California: Art, image, and identity, 1900–2000*, University of California Press, Berkeley, 2000, pp. 50–67. For a first-hand history of The Automobile Club of Southern California, see Phil Townsend Hanna, *The wheel and the bell: The story of the first fifty years of The Automobile Club of Southern California*, The Pacific Press, Los Angeles, 1950. Later histories of the club include Richard R. Mathison, *Three cars in every garage: A motorist's history of the automobile and the automobile club in Southern California*, Doubleday, New York, 1968; and Kathy Talley-Jones and Letitia Burns O'Connor, *The road ahead: The Automobile Club of Southern California, 1900–2000*, Automobile Club, Los Angeles, 2000.

122. Starr, *Material dreams*, p. 314.

123. See Talley-Jones and O'Connor, pp. 41–42.

124. Ott, p. 53.

125. Charles Hamilton Owens began as a sketch artist in San Francisco and worked for some years in New York City. From 1906 he was an illustrator for the *Los Angeles Times*. In addition to numerous illustrations for *Touring Topics* and other regional magazines, Owens also made black-and-white drawings for local history books such as Seewerker and Jones, *Nuestro pueblo: Los Angeles, city of romance*, Houghton Mifflin, Boston, 1940. See Edan Hughes, *Artists in California, 1786–1940*, Hughes Publication Co., San Francisco, 1986, p. 418; *Who was who in American art, 1564–1975*, Soundview Press, Madison, CT, 1999, vol. ii, p. 2490; and Nancy Dustin Wall Moure, *Dictionary of art and artists in Southern California before 1930*, private pub., Los Angeles, 1975.

126. See Watters, vol. ii, p. 353.

127. On Geritz, see Michael Dawson (ed.), *et. al, LA's early moderns: Art, architecture, photography*, Balcony Press, Los Angeles, 2003, pp. 41, 53, 55; *DAA*, p. 98; and Hughes, p. 424.

128. Fred Archer is credited with devising the use of photographic backgrounds in movie titles, as well as using animation in titles. On Archer, see Michael G. Wilson and Dennis Reed, *Pictorialism*

in California, The Getty Museum, San Marino and The Henry E. Huntington Library, Malibu, 1994; and Michael Dawson, 'Fred Archer: A Southern California innovator', in Victoria Dailey, Natalie Shivers and Michael Dawson, *LA's early moderns: Art, architecture, photography*, Balcony Press, Los Angeles, 2003, pp. 264–65.

129. Karl Struss had studied with Clarence White and other Photo-Secessionists in New York before coming to California in 1919; he went on to be a famous cinematographer in Hollywood, filming such works as *Ben Hur* (1925) and *Dr Jekyll and Mr Hyde* (1931). See *Karl Struss, man with a camera: The artist–photographer in New York and Hollywood*, Cranbrook Academy of Art/Museum, Bloomfield Hills, Michigan, 1976; and Barbara McCandless, *New York to Hollywood: The photography of Karl Struss*, Amon Carter Museum and University of New Mexico Press, Fort Worth, 1995.

130. *Touring Topics*, vol. 16, no. 7, July 1924, Rotagravure Section.

131. Starr, *Material dreams*, p. 313. On Hanna, see also Dawson, pp. 56–57, 280–83.

132. Dawson, p. 281.

133. ibid., pp. 252–57; and Ott, pp. 58–65.

134. *Touring Topics*, February 1929, pp. 38–43, 48.

135. *Touring Topics*, March 1928, p. 41.

136. Ott, p. 58.

137. 'Aside from Edward Weston, only Will Connell was involved in a highly varied group of intellectual and artistic circles. Connell's work not only bridges the shift of fine art photography from pictorialism to modernism, but also makes a transition from the intellectual communities of the art world to the practice of commercial photography.' Dawson, p. 280. In 1941, no doubt inspired by the continuing craze for California's Spanish past, Connell produced a photobook called *The missions of California*, illustrated with his own photographs of all the missions.

138. Dawson, p. 56; Moure, *Dictionary of art and artists*, pp. 170–71; and Starr, *Material dreams*, p. 320.

139. *Touring Topics*, October 1925, p. 20.

140. Hanna writes about Mannheim in the same issue, p. 3.

141. The National Library of Australia has the entire run of *Touring Topics/Westways*, although there is no indication of whether the magazine was known in Australia in the 1920s and 1930s, or was purchased at a later date.

142. Talley–Jones and O'Connor, p. 84.

143. Starr, *Material dreams*, p. 305.

144. Merle Armitage, *West Coaster*, 1 September 1928. Armitage wrote several books, including an autobiography in which he comments again about the smallness of Los Angeles culture in the 1920s, including 'painters myopically fascinated by eucalyptus trees'. See Armitage, *Accent on life*, Iowa State University Press, Ames, 1965. Armitage also figures prominently in Dawson's book, *LA's early moderns*; see especially Chapter 6, 'Edward Weston and Merle Armitage', pp. 252–57, which discusses Armitage's role in the publication of 'one of the first monographs on photography of the modern era', *Edward Weston*, designed by Armitage for E. Weyhe in 1932 (p. 257).

145. See Nancy Dustin Wall Moure, 'Impressionism, post–impressionism, and the Eucalyptus School in Southern California', in Ruth Westphal, *Plein air painters of California: The Southland*, Westphal Publishing, Irvine, 1982, pp. 34–35.

146. McWilliams, *Southern California*, rev. edn, 1973, p. 358.

147. ibid., p. 360.

148. For a discussion of architectural historian Esther McCoy's standard championing of the modernist view and dismissal of California's Spanish Style adaptations, see William Alexander McClung, *Landscapes of desire: Anglo mythologies of Los Angeles*, University of California Press, Berkeley, 2000, pp. 98–106.

149. Stephanos Polyzoides, 'The Mediterranean Style', lecture, Gosney Hall, Polytechnic School, Pasadena, 21 March 2007.

150. Leon Whitson, '20s Spanish Style needs no revival: red tile roofs, white walls endure as Southland favorites', *Los Angeles Times*, 5 March 1989, section VIII, p. 26; quoted in McClung, p. 104.

151. Polyzoides, lecture, 21 March 2007.

1920s: Australia and Spanish Style architecture

We should turn to the Mediterranean, which is the cradle of some of the finest architecture ever produced, with the exception of the great Gothic work of Northern France and Europe. We should turn to Italy and to Spain, particularly to Spain, and also across the Pacific to California and Mexico.
—Leslie Wilkinson, 'Domestic architecture', *Building*, 1921.[1]

~

It is hard to typify houses as belonging to a certain style, although it has become a habit to refer to any cream house as being 'Spanish' and the red brick type to 'bungalow' ... Too much stress cannot be given to the importance of laying out the garden in conjunction with the house, and also the preservation of trees. Nature can do far more towards beautifying the house and environments than man.
—John R. Brogan, *101 Australian homes designed by John R. Brogan*, 1935.[2]

~

As the present century advanced into the 'twenties and 'thirties, new devices for the dissemination of popular culture continued to draw Australia steadily into the American sphere of influence, reinforcing the effects of the printed word and picture ... Hollywood became the glamorous world capital of the movies while Sydneysiders settled into their pseudo-Pasadena bungalows. California! ... it seemed to be everything that southeastern Australia might one day become, given more people, more money and more dynamic enterprise.
—Richard Apperly, 'Sydney Houses 1914—1939', 1972.[3]

Across the Pacific, in the eucalypt's native environment, the adaptation of Mediterranean styles of architecture and Mediterranean-inspired landscape design—the styles that in California incorporated so many Australian trees and other flora—followed a different aesthetic trajectory. Ironically, the gum tree and other native plants played a much smaller part in the 'Mediterraneanising' process. While Australians did not have the direct example of the California missions or proximity to Mexico and Spanish America to justify as clearly a symbolic adherence to Hispanic American/Mediterranean styles, Australians in the 1920s still looked directly to Southern California, at least on a popular level, for many of their markers of modernity. Through magazines, posters and films, they

were aware of the popular manifestations of the Hispanic and Mediterranean-inspired modes showing up everywhere on the other side of the Pacific. In the hands of many Australian architects and builders, these fashionable adaptations had as much to do with California—and, in its final manifestations, with Hollywood—as it did with any direct appropriation of the building forms of the Mediterranean region.

In such 'lifestyle' publications as *The Home* and *The Australian Home Beautiful*, reproduced images presented to the middle-class public a popularised kind of modernity and stylishness in art, architecture and garden design which by the end of the decade focused most frequently on a Mediterranean look. These ideas, manifested in the images these magazines and books reproduced of Southern Californian *haciendas* and their landscaped grounds, also led Australians to begin to modify their feelings about the native Australian landscape and its flora as a source of aesthetic pleasure in gardens. Even more so than with the California bungalow, Australian architects and designers found in Spanish Style houses and Mediterranean gardens an aesthetic attitude that could impart a sense of these Pacific regions' shared climate, geographical similarities and an informal outlook to life and culture.

Despite ongoing communication and cultural exchange between the two Pacific coasts, Australia in the 1920s was a very different place than exuberant, rapidly growing, California. The country's losses in World War I were devastating to the Australian economy and to their confidence as a nation. The experience of the ANZACS at Gallipoli and elsewhere may have 'forged a national identity',[4] but it also shattered much of Australia's sense of independence. Many communities retreated into a greater dependence on their ties to the British Empire.

As the writer David Malouf put it, 'Through most of the 1920s and 1930s we seem to have been too stunned to take any sort of initiative … We drew in behind our ocean wall and sulked. We turned our back on everything foreign or new or contemporary.'[5] In this kind of national atmosphere, the 'Americanisation' of popular culture was considered by many a danger to morality and to true Australianness.[6]

Despite such a gloomy economic and psychic outlook, the rise of a jazzy popular culture emanating out of America and transmitted through new forms of communication could not be stopped.[7] The appearance in Australia of American magazines, illustrated books, films, radio programs and gadgets led to enormous changes in the country's social and cultural life. From the beginning of the century, and especially after World War I, modern mass media and technology were adopted enthusiastically throughout the country. Artistically, creative subcultures in the cities did produce a semblance of 'Roaring Twenties' bohemianism and artistic society, most clearly linked to literary and aesthetic developments in Europe, but aware as well of the literary figures of San Francisco's Bohemian Club and artists at colonies such as Carmel.[8] Publisher Sydney Ure Smith (1887–1949) in Sydney promoted modern art and sophisticated taste in all forms in his publications *Art in Australia* and especially in *The Home* (1920–1942). Described as a 'taste-maker for a modern lifestyle in Australia',[9] this latter journal was geared toward an upmarket clientele, emulating such American publications as *Vogue* and *Vanity Fair*, with great emphasis on modern design, fashion photography and 'tasteful' cover art. Ure Smith's friend and associate Charles Lloyd Jones (1878–1958), proprietor of Sydney's leading department store David Jones, was also an active patron of the arts, providing an art gallery in his elegant Elizabeth Street store, where some of the first exhibits of modern

art in Australia were held.[10] Jones was particularly aware of the latest American trends in advertising techniques and applied his creativity to commercial designs for the store and in publications. Interestingly, then, these important purveyors of 'high culture' in this period came from the worlds of publishing, retail and advertising rather than the academy or artistic life.

As a 'new' young society in a sunny clime that embraced modern technology, Australians were ready in this decade to be up-to-date with all the modern conveniences. By 1920, they had taken to the automobile with as much fervour as Californians. The Royal Automobile Club of Australia was founded in 1903. Its magazine, *The Open Road*, while not as graphically ambitious as The Automobile Club of Southern California's *Touring Topics*, nonetheless promoted motor tourism and compared Australia's highways and roadside conveniences with those in the United States. Commercial radio began broadcasts in Sydney in 1924, and in 1927, radio stations were already transmitting programs from Britain. By 1929, the Australian Broadcasting Company (ABC) was formed, reaching national audiences by 1932 when it was nationalised. Particularly prized by those who lived in the vast expanses of the country's outback, these services brought access to a world of music, information and sophistication that lifted them out of cultural isolation and connected them to urban Australia in a way that had never happened before.[11]

Most importantly in terms of an absorption of popular aesthetic images, Australians became the most enthusiastic moviegoers in the world. A thriving homegrown film industry in the early years of the century was by the 1920s nearly entirely eclipsed by Hollywood films through the American studios' control of distribution and movie houses.[12] Consequently, features about Hollywood film stars and their glamorous lives and surroundings in California became a major part of the lifestyle magazines that also highlighted in their pages overseas architecture and home decor.

While these popular Australian magazines would by the middle of the 1920s take up Spanish modes as an appropriate style for small suburban houses and gardens, the first significant impetus for 'Mediterranean' architecture appeared in the country in more suitably sophisticated applications.[13] In 1918, only a few months before the end of World War I, a 35-year-old Englishman arrived to take up a chair at The University of Sydney as the country's first Professor of Architecture. Leslie Wilkinson (1882–1973) was already a well-established architect who had studied at the Royal Academy and travelled extensively throughout Europe, especially in France, Italy and Spain. He was a brilliant draughtsman who had in the early years of the new century spent his time on a travelling scholarship measuring and drawing Renaissance buildings. He produced beautiful watercolours and drawings of his favourite monuments in southern Europe. The church of Santa Maria della Salute in Venice, which he rendered in pencil and wash in 1906, remained one of his favourite buildings throughout his life.

Wilkinson, then, was well-steeped in the aesthetics of Mediterranean architecture and attracted to its classical simplicity by the time he came to Australia. Most importantly, his experience in the warm climate of southern Europe taught Wilkinson the importance of an architecture appropriate to the country's landscape and levels of light. This conviction led him from the beginning of his time in the antipodes to champion Mediterranean style as the most sensible choice for home building, as well as for public structures, in the salubrious sunshine of the Australian continent.

Wilkinson's implementation of a classically inspired, traditional architecture was not

rigidly dogmatic nor purist in its final appearance. While adhering firmly to a romantic's resistance to modernist developments—he maligned the 'Bolshevistics' of most contemporary architectural developments[14]—Wilkinson was not averse to other architects' work, nor was he inflexibly English or European in his approach to building. He admired, for example, the classical simplicity and landscape design of such Americans as the Bostonian Charles A. Platt (1861–1933). He had even gone to Boston to visit Platt when he travelled through America en route to Australia. Once in Australia, according to his grandson David, Wilkinson prized his copy of *Monograph of the work of Charles A Platt*:[15] 'it was referred to from time to time when he was designing major residential projects'.[16]

Wilkinson's first building in his new city was his own residence on the Sydney Harbour in Vaucluse, named 'Greenway', in honour of Australia's early Georgian architect Francis Greenway (1777–1837). Here he incorporated many Mediterranean features that would characterise his most successful houses: groin-vaulted arcades, loggias, French windows, wooden-beamed ceilings, facades and surfaces painted in light colours, and classic proportions.

Most importantly, Wilkinson considered every aspect of the house's physical location to take advantage of the natural contours of the land. As David Wilkinson has written, 'it is a house in harmony with its setting, with the rocks and trees of the original site left undisturbed'.[17] He even chose the colour for the house's exterior walls to match the pink of the native angophora trees on the property. In his consideration of views from his buildings and its proper setting amidst natural surroundings, Wilkinson was indebted to the landscape design of Platt. Platt's formulations about Italian gardens had appeared in *Harper's New Monthly Magazine* in 1893 and in a

compilation of the articles in 1894; they were also discussed in the monograph on Platt that Wilkinson owned.[18]

But Wilkinson's most obvious inspiration was the Australian landscape itself. His colleague George Molnar later provided a revealing anecdote about his choice of colours for his houses:

The Prof picked up some gumtree bark. 'What a pleasant colour. Pink-brown. A building among

Fig. 7.01 Leslie Wilkinson (arch.), Greenway, Vaucluse, Sydney, New South Wales, 1923. Photograph: courtesy of Anne Higham, RAIA (NSW).

trees should either be contrasting, standing out, or it should be part of the colour scheme of the trees. Some people paint their houses green, but that is wrong. Brown-pink. I will have my next house painted that colour.' And so he did. The following year a great number of the harbourside villas, formerly white, pink or cream, turned slowly gumbark colour.[19]

Wilkinson's elegant solutions to building on Sydney's harbourside lots and in the newly established exclusive suburbs such as Bellevue Hill endeared him especially to the city's upper classes. These clients were seeking appropriately grand houses that would demonstrate their affluent yet casual lifestyle. He built several of these houses in and around Sydney from the 1920s into the 1960s, each displaying his adaptation of Mediterranean proportion and a concern for the surrounding gardens and natural vegetation.

The Dowling family home on Rose Bay Avenue in Bellevue Hill (1924) is exemplary of his approach as it appeared in his first years in Australia. Interestingly, this house was completed in collaboration with a young John D. Moore. Moore was the architect who had worked with Bertram Goodhue in New York and had travelled in Mexico in the 1910s.[20] In the same year he worked with Wilkinson on the Dowling House, he wrote a memorial appreciation for Goodhue in Sydney's *Architecture* magazine[21]—evidence that at least through conversations with Moore, Wilkinson would have been aware of Goodhue's architectural ideas. With its pergola covered in bougainvillea and its views to Rose Bay, the residence reveals Wilkinson's

Fig. 7.02 Leslie Wilkinson and **John D. Moore** (archs), Dowling House, Rose Bay Avenue, Bellevue Hill, Sydney, New South Wales, 1924. Photograph: courtesy of David Wilkinson, Melbourne.

characteristic Mediterranean stylings, as well as his penchant, in the manner of Charles Platt, for integrating the structure with the garden (see Fig. 7.02 on page 297).

Wilkinson applied these same principles to apartment buildings such as Carinya (1934), with its lightly coloured walls sitting amidst all the dark brick of neighbouring buildings.[22] He also created several bucolic country estates, including Shadowood (1927, now San Michele) in Bowral in the Southern Highlands of New South Wales that he so loved. The house with courtyard appears, in early photographs by the great Sydney photographer Harold Cazneaux, to sit in its bush environment, surrounded by trees, as if it were 200 years old. Its sprawling single-storey plan and arched entrance to the courtyard, as well as the use of red roof tiles, makes Shadowood appear strongly reminiscent of the houses being built at the same time at

Rancho Santa Fe in San Diego (see Fig. 6.20 on page 275).

Wilkinson was also at times able to persuade the notoriously conservative bureaucrats of The University of Sydney to allow him to apply these Mediterranean principles to some of the buildings he designed for the campus. He had conceived integrated plans for the campus in its entirety—plans that never materialised. Wilkinson would have an often rocky relationship with the university administration over aesthetic and professional differences; nonetheless, as much because of his many pronouncements on the subject as for actual building projects, he was soon considered an authority on campus design.[23] His buildings along Science Road for the campus, never completed as Wilkinson had initially proposed, and his finished Physics Building on Physics Road presented most dramatically

Fig. 7.03 Leslie Wilkinson (arch.), Shadowood, Bowral, NSW, 1928. Photograph: Harold Cazneaux, 1933. Courtesy of National Library of Australia, Canberra.

Fig. 7.04 Leslie Wilkinson
(arch.), Physics Building,
Physics Road, University
of Sydney, c. 1925.
Courtesy of University of
Sydney Archives.

the validity of Mediterranean-inspired design for institutional buildings in Australia's warm climate.

In all cases, Wilkinson talked about his work as creating 'present-day Australian architecture'.[24] Committed as he was to traditional architectural modes, Wilkinson saw himself as creating a distinctly Australian approach that addressed modern needs and modern lifestyles. Architects like Wilkinson and those who worked with him did not think of themselves as 'period revivalists' or historicists, but that they were contributing to the development of new building types, with enduring aesthetic solutions appropriate to a new age.

Other Sydney architects, also seeking the most fruitful sources toward the creation of an Australian architecture, could not help but be influenced by Wilkinson's example. They, too, would have been aware through magazines and travel of the most up-to-date Mediterranean modes coming out of America (Florida as well as California), but Wilkinson certainly provided the most immediate encouragement to venture into adaptations of these period styles. In some cases, the new Professor worked in collaboration with these younger architects,

as he did on the Dowling House with John Moore. Another protégé was Bertrand James Waterhouse (1876–1975), who worked with Wilkinson on some of the university buildings.[25] Inspired by Wilkinson's designs for houses on Sydney Harbour, Waterhouse built many houses around the region, most famously Nutcote, the residence for the famous children's writer May Gibbs and probably the most recognisably Spanish Style house in Sydney (see Fig. 7.05 on page 300).

The offices of Peddle, Thorp, & Walker—enthusiastic adherents of the California bungalow after Peddle's stay in Pasadena in the 1910s—also began specialising in Spanish Style homes and apartment buildings by the middle of the 1920s, as Thorp's influence on the firm's directions began to overtake the more Craftsman-era concerns of an ageing James Peddle (see Fig. 7.06 on page 301).[26] Here, too, the presence of new partner F. H. E. Walker, who had worked in the United States in Goodhue's offices at the time Goodhue was designing the Nebraska State Capitol and the Los Angeles Public Library, would have had an impact on the move toward Mediterranean modes.

Wilkinson also shared many philosophical ideas about appropriate architecture for Australia with the other leading thinker in Sydney's architectural world, William Hardy Wilson (1881–1955). Wilson was the first person to welcome Wilkinson to Australia, and they remained friends and colleagues throughout their lives. Wilson was even more directly impressed by American architecture, both historic and contemporary, than Wilkinson had been, for he had spent several months there. In his 1919 article on domestic architecture in Australia, he proclaimed that contemporary American architects would surpass in their creativity the work of the Renaissance Italians.[27] What had struck Wilson so deeply in America was colonial architecture, and the restoration work carried out at places such as Williamsburg, Virginia. Inspired by these efforts, Wilson published his own study of Australian colonial houses, *Old colonial architecture in New South Wales and Tasmania.* He had already built his own house, Purulia (1916), along Colonial Georgian lines. Wilson subsequently travelled to China, returning convinced that the East provided the most logical source of inspiration for Australian builders (see fig 7.07 on page 302).

In all this seeking for relevant examples in other places and in period styles, Wilson shared with Wilkinson a sincere desire to devise for Australia its own aesthetics of place. A later description of Wilson could be applied as easily to Wilkinson: 'A key aspect of his thinking is the way Australia is defined in relation to a set of elsewheres.'[28] Along with Wilkinson's Mediterraneanism, Wilson's championing of colonial modes, both American and Australian, provided the most fruitful stylistic idioms for Sydney architects in the 1920s and 1930s.

Another vivid example of these 'elsewheres'—the eclectic sources affecting young Australian architects in the 1920s—appears in

Fig. 7.05 B. J. **Waterhouse** (arch.), Nutcote, Sydney, New South Wales, 1925. Author's photograph.

the correspondence between John D. Moore and his revered mentor Bertram Goodhue while Moore was serving on the Front in France during World War I. Moore and the older Goodhue carried on lively discussions, not only about the current political situation, but about architectural ideas as well. Here Moore expressed hopes for his practice once he returned to Sydney:

Architecture and all that kind of thing seems to me to be something very far away, almost indefinate [*sic*] but having three attractions still. All about the same value, they are the Georgian of England. The earlier American stuff one sees in the Eastern states and thirdly a romantic jumble of colonial Spanish, Northern African, and Persian. If I land back in Australia with this to draw from, I might get something suitable to that climate.[29]

About this house one finds the most charming and reposeful corners.

Fig. 7.06 Peddle, Thorp, & Walker (archs), house for L. Waterhouse, Sydney, New South Wales. Photograph: Harold Cazneaux in *The Australian Home Beautiful*, 7 June 1926, p. 15. Courtesy of Caroline Simpson Library and Research Collection, Historic Houses Trust of New South Wales, Sydney.

Just as Californian architects were inspired by the past in their search for modern styles suitable for their unique landscape and sunny climate, so did ambitious Australians welcome the efforts of Wilkinson and others who looked to 'foreign' models to create an appropriate mode of building for their own country.

Wilkinson's position of authority as the nation's first Professor of Architecture began to have an impact nationally, thus spreading the Mediterranean ideal across the continent. When the University of Western Australia in Perth sought to implement a comprehensive design plan for its fledgling campus in 1926, Wilkinson served as advisor. An international competition for design of the campus in 1914—inspired by a similar and well-publicised competition in 1899 for the Berkeley campus in California[30]—had selected Melbourne architect Harold Desbrowe-Annear as the designer of the campus. Annear was one of the leading voices for a 'modern' approach to an Australian architectural style. He, too, wrote an essay for the 1919 special architecture issue of *Art and Australia* where Wilkinson and Hardy

Wilson expressed their views on future architectural directions. His ideas for Perth strongly incorporated 'a landscape sensibility'[31], but the war and death of the university's Chancellor and main supporter of the campaign, John Winthrop Hackett (1848–1916), caused the plan to languish. By the mid-1920s, a new initiative led the university to call for another competition. At this point Wilkinson's advice was sought to create an overall campus plan. Here he strongly advised integrating landscape aspects into the design from which the winners of the competition would work. His greatest contribution in this plan was that he simply elaborated on Annear's original scheme to enhance the natural setting along the Swan River.

The winners of the second competition were the Melbourne architects Rodney Alsop (1881–1932) and Conrad Sayce (1888–1935).[32] Informed by Wilkinson and Annear's opinions about the site and by the opportunity to implement their own ideas concerning the appropriateness of Mediterranean elements for Australia's climate, Alsop and Sayce created by the early 1930s an eclectic set of buildings that have been variously described as Moorish/Renaissance,[33] 'Inter-War Romanesque'[34] and 'essentially Mediterranean'.[35] Of greatest importance is that these buildings set the standard for future development of the Western Australian campus, 'arguably the nation's most beautiful',[36] in which the landscaping became an integral factor. Wilkinson's role in emphasising the importance of landscape elements, along with Alsop's own adherence to Mediterranean ideals, influenced this important and coherent architectural statement—one in which the references to California are particularly cogent.

It cannot be entirely coincidental that the university's 'signature building', Winthrop Hall (see Fig. 7.08 on page 303), completed in 1931, bears a decided resemblance to Royce

Hall, the first building at the new campus of the University of California at Los Angeles (UCLA). Built at precisely the same time (1928–1929) by the Los Angeles firm of Allison & Allison,[37] its style was described as 'the Lombardian type of the Italian Romanesque style' (see Fig. 7.09 on page 304).[38]

Architects and administrators at both campuses took seriously the design of the landscape as important to the symbolic intentions that the university was to express. As Charles Moore wrote about UCLA, the designs for the grounds by Ralph Cornell and others 'transcend the limits of a botanical garden; the whole campus comes off as a genuinely bountiful California landscape'.[39] Further, the development of Westwood Village around the UCLA campus was considered as an integral part of the university's design, and its buildings and the accompanying landscaping were meant to evoke a 'Spanish style and especially of the type known as Monterey'.[40]

Landscape architect Christopher Vernon emphasises the same landscaping effect in Perth, based on Wilkinson's initial 1927 conception, when he writes that '[u]nlike campuses elsewhere in the nation, the University of Western Australia's "signature" is inscribed not by individual buildings, but by a sense of the collective campus landscape'.[41] (See Fig. 7.10 on page 305.) The frequently repeated comparisons between the 'feeling' of Perth and Californian cities originate in these symbolically resonant Mediterranean styles created in both places in the 1920s.[42]

Part of UCLA's 'bountiful California landscape' included famous stands of eucalypts—ones that still occupy a significant place on the edges of the campus and in the hearts of many Angelenos (see Fig. 7.11 on page 306). In Perth, while some native plants are incorporated into the overall vegetation, its Mediterranean references are more appropriately tied to the planting of cypress trees and

other imported species (although architectural historian Robin Boyd maintains that Perth was the most likely place for native Australian plants to be used ornamentally).[43] In the 1920s and 1930s, most Australians were not yet entirely ready to embrace their native flora as picturesque or appropriate for grand landscaping designs, and Mediterranean gardens did not usually incorporate Australian plants. Despite Wilkinson's admiration for the colours of the tree, the eucalypt, then, was not tied to a Spanish Style aesthetic as had serendipitously happened in California at this time. Whereas the gum tree in California initially appeared

Fig. 7.07 William Hardy Wilson (arch.), corner of a garden at Eryldene, Gordon, New South Wales, 1930. Photograph: E. O. Hoppé. © E. O. Hoppé Estate, Curatorial Assistance, Inc., Los Angeles, California.

Fig. 7.08 Alsop & Sayce
(archs), view of Winthrop
Hall from the south,
c. 1933. University
of Western Australia
Archives. Courtesy of West
Australian Newspapers
Ltd.

'exotic' in the landscape and thus appropriate for a Mediterranean design, in Australia, the tree's ubiquity contributed for a long time to its relegation to a role as an aesthetically monotonous plant.

In his famous book *Australia's home*, Robin Boyd (1919–1971) wrote '[n]o decorative fashion of the twentieth century owed as much to one man as did the Spanish Mission to Professor Leslie Wilkinson of the University of Sydney'.[44] This single sentence reveals several aspects of the debate about architectural 'eclecticism' in the 1920s that has hampered a true appraisal of the decade's influences and accomplishments. Writing at a time when modernism reigned in architecture—International Style-brand modernism arrived in Australia in the late 1940s and early 1950s—Boyd downplayed Wilkinson's and others' earlier attempts to create an appropriately Australian style as mere 'decorative fashion'. (Freeland, too, in his book dismisses most of this work as superficial and eventually debased.)[45] Further, Boyd applied the misleading and inaccurate term of 'Spanish Mission' to the Professor's work. Wilkinson never created anything that could rightfully be labelled as 'Mission Style', nor did his architectural followers. More than anything, his brand of Mediterranean-style house has been accurately defined as 'a regionalisation of Georgian domestic architecture',[46] in keeping with the ideas that he and people like Hardy Wilson had expressed in their 1919 essays.[47]

Despite the inaccuracy of the 'Spanish Mission' term, its frequent use by Australian writers, both at the time and subsequently, indicates that the *assumed* source for the entire gamut of these stylistic elements was California, or at least Spanish America, rather than the Mediterranean region itself. Indeed, very little true Mission Style ever appeared in the antipodes,[48] although some stylistic elements associated with the Californian examples—a scalloped parapet, quatrefoil windows and low-pitched tile roofs—were incorporated into the more popularised Spanish styles in the cities (see Fig. 7.12 on page 307).[49]

Even more so than happened in California, the confusion and misinterpretations surrounding the use of architectural terminology to describe Mediterranean and Spanish American-influenced styles prevailed in the Australian popular press, although

many Australian writers were aware of the distinctions and went to some lengths to delineate the differences. Boyd's summation of Wilkinson's work as 'Spanish Mission' does at least raise the important point that even such a serious, European-trained, architect as Wilkinson was seen to be inspired during the 1920s by the examples of Mediterranean/ Hispanic adaptations originating on the American West Coast.

In the 'Special Number' of *Art in Australia* titled *Domestic architecture in Australia* (1919), Wilkinson wrote a chapter, along with fellow architects Hardy Wilson, Desbrowe-Annear, W. S. Bagot (1880–1963) and R. S. Dods (1868–1920). Describing in this issue his opinions on how to develop an Australian style—apparently written only months after arriving in the country—Wilkinson acknowledged straight away that adaptations of the

Fig. 7.09 Allison & Allison (archs), Royce Hall, University of California at Los Angeles, Los Angeles, California, 1928–29. Thelner Barton Hoover (UCLA 1930) and Louise Brown Hoover (UCLA 1930) Photographic Collection, UCLA University Archives, Los Angeles, California.

Fig. 7.10 Alsop & Sayce (archs), University of Western Australia campus aerial view, Court of Honour, Perth, Australia, 1935. University of Western Australia Archives. Courtesy of West Australian Newspapers Ltd.

Mediterranean styles rather than a continued reference to England offered the most logical source of inspiration, as Australia's Pacific Rim neighbour had already recognised:

> From a brief study of domestic architecture in Australia it is evident that the trend of development has followed closely that of English work. All are there, the good and bad. In addition there has latterly been added a manner of home building showing influences from both sides of the Pacific ... Although it is generally granted that most English domestic work reaches a high standard, the climatic and other conditions here are such that considerable modifications must be made in adapting it to these new circumstances. And is it certain that it is wise to attempt to follow Northern methods of building under conditions so dissimilar? Geography suggests that the shores of the Mediterranean may be richer in suggestion, or the Californian coast manner so largely derived therefrom.[50]

Wilkinson's source for such knowledge would have been the books and journals, both American and Australian, that depicted these villas and country estates, as well as conversations with colleagues who had travelled and studied in the western United States.

Another intriguing example of Mediterranean elements appearing in significant Australian buildings in the 1920s centres on the nation's newborn capital, Canberra. Here, too, Wilkinson eventually had a hand in the final appearance of some of the early buildings; indeed, Robin Boyd considered his style to have served as the 'unofficial design' for the new town's domestic architecture.[51]

Fig. 7.11 *Ready for UCLA Elementary School, 4-25-1936*, photographic view toward Royce Hall, UCLA campus, Los Angeles, California. Thelner Barton Hoover (UCLA 1930) & Louise Brown Hoover (UCLA 1930) Photographic Collection, UCLA University Archives, Los Angeles, California.

The American designer of the city, Walter Burley Griffin, caught up in endless political battles for artistic control of the city's plan, left Canberra having constructed no buildings for the new city.[52] The final layout of the city nonetheless derives essentially from Griffin's plan, and some of the earliest residences and hotels demonstrate a clear connection to the Chicago architect's Prairie School and Arts & Crafts influences. These structures were largely the work of J. S. Murdoch (1862–1945), the government architect who had been one of Griffin's greatest supporters at the time of the international competition.[53] But the nascent civic structures were the product of the Chairman of the Federal Capital Advisory Committee, the venerable Sir John Sulman (1849–1934), along with his assistant J. H. Kirkpatrick.[54]

Sulman had come to Australia from England in the 1880s already knowledgeable of William Morris, with whom he was acquainted, and a strong advocate of the Garden City Movement.[55] He had travelled throughout Europe and as early as the 1870s had absorbed elements taken from Italian architecture. He became an influential figure in Sydney architectural circles by the 1880s. Even before travelling to America to examine their architectural schools in the 1890s, Sulman had written articles about elements of verandahs and loggias as they appeared in American country houses, referring to examples published in *Century Magazine*, a publication readily available in Australia at that time.[56]

Much earlier than Wilkinson, Sulman was

deeply concerned with the question of an 'Australian Style' of architecture, one that he thought must draw upon the past to produce a kind of 'progressive eclecticism', and that would be appropriate to its climate.[57] Not surprisingly, Sulman and Wilkinson became close colleagues, resulting by 1924 in Wilkinson's appointment by Sulman to the National Capital Planning Committee where he assessed several competitions for Canberra buildings.[58]

By the beginning of the twentieth century, Sulman's greatest interest was in the new field of town planning, about which he wrote numerous articles and in 1921 a book, *An introduction to the study of town planning in Australia*. He was President of the Town Planning Association of New South Wales from 1913 to 1925; and from 1921 to 1924, once Griffin was gone, Chairman of Canberra's Federal Capital Advisory Committee. In 1924 Sulman was appointed by the Commonwealth and State Governments to attend the International Garden Cities and Town Planning Association Conferences in Paris and Amsterdam. On this same trip he represented Australia at the Royal Institute of British Architects meeting in Oxford (along with *Building* magazine's Florence Taylor and Sydney architect Alfred Spain—the latter the one who so enthusiastically collected photographs of Los Angeles architecture). He was also knighted at this time for his services to the Commonwealth as part of the Federal Capital Advisory Committee.

This trip also included a tour to North American cities to study 'Commission Government', a project Sulman had requested to undertake for the Australian Government. According to the report he submitted upon his return to Canberra in 1925, he travelled

Fig. 7.12 Mission Style residence at New Farm, Brisbane. State Library of Queensland, Brisbane, Queensland.

Fig. 7.13 Bakewell & Brown (archs), Pasadena City Hall, 1927. Author's photograph.

to cities in Canada and on the American east coast, then ended his tour by visiting the Pacific coast cities of Seattle, Washington; and San Francisco, Los Angeles, Pasadena and Stockton, California.[59] He was in Pasadena in October 1924, and later wrote about its civic projects enthusiastically:

> [T]he satellite city of Pasadena (population, 70,000) is as charming a place as can be found in the length and breadth of the land, and its development reflects the highest credit on its citizens, more especially as it possessed no natural beauties to start with, except that it has the fine background of the Sierra Madre Mountains just beyond its borders. The way in which dry creeks and other defects have been utilised to form beautiful recreation centres is a lesson to all town planners. At the time of my visit, buildings were being pulled down to make space for a civic centre, of original and most artistic design, comprising a new City Hall, an Auditorium and a Public Library, which the authorities say they will have ready to open in two years' time; and I expect they will do it. With its tree-planted streets, well-designed dwellings, and beautiful gardens, it is the ideal garden city realised.[60]

While visiting these California cities, Sulman would have seen the many Mediterranean-style buildings being erected everywhere. From the praises heaped on Pasadena, he must also have seen the plans for the civic centre then under construction. Given his later contribution to the architecture of Canberra, and his long-professed interest in arcades, he would have looked with interest at the arcaded shopping areas created in such places as Los Angeles, Pasadena, Santa Barbara and Ojai. Once he

Fig. 7.14 John Sulman
(arch.), drawing for
Melbourne and Sydney
buildings, Canberra Civic,
c. 1925. Map Section,
National Library of
Australia, Canberra.

returned to Canberra and had submitted his report to the Commonwealth Government, Sulman resigned as President of the Town Planning Association and spent a little more time on designs for Canberra before retiring from architectural practice in 1928.

One of Sulman's last designs, and amongst the first buildings constructed in Canberra, was the arcaded commercial structures, the Sydney and Melbourne Buildings, for the town's civic centre. These buildings remain an aesthetically defining aspect of Canberra to this day.[61] Writers point to the very obvious references made by Sulman to Brunelleschi's Ospedale degli Innocenti in Florence (1424) and some critics acknowledge that the colonnaded walkways were Sulman's response to his oft-cited aversion—his 'personal hobby horse', to quote one critic—to the usual verandahs of Australian towns' shopping streets.[62] Rarely does anyone dig deeper to explain the architect's conscious choice of Mediterranean motifs for the civic centre of the new national capital.[63]

Wilkinson's presence in Sydney and on the National Capital Planning Committee provided some impetus for this direction. 'The Mediterranean' was certainly in the air and in the pages of the mass media and trade publications. Sulman could also have been directly inspired by similar civic projects in California. Requa's arcaded city centre for Ojai, restoration work on El Paseo in Santa Barbara, the arcades of Venice and many projects in Pasadena and Los Angeles—all would have furthered Sulman's ideas in 1924. His Canberra buildings offered a final opportunity for the architect to express his aesthetic hopes for contemporary Australian architecture, to champion a style appropriate to the country's climate and that moved away from the British architectural models that Sulman and many others saw as ill-suited to a new Australian city.[64]

Not surprisingly, given that the Sulman buildings were the first conspicuous public structures in the new town, this Mediterranean vision of Canberra served as the most inspiring motif for the first graphic representations of the city, the tourist campaign to sell the place to the public (see fig 0.02 on page 16). In 1933, by which time Canberra's Parliament House had also opened, and some people had begun to arrive in the fledgling settlement and to settle into the first residential neighbourhoods, the newly formed Australian National Travel Association, looking for ways to promote the town, sent leading commercial artist James Northfield (1887–1973) to Canberra. Northfield was to produce a poster

to be distributed throughout Australia and internationally.⁶⁵

As his central iconographic focus for selling the city as a tourist destination, Northfield chose Sulman's Mediterranean arches. In his image, two fashionably dressed people stand next to the arch's column; they are depicted as elegant and modern, identified as tourists by their binoculars. They aim their gaze out across a sunny landscape, filled with bulbed flowers (a garden element uncommon in Australia, and so emphasised as an inviting aspect unique to Canberra). In the middle ground, amidst the carefully laid out streets of the town, and most prominently displayed, is a red-roofed building, behind which one can see smaller red-roofed buildings and a mountain range bathed in light.⁶⁶ The poster's lettering is in the most modern font, a sans-serif red. The message, then, was clear: 'Come to Canberra, a sunny place with Mediterranean architecture, elegant, modern, and with an attractive landscape.' Most significantly, there was nothing British about this image at all. Its romantic mood, in fact, was reminiscent of other tourist posters for the French Riviera and for California. Finally, the pictorial trope of red roofs in the distance, and pier and archway in the foreground looking across an expansive sunlit landscape with a mountainous background, is strikingly similar in mood to the standard motifs from California's ubiquitous fruit-box labels (see Fig. 0.03 on page 17). More than in any other medium, the illustrative modes in magazines, books and posters used to sell Australia to the world wedded the Mediterranean style to a vision of a Pacific modernity, emphasising a new way of living more closely aligned to the other side of the ocean than to southern Europe.

This illustrative mode along with photographs reproduced in the pages of Australia's magazines offered the most convenient and accessible opportunity to spread this new Californianised ideal. Here Californian examples were most frequently presented as the source of Spanish/Mediterranean style architecture and landscape design appropriate for modern Australia. The term 'Spanish Mission' takes on at this point its most pervasive (and misunderstood) use, applied to the design of small houses in Australia and its popularisation as a suburban style.

Just as the forms of the California bungalow were championed in the 1910s by publications such as *Building*, now more elegant magazines such as *The Home*, and especially *The Australian Home Beautiful*, focused most exuberantly on Hispanic modes throughout the 1920s, and into the early years of the 1930s, before the Depression put an end to most ambitious building projects. What is most apparent in these articles is that the majority of illustrations depicting the style are American rather than European. In some cases, they include photographs of houses in Florida—which, of course, was constructing in the 1920s its own tropical Mediterranean image based on its own connections to a Spanish past.⁶⁷ Some magazines even included occasional reproductions of buildings from Spanish America. The most frequently reproduced examples and the articles that accompanied them nonetheless depicted Southern Californian buildings.

The Taylors in *Building* magazine had already reproduced illustrations of many so-called 'Mission Style' buildings gleaned from their own travels and from the many American magazines that were their main illustrative source from the beginning of the journal's long run. The couple never seemed as enthusiastic about these Spanish directions as they had been about the bungalow out of California or the work of the Chicago architects. Their trip through America in 1914 resulted inevitably in the publication of many

Californian examples that already revealed Mediterranean approaches, including some of the buildings from the Panama–Pacific International Exposition in San Francisco and the 'Spanish Style' work at Stanford University (which they incorrectly attributed to Richardson rather than Richardson's pupil Charles Allerton Coolidge [1858–1936]).[68] They were particularly delighted by the appearance of the Santa Fe Railway stations throughout the south-western United States, which they described in the May 1915 issue of the magazine as 'The Most American of Architectural Types'.[69]

As the decade progressed, and Mediterranean styles became more prominent in Australian suburbs, the Taylors occasionally depicted representative examples, some American and some Australian. In 1927, they reproduced Bertram Goodhue's Churrigueresque doorway for the Coppell House in Pasadena, finding it to be 'of considerable artistic taste', and included captions to other houses from Texas and South America.[70] By the end of that year, they included, if still somewhat ambivalently, Australian adaptations of the 'Spanish–American' style, such as those by Sydney architect H. V. Vernon. Always ready to offer their own critiques and explanations of what aspects were essential to any style, they included under the illustrations of Vernon's Quamba in Wahroonga, New South Wales, the statement that 'the tiled roof, white walls and green foreground are not only a necessary combination but are in accordance with the traditions of the style'.[71]

The January 1928 issue of *Building* included a drawing for a Spanish façade reprinted from *Architectural Forum*[72] and a photograph of another of Vernon's Sydney houses 'determined by the Latin American architecture'.[73] This issue was the last one produced under George Taylor's editorship, for he drowned in his

bathtub at the end of that month.[74] Despite this distressing loss, his wife Florence Taylor, herself an architect, kept the magazine going under her own hand without missing a single issue. The publication's graphic style never modernised and although always rich in illustration, continued to the end to appear as if it were a trade journal.

Despite Florence Taylor's hesitations about this 'alien' direction, the popular fashion for Spanish-inspired building by this time had reached such a height in Australia that *Building* was compelled to examine the style's effects on the domestic architectural scene more deeply. In October 1928, the lead article in the magazine was entitled 'The Spanish–American influence in Australia: Will the colourful style be transitory?'[75] The illustrations included not only American monuments such as Reginald Johnson's Biltmore Hotel in Santa Barbara, but also a variety of Australian buildings.

Taylor's descriptions vacillate between resigned acceptance of the appearance of this 'foreign' style and an outright rejection of its faddishness as inappropriate for Australia. She acknowledged that 'Australia, being a comparatively new country with a constant demand for new buildings, has seized upon this new decorative expression for domestic architecture', pointing out that it was only logical that such a new country would look to America, 'which undoubtedly at the present date leads the world in architectural development'.[76] Just as categorically, she then shifted allegiances to dismiss these directions, saying that the 'style lends itself to cheap modern construction'; she believed 'one may as well go straight to Spain for the right inspiration as turn to America to be misled.'[77] Such inconsistencies in tone marked much of *Building*'s outlook in the 1920s and in the last years of its publication. As late as 1931, Florence was still able to praise 'the delightful little town of Santa Barbara', calling it 'a unique

architectural city',[78] but this enthusiasm for a Californian town adopting Spanish Style architecture as its organising mode did not transfer to examples of this style adapted to Australia. The Taylors' moment, when they championed the California bungalow, Walter Burley Griffin and other American architects as offering the best inspiration for Australians to follow in their development of a national style, had passed.

When it first appeared in 1925, the graphic appearance and philosophical outlook of *The Australian Home Beautiful* could not have differed more dramatically from *Building*'s stodginess.[79] Growing out of the realtors' and builders' publication *Real Property Annual* (1912–1922; known as *Australian Home Builder* 1922–1925), *The Australian Home Beautiful* (hereafter called *Home Beautiful*) modelled itself visually on American publications such as *Ladies' Home Journal* (1883–present) and the Hearst publication *House Beautiful* (1896–present). It was unapologetically geared to the newly emerging suburban dwellers looking for handy tips on home improvements, and examples of fashionable house style and gardening plans that could help them construct their own home and create their personal quarter acre of green space. It was clearly a 'lifestyle' magazine, extolling an up-to-date stylishness that was attractive to a younger Australian audience. While at times it did highlight public buildings and grander estates by leading architects, increasingly its articles focused on suburban houses, both architect- and builder-built, and the design needs of the middle class.

As early as 1923, when the magazine was still called *Australian Home Builder*, the Melbourne architect Percy Everett included in its pages references to the new Californian styles that could be used to inspire an '"Auspano" treatment';[80] and Leslie Perrott, an expert in concrete construction, also used

February 1, 1928. THE AUSTRALIAN HOME BEAUTIFUL 13

A Spanish House that is True to Type
First of a New Series of Studies of Notable Australian Homes.
Description by RUTH LANE-POOLE. Photographs by NASH-BOOTHBY.

THERE is no term so overworked or misapplied in the Australian architectural vocabulary as "Spanish," occasionally expanded to Spanish Mission.

Take any building which is rough dashed and boasts of two or three ill-proportioned arches at its entrance porch, cordova tiles on its roof, and possibly an iron grille at the hall door, and you will find its designer dubbing it "Spanish architecture."

If you are sufficiently courageous to enter through the arches, you will find the illusion ends in a sudden and somewhat unpleasant manner, for you will find yourself walking into what is nothing more than a suburban villa, with the usual 16 x 14 drawing room, and off that the still smaller dining room, a kitchenette in close proximity, and a back garden which by no stretch of the imagination can we believe has its prototype in Granada.

If we are going to build Spanish houses in Australia, and it must be acknowledged that the conditions in many of our States are particularly suited to this style of architecture, then we must employ

The entrance holds a pair of beautiful wrought-iron Florentine gates that Mr Alsop brought from Italy.

architects who have intimate personal knowledge of the country whose architecture we wish to emulate.

Not only must the exterior be reminiscent of Southern Europe, but the best points adapted to our needs and requirements must be reproduced in the interior.

While the courtyard house so frequently met with in Italy and Spain makes its appeal, yet it would be a costly form of architecture in Australia, and one which is hardly suited to our cold wet winters—but —the house for the climate like ours, in which a semi-outdoor life can be led, may well be adapted from those of the South of Europe—and this Mr Rodney Alsop, the well-known Australian architect, who is also a Fellow of the Royal Institute of British Architects, has most successfully achieved in his own house in Tintern avenue, Toorak, Victoria.

Following an irregular sloping flagged path, bordered on either side with cottage flowers, we come upon an almost typical Southern European two-storied white-washed house.

There is nothing forced or artificial looking in its appear-

the *Home Builder* in 1925 to spread the word of his 'Mission Style' findings on his trip through California.[81] Construction in concrete is an important aspect of the Australian consideration of Mediterranean styles in home building. It seemed the perfect material with which to reproduce the look of adobe brick buildings, so the style provided a convenient form on which to give the sales pitch about concrete's functional advantages.

From its first years, then, *Home Beautiful* knew of Californian trends and took up the cause of Spanish/Mediterranean modes with

Fig. 7.15 'A Spanish house that is true to type' (Rodney Alsop's Toorak House), in *The Australian Home Beautiful*, 1 February 1928, p. 13. Courtesy of Caroline Simpson Library and Research Collection, Historic Houses Trust of New South Wales, Sydney.

the enthusiasm of the true convert. In the June 1926 issue, staff writer Nora Cooper highlighted a 'Spanish Mission' house designed for Mrs. L. V. Waterhouse by none other than Peddle, Thorp, & Walker (see Fig. 7.06 on page 301).[82] Fashionable Sydney photographer Harold Cazneaux provided the photographs—indicating that the magazine's editors were interested in home-grown graphics in modern design as part of the message they wanted to convey. The author was particularly taken with the house's simplicity and 'the delightful informality of the garden'.[83]

From this date until the mid-1930s, Spanish Style dominated the pages of the magazine. 'Without doubt the architecture best suited to our sunny Australian climate is the Spanish type', an article declared in 1927, present-

ing with approval some recent examples of apartment houses constructed in Melbourne in this fashion.[84] The style was in full swing in these few years before the Depression, presented as adaptable to all Australian conditions in every region. Whether Rodney Alsop's own house in Toorak, Victoria,[85] or 'A "Little Bit of Old Spain" on the shores of Sydney Harbour' in Clifton Gardens,[86] the style was lauded in many magazines as a happy architectural solution to the special needs of a warm country, where the outdoor surroundings were as important to the aesthetic environment as the residence itself.

Particularly striking about *Home Beautiful*'s championing of Spanish Style was that this preference affected the entire graphic appearance of the magazine as well as its articles and photographs. The

Fig. 7.16 'Casa di Lucia: A "little bit of Old Spain" on the shores of Sydney Harbour', in *The Australian Home Beautiful*, 2 December 1929, p. 13.

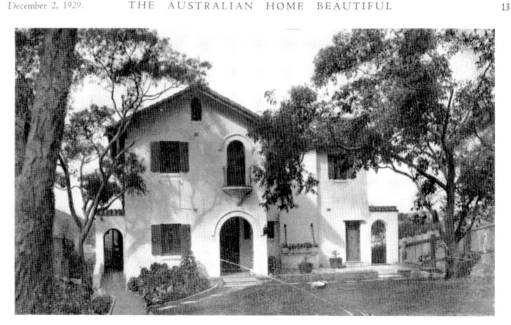

December 2, 1929. THE AUSTRALIAN HOME BEAUTIFUL 13

The afternoon sun paints deep shadows on the high walls.

CASA DI LUCIA:
A "Little Bit of Old Spain" on the Shores of Sydney Harbour.
By NORA COOPER

central figure in the implementation of the magazine's colourful style of illustration was F. Hedley Sanders (b. 1902), an American-trained illustrator whose first cover for the magazine appeared in 1927. As Peter Cuffley describes him, Sanders was 'the man who captured, with pencil, pen and brush, the Australian ideals of house and home'.[87] His cover for August 1927 depicted, in colour, Bruce Manor, the Prime Minister's newly built home in Frankston, Victoria (see Fig. 7.17 on page 223). The image epitomises the graphic style that would identify *Home Beautiful* as a modern magazine: stylised trees surrounding the Mediterranean façade of the building. Here was as well one of the official models for all those red-tiled-roof houses that came to identify Canberra and the suburbs of other Australian cities.

For many years Sanders' graphic style set the tone for *Home Beautiful*'s version of Australian modernity, at least as it was envisioned by Australia's middle classes. His rendering for the 'Small House Number' in August 1928 extended the artist's command of pleasing architectural illustration, again with a cosy stuccoed house surrounded by abstracted trees whose forms mirrored earlier renditions of sinuous eucalypts. The same issue included an article by Melbourne architect G. A. Soilleux on 'The small home in California', complete with vignette drawing of El Caralo, a new Spanish building in Santa Barbara, drawn by Soilleux. The article included photographs of homes in Pasadena, Los Angeles and Santa Barbara.[88]

Although some attempts were made in this and other Australian periodicals' articles to delineate what constituted 'Spanish' design, the use of the term 'Mission'—adopted from its earlier application to Craftsman furniture and the introduction into Australia of the California bungalow—referred now generally to any vaguely Spanish style inspired by

examples from the other Pacific coast. Writer Easter Soilleux, in the 2 December 1929 issue of *Home Beautiful*, pointed out this generalised use of terms:

> So many houses are labelled Spanish these days that the term is in danger of becoming discredited ... The Spanish houses that are genuinely true to type are few and far between in Victoria, although those that are incorrectly called so are legion.[89]

Soilleux went on to say that the 'true Spanish house, which should have walls that are feet, instead of inches, thick, a complete absence of eaves and their attendant spoutings, and with its rooms built around an inner courtyard, is suitable for this climate'. The importance, then, of the Spanish Style house in Australia was tied directly to its relation to a sunny landscape and nature surrounding the house. In this same article, Soilleux points to an appropriately adapted house in East Malvern, Melbourne, stating that it is successful because of its setting, in what she describes as a 'delightful old-world garden'.[90]

This connection to the garden continued to be a focus of *Home Beautiful* articles. John R. Parry in 1929 lucidly outlined the elements necessary for a true Spanish garden, from the inclusion of tiles, fountains and benches to the desired effects of plants placed against coloured walls. The eucalypt and other Australian natives were still not regularly integrated into the concept of a Mediterranean garden, but the plantings around Spanish Style houses were usually less formal, less English and more colourful than earlier Australian efforts. The outlook about gardens presented in *Home Beautiful* in these years had much to do with bringing about a change in Australian planting practices and the public's attitudes toward not only the home garden, but the native Australian landscape itself. Central to this

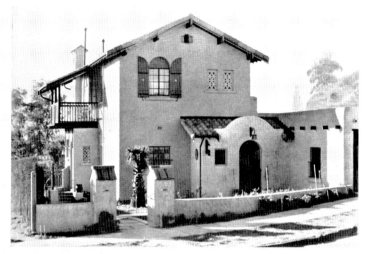

The southern front of Rio Nido, a Spanish home that faces Copelen Street, South Yarra.

The House a Man Built to Please His Wife

By THE VICTIM

Who also explains the origin and advantages of the Spanish style in Architecture

Photos by Commercial Photographic Company.

Fig. 7.18 The Victim, 'The house a man built to please his wife', *The Australian Home Beautiful*, 2 September 1929, p. 18. Courtesy of Caroline Simpson Library and Research Collection, Historic Houses Trust of New South Wales, Sydney.

change was Edna Walling (1896–1973), the most important figure in Australian landscape design in this crucial period, who wrote the gardening column for *Home Beautiful* from 1927 until 1948.[91]

Increasingly the magazine's articles emphasised Australian builders' adaptations of Spanish Style and Mediterranean elements, indicating the most popularised versions of what Australians had gleaned from reading, travelling to California and Europe, and, most significantly, from what they saw in films out of Hollywood. One writer, described humorously as 'The Victim', and entitling his article 'The house a man built to please his wife', recounted how a Melbourne couple's train trip through California, 'from San Francisco to the Mexican border', inspired them to build their own Spanish home once they returned home.[92] The photographs of the house that resulted from this California tour reveal a 'do-it-yourself' mishmash of stylistic elements far removed from any legitimate adaptation or imitation

of true Mediterranean forms. Advertisements by builders in the same magazines show a similar bastardisation, adding a few curlicue columns, Mission parapets and red-tile roofs to otherwise ill-proportioned boxes. Robin Boyd's declaration of Spanish Mission as mere 'decorative fashion' pertain to these houses, signalling the style's acquiescence to the contractors' market, in which Hollywood Spanish Revival as it appeared to Australians in magazines and in films triumphed over more considered architectural choice.[93]

These adaptations of Spanish Style derived from theatrical Californian versions are nowhere more clearly evident in Australia than in two quintessentially modern forms of popular public building types: the movie house and the service station. The 'picture palace' era hit Australia in the 1920s and borrowed all of the extravagances of the American prototype. In Sydney, Melbourne and even Perth, 'atmospheric theatres', some of them built from designs of the great exponent of these fantasy buildings in America, John Eberson (1875–1964), included ornate decorations, special effects such as twinkling stars in the ceiling and painted or stuccoed murals of villages, and enormous Wurlitzer organs that came up out of the orchestra pit. Almost all of these 1920s theatres, built for the most part by two chains, Stuart Doyle's (1887–1945) Union Theatres and Frank Thring's (1882–1936) Hoyts Theatres, were in some way alluding to Italianate, Hispanic or Mediterranean/Moorish styles in their ornamentation and architectural forms.

The Regent Theatre in Melbourne (see Fig. 7.19 on page 316), Thring's grandest project, was (according to Thring) inspired by the grandiose New York projects of Thomas W. Lamb.[94] Designed by Melbourne architect Cedric Ballantyne (1876–1951)—the same architect who built many bungalows and other structures throughout the Melbourne

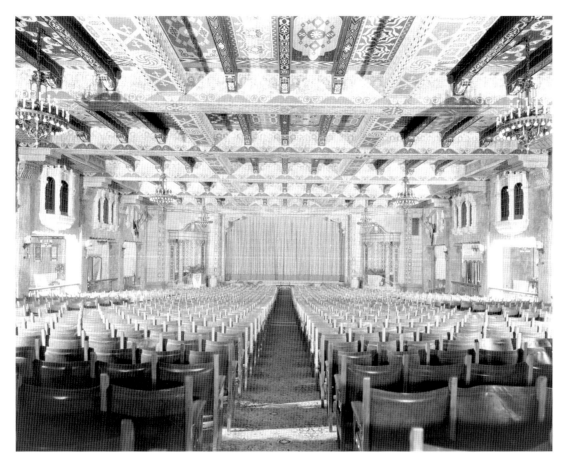

Fig. 7.19 Cecil Ballantyne (arch.), interior, Regent Theatre, Melbourne, 1929. La Trobe Picture Collection, State Library of Victoria, Melbourne, Victoria.

region—the theatre actually contained two venues, the 3300-seat Regent, and below this immense auditorium, the smaller Plaza Theatre. Ballantyne made a study tour to the United States before he designed these and other Regent Theatres around Australia, and Thring sent his 'theatre man' A. B. 'Bert' Cowen to America to purchase furnishings and mechanical equipment.[95] Both theatres were elaborately Spanish in their interiors. The Plaza particularly included 'Spanish period furnishings' such as a model galleon and Churrigueresque plaster ornamentation. According to accounts of the time, including an article in *Home Beautiful*, the foyer was meant to simulate a Spanish courtyard.[96] The Plaza's ceilings, incomprehensibly labelled as 'Aztec', were painted with colourful heraldic ornaments, reminiscent (at least in intention

if not authenticity) of the ceilings done by Giovanni Smeraldi for California buildings such as The Atheneaum at the California Institute of Technology in Pasadena, and in Los Angeles at The Biltmore Hotel and The Jonathan Club.[97] While the exterior of Ballantyne's Regent Theatres (he produced others in other Australian cities) never took on a full-blown Spanish Revival style like so many of the 'atmospheric' California picture palaces did, the interiors displayed extravagantly 'Hollywood Mediterranean' medievalism in some form or another.

The same could be said for the equally ornate theatres of Thring's main competitor, Stuart Doyle, under whose command the largest cinemas were built throughout Australia.[98] The greatest of these was Sydney's State Theatre, seating 4000 and built in a very short time to

the original plans of John Eberson—described in a *Home Beautiful* article as 'the company's New York architect'.[99] This same article went on to describe the alluring appeal of these 'atmospheric' productions for a showman like Doyle:

> Who ... will think in terms of bricks and mortar ... when they find themselves transported into the atmosphere of a Florentine garden; when they walk along the Flirtation Balcony, similar to that of the Doges' Palace in Venice, or are seated in a vast auditorium with an apparently blue sky above them, across which white fleecy clouds are moving, and in which stars are twinkling bright?[100]

As true fantasy productions, the architectural and decorative elements of these cinemas were never meant to be authentically of any specific period or tasteful style. They were in every way escapist illusion providing spectacle and evoking mood, albeit of an exotic world alluding to some place on the Mediterranean.

These architectural fantasies in public structures are far removed from the con-sidered forms and classical proportions of Wilkinson's Mediterraneanism, or any of the efforts at architect-built Spanish Style residences in California or Australia. Still, as Conrad Hamann has written, these illusions mimicked in mood some of the effects being applied to contractor-built Australian houses of the time:

> Now the new cinemas were striving not only to give solace and edification through atmosphere, they were functioning more and more as visual climaxes to suburbs where 'Spanish mission' in houses and shopfronts was the new mode.[101]

Such a Hollywood-inspired approach indeed informed the look of entire Australian neigh-bourhoods, built on speculation in the cities' suburbs in the late 1920s and into the 1930s. Architect/developer Howard Lawson (1886–1946), for example, formed Beverley Hills Co. in the 1920s and built a number of apartment blocks in vaguely 'Californian' style in South Yarra.[102] Significantly, Lawson was also responsible in the late 1930s for The Gardens of the Moon on Mornington Peninsula,

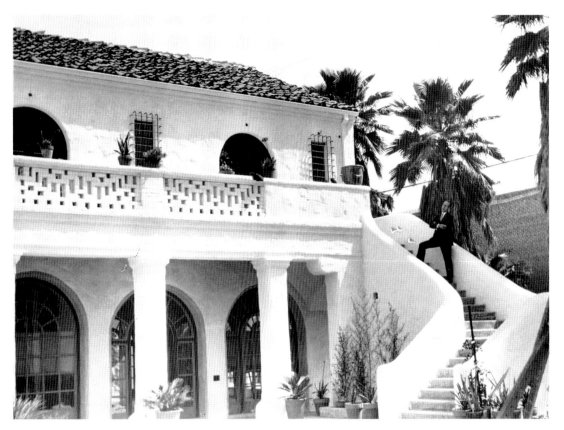

Fig. 7.22 Elmer Grey
(arch.), Pasadena
Playhouse, Pasadena,
California, 1925. Courtesy
of The Huntington Library,
San Marino, California.

of the Moon on Mornington Peninsula, described as 'a residential development along with entertainment facilities that would entice the holiday maker'.[103]

In the bayside suburb of St Kilda in Melbourne, apartment buildings 'in a style direct from Westwood, Los Angeles' began to appear.[104] The Belvedere on The Esplanade, very near the amusement park Luna Park, completed in 1928, with curlicue colonettes in the tiled bathrooms, Spanish ironwork, Juliet balconies and decorative rafters, is one of the most ambitious examples. The references were unashamedly inspired by Hollywood as absorbed from films and illustrations in popular magazines. Other Australian builders, from Brisbane to Perth, cashed in on the fashion for all things Californian and seen at the movies, building houses sometimes attempting to be true to period styles, and sometimes not.[105]

At least one Australian public building of the period exhibited architectural aspirations more in keeping with the aims of serious American architects using Mediterrranean elements. The Roxy Theatre in Parramatta near Sydney, one of the Hoyts chain, was built by L. F. Herbert and E. D. Wilson, and opened in 1930 (see Fig. 7.21 on page 224).[106] As Hamann points out, Herbert and Wilson's references to a 'Spanish colonial church' seems more inspired by John D. Moore's American mentor Bertram Goodhue's work for the 1915 San Diego Exposition than by Hollywood picture palaces. Hamann acknowledges Goodhue's popularity among Australian architects: ' … his fusion of blank masses with intense bursts of ornament in stylised gothic or Spanish colonial was seen then as a genuinely modern architecture'.[107] In its layout, with a central towered entrance flanked by side arcades, The Roxy is also reminiscent of other Southern California

theatres of the time in a Spanish Style, such as Elmer Grey's Pasadena Playhouse. While these Australian urban theatres were never as richly landscaped as most Californian examples, reference to the 'exotic' sometimes appeared in the landscaping around the picture palaces in the form of an occasional palm tree or planting of ferns.

That Hollywood rather than more traditional architectural sources, Mediterranean or otherwise, provided inspiration for some of the flashiest Australian constructions in the 1920s is most exuberantly exhibited in Boomerang, completed in Sydney in 1926 for music publisher and entertainment entrepreneur Frank Albert (1874–1962).[108] By far the most extravagant residence ever built in the city, combining high theatricality with a modicum of architectural integrity, this enormous harbourside villa was the work of English-born Neville Hampson (1873–c. 1928), a relatively unknown architect working in Sydney who had previously produced Arts & Crafts-style

homes, primarily on the city's North Shore.[109] The owner of the estate, Albert was the proprietor of Australia's largest music business, selling both sheet music and musical instruments (especially harmonicas). Since the 1890s, the company's products carried the name and logo 'Boomerang'; so it was no surprise when Albert chose the name for his luxury home, especially considering that an earlier residence on his harbour site had also been designated Boomerang.[110]

In 1919 Albert travelled to the United States and sent Hampson to California as well, to see how American moguls were living.[111] When they returned from America, Albert pulled out all the stops in his orders to his architect, telling him to make the house like 'the best of Hollywood'.[112] Boomerang was always meant to be a flagrant symbol of wealth and prestige, in keeping with Albert's position in the entertainment industry (he went on to be a director of the ABC and ran a chain of suburban movie theatres and radio

Fig. 7.23 Neville Hampson (arch.), Boomerang, Sydney New South Wales, 1926–29. *Building*, 12 October 1928, p. 60.

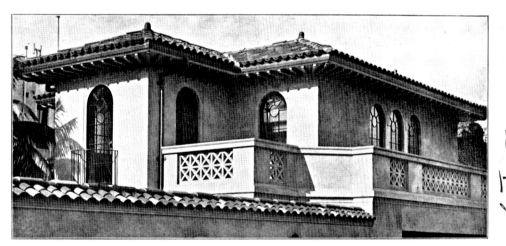

UPPER FLOOR OF "BOOMERANG," ELIZABETH BAY, SYDNEY

In criticising this glimpse of "Boomerang," Mr. Albert's residence at Elizabeth Bay, as seen over the high stone wall, the first thought that strikes us is that "economy" was not dinned into the architect's ears all the while he was designing it, as is so often the case. The bold corrugations of the tilings, even when only covering the thickness of the wall, are effective, as also is the pierced diaper work in the parapet. As to the eaves which, by their great projection give both coolness and shadow effect, there can be no doubt that by breaking the flatness of the soffit by consoles, a good effect has been obtained, whilst the radiating spacing with a joist under the hip at the angle is very unusual, but good. Possibly the large circular headed windows which give access to the balconies may be open to criticism by professional folk, as the shape and make do not suggest good practical results, whilst the very light arch indication—the radiations from a central eye—would be better if either greatly strengthened in appearance or totally omitted. A roofless balcony is very effective in appearance and under many conditions is preferable to one of the usual roofed type, especially as it admits direct sunlight and air to the rooms which a roof hampers. To many Australians a small cottage with a verandah all round without any break whatever is typical of what balconies and verandahs should be, so that they would need to be educated up to this. If they saw the colourful and delightful effects that this building produces, such education would be comparatively easy. (See also cover and pages 61 and 62).

stations). It cost an estimated 60,000 pounds to build, an enormous sum for the time—and this was a figure that Albert gladly fed to the newspapers and magazines.[113]

As its current Heritage Office listing describes it, Boomerang exemplifies 'the Hollywood derived taste for the Spanish mission style in a pastiche of palms, splashing fountains and "Spanish" architectural details: perforated screens, rough stucco, collonades, grilles, loggias and barley twist columns'.[114] Three storeys high, the residence included a 40-seat cinema, more than 30 rooms, numerous marbled bathrooms, pools, Wunderlich tiled roofs and one of the most spectacular garden settings on several acres leading down to Elizabeth Bay's harbour waters. The house was the talk of all the lifestyle magazines and newspapers and came to epitomise Sydney's obsession—even in the 1920s—with glamorous real estate. As for the correct label for this type of domestic architecture, everyone knew that it looked vaguely Mediterranean and 'exotic', although no-one was quite sure what to call it. Nora Cooper, one of the columnists then currently enthusing about Spanish Style homes in *Home Beautiful*, summarised it best: 'Just what is the style of this house? It is hard to say. Spanish Mission, perhaps, but Spanish Mission come into a fortune.'[115]

Aside from its continuing prominence in Sydney's favourite parlour game of 'most expensive real estate', one of Boomerang's most intriguing aspects in terms of its impact on future architecture and design in Australia concerns the gardens. At the time of the construction of the house, Albert hired as his landscapist Max Shelley (1895–1954), a young man already writing about garden design for magazines such as *Home*.[116] Shelley must have been thrilled to receive such an ambitious commission, especially given the symbolic implications of Albert's lot on the harbour. His property incorporated a large segment

of the 54-acre original estate of Alexander Macleay (1767–1848), the most famous scientist in nineteenth-century Australia, a member of the Linnean Society and renowned for his introduction of rare plants into the colony.[117] Albert's site had been the home of Macleay's Linnean Hall, a museum of plants and insects, as well as his famous gardens. Many of Macleay's plants were still on the property when Shelley began his designs for the grounds of Boomerang, including one of the first avocados in the colony and several stands of rare palms.

Shelley feasted on this lush legacy, creating appropriately Mediterranean gardens that incorporated these plants, with special focus given to the palms. He added Mediterranean cypress as well as Australian natives (although no eucalypts in ornamental placings) amidst 'crazy paving' walkways, fountains, tiled pools and 'square Moorish concrete and multicoloured ceramic tile planter tubs'.[118] The house and its extravagances were well out of the range of nearly every Australian, except as a source of voyeuristic spectacle to be consumed in the pages of the lifestyle magazines. But the appearance of Shelley's densely designed landscaping, clearly visible from the harbour, must have inspired many do-it-yourself gardeners to consider alternatives to the cottage and formal English gardens that had so long dominated Australian landscaping. While Australian native plants were not yet as enthusiastically adopted into this landscape aesthetic as they were in California, most builders adopting the Mediterranean style in domestic and public architecture now recognised that they needed to consider a Mediterranean approach to the garden as well. Inevitably, this approach led to more tropical plantings and native plants entered more naturally into the landscaping decisions of both professionals and amateurs.

Frank Albert's Boomerang offers the most grandiose example of Hollywood Style applied

America had by the 1920s already been applying all sorts of Revival styles to its petrol stations, largely dependent on ideas of regionalist forms.[119] Even well-known architects of wealthy houses such as Los Angeles's Roland Coate (1890–1958) applied their hand to 'filling station design',[120] including his 1927 Orientalist fantasy for a Calpet station on fashionable Wilshire Boulevard.[121] But in California, and the south-west United States in general, Mission Style and *hacienda*–like forms became the most logical motifs to be used for the service station, just as this style had been adapted for earlier railroad stations. Texaco Oil, for example, applied the red-tiled roofs and whitewashed walls to most of their stations across the south-west. These were the structures illustrated artistically in the company's advertisements in *Touring Topics* and *Sunset*, fitting in seamlessly with the magazines' overall regional aesthetic of missions, palm trees, sunshine and open spaces. Just as Lilian Rice had created an 'Hispanic' filling station for Rancho Santa Fe, other architects in other California communities created an illusionistic atmosphere of Old Spain even in this most commercially functional of roadside structures.

As part of the highway landscape that tourists and travellers would have seen in California, and as part of the iconography of the Pacific Rim presented so relentlessly in the California magazines readily accessible even to Australians who never went overseas, the appearance of Spanish Style service stations was just as inevitable to seaside Australia as was the Hollywood Style 'atmospheric' theatre. In a September 1927 issue of *Building* magazine, the Taylors considered the significance of the architecture for such a prominent aspect of the modernised world. 'This state of things is responsible for a demand for a number of filling stations', they wrote, 'and as these must necessarily stand in prominent positions near

Fig. 7.24 Shell service station, advertisement, *Touring Topics*, September 1928. Courtesy of The Huntington Library, San Marino, California.

in Australia, but other public structures of a much more mundane function also give evidence of a theatrical flair emanating originally from the other side of the Pacific. Inspired by examples viewed in American magazines, and on an even more modest scale, the humble service station—the quintessential exemplar of architectural modernity on the most vernacular of levels—became the perfect place to evoke a particularly accessible aesthetic form, in which fantasy could be given full reign.

Fig. 7.25 The former Auckland Garage, cnr. Gilbert and West Promenade, Manly. Photograph: Ian Kirk. Courtesy of Caroline Simpson Library and Research Collection, Historic Houses Trust of New South Wales, Sydney.

the road, their design should be well considered and made as attractive as possible'.[122]

The service station illustrated above this caption, in Chatswood, Sydney, was a functional brick structure of little perceptible aesthetic quality. A few months later, the same magazine illustrated a service station in Coogee, near the beach, which was thoroughly Mediterraneanised. The Taylors found its form entirely appropriate:

> The design would appear to be of American inspiration, but loses nothing on that score. The light color of the building is very suitable for its purpose and it is distinguished by a desirable lack of gaudy advertisement which usually is the chief disparagement of such places. It is pleasing to note that a building, which must necessarily be a prominent feature of the street frontage can be sufficiently attractive in appearance and still advertise its commercial use in an efficient and artistic manner.[123]

Soon other stations of like design began appearing in every city in Australia. Nelson's Garage in Wollongong (1930), for example, evokes the same red-tiled iconography as a California Shell station or the others so stylised in advertisements in *Sunset* and *Touring Topics*. While most service stations continued to be built by builders rather than architects, some notable architects in Australia began to gain commissions to build substantial service stations, just as had happened in California. Intriguingly, and unlike anything that occurred in California, a number of these structures in Sydney combined petrol stations with a block of flats, apparently envisioned as the epitome of modern living and convenience.[124] The most ambitious example of this type was 'The Broadway', which appeared on a fashionable corner of Bellevue Hill, created by Emil Sodersten (1899–1961), later to be the architect of Canberra's War Memorial and, along with his partner Bruce Delitt (1898–1942), one of Australia's leading exponents of the Art Deco style.[125] A three-storey building rounding the intersection's corner, with 12 flats above, and six shops, full garage and service station below, the façade demonstrates one of the most accomplished examples of the Mission Style in Australia.[126]

While this combined form of residential and commercial building seems to have been confined to Sydney, other service stations throughout Australia in this period

often included ornamental references to the Mediterranean fashion, with red-tiled roofs, Mission parapets and/or baroque curlicue columns. A Victorian example in this vein was the Kellow Falkner Car Showroom (also called Badenach House, 1929) in South Yarra, once again stylish commercial architecture associated with the automobile and built by leading Melbourne architect Harry Norris (1888–1966). Covered in Goodhue-like terracotta ornamental friezes and Wunderlich roof tiles, this still extant building was one of the earliest custom-built motor showrooms in Victoria. According to its National Trust entry, it 'housed large bronze-framed show windows displaying American motor cars'.[127]

For a brief moment in Australia, then, the evocation of Hollywood and all things Californian appeared on the most popular level in buildings, landscape designs and graphic illustration with references to ornamentation, forms and stylistic elements originally associated with the Iberian Peninsula and Spanish America. These fashionable applications, consciously alluding to a media-generated concept of Pacific modernity and stylishness, were bound to be short-lived, as fashions changed on both sides of the ocean. More significantly, the economic effects of the Great Depression and then the hardships of World War II cut short any further Australian development of these decorative directions. Once the war ended, the hegemony of International Style modernism put an end to any frivolous experimentation with period revivalism as expressive of national identity or modernity.

Still, the considered efforts of Leslie Wilkinson and other prominent architects to introduce Mediterranean architectural forms to Australia were successful in presenting

an alternative to the climatically inappropriate English styles that had previously been the most prominent source of inspiration for Australian builders. That these new styles were taken up with such alacrity at all levels of society and in all aesthetic forms owes as much to Australia's neighbour on the Pacific as it does to any high-minded architectural pronouncements. California, seeking its own form of modern architecture and an aesthetics that would represent a unique sense of its place on the Pacific, presented Australia, through reproduced illustrations and experienced examples, with the most alluring iconographic possibilities.

NOTES

1. Leslie Wilkinson, 'Domestic architecture', *Building,* 12 September 1921, p. 64.
2. John R. Brogan, *101 Australian homes designed by John R. Brogan*, Building Publishing Co. Ltd, Sydney, 1935.
3. Apperly, 'Sydney Houses', vol. i, p. 98.
4. As John F. Williams wrote: 'Their national image had changed in four years from that of a rather self-deprecating people into one of a people who had been encouraged to believe they'd almost won the war single-handedly. It is not helpful for a small, new nation to have to deal with a press-inspired sense of national superiority; for its most logical consequence, apart from insularity, is almost certainly complacency … This overdone and, ultimately, self-defeating propaganda had little basis in fact and played no small part in the malaise of the 1920s.' In '1914–19: Gilding battlefield lilies', *Quarantined culture: Australian reactions to modernism 1913–1939*, Cambridge University Press, Cambridge, UK, 1995, pp. 80–81.
5. Malouf, p. 94.
6. See White, pp. 141–43.
7. Williams, *Quarantined culture*, p. 11.
8. See White, *Inventing Australia;* Tony Moore, 'Australia's bohemian tradition: Take two', *Journal of Australian Studies*, no. 58, 1998, pp. 56–65; and Peter Kirkpatrick, *The sea coast of bohemia: Literary life in Sydney's Roaring Twenties*, University of Queensland Press, St Lucia, 1992.
9. Nancy D. H. Underhill, *Making Australian art 1916–1949: Sydney Ure Smith, patron and publisher*, Oxford University Press, Oxford, 1991, p. 154. On Ure Smith, see also Underhill, 'Smith, Sydney George Ure (1887 – 1949)', *ADB*, vol. 11, pp. 662–63.
10. On Lloyd Jones, see R. M. Thompson, 'David Jones' in War and Peace', BA (Hons) thesis, Macquarie University, Sydney, 1980; and Thompson, 'Jones, Sir Charles Lloyd (1878–1958)', *ADB*, vol. 9, pp. 507–08.
11. *Australian encyclopedia*, 1956, vol. ii, pp. 136–56.
12. 'So popular had a visit to the flicks become that Australians were said to be among the keenest filmgoers in the world. By 1921 picture shows dominated entertainment tax receipts with more than sixty-eight million admissions. The theatre and horse racing came next but between them they shared less than sixteen million attendances.' Diane Collins, 'Two shopfronts and picture showmen: Film exhibition to the 1920s', in *A century of Australian cinema*, Australian Film Institute, South Melbourne, 1995, pp. 40–41.
13. Some elements of Mediterranean styles were appearing in Australian architectural designs prior to Leslie Wilkinson's arrival in the country, most notably amongst those architects who had already been in the United States or who were directly influenced by their contacts with American architects. See for example the design by John Burcham Clamp for 'Residential Flats, Macquarie Street, Sydney', illustrated in *Building*, 12 December 1913, p. 101.
14. Leslie Wilkinson, 'Domestic architecture', in Ure Smith and Bertram Stevens (eds), in collaboration with W. W. Hardy Wilson, *Domestic architecture in Australia*, Special Number of *Art in Australia*, Angus & Robertson, Sydney 1919, p. [4].
15. *Monograph of the work of Charles A Platt with an introduction of Royal Cortissoz*, The Architectural Book Publishing Co., New York, 1913.
16. David Wilkinson, email correspondence to Trevor Howells, 31 July 2007.
17. David Wilkinson in Sue Falkiner (ed.), *Leslie Wilkinson: A practical idealist*, Valadon Publishing, Sydney, 1982, p. 40.
18. Charles A. Platt, 'Italian gardens', *Harper's New Monthly Magazine*, July and August 1893, pp. 165–80; and *Italian gardens*, Harper's, New York, 1894. According to Royal Cortissoz, on page iv of the introduction to the 1913 Platt monograph, Platt 'published a series of chapters in "Harper's Magazine" and afterwards gathered them together in a book, "Italian Gardens," which was brought

out in 1894, the forerunner of all those innumerable volumes which have since, in England and America, made the subject more familiar'.

19. George Molnar, 'The Prof', in Falkiner, p. 102.

20. Moore wrote in a letter to Goodhue, in a discussion about North African illustrations they had shared, 'I've a weakness for that particular variety of architecture, for I'm a sun worshipper and they stand for sunlight and color for me.' John D. Moore, letter to Bertram Goodhue, [c. August 1917], Goodhue Papers, The Avery Library, Columbia University, New York, New York (Box 6: 19 [M]).

21. See John D. Moore, 'Bertram Grosvenor Goodhue: An appreciation', *Architecture: Proceedings of The Institute of Architects of New South Wales*, vol. 13, no. 9, September 1924, pp. 8–11.

22. Wilkinson himself recounted later: '"White-wash" they used to call me when I first came here in 1921. People thought I wanted to paint every building on the Sydney foreshores white. In fact I like any weathered pastel—green, blue, pink—like the buildings in Italy. White can sometimes be too staring.' Quoted in Falkiner, p. 40.

23. See ibid., Chapter 3, 'Leslie Wilkinson at Sydney University', pp. 53–87.

24. ibid., p. 46.

25. On Waterhouse, see Michael Waterhouse, 'Waterhouse, Bertrand James (1876–1965)', *ADB*, vol. 12, pp. 388–89; and *From Nutcote to Elwatan: The art and architecture of B. J. Waterhouse*, exhibition catalogue, Mosman Art Gallery, Mosman, New South Wales, 4 September–17 October 2004.

26. See Nora Cooper, 'New ideas allied to Old-World Styles', *The Australian Home Beautiful*, 7 June 1926, pp. 14–19.

27. W. Hardy Wilson, 'Building Purulia', in Smith and Stevens (eds), *Domestic architecture in Australia*, 1919, pp. 13–14.

28. Paul Hogben and Stanislaus Fung, 'Landscape and culture, geography & race: Some shifts in Australian architectural commentary', *Voices: The Quarterly Journal of the National Library of Australia*, vol. 7, no. 2, Winter 1997, p. 8.

29. John D. Moore, letter to Bertram Goodhue, France, [August 1917?], in Goodhue Papers, The Avery Library, Columbia University, New York, New York (Box 6: 19 [M], pp. 3–5).

30. On the design process for the Perth campus, see Christopher Vernon, 'Landscape (+) architecture at UWA', *Architecture Australia*, July–August 2001, viewed 9 August 2007, <http://72.14.253.104/ search?q=cache:3MyZDQFREDcJ:www. architectureaustralia.com/aa/aaissue.php%3Fissueid %3D200107%26article%3D8%26typeon%3D2+u niversity+western+australia+architecture+wilkinson &hl=en&ct=clnk&cd=1&gl=us>; Gillian Lilleyman and George Seddon, *A landscape for learning: A history of the grounds of the University of Western Australia*, University of Western Australia, Perth, 2006; and Ian Tyrrell's review of Lilleyman and Seddon's book, 'Environment, landscape and gardening in Australia', *Australian Historical Studies*, vol. 38, no. 130, October 2007, pp. 339–447.

31. Vernon, 'Landscape (+) architecture'.

32. On Alsop, see George Tibbits, 'Alsop, Rodney Howard (1881–1932)', *ADB*, vol. 7, 1979, pp. 47–48. On Sayce, see 'Wikipedia', viewed 24 September 2007, <http://en.wikipedia.org/wiki/Conrad_Sayce>.

33. Vernon, 'Landscape (+) architecture'.

34. Apperly, *A pictorial guide*, p. 194.

35. The 'Australian Heritage Database' entry for Hackett Memorial Buildings, University of Western Australia, Mounts Bay Rd, Crawley, Western Australia, viewed 13 August 2007, <http://www.environment.gov. au/heritage/>.

36. Vernon, 'Landscape (+) architecture'.

37. On the work of Allison & Allison, see Sally Sims Stokes, 'In a climate like ours: The California campuses of Allison & Allison', *California History*, vol. 84, no. 4, Fall 2007, pp. 26–65, 69–73.

38. *California of the Southland: A history of the University of California at Los Angeles*, The University of California at Los Angeles Alumni Association, Los Angeles, 1937, p. 35. See also Moore, *Los Angeles*, p. 200. Stokes calls Allison's design 'Lombard Romanesque', p. 52.

39. ibid.

40. *California of the Southland*, p. 52.

41. Vernon, 'Landscape (+) architecture'.

42. Western Australia had its own eccentric source for Spanish Style architecture, the outback priest John Cyril Hawes (1876–1956), who constructed several Spanish–inspired cathedrals, including the masterful St Francis Xavier Cathedral (1916) in Geraldton, Western Australia. See Freeland, *Architecture in Australia*, pp. 233–35. I thank Harriet Edquist, RMIT, for reminding me of this important figure.

43. 'The fashion of sympathetic garden treatment was received with the greatest enthusiasm in Perth. Native trees and shrubs had always been accepted in this lately developed city; imported deciduous trees were hardly known. Now spare young white gums,

handsome red flowering-gums and mauve-flowering, lacy jacarandas grew thickly in front gardens and on wide lawn side-walks.' Robin Boyd, *Australia's home: Its origins, builders and occupiers*, Melbourne University Press, Melbourne, 1961, p. 79.

44. ibid., p. 81. In his *Architecture in Australia*, Freeland repeats the same sentiment, p. 233: 'Almost single-handedly Wilkinson was responsible for making the Spanish Mission style popular in all the eastern states of Australia.'

45. ibid., p. 233.

46. Richard Apperly more correctly labels Wilkinson's work as 'Inter-War Mediterranean' and comments, 'Buildings in the Inter-War Mediterranean style are often pleasant and useful elements in the built environment, and they seem to have relatively little trouble surviving the passing parade of architectural fashions.' *A pictorial guide*, pp. 172–73.

47. Evidence of Wilkinson and Wilson's shared aesthetic based on a climatically appropriate style is evident in one of Wilkinson's first articles in *Building*: 'It is a thousand pities that the chaos of mid 19th Century Europe was allowed to influence this country, and interrupt the fine lines on which Australian architecture was started by Governor Macquarie. The comfortable and beautiful homesteads, which the older settled parts still retain, show a logical development of the Georgian, from which they sprang; but later we see the slum terraces, the pretentious villas and all the incorrect horrors of contemporary work in England.' In 'Domestic architecture', p. 63.

48. One of the purest examples of an adaptation of Mission Style appears in Auckland, New Zealand. The Auckland Grammar School, an Anglican school completed in 1916 by Richard Atkinson Abbott (1883–1954), employs a pebbly surface to give an effect of adobe walls. See Peter Shaw, *A history of New Zealand architecture*, Hodder Moa Beckett, Auckland, 1997. Shaw also suggests that Abbott may have seen photographs of George Costerisan's Long Beach High School of 1898. I am grateful to Walter Cook, librarian, The Alexander Turnbull Library, Wellington, New Zealand, for providing me with this reference.

49. For the best definitions of the various Spanish styles, see Winter and Gebhard, *Architecture in Los Angeles*.

50. Wilkinson, 'Domestic architecture', p. 3.

51. 'The best qualities of Wilkinson's work were appreciated by other architects. In the next few years the style developed in the upper-middle class houses of Sydney and Melbourne, and by 1927 growing Canberra had adopted it as an unofficial design'. Boyd, *Australia's home*, p. 81.

52. One of the best summaries of the political intrigues surrounding Griffin's experience in Canberra is Roger Pegrum, 'Canberra: The bush capital', in Pamela Statham (ed.), *The origins of Australia's capital cities*, Cambridge University Press, Cambridge, England, 1989, pp. 317–40. See also Apperly, 'Walter Burley Griffin: The Canberra controversy', in his 'Sydney Houses', pp. 178–84.

53. On Murdoch, see D. I. McDonald, 'Murdoch, John Smith (1862–1945)', *ADB*, vol. 10, pp. 621–22.

54. On Sulman, see particularly John Phillips, 'John Sulman and the question of an "Australian style of architecture"', *Fabrications*, no. 8, July 1997, pp. 87–116; and Robert Freestone, 'Sunlight, space and suburbs: The physical planning ideas of Sir John Sulman', *Journal of the Royal Australian Historical Society*, vol. 8, part 2, December 1995, p. 139.

55. See Percival Serle, *DAB*, vol. ii, p. 392.

56. See John Sulman, 'Verandahs and loggiae ii', *Australasian Builder and Contactors' News*, 21 May 1887 and 'Verandahs and Loggiae iii', *Australasian Builder and Contactors' News*, 28 May 1887.

57. Quoted in Phillips, 'John Sulman', p. 98.

58. See Peter Proudfoot, 'Canberra: The triumph of the Garden City', *Journal of the Royal Australian Historical Society*, vol. 77, part 1, 1991, pp. 20–39; and Paul Reid, *Canberra following Griffith*, National Archives of Australia, Canberra, 2002.

59. See also Zeny Edwards, 'The Life and Work of Sir John Sulman, 1849–1934', PhD thesis, 3 vols, University of Technology, Sydney, 2007.

60. John Sulman, 'Town planning in Great Britain, Europe and America', Legislative Assembly reports from International Town-Planning Conference, Amsterdam, July 1924, NSW Parliamentary Papers, 1925, no. 1, pp. 151–61. I am most grateful to Robert Freestone, Professor, Planning and Urban Development Program, School of the Built Environment, University of New South Wales, Sydney, for providing this information.

61. In a talk at the National Archives of Australia in Canberra in 2002, Walter Burley Griffin expert and Professor of Architecture James Weirick stated that the Sydney and Melbourne Buildings, with their Renaissance references, set the 'tone' of Canberra as something different and grander than Australian country towns. From transcript of talk, National Archives of Australia, Canberra, 12 August 2002,

pp. 18–19. I am grateful to Chris Bettle, Canberra, for providing this transcript.

62. Reid, p. 157.

63. The Taylors' first reproduction of the 'Commercial Centre at Canberra' in *Building* appeared in the 12 October 1927 issue, p. 76. The illustration included a caption, calling the buildings 'happy in appearance', but then, in typically eccentric Taylor fashion, stating that 'the structure seems to require a campanile, or a similar structure, in its proximity to give it balance'.

64. Robert Freestone points out that in his 1926 diary, about a motor trip to Canberra, Sulman expressed displeasure with the final result of his design, which had been completed by Kirkpatrick: 'Civic Centre shops dreadful combination of light Italian Renaissance arcades and heavy Georgian centres and corners.' As Freestone states, 'I have never quite been able to reconcile this comment with his own involvement; maybe he was displeased with the detail design by Kirkpatrick.' In email note to the author, 17 August 2007.

65. See Hetherington, *James Northfield and the art of selling Australia*, 2006.

66. According to John Phillips, Sulman was 'one of the first architects in Sydney to employ the red Marseilles pattern tile ... on the roofs of his buildings'. In 'John Sulman', footnote 57, p. 116.

67. On the 'invention' of Florida's Mediterranean Style architecture, see Beth Dunlop, 'Inventing antiquity: The art and craft of Mediterranean Revival architecture', *The Journal of Decorative and Propaganda Arts*, vol. 23, 1998, pp. 191–207. W. A. Drummond travelled to Florida in 1927; his own photos in Florida are used in 'Spanish Style in home building: Australian architect explains advantages', *The Australian Home Beautiful* (*AHB*), 1 February 1928, pp. 28–29, 53.

68. *Building*, 12 February 1915, p. 99.

69. *Building*, 12 May 1915, p. 104.

70. *Building*, 12 September 1927, p. 101.

71. *Building*, 12 November 1927, p. 89.

72. *Building*, 12 January 1928, p. 119.

73. ibid., p. 57.

74. See Florence M. Taylor, 'A tribute to the late George A. Taylor', *Building*, 13 February 1928, pp. 44–46.

75. *Building*, 12 October 1928, pp. 57–64.

76. ibid., p. 59.

77. ibid., p. 63.

78. *Building*, 13 April 1931, p. 35.

79. See Julie Oliver, The Australian Home Beautiful: *From hills hoist to high rise*, Pacific Publications, McMahon's Point, NSW, 1999.

80. Percy Everett, 'Architectural tendencies', *The Australian Home Builder*, August 1923, n.p.

81. Leslie M. Perrott, *The Australian Home Builder*, May 1925, p. 25. See also Perrott's *Concrete homes*, G. W. Green, Melbourne, 1930; and Richard Apperly's discussion of these developments in his thesis, 'Sydney Houses', pp. 98–114.

82. Nora Cooper, 'New ideas allied to Old-World Styles', *AHB*, 7 June 1926, cover, pp. 14–19. An example of Peddle, Thorp, & Walker's use of Mission Styles appeared earlier in *Distinctive Australian homes* in a house designed in Edgecliff in 1925, 'covered in Medusa Waterproof Cement in salmon chrome and ... roofed with Spanish tiles'. See John R. P. Adams, *Distinctive Australian homes*, Sydney, 1925, p. 55.

83. ibid., p. 16.

84. 'Some of Melbourne's notable flats', *AHB*, 1 April 1927, pp. 14–17.

85. Ruth Lane-Poole, 'A Spanish house that is true to type: First of a new series of studies of notable Australian homes', *AHB*, 1 February 1928, pp. 12–19.

86. Nora Cooper, 'Casa di Lucia: A "little bit of Old Spain" on the shores of Sydney Harbour', *AHB*, 2 December 1929, pp. 13–16.

87. Cuffley, p. 6.

88. G. A. Soilleux, 'The small home in California: Its lesson and a note of warning', *AHB*, 1 August 1928, pp. 16–18. Soilleux apparently worked in the 1950s on the building of the United Nations headquarters in New York City. See 'Cheops' architect', *Time*, 22 September 1952, p. 2; viewed January 2009, <www.time.com/time/magazine/article/0,9171,822508,00.html>.

89. Easter Soilleux, 'A notable modified Spanish home', *AHB*, 2 December 1929, p. 19.

90. ibid.

91. On Walling, see Margaret Barrett (ed.), *The Edna Walling book of Australian garden design*, Anne O'Donovan, Richmond, 1980; *Edna Walling's year*, Anne O'Donovan, South Yarra, Victoria, 1990; Trisha Dixon and Jennie Churchill, *The vision of Edna Walling: Garden plans 1920–1951*, Bloomings Books, Hawthorn, Victoria, 1998; and the Australian Broadcasting Commission, Cinemedia and State Library of Victoria, 'The Edna Walling Website', Tantamount Productions, 2001, viewed 4 January 2009, <http://www.abc.net.au/walling>.

92. The Victim, 'The house a man built to please his wife', *AHB*, 2 September 1929, pp. 18–22.

93. Richard Apperly maintains that the 'architectural profession never abandoned the Spanish Mission Style to the speculative builder as it had abandoned the California Bungalow', but many advertisements in *Home Beautiful* depict Spanish Style homes that builders in Melbourne and Sydney could construct along with other styles that might appeal to the middle-class owner. See 'Sydney Houses', vol. i, p. 108.

94. See Frank van Straten and Elaine Marriner, *The Regent Theatre: Melbourne's palace of dreams*, ELM Publishing, Melbourne, 1996; and Louise Blake, 'Rescuing the Regent Theatre', *Journal of the Public Record Office Victoria*, no. 4, September 2005, pp. 2–6, viewed 10 September 2007, <http://www.prov.vic.gpv.au/provenance/no4/RescuingTheRegentTheatre2.asp>. On Thring, see J. P. Holroyd, 'Thring, Francis William (1882–1936)', *ADB*, vol. 12, Melbourne University Press, 1990, pp. 221–22.

95. Van Straten and Marriner, p. 13.

96. ibid., p. 18; and *AHB*, 1 April 1929, p. 63.

97. ibid., p. 19. On Smeraldi, see Robert Winter, *The architecture of entertainment: LA in the Twenties*, Gibbs-Smith, Salt Lake City, 2006; and 'Genius—and art', in *Ars gratia artis: The story behind one of the West's historical and artistic masterpieces, The L.A. Biltmore Hotel*, n.d., in Pasadena Public Library, California artists' biographies notebook.

98. On Doyle, see Graham Shirley, 'Doyle, Stuart Frank (1887–1945)', *ADB*, vol. 8, Melbourne University Press, 1981, pp. 337–38.

99. 'The rise of the new State Theatre: A marvel of modern building and engineering skill', *AHB*, 1 February 1929, pp. 60–62.

100. ibid., p. 61.

101. Conrad Hamann, 'Five heralds of free enterprise: Australian cinemas and their architecture from the 1900s to the 1940s', in *A century of Australian cinema*, p. 101.

102. See Caroline Bowdon-Butler and Charles Pickett, 'Homes in the sky', *Architecture Australia*, May–June 2007, viewed 10 September 2007, <http://www.architectureaustralia.com/aa/aaissue.php?issueid=200705>.

103. Entry at 'Aussie Heritage' website for Gardens of the Moon, Arthurs Seat, Victoria, viewed 10 September 2007, <http://www.aussieheritage.com.au/>.

104. Richard Peterson, 'No. 10: The Esplanade (formerly Belvedere)', *A place of sensuous resort: Buildings of St Kilda and their people*, St Kilda Historical Series, no. 6, St Kilda Historical Society, Balaclava, Victoria, 2005, viewed 11 September 2007, <http://www.skhs.org.au/SKHSbuildings/buildings.htm>.

105. In an article on Spanish Mission Style in Brisbane, architectural historian Graham de Gruchy comments: 'If the spaciousness and rich decorative qualities of the Spanish Mission style in the U.S.A. suffered in the transplantation process—even with local architects in control—then the small, speculatively built house … was no more than 'skin deep' in style. A few of the basic characteristics were applied to the façade to stamp the small house as Spanish Mission revival in flavour but that was about as far as it went.' In 'The Spanish Mission Revival Style in Brisbane: An outline of the development of the style in the 1920s and 1930s', *SAHANZ 87: Society of Architectural Historians Australia and New Zealand. Papers*, Fourth Annual Conference, Adelaide, 9–10 May 1987, p. 30.

106. Apperly, *A pictorial guide*, pp. 176–77.

107. Hamann, pp. 99, 101.

108. On the fascinating life of Frank Albert, see 'Albert, Michel François (1874–1962)', *ADB*, vol. 7, pp. 27–28; and Richard Guilliatt, 'Old gold', *The Sydney Morning Herald*, 'Spectrum', 8 April 1995.

109. Biographical information, RAIA files; and *Salon: Journal of the Royal Australian Institute of Architects*, vol. 2, no. 7, February 1914, pp. 430–431; and vol. 2, no. 9, April 1914, p. 543.

110. NSW Heritage Office, Parramatta, New South Wales, Heritage Item listing for Boomerang, viewed 17 September 2007, <http://www.heritage.nsw.gov.au>, (file no. S90/01684 & HC 32046).

111. See Jahn, p. 115.

112. '$22 million Boomerang returns as a rich man's residence', *Gold Coast Bulletin*, 7 February 2002. As Richard Apperly has written, '[h]is architect, one feels, must have worked hard to earn the substantial fee which a job the size of "Boomerang" would have commanded'. See 'Sydney Houses', vol. i, p. 113.

113. Julie Huffer, '$20m Boomerang back on the market', *The Sydney Morning Herald,* 19 February 2005.

114. NSW Heritage Office listing.

115. Nora Cooper, 'Boomerang', *AHB*, April 1930, p. 13.

116. See Stuart Read, 'Shelley, Max Robert', in Richard Aiken and Michael Looker (eds), *The Oxford companion to Australian gardens*, Oxford University Press, South Melbourne, 2002, p. 548; NSW Heritage Office listing; 'Early twentieth century landscape designers in NSW', *The News: The Twentieth*

Century Heritage Society of NSW Inc., vol. 4, Summer–Autumn 2007, p. 8; and Stuart Read, 'The mysterious Mr Shelley', *Australian Garden History*, vol. 14, no. 2, September–October 2002, pp. 11–21.

117. On Macleay, see C. Davis, "McLeay (Macleay), Alexander (1767–1848)', *ADB*, vol. 2, pp. 177–80; and *Australian encyclopedia*, 1956, vol. 5, pp. 440–41.

118. NSW Heritage Office listing.

119. See Daniel Vieyra, *'Fill 'er up': An architectural history of America's gas stations*, Collier Books, New York, 1979; and Bruce A. Lohof, 'The service station in America: The evolution of a vernacular form', in Thomas J. Schlereth (ed.), *Material culture studies in America*, American Association for State and Local History, Nashville, 1982, pp. 251–58, 399–400.

120. Vieyra, pp. 24–26; and *Johnson, Kaufmann, Coate: Partners in the California style*, exhibition catalogue, Lang Art Gallery, Scripps College, Claremont, California, 1992 and Capra Press, Santa Barbara, 1992, pp. 44–45.

121. On Coate, see *Johnson, Kaufmann, Coate*, pp. 42–55.

122. *Building*, 12 September 1927, p. 126.

123. ibid., p. 95.

124. According to Megan Martin, senior librarian and curator, The Caroline Simpson Library and Research Collections, Historic Houses Trust of New South Wales, this 'functional form' combination alluded as well to a popular belief that petrol fumes could actually have beneficial effects. The author is grateful to Ms Martin for her insights into this phenomenon, and for providing her research paper on the topic. See Ian Kirk and Megan Martin, 'Study of inter-war garages & service stations in New South Wales', typescript, December 2006, Historic Houses Trust of New South Wales, Sydney.

125. Peter Reynolds and Poppy Biazos Becerra, 'Sodersten, Emil Lawrence (1899–1961)', *ADB*, vol. 16, pp. 279–80; and P. Biazos (Becerra), 'The Life and Works of Emil Lawrence Sodersten', BArch thesis, University of New South Wales, Sydney, 1987. On Delitt, see Peter Reynolds and Richard E. Apperly, 'Dellit, Charles Bruce (1898–1942)', *ADB*, vol. 13, pp. 612–13.

126. See Kirk and Martin, pp. 11, 22–29. See also Kouvaris, pp. 94–96.

127. See National Trust of Australia, Victoria (file no. B4870), viewed 24 September 2007, <http://www.nattrust.com.au/trust_register/search_the_register/kellow_falkiner_car_showroom_form>.

Coda

To be a Californian was to see oneself, if one believed the lessons the place seemed most immediately to offer, as affected only by 'nature', which in turn was seen to exist simultaneously as a source of inspiration or renewal ... Much of the California landscape has tended to present itself as metaphor ...
—Joan Didion, *Where I was from* (2003)[1]

~

We can learn to appreciate kinds of landscape other than the one we grew up with, to see what is unique and a source of beauty in them. But the landscape we most deeply belong to, that connects with our senses, that glows in our consciousness, will always be the one we are born into.
—David Malouf, *A spirit of play* (1998)[2]

These quotations from two renowned contemporary authors, one Californian and the other Australian, serve to refocus, to bring us back to the intentions underlying the writing of these chapters. In the visual sphere rather than the literary, I wanted in this study to consider how people of Eurocentric cultures, thrust into a new landscape, an unknown geography, were able with the aid of images to make the place their own. Ending these ruminations in 1935 was not an entirely arbitrary decision. Aesthetic exchange through reproducible images and a sharing of the emblems of popular culture continued between these two Pacific regions after this date, and continues still. But in the early twentieth century historic transformations in art and mass media changed the nature of the concepts of itinerancy, reproducibility and portability. In architecture, the worldwide Depression of the 1930s curtailed construction in Australia and limited direct interaction with the wider world, thus ending any extravagant imitation of Hollywood houses and Spanish Style fantasies. Further, the whole notion of Hollywood in this era caused a global shift in how images appeared in cultures and how they were absorbed into the vernacular psyche. Once the California-based movie industry gained global hegemony over popular culture, with animated icons such as Mickey Mouse and films using the landscape of Southern California as a backdrop, the possibilities of tracing the specific origins of a particular

aesthetic or visual strand became increasingly difficult. The nature of itinerancy changed, as moving pictures emanating out of California and driven by American marketing methods were sent around the world and consumed immediately everywhere.

These new forms of mass media—film, radio, and eventually television and the internet—have offered a mixing of cultural information that is particularly suited to the post-colonial attitudes that Australia—and yes, California—so clearly represent. These media, these ubiquitous conduits of visual imagery, can overcome that 'tyranny of distance'—so famously described by historian Geoffrey Blainey[3]—more rapidly than the older printed forms of illustration and reproduction. These new technologies were by definition linked with the idea of the new, of a modernity that especially spoke to the needs of young societies. When in 1938 former Australian Prime Minister W. M. 'Billy' Hughes opened a direct radio telephone service with Washington, his remarks stressed the important affinities between Australia and the United States, implying that only 'new' cultures could fully grasp the significance of these modern developments: 'What we are, you were; and what you are, we hope to be … On us, the people of the new world, much of the future of civilisation depends.'[4] In such an outlook, Australia and California carried the responsibility for advancing Western culture, a culture that increasingly depended on images to construct its sense of meaning and belonging in the world.

Globalisation, beginning in the mid-twentieth century, has obscured any definitive origins of recent visual borrowings between Western countries. But as the evidence presented in these chapters substantiates, the previous 150 years of association between Australia and California, at a time when both regions were striving to create distinct cultural identities, consisted of continuous exchange of all kinds of images and aesthetic ideas. As my reaction to the juxtaposition of Northfield's Canberra poster and a California citrus–box label reveals, such reproducible images, dispersed freely from one Pacific coast to the other, sought visually to define a sense of place.

In the end, my purpose in discussing these wide-ranging topics about a shared visual culture mirrors the concerns of Joan Didion and David Malouf: to consider the idea of an aesthetics of place. My own iconography of place—my sense of what is familiar and comfortable in the landscape as rendered through images—has been determined by my experience in these two cultures of the Pacific Rim. The images and the examples presented in this book suggest that this shared visual template is not simply serendipitous, but is the result of prolonged interaction between two peoples whose societies came of age at the same time, and in an environment that had much in common.

NOTES
1. Joan Didion, *Where I was from*, Knopf, New York, 2003, p. 66.
2. Malouf, p. 49.
3. Geoffrey Blainey, *The tyranny of distance: How distance shaped Australia's history*, Sun Books, Melbourne, 1966.
4. In *The Sydney Morning Herald*, 22 December 1938, quoted in F. K. Crowley, *Modern Australia in documents 1901–1939*, Wren Publishing, Melbourne, 1973, pp. 591–92.

LIST OF ILLUSTRATIONS

Fig. 0.01 (frontispiece). Pacific Brand label, Johnston Fruit Co., Santa Barbara, California, 1917. Courtesy of The Jay T. Last Collection. The Huntington Library, San Marino, California.

Fig. 0.02 James Northfield, *Canberra, Federal Capital & Garden City, Australia*, c. 1930. Colour lithograph. Courtesy of the James Northfield Heritage Art Trust ©.

Fig. 0.03 Glendora Brand citrus label, c. 1925. Courtesy of The Jay T. Last Collection. The Huntington Library, San Marino, California.

Fig. 1.01 Clipper ship card for *Coringa*, sailing between New York and Melbourne, c. 1870s. Robert B. Honeyman, Jr, Collection of Early Californian and Western American Pictorial Material. Bancroft Library, University of California, Berkeley, California.

Fig. 1.02 *The Mammoth Trees*, in *Hutchings' California Scenes*, 1854. Letter-sheet engraving. Courtesy of The Huntington Library, San Marino, California.

Fig. 1.03 Attributed to Joseph B. Starkweather, 1852. Daguerreotype. Nevada City. Courtesy of the California History Room, California State Library, Sacramento, California.

Fig. 1.04 Merlin & Bayliss, *Studios of American & Australasian Photographic Company, Tambarorra Street, Hill End, showing members of staff and passers-by*, c. 1870–75. Photograph. Holtermann Collection, State Library of New South Wales, Sydney.

Fig. 1.05 Merlin & Bayliss, reverse of Merlin's *cartes*, with trademark of American & Australasian Photographic Company's Sydney office in George Street. Private collection.

Fig. 1.06 George Robinson Fardon, *San Francisco album*, 1856, p. 5. View down Stockton Street to Bay. Albumen print. Courtesy of The Huntington Library, San Marino, California.

Fig. 1.07 Alexander Fox, *Panorama of View Point, Bendigo*, 2 views, October 1858. Courtesy of Bendigo Art Gallery, Bendigo, Victoria.

Fig. 1.08 Henri Penelon, *Portrait of Penelon at easel in his studio*, c. 1870. Photograph. Seaver Center for Western History Research, Natural History Museum of Los Angeles County, California.

Fig. 1.09 Thomas Flintoff, *Baby Bernard*, c. 1870s. *Cartes de visite*. Photograph. Courtesy of Mitchell Library, State Library of New South Wales, Sydney.

Fig. 1.10 Isaac Wallace Baker, *Baker standing in front of Batchelder's Daguerreian Saloon*, 1852. Daguerreotype. Collection of the Oakland Museum of California, Oakland, California.

Fig. 1.11 Benjamin Batchelder, *Sonora*, 1856. Stereograph. Courtesy of Haggin Museum, Stockton, California.

Fig. 1.12 Benjamin Batchelder, *Batchelder and wife (Nancy) in Stockton studio at 183 El Dorado Street*, c. 1885. Stereograph. Courtesy of Haggin Museum, Stockton, California.

Fig. 1.13 *Miners at Taylorsville, California*, c. 1851. Daguerreotype. Courtesy of The Huntington Library, San Marino, California.

Fig. 1.14 Fauchery & Daintree, *Group of diggers*, 1858. Albumen silver photograph. From *Australia. Sun pictures of Victoria*, Melbourne, 1858. La Trobe Picture Collection, State Library of Victoria, Melbourne.

Fig. 1.15 Frederick Grosse, *Gold diggers' puddling machine*. Wood-engraving. Published by John P. Brown, Melbourne, April 1858. Image by Nicholas Chevalier. National Library of Australia, Canberra.

Fig. 1.16 Augustus Baker Peirce, *Peirce and Creelman with Batchelder cart*. Illustration in Peirce, *Knocking About*, Yale University Press, New Haven, 1924, p. 32.

Fig. 1.17 Benjamin Batchelder, *Sayer Brothers' Norfolk Brewery, Bayne Street frontage, Bendigo*, 1861. Albumen photograph. La Trobe Picture Collection, State Library of Victoria, Melbourne, Victoria.

Fig. 1.18 Benjamin Batchelder, *View of Littlehale's croquet tent, Stockton, California*, c. 1885. Stereograph. Courtesy of Haggin Museum, Stockton, California.

Fig. 2.01 J. C. F. Johnson, *Euchre in the bush*, c. 1872. Oil on canvas, mounted on board, 42 x 60.2 cm. Bequest of Clarice May Megaw, 1980. Collection, Art Gallery of Ballarat, Ballarat, Victoria. **Colour Plate**

Fig. 2.02 J. C. F. Johnson, *A game of euchre*. Wood-engraving, in *Australasian Sketcher*, Melbourne, 25 December 1876. National Library of Australia, Canberra.

Fig. 2.03 Anonymous, *Emu in Woodward's Gardens*, 1874. Photograph. San Francisco History Center, San Francisco Public Library.

Fig. 2.04 *Woodward's Gardens diorama*. Stereograph. Courtesy of the California History Room, California State Library, Sacramento, California.

Fig. 2.05 Joseph Hull, illustration for Bret Harte's *The heathen Chinee: Plain language from Truthful James*. Lithograph, no. 4 of 9 illustrated cards. The Western News Co., Chicago, 1870. Courtesy of The Huntington Library, San Marino, California.

Fig. 2.06 Anonymous, cover, *The 'Heathen Chinee' musical album: Containing 15 pieces of the most popular songs, mostly comic*. Lithograph. Robert De Witt, New York, 1871. Courtesy of The Huntington Library, San Marino, California. **Colour Plate**

Fig. 2.07 Anonymous, cover, *'The Heathen Chinee', words by Bret Harte, music by F. B.* Lithograph. Oliver Ditson, Boston, c. 1870. Courtesy of The Huntington Library, San Marino, California.

Fig. 2.08 Anonymous, cover, *Musical Bouquet./*

PULL AWAY CHEERILY! THE GOLD DIGGER'S SONG./written and sung by Harry Lee Carter, in his entertainment of 'The Two Lands of Gold'. Also Sung by George Henry Russell, in Mr. Payne's Popular Entertainment, 'A Night in the Lands of Gold.'/Music composed by Henry Russell. Wood-engraving. Musical Bouquet Office, London, 1853. Reproduced in *California sheet music covers*, The Book Club of California Keepsake Series, 1959. Courtesy of The Huntington Library, San Marino, California.

Fig. 2.09 Harden S. Melville, cover, *News from home quadrille by Jullien*. Baxter colour print after oil painting by Melville. Jullien & Co., London, c. 1851. Music Collection, National Library of Australia, Canberra.

Fig. 2.10 Quirot & Co., cover, *The California pioneers: A song*. Lithograph. Atwill & Co., San Francisco, 1852. Courtesy of The Huntington Library, San Marino, California.

Fig. 2.11 Stephen C. Massett, cover, *'Clear the way!' Or, Song of the wagon road; music composed and dedicated to the pioneers of the Great Pacific Rail Road!* Lithograph. Published by the author, San Francisco, 1856. Courtesy of The Huntington Library, San Marino, California.

Fig. 2.12 Edmund Thomas, cover for Massett, *When the moon on the lake is beaming*. Lithograph. J. R. Clarke, Sydney, c. 1860. Music Collection, National Library of Australia, Canberra.

Fig. 2.13 Walter G. Mason, *Comic sketch of Mrs Waller as Ophelia*, pl. 56 in *Australian Picture Pleasure Book*. Wood-engraving. J. R. Clarke, Sydney, 1857. National Library of Australia, Canberra.

Fig. 3.01 J. W. Lindt, *Joe Byrne's body outside Benalla Police Station*, 1880. Photograph. Courtesy of National Gallery of Australia, Canberra.

Fig. 3.02 E. McD. Johnstone, *The unique map of California*. Lithograph. Dickman-Jones Co.,

New South Wales, Sydney. **Colour Plate**

Fig. 4.21 George Hudson & Son Ltd, advertisement, 'Timber Yards', 1913, *Salon*, October 1913.

Fig. 4.22 A.D. Hall & Co. Furniture Co., trade advertisement, 'Mission furniture', c. 1915. Courtesy of Caroline Simpson Library and Research Collection, Historic Houses Trust of New South Wales, Sydney.

Fig. 4.23 Cover, *Building*, vol. 14, no. 84, August 1914. Courtesy of Caroline Simpson Library and Research Collection, Historic Houses Trust of New South Wales, Sydney.

Fig. 4.24 George Taylor, Cartoon of George Taylor with Louis Sullivan. Courtesy of Caroline Simpson Library and Research Collection, Historic Houses Trust of New South Wales, Sydney.

Fig. 4.25 E. O. Hoppé, *Canberra, Sydney & Melbourne Buildings*, ACT, 1930. Photograph. © E. O. Hoppé Estate, Curatorial Assistance, Inc., Los Angeles, California.

Fig. 4.26 Walter Burley Griffin & Marion Mahony Griffin (archs), Kerr Bros., *Interior view of the Banquet Hall with balcony and mural, Cafe Australia, Melbourne*, 1916 (now demolished). Eric Milton Nicholls Collection, National Library of Australia, Canberra.

Fig. 4.27 James Peddle, 'The bush bungalow', *The Home*, September 1920, p. 191.

Fig. 4.28 James Peddle (arch.), *Country house at Bundanoon for Eric Lloyd Jones 1919*, Lyndholme [now Spring Hill], Bundanoon, New South Wales. Courtesy of PTW Architects, Sydney.

Fig. 4.29 James Peddle (arch.), Ga-di-Rae, Bellevue Hill, New South Wales, 1916. Photograph: courtesy of Annabelle Chapman.

Fig. 4.30 James Peddle and S. G. Thorp (archs), The Cobbles, Seaview Terrace, Neutral Bay, New South Wales, 1922. Author's photograph.

Fig. 4.31 Alexander Jolly (arch.), Belvedere, Cranbrook Avenue, Mosman, New South Wales, 1919. Photograph: Anne Higham, RAIA.

Fig. 4.32 *Redwood bungalow at Rosebery*, in *Building*, 12 October 1916.

Fig. 4.33 Foldout brochure, Haberfield, New South Wales, c. 1915. Courtesy of Caroline Simpson Library and Research Collection, Historic Houses Trust of New South Wales, Sydney.

Fig. 5.01 Cover, *Sunset*, vol. 34, January 1915. Courtesy of The Huntington Library, San Marino, California.

Fig. 5.02 'The International Exhibition, Sydney, 1879–80,' supplement to *Illustrated Sydney News*, January 1880. Chromolithograph. National Library of Australia, Canberra. **Colour Plate**

Fig. 5.03 Harry Fenn, *The California Building*, in Walton, *World's Columbian Exposition: Art and architecture*, G. Barrie, Philadelphia, 189395, opp. p. 173. Balch Art Research Library, Los Angeles County Museum of Art, Los Angeles, California.

Fig. 5.04 Agricultural Building, California Midwinter international exposition, 1894, San Francisco. Courtesy of the Bancroft Library, University of California, Berkeley, California.

Fig. 5.05 *The Midwinter fair at San Francisco*, in *The Illustrated Australian News*, 1 May 1894. La Trobe Picture Collection, State Library of Victoria, Melbourne, Victoria.

Fig. 5.06 'The Pacific Limited: Chicago to California, San Diego Exposition All of 1916', postcard from the Chicago, Milwaukee, St Paul and the Southern Pacific Railways. Courtesy of San Diego Historical Society, San Diego, California. **Colour Plate**

Fig. 5.07 'An architectural gem: 'Spring' niche in Court of Four Seasons, 'Frisco Exhibition, 1915', in *Building*, 12 April 1915, p. 67.

Fig. 5.08 G. J. Oakeshott (arch.), Australian Pavilion at the Panama–Pacific international exposition, San Francisco, 1915. San Francisco History Center, San Francisco Public Library, San Francisco, California.

Fig. 5.09 'Home of the Redwood', exhibition home at the Panama–Pacific international exposition, brochure. Courtesy of the Alice Phelan Sullivan Library at The Society of California Pioneers, San Francisco.

Courtesy of San Diego Historical Society.

Fig. 6.21 Santa Barbara Courthouse with eucalypts. Author's photograph. **Colour Plate**

Fig. 6.22 George Washington Smith (arch.), El Hogar, Montecito, California, 1927. In *California Southland*, December 1927, p. 13.

Fig. 6.23 Spanish Style house, Pasadena, California. Courtesy of The Huntington Library, San Marino, California.

Fig. 6.24 'Putting more beauty into the landscape' (Reginald D. Johnson, arch.), in *California Southland*, December 1927, p. 11.

Fig. 6.25 R. F. Heckman, cover, *Touring Topics*, April 1925. Permission of The Automobile Club of Southern California Archives. Photograph: courtesy of The Huntington Library, San Marino, California. **Colour Plate**

Fig. 6.26 Karl Struss, *In the Gloaming*, Rotogravure Section, *Touring Topics*, vol. 17, April 1925. Permission of The Automobile Club of Southern California Archives. Photograph: courtesy of The Huntington Library, San Marino, California.

Fig. 6.27 Charles Hamilton Owens, cover, *Touring Topics*, January 1923. Permission of The Automobile Club of Southern California Archives. Photograph: courtesy of The Huntington Library, San Marino, California.

Fig. 6.28 Paul Hoffmann Studebaker, advertisement, *Touring Topics*, January 1923, opp. p. 25. Permission of The Automobile Club of Southern California Archives. Photograph: courtesy of The Huntington Library, San Marino, California.

Fig. 6.29 Franz Geritz, cover, *Touring Topics*, January 1926. Permission of The Automobile Club of Southern California Archives. Photograph: courtesy of The Huntington Library, San Marino, California. **Colour Plate**

Fig. 6.30 Fred Archer, *California Eucalypti*, in *Touring Topics*, Rotogravure Section, vol. 16, July 1924. Permission of The Automobile Club of Southern California Archives. Photograph: courtesy of The Huntington Library, San Marino, California.

Fig. 6.31 Arthur Millier, *Sentinel of the Mission*,

in *Touring Topics*, vol. 17, October 1925, p. 20. Permission of The Automobile Club of Southern California Archives. Photograph: courtesy of The Huntington Library, San Marino, California.

Fig. 6.32 Guy Rose, *Laguna eucalyptus*, c. 1917. Oil on canvas, 101.6 x 76.2 cm. Courtesy of Irvine Museum, Irvine, California. **Colour Plate**

Fig. 7.01 Leslie Wilkinson (arch.), Greenway, Vaucluse, Sydney, New South Wales, 1923. Photograph: courtesy of Anne Higham, RAIA (NSW).

Fig. 7.02 Leslie Wilkinson and John D. Moore (archs), Dowling House, Rose Bay Avenue, Bellevue Hill, Sydney, New South Wales, 1924. Photograph: courtesy of David Wilkinson, Melbourne.

Fig. 7.03 Leslie Wilkinson (arch.), Shadowood, Bowral, NSW, 1928. Photograph: Harold Cazneaux, 1933. Courtesy of National Library of Australia, Canberra.

Fig. 7.04 Leslie Wilkinson (arch.), Physics Building, Physics Road, University of Sydney, c. 1925. Courtesy of University of Sydney Archives.

Fig. 7.05 B. J. Waterhouse (arch.), Nutcote, Sydney, New South Wales, 1925. Author's photograph.

Fig. 7.06 Peddle, Thorp, & Walker (archs), house for L. Waterhouse, Sydney, New South Wales. Photograph: Harold Cazneaux in *The Australian Home Beautiful*, 7 June 1926, p. 15. Courtesy of Caroline Simpson Library and Research Collection, Historic Houses Trust of New South Wales, Sydney.

Fig. 7.07 William Hardy Wilson, corner of a garden at Eryldene, Gordon, New South Wales, 1930. Photograph: E. O. Hoppé. © E. O. Hoppé Estate, Curatorial Assistance, Inc., Los Angeles, California.

Fig. 7.08 Alsop & Sayce (archs), view of Winthrop Hall from the south, c. 1933. University of Western Australia Archives. Courtesy of West Australian Newspapers Ltd.

Fig. 7.09 Allison & Allison (archs), Royce Hall, University of California at Los Angeles,

Architecture and Design Collection, University Art Museum, University of California, Santa Barbara, California.

The Automobile Club of Southern California Collection of Photographs and Negatives, The Huntington Library, San Marino, California.

B. P. & H. Research Room, George Ellery Hale Building, Permit Center, Pasadena, California.

Isaac Wallace Baker Papers, Bancroft Library, University of California, Berkeley, California.

Ballarat Fine Art Gallery, Ballarat, Victoria.

Batchelder Collection, Phillips Library, Peabody Essex Museum, Salem, Massachusetts.

Photographic Collection, California Historical Society, San Francisco, California.

California State Library, California History Room, Sacramento, California.

Jeanne C. Carr Papers, The Huntington Library.

William M. Clarke Architectural Negative Collection, The Huntington Library.

George Collingridge Papers, Manuscripts Collection, National Library of Australia, Canberra, Australian Capital Territory.

Alfred Deakin Papers, National Library of Australia.

Francesco Franceschi Papers, Bancroft Library.

A. H. Fullwood Papers, National Library of Australia.

Photographs Collection, The J. Paul Getty Museum, Los Angeles, California.

Goodhue Papers, The Avery Library, Columbia University, New York, New York.

Greene & Greene Archives, The Gamble House, University of Southern California, Los Angeles, California.

Library, Haggin Museum, Stockton, California.

The Caroline Simpson Library and Research Collections, Historic Houses Trust of New South Wales, Sydney, New South Wales.

Helen Hunt Jackson Collection, The Huntington Library.

George Wharton James Papers, The Huntington Library.

Charles Keeler Papers, Bancroft Library.

Charles Augustus Keeler Collection, The Huntington Library.

Rex Nan Kivell Collection, National Library of Australia.

Balch Art Research Library, The Los Angeles County Museum of Art, Los Angeles, California.

Theodore Lukens Papers, The Huntington Library.

William Macleod Papers, Mitchell Library, State Library of New South Wales, Sydney, New South Wales.

James Wylie Mandeville Papers, The Huntington Library.

John Muir Papers, University of the Pacific, Holt–Atherton Special Collections, Stockton, California.

Music Collection, Petherick Reading Room, National Library of Australia.

National Archives of Australia, Canberra, Australian Capital Territory.

Library, National Gallery of Australia, Canberra, Australian Capital Territory.

Library, PTW Architects, Sydney, New South Wales.

Parliamentary Archives, Parliament of New South Wales, Sydney, New South Wales.

Research Library, Pasadena History Museum, Pasadena, California.

History Room, Pasadena Public Library, Pasadena, California.

Theodore Payne Papers, Theodore Payne Foundation, Sun Valley, California.

Pictures Collection, National Library of Australia.

Ellis Rowan Papers, National Library of Australia.

San Diego Historical Society, Balboa Park, San Diego, California.

Frederic B. Schell Photographic Collection, Yale University Art Gallery Print Room, New Haven, Connecticut.

William Smedley Papers, Archives of American Art, Smithsonian Institution, microfilm at The Huntington Library.

Alice Phelan Sullivan Library, Society of California Pioneers, San Francisco, California.

William Henry Traill Papers, Mitchell Library, State Library of New South Wales.

Thesis Library, Faculty of the Built Environment, University of New South Wales, Sydney, New South Wales.

Photographic Collection, Yosemite Museum, Yosemite, California.

Abraham, Mildred K. and Sue Rainey (eds), *Embellished with numerous engravings: The works of American illustrators and wood engravers, 1670–1880*, exhibition catalogue, Rare Book Department, University of Virginia Library, Charlottesville, 1987.

Adam, John P., '"True California gardens" … and the Australian connections', presentation, 'Browned Off: Old Gardens in a New World', 25th Annual Conference of the Australian Garden History Society, 15 October 2004, Sydney.

Adams, John R. P., *Distinctive Australian homes*, Sydney, 1925.

Aiken, Richard and Michael Looker (eds), *The Oxford companion to Australian gardens*, Oxford University Press, South Melbourne, 2002.

Albert, Frank, 'Albert, Michel François (1874–1962)', *ADB*, vol. 7, pp 27–28.

Alexander, J. A., *The life of George Chaffey: A story of irrigation beginnings in California and Australia*, Macmillan, London and Melbourne, 1928.

All about Burns, Philp & Company, Limited, their shipping agencies, branches & steamers, John Andrew & Co., Sydney, 1903.

Ambrose, Stephen E., *Nothing like it in the world: The men who built the transcontinental railroad, 1863–1869*, Simon & Schuster, New York, 2000.

Amero, Richard W., 'Balboa Park Notes', Balboa Park History Project, San Diego Historical Society, Richard Amero Collection, <http://www.sandiegohistory.org/amero/notesa.htm>.

—'History of the Administration Building in Balboa Park', San Diego Historical Society, <http://www.sandiegohistory.org/bpbuildings/admin.htm> .

—'A History of the East Side of Balboa Park', <http://members.cox.net/ramero/history-east-side-balboa-park.htm.

—'The making of the Panama–California Exposition 1909–1915', *Journal of San Diego History*, vol. 36, Winter 1990, p. 3.

Andrews, B. G., 'Hopkins, Livingston York (Yourtee) (1846 - 1927)', *ADB*, vol. 4, pp. 421–22.

—'Macleod, William (1850–1929)', *ADB*, vol. 10, pp 335–36.

—'Mahony, Francis (Frank) (1862–1916)', *ADB*, vol. 10, p. 381.

—'Traill, William Henry (1843–1902)', *ADB*, vol. 6, pp. 298–99.

Anthony, A. V. S., *Life and character: Drawings by W. T. Smedley, A.N.A.*, Harper & Bros., New York and London, 1899.

Apostol, Jane, *Painting with light: A centennial history of the Judson Studios*, Historical Society of Southern California, Los Angeles, 1997.

Apperly, Richard, et al., *A pictorial guide to identifying Australian architecture: Styles and terms from 1788 to the present*, Angus & Robertson Sydney, 1989.

—'Sydney Houses 1914–1939', 2 vols, MArch thesis, University of New South Wales, Kensington, 1972.

Appleton, Marc (ed.), *George Washington Smith: An architect's scrapbook*, Tailwater Press, Los Angeles, 2001.

Appleyard, Ron, et al., *S. T. Gill: The South Australian years*, Art Gallery of South Australia, Adelaide, 1986.

'Architects' meeting', *The Los Angeles Builder and Contractor*, 12 September 1912, p. 4, col. 1.

Armitage, Merle, *Accent on life*, Iowa State University Press, Ames, 1965.

Ashton, Julian, *Now came still evening on*, Angus & Robertson, Sydney, 1941.

'An Australian art industry', *The Australian*, 2 October 1886.

'The Australian Building at the Panama Exposition', *Adelaide Register*, 23 February 1915.

Australian dictionary of biography (ADB), Melbourne University Press, Melbourne, 1966–2003, <http://www.adb.online.anu.edu.au/adbonline.htm>.

The Australian encyclopedia, Angus & Robertson, Sydney, 1958.

Ayres, Atlee B., *Mexican architecture: Domestic, civil & ecclesiastical*, William Helburn, Inc., New York, 1926.

Baird, Joseph, *California's pictorial letter sheets, 1849–1869*, D. Magee, San Francisco, 1967.

Banham, Reyner, 'Death and life of the Prairie School', *Architectural Review*, vol. 154, August 1973, pp. 99.

Barrett, Peter, 'Building through the Golden Gate: Architectural Influences from Trans-Pacific Trade and Migration between Australia and California 1849–1914', MArch thesis, University of Melbourne, Melbourne, 2001.

Barrett, Margaret (ed.), *The Edna Walling book*

of Australian garden design, Anne O'Donovan, Richmond, 1980.

Barry, John D., *The Palace of Fine Arts & the French and Italian Pavilions*, Taylor & Taylor, San Francisco, 1915.

Barry, W. Jackson, *Past & present, and men of the times*, McKee & Gamble, Wellington, 1897.

—*Up and down, or, fifty years' colonial experiences in Australia, California, New Zealand, India, China, and the South Pacific*, Sampson Low, Marston, Searle & Rivington, London, 1879.

Barton, Hilton, 'Bret Harte and Henry Lawson: Democratic realists', *The Realist*, vol. xxvi, no. 26, Winter 1967, Sydney, pp. 7–10.

Bateson, Charles, *Gold fleet for California: Forty-Niners from Australia and New Zealand*, Michigan State University Press, East Lansing, 1963.

The Bay of San Francisco: The metropolis of the Pacific coast and its history, vol. ii, Lewis Publishing Co., Chicago, 1892.

Bearchell, Charles and Larry D. Fried, *The San Fernando Valley then and now: An illustrated history*, Windsor Publications, Northridge, California, 1988.

Bell, Philip and Roger Bell, *Americanization and Australia*, UNSW Press, Sydney, 1998.

Benedict, Burton, 'The anthropology of world's fairs', in Benedict, et al., *The anthropology of world's fairs: San Francisco's Panama Pacific International Exposition of 1915*, The Lowie Museum of Anthropology in association with Scholar Press, London and Berkeley, 1983, pp. 43–52.

Beresford, Hattie, 'The way it was: Franceschi and Eaton landscape Montecito', *Montecito Journal*, 19 April 2007, <http://www.montecitojournal.net/archive/13/16/946/>.

Biazos (Becerra), P., 'The Life and Works of Emil Lawrence Sodersten', BArch thesis, University of New South Wales, Sydney, 1987.

Bingham, Edwin R., *Charles F. Lummis, Editor of the southwest*, The Huntington Library, San Marino, 1955.

Blake, Alison, 'Melbourne's Chinatown: The Evolution of an Inner Ethnic Quarter', BA (Hons) thesis, Department of Geography, University of Melbourne, Melbourne, 1975.

Blake, Louise, 'Rescuing the Regent Theatre', *Journal of the Public Record Office Victoria*, no. 4, September 2005, pp. 2–6, <http://www.prov.vic.gpv.au/provenance/no4/RescuingTheRegentTheatre2.asp>.

Blodgett, Peter J., *Land of golden dreams: California in the gold rush decade, 1848–1858*, Huntington Library Press, San Marino, 1999.

Bogart, Michele H., *Artists, advertising, and the borders of art*, University of Chicago, Chicago, 1996.

Bokovoy, Matthew F., *The San Diego world's fairs and southwestern memory, 1880–1940*, University of New Mexico Press, Albuquerque, 2005.

Bonyhady, Tim, *The colonial image: Australian painting 1800–1880*, Ellsyd Press, Chippendale, NSW, 1986.

—*The colonial earth*, Miegunyah Press, Melbourne, 2000.

'A book firm in trouble', *Los Angeles Times*, 18 June 1891, p. 1.

Borthwick, James, *Three years in California*, William Blackwood, London, 1857.

Bosley, Edward R., *Greene & Greene*, Phaidon, London, 2000.

Bossom, Alfred C., *An architectural pilgrimage in old Mexico*, C. Scribner's Sons, New York, 1924.

Bowden, Keith Macrae, *Samuel Thomas Gill: Artist*, Hedges and Bell, Melbourne, 1971.

Bowdon-Butler, Caroline and Charles Pickett, 'Homes in the sky', *Architecture Australia*, May–June 2007, <http://www.architectureaustralia.com/aa/aaissue.php?issueid=200705>.

Boyd, Robin, *The Australian ugliness*, F. W. Cheshire, Melbourne, 1960.

—*Australia's home: Its origins, builders and occupiers*, Melbourne University Press, Melbourne, 1961.

Bramen, Carrie Tirado, 'The urban picturesque and the spectacle of Americanization', *American Quarterly*, vol. 52, no. 3, September 2000, pp. 444–77.

Brechin, Grey, 'Sailing to Byzantium: The architecture of the fair', in Benedict Burton et al., *The anthropology of world's fairs: San Francisco's Panama Pacific International Exposition of 1915*, The Lowie Museum of Anthropology in association with Scholar Press, London and Berkeley, 1983.

—'*The Wasp*: Stinging editorials and political cartoons', *Bancroftiana*, vol. 121, Fall 2002, pp. 1, 8; <http://bancroft.berkeley.edu/events/bancroftiana/121/wasp.html>.

Brogan, John R., *101 Australian homes designed by John R. Brogan*, Building Publishing Co. Ltd., Sydney, 1935.

Brown, Joshua, *Beyond the lines: Pictorial reporting, everyday life, and the crisis of Gilded Age America*, University of California Press, Berkeley, 2002.

Brown, Julie K., *Contesting images: Photography and the World's Columbian Exposition*, University of Arizona Press, Tucson, 1994.

Buckbee, Edna Bryan, *The saga of old Tuolumne*, The Press of the Pioneers, New York, 1935.

Buley, C. *Australian life in town and country*, The Knickerbocker Press, New York and London, 1905.

Bull, Gordon, 'Taking place: Panorama and panopticon in the colonisation of New South Wales', *Australian Journal of Art*, vol. 12, 1994–95, pp. 75–95.

'"The Bunyas", the residence of Richard Stanton, Esq, Haberfield, Sydney', *Home & Garden Beautiful*, 1 February 1913, Australia, cover, pp. 145, 147, 149, 151, 156.

Burg, David F., *Chicago's White City of 1893*, University of Kentucky Press, Lexington, 1976.

Burgess, Gelett, *The Purple Cow and other poems*, Huntington Library, Pasadena, 1968.

Burgess, Verona, 'Picking up a tune: Researching the provenance of Australian traditional music', *NLA News*, vol. xii, no. 3, December 2001, p. 12.

'Burials in rural cemetery, Stockton, California' in *Old cemeteries of San Joaquin County, California*, vol. ii, San Joaquin Genealogical Society, Stockton, California, 1962.

Burke, Keast, *Newsreel in 1862: Moving diorama of the Victorian exploring expedition*, Australian Documentary Facsimile Society, Sydney, 1966.

—*Gold and silver: Photographs of Australian goldfields from the Holtermann Collection*, Penguin, Ringwood, Victoria, 1973.

Butcher, Mike and Yolande M. J. Collins, *An American on the goldfields: The Bendigo photographs of Benjamin Pierce Batchelder*, Holland House, Burwood, Victoria, 2001.

Butler, Graeme, *The Californian bungalow in Australia*, Lothian, Melbourne, 1992.

Butler, Roger, *Printed images in colonial Australia 1801–1901*, National Gallery of Australia, Canberra, 2007.

—'Printmaking and photography in Australia: A shared history', *Imprint: The Journal on Australian Printmaking*, vol. 24, no. 4, December 1989, p. 3.

—*Printmaking and Australia: Means of production*, typescript, Canberra, c. 1985.

Butterfield, Harry. M., 'Builders of California horticulture, part I', *Journal of the California Horticultural Society*, vol. xxii, no. 1, January 1961, pp. 6–7.

—'Builders of California horticulture, part II', *Journal of the California Horticultural Society*, vol. xxii, no. 3, July 1961, pp. 102–07.

—'The introduction of eucalyptus into California, *Madroño*, vol. 3, 1 October 1935, pp. 149–54.

Caban, Geoffrey, *A fine line: A history of Australian commercial art*, Hale & Ironmonger, Sydney, 1983.

California: A guide to the Golden State, American Guide Series, Hastings House, New York, 1939.

California of the Southland: A history of the University of California at Los Angeles, The University of California at Los Angeles Alumni Association, Los Angeles, 1937.

Callaway, Anita, *Visual ephemera: Theatrical art in nineteenth-century Australia*, University of New South Wales Press, Sydney, 2000.

Capturing light: Masterpieces of California photography, 1850 to the present, exhibition catalogue, Oakland Museum of California, Oakland, 2001.

Carlson, Lewis H. and George A. Colborn (eds), *In their place: White America defines her minorities 1850–1950*, Wiley, New York, 1972.

Carmel, John Prosper, 'The American view of Australia', *The Lone Hand*, 1 November 1909, pp. 37–44.

Carter, Harry Lee, *The two lands of gold, or, the Australian and Californian directory for 1853*, Crozier & Mullin, London, 1853.

Carter, Nancy Carol, 'When Dr Fairchild visited Miss Sessions: San Diego 1919', *Journal of San Diego History*, vol. 50, nos. 3 and 4, Summer–Fall 2004, pp. 75–89.

Carr, Ezra S., *The patrons of husbandry on the Pacific Coast*, A. L. Bancroft & Co., San Francisco, 1875.

Carrillo, Leo, *The California I love*, Prentice-Hall, Englewood Cliffs, New Jersey, 1961.

Cassell's picturesque Australasia, Cassell's, London, 1887–89.

Cato, Jack, *Story of the camera in Australia*, Georgian House, Melbourne, 1955.

Chalmers, Claudine, *Splendide Californie! Impressions of the Golden State by French artists, 1786–1900*, no. 212, Book Club of California, San Francisco, 2001.

Chartier, JoAnn, *With great hope: Women of the California gold rush*, TwoDot, Guildford, Connecticut, 2000.

'Cheops' architect', *Time*, 22 September 1952, p. 2; <www.time.com/time/magazine/article/0,9171,822508,00.html>.

'The Chinese in Australia (Melbourne Cor. New York Age)', *Los Angeles Times*, 21 April 1888.

Chou, Bon-Wau, 'The Chinese in Victoria: A Longterm Survey', PhD thesis, University of Melbourne, Melbourne, 1993.

Christman, Florence, *The romance of Balboa Park*, San Diego Historical Society, San Diego, 1985.

Churchward, L. G., 'Australia and America: A Sketch of the Origin and Early Growth of Social and Economic Relations between Australia and the United States of America, 1790–1876', unpublished MA thesis, University of Melbourne, 1941.

—'Australian–American relations during the gold rush', *Historical Studies/Australia & New Zealand*, vol. 2 , no. 5,April 1942.

Clarke, Harold George, *The centenary Baxter book*, Sign of the Dove with the Griffin, Royal Leamington Spa, 1936.

Clary, Raymond H., *The making of Golden Gate Park, 1906–1950*, Don't Call it Frisco Press, San Francisco, 1987.

Colligan, Mimi, *Canvas documentaries: Panoramic entertainments in nineteenth-century Australia and New Zealand*, Melbourne University Press, Carlton South, 2002.

Collingridge, George, '"Our" Pacific Ocean', *The Lone Hand*, 1907, p. 115.

Collins, Diane, 'Two shopfronts and picture showmen: Film exhibition to the 1920s', in *A century of Australian cinema*, Australian Film Institute, South Melbourne, 1995.

Coleman, Marion Moore, *Fair Rosalind: The American career of Helena Modjeska*, Cherry Hill Books, Cheshire, Connecticut, 1969.

Connell, Will, *The missions of California*, Hastings House, New York, 1941.

Conner, E. Palmer, *The romance of the ranchos*, Title Insurance and Trust Company, Los Angeles, 1929.

Conzen, Kathleen Neils, 'Saga of families', in *The Oxford history of the American West*, Oxford University Press, New York, 1994, pp. 315-357.

Coolbrith, Ina D., 'Introduction', in Bret Harte, *The heathen Chinee: Plain language from Truthful James*, Book Club of California, San Francisco, 1934.

Cooper, Ellwood, 'Life of Ellwood Cooper', private pub., Santa Barbara, 1913.

Cooper, Nora, 'Boomerang', *The Australian Home Beautiful*, April 1930, p. 13.

—'Casa di Lucia: A "little bit of Old Spain" on the shores of Sydney Harbour', *The Australian Home Beautiful*, 2 December 1929, pp. 13–16.

—'New ideas allied to Old–World Styles', *The Australian Home Beautiful*, 7 June 1926, cover, pp. 14–19.

Cordingley, James, *Early colour printing and George Baxter: A monograph*, North-Western Polytechnic, London, 1949.

Cowles, Christopher and Walker, David, *The art of apple branding: Australian apple case labels and the industry since 1788*, Apples from Oz, Hobart, 2005.

Crowley, F. K., *Modern Australia in documents 1901–1939*, Wren Publishing, Melbourne 1973.

Cuffley, Peter, *Australian houses of the '20s & '30s*, Five Mile Press, Fitzroy, Victoria, 1989, p. 35.

'Daceyville: The N.S.W. state garden suburb', *Building*, vol. 16, 12 November 1912, p. 47.

Dailey, Victoria, 'The illustrated book in California 1905–1940', *The Journal of Decorative and Propaganda Arts*, vol. 7, Winter 1988, pp. 72–87.

—and Natalie Shivers and Michael Dawson (eds), *LA's early moderns: Art, architecture, photography*, Balcony Press, Los Angeles, 2003.

Dana, Richard Henry, Jr, *Two years before the mast*, Modern Library, New York, 2001.

Dash, Mike, *Tulipomania: The story of the world's most coveted flower and the extraordinary passions it aroused*, Three Rivers Press, New York, 1999.

Davey, Annabelle, 'James Peddle: Craftsman Architect', BArch thesis, School of Architecture, University of New South Wales, Kensington, 1981.

Davies, Alan, *An eye for photography: The camera in Australia,* Miegunyah Press, Carlton, Victoria, 2004.

—and Peter Stanbury, *The mechanical eye in Australia: Photography 1841–1900*, Oxford University Press, Sydney, 1985.

Davis, C., "McLeay (Macleay), Alexander (1767–1848)', *ADB*, vol. 2, pp. 177–80.

Davison, Graeme, *Australia 1888*, Fairfax, Syme & Weldon, Sydney, 1987.

—'Exhibitions', *Australian Cultural History*, no. 2, 1982–83, pp. 5–21.

—*The rise and fall of marvellous Melbourne*, Melbourne University Press, Carlton, Victoria, 1978.

Davison, Nancy R., 'The grand triumphal quick-step; or sheet music covers in America', in John D. Morse (ed.), *Prints in and of America to 1850*, Winterthur Conference Report 1970, University Press of Virginia, Charlottesville, 1970, pp. 264–68.

Dawson, Michael, 'Fred Archer: A Southern California innovator', in Dailey, et al., *LA's early moderns: Art, architecture, photography*, Balcony Press, Los Angeles, 2003, pp. 264–65.

Day, Melvin N., *Nicholas Chevalier, artist: His life and work with special reference to his career in New Zealand and Australia*, Millwood, Wellington, New Zealand, 1981.

de Gruchy, Graham, 'The Spanish Mission Revival Style in Brisbane: An outline of the development of

the style in the 1920s and 1930s', in *SAHANZ 87: Society of Architectural Historians Australia and New Zealand. Papers*, Fourth Annual Conference, Adelaide, 9–10 May 1987.

DeLyser, Dydia, *Ramona memories: Tourism and the shaping of Southern California*, University of Minnesota Press, Minneapolis, 2005.

Department of Architecture, The University of Pennsylvania 1874–1934, University of Pennsylvania Press, Philadelphia, 1934.

Deverell, William, *Railroad crossing: Californians and the railroad, 1850–1910*, University of California Press, Berkeley, 1994.

—*Whitewashed adobe: The rise of Los Angeles and the remaking of its Mexican past*, University of California Press, Berkeley, 2004.

Dewar, John, *Adios Mr Penelon!*, Los Angeles County Museum of Natural History, Los Angeles, 1968.

Didion, Joan, *Where I was from*, Knopf, New York, 2003, p. 66.

Dixon, Joseph K., *The vanishing race: The last great Indian Council*, Doubleday, Page & Co., Garden City, New York, 1914.

Dixon, Trish and Jennie Churchill, *The vision of Edna Walling: Garden plans 1920–1951*, Bloomings Books, Hawthorn, Victoria, 1998.

Dobkin, Marjorie M., 'A twenty-five-million-dollar mirage', in Burton Benedict, et al., *The anthropology of world's fairs: San Francisco's Panama Pacific International Exposition of 1915*, pp. 66–93.

Doherty, Erin M., 'Jud Yoho and the Craftsman Bungalow Company: Assessing the Value of the Common House', MArch thesis, University of Washington, Seattle, 1997.

Dow, David M., 'The spirit of San Francisco', *The Lone Hand*, 1 December 1908, pp. 172–75.

Dow, T. K., 'A tour in America', *The Australasian*, Melbourne, 1884.

Driesbach, Janice T., *Art of the gold rush*, Oakland Museum of California and University of California Press, Berkeley, 1998.

—and William H. Gerdts, *Direct from nature: The oil sketches of Thomas Hill*, Yosemite Association and Crocker Art Museum, Sacramento, 1997.

Drummond, W. A., 'Spanish Style in home building: Australian architect explains advantages', *The Australian Home Beautiful*, 1 February 1928, pp. 28–29, 53.

Duggan, Mary Kay, 'Music publishing and printing in San Francisco before the earthquake & fire of 1906', *The Kemble Occasional*, no. 24, Autumn 1980.

— 'Nineteenth century California sheet music',<http://www.sims.berkeley.edu/~mkduggan/art.html>.

Dumke, Glenn S., *The boom of the eighties in Southern California*, The Huntington Library, San Marino, 1944.

Dunlop, Beth, 'Inventing antiquity: The art and craft of Mediterranean Revival architecture', *The Journal of Decorative and Propaganda Arts*, vol. 23, 1998, pp. 191–207.

'Early twentieth century landscape designers in NSW', *The News: The Twentieth Century Heritage Society of NSW Inc.*, vol. 4, Summer–Autumn 2007.

Ebbutt, Vanessa Ann, 'Haberfield and the Garden Suburb Concept', BLArch thesis, University of New South Wales, Sydney, 1987.

Eddy, Lucinda, 'Frank Mead and Richard Requa', in Robert Winter (ed.), *Toward a simpler life*, University of California Press, Berkeley, 1997.

—'Lilian Jenette Rice: Search for a regional identity', *Journal of San Diego History*, vol. 29, no. 4, Fall 1983, pp. 262–85.

Edminson, Ross Wilton, 'The possibilities in a bungalow,' *Sunset*, vol. 34, February 1915, pp. 350–54.

Edquist, Harriet, *Harold Desbrowe-Annear: A life in architecture*, Miegunyah Press, Melbourne, 2004.

—*Pioneers of modernism: The Arts and Crafts movement in Australia*, Miegunyah Press, Melbourne, 2008.

Edwards, Zeny, 'The Life and Work of Sir John Sulman, 1849–1934', PhD thesis, 3 vols, University of Technology, Sydney, 2007.

Eggener, Keith L., 'Maybeck's melancholy: Architecture, empathy, empire, and mental illness at the 1915 Panama–Pacific International Exposition', *Winterthur Portfolio*, vol. 29, no. 4, Winter 1994, pp. 211–26.

Ehrlich, George, 'Technology and the Artist: A Study of the Interaction of Technological Growth and Nineteenth Century American Pictorial Art', PhD thesis, University of Illinois, Urbana, 1960.

Elford, Eddy, *The log of a cabin boy*, San Francisco, 1922.

Elias, Judith W., *Los Angeles: Dream to reality, 1885–1915*, California State University Northridge Libraries, Northridge, 1983.

Elliott, Alan F., *The Woodbury papers: Letters and documents held by the Royal Photographic Society*, A. F. Elliott, South Melbourne, 1996.

Elliot, W. Rodger and David L. Jones, *Encyclopedia of Australian plants*, Lothian, Melbourne, 1980.

Ennis, Helen, *Cazneaux: The quiet observer*, National Library of Australia, Canberra, 1994.

—*Intersections: Photography, history and the National Library of Australia*, National Library of Australia, Canberra, 2004.

—*Photography and Australia*, Reaktion Books, London, 2007.

Esau, Erika, 'Behind the camera: The family albums of Harold Cazneaux', *National Library of Australia News*, November 1999, pp. 3–7.

—'Labels across the Pacific' in Prue Ahrens and Chris Dixon (eds), *Coast to coast: Case histories of modern Pacific crossings*, Cambridge Scholar's Publishing – Pacific Focus Series, UK, forthcoming.

—'Thomas Glaister and early Australian photography', *History of Photography*, vol. 23, no. 2, Spring 1999, pp.187–91.

—and George Boeck, *Blue guide Australia*, A & C Black, London, 1999.

'Ernest Braunton: In memoriam, August 21, 1867–March 22, 1945', in *California Avocado Society Yearbook*, vol. 30, 1945, pp. 106–07.

Estavan, Lawrence (ed.), *San Francisco theatre research*, vol. 1, WPA Project 8386, May 1938, San Francisco.

Evans, Martha M., *Claude Raguet Hirst: Transforming the American still life,* Hudson Hills Press, New York, 2005.

Everett, Marshall, *Complete life of William McKinley and story of his assassination*, [Chicago?], 1901.

Everett, Percy, 'Architectural tendencies', *The Australian Home Builder*, August 1923, p. 15.

Ewers, John C., 'Not quite Redmen: The Plains Indian illustrations of Felix O. C. Darley', *American Art Journal*, vol. 3, no. 2, Autumn 1971, pp. 88–98.

Fairchild, David, *The world was my garden: Travels of a plant explorer*, Scribner's, New York, 1944 [c. 1938].

Falkiner, Sue (ed.), *Leslie Wilkinson: A practical idealist*, Valadon Publishing, Sydney, 1982.

Farmer, Jared, 'Gone native', *Huntington Frontiers*, Spring–Summer 2007, p. 18.

Fauchery, Antoine, *Sun pictures of Victoria: The Fauchery–Daintree collection 1858*, text by Dianne Reilly and Jennifer Carew, Library Council of Victoria, South Yarra, 1983.

—*Lettres d'un mineur en Australie; précédées d'une lettre de Théodore de Banville*, Poulet-Malassis et de Broise, Paris, 1857.

'The federal city', *Building*, vol. 6, no. 67, 12 March 1913, p. 37.

Fenn, William P., *Ah Sin and his brethren in American literature*, College of Chinese Studies cooperating with California College in China, Peking, 1933.

Ferguson, Charles D., *The experiences of a Forty-Niner during thirty-four years' residence in California and Australia*, Frederick T. Wallace (ed.), The William Publishing Co., Cleveland, 1888.

Fisher, William Arms, *Notes on music in old Boston*, Oliver Ditson Co., Boston, 1918.

—*One hundred and fifty years of music publishing in the United States*, Oliver Ditson Co., Boston, 1933.

Fitzpatrick, Peter, *The sea coast of bohemia: Literary life in Sydney's Roaring Twenties*, University of Queensland Press, Brisbane, 1992.

Flanigan, Kathleen, 'William Sterling Hebbard: Consummate San Diego architect', *Journal of San Diego History*, vol. 33, no. 1, Winter 1987, pp. 1–35.

Flower, Cedric, 'Moore, John Drummond Macpherson (1888–1958)', *ADB*, vol. 10, pp. 566–67.

Folsom, Ed, '"This heart's geography's map": The photographs of Walt Whitman', *The Virginia Quarterly Review*, 2005.

Fox, Paul, 'The intercolonial exhibition (1866): Representing the colony of Victoria', *History of Photography*, vol. 23, no. 2, Summer 1999.

Franceschi, F., *Santa Barbara exotic flora: A handbook of plants from foreign countries grown at Santa Barbara, California*, Santa Barbara, 1895.

Freeland, J. M., *Architect extraordinary: The life & work of John Horbury Hunt 1838–1904*, Cassell, Melbourne, 1970.

—*Architecture in Australia: A history*, Penguin Books Australia, Ringwood, Victoria, 1972.

Freestone, Robert and Bronwyn Harris, *Florence Taylor's hats*, Haltead Press, Ultimo, NSW, 2007.

—'Sunlight, space and suburbs: The physical planning ideas of Sir John Sulman,' *Journal of The Royal Australian Historical Society*, vol. 8, pt. 2 (December 1995), p.139.

'Fresh literature', *Los Angeles Times*, 16 December 1889, p. 2.

'The 'Frisco Exhibition: Walter Burley Griffin tells of a remarkable feature', *Building*, 12 February 1914, pp. 165–66.

From Nutcote to Elwatan: The art and architecture of B. J. Waterhouse, Mosman Art Gallery, Mosman, New South Wales, 2004.

'El Fuereides', *Sunset*, vol. xxxii, May 1914, pp. 1060–63.

Fullerton, Patricia, *The flower hunter: Ellis Rowan,*

National Library, Canberra, 2002.

Galbally, Ann, *Charles Conder: The last bohemian*, Melbourne University Press, Carlton South, Victoria, 2002.

Gambee, Budd Leslie, Jr, '*Frank Leslie's Illustrated Newspaper, 1855–1860*: Artistic and Technical Operations of a Pioneer Pictorial News Weekly in America', PhD thesis, University of Michigan, Ann Arbor, 1963.

Garran, Andrew, (ed.), *The Picturesque atlas of Australasia*, The Picturesque Atlas Publishing Co., Sydney, 1887.

Garrison, G. Richard and George W. Rustay, *Mexican houses: A book of photographs & measured drawings*, Architectural Book Publishing Company, Inc., New York, 1930.

Gault-Williams, Malcolm, 'Legendary surfers: A definitive history of surfing's culture and heroes, *Surfer Magazine*, vol. 1, chapter 10.

Gebhard, David, *George Washington Smith, 1876–1930: The Spanish Colonial Revival in California*, University of California Santa Barbara Art Gallery, Santa Barbara, 1964.

—*Lutah Maria Riggs*, Capra Press, Santa Barbara, 1992.

—'The Spanish Colonial Revival in Southern California (1895–1930)', *The Journal of the Society of Architectural Historians*, vol. 26, no. 2, May 1967, pp. 131–47.

—and Robert Winter, *Los Angeles: An architectural guide*, Gibbs–Smith, Salt Lake City, 1994.

Gebhard, Patricia and Kathryn Masson, *The Santa Barbara County Courthouse*, Daniel & Daniel, Santa Barbara, 2001.

Gerard, Frank R. and Franklin H. Perkins, *Ojai the beautiful*, Ojai Publishing Co., Ojai, 1927.

Gibbs, R. M., 'Johnson, Joseph Colin Francis (1848–1904)', *ADB*, vol. 9, 1983, pp 495–96.

Gilbert, James, *Perfect cities: Chicago's utopias of 1893*, University of Chicago Press, Chicago, 1991.

Giles, J. M., *Some chapters in the life of George Augustine Taylor*, Building Pub. Co. Pty. Ltd., Sydney 1917.

Gill, S. T., *Victoria gold diggings and diggers as they are*, Macartney & Galbraith, Melbourne, 1852.

Gisel, Bonnie Johanna, *Kindred and related spirits: The letters of John Muir and Jeanne C. Carr*, University of Utah Press, Salt Lake City, 2001.

Goldie, Albert, 'The Garden Suburb idea', *The Lone Hand*, 2 June 1913, pp. 163–67.

Goodman, David, *Gold seeking: Victoria and California in the 1850s*, Allen & Unwin, St Leonards, NSW, 1994.

Gopnik, Adam, 'Homer's wars,' *The New Yorker*, 31 October 2005, pp. 69–70.

—'Will power', *The New Yorker*, 13 September 2004, p. 90.

Gordon, Mary McDougall, '"This Italy and garden spot of All-America": A Forty–Niner's letter from the Santa Clara Valley in 1851', *Pacific Historian*, vol. xxix, no. 1, Spring 1985, pp. 4–16.

Goss, Peter L., and Kenneth R. Trapp, *The bungalow lifestyle and the Arts & Crafts Movement in the intermountain West*, Utah Museum of Fine Arts, University of Utah, Provo, Utah, 1995.

Grant, George Monro (ed.), *Picturesque Canada: The country as it was and is*, Belden, Toronto, 1882.

Greene, Julie, *The canal builders: Making America's Empire at the Panama Canal*, Penguin Press, New York, 2009.

Grishin, Sasha, 'S. T. Gill: Defining a landscape', *Voices*, National Library of Australia, vol. ii, no. 4, Summer 1992–93, pp 5–19.

—*S. T. Gill: Dr Doyle's sketches in Australia*, Mitchell Library and Centaur Press, Sydney, 1993.

Gruber, F., *Illustrated guide and catalogue of Woodward's Gardens*, Francis, Valentine, & Co., Book and Job Printers, San Francisco, 1879.

Guilliatt, Richard, 'Old gold', *The Sydney Morning Herald*, Spectrum, 8 April 1995.

Gulliver, Harold G., 'Arbolada in the Ojai Valley of Southern California'; reprint from *Country Life*, September 1924, pp. 4–5.

Gutzkow, F., George Chismore and Alice Eastwood, *Doctor Hans Herman Behr*, California Academy of Sciences, San Francisco, 1905.

Haas, Robert Bartlett, 'William Herman Rulofson: Pioneer daguerreotypist and photographic educator', *California Historical Society Quarterly*, vol. xxxiv, no. 4, December 1955, pp. 289–300.

Hagerty, Donald J., *Desert dreams: Maynard Dixon*, Gibbs-Smith, Salt Lake City, 1993.

Hall, Barbara and Jenni Mather, *Australian women photographers 1840–1960*, Greenhouse Publications, Richmond, Victoria, 1986.

Hall, Norman, *Botanists of the eucalypts*, CSIRO, Melbourne, 1978.

Hamann, Conrad, 'Five heralds of free enterprise: Australian cinemas and their architecture from the 1900s to the 1940s', in *A century of Australian cinema*, Australian Film Institute, South Melbourne, 1995, pp. 84–111.

Hanna, Phil Townsend, *The wheel and the bell: The story of the first fifty years of The Automobile Club of Southern California*, The Pacific Press, Los Angeles, 1950.

Hargraves, Edward Hammond, *Australia and its gold fields: A historical sketch of the progress of the Australian colonies, from the earliest times to the present day; with a particular account of the recent gold discoveries, and observations on the present aspect of the land question. To which are added notices on the use and working of gold in ancient and modern times; and an examination of the theories as to the sources of gold*, H. Ingram and Co., Milford House, London, 1855.

Harper, J. Henry, *The house of Harper: A century of publishing in Franklin Square*, Harper & Bros., Publishers, New York and London, 1912.

Harrison, Alfred C., Jr and Ann Harlow (eds), *William Keith: The Saint Mary's College collection*, Hearst Art Gallery, Saint Mary's College of California, Moraga, California, 1988.

Harte, Bret, 'The Ballad of the Emeu', *Californian*, vol. 1, no. 1, May 28, 1864, p. 1.

—'The Heathen Chinee', words by Bret Harte, music by Chas. Tourner, illustration by Vallendar & Co., S. Brainard's Sons, Cleveland, 1870.

—'The Heathen Chinee'; *words by Bret Harte, music by F. B.*, lithography by J. H. Bufford's Lith., Oliver Ditson & Co., Boston, 1870.

—*The heathen Chinee songster*, Beadle & Co., New York, 1871.

—*The 'Heathen Chinee' musical album: Containing 15 pieces of the most popular songs, mostly comic*, music by Henry Tucker, R. M. DeWitt Publisher, 33 Rose St, New York, 1871.

—*The 'Heathen Chinee' musical album: containing 15 pieces of the most popular songs, mostly comic* (another version), with music by Matthias Keller, J. F. Loughlin, Boston, 1871.

—'That Heathen Chinee' *& other poems mostly humorous by F. Bret Harte, author of 'The Luck of Roaring Camp' and 'Sensation Novels Condensed', the music by Stephen Tucker, composer of* Beautiful isle of the sea, John Camden Hotten, London, 1871.

—*The heathen Chinee: Plain language from Truthful James*, Book Club of California, San Francisco, 1934.

Harte, Francis Bret, 'Plain language from Truthful James: Table Mountain, 1870', in Thomas R. Lounsbury (ed.), *Yale book of American verse*, Yale University Press, New Haven, 1912.

Hayes, John, 'Life in the bush', *Overland Monthly*, vol. 5, July–December 1870, pp. 495–504.

Hazzard, Margaret, 'Rowan, Marian Ellis (1848–1922)', *ADB*, vol. 11, pp. 465–66.

Hennessy, Jack F., 'A few impressions of modern America', *Art & Architecture: Being the Journal of The Institute of Architects of New South Wales*, vol. ix, no. 3, May–June 1912, p. 486.

Herny, Ed, et al., *Berkeley bohemia: Artists and visionaries of the early 20th century*, Gibbs-Smith, Salt Lake City, 2008, pp. 33–50.

Hetherington, Michelle, *James Northfield and the art of selling Australia*, National Library of Australia, Canberra, 2006.

Hewett, Edgar L. and Johnson, William Templeton, 'Architecture of the exposition', *Papers of the School of American Archaeology*, Archaeological Institute of America, no. 32, Washington, DC, 1916.

Hewson, H. and Hazzard, M., *Flower paintings of Ellis Rowan*, National Library of Australia, Canberra, 1982.

Heyman, Harriet, 'Blue gum fever', *Pacific Horticulture*, vol. 56, no. 3, Fall 1995, pp. 17–21.

Hines, Thomas S., *Burnham of Chicago*, Oxford University Press, New York, 1974.

—*Irving Gill and the architecture of reform*, The Monacelli Press, New York, 2000.

'The History of the Panama–California Exposition', San Diego Historical Society, <http://www.sandiegohistory.org/pancal/sdexpo35.htm>.

Hogben, Paul and Fung, Stanislaus, 'Landscape and culture, geography & race: Some shifts in Australian architectural commentary', *Voices: The Quarterly Journal of the National Library of Australia*, vol. 7, no. 2, Winter 1997, pp. 5–14.

Holliday, J. S., *Rush for riches: Gold fever and the making of California*, University of California Press, Berkeley, 1999.

—*The world rushed in: The California gold rush experience*, Simon & Schuster, New York, 1981.

Holmes, Robyn and Martin, Ruth Lee, *The collector's book of sheet music covers*, National Library of Australia, Canberra, 2001.

Hopkins, Una Nixson, 'The California bungalow', *The Architect and Engineer of California*, vol. iv, no. 3, April 1906, p. 36.

Howard, Clara E. (ed.), *Three pioneer California gold rush songs*, private pub., Menlo Park, California, 1948.

Huffer, Julie, '$20m Boomerang back on the market', *The Sydney Morning Herald*, 19 February 2005.

Hughes, Edan, *Artists in California, 1786–1940*, Hughes Publication Co., San Francisco, 1986.

Hughes-d'Aeth, Tony, 'An Atlas of a Difficult World: *The Picturesque Atlas of Australasia* (1886–1888)', PhD thesis, University of Western Australia, Perth, 1998.

—*Paper nation: The story of the* Picturesque atlas of Australasia *1886–1888*, Melbourne University Press, Melbourne, 2001.

Hyde, Ralph, *Panoramania: The art and entertainment of the 'all-embracing' view*, Trefoil Publications in association with Barbican Art Gallery, London, 1988.

Hyde, Stuart W., 'The Chinese stereotype in American melodrama', *California Historical Society Quarterly*, vol. 34, 1955, pp. 357–67.

The illustrations of W. T. Smedley (1858–1920), Brandywine River Museum of the Brandywine Conservancy, Inc., Chadds Ford, Pennsylvania, 1981.

Inglis, K. S., 'The Anzac tradition', *Meanjin Quarterly*, March 1965, pp. 25–44.

'The J. Dewing Company. A glimpse at a large and artistic business', *San Francisco Chronicle*, 6 December 1889, p. 5, cols 5 and 6.

Jackson, Helen Hunt, *One woman and sunshine*, unpublished manuscript, Helen Hunt Jackson Papers, The Huntington Library, San Marino, California, 1907.

—*Ramona: a story*, Roberts Bros., Boston, 1884.

Jahn, Graham, *Sydney architecture*, Watermark Press, Sydney, 1997.

James, George Wharton, 'The Arroyo Craftsman', *Arroyo Craftsman*, no. 1, October 1909, p. 52.

—'Charles Keeler, scientist and poet', in *Heroes of California*, Little, Brown, & Co., Boston, 1910, p. 20.

—'The influence of the "Mission Style" upon the civic and domestic architecture of modern California', *The Craftsman*, vol. v, no. 5, February 1905, pp. 458–69.

—'Franciscan mission buildings of California', *The Craftsman*, vol. v, no. 4, January 1905, pp. 321–35.

James, Juliet H., *Palaces and courts of the exposition*, California Book Co., San Francisco, 1915.

Jameson, R. G., *Australia & her gold regions*, Cornish, Lamport & Co., New York, 1852.

Jeffrey, Ian, *Photography: A concise history*, Oxford University Press, New York, 1981.

Jochmus, A. C., *Monterey: All of it between two covers, 1542–1930*, Pacific Grove, 1930.

—*Monterey, California: First capital of the state*, Pacific Grove, 1925.

Johnson, Kaufmann, Coate: Partners in the California style, exhibition catalogue, Lang Art Gallery, Scripps College, Claremont, California, 1992 and Capra Press, Santa Barbara, 1992.

Johnson, Bruce L., 'Labels, lithography, and Max Schmidt', *The Kemble Occasional*, no. 22, Autumn 1979, pp. 1–4.

Johnson, Donald Leslie, *The architecture of Walter Burley Griffin*, Macmillan, Melbourne, 1977.

—*Australian architecture, 1901–1951: Sources of modernism*, University of Sydney Press, Sydney, 1980.

—et al., *F. Kenneth Milne: Portrait of an architect*, exhibition catalogue, Flinders University Art Museum, Adelaide, 1984.

Johnson, J. C. F., *An Austral Christmas*, 2nd edn, W. K. Thomas & Co., Printers, Grenfell Street, Adelaide, 1889.

—'Christmas on Carringa', Wigg & Son, Adelaide, 1873.

—'A game of euchre', wood-engraving, *Australasian Sketcher*, Melbourne, 25 December 1876.

—*Getting gold: A gold-mining handbook for practical men*, Charles Griffin, London, 1897.

—*To Mount Browne and back, or, Moses and Me*, Advertiser Print, Adelaide, 1881.

Johnson, Drew Heath and Marcia Eymann (eds), *Silver & gold: Cased images of the California gold rush*, University of Iowa Press for the Oakland Museum of California, Iowa City, 1998.

Jussim, Estelle, *Visual communication and the graphic arts*, Bowker, New York, 1983.

Kamerling, Bruce, *Irving Gill, architect*, San Diego Historical Society, San Diego, 1993.

—'Hebbard & Gill, architects', *Journal of San Diego History*, vol. 36, 1990, pp. 106–29.

Keeler, Charles A., *Southern California*, illustrated with drawings from nature and from photographs by Louise M. Keeler, Passenger Department, Santa Fe Route, Los Angeles, 1899.

—*The simple home*, with a new introduction by Dimitri Shipounoff, P. Elder, San Francisco, 1904; reprint Peregrine Smith, Santa Barbara and Salt Lake City, 1979.

Keesing, Nancy (ed.), *Gold fever: The Australian goldfields 1851 to the 1890s*, Angus & Robertson, Sydney, 1967.

Keith, Henrietta, 'The trail of Japanese influences in our modern domestic architecture', *The Craftsman*, vol. 12, July 1907, pp. 446–51.

Kent, D. A., '*The Anzac book* and the Anzac legend: C. E. W. Bean as Editor and image-maker', *Historical Studies*, vol. 21, no. 84, April 1985, pp. 376–90.

Kerr, Joan (ed.), *Dictionary of Australian artists (DAA)*, Oxford University Press, Melbourne, 1992.

Kimes, William F. and Maymie B. (eds), *John Muir: A reading bibliography*, Panorama West Books, Fresno, California, 1986.

Kinney, Abbot, *Eucalyptus*, R. R. Baumgardt & Co., Los Angeles, 1895.

Kirk, Ian and Megan Martin, 'Study of inter-war garages & service stations in New South Wales', typescript, December 2006, Historic Houses Trust of New South Wales, Sydney.

Kirker, Harold, *California's architectural frontier*, Peregrine Smith, Santa Barbara and Salt Lake City, 1973.

Kirkpatrick, Peter, *The sea coast of bohemia: Literary life in Sydney's Roaring Twenties*, University of Queensland Press, St Lucia, 1992.

Kitton, Frederic G., *Dickens and his illustrators: Cruikshank, Seymour, Buss, 'Phiz', Cattermole, Leech, Doyle, Stanfield, Maclise, Tenniel, Frank Stone, Landseer, Palmer, Topham, Marcus Stone, and Luke Fildes*, George Redway, London, 1899.

Kohen, Helen L., 'Perfume, postcards, and promises: the orange in art and industry', *The Journal of Decorative and Propaganda Arts*, vol. 23, 1998, pp. 32–47.

Kouvaris, Poppy, 'The Origins of the Spanish Mission Style', BArch thesis, University of New South Wales, Kensington, 1992.

Kropp, Phoebe S., *California vieja: Culture and memory in a modern American place*, University of California Press, Berkeley, 2006.

Krythe, Maymie R., *Port Admiral: Phineas Banning, 1835–1885*, California Historical Society, San Francisco, 1957.

Kurutz, Gary F., *The California gold rush: A descriptive bibliography of books and pamphlets covering the years 1848–1853*, Book Club of California, San Francisco, 1997.

—*California Pastorale: Selected photographs 1860–1920*, Windgate Press, Sausalito, California, 1998.

Lane-Poole, Ruth, 'A Spanish house that is true to type: First of a new series of studies of notable Australian homes', *The Australian Home Beautiful*, 1 February 1928, pp. 12–19.

Larson, Erik, *The devil in the White City: Murder, magic, and madness at the fair that changed America*, Random House, New York, 2003.

Larson, Roger Keith, *Controversial James: An essay on the life and work of George Wharton James*, Book Club of California, San Francisco, 1991.

Lawson, Henry, 'Eureka (A Fragment)', quoted in Hilton Barton, 'Bret Harte and Henry Lawson: Democratic realists,' *The Realist*, vol. xxvi, no. 26, Winter 1967, Sydney, p. 7.

Lawson, Sylvia, *The Archibald paradox*, Penguin, Ringwood, Victoria, 1983.

Lendon, Nigel, 'Ashton, Roberts and Bayliss: Relationships between illustration, painting and photography in the late nineteenth century', in T. Smith and A. Bradley (eds), *Australian art and architecture: Essays presented to Bernard Smith*, Oxford University Press, Melbourne, 1980.

Leslie, Mrs Frank, *California: A pleasure trip from Gotham to the Golden Gate (April, May, June, 1877)*, G. W. Carleton & Co., Publishers, New York, and S. Low, Son & Co., London, 1877.

Levin, JoAnn Early, 'The Golden Age of Illustration: Popular Art in American Magazines', PhD thesis, University of Pennsylvania, Philadelphia, 1980.

Levy, JoAnn, *They saw the elephant: Women in the California gold rush*, University of Oklahoma Press, Norman, 1992.

Levy, Lester S., *Grace notes in American history: Popular sheet music from 1820 to 1900*, University of Oklahoma Press, Norman, 1967.

—*Picture the songs*, Johns Hopkins, Baltimore, 1976.

Lewis, C. T. Courtney, *The picture printer of the nineteenth century, George Baxter, 1804–1867*, S. Low, Marston & Co., London, 1911.

Lewis, Miles, 'Prefabrication in the gold rush era: California, Australia, and the Pacific', *APT Bulletin*, vol. xxxvii, no. 1, 2006, pp. 7–16.

Lewis, Oscar, *The Big Four: The story of Huntington, Stanford, Hopkins, and Crocker, and of the building of the Central Pacific*, A. A. Knopf, New York and London, 1938.

Lilleyman, Gillian and Seddon, George, *A landscape for learning: A history of the grounds of the University of Western Australia*, University of Western Australia, Perth, 2006.

Lohof, Bruce A., 'The service station in America: The evolution of a vernacular form', in Thomas J. Schlereth, *Material culture studies in America*, The American Association for State and Local History, Nashville, 1982, pp. 111–43.

Lorck, W. (ed.), *The Eastern and Australian Steamship Company's illustrated handbook to the East: Australia, Manila, China and Japan, including trips to America and Europe*, 3rd edn, Edward Lee & Co., Sydney, November 1904.

Los Angeles Centennial Celebration Literary Committee, *An historical sketch of Los Angeles County, California: From the Spanish occupancy, by the founding of the mission San Gabriel Archangel, September 8, 1771, to July 4, 1876*, Louis Lewin & Co., Los Angeles, 1876.

Luck, Peter, *A time to remember*, Mandarin, Port Melbourne, 1991.

MacDonald, William, 'The California Expositions',

The Nation, 21 October 1915; reprinted in *Fifty years of American idealism: The New York Nation, 1865–1915*, Houghton Mifflin, Boston, 1915, pp. 442–54.

Mackintosh, Graham (ed.), *Southern California at the turn of the century*, Ross-Erikson, Santa Barbara, California, 1977.

Macleod, Conor, *Macleod of 'The Bulletin': The life & work of William Macleod*, Snelling Printing Works, Sydney, 1931.

MacPhail, Elizabeth, *Kate Sessions: Pioneer horticulturalist*, San Diego Historical Society, San Diego, 1976.

Macomber, Ben, *The jewel city*, John H. Williams, San Francisco and Tacoma, 1915.

Mahood, Marguerite, *The loaded line: Australian political caricature 1788–1901*, Melbourne University Press, Carlton, 1973.

Malouf, David, *A spirit of play: The making of Australian consciousness*, ABC Books, Sydney, 1998.

Makinson, Randell L., *Greene & Greene: Architecture as a fine art*, Gibbs M. Smith, Salt Lake City, 1977.

Manning, John, 'Bold Dick Donohue', *Overland Monthly*, vol. 5, July–December 1870, pp. 147–52.

Marsh, John L., 'Drama and spectacle by the yard: The panorama in America', *Journal of Popular Culture*, vol. 10, Winter 1976, pp. 581–90.

Mason, Walter G., *Australian picture pleasure book: Illustrating the scenery, architecture, historical events, natural history, public characters &c., of Australia*, J. R. Clarke, Sydney, 1857.

Mathison, Richard R., *Three cars in every garage: A motorist's history of the automobile and the automobile club in Southern California*, Doubleday, New York, 1968.

Maynard, Margaret, *Fashioned from penury: Dress as cultural practice in colonial Australia*, Cambridge University Press, New York, 1994.

McCandless, Barbara, *New York to Hollywood: The photography of Karl Struss*, Amon Carter Museum and University of New Mexico Press, Fort Worth, Texas, 1995.

McClatchie, Alfred, 'Eucalypts cultivated in the United States', Bulletin 35, Bureau of Forestry, US Department of Agriculture, 1903.

McClelland, Gordon T. and Last, Jay T., *California orange box labels*, Hillcrest Press, Beverly Hills, 1985.

McClung, William Alexander, *Landscapes of desire: Anglo mythologies of Los Angeles*, University of California Press, Berkeley, 2000.

McCoy, Esther, *Five California architects*, Praeger, New York, 1975.

—'Roots of Californian contemporary architecture', *Arts & architecture*, vol. 73, no. 10, October 1956, California, pp. 14–19.

McCulloch, Allan, *Artists of the Australian gold rush*, Lansdowne Editions, Melbourne, 1977.

McDonald, D. I., 'Murdoch, John Smith (1862–1945)', *ADB*, vol. 10, pp. 621–22.

McGrath, Robert L., 'The endless trail of the *End of the trail*', *Journal of the West*, vol. 40, no. 4, Fall 2001, pp. 8–15.

McGregor, Russell, *Imagined destinies: Aboriginal Australians and the doomed race theory*, Melbourne University Press, Melbourne, 1997.

McLaren, John, *Gardening in California: Landscape and flower*, A. M. Robertson, San Francisco, 1909.

McWilliams, Carey, *Southern California country: An island on the land*, Peregrine Smith, Salt Lake City, 1946; revised edition, title change, *Southern California: An island on the land*, 1973.

'Medicinal plants in California', *Botanical gazette*, vol. 3, no. 10, October 1878, p. 86.

Millar, Louis du Puget, 'The bungalow courts of California: Bowen's Court. Arthur S. Heinemann Architect', *House Beautiful*, (USA), vol. 40, November 1916, pp. 338–39.

'Minutes of Evidence taken before The Select Committee on the Picturesque Atlas Company', Legislative Assembly, New South Wales, Thursday 16 February 1893, section 99, p. 111.

Missal, Alexander, *Seaway to the future: American social visions and the construction of the Panama Canal*, University of Wisconsin Press, Madison, 2008.

Modjeska, Helena, *Memories and impressions of Helena Modjeska: An autobiography*, Macmillan, New York, 1910.

Monaghan, Jay, *Australians and the gold rush*, University of California Press, Berkeley, 1966.

Monograph of the work of Charles A Platt with an introduction of Royal Cortissoz, The Architectural Book Publishing Co., New York, 1913.

Moore, Bruce (ed.), *Gold! Gold! Gold! The language of the nineteenth-century Australian gold rushes*, Oxford University Press, South Melbourne, 2000.

Moore, Charles, *Los Angeles: The city observed*, Hennessey + Ingalls, Santa Monica, 1998.

Moore, John D., 'Bertram Grosvenor Goodhue: An appreciation', *Architecture: Proceedings of The Institute of Architects of New South Wales*, vol. 13, no. 9, September 1924, pp. 8–11.

Moore, Tony, 'Australia's bohemian tradition: Take

two', *Journal of Australian Studies*, no. 58, 1998, pp. 56–65.

Morgan, E. J. R., 'Gill, Samuel Thomas (1818–1880)', *ADB*, vol. 1, Melbourne University Press, 1966, pp. 444–45.

Moritz, Albert F., *America the picturesque in nineteenth century engraving*, New Trend, New York, 1983.

Morrison, Hugh, *Louis Sullivan: Prophet of modern architecture*, W. W. Norton, New York, 1998.

Mostardi, David, *A checklist of the publications of Paul Elder*, 2nd edn, Morgan Shepard, Washington, DC, 2004.

Mountford, Ben, 'Hume Nisbet's Little Bourke Street: "Slumming" it in 1880s Melbourne', first place winner, essay competition, Melbourne Arts Student Society, 2007, <http://www.m–assonline.com/1stPlaceBen.doc>.

Moure, Nancy Dustin Wall, *California art: 450 years of painting and other media*, Dustin Publications, Los Angeles, 1998.

—*Dictionary of art and artists in Southern California before 1930*, private pub., Los Angeles, 1975.

—'Impressionism, post–impressionism, and the Eucalyptus School in Southern California', in Ruth Westphal, *Plein air painters of California: The Southland*, Westphal Publishing, Irvine, 1982.

—*Loners, mavericks and dreamers: Art in Los Angeles before 1900*, Laguna Art Museum, Laguna, California, 1993.

Muccigrosso, Robert, *Celebrating the New World: Chicago's Columbian Exposition of 1893*, Ivan R. Dee, Chicago, 1993.

Muir, John, (ed.), *Picturesque California*, The J. Dewing Co., San Francisco and New York, 1888.

Mullgardt, Louis Christian, *The architecture and landscape gardening of the exposition*, Paul Elder, San Francisco, 1915.

Mungen, William, '"The heathen Chinese"; Speech of Hon. William Mungen, of Ohio, delivered in the House of Representatives, January 7, 1871', F. & J. Rivers & Geo. A. Bailey, Washington, DC, 1870.

Murdock, Charles, 'History of printing in San Francisco part xii', *The Kemble Occasional*, no. 35, Winter 1985, p. 2.

Murray, Les, *Selected poems: The vernacular republic*, Angus & Robertson, Sydney, 1980.

Myrick, David F., *Montecito and Santa Barbara*, 2 vols, Trans-Anglo Books, Glendale, 1988 and 1991.

Nadeau, Remi A., *City makers: The men who transformed Los Angeles from village to metropolis during the first great boom, 1868–76*. Doubleday, New York, 1948.

Nelson, Ruth R., *Rancho Santa Fe—yesterday and today*, Coast-Dispatch, Encinitias, California, 1947.

Nelson's biographical dictionary and historical reference book of Erie County, S. B. Nelson, Erie, Pennsylvania, 1896.

Neuhaus, Eugen, *The San Diego Garden Fair: Personal impressions of the architecture, sculpture horticulture, color scheme & other aesthetic aspects of the Panama–California International Exposition*, Paul Elder, San Francisco, 1916.

—et al., *The art of the exposition: Personal impressions of the architecture, sculpture, mural decorations, color scheme & other aesthetic aspects of the Panama–Pacific International Exposition*, Paul Elder & Co., San Francisco, 1915.

'New ideas allied to Old–World Styles', *The Australian Home Beautiful*, 7 June 1926, pp. 15–19.

Newcomb, Rexford, *Mediterranean domestic architecture in the United States*, J. H. Jansen, Cleveland, 1928; reprint Acanthus Press, New York, 1999.

—*The Spanish house for America: Its design, furnishing, and garden*, J. B. Lippincott Co., London and Philadelphia, 1927.

Newton, Gael, *Shades of light: Photography and Australia, 1839–1988*, Australian National Gallery and Collins Australia, Canberra, 1988.

Richard E. Nicholls, in John Muir (ed.), *West of the Rocky Mountains*, J. Dewing, New York, 1888; Running Press, Philadelphia, 1974.

Odell, George C. D., *Annals of the New York stage*, New York, 1931.

The official catalogue of the California Midwinter-International-Exposition San Francisco, California, 2nd edn, Harvey, Whitcher & Allen, San Francisco, 1894.

Official guide to the World's Columbian Exposition in the City of Chicago, Handbook Edition, The Columbian Guide Company, Chicago, 1893.

'Old time Australian shipping', *The Lone Hand*, 1 July 1913, p. 212.

Oliver, Julie, The Australian Home Beautiful: *From hills hoist to high rise*, Pacific Publications, McMahon's Point, NSW, 1999.

Oliver, Richard, *Bertram Grosvenor Goodhue*, MIT Press, Cambridge, Massachusetts, 1983.

Opitz, Glenn B. (ed.), *Mantle Fielding's dictionary of American painters, sculptors and engravers*, Apollo, New York, 1983.

Ore, Janet, 'Jud Yoho, "The bungalow craftsman", and the development of Seattle suburbs' in Carter Hudgins and Elizabeth Cromley (eds), *Shaping communities: Perspectives in vernacular architecture IV,* University of Tennessee Press, Knoxville, 1997.

Orth, Myra Dickman, 'The influence of the "American Romanesque" in Australia', *Journal of the Society of Architectural Historians,* vol. 34, no. 1, 1975, pp. 3–18.

Ott, John, 'Landscapes of consumption: Auto tourism and visual culture in California, 1920–1940', in Stephanie Barron, et al., *Reading California: Art, image, and identity, 1900–2000,* University of California Press, Berkeley, 2000.

Our society directory for San Francisco, Oakland and Alameda. Containing the residence address of over eight thousand society people and a complete visiting, club, theatre and shopping guide, The J. Dewing Co., Publishers, San Francisco, 1888.

Padilla, Victoria, *Southern California gardens: An illustrated history,* University of California Press, Berkeley, 1961.

Palmquist, Peter, *A bibliography of writings by and about women in photography, 1850–1990,* Borgo Press, Arcata, California, 1994.

—'The sad but true story of a Daguerreian Holy Grail', in Drew Heath Johnson and Marcia Eymann (eds), *Silver & gold: Cased images of the California gold rush,* University of Iowa Press for the Oakland Museum of California, Iowa City, 1998.

—*Women photographers: A selection of images from the* Women in Photography International Archive, *1852–1997,* Iaqua Press, Arcata, California, 1997.

—and Thomas R. Kailbourn, *Pioneer photographers of the Far West: A biographical dictionary, 1840–1865,* Stanford University Press, Stanford, 2000.

Parker, Gilbert, 'Glimpses of Australian life', *Harper's Weekly,* vol. xxxv, no. 1791, 18 April 1891, pp. 232–36.

Parker, Matthew, *Panama fever: The epic story of one of the greatest achievements of all time—The building of the Panama Canal,* Doubleday, New York, 2008.

Payne, Theodore, 'The eucalyptus in California: The eucalyptus centennial', *Golden Gardens,* January 1957, pp. 9–12.

—*Life on the Modjeska Ranch in the Gay Nineties,* Los Angeles, 1962.

—and Elizabeth Pomeroy (ed.), *Theodore Payne in his own words: A voice for California native plants,* Many Moons Press, Pasadena, 2004.

Peddle, James, 'The bush bungalow', *The Home,* September 1920, pp. 29–30.

—'Some lessons we can learn from our American neighbours', *Building,* vol. 20, no. 110, 12 October 1916, pp. 90–94 and no. 113, 12 January 1917, pp. 98–99.

Pegrum, Roger, 'Canberra: The bush capital', in Pamela Statham (ed.), *The origins of Australia's capital cities,* Cambridge University Press, Cambridge, England, 1989, pp. 317–40.

Peirce, Augustus Baker, *Knocking about: Being some adventures of Augustus Baker Peirce in Australia,* Mrs. Albert T. Leatherbee (ed.), with an introduction by Edwin Howard Brigham, MD, illustrated by the writer, Oxford University Press, London and Yale University Press, New Haven, 1924.

Peixotto, Ernest, 'Italy's message to California', *Sunset,* March 1903, pp. 366–78.

Perry, Claire, *Pacific arcadia: Images of California 1600–1915,* Oxford University Press, New York, 1999.

Pescott, R. T. M., 'W. R. Guilfoyle (1840–1912): The master of landscape', *ADB,* vol. 4, p. 307.

Peters, Harry T., *California in stone,* Doubleday, New York, 1935.

Peterson, Richard, 'No. 10: The Esplanade (formerly Belvedere)', *A place of sensuous resort: Buildings of St Kilda and their people,* St Kilda Historical Series, no. 6, St Kilda Historical Society, Balaclava, Victoria, 2005, <http://www.skhs.org.au/SKHSbuildings/buildings.htm>.

Peterson, Richard H., *The bonanza kings: The social origins and business behavior of western mining entrepreneurs, 1870–1900,* University of Nebraska Press, Lincoln, 1977.

Pfister, Harold Francis, *Facing the light: Historic American portrait daguerreotypes,* National Portrait Gallery by Smithsonian Institution Press, Washington, DC, 1978.

Phillips, David Clayton, 'Art for Industry's Sake: Halftone Technology, Mass Photography and the Social Transformation of American Print Culture, 1880–1920', PhD thesis, Yale University, New Haven, 1996.

Phillips, John, 'John Sulman and the question of an "Australian style of architecture,"' *Fabrications,* no. 8, July 1997, pp. 87–116.

'Picturesque California', *Overland Monthly,* vol. xii, 2nd series, no. 72, December 1888, pp. 659–60.

'Picturesque Southern California', *Los Angeles Times,* 1 January 1890, p. A1.

Pinckney, Pauline A., *Painting in Texas: The nineteenth century,* University of Texas Press, Austin, 1967.

Pitt, Leonard and Dale Pitt (eds), *Los Angeles A to Z: An encyclopedia of the city and county*, University of California Press, Berkeley, 1997.

Platt, Charles A., 'Italian gardens', *Harper's New Monthly Magazine*, July and August 1893, pp. 165–80.

—*Italian gardens*, Harper's, New York, 1894.

Pomeroy, Elizabeth, *John Muir: A naturalist in Southern California*, Many Moons Press, Pasadena, California, 2001.

Potts, Daniel, *Young America and Australian gold*, University of Queensland Press, St Lucia, 1974.

Powell, Lawrence Clark, 'Eucalyptus trees & lost manuscripts', *California Librarian*, January 1956, pp. 32–33, 57.

Priessnitz, Horst, 'Dreams in Austerica: a preliminary comparison of the Australian and the American Dream,' *Westerly*, no. 3, Spring 1994, pp. 45–64.

Proudfoot, Peter, 'Canberra: The triumph of the Garden City', *Journal of the Royal Australian Historical Society*, vol. 77, part 1, 1991, pp. 20–39.

'Railroad advertising of the Far West: A portfolio,' *California History*, vol. 69, Spring 1991, pp. 65–75.

Rainey, Sue, *Creating Picturesque America: Monument to the natural and cultural landscape*, Vanderbilt University Press, Nashville, 1994.

—'Picturesque California: How Westerners Portrayed the West in the Age of John Muir', www.common-place.org, vol. 7, no. 3, April 2007, <http://www.common-place.org/vol-07/no-03/rainey/>.

'The reception of the American Fleet', *Art & Architecture: Being the Journal of The Institute of Architects of New South Wales*, vol. v, no. 3, May–June 1908, pp. 96–97.

Reid, Paul, *Canberra following Griffith*, National Archives of Australia, Canberra, 2002.

Remondino, Peter, *The Mediterranean shores of America: Southern California, its climate, physical, and meteorological conditions*, The F.A. Davis Co., Philadelphia and London, 1892.

Reynolds, Peter, 'Clamp, John Burcham (1869–1931)', *ADB*, vol. 8, p. 1.

—'Vernon, Walter Liberty (1846–1914)', *ADB*, vol. 12, pp. 320–22.

—and Richard E. Apperly, 'Dellit, Charles Bruce (1898–1942)', *ADB*, vol. 13, pp. 612–13.

—et al., *John Horbury Hunt: Radical architect 1838–1904*, Historic Houses Trust of New South Wales, Sydney, 2002.

Requa, Richard S., *Architectural details of Spain and the Mediterranean*, J. H. Jansen, Cleveland, 1926.

—*Old World inspiration for American architecture*, Monolith Portland Cement Co., Los Angeles, 1929.

Richards, S. L. and G. M. Blackburn, 'The Sydney Ducks: A demographic analysis', *Pacific Historical Review*, no. 42, 1973.

'The rise of the new State Theatre: A marvel of modern building and engineering skill', *Australian Home Beautiful*, 1 February 1929, pp. 60–62.

Roberts, J. H., 'Through Australian eyes—'Frisco', *Building*, 12 February 1914, pp. 35–43.

Rudisill, Richard, *Mirror image: The influence of the daguerreotype on American society*, University of New Mexico Press, Albuquerque, 1971.

Russell, Penny, '*A wish of distinction*': Colonial gentility and femininity, Melbourne University Press, Melbourne, 1994.

Salvator, Ludwig, *Eine Blume aus dem Goldenen Lande oder Los Angeles*, H. Mercy, Prague, 1878.

Satzman, Darrell, 'Eucalyptus trees are rancher's legacy', *Los Angeles Times*, 24 August 1997.

A sampler of California's pictorial letter sheets 1849–1869, The Zamorano Club, Los Angeles, 1980.

Sandweiss, Martha A., *Print the legend: Photography and the American West*, Yale University Press, New Haven, 2002.

Sanjek, Russell, *American popular music and its business: The first four hundred years,* Oxford University Press, Oxford, 1988.

Santos, Robert L., *The eucalyptus of California: Seeds of good or evil?*, Alley-Cass Publications, Denair, California, 1997.

—'The eucalyptus of California', *Southern California Quarterly*, vol. lxxx, no. 2, Summer 1998, p. 110.

'Say it is a broken contract; Walbridge & Co. sue the J. Dewing Publishing Company', *Brooklyn Eagle*, 26 January 1893, p. 1.

Schaffer, Sarah J., 'A civic architect for San Diego: The work of William Templeton Johnson', *The Journal of San Diego History*, vol. 45, no. 3, Summer 1999, pp. 166–87.

Scharnhorst, Gary, *Bret Harte: A bibliography*, Scarecrow Author Bibliographies, no. 95, Scarecrow Press, Lanham, Maryland, and London, 1995.

—*Bret Harte's California: Letters to the* Springfield Republican *and* Christian Register, *1866–67*, University of New Mexico Press, Albuquerque, 1990.

—'"Ways that are dark": Appropriations of Bret Harte's "Plain Language from Truthful James"', *Nineteenth-century literature*, vol. 51, 1996–97, pp. 377–99.

Schell, Frederic B., 'How books are illustrated', in *Centennial Magazine*, vol. i, no. 2, September 1888, pp. 118–21.

Schmidt, Max Jr, et al. and Ruth Teiser (interviewer), *The Schmidt Lithographic Company*, vols i and ii, Regional Oral History Office, The University of California, Berkeley, California, 1968.

Seewerker, Joseph and Charles H. Jones, *Nuestro pueblo: Los Angeles, city of romance*, Houghton Mifflin, Boston, 1940.

Serle, Geoffrey, *The creative spirit in Australia: A cultural history*, Heinemann, Richmond, Victoria, 1987.

—*From deserts the prophets come: The creative spirit in Australia, 1788–1972*, Heinemann, Melbourne, 1973.

—*The golden age: A history of the colony of Victoria, 1851–1861*, rev. edn, Melbourne University Press, Melbourne, 1963.

—*The rush to be rich: A history of Victoria 1883–1889*, Melbourne University Press, Melbourne, 1971.

Seropian, Nurair, 'California Bungalow', MBEnv thesis, University of New South Wales, Kensington, 1986.

Sharp, Dennis G., 'Reconstructed adobe: The Spanish past in the architectural records of the San Diego Historical Society, 1907–1919', *Journal of San Diego History*, vol. 49, nos 3 and 4, Summer–Fall 2003, pp. 127–30.

Shaw, Peter, *A history of New Zealand architecture*, Hodder Moa Beckett, Auckland, 1997.

Sherer, John, *The gold-finder of Australia: How he went, how he fared, how he made his fortune; edited by John Sherer; illustrated with forty-eight magnificent engravings from authentic sketches taken in the colony*, Clarke, Beeton, London, 1853.

Sherwood, M. E. W., *An epistle to posterity: Being rambling recollections of many years of my life*, Harper's, New York, 1897.

Shields, Scott A., *Artists at continent's end: The Monterey Peninsula Art Colony, 1875–1907*, University of California Press, Berkeley, 2006.

Sloane, Julia M., *The smiling hilltop, and other California sketches*, Scribner's, New York, 1919.

Smith, Bernard, 'Architecture in Australia', *Historical Studies*, vol. 14, no. 53, pp. 90–91.

—*Australian painting 1788–1990*, Oxford University Press, Melbourne, 1991.

—*Place, taste and tradition*, Ure Smith, Sydney, 1945; and 2nd edn, Oxford, South Melbourne, 1979.

—*The spectre of Truganini*, ABC Broadcasting, Sydney, 1980.

—'Dickinson, Sidney (1851–1919)', *ADB*, vol. 8, pp. 302–03.

Soilleux, Easter, 'A notable modified Spanish home', *The Australian Home Beautiful*, 2 December 1929, p. 19.

Soilleux, G. A., 'The small home in California: Its lesson and a note of warning', *The Australian Home Beautiful*, 1 August 1928, pp. 16–18.

Solnit, Rebecca, *River of shadows: Eadweard Muybridge and the technological Wild West*, Viking, New York, 2003.

'Some of Melbourne's notable flats', *The Australian Home Beautiful*, 1 April 1927, pp. 14–17.

Sontag, Susan, *In America*, Farrar Strauss Giroux, New York, 2000.

Soros, Susan Weber (ed.), *E. W. Godwin: Aesthetic Movement Architect and Designer*, Yale University Press, New Haven, 1999.

Soulé, Frank, et al. (eds), *The annals of San Francisco*, D. Appleton & Co., New York, 1855.

Spalding, William A., *History and reminiscences of Los Angeles City and County, California*, J. R. Finnell & Sons, Los Angeles, [1930].

Spearritt, Peter, 'Spain, Alfred (1868–1954)', *ADB*, vol. 12, pp. 25–26.

Stanford, Leland G., 'San Diego's eucalyptus bubble', *The Journal of San Diego History*, vol. 16, no. 4, Fall 1970, p. 17.

Starr, George, 'Truth unveiled: The Panama Pacific International Exposition and its interpreters', in Burton Benedict, et al., *The anthropology of world's fairs: San Francisco's Panama Pacific International Exposition of 1915*, pp. 134–75.

Starr, Kevin, *Americans and the California dream 1850–1915*, Oxford University Press, New York, 1973.

—*California: A History*, Modern Library, New York, 2005.

—*Coast of dreams: California on the edge, 1990–2003*, Knopf, New York, 2004.

—*The dream endures: California enters the 1940s*, Oxford University Press, New York, 1997.

—*Material dreams: Southern California through the 1920s*, Oxford University Press, New York and Oxford, 1990.

—'*Sunset* and the phenomenon of the Far West', in *Sunset Magazine: A century of western living, 1898–1998: Historical portraits and a chronological bibliography of selected topics*, Stanford University Libraries, Palo Alto, California, 1998.

Stephens, John, *Henry Russell in America: Chutzpah and huzzah*, University of Illinois, Urbana-Champaign, 1975.

Stevens, Bertram, 'A. H. Fullwood', *Art in Australia*, no. 8, 1921, n.p.

Stevenson, R., 'California pioneer sheet music publishers and publications', *Inter-American Music Review*, vol. viii, no, 1, 1986, pp. 1–7.

Stewart, George R., *Bret Harte: Argonaut and exile*, Houghton Mifflin, Boston, 1931.

Stickley, Gustav, 'Nature and art in California', *The Craftsman*, vol. 6, no. 4, July 1904, pp. 370–90.

Stokes, Sally Sims, 'In a climate like ours: The California campuses of Allison & Allison', *California History*, vol. 84, no. 4, Fall 2007, pp. 26–65, 69–73.

Storrs, Les, *Santa Monica: Portrait of a city yesterday & today*, SM Bank, Santa Monica, 1974.

Street, Arthur I., 'Seeking trade across the Pacific', *Sunset*, vol. 15, no. 5, September 1905, p. 407.

Streatfield, David C., *Californian gardens: Creating a new Eden*, Abbeville Press, New York, 1994

—'"Paradise" on the frontier', *Garden History*, vol. 12, no. 1, Spring 1984, pp. 58-80.

Struss, Karl, Susan Edwards Harvith and John Harvith, *Karl Struss, man with a camera: The artist–photographer in New York and Hollywood*, Cranbrook Academy of Art Museum, Bloomfield Hills, Michigan, 1976.

Sulman, John, 'Verandahs and loggiae II', *Australiasian Builder and Contractors' News*, 21 May 1887.

—'Verandahs and loggiae III', *Australiasian Builder and Contractors' News*, 28 May 1887.

Summers, Anne, *Damned whores and God's police*, 2nd edn, Penguin, Melbourne, 1994.

Sumner, Ray, 'The tropical bungalow—the search for an indigenous Australian architecture', *Australian Journal of Art*, vol. 1, 1978, pp. 27–39.

Swingle, John and Mary, 'California sheet music covers', Book Club of California Keepsakes, no. 3, 1959.

Talley-Jones, Kathy and Letitia Burns O'Connor, *The road ahead: The Automobile Club of Southern California, 1900–2000*, Automobile Club, Los Angeles, 2000.

Tanner, Howard, 'Stylistic influences on Australian architecture: Selective simplification 1868–1934', *Architecture in Australia*, April 1974.

Tatham, David, *The lure of the striped pig: The illustration of popular music in America 1820–1870*, Barre, Massachusetts, 1973.

Taylor, Frank J., *Land of homes … of the series California*, Powell Publishing Company, Los Angeles, California, 1929.

Taylor, George A., 'Art and architecture at the San Francisco Exposition', *Building*, 12 February 1915, p. 111.

—'The city of the Golden Gate', *Building*, 12 February 1915, pp. 110–11.

—'A magic city of temples', in *There! Being the American adventures of three Australians during the period of the Great European War*, first printed in *Building*, 12 March 1915, pp. 96–107.

—*'Those were the days': Being reminiscences of Australian artists and writers*, Tyrrell's, Sydney, 1918.

Tebbel, John and Mary Ellen Zuckerman, *The magazine in America 1741–1990*, Oxford University Press, New York, 1991.

Terry, Martin, 'Fullwood, Albert Henry (1863–1930)', *ADB*, vol. 8, pp. 598–99.

Thieme-Becker, *Allgemeines Lexikon der bildenden Künstler*, Leipzig, 1915.

Thomas, Daniel, 'Edward La Trobe Bateman', *ADB*, vol. 3, pp. 117–118.

Thomas, Jeffery Allen, 'Promoting the Southwest: Edgar L. Hewett, Anthropology, Archaeology, and the Santa Fe Style', PhD thesis, Texas Tech University, Lubbock, 1999.

Thompson, R. M., 'David Jones' in War and Peace', BA (Hons) thesis, Macquarie University, Sydney, 1980.

—'Jones, Sir Charles Lloyd (1878–1958)', *ADB*, vol. 9, pp. 507–08.

Tibbits, George, 'Alsop, Rodney Howard (1881–1932)', *ADB*, vol. 7, 1979, pp. 47–48.

Todd, Frank Morton, *The story of the exposition*, G. P. Putnam's, New York, 1921.

Topliss, Helen, *The artists' camps*, Hedley, Melbourne, 1992.

'Town planning and its architectural essentials', *Building*, 11 October 1913, pp. 50–60.

'Town planning for Australia: An enterprising realty man's tour', *Building*, 12 March 1913, pp. 146–47.

Trachtenberg, Alan, 'The daguerreotype and antebellum America', in Grant B. Romer and Brian Wallis (eds), *Young America: The daguerreotypes of Southworth & Hawes*, Steidl, Göttingen, Germany; The George Eastman House, Rochester, New York; The International Center of Photography, New York, 2005.

Traill, William, 'The genesis of "The Bulletin"', *The Lone Hand*, 1 November 1907, p. 68.

Tregenza, J., 'The visual dimension of colonial history', *Art and Australia*, vol. 19, no. 1, 1981, pp. 91–96.

Trollope, *Australia and New Zealand*, Chapman and Hall, London, 1873.

Tucker, John M., 'Francesco Franceschi', *Madroño*, vol. 7, 1943, p. 19.

Tucker, Maya V., 'Centennial celebrations 1888: Australasia: Her trials and triumphs in the past: Her union and progress in the future', in Graeme Davison, et al., *Australia 1888*, Fairfax, Syme & Weldon, Sydney, vol. 7, 1987.

Turrill, Charles B., *California notes*, E. Bosqui & Co., San Francisco, 1876.

Twain, Mark, *Following the equator*, American Publishing Company, Hartford, 1897.

'$22 million Boomerang returns as a rich man's residence', *Gold Coast Bulletin*, 7 February 2002.

Tyrrell, Ian, *True gardens of the gods: Californian–Australian environmental reform, 1860–1930*, University of California Press, Berkeley, 1999.

Underhill, Nancy D., *Making Australian art 1916–1949: Sydney Ure Smith, patron and publisher*, Oxford University Press, Oxford, 1991.

—'Smith, Sydney George Ure (1887–1949)', *ADB*, vol. 11, pp. 662–63.

Van Dyke, E., 'Blue gum eucalyptus in the Elkhorn Watershed: 1930–present', presentation, Ecology and Impacts of Blue Gum Eucalyptus in Coastal California Conference, Elkhorn Slough National Estuarine Research Reserve, Coastal Training Program, California Invasive Plant Council, 3 June 2004.

Van Pelt, Garrett, Jr, *Old architecture of southern Mexico*, J. H. Jansen, Cleveland, 1926.

Van Straten, Frank and Marriner, Elaine, *The Regent Theatre: Melbourne's palace of dreams*, ELM Publishing, Melbourne, 1996.

Van Tilburg, Walter (ed.), *The journals of Alfred Doten 1849–1903*, University of Nevada Press, Reno, 1973.

Vernon, Christopher, 'Landscape (+) architecture at UWA', *Architecture Australia*, July–August 2001, <http://www.architectureaustralia.com>.

The Victim, 'The house a man built to please his wife', *The Australian Home Beautiful*, 2 September 1929, pp. 18–22.

Vieyra, Daniel, *'Fill 'er up': An architectural history of America's gas stations*, Collier Books, New York, 1979.

Walling, Edna, *Edna Walling's year*, Anne O'Donovan, South Yarra, Victoria, 1990.

Warner, Charles Dudley, *Our Italy*, Harper's, New York, 1891.

Warren, Viola Lockhart, 'The eucalyptus crusade', *Southern California Quarterly*, vol. 44, 1962, pp. 31–42.

Waterhouse, Michael, 'Waterhouse, Bertrand James (1876–1965)', *ADB*, vol. 12, pp. 388–89.

Watters, Sam, *Houses of Los Angeles, 1885–1919*, vol. i, Acanthus Press, New York, 2007.

—*Houses of Los Angeles, 1920–1935*, vol. ii, Acanthus Press, New York, 2007.

Weed, C. L., *Scenes of wonder and curiosity in California*, Hutchings & Rosenfield, San Francisco, 1861.

Weinberg, Albert K., *Manifest Destiny: A study of nationalist expansionism in American history*, Johns Hopkins, Baltimore, 1935.

Weitze, Karen, *California's Mission Revival*, California Architecture and Architects, no. iii, Hennessey & Ingalls, Los Angeles, 1984.

Westcott, Peter, 'Chaffey, George (1848–1932)', *ADB*, vol. 7, pp. 599–601.

West, Richard Samuel, *The San Francisco Wasp: An illustrated history*, Periodyssey Press, Easthampton, Massachusetts, 2004.

West Coast expositions and galas, Keepsake Series, folder no. 6, Book Club of California, San Francisco, 1970.

Whitaker, Herman, 'Berkeley the beautiful', *Sunset*, vol. 18, December 1906, pp. 138–44.

White, Richard, *Inventing Australia: Images and identity 1688–1980*, Allen & Unwin, Sydney and London, 1981.

Whitson, Leon, '20s Spanish Style needs no revival: red tile roofs, white walls endure as Southland favorites', *Los Angeles Times*, 5 March 1989, section viii, p. 26.

Whittlesey, Austin, *The Renaissance architecture of central and northern Spain: A collection of photographs and measured drawings*, Architectural Book Pub. Co., New York, 1920.

Who was who in American art, 1564–1975, Soundview Press, Madison, Connecticut, 1999.

Wickson, Edward J., 'The Vacaville early fruit district of California', *California Illustrated No. I*, California View Publishing Co., San Francisco, 1888.

Wilde, William H., et al., *Oxford companion to Australian literature*, 2nd edn, Oxford University Press, Melbourne, 1994.

Wilkinson, B. A. and R. K. Willson, *The main fleet of Burns Philp*, The Nautical Association of Australia, Canberra 1981.

Wilkinson, Leslie, 'Domestic architecture', in Ure Smith and Bertram Stevens (eds) in collaboration with W. W. Hardy Wilson, *Domestic architecture in Australia*, Special Number of *Art in Australia*, Angus & Robertson, Sydney 1919.

—'Domestic architecture', *Building*, 12 September 1921, p. 63.

Willard, Myra, *History of the White Australia Policy*

to 1920, Melbourne University Press, Melbourne, 1923.

Willard, Walter, 'Moving the factory back to the land', *Sunset*, March 1913, pp. 299–304.

Williams, John, '"Art, war and agrarian myths": Australian reactions to modernism 1913–1931', in Judith Smart and Tony Wood (eds), *An Anzac muster: War and society in Australia and New Zealand 1914–18 and 1939–45*, Monash Publications in History, no. 14, 1992, pp. 40–57, Monash University Press, Melbourne.

Williams, John F., '1914–19: Gilding battlefield lilies', in his *Quarantined culture: Australian reactions to modernism 1913–1939*, Cambridge University Press, Cambridge, UK, 1995.

Willis, Alfred, 'A survey of the surviving buildings of the Krotona Colony in Hollywood', *Architronic*, vol. 8, no. 1, 1998.

Willis, Anne-Marie, *Picturing Australia: A history of photography*, Angus & Robertson, North Ryde, NSW, 1988.

Wilson, Carol Green, *Gump's treasure trade: A story of San Francisco*, Crowell, New York, 1949; reprinted in 1965.

Wilson, Iris Higbie, *William Wolfskill: Frontier trapper to California ranchero*, A. H. Clark Co., Glendale, 1965.

Wilson, Michael G. and Dennis Reed, *Pictorialism in California*, The Getty Museum, San Marino and Henry E. Huntington Library, Malibu, 1994.

Wilson, W. Hardy, 'Building Purulia', in Ure Smith and Bertram Stevens (eds) in collaboration with W. W. Hardy Wilson, *Domestic Architecture in Australia,* Special Number of *Art in Australia*, Angus & Robertson, Sydney 1919, pp. 13–14.

Winter, Robert, *The architecture of entertainment: LA in the Twenties*, Gibbs-Smith, Salt Lake City, 2006.

—*The California bungalow*, Hennessey & Ingalls, Los Angeles, 1980.

—and David Gebhard, *Architecture in Los Angeles: The complete guide*, Gibbs-Smith, Salt Lake City, 1985.

Wolff, Lisa, 'Requa rediscovered', *Decor & Style*, December 1998.

Wood, John, *The photographic arts*, Iowa City, University of Iowa Press, Iowa City, 1997.

Workman, Boyle, *The city that grew*, Southland, Los Angeles, 1936.

The world's fair, being a pictorial history of the Columbian Exposition, Chicago Publication and Lithograph, Chicago, 1893; reprint by Chicago Historical Society.

Wylie, Romy, *Bertram Goodhue: His life and residential architecture*, W. W. Norton, New York, 2007.

Yates, Morgan, 'Track stars', *Westways*, January–February 2004.

Yoch, James J., *Landscaping the American dream: The gardens and film sets of Florence Yoch: 1890–1972*, Abrams, New York, 1989.

Yoho, Jud, *Craftsman master built homes catalogue*, Seattle, Washington, 1915.

Zacharin, Robert Fyfe, *Emigrant eucalypts: Gum trees as exotics*, Melbourne University Press, Melbourne, 1978.

Zierer, Clifford M., 'The citrus fruit industry of the Los Angeles Basin', *Economic Geography*, vol. 10, no. 1, January 1934, pp. 53–73.